General Editor, Jack Flam
Founding Editor, Robert Motherwell

Other titles in the series available from University of California Press:

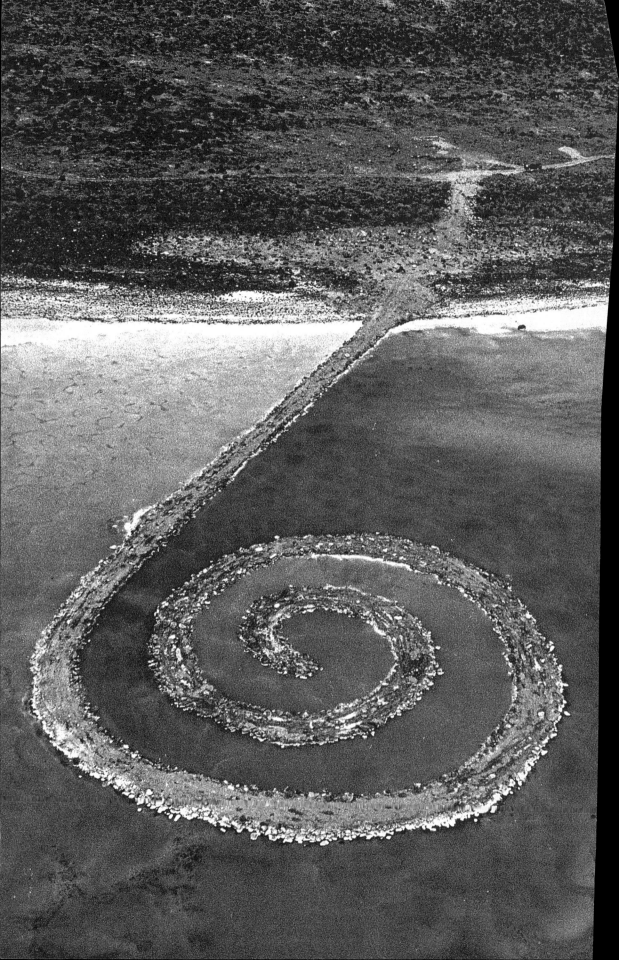

ROBERT SMITHSON:
THE COLLECTED WRITINGS

EDITED BY JACK FLAM

UNIVERSITY OF CALIFORNIA PRESS

University of California Press
Oakland, California

Library of Congress Cataloging-in-Publication Data
Smithson, Robert.
 Robert Smithson, the collected writings / edited, with an
Introduction by Jack Flam.
 p. cm. — (The documents of twentieth century art)
 Originally published: The writings of Robert Smithson. New York :
New York University Press, 1979.
 Includes bibliographical references and index.
 ISBN 978-0-520-20385-3 (pbk. : alk. paper)
 1. Art. I. Title. II. Series.
N7445.2.S62A35 1996
700—dc20
 95-34773
 CIP

Printed in the United States of America

25 24 23 22 21 20
15 14 13

The paper used in this publication meets the minimum requirements of
ANSI/ NISO Z39.48-1992 (R 1997) (*Permanence of Paper*). ∞

The cover and frontispiece photographs are by Gianfranco Gorgoni.

CONTENTS

INTERVIEWS

UNPUBLISHED WRITINGS

PREFACE

This book is a revised and expanded edition of *The Writings of Robert Smithson*, edited by Nancy Holt and published by New York University Press in 1979. Like the first edition, this book is organized into three sections, consisting of Published Writings, Interviews, and Unpublished Writings. Within each section, the texts are arranged chronologically.* To the Published Writings have been added four texts that have subsequently come to light; the Interviews now include three more items; and over thirty texts have been added to the section of Unpublished Writings. (Of these new unpublished texts, eight have previously appeared in Eugenie Tsai's *Robert Smithson Unearthed: Drawings, Collages, Writings*, published by Columbia University Press in 1991. We place them in the unpublished category because they were not published until well after Smithson's death. The interviews by Dennis Wheeler were also first published in the Tsai book.)

The unpublished writings are comprised of texts that for one reason or another Smithson himself decided not to publish but which are self-contained and interesting examples of his thought. In a sense they are "artifacts," which reveal a number of concerns that underlay his published writings, sometimes recontextualized or articulated in rather different ways. Given Smithson's historical importance and enormous presence for contemporary artists and theorists, it was decided to publish them even though Smithson himself had not chosen to do so. (The original manuscripts for these, along with more fragmentary writings, which we have decided not to publish here, are on deposit at the Archives of American Art in Washington, D.C.; microfilms are available at the regional research centers of the Archives.) We have also decided not to publish here texts that are part of completed works of art, such as the Non-Sites or the slide/audiotape work *Hotel Palenque*, since they were felt to be inseparable from the works to which they belong.

We have included a small selection of Smithson's early poems among the unpublished writings, most in manuscript form. Though they are derivative and strongly echo the rhetoric of T. S. Eliot's "Ash Wednesday," they nonetheless show the intensity of Smithson's early engagement with religious imagery as well as with poetry, and they relate directly to some of his early paintings, such as the two versions of *Walls of Dis* (1959) and *The Eye of Blood* (1960).

Although we do not publish Smithson's general correspondence, we do include a few letters that are directly relevant to his writings.

*Because of an initial error in documentation discovered too late to allow for a change, *Strata: A Geophotographic Fiction* is out of sequence.

We also include, with some corrections, the Biographical Note from the first edition, which was a collaborative effort by Nancy Holt, Philip Leider, and Sol LeWitt, and which conveys the personal warmth and sense of loss felt by those close to Smithson in the years immediately following his untimely death. A detailed chronology, which includes exhibitions, may be found in Robert Hobbs's *Robert Smithson: Sculpture* (Ithaca and London: Cornell University Press, 1981).

The general layout of this edition is meant to reflect the spirit of Sol LeWitt's design for the first edition. As in the first edition, those articles that were originally laid out by Robert Smithson have either been reproduced exactly as they first appeared or have been followed as closely as the present format allows. These include "The X Factor in Art," "The Domain of the Great Bear," "Quasi-Infinities and the Waning of Space," "Ultramoderne," and "Strata: A Geophotographic Fiction."

In the presentation of Smithson's texts, we have decided to intrude as little as possible with editorial material, so as to let them speak for themselves. People who figure prominently in the texts, along with the names of interviewers, collaborators, and writers of pieces within Smithson's texts, are identified in a brief Glossary of Names at the end of the book. Certain inconsistencies of spelling have been left as they were in the originals; these include "esthetics," the spelling Smithson generally preferred, but which is sometimes spelled "aesthetics," and the variants of Non-Site (also given as "Nonsite," "non-site," and "nonsite").

Our bibliography is limited to a chronological account of Smithson's published writings. An extensive bibliography of publications about Smithson during his lifetime, compiled by Peter Chametzky, can be found in Hobbs's *Robert Smithson: Sculpture*. An interesting discussion of Smithson's writings, with particular attention to his interest in science fiction, is given in Robert A. Sobieszek's catalogue, *Robert Smithson: Photo Works* (Los Angeles County Museum of Art and University of New Mexico Press, 1993). A useful overview of writings about Smithson, along with many insights into his works, may be found in Gary Shapiro's comprehensive and thoughtful book *Earthwards: Robert Smithson and Art after Babel* (Berkeley, Los Angeles, and London: University of California Press, 1995). A number of texts by Smithson have been translated into foreign languages. Substantial selections are included in recent German, Spanish, and French catalogues: *Robert Smithson: Zeichnungen aus dem Nachlass/Drawings from the Estate* (Münster: Westfalisches Landesmuseum fur Kunst und Kulturgeschichte, 1989); *Robert Smithson: El Paisaje Entrópico* (Valencia: IVAM Centro Julio Gonzalez, 1993); *Robert Smithson, Une retrospective: Le paysage entropique 1960–1973* (Marseille: Musées de Marseille-Réunion des Musées Nationaux, 1994).

Nancy Holt played an important role in every phase of compiling this edition, of which she has in effect been the co-editor. She has participated in

most of the editorial decisions, supplied the additional texts, furnished dates for the unpublished texts, and contributed photographs for the reproductions. Without her continued commitment and acute discernment it could not have been realized.

We wish to thank Elizabeth Denholm Mazza and also Elyse Goldberg and Jeffrey Levine at the John Weber Gallery for their help with the preparation of this book. Eva Schmidt, Eugenie Tsai, Suzaan Boettger, and John Angeline also supplied useful information. Special thanks are due Charlene Woodcock at the University of California Press for her enthusiastic support of this project and for her extensive help in bringing it to fruition.

INTRODUCTION: READING ROBERT SMITHSON

By Jack Flam

Robert Smithson, who died in a plane crash in 1973, remains as compelling a presence among artists today as he was then. During his lifetime he was greatly respected (and disliked by some) for the uncompromising integrity and intensity with which he created his art and set forth his ideas, and for the crucial role he played in helping to redefine the practices and parameters of contemporary art. In recent years, the iconoclastic Smithson has himself become part of the art-historical canon that he fought against so vigorously—and that he helped to enlarge. He has now come to symbolize the expansive, antiformalist movements that emerged in the mid-1960s and early 1970s, and he is acknowledged as an early and influential advocate of cultural and historical relativism.

Smithson not only insisted on redefining the physical nature of art and its role within society, he also focused attention on what he took to be the arbitrary and unreflecting intellectual and historical frameworks within which art and criticism were conceived and presented. He relentlessly questioned established attitudes about art, knowledge, and culture, in ways that we now take for granted (partly as a result of his efforts), but which at the time seemed as bizarre as they were stimulating—as in his assertion that "there is nothing 'natural' about the Museum of Natural History. 'Nature' is simply another 18th- and 19th-century fiction." [1]

Smithson's beliefs were articulated not only by the objects and images that he created but also, and especially, through his written texts, which occupy a unique place among artists' writings generally. His art and his writings are so closely related that they can be understood to be very much part of the same undertaking, which involved a reciprocal interaction between word and image. Many of his published articles integrate visual images within their very structure, and sometimes he literally incorporated written texts, such as those that accompany what he called Non-Sites, into individual works of art. The act of writing—like the activities of drawing, mapping, mirroring, digging, diagramming, and photographing—was an integral part of Smithson's overall practice as an artist.

It is significant that Smithson's maturity as a maker of objects and images coincided almost exactly with his maturity as a writer. He started out as a painter, working in a gestural manner that grew out of Abstract Expressionism, and it was not until around 1964 that he began to produce his mature works: monumental geometric sculptures, Non-Sites, earthworks, and mixed-media projects. His writing developed in a parallel way; his early poetry was deeply

felt but derivative, with strong echoes of T. S. Eliot, and it was only around 1965 that he began to emerge as a writer with an original voice.

It seems more than merely fortuitous that Smithson's first mature writings coincided with his interest in the work of the Argentinean writer Jorge Luis Borges, whom he became interested in around the same time that writing became one of his main endeavors. Specific elements of Borges's writing style sometimes reverberate in Smithson's prose, especially in his use of compressed hyperbole, as in his characterization of a proposed air terminal: "This inscrutable terminal exceeds and rejects all termination."[2] But more important, Smithson seems to have got from Borges a heightened sense of the ways in which direct and highly concentrated writing could reach out and suggest the broadest abstractions without losing a sense of the specific. In Borges's story "Funes the Memorious," for example, Ireneo Funes develops total recall as the result of a riding accident. He is able to remember "not only every leaf of every tree of every wood, but also every one of the times he had perceived or imagined it." With his infinitely compounded capacity for recollection, in which memory reflects itself endlessly within itself, like the infinite reflections of facing mirrors, Funes both suggests and ultimately denies the possibility of gathering the totality of all time and all memory in a single place or person. And he does so not merely as an abstract proposition, but as a specific embodiment within a single mortal being, thus revealing rather than expounding to the reader a complex network of meditations on the nature of time and happening.

A similar desire to fuse the abstract and the specific, and a similar passion for intensely distilled philosophical rumination, informs much of Smithson's work. What also seems to have appealed to Smithson in this and other of Borges's stories was an element that he also intuited in "bastard" literary genres and "mixed" cultural sites, such as science fiction writing and the American Museum of Natural History: unusual combinations of the imaginary and the real that seemed to evoke the vastness of time itself. "Many architectural concepts found in science fiction have nothing to do with science or fiction," he declares in "Entropy and the New Monuments" (1966), in which he sets forth a new model for the function of time in art. Here he invokes what he characterizes as a "sense of extreme past and future," which he sees as having "its partial origin with the Museum of Natural History," where the " 'cave-man' and the 'space-man' may be seen under one roof. In this museum all 'nature' is stuffed and interchangeable."[3] One of Smithson's main ambitions seems to have been to create works which (not unlike the Museum of Natural History) are not "natural" but which nonetheless aspire to engage and reveal, even if they cannot contain, the whole of nature and the distant extremes of time.

Smithson disregarded reigning orthodoxies about the "purity" of art. He mixed things up in an exciting and iconoclastic way—cramming together fragments of texts and images drawn from diverse and divergent sources—philosophy, literature, natural history, and popular culture. He shunned *a priori*

limits. Just as his pictorial art could include words, so his texts are not merely linear but often include varied pictorial images, cartouches, sidebars, and other kinds of encapsulated fragments. This allows him to give a special kind of accent to apparently random perceptions, which would not easily find a place within an expository text, but which can create flashes of illumination when properly placed or *glanced* at. In his writings, Smithson is a master of the glance—of the obliquely placed perception that sometimes allows the sublime and the bathetic to be encompassed in a single phrase. One characteristically rich example of this is found in "The Domain of the Great Bear" (1966), in which various kinds of information are presented as part of a complex network of different narrations that sometimes coalesce into specific ideas but that are also left open and suggestive. Sometimes they are set forth with a sly irony that is at once humorous and profound, as in the glancing mention, without further verbal commentary, of the sign above the staircase at the Hayden Planetarium:

SOLAR SYSTEM
& REST ROOMS

The use of the little box with the sign for the hand here becomes at once a simulacrum for the original sign and—in its very incongruousness—a kind of commentary on it. Its effectiveness resides precisely in the way that it plays with the relative physical positions of words and images. Here, as elsewhere, Smithson's playfulness and humor grow out of the way the self sees itself slamming up against random experiences, creating a goofy, almost slapstick quality that is at once both funny and dead serious—at once obvious and full of subtle overtones. Significantly, one of Smithson's most thoughtful statements about the nature of language, "Language to be Looked at and/or Things to be Read," is presented in the form of a press release and signed "Eaton Corrasable."

In a way, Smithson saw and treated the world as an enormous text, reminiscent of the library in Borges's "Library of Babel," which is synonymous with the universe itself, "composed of an indefinite and perhaps an infinite number of hexagonal galleries"—which seem to prefigure the crystalline structures that Smithson himself favored. Borges's library, moreover, is defined as *"a sphere whose exact center is any one of its hexagons and whose circumference is inaccessible,"* recalling Smithson's favorite quote from Pascal, that "Nature is an infinite sphere whose center is everywhere and whose circumference is nowhere." Significantly, in a 1968 citation of Pascal's statement, Smithson added "or *language becomes an infinite museum whose center is everywhere and whose limits are nowhere.*"[4]

Indeed, Smithson treated written texts as if they too—like his plastic works—were made of solid materials; as if words were not only abstract signs for things and concepts, but also a form of matter. Asked in 1972 whether his

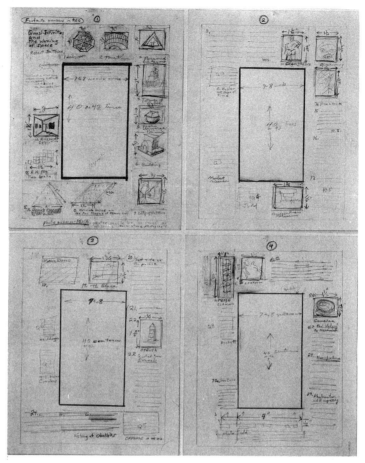

Quasi-Infinities and the Waning of Space, 1966. Graphite, colored pencil, ink, and greased crayon, 14 x 11 1/16".

writing affected the development of the things he made, Smithson answered that "language tended to inform my structures. In other words, I guess if there was any kind of notation it was a kind of linguistic notation. . . . But I was interested in language as a material entity, as something that wasn't involved in ideational values." This materiality, he felt, distinguished his work from conceptual art, which he characterized as "essentially ideational." When asked what he meant by the "material" quality of language, Smithson elaborated: "Well, just as printed matter—information which has a kind of physical presence for me. I would construct my articles the way I would construct a work."[5]

This is apparent in a number of different ways, ranging from works such as *A Heap of Language* (1966), in which the image is quite literally built with words, to published articles such as "Quasi-Infinities and the Waning of Space," which is a complex collage of words and images. In articles such as the latter, verbal continuity and pictorial placement are played off against each other in a way that creates a new kind of "text"—one that is spatial rather than linear,

discontinuous rather than discursive, composed of fluid rather than fixed parts.

Moreover, Smithson saw words themselves as containing a crucial (if usually overlooked) physicality which, through a slight shift in perceptual emphasis, could be seen to contain its own network of meanings: "Words and rocks contain a language that follows a syntax of splits and ruptures. Look at any *word* long enough and you will see it open up into a series of faults, into a terrain of particles each containing its own void."[6] This kind of byplay between thing and idea lies at the core of Smithson's whole undertaking as a writer and as an artist. "My work is impure," he asserted in 1969, "it is clogged with matter. There is no escape from the physical nor is there any escape from the mind. The two are in a constant collision course. You might say that my work is like an artistic disaster. It is a quiet catastrophe of mind and matter."[7]

Throughout his writings, Smithson mounts a persistent attack against the traditional categories usually applied to the plastic arts—such as painting, sculpture, and architecture. Given his professed dislike of such categories, it is doubly ironic that most histories of recent art place him in yet another category, which hardly begins to do justice to his accomplishment—that of "earthworks" or "earth art." But as the writings in this book make abundantly clear, Smithson's work can hardly be contained by that category either. In fact, his own practice as an artist transcended not only the traditional categories of making art, but also the usual definition of what "being an artist" entailed. He saw that activity as going beyond the creation of *objects*, as an ongoing *process* that involved an engagement with both abstract ideas and specific material presences, and that asserted the artist's freedom to act, unconstrained by the material results of his action. Like many artists of the period, he sought to create in a way that would be free of the strictures imposed by the art market. "Critics," he wrote in 1968, "by focusing on the 'art object,' deprive the artist of any existence in the world of both mind and matter. The mental process of the artist which takes *place* in time is disowned, so that a commodity value can be maintained by a system independent of the artist. . . ."[8] Smithson put a premium on his freedom to act outside traditional definitions and expectations, and to maintain a constant tension between a number of polar oppositions: image and word, object and idea, inside and outside.

A number of Smithson's texts are polemical, most especially in reaction against those categories of art practice that stymied what he believed to be the broadest potentials of creation. His ambition was not only to reach outside of the studio or museum space, as had Duchamp, for example, but also to create a new kind of continuity between the very notion of "inside" and "outside." This usually involved extreme contrasts, as between the immediate present and the most remote geological past, or between the enormity of the earth itself and the significance that can be contained by a small section of it, as in one of his Non-Sites. That is why the inverse symmetry or "mirror-relationship" be-

tween the site and the Non-Site is so important to him. The site represents the world itself, the unedited text with all of its complexities and possibilities, vast and remote—evocative but without *logos*. The Non-Site represents the focused articulation of part of the site which to some degree comes to stand for the site itself; but which like all metynomic tropes takes on a life of its own and becomes a form of speech: "It is by three dimensional metaphor that one site can represent another site which does not resemble it—thus *The Non-Site*," he wrote in 1967. "To understand this language of sites is to appreciate the metaphor between the syntactical construct and the complex of ideas, letting the former function as a three dimensional picture which doesn't look like a picture. . . ."[9] The Non-Site to some degree brings the site from the geographical, psychological, and social margins to a "center"—be it the artist's studio, an art gallery, a museum, or a page of a book.

In fact, Smithson's conception of art in general allows for great fluidity between the various incarnations of a work and involves resistance to a single, simple time and place, even to a single physical form. A number of the physical "works" discussed in the following texts, such as the Yucatan mirror displacements, now exist only as combinations of texts and photographs or drawings—as images in the mind, memory traces that have come to have an almost mythic resonance. Because of the fluid relationship between the different incarnations of specific works, in a curious way we are not especially bothered by the frequent inaccessibility of certain of them—including the celebrated *Spiral Jetty*—which are known primarily through the indirect and "impure" medium of print, in the form of reproduced drawings and photographs, and of words.

If Smithson saw the world as a text, he conceived of his own vocation as an artist not to interpret or explain it, but rather to *reveal* it—to himself and to us, his readers. Hence, in his polemical writings he brings extraordinary energy to the question of what the artist's field of action should be. This is especially apparent in the way he argues against the notion of high modernism embodied in the works of certain artists (such as Anthony Caro, Jules Olitski, and Kenneth Noland) who were promoted by Clement Greenberg or Michael Fried. To some degree this polemic has to do with a battle of schools, Smithson staking out the territory of his own work and of the artists with whom he is allied, in opposition to what at the time was considered the canonical mainstream. (The degree to which that situation has changed gives some idea of just how influential the thinking of Smithson and his colleagues was.)

But there was also another, deeper issue at stake, which had to do with what Smithson saw as the extreme limitations of the biological and humanistic models that he believed underlay the Western tradition as a whole. His polemics against "humanism" are not framed in terms of an opposition between humanism and deism. Rather he takes humanism to be a belief system that can be described as being "premised on ontological differences between humanity and the rest of nature, and according priority to it in the explanation

of society, history and culture."[10] For Smithson, this kind of humanism, along with the artistic egotism that he identified with the Renaissance tradition, was flawed not only on esthetic grounds but also (and mainly) because it involved what he considered to be a philosophical misrepresentation. It cut art off, he believed, from a deeper and broader sense of reality, and falsified the relationship between art and the surrounding universe, making the art experience isolatable from the "real"—indeed in extreme cases making it seem that reality would only "contaminate" art. This "purist" attitude Smithson associated with the formalism of Greenberg and his disciples, which he felt was overly self-contained and self-centered, and also politically inadequate, since it supported prevailing power structures. Smithson himself, by contrast, sought an art that would be continuous, even to some degree coterminous, with the real world, but at the same time would go beyond surface appearances and transcend the realm of the organic—an art that could evoke the farthest reaches of time and the most remote and incomprehensible notions of space. In contrast to the humanistic and organic, his writings and images posit the notion of the "crystalline," a glacial and impersonal concept that disdains viewing existence from a single portion of time and space.

In fact, Smithson takes time itself not only as one of the main *themes* of his art, but also as one of his most important *mediums*. This is made clear in one of his earliest published articles, "Entropy and the New Monuments," where he speaks of the way in which the new kind of monumental works being created by him and some of his contemporaries "bring to mind the Ice Age rather than the Golden Age," and "instead of causing us to remember the past . . . seem to cause us to forget the future." Time, moreover, is crucial to the whole notion of entropy that Smithson began to elaborate in his earliest published writings and which emerged as one of the overriding concerns of both his art and his writings. It is in a sense the matrix that holds together the whole diverse body of his work—words and images, philosophical concerns and the secularized remnants of religion, even his political and social engagements: "Every object, if it is art, is charged with the rush of time even though it is static," he wrote in 1968. But, he continues, much depends on the viewer. "Not everybody sees the art in the same way, only an artist viewing art knows the ecstasy or dread, and this viewing takes place in time. A great artist can make art by simply casting a glance. . . . Any critic who devalues the *time* of the artist is the enemy of art and the artist."[11]

For Smithson, time is never only a disembodied abstraction but always a tangible and material reality. Time must have coordinates in space, must even be made manifest in a quite specific kind of place and thus inhabit as well as contain the material world. One of the central paradoxes of his art is that time measured in eons is always set hard by the most banal and temporally bound realms of experience. The evidence of geological time is captured by that most ordinary of recording instruments, a Kodak "Instamatic" camera. In "Art

Through the Camera's Eye" (1971–72) the artist muses on that apparatus's little coded symbols for sun and clouds and invites us to scrutinize those hackneyed symbols as if they were universal, cosmic hieroglyphs—"a secret code." Here as elsewhere, high seriousness is ironically played off against the trivia of everyday life. The vastness of the universe is viewed from the everyday perspective of roadsides and shopping malls. Eternal Rome is juxtaposed with the "monuments" of Passaic, New Jersey.

New Jersey occupies an important place in Smithson's writings, both as a place and as a state of mind. It was the part of the earth where he was born and raised and that he knew best, where he had roamed as a child, exploring and gathering rocks for his mineral collection. He was especially interested in its varied geological formations, and he used them as the sites for a number of his Non-Sites. But in many ways New Jersey was also the least "artistic" place that he knew, with its industrial ruins, its suburban sprawl, and what he took to be its extraordinary banality, even ugliness. In Smithson's youth it probably would have seemed to represent the exact opposite of "art." But as he matured, he seems to have come to understand that for better or worse, this exhausted and exhausting place constituted an important part of *his* reality. In a number of his earlier writings he discusses the importance of rejecting Europe, and it seems likely that the necessary rejection of European artistic and cultural values involved to some degree the necessity of accepting the reality of New Jersey. This rejection of Europe, of course, was not unique to Smithson's generation. Previous American artists, however, had usually felt that it was possible to devise an essentially American version of the art forms that had been invented and developed in Europe—such as easel paintings, single-sheet drawings, and self-contained sculptures on pedestals—by modifying them somewhat but nonetheless accepting all the art-historical baggage they carried, whether from the "classical" or the "primitive-modernist" tradition.

Smithson took a more aggressive stance. Along with traditional genres, and their traditional boundaries, he also renounced traditional notions of beauty and of the picturesque—and the nostalgia and sentimentality often associated with those values. In his writings, he devotes a great deal of energy to the refutation and disavowal of history, seeing the whole history of art—especially as presented by museums—as an unbearably tyrannical and useless burden for American artists of his generation. Accordingly, like several other artists of the period, he maintains a special animus toward museums and the ways in which they define art and its history. "History," he wrote as early as 1967, "is a facsimile of events held together by flimsy biographical information. Art history is less explosive than the rest of history, so it sinks faster into the pulverized regions of time. . . .Visiting a museum is a matter of going from void to void. Hallways lead the viewer to things once called 'pictures' and 'statues.' Anachronisms hang and protrude from every angle. Themes without meaning press on the eye. . . .

Blind and senseless, one continues wandering around the remains of Europe, only to end in that massive deception 'the art history of the recent past.'"[12]

Smithson in effect set aside European culture by sweeping away history itself and by addressing instead the metahistorical extremes of time—the remote past and the remote future. "I guess I was always interested in origins and primordial beginnings, you know, the archetypal nature of things," he told Paul Cummings in 1972.[13] And here, New Jersey could play a paradoxical and important role in his personal mythology. If the New Jersey suburbs seemed to personify a certain kind of late industrial banality, they also resonated with mythic and primordial undertones, evident in the land on which they were built and evoked anew by their virtually constant excavation by builders and developers.

Northern New Jersey, as invoked in William Carlos Williams's long poem *Paterson*, contained the ancient sites of Indian rituals. And however unartistic the contemporary culture of New Jersey might be, it had also been the home of two poets who occupied an important place in Smithson's mind, Williams (who had been his pediatrician) and Allen Ginsberg. Moreover, the very shoddiness of the New Jersey suburbs seemed to be a tangible embodiment of the entropic condition, constantly falling apart at the same time that it was in the process of being rebuilt, creating what Smithson described as "ruins in reverse." This was the kind of "artificial landscape without cultural precedent" that had led the sculptor Tony Smith to speak, in 1966, of "a reality that had not had any expression in art," an observation that made a deep impression on Smithson.[14]

In "A Tour of the Monuments of Passaic, New Jersey" (1967), the town where Smithson was born is described in terms of a "zero panorama," in which those "*ruins in reverse*," that is all the new construction that would eventually be built, were like "memory-traces of an abandoned set of futures."[15] The city of Passaic itself he describes in a kind of cosmic-ironical way, as a parodic negative version of Pascal's description of the universe: "Actually, Passaic center was no center—it was instead a typical abyss or an ordinary void." To which he cannot resist adding, "What a great place for a gallery!"[16]

Through a process of social and commercial decay, what had once been the vital rail link between Passaic and its surroundings had been covered over and transformed into a "monumental parking lot" that ran through the center of town. Of this evidence of late-industrial disintegration, Smithson remarks: "There was nothing *interesting* or even strange about that flat monument, yet it echoed a kind of cliché idea of infinity; perhaps the 'secrets of the universe' are just as pedestrian—not to say dreary." Perhaps those secrets, or at least part of them, he suggests, actually exist in Passaic. "I am convinced," he continues, "that the future is lost somewhere in the dumps of the non-historical past; it is in yesterday's newspapers, in the *jejune* advertisements of science-fiction movies,

in the false mirror of our rejected dreams. Time turns metaphors into *things*, and stacks them up in cold rooms, or places them in the celestial playgrounds of the suburbs."

This brings him to the essential question, at once ironical and yet deadly serious: "Has Passaic replaced Rome as The Eternal City? If certain cities of the world were placed end to end in a straight line according to size, starting with Rome, where would Passaic be in that impossible progression?" [17]

Even Allan Kaprow, who taught in New Jersey and knew some of that terrain nearly as well as Smithson, was unable to grasp the full extent of the tension between irony and seriousness that informed Smithson's thinking about New Jersey. In their published dialogue, Kaprow asks Smithson whether there isn't "an alternative on the fringes of life and art, in that marginal or penumbral zone which you've spoken so eloquently of, at the edges of cities, along vast highways . . . whether that isn't the world that's for you at least. I mean, can you imagine yourself working in that kind of environment?" To which Smithson replies, "I'm so remote from that world that it seems uncanny to me when I go out there; so not being directly involved in life there, it fascinates me, because I'm sure of a distance from it, and I'm all for fabricating as much distance as possible. It seems to me that I like to think and look at those suburbs and those fringes, but at the same time, I'm not interested in living there. It's more of an aspect of time. It is the future—the Martian landscape. By a distance, I mean a consciousness devoid of self-projection." [18]

In his writings as well as in his plastic works, Smithson directly confronts the conventional aspects of what had been taken to seem like "natural" aspects of art making. In the series of works referred to as "flows," for example, in which large quantities of asphalt, concrete, mud, or glue were poured across parts of landscapes, Smithson challenged the very essence of the act of painting. In the first of these "flows," *Asphalt Rundown* (1969), a dump truck released a load of asphalt from the top of an eroded hillside in an abandoned area of a dirt and gravel quarry in Rome. The effect, as seen in photographs, at first seems to resemble an enormous Abstract-Expressionist pouring of paint, and appears to be a direct continuation of the large-scale and heroic physical gestures associated with Jackson Pollock's canvases. But at the same time that Smithson seems to be continuing the tradition of Abstract-Expressionist "action" painting, he also deconstructs that practice by emphasizing how the essentially entropic nature of the act of pouring differs from the individualistic gesture of painting. The implications of Smithson's "flows" did not pass unnoticed. Recently, for example, Frank Stella remarked to me that *Asphalt Rundown* was perceived as a powerful, annihilating gesture that had forced all thoughtful artists to seriously reconsider the role of touch and surface in painting.

Reading Smithson encourages you to reconsider a number of things that you might be inclined to take for granted, including the problem of how

questions of artistic unity may be settled, or left unsettled. In many aspects of his work, Smithson brings together what seem to be impossible polarities and makes them meaningful precisely because the tensions that they contain cannot be satisfactorily resolved. As his writings in particular make clear, Smithson revels in contradiction and paradox. "Actually it is the mistakes we make that result in something," he reflected in 1969, adding, "An art against itself is a good possibility, an art that always returns to essential contradiction."[19]

In fact, Smithson seems to embody a number of contradictory and even opposing tendencies within modernist art as a whole.[20] On the one hand he is directly within the artistic lineage of Marcel Duchamp, in his emphasis upon the intangible and the ambiguous and in his insistence on breaking down categories and expanding the boundaries of art and its practice. It is worth noting that Smithson, like Duchamp, started out as a painter but came to find the medium of painting itself inadequate to what he desired to express. "A God that can be measured has to be man-made," Smithson wrote just as he himself was about to give up painting. "Revelation has no dimensions. If it did, it would be dead in space and time. . . . Marcel Duchamp stopped painting early in his life, because he *wasted* his art in time and space."[21]

In contrast to Duchamp, however, whose esthetic would turn on the evanescence of what he called "the infrathin," Smithson desired a more material basis for his art and wanted some evidence of the process of fabrication to survive in the work itself. Thus, at the same time that Smithson is within the Duchampian lineage of the artistic antihero, he also seems to have inherited in equal measure the heroic position of Jackson Pollock. As a result of the elemental force of his Non-Sites, the sweeping gestures of earthworks such as *The Spiral Jetty*, and the dramatic photographs taken of him on his earthworks toward the end of his life, he has come to be regarded as an artist-hero to a degree unknown since the death of Pollock. But although Smithson represents a continuation of that essentially romantic image of the artist, he recasts it in an unexpected way.

One of the most striking aspects of Smithson's work as a whole is the way in which he uses a strongly anti-romantic, anti-sublime stance to create, paradoxically, what seems to be a romantic evocation of the sublime. Or, more accurately, in many of his later works especially, both the sublime and its opposite seem to coexist with, and even energize, each other. In Smithson's work the sublime is not framed in terms of a physically insignificant but passionate human presence lost amid the vastness of organic nature. Rather humanity is positioned bravely, even rather coolly, in relation to the awe-inspiring but basically indifferent (one is tempted to write "crystalline") phenomenon of the infinity of time and space.

One of the classic oppositions between different concepts of the sublime turns around the argument as to whether the sublime is located, as Edmund Burke believed, in nature itself, or whether it resides in the mind of the be-

holder, as held by Immanuel Kant. Smithson's notion of the sublime in a sense supersedes this distinction by locating the sublime beyond the bounds of beholding—by situating it within so vast a scale that the question of mind and "nature" appears to be obliterated. Yet at the same time, Smithson's evocation of the sublime is fraught with irony, as if to suggest that the artist's very enthusiasm for the absolute must necessarily be tempered by his own ironical awareness of the ultimate inadequacy of any attempt to represent or evoke it. This simultaneous embracing and preempting of the sublime is typical of the paradoxical nature of Smithson's work.

In a very real sense, Robert Smithson's early death constituted a premature closure of his enterprise as an artist. But in another sense, it has allowed his career effectively to escape a sense of closure. Because he himself was deprived of being able to carry forward and resolve a number of the issues he raised, in what almost certainly would have been his own idiosyncratic way, those issues have been left perpetually open. This lack of closure has become all the more apparent to us today because of the drastic ways in which life has changed in the twenty-odd years since Smithson's death. The advent of personal computers, the intense commercialization of the art world, and the development of new cosmological theories, as well as other scientific, technological, political, and social changes, would doubtless have drawn lively and original responses from him. But because this did not happen, when we look at his career we read it not only in terms of a number of substantial and historically significant accomplishments, but also as a series of perpetually unrealized possibilities.

Reading Robert Smithson is an ongoing process—both in the literal and the interpretive sense of "reading." It involves a kind of unspoken admonition to remain alert to possibilities, and a heightened awareness that makes you look at the world itself differently—whether that world be the vastness of the southwestern desert or the decaying infrastructure of post-industrial urban areas. In a curious way, although Smithson's works now seem clearly to reflect a certain moment in history—the idealism, activism, and spiritual openness of the late 1960s—it is now equally clear that they also transcend the specificity of that historical moment and attain a true universality.

Many of the issues that are dealt with in the texts that follow are as pertinent today as they were a quarter of a century ago. Smithson had an uncanny instinct for putting his finger on what was important, and at times his judgments about how certain issues would turn out seem prescient—as in his 1967 observation that "the whole idea of the museum seems to be tending more toward a kind of specialized entertainment."[22]

More intensely perhaps than any other artist of his generation, Smithson was actively engaged with the theoretical aspects of the major artistic, art-historical, and cultural issues of his time. He, in effect, put into practice what others only

speculated about and what they often did not even recognize when it was given tangible form. But Smithson was above all a practicing artist rather than a theorist, so at the same time that he makes us aware of the value of having a theoretical overview, he also conveys an important admonition about distinctions between theory and practice. At the end of "A Provisional Theory of Non-Sites," he reminds us that his "little theory is tentative and could be abandoned at any time." From which he draws the natural entropic conclusion: "Theories like things are also abandoned. That theories are eternal is doubtful. Vanished theories compose the strata of many forgotten books."

NOTES

1. P. 85
2. P. 56
3. P. 15
4. P. 78
5. P. 294
6. P. 107
7. P. 194
8. P. 111
9. P. 364
10. J. O. Urmson and Jonathan Rée, *The Concise Encyclopedia of Western Philosophy and Philosophers,* London, 1989.
11. P. 111
12. Pp. 41–42
13. P. 286
14. Samuel Wagstaff, Jr., "Talking with Tony Smith," *Artforum,* December 1966, p. 19.
15. P. 72
16. P. 73
17. P. 74
18. P. 45
19. P. 199
20. In his constant polemic against traditional categories and the definition of those categories by critics such as Clement Greenberg and Michael Fried, Smithson is now seen as articulating an anti-, and indeed post-modernist position. It seems to me, however, that in the last analysis Smithson's total enterprise is very much part of "modernism" broadly conceived. This is apparent in his inclination toward paradoxical ambiguity and in the collage-like technique that underlies much of his writing and image-making. His work as a whole continues the transgressive breaking down of boundaries and hierarchies that started with the early modernists and can be traced back at least as far as Courbet, another artist who was proud to declare that he could "make stones think." It now seems clear that Greenberg's definition of modernism was not in fact synonymous with the practices of the artists whom we associate with the greater part of the history of modernist art, but is rather a historically determined response to them—and one that is no longer especially useful.
21. P. 322
22. P. 44

BIOGRAPHICAL NOTE

Until Robert Smithson arrived on the art scene, sculpture was basically a gallery art or seen as an addition to architecture, with its subject matter derived from either the human figure or geometric abstraction. Smithson's earthwork proposals of 1966 and the *Non-Sites* exhibited in New York City in 1967 dislocated this prevailing outlook by returning sculpture to the landscape. His *Spiral Jetty* of 1970 was built on the shore of the Great Salt Lake, in Utah, at a scale comparable to the ancient monuments of past civilizations, but unlike those monuments of the past, which evolved out of the matrix of beliefs and religions of their time, the *Spiral Jetty* came into existence as the individual vision of a single artist.

Robert Smithson was born in Passaic, New Jersey, on January 2, 1938. His parents, Susan Duke Smithson and Irving Smithson, moved back to his father's hometown, Rutherford, New Jersey, shortly after his birth. Robert Smithson was an only child—his nine-year-old brother, Harold, died of leukemia two years before he was born. (Irving Smithson died of cancer at age 67 on April 13, 1973, three months before Robert's death. His mother died of cancer on November 30, 1991, at the age of 83.) His aunt Julia Duke, who remained single and lived with the family throughout Robert's life, was like a second mother to him and encouraged him in his endeavors until her death in 1961. In his childhood, Smithson was cared for by his hometown pediatrician, William Carlos Williams, whose poetry and writing were later to influence him.

From his earliest years he displayed an extraordinary interest in natural history and art, frequently visiting the Museum of Natural History in New York City, where he first saw Charles Knight's paintings of what dinosaurs might have looked like. At the age of seven he drew a mural-sized dinosaur for the hallway of his school. In 1948 the Smithson family moved to nearby Clifton, New Jersey, where his father, a mortgage and loan executive, built a special room in the basement of their home for Robert's collection of live reptiles, snakes, preserved specimens, and fossils. Beginning at about this time Robert was encouraged by his parents to research and plan the family vacation trips to various places in the United States, including Yellowstone Park, the Oregon Caves, the California Redwoods, the Grand Canyon, the Mojave Desert, and Sanibel Island. In 1950 Smithson visited Ross Allen's reptile farm in Florida, where he returned several times as he was beginning to plan a career as a naturalist.

At the age of 16 he won a scholarship to the Art Students League in New York City. (He received another scholarship the following year.) His principal at Clifton High School allowed him to attend high school half a day, so he

could commute each afternoon to the Art Students League. He began to frequent the Cedar Bar and Village coffee houses, where he met many artists.

In 1956, one week after graduating from high school, Smithson joined the army reserves, where he was assigned to Special Services. His six-month period of active duty was spent in Fort Knox, Kentucky, where, after basic training, he was made artist-in-residence, doing posters for the camp and murals for the mess hall. He eventually obtained a discharge from the reserves on the grounds that continued service would ruin his creativity.

Between 1956 and 1958 he hitchhiked extensively around the United States and Mexico.

Smithson's first one-man exhibition was of abstract paintings at the Artists Gallery, New York City, in 1959. In 1961 he had a one-man exhibition of paintings at Galleria George Lester, Rome, and in 1962 a one-man exhibition of assemblage works at the Richard Castellane Gallery, New York City. After this exhibition, he withdrew from the art world for a period of introspection and assessment, marrying the artist Nancy Holt in 1963. Smithson re-emerged in 1965 by showing sculpture at the Daniels Gallery, where he met various leading American sculptors of the 1960s. His first published writing on art appeared, and from this time on he continuously exhibited and wrote.

In 1966 he joined the Dwan Gallery, New York City, where he had four one-man exhibitions of sculpture between 1966 and 1970. At about the same time (1966–1969) he began excursions, usually with friends, sometimes alone, to New Jersey's decaying urban sites, industrial wastelands, and abandoned quarries. Out of this new consciousness of the postindustrial terrain emerged Smithson's *Non-Sites*, which created a wholly new premise for contemporary sculpture. It was in 1966 also that he proposed his first earthwork, *Tar Pool and Gravel Pit,* for Philadelphia, and other earthworks for the fringes of the Dallas–Fort Worth Regional Airport, as part of his work as an artist-consultant with an architectural firm that was competing for the airport design contract.

In the summer of 1968, he traveled to the deserts of California, Nevada, and Utah seeking sites for art. In 1969, in order to build a large work of art, he negotiated successfully with the government of British Columbia for a lease on an island near Vancouver. Later, however, the government's permission was rescinded, and the work was never built. Smithson was able, in 1969, to build *Asphalt Rundown* in a quarry near Rome, Italy. In 1970 he completed *Partially Buried Woodshed*, Kent, Ohio, and the *Spiral Jetty* in the Great Salt Lake, along with a film of the same name that revolves around that work.

From 1970 onward Smithson made many trips around the United States searching for sites for his work—the Florida Keys, Texas quarries, Salton Sea in California, Maine, and to islands on the Atlantic coast. He proposed many art works in the landscape that were ultimately rejected by various local sponsoring institutions. By reclaiming land in terms of earth art, he felt that art could be economically and politically integrated into society. In his mind this could

best be accomplished by working with mining companies to reclaim devastated strip-mined land as earth art.

In 1971 he built *Broken Circle-Spiral Hill* in a quarry near Emmen, Holland, which was scheduled to be abandoned and returned to the people of the area. With this work Smithson realized his concern for recycling a mined site, in this case a sand quarry, into an art work. His desire to have art be a necessary part of society was gratified when the people of Emmen voted to keep and maintain the work after its completion.

From 1971 to 1973, he wrote to and visited many strip-mining companies, making drawings and proposals for landscape works. He also wrote public statements that pointed out the limiting confines of the art establishment. The mining industry unfortunately was not very far-sighted, and rejected Smithson's visionary proposals.

Finally, a few weeks before his death, Smithson visited Creede, Colorado, where he had his first opportunity to propose a project for a tailings site to an interested mining company. Since the company was not ready to begin the project right away, Smithson traveled to a desert lake he had heard of in Amarillo, Texas. He decided that it was an excellent site for what was to be his last work, *Amarillo Ramp*, which was commissioned by the owner of the property. After trying out various ideas and dimensions, Smithson staked out *Amarillo Ramp* in its final form. On July 20, 1973, while he and a photographer were photographing the staked-out work from the air, the plane they were in crashed on a rocky hillside a few hundred feet from the site of the art, killing the pilot, the photographer, and Robert Smithson.

PUBLISHED WRITINGS

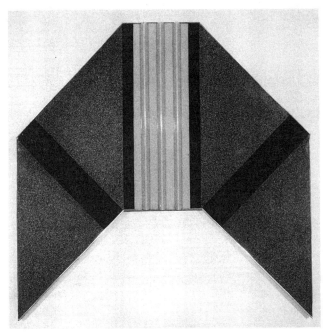

ROBERT SMITHSON, *Quick Millions*, 1965. Plexiglass and corrugated acrylic, 54⅛ x 56".

QUICK MILLIONS (1965)

ARTIST'S STATEMENT:

For me *Quick Millions* comes out of a world of remote possibilities, held together by incomprehensible motives. The work is named after a movie I have never seen. All my original intentions for creating the work are out of sight and out of mind. It is a terminal work: sealed, impenetrable, unrevealing—forever hidden. I like plastic as a medium because it can be both real and/or unreal, according to your mood. Plastic exists between a solid specific and a glittering generality. *Quick Millions* might be an anti-parody of obsolete science-fiction-type architecture, or slippery forms and spaces, but I doubt it. One could also say it has a "non-content." All kinds of engineering fascinates me, I'm for the automated artist.

Brian O'Doherty, *Lesser Known and Unknown Painters,* American Express Pavilion. Worlds Fair, New York, 1965

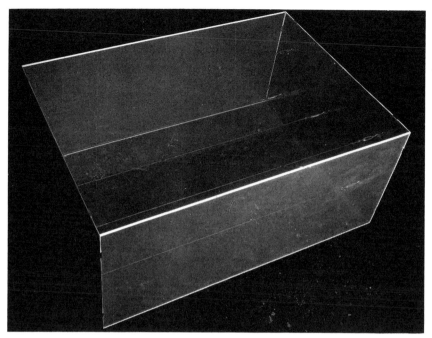

DONALD JUDD, *Untitled*, 1965. Steel and plexiglas, 20 x 48 x 34″.

DONALD JUDD (1965)

Donald Judd has set up a "company," that extends the technique of abstract art into unheard-of places. He may go to Long Island City and have the Bernstein Brothers, Tinsmiths put "Pittsburgh" seams into some (Bethcon) iron boxes, or he might go to Allied Plastics in Lower Manhattan and have cut-to-size some Rohm-Haas "glowing" pink plexiglas. Judd is always on the lookout for new finishes, like Lavax Wrinkle Finish, which a company pamphlet says, "combines beauty and great durability." Judd likes that combination, and so he might "self" spray one of his fabricated "boxes" with it. Or maybe he will travel to Hackensack, New Jersey to investigate a lead he got on a new kind of zinc based paint called Galvanox, which is comparable to "hot-dip" galvanizing. These procedures tend to baffle art-lovers. They either wonder where the "art" went or where the "work" went, or both. It is hard for them to comprehend that Judd is busy extending art into new mediums. This new approach to technique has nothing to do with sentimental notions about "labor." There is no subjective craftsmanship. Judd is not a specialist in a certain kind of labor, but a whole artist engaged in a multiplicity of techniques.

In Judd's first exhibition in 1963, his plywood and aluminum structures disclosed an awareness of physical "mass" in the form of regular intervals of bulk

Philadelphia Institute of Contemporary Art Catalog, *7 Sculptors*, 1965

The intrinsic virtue of "primary matter" was very much in evidence. Each work offered a different solution for the dislocation of space. One wooden box, for example, contained a series of recessed slats, exposed only by a slight concave opening on top of the box. This opening took up only about 20% of the top surface. The slats were more closely spaced at one end than the other; as a result, the space seemed squeezed out. Inertia appeared to be subdivided into remote areas of force. A black pipe-like axis, in another work, was polarized between two massive plywood squares, yet no rotation seemed possible because the black pipe was flanked by six polarizing square beams that were bolted into the wooden squares. This non-rotation aspect breaks the suggestion of dynamic space. Matter, not motion, had become Judd's prime concern. Each of Judd's structures brought into question the very *form* of matter. This is contrary to the abstract notion that movement is the direct result of space. All "created nature" seems to have been abstracted out of Judd's concept of physical mass. Just as the Mannerist artists of the sixteenth century permuted the facts of the Classic Renaissance, so has Judd permuted the facts of Modern Reality. By such means, Judd discovered a new kind of "architecture," yet his contrary methods make his "architecture" look like it is built of "antimatter." Perhaps "primary matter" and "antimatter" are the same thing.

A lack of consciousness of mass seems to have caused the demise of "action-painting," and that might explain also the dissolution of "assemblage" and "the happening." If action, energy, motion, and other kinetics are the main motives of an artist, his art is quick to atrophy.

While he was making his aluminum and wood structures, Judd developed an idea for a "space-lattice." This was made out of pipe with "ball fittings," that stood 4 feet high and about 6 feet long. Constructed with the help of a plumber, Judd put together this rectangular parallel, piped with a quartet of pipes conjoining in the center of the work in the shape of a cross.

In the work of Frank Stella and Barnett Newman the "framing support" is both hinted at and parodied. Clement Greenberg recognized an element of "parody," perhaps unconscious, in Barnett Newman's "field" paintings, which called attention to the "frame." This element becomes less of a parody, and more of a conscious fact, in Frank Stella's "shaped canvases." Judd's symmetric, free-standing structure eliminated all doubts about the importance of the framework by asserting its formal presence beyond any reference to "flat" painting. All surfaces vanish in this important work, but return later in his fabricated works with startling new implications.

With Judd there is no confusion between the anthropomorphic and the abstract. This makes for an increased consciousness of structure, which maintains a remote distance from the organic. The "unconscious" has no place in his art. His crystalline state of mind is far removed from the organic floods of "action painting." He translates his concepts into artifices of fact, without any illusionistic representations.

Space in Judd's art seems to belong to an order of increasing hardness, not unlike geological formations. He has put space down in the form of deposits. Such deposits come from his mind rather than nature. Instead of bringing Christ down from the cross, the way the painters of the Renaissance, Baroque, and Mannerist periods did in their many versions of The Deposition, Judd has brought space down into an abstract world of mineral forms. He is involved in what could be called, "The Deposition of Infinite Space." Time has many anthropomorphic representations, such as Father Time, but space has none. There is no Father Space or Mother Space. Space is *nothing*, yet we all have a kind of vague faith in it. What seems so solid and final in Judd's work is at the same time elusive and brittle.

The formal logic of crystallography, apart from any preconceived scientific content, relates to Judd's art in an abstract way. If we define an abstract crystal as a solid bounded by symmetrically grouped surfaces, which have definite relationships to a set of imaginary lines called axes, then we have a clue to the structure of Judd's "pink plexiglas box." Inside the box five wires are strung in a way that resembles very strongly the crystallographic idea of axes. Yet, Judd's axes don't correspond with any natural crystal. The entire box would collapse without the tension of the axes. The five axes are polarized between two stainless steel sides. The inside surfaces of the steel sides are visible through the transparent plexiglass. Every surface is within full view, which makes the inside and outside equally important. Like many of Judd's works, the separate parts of the box are held together by tension and balance, both of which add to its static existence.

A reversible up and down quality was an important feature of the work which Judd showed in the VIII São Paulo Bienale. It is impossible to tell what is hanging from what or what is supporting what. Ups are downs and downs are ups. An uncanny materiality inherent in the surface engulfs the basic structure. Both surface and structure exist simultaneously in a suspended condition. What is outside vanishes to meet the inside, while what is inside vanishes to meet the outside. The concept of "antimatter" overruns, and fills everything, making these very definite works verge on the notion of disappearance. The important phenomenon is always the basic lack of substance at the core of the "facts." The more one tries to grasp the surface structure, the more baffling it becomes. The work seems to have no natural equivalent to anything physical, yet all it brings to mind is physicality.

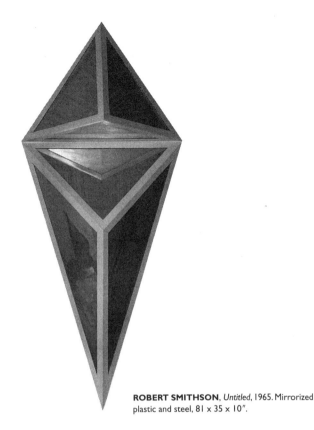

ROBERT SMITHSON, *Untitled*, 1965. Mirrorized plastic and steel, 81 x 35 x 10″.

THE CRYSTAL LAND　　(1966)

> Ice is the medium most alien to organic life, a considerable accumulation
> of it completely disrupts the normal course of processes in the biosphere.
> P. A. Shumkii, *Principles of Structural Glaciology*

The first time I saw Don Judd's "pink plexiglas box," it suggested a giant crystal from another planet. After talking to Judd, I found out we had a mutual interest in geology and mineralogy, so we decided to go rock hunting in New Jersey. Out of this excursion came reflections, reconstituted as follows:

Near Paterson, Great Notch, and Upper Montclair are the mineral-rich quarries of the First Watchung Mountain. Brian H. Mason, in his fascinating booklet, *Trap Rock Minerals of New Jersey*, speaks of the "Triassic sedimentary rocks of the Newark series," which are related to those of the Palisades. In these rocks one might find: "actinolite, albite, allanite, analcime apatite, anhydrite, apophyllite, aurichalcite, axinite, azurite, babingtonite, bornite, barite, calcite, chabazite, chalcocite, chalcopyrite, chlorite, chrysocolia, copper, covellite,

Harper's Bazaar, May 1966

cuprite, datolite, dolomite, epidote, galena, glauberite, goethite, gmelinite, greenockite, gypsum, hematite, heulandite, hornblende, laumontite, malachite, mesolite, natrolite, opal, orpiment, orthoclase, pectolite, prehnite, pumpellyite, pyrite, pyrolusite, quartz, scolecite, siderite, silver, sphalerite, sphene, stevensite, stilbite, stilpnomelane, talc, thaumasite, thomsonite, tourmaline, ulexite."

Together with my wife Nancy, and Judd's wife, Julie, we set out to explore that geological locale.

Upper Montclair quarry, also known as Osborne and Marsellis quarry or McDowell's quarry, is situated on Edgecliff Road, Upper Montclair, and was worked from about 1890 to 1918. A lump of lava in the center of the quarry yields tiny quartz crystals. For about an hour Don and I chopped incessantly at the lump with hammer and chisel, while Nancy and Julie wandered aimlessly around the quarry picking up sticks, leaves and odd stones. From the top of the quarry cliffs, one could see the New Jersey suburbs bordered by the New York City skyline.

The terrain is flat and loaded with "middle-income" housing developments with names like Royal Garden Estates, Rolling Knolls Farm, Valley View Acres, Split-level Manor, Babbling Brook Ranch-Estates, Colonial Vista Homes—on and on they go, forming tiny boxlike arrangements. Most of the houses are painted white, but many are painted petal pink, frosted mint, buttercup, fudge, rose beige, antique green, Cape Cod brown, lilac, and so on. The highways crisscross through the towns and become man-made geological networks of concrete. In fact, the entire landscape has a mineral presence. From the shiny chrome diners to glass windows of shopping centers, a sense of the crystalline prevails.

When we finished at the quarry, we went to Bond's Ice Cream Bar and had some AWFUL-AWFULS—"awful big—and awful good . . . it's the drink you eat with a spoon." We talked about the little crystal cavities we had found, and looked at *The Field Book of Common Rocks and Minerals* by Frederic Brewster Loomis. I noticed ice is a crystal: "Ice, H_2O, water, specific gravity—.92, colorless to white, luster adamantine, transparent on thin edges. Beneath the surface the hexagonal crystals grow downward into the water, parallel to each other, making a fibrous structure, which is very apparent when ice is 'rotten.' . . ."

After that we walked to the car through the charming Tudoroid town of Upper Montclair, and headed for the Great Notch Quarry. I turned on the car radio: " . . . countdown survey . . . chew your little troubles away . . . high ho hey hey. . . ."

My eyes glanced over the dashboard, it became a complex of chrome fixed into an embankment of steel. A glass disc covered the clock. The speedometer was broken. Cigarette butts were packed into the ashtray. Faint reflections slid over the windshield. Out of sight in the glove compartment was a silver flashlight and an Esso map of Vermont. Under the radio dial (55-7-9-11-14-16) was a row of five plastic buttons in the shape of cantilevered cubes. The rearview

mirror dislocated the road behind us. While listening to the radio, some of us read the Sunday newspapers. The pages made slight noises as they turned; each sheet folded over their laps forming temporary geographies of paper. A valley of print or a ridge of photographs would come and go in an instant.

We arrived at the Great Notch Quarry, which is situated "about three hundred yards southwest of the Great Notch station of the Erie Railroad." The quarry resembled the moon. A gray factory in the midst of it all, looked like architecture designed by Robert Morris. A big sign on one building said THIS IS A HARD HAT AREA. We started climbing over the piles and ran into a "rock hound," who came on, I thought, like Mr. Wizard, and who gave us all kinds of rock-hound-type information in an authoritative manner. We got a rundown on all the quarries that were closed to the public, as well as those that were open.

The walls of the quarry did look dangerous. Cracked, broken, shattered; the walls threatened to come crashing down. Fragmentation, corrosion, decomposition, disintegration, rock creep, debris slides, mud flow, avalanche were everywhere in evidence. The gray sky seemed to swallow up the heaps around us. Fractures and faults spilled forth sediment, crushed conglomerates, eroded debris and sandstone. It was an arid region, bleached and dry. An infinity of surfaces spread in every direction. A chaos of cracks surrounded us.

On the top of a promontory stood a motionless rockdrill against the blank which was the sky. High-tension towers transported electric cable over the quarry. Dismantled parts of steam shovels, tread machines and trucks were lined up in random groups. Such objects interrupted the depositions of waste that formed the general condition of the place. What vegetation there was seemed partially demolished. Newly made boulders eclipsed parts of a wire and pipe fence. Railroad tracks passed by the quarry, the ties formed a redundant sequence of modules, while the steel tracks projected the modules into an imperfect vanishing point.

On the way back to Manhattan, we drove through the Jersey Meadows, or more accurately the Jersey Swamps—a good location for a movie about life on Mars. It even has a network of canals that are choked by acres of tall reeds. Radio towers are scattered throughout this bleak place. Drive-ins, motels and gas stations exist along the highway, and behind them are smoldering garbage dumps. South, toward Newark and Bayonne, the smoke stacks of heavy industry add to the general air pollution.

As we drove through the Lincoln Tunnel, we talked about going on another trip, to Franklin Furnace; there one might find minerals that glow under ultraviolet light or "black light." The countless cream colored square tiles on the walls of the tunnel sped by, until a sign announcing New York broke the tiles' order.

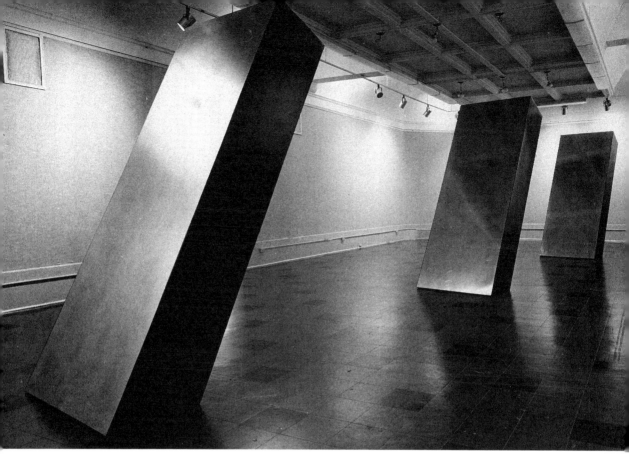

RONALD BLADEN, *Untitled,* 1965. Aluminum and
painted wood, each element, 108 x 48 x 120 x 21″.

ENTROPY AND THE NEW MONUMENTS (1966)

> On rising to my feet, and peering across the green glow of the Desert,
> I perceived that the monument against which I had slept was but one
> of thousands. Before me stretched long parallel avenues, clear to the
> far horizon of similar broad, low pillars.
>
> <div align="right">John Taine (Eric Temple Bell) "THE TIME STREAM"</div>

Many architectural concepts found in science-fiction have nothing to do with
science or fiction, instead they suggest a new kind of monumentality which
has much in common with the aims of some of today's artists. I am thinking in
particular of Donald Judd, Robert Morris, Sol LeWitt, Dan Flavin, and of cer-
tain artists in the "Park Place Group." The artists who build structured canvases
and "wall-size" paintings, such as Will Insley, Peter Hutchinson and Frank
Stella are more indirectly related. The chrome and plastic fabricators such as
Paul Thek, Craig Kauffman, and Larry Bell are also relevant. The works of
many of these artists celebrate what Flavin calls "inactive history" or what the

Artforum, June 1966

physicist calls "entropy" or "energy-drain." They bring to mind the Ice Age rather than the Golden Age, and would most likely confirm Vladimir Nabokov's observation that, "The future is but the obsolete in reverse." In a rather round-about way, many of the artists have provided a visible analog for the Second Law of Thermodynamics, which extrapolates the range of entropy by telling us energy is more easily lost than obtained, and that in the ultimate future the whole universe will burn out and be transformed into an all-encompassing sameness. The "blackout" that covered the Northeastern states recently, may be seen as a preview of such a future. Far from creating a mood of dread, the power failure created a mood of euphoria. An almost cosmic joy swept over all the darkened cities. Why people felt that way may never be answered.

Instead of causing us to remember the past like the old monuments, the new monuments seem to cause us to forget the future. Instead of being made of natural materials, such as marble, granite, or other kinds of rock, the new monuments are made of artificial materials, plastic, chrome, and electric light. They are not built for the ages, but rather against the ages. They are involved in a systematic reduction of time down to fractions of seconds, rather than in representing the long spaces of centuries. Both past and future are placed into an objective present. This kind of time has little or no space; it is stationary and without movement, it is going nowhere, it is anti-Newtonian, as well as being instant, and is against the wheels of the time-clock. Flavin makes "instant-monuments"; parts for "Monument 7 for V. Tatlin" were purchased at the Radar Fluorescent Company. The "instant" makes Flavin's work a part of time rather than space. Time becomes a place minus motion. If time is a place, then innumerable places are possible. Flavin turns gallery-space into gallery time. Time breaks down into many times. Rather than saying, "What time is it?" we should say, "Where is the time?" "Where is Flavin's Monument?" The objective present at times seems missing. A million years is contained in a second, yet we tend to forget the second as soon as it happens. Flavin's destruction of classical time and space is based on an entirely new notion of the structure of matter.

Time as decay or biological evolution is eliminated by many of these artists; this displacement allows the eye to see time as an infinity of surfaces or struc-tures, or both combined, without the burden of what Roland Barthes calls the "undifferentiated mass of organic sensation." The concealed surfaces in some of Judd's works are hideouts for time. His art vanishes into a series of motion-less intervals based on an order of solids. Robert Grosvenor's suspended struc-tural surfaces cancel out the notion of weight, and reverse the orientation of matter within the solid-state of inorganic time. This reduction of time all but annihilates the value of the notion of "action" in art.

Mistakes and dead-ends often mean more to these artists than any proven problem. Questions about form seem as hopelessly inadequate as questions about content. Problems are unnecessary because problems represent values

that create the illusion of purpose. The problem of "form vs. content," for example, leads to illusionistic dialectics that become, at best, formalist reactions against content. Reaction follows action, till finally the artist gets "tired" and settles for a monumental inaction. The action-reaction syndrome is merely the leftovers of what Marshall McLuhan calls the hypnotic state of mechanism. According to him, an electrical numbing or torpor has replaced the mechanical breakdown. The awareness of the ultimate collapse of both mechanical and electrical technology has motivated these artists to build their monuments to or against entropy. As LeWitt points out, "I am not interested in idealizing technology." LeWitt might prefer the word "sub-monumental," especially if we consider his proposal to put a piece of Cellini's jewelry into a block of cement. An almost alchemic fascination with inert properties is his concern here, but LeWitt prefers to turn gold into cement.

The much denigrated architecture of Park Avenue known as "cold glass boxes," along with the Manneristic modernity of Philip Johnson, have helped to foster the entropic mood. The Union Carbide building best typifies such architectural entropy. In its vast lobby one may see an exhibition called "The Future." It offers the purposeless "educational" displays of Will Burtin, "internationally acclaimed for his three-dimensional designs," which portray "Atomic Energy in Action." If ever there was an example of action in entropy, this is it. The action is frozen into an array of plastic and neon, and enhanced by the sound of Muzak faintly playing in the background. At a certain time of day, you may also see a movie called "The Petrified River." A nine-foot vacuum-formed blue plexiglass globe is a model of a uranium atom—"ten million trillion trillion times the size of the actual atom." Lights on the ends of flexible steel rods are whipped about in the globe. Parts of the "underground"

ROBERT SMITHSON, *Cryosphere*, 1966. Painted steel w/chrome inserts, six modules, 17 x 17 x 6".

DAN FLAVIN, installation view, November 1964.

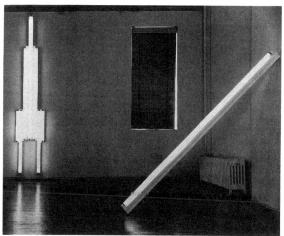

movie, "The Queen of Sheba Meets the Atom Man," were filmed in this exhibition hall. Taylor Mead creeps around in the film like a loony sleepwalker, and licks the plastic models depicting "chain-reaction." The sleek walls and high ceilings give the place an uncanny tomb-like atmosphere. There is something irresistible about such a place, something grand and empty.

This kind of architecture without "value of qualities," is, if anything, a fact. From this "undistinguished" run of architecture, as Flavin calls it, we gain a clear perception of physical reality free from the general claims of "purity and idealism." Only commodities can afford such illusionistic values; for instance, soap is 99^{44}/$_{100}$% pure, beer has more spirit in it, and dog food is ideal; all and all this means such values are worthless. As the cloying effect of such "values" wears off, one perceives the "facts" of the outer edge, the flat surface, the banal, the empty, the cool, blank after blank; in other words, that infinitesimal condition known as entropy.

The slurbs, urban sprawl, and the infinite number of housing developments of the postwar boom have contributed to the architecture of entropy. Judd, in a review of a show by Roy Lichtenstein, speaks of "a lot of visible things" that are "bland and empty," such as "most modern commercial buildings, new Colonial stores, lobbies, most houses, most clothing, sheet aluminum, and plastic with leather texture, the formica like wood, the cute and modern patterns inside jets and drugstores." Near the super highways surrounding the city, we find the discount centers and cut-rate stores with their sterile facades. On the inside of such places are maze-like counters with piles of neatly stacked merchandise; rank on rank it goes into a consumer oblivion. The lugubrious complexity of these interiors has brought to art a new consciousness of the vapid and the dull. But this very vapidity and dullness is what inspires many of the

ROBERT GROSVENOR, *Transoxiana,* 1965. Painted wood, polyester and steel, 126 x 372 x 36".

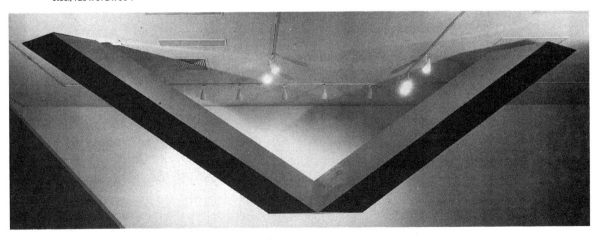

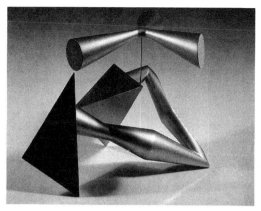

FORREST MYERS, *E/3*, 1965. Aluminum and lacquer paint, 16 x 16 x 16".

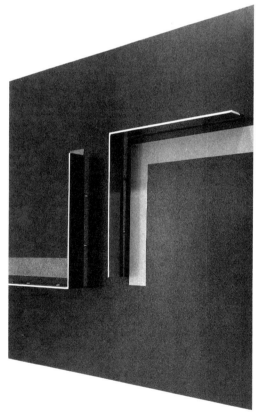

JOHN CHAMBERLAIN, *Conrad*, 1964. Auto lacquer, metal flake on formica with chrome, 48 x 48".

more gifted artists. Morris has distilled many such dull facts and made them into monumental artifices of "idea." In such a way, Morris has restored the idea of immortality by accepting it as a fact of emptiness. His work conveys a mood of vast immobility; he has even gone so far as to fashion a bra out of lead. (This he has made for his dance partner, Yvonne Rainer, to help stop the motion in her dances.)

This kind of nullification has re-created Kasimir Malevich's "non-objective world," where there are no more "likenesses of reality, no idealistic images, nothing but a desert!" But for many of today's artists this "desert" is a "City of the Future" made of null structures and surfaces. This "City" performs no natural function, it simply exists between mind and matter, detached from both, representing neither. It is, in fact, devoid of all classical ideals of space and process. It is brought into focus by a strict condition of perception, rather than by any expressive or emotive means. Perception as a deprivation of action and reaction brings to the mind the desolate, but exquisite, surface-structures of the empty "box" or "lattice." As action decreases, the clarity of such surface-structures increases. This is evident in art when all representations of action pass into oblivion. At this stage, lethargy is elevated to the most glorious magnitude. In Damon Knight's Sci-fic novel, "Beyond the Barrier," he describes in a phenomenological manner just such surface-structures: "Part of the scene before them seemed to expand. Where one of the flotation machines had been, there was a dim lattice of crystals, growing more shadowy and insubstantial as it swelled; then darkness; then a dazzle of faint prismatic light—tiny complexes in a vast three-dimensional array, growing steadily bigger." This description has none of the "values" of the naturalistic "literary" novel, it is crystalline, and of the mind by virtue of

being outside of unconscious action. This very well could be an inchoate concept for a work by Judd, LeWitt, Flavin, or Insley.

It seems that beyond the barrier, there are only more barriers. Insley's "Night Wall" is both a grid and a blockade; it offers no escape. Flavin's fluorescent lights all but prevent prolonged viewing; ultimately, there is nothing to see. Judd turns the logic of set theory into block-like facades. These facades hide nothing but the wall they hang on.

LeWitt's first one-man show at the now defunct Daniel's Gallery presented a rather uncompromising group of monumental "obstructions." Many people were "left cold" by them, or found their finish "too dreary." These obstructions stood as visible clues of the future. A future of humdrum practicality in the shape of standardized office buildings modeled after Emery Roth; in other words, a jerry-built future, a feigned future, an ersatz future very much like the one depicted in the movie "The Tenth Victim." LeWitt's show has helped to neutralize the myth of progress. It has also corroborated Wylie Sypher's insight that "Entropy is evolution in reverse." LeWitt's work carries with it the brainwashed mood of Jasper Johns' "Tennyson," Flavin's "Coran's Broadway Flesh," and Stella's "The Marriage of Reason and Squalor."

Morris also discloses this backward looking future with "erections" and "vaginas" embedded in lead. They tend to illustrate fossilized sexuality by mixing the time states or ideas of "1984" with "One Million B.C." Claes Oldenburg achieves a similar conjunction of time with his prehistoric "ray-guns." This sense of extreme past and future has its partial origin with the Museum of Natural History; there the "cave-man" and the "space-man" may be seen under one roof. In this museum all "nature" is stuffed and interchangeable.

PAUL THEK, *Hippopotamus*, 1965. 19¾ x 11 x 11¼".

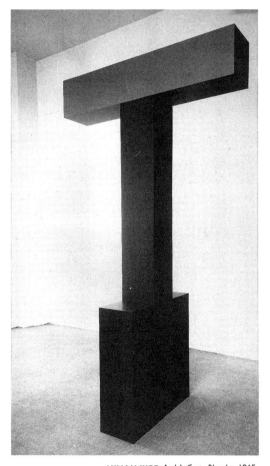

LYMAN KIPP, *Andy's Carte Blanche*, 1965. Painted plywood, 96 x 36 x 60".

This City (I thought) is so horrible that its mere existence and perdurance, though in the midst of a secret desert, contaminates the past and future and in some way even jeopardizes the stars.

Jorge Luis Borges, *The Immortal*

Tromaderians consider anything blue extremely pornographic.

Peter Hutchinson, *Extraterrestrial Art*

"Lust for Life" is the story of the great sensualist painter Vincent Van Gogh, who bounds through the pages and passions of Irving Stone's perennial bestseller. And this is the Van Gogh overwhelmingly brought before us by Kirk Douglas in M-G-M's film version, shot in Cinemascope and a sun-burst of color on the actual sites of Van Gogh's struggles to feel feelings never felt before.

Promotion Copy, quoted in
Vincent Van Gogh—The Big Picture, John Mulligan

Unlike the hyper-prosaism of Morris, Flavin, LeWitt, and Judd, the works of Thek, Kauffman, and Bell convey a hyper-opulence. Thek's sadistic geometry is made out of simulated hunks of torn flesh. Bloody meat in the shape of a birthday cake is contained under a pyramidal chrome framework—it has stainless steel candies in it. Tubes for drinking "blood cocktails" are inserted into some of his painful objects. Thek achieves a putrid finesse, not unlike that disclosed in William S. Burroughs' *Nova Express*; "—Flesh juice in festering spines of terminal sewage—Run down of Spain and 42nd St. to the fish city of marble flesh grafts—." The vacuum-formed plastic reliefs by Kauffman have a pale lustrous surface presence. A lumpy sexuality is implicit in the transparent forms he employs. Something of the primal nightmare exists in both Thek and Kauffman. The slippery bubbling ooze from the movie "The Blob" creeps into one's mind. Both Thek and Kauffman have arrested the movement of blob-type matter. The mirrored reflections in Bell's work are contaminations of a more elusive order. His chrome-plated lattices contain a Pythagorean chaos. Reflections reflect reflections in an excessive but pristine manner.

Some artists see an infinite number of movies. Hutchinson, for instance, instead of going to the country to study nature, will go to see a movie on 42nd Street, like "Horror at Party Beach" two or three times and contemplate it for weeks on end. The movies give a ritual pattern to the lives of many artists, and this induces a kind of "low-budget" mysticism, which keeps them in a perpetual trance. The "blood and guts" of horror movies provides for their "organic needs," while the "cold steel" of Sci-fic movies provides for their "inorganic needs." Serious movies are too heavy on "values," and so are dismissed by the more perceptive artists. Such artists have X-ray eyes, and can see through all of that cloddish substance that passes for "the deep and profound" these days.

Some landmarks of Sci-fic are: *Creation of the Humanoids* (Andy Warhol's fa-

ROBERT MORRIS, *Untitled*, 1963. Lead, 10 x 8".

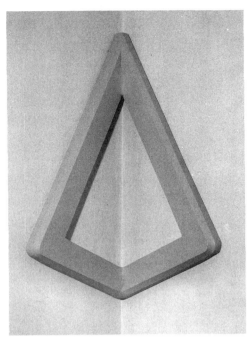

PETER HUTCHINSON, *Silver Highlight*, 1966. Liquitex on canvas, 72 x 7".

vorite movie), *The Planet of the Vampires* (movie about entropy), *The Thing, The Day the Earth Stood Still, The Time Machine, Village of the Giants* (first teen-science film), *War of the Worlds* (interesting metallic machines). Some landmarks of Horror are: *Creature from the Black Lagoon, I Was a Teenage Werewolf, Horror Chamber of Dr. Faustus* (very sickening), *Abbott and Costello Meet Frankenstein.* Artists that like Horror tend toward the emotive, while artists who like Sci-fic tend toward the perceptive.

Even more of a mental conditioner than the movies, is the actual movie house. Especially the "moderne" interior architecture of the new "art-houses" like Cinema I and II, 57th St. Lincoln Art Theatre, the Coronet, Cinema Rendezvous, the Cinema Village, the Baronet, the Festival, and the Murray Hill. Instead of the crummy baroque and rococo of the 42nd Street theaters, we get the "padded cell" look, the "stripped down" look, or the "good-taste" look. The physical confinement of the dark box-like room indirectly conditions the mind. Even the place where you buy your ticket is called a "box-office." The lobbies are usually full of box-type fixtures like the soda-machine, the candy counter, and telephone booths. Time is compressed or stopped inside the movie house, and this in turn provides the viewer with an entropic condition. To spend time in a movie house is to make a "hole" in one's life.

Recently, there has been an attempt to formulate an analog between "communication theory" and the ideas of physics in terms of entropy. As A. J. Ayer has pointed out, not only do we communicate what is true, but also what is false. Often the false has a greater "reality" than the true. Therefore, it seems

that all information, and that includes anything that is visible, has its entropic side. Falseness, as an ultimate, is inextricably a part of entropy, and this falseness is devoid of moral implications.

Like the movies and the movie houses, "printed-matter" plays an entropic role. Maps, charts, advertisements, art books, science books, money, architectural plans, math books, graphs, diagrams, newspapers, comics, booklets and pamphlets from industrial companies are all treated the same. Judd has a labyrinthine collection of "printed-matter," some of which he "looks" at rather than reads. By this means he might take a math equation, and by sight, translate it into a metal progression of structured intervals. In this context, it is best to think of "printed-matter" the way Borges thinks of it, as "The universe (which others call the library)," or like McLuhan's "Gutenberg Galaxy," in other words as an unending "library of Babel." This condition is reflected in Henry Geldzahler's remark, "I'm doing a book on European painting since 1900—a drugstore book. Dell is printing 100,000 copies." Too bad Dell isn't printing 100,000,000,000.

Judd's sensibility encompasses geology, and mineralogy. He has an excellent collection of geologic maps, which he scans from time to time, not for their intended content, but for their exquisite structural precision. His own writing style has much in common with the terse, factual descriptions one finds in his collection of geology books. Compare this passage from one of his books, "The Geology of Jackson County, Missouri" to his own criticism: "The interval between the Cement City and the Raytown limestones varies from 10 to 23 feet. The lower three-quarters is an irregularly colored green, blue, red, and yellow

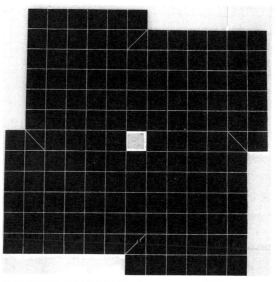

WILL INSLEY, *Night Wall,* 1964. Lead, oil on masonite, 8′8″ high.

shale which at some places contains calcareous concretions." And now an excerpt from Judd's review of Dan Flavin's first one-man show: "The light is bluntly and awkwardly stuck on the square block; it protrudes awkwardly. The red in the green attached to a lighter green is odd as color, and as a sequence."

> I like particularly the way in which he (Robert Morris) subverts the "purist" reading one would normally give to such geometric arrangements.
>
> Barbara Rose, "Looking at American Sculpture, "
> *Artforum*, February 1965

> "Point Triangle Gray" Faith sang, waving at an intersection ahead. "That's the medical section. Tests and diseases, injuries and—" she giggled naughtily—"Supply depot for the Body Bank."
>
> J. Williamson & F. Pohl, *The Reefs of Space*

> Make a
> sick
> picture
> or a sick
> Readymade
>
> Marcel Duchamp, from the *Green Box*

Many of Morris's wall structures are direct homages to Duchamp; they deploy facsimiles of ready-mades within high Manneristic frames of reference. Extensions of the Cartesian mind are carried to the most attenuated points of no return by a systematic annulment of movement. Descartes' cosmology is brought to a standstill. Movement in Morris's work is engulfed by many types of stillness: delayed action, inadequate energy, general slowness, an all over sluggishness. The ready-mades are, in fact, puns on the Bergsonian concept of "creative evolution" with its idea of "ready made categories." Says Bergson, "The history of philosophy is there, however, and shows us the eternal conflict of systems, the impossibility of satisfactorily getting the real into the ready-made garments of our ready-made concepts, the necessity of making to measure." But it is just such an "impossibility" that appeals to Duchamp and Morris. With this in mind, Morris's monstrous "ideal" structures are inconsequential or uncertain ready-mades, which are definitely outside of Bergson's concept of creative evolution. If anything, they are uncreative in the manner of the 16th-century alchemist-philosopher-artist. C. G. Jung's writing on "The Materia Prima" offers many clues in this direction. Alchemy, it seems, is a concrete way of dealing with sameness. In this context, Duchamp and Morris may be seen as artificers of the uncreative or decreators of the Real. They are like the 16th-century artist Parmigianino, who "gave up painting to become an alchemist." This might help us to understand both Judd's and Morris's interest in geology. It is also well to remember that Parmigianino and Duchamp both painted "Vir-

gins," when they did paint. Sydney Freedberg observed in the work of Parmigianino "an assembly of surfaces, nothing is contained within these surfaces." Such an observation might also be applied to Duchamp's hollow "Virgins," with their insidious almost lewd associations. The "purist" surfaces of certain artists have a "contamination" in them that relates to Duchamp and Parmigianino, if not in fact, at least in idea.

The impure-purist surface is very much in evidence in the new abstract art, but I think Stella was the first to employ it. The iridescent purple, green, and silver surfaces that followed Stella's all-black works, conveyed a rather lurid presence through their symmetries. An exacerbated, gorgeous color gives a chilling bite to the purist context. Immaculate beginnings are subsumed by glittering ends. Like Mallarmé's "Herodiade," these surfaces disclose a "cold scintillation"; they seem to "love the horror of being virgin." These inaccessible surfaces deny any definite meaning in the most definite way. Here beauty is allied with the repulsive in accordance with highly rigid rules. One's sight is mentally abolished by Stella's hermetic kingdom of surfaces.

Stella's immaculate but sparkling symmetries are reflected in John Chamberlain's "Kandy-Kolored" reliefs. "They are extreme, snazzy, elegant in the wrong way, immoderate," says Judd. "It is also interesting that the surfaces of the reliefs are definitely surfaces." Chamberlain's use of chrome and metalflake brings to mind the surfaces in *Scorpio Rising*, Kenneth Anger's many-faceted horoscopic film about constellated motorcyclists. Both Chamberlain and Anger have developed what could be called California surfaces. In a review of the film, Ken Kelman speaks of "the ultimate reduction of ultimate experience to brilliant chromatic surface; Thanatos in Chrome—artificial death" in a way that evokes Chamberlain's giddy reliefs.

Judd bought a purple Florite crystal at the World's Fair. He likes the "uncreated" look of it and its impenetrable color. John Chamberlain, upon learning of Judd's interest in such a color, suggested he go to the Harley Davidson Motorcycle Company and get some "Hi-Fi" lacquer. Judd did this and "self" sprayed some of his works with it. This transparent lacquer allows the "star-spangled" marking on the iron sheet to come through, making the surfaces look mineral hard. His standard crystallographic boxes come in a variety of surfaces from Saturnian orchid-plus to wrinkle-textured blues and greens—alchemy from the year 2000.

> But I think nevertheless, we do not feel altogether comfortable at
> being forced to say that the crystal is the seat of greater disorder
> than the parent liquid.
>
> P. W. Bridgman, *The Nature Of Thermodynamics*

The formal logic of crystallography, apart from any preconceived scientific content, relates to Judd's art in an abstract way. If we define an abstract crystal as a solid bounded by symmetrically grouped surfaces, which have definite re-

lationships to a set of imaginary lines called axes, then we have a clue to the structure of Judd's "pink plexiglas box." Inside the box five wires are strung in a way that resembles very strongly the crystallographic idea of axes. Yet, Judd's axes don't correspond with any natural crystal. The entire box would collapse without the tension of the axes. The five axes polarize between two stainless steel sides. The inside surfaces of the steel sides are visible through the transparent plexiglas. Every surface is within full view, which makes the inside and outside equally important. Like many of Judd's works, the separate parts of the box are held together by tension and balance, both of which add to its static existence.

> Like energy, entropy is in the first instance a measure of something that happens when one state is transformed into another.
> P. W. Bridgman, *The Nature of Thermodynamics*

The Park Place Group (Mark di Suvero, Dean Fleming, Peter Forakis, Robert Grosvenor, Anthony Magar, Tamara Melcher, Forrest Myers, Ed Ruda, and Leo Valledor) exists in a space-time monastic order, where they research a cosmos modeled after Einstein. They have also permuted the "models" of R. Buckminster Fuller's "vectoral" geometry in the most astounding manner.

Fuller was told by certain scientists that the fourth dimension was "ha-ha," in other words, that it is laughter. Perhaps it is. It is well to remember that the seemingly topsy-turvy world revealed by Lewis Carroll did spring from a well ordered mathematical mind. Martin Gardner in his "The Annotated Alice," notes that in a science-fiction story "Mimsy Were the Borogroves" the author Lewis Padgett presents the Jabberwocky as a secret language from the future, and that if rightly understood, it would explain a way of entering the fourth dimension. The highly ordered non-sense of Carroll, suggests that there might be a similar way to treat laughter. Laughter is in a sense a kind of entropic "verbalization." How could artists translate this verbal entropy, that is "ha-ha," into "solid-models"? Some of the Park Place artists seem to be researching this "curious" condition. The order and disorder of the fourth dimension could be set between laughter and crystal-structure, as a device for unlimited speculation.

Let us now define the different types of Generalized Laughter, according to the six main crystal systems: the ordinary laugh is cubic or square (Isometric), the chuckle is a triangle or pyramid (Tetragonal), the giggle is a hexagon or rhomboid (Hexagonal), the titter is prismatic (Orthorhombic), the snicker is oblique (Monoclinic), the guffaw is asymmetric (Triclinic). To be sure this definition only scratches the surface, but I think it will do for the present. If we apply this "ha-ha-crystal" concept to the monumental models being produced by some of the artists in the Park Place group, we might begin to understand the fourth-dimensional nature of their work. From here on in, we must not think of Laughter as a laughing matter, but rather as the "matter-of-laughs."

Solid-state hilarity, as manifest through the "ha-ha-crystal" concept, appears

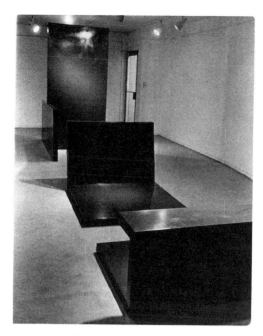

SOL LeWITT, 1965. Installation view.

in a patently anthropomorphic way in *Alice in Wonderland*, as the Cheshire Cat. Says Alice to the Cat, "you make one quite giddy!" This anthropomorphic element has much in common with impure-purist art. The "grin without a cat" indicates "laugh-matter and/or anti-matter," not to mention something approaching a solid giddiness. Giddiness of this sort is reflected in Myers' plastic contraptions. Myers sets hard titter against soft snickers, and puts hard guffaws onto soft giggles. A fit of silliness becomes a rhomboid, a high-pitched discharge of mirth becomes prismatic, a happy outburst becomes a cube, and so forth.

> You observed them at work in null time. From your description of what they were about, it seems apparent that they were erecting a transfer portal linking the null level with its corresponding aspect of normal entropy—in other words, with the normal continuum.
>
> Keith Laumer, *The Other Side of Time*

Through direct observation, rather than explanation, many of these artists have developed ways to treat the theory of sets, vectoral geometry, topology, and crystal structure. The diagrammatic methods of the "new math" have led to a curious phenomenon. Namely, a more visible math that is unconcerned with size or shape in any metrical sense. The "paper and pencil operations" that deal with the invisible structure of nature have found new models, and have been combined with some of the more fragile states of mind. Math is dislocated by the artists in a personal way, so that it becomes "Manneristic" or

separated from its original meaning. This dislocation of meaning provides the artist with what could be called "synthetic math." Charles Peirce (1839-1914), the American philosopher, speaks of "graphs" that would "put before us moving pictures of thought." (See Martin Gardner's *Logic Machines and Diagrams*.) This synthetic math is reflected in Duchamp's "measured" pieces of fallen threads, "Three Standard Stoppages," Judd's sequential structured surfaces, Valledor's "fourth dimensional" color vectors, Grosvenor's hypervolumes in hyperspace, and di Suvero's demolitions of space-time. These artists face the possibility of other dimensions, with a new kind of sight.

Simplicity of shape does not necessarily equate with simplicity of experience. Unitary forms do not reduce relationships. They order them. If the predominant hieratic nature of the unitary form functions as a constant, all those particularizing relations of scale, proportion, et cetera, are not thereby canceled. Rather they are bound more cohesively and indivisibly together. The magnification of this single most important sculptural value, shape, together with greater unification and integration of every other essential sculptural value... establishes both a new limit and freedom for sculpture.—*Robert Morris*

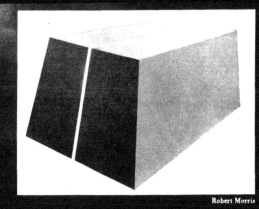

Robert Morris

THE
X
FACTOR
IN ART

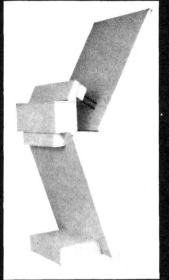

Ronald Bladen

In the film *Planet of the Vampires,* we see an enormous spaceship, the construction of which includes no right angles. The metal interior compartments have sloping walls, rounded corners, and are symmetrical after geometric figures other than the rectangle. As the film progresses, we enter yet another alien spaceship, long abandoned on an airless planet. Even more enormous, this ship takes us a step further: the huge corridors are circular and segmented, the segments being divided into bivalves. A magnetic property activates the ship's mechanisms when living bodies enter a section. Triangular plastic forms, pale orange and opaquely fluorescent, rhythmically pulsate. Electronic mechanisms—without wires, moving parts or obvious power source—activate the atmosphere locks... electronic tapes begin to speak an indecipherable tongue in the subjective time sequence of an alien race.—*Peter Hutchinson*

The time of our minds is no longer that of the clocks.—*Alain Robbe-Grillet*

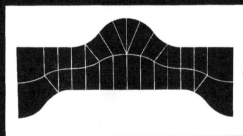

Will Insley

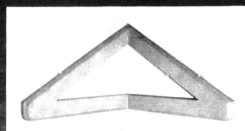

Peter Hutchinson

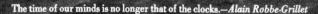

Robert Smithson

The new art is alien and distant, yet it is reflected in the familiar and common things of this planet. It shares with the new math the ability to manifest number relationships. The artist embodies in his work not only the facts of addition, subtraction, multiplication and division, but also the structure of the numbers system in terms of modules and units. Concepts such as mathematical crystal structure, set theory, clock math, and the Cuisenaire rod method, disclose to the new artist uncharted, abstract territories of the mind that he explores in terms of concrete structure.—*Robert Smithson*

Sol LeWitt

"Abstract painting, 1960", 60 x 60 inches, oil on canvas A square (neutral, shapeless) canvas, five feet wide, five feet high, as high as a man, as wide as a man's outstretched arms (not large, not small, sizeless), trisected (no composition), one horizontal form negating one vertical form (formless, no top, no bottom, directionless), three (more or less) dark (lightless) non-contrasting (colorless) colors, brushwork brushed out to remove brushwork, a mat, flat, free-hand painted surface (glossless, textureless, non-linear, no hard edge, no soft edge) which does not reflect its surroundings—a pure, abstract, non-objective, timeless, spaceless, change-less, relationless, disinterested painting—an object that is self-conscious (no unconsciousness), ideal, transcendent, aware of no thing but art (absolutely no anti-art). Ad Reinhardt, 1960.

Dan Flavin

With the nominal three, I will exult primary figures and their dimensions. Here will be the basic counting marks (primitive abstractions) restated long in the daylight glow of common fluorescent tubes. Such an elemental system becomes possible (ironic) in the context of my previous work.—*Dan Flavin*

Don Judd

The 'unconscious' has no place in Don Judd's art. His crystalline state of mind is far removed from the organic floods of action painting. He translates his concepts into artifices of fact. Space in Judd's art seems to belong to an order of increasing hardness, not unlike geological formations. He has put space down in the form of deposits. Such deposits come from his mind rather than nature. Judd has brought space down into an abstract world of mineral forms.—*Robert Smithson*

What comes into appearance must segregate in order to appear.—*Goethe*

The Domain of the Great Bear

By Mel Bochner & Robert Smithson

FOR SOME, INFINITY IS THE PLANETARIUM, A FROZEN WHIRLPOOL AT THE END OF THE WORLD, A VAST STRUCTURE OF CONCENTRIC CIRCLES, ROUND WHOSE BORDERS ONE MAY FIND AN INTERMINABLE COLLECTION OF IDEAS AS OBJECTS, A REPOSITORY OF MODEL UNIVERSES. HERE ALSO IS THE DOMAIN OF THE GREAT BEAR.

> *Nature is an infinite sphere, whose center is*
> *everywhere and whose circumference is nowhere.*
> —PASCAL

in the center of the infinite

Borges speaks of a labyrinth that is a straight line, invisible and unceasing. Overwhelming in its symmetries, the architecture of the planetarium is more labyrinthian. Circular, insular, windowless, it renders the mind itself invisible. An artistic conception of the inconceivable, it conforms to no outer necessity. Edges blur as one tries to distinguish an outline. The ambulatories become vast interminable spaces; traversing them becomes an interstellar journey. Once such expectations occur, there no longer exist any realities. Just vague disorders and contingencies. The planetarium becomes the same size as the universe; which it is. Perplexed, dizzied, one encounters here a cosmic nostalgia. Vertigo at contemplating man's most futile gesture—patrimony of the infinite. Above the staircase a sign:

> ## SOLAR SYSTEM
> ## ☞ & REST ROOMS

The walls of the original sections of the building have a clotted surface and are painted sky-blue. They are a last refuge from the sleek and streamlined. There is a toneless, bleak feeling in the blank stone facing, the wide stretches of deserted corridor, the dark shrouded corners. A supernatural, immobilizing effect. But the light of recently installed exhibitions is bleaching out the dim uncertainties of 1934. New notions of the future and space, more optimistic and satisfying, are supplanting the dreary void. Formica and fluorescent, chrome and plexiglass are replacing the beaverboard, textured cement, glass and plywood. The dismal maroons and blacks are being repainted aqua, chartreuse, cerise or tangerine.

The conundrum, however, remains.

captives of the planets

At first only the image of a yellow light bulb is visible, suspended from the ceiling. A small globe of yellow incandescent light sunk in a dim background. Slowly other groupings of lights appear, advancing or retreating sluggishly as they move out from the center along wider and wider tracks. In orbit about the second order of lamps, further diminished lights revolve, sometimes indistinct, sometimes overlapping, hanging from boxes and armatures or other less simple shapes. This is the Solar System.

On the floor, in the center of the circular room, beneath the sun, is a twelve-foot reproduction of the Aztec Calendar Stone. The core of the design is a face of the Sun God. Its close-set eyes are crossed. Its expression vaguely cruel. On either side of the Sun, claws enclosed in circles are grasping human hearts.

About the stone in concentric rows are the seats. In the seats, in stupor, the audience. . . . Captives of the Planets. The atmosphere is violet, silent and inert. A recorded lecture drones in a basal monotone. Vacancy adds to the lifelessness. The axes of the system cut four aisles through the tightly wound rings of chairs. The aisles terminate in four sets of double doors at the outermost reaches. The doors, once closed, expel temporality. Enormous lengths of time are compressed into the room. Light-years pass in minutes. Life so extended becomes negligible. The cycle of the planets occurs and reoccurs. The Solar System, this mechanical collection of tracks, boxes, bulbs, gears, armatures, rods, seems tired, torpid. A chamber of ennui. And fatigue. It is endless, if only the electricity holds out.

All photos courtesy of American Museum of Natural History

"Under the great dome, the lecturer, with a complicated series of buttons, dials and switches to manipulate, and with over two thousand possible combinations at his command, is virtually in control of the universe."

Hayden Planetarium
Guide Book

LONGITUDINAL SECTION OF THE HAYDEN PLANETARIUM

at the perimeter

Beyond the malevolent red exit sign of the Solar System rests the Williamette meteor. It is, presumably, one of the largest meteors in captivity. Behind it a caption from another exhibit reads "The Future."

It is here, at the perimeter of the old sensibility, that the Viking Rocket display lies, caught between the old humanism and the new technologism. Along its fifty-foot length are inset twenty plastic windows. Ten of these are clear and transparent. Four are green. Three are red. Two are blue. The remaining one is of an indeterminate cast. The body of the rocket was at one time white. It has become overcast, marred in spots, gray, somehow decadent. The nose cone appears to be of another material or else the same material unpainted. The interior looks uncomplicated. Various square, cylindrical or polygonal boxes and compartments, either open or closed, perforated or solid, are interconnected by means of single or grouped wires. The parts are labeled: Cosmic Ray Coincidence Amplifier, Solar Aspect, Gimbal Ring, Doppler Antenna, X-Ray Densitometer. In the central cavity of the elongated main section is the fuel tank. Three plastic windows reveal the red void, a chilly container of nothingness. The next opening along the fuselage proceeding from left to right is the oxidizer tank. It is a vitriolic green in color, cleaner in appearance, and bored through centrally by a standpipe. The rear exhaust, directly behind the aft instrumentation compartment, is joined to the main body by four large red hoses. The whole apparatus is set into the posterior orifice beneath a cylindrical casing with nine plugs attached to the end of it terminating in a series of stranded white wires that disappear somewhere off to the left behind a lateral appendage clearly marked *Yaw Servo*.

The supposed factuality yields no information. Nothing is known but the impenetrable surfaces.

beyond the possibility threshold

For some, reality is not enough. Others, perhaps those whose anxieties have been deadened by lethargy and inactivity, find in the inert forms of reality a rare intoxication. The shapes of the physical world, once assimilated, become detached identities. The random dimensions of reality lose their subjectivity. Duration becomes a coefficient of weight. It is beyond this possibility threshold that the "black-light" mural room exists.

Entry to the mural hall is gained by skirting a floor-to-ceiling blockade. Immediately a misty carnival of space sensations is encountered. Bloated visions of "Saturn and Its Rings," "Moon in Eclipse," "Giant Nebulae of Orion," "Lunar Landscape." The luminescent whites and yellows are activated by the dim "black-light." Backgrounds are dark, velvety, vast, infinite, spectacular. But oddly, the reverse effect is achieved. The hall is confining, claustrophobic. If this is outer space, any closet will do. These flat heavenly bodies are nothing more than transposed images of mental fixity. The room a replica of quasi-deaths.

Here, as everywhere in this labyrinth of inefficient senses and circular reasons, there is a center. The Ahnighito Meteor. "In 1956 the Toledo Scale Company built a special scale which was assembled in this corridor. . . . The weight of the meteor was discovered to be 68,085 pounds. Visitors, by stepping on the scale platform, may see the hand of the scale move slightly as their own weight is added to that of the gigantic meteorite."

More incredible than the Scale, more artificial and unreal than the fluorescing pigment of the murals, are the unsuspecting visitors. Their shirts gather the impossible luminescence. Their glowing teeth become more stellar, more remote than the tiny specks of distant planets which surround them. Trapped in this chamber of the unceasing Planetarium, the duration of their stay is heavier than Ahnighito's thirty-four tons.

secrets of the ambulatories

1. THE GLORIFIED ORRERY, FORTY FEET IN DIAMETER . . .
2. EXACT REPLICA OF AZTEC CALENDAR STONE . . .
3. COLORED PANELS OF THE SOLAR PROMINENCES . . .
4. LOAN COLLECTIONS OF ASTROLABES, COMPASSES, AND HOURGLASSES . . .
5. AN IMAGINARY 10,000,000,000,000,000,000 MILE TRIP . . .
6. THE LUNAR LANDSCAPE PAINTED BY HOWARD RUSSELL BUTLER . . .
7. THE ELEPHANTS AND A TORTOISE SUPPORT A HEMISPHERICAL EARTH . . .
8. THE WORLD SERPENT TWINED ABOUT EARTH EGG . . .
9. THE BABYLONIAN IDEA OF THE UNIVERSE AS A BOX . . .
10. APOPI, WHO LIVED IN THE DEPTHS OF THE CELESTIAL RIVER . . .
11. TWO THOUSAND TIMES THE WEIGHT OF PLATINUM . . .
12. THE ABANDONMENT OF SPLENDID SPECULATION . . .
13. MODEL OF THE EINSTEIN TOWER AT POTSDAM . . .
14. A SHIP WHIRLING ABOUT IN THE FUNNEL OF THE MAELSTROM . . .
15. AN ENTIRE DAY IN THREE MINUTES . . .
16. THE SO-CALLED "LAW OF THE CONSERVATION OF MATTER" . . .
17. AN IMPONDERABLE, ALL-PERVASIVE, AND INTERMEDIATE SUBSTANCE . . .
18. THE OLD LUMINIFEROUS ETHER DOES NOT FUNCTION . . .
19. THE BRITISH ECLIPSE EXPEDITIONS OF 1919 . . .
20. SUNDIAL MOTTO: "I MARK ONLY THE SUNNY HOURS" . . .
21. ORDINARY X-RAYS ARE A KIND OF INVISIBLE LIGHT . . .
22. VARIATION OF RAY INTENSITY WITH ALTITUDE . . .

1. BAYER'S HISTORIC URANOMETRIA . . .
2. MORE THAN 120 STEREOPTICON LANTERNS . . .
3. WHIRLPOOLS OF MAGNETIC ACTIVITY . . .
4. THE DARK WEDGE OF SYRTIS MAJOR . . .
5. PHILOLAUS AND THE COSMIC OCTAVE . . .
6. THE CIGAR THAT LASTS TWICE AS LONG . . .
7. SHIFTING OF THE SPECTRUM LINES . . .
8. EDDINGTON'S IMAGINARY EXPERIMENT . . .
9. DEMOCRITUS AND THE THEORY OF COMETS . . .
10. AN IRON CEILING OVER THE UNIVERSE . . .
11. BROWNIAN MOVEMENT EQUATION (1905) . . .
12. PHOTO-ELECTRIC EQUATION (1905) . . .
13. A CERTAIN HAZY CONDITION . . .
14. APPROXIMATELY FIFTEEN TONS . . .
15. 33-INCH TELESCOPE AT MEUDON . . .
16. TWELVE MASSIVE PILLARS . . .
17. TIME KEPT BY A FICTITIOUS SUN . . .
18. NORMAL TIME AT THE 75TH MERIDIAN . . .
19. COSMIC RAYS IN THE STRATOSPHERE . . .
20. A FIRM FOUNDATION . . .

SATURN

1. FRIGID IN DARKNESS . . .
2. THE SPECTROHELIOSCOPE . . .
3. THE GOD SHU . . .
4. MUSIC OF THE SPHERES . . .
5. THE AKELEY CEMENT GUN . . .
6. CENTRIPETAL FORCE . . .
7. THE VERNAL EQUINOX . . .
8. A WORLD WITHOUT LIFE . . .
9. 200° BELOW ZERO . . .

secrets of the domes

1. DRIVEN DOWN BY MEANS OF A 6,500 POUND STEAM HAMMER . . .
2. THE CORONA IS CORRELATED WITH THE PERIODICITY OF SUNSPOTS . . .
3. SUSPENDED FROM SMALL T-SHAPED BAR ANCHORS . . .
4. "SPOT" WELDED ALONG THE LAPS AT ONE-INCH INTERVALS . . .
5. TWO FALSE-WORK SURFACES HELD AT EQUAL DISTANCES . . .
6. GAUZELIKE WINGS HIDE MYRIAD SUNS FROM VIEW . . .
7. MASSES OF OPAQUE MATTER OBSCURING THE LIGHT OF STARS . . .
8. DESIGNED TO MINIMIZE STRAIN ON THE NECK . . .
9. THE GIANT APPARATUS TURNS AND TWISTS . . .
10. SEPARATED FROM THE EARTH BY 240,000 MILES . . .
11. A DECADE OF STUDY OF CERTAIN CRATERS . . .
12. THE GREEKS BELIEVED THE EARTH TO BE A DISK . . .
13. WHITE-ROBED PRIESTS STANDING MOTIONLESS . . .
14. ILLUMINATED BY FLOODLIGHTS CONCEALED ABOVE THE MARQUEE . . .
15. THAT MANY-SIDED GENIUS—THE LATE CARL AKELEY . . .
16. *RIME OF THE ANCIENT MARINER* AND THE "HORNED MOON" . . .
17. ALLEGHANY OBSERVATORY STAFF DISCOVERS "FURNACE COMETS" . . .
18. THE BIG DIPPER, FOUND IN THE NARROW BELT CALLED THE ZODIAC . . .
19. NATURAL TENDENCY OF ALL KNOWLEDGE TO "UNITY AND SIMPLICITY" . . .
20. REAL COLLISION, GRAZING COLLISION, OR NEAR COLLISION . . .
21. EUCLIDEAN GEOMETRY—LENGTH, BREADTH, AND THICKNESS . . .
22. THE LEAGUE OF NATIONS CONSIDERED A REVISION OF THE CALENDAR . . .

1. LIGHT RAYS ARE BENT BY GRAVITY . . .
2. MILLIONS OF SMALL "MOONLETS" . . .
3. 90° IN A STIFFENING RIB ONE INCH WIDE . . .
4. 326 PILES WERE NECESSARY . . .
5. ROUND IRON RODS IMBEDDED IN CONCRETE . . .
6. S-SHAPED OBSCURATION WINDS . . .
7. THE PREVENTION OF DISTURBING ECHOES . . .
8. COMFORTABLE SEATING ARRANGEMENTS . . .
9. THE GREAT NEBULA IN ORION . . .
10. IRON PEDESTALS BOLTED TO THE FLOOR . . .
11. ONCE THOUGHT TO BE HOLES IN THE SKY . . .
12. HOLLOW SPHERES OF GASEOUS MATERIAL . . .
13. ALL THE POINTS OF THE COMPASS . . .
14. IN THE VALLEY OF TEN THOUSAND SMOKES . . .
15. *EASY LESSONS IN EINSTEIN* . . .
16. NEWTON AND ABSOLUTE SPACE . . .
17. SMALL-HEADED NAILS WERE USED . . .
18. THE PRESENT ORBIT OF NEPTUNE . . .
19. THE SATELLITES OF JUPITER . . .
20. VELOCITY 12,000 MILES PER SECOND . . .

1. A GIGANTIC SIEVE . . .
2. *ASTRONOMY FOR AMATEURS* . . .
3. A LAYER OF "ROCK CORK" . . .
4. THE RED SHIFT . . .
5. THE SWITCHBOARD . . .
6. "ALADDIN'S LAMP" . . .
7. NEWTON WITH HIS PRISM . . .
8. THE DOPPLER EFFECT . . .
9. RIGIDLY FIXED . . .

the domain of the great bear

SHOW SETTING:

Latitude 40°N, May 31, 1966, 9:00 hours on meridian. Geocentric earth set to 40°N Latitude, N.Y. on meridian. Red and green platform lights, blue pans, and cove lights up.

OPERATION I:

1. Red and green platform lights and cove lights should be out by end of introductory music.
2. On cue before music ends, technician projects slides showing title—first part—and then photo of bear and second part of title.
3. Lecturer fades in geocentric earth and signals off title and bear slides.
4. Lecturer fades in winter sun, moves geocentric earth to demonstrate its motion.
5. Lecturer switches to spring sun and demonstrates motion.
6. Lecturer switches to summer sun and demonstrates motion.
7. Lecturer stops geocentric earth and switches on all three suns.
8. Lecturer moves triple suns over earth.
9. Lecturer points out Tropic Zone of earth, Arctic Zone of earth, and Temperate Zone of earth.

Topic:

Introduction. Domain of Bear is Arctic. Demonstrate motions of winter, spring, summer suns over earth. Show how each will appear or not appear from Arctic region. Demonstrate and explain Tropic and Arctic Circles; Tropic, Arctic, and Temperate Zones on earth. Introduce next topic, viz, that Domain of Bear is also our spring evening sky.

Insert:

Tendency to immobilize the constellations into a concave grid-system. 'Stars' are projected from below, thus inverting the temporal 'naturalism' of the Copernican Solar System. The 'starry sky' is crystallized into square surfaces. Ursa-Major is represented by a slide (a stuffed Kodiac Bear) from the Museum of Natural History. The organic metaphor of the 'Bear' is replaced by an abstract grid-system that compacts all the seasons of the year, thus eliminating the passage of time through space. Space is almost excluded. Time is solidified. The Arctic Circle replaces the Tropic Circles. The 'Equator' within the actual limits of the Planetarium undergoes a meta-ice-age. Time becomes an actual-object. The stars of Ursa Major are frozen into a global arctic that covers all the zones on earth. (See illustration of 'the Bear' in the depiction of Washington, D.C. undergoing an 'ice-age.')

OPERATION II:

1. Lecturer fades out triple suns, signals for N.Y. daytime horizon, fades out geocentric earth, fades in Zeiss sun in slow diurnal motion.
2. Lecturer signals for sunset clouds, sunset and star music. Technician starts clouds in motion, starts tape, and fades out blue pans. Technician, on music cues, filters blue over daytime horizon and dissolves for nighttime horizon, fading out night horizon by end of star music.
3. Lecturer fades up stars.

The Zeiss Projector. Art work by Helmut Wimmer.

Topic:

Sunset, stars of the spring sky, the Domain of the Bear. Lecturer should prepare for next operation by setting pointer stars on meridian.

Insert:

Rapid motion of the false stars produces mild nausea or seasickness. Canned 'classical music' adds to the effect.

OPERATION III:

1. Signal for 3 x 4 slide of Big Dipper clock (with hour hand up in midnight position for early March). Use diurnal motion to demonstrate clock, stopping with Arcturus on meridian.
2. Signal off clock slide.
3. Signal for slide of Owl Nebula, M-51 (Whirlpool Galaxy) and M-81 & M-82, all projected in position within the constellation.
4. Signal off slides.
5. Signal for sequence of 7 slides, showing nature of 7 Dipper stars, switched on one-by-one, at five-second intervals.

6. Signal off all slides except slide showing Mizar as a double.
7. Signal for spectrum device.
8. Signal for motion in spectrum demonstrator.
9. Signal off spectrum demonstrator. Technician then dissolves in two spectroscopic binary slides for Mizar slide.
10. Signal for slide showing Alcor as a binary.
11. Signal off all slides.

Topic:

Big Dipper star clock. Deep space objects in direction of Ursa Major. Nature of Big Dipper stars.

Insert:

The third dimension is diminished. Also tends toward binary dualism—an interminable *regressus* against the unity of a single star. 'Deep space' is explained by two-dimensional slide projections. There is no time apart from the actual lecture-time. The mind is brought to absolute rest for the duration of the lecture. Moments, intervals and sequences are coded into a landscape of ice. Chronology contradicts, repeats, bifurcates, and gets heavier with thoughts of the Polar regions. Matter is seen to be both solid and dualistic.

OPERATION IV:

1. Signal for each of four slides showing head, paws, and hindquarters of Bear over constellation. Each is switched on at ten-second intervals.
2. Signal for slide of tail.
3. Signal off slides.
4. Signal for music and change to Latitude 80°North.

Topic:

Identifying the constellation Ursa Major. Journey to Arctic.

Insert:

Ten-second intervals are coded into the polar regions. Ice belongs to the ditrigonal-pyramidal type of symmetry in trigonal system. The 'Bear' is divided and coded into that system. The 'Bear' vanishes into glacial grids. Time does not pass during the actual moments of these intervals, but is crystallized into the faceted present of the mind. The time of our mind becomes a frozen actuality, while the clock is forgotten.

* Show Outline, courtesy of the Museum of Natural History—Hayden Planetarium. Inserts by the author.

Drawing of dinosaur watching a bolide.

An increase in the Sun's energy.

"The End of the World"—a bombardment of meteors.

Artist's impression of the Earth doomed to a frigid death as the Sun gradually cools. Drawings by T. Voter.

illustrations of catastrophe and remote times

. . . the inevitable catastrophe is at hand.
— Edgar Allan Poe, *Eureka*

Artists employed by both the Planetarium and the Museum of Natural History have illustrated expendable "conceptions" of ultimate catastrophe, based on the more inaccessible regions of "space and time." In their minds they have traveled into the forbidden zones, into the dazzling realms. They have imagined dimensions beyond the walls of time; and have established provisional limits on a grand scale in order to re-invent the cosmos. The problem of the "human figure" vanishes from these illustrated infinities and prehistoric cataclysms. Time is deranged. Oceans become puddles, monumental pillars of magma rise from the dark depths of a cracking world. Disasters of all kinds flood the mind at the speed of light. Anthropomorphic concerns are extinct in this vortex of disposable universes. A bewildered "dinosaur" and displaced "bears" are trapped in amazing time dislocations. "Nature" is simulated and turned into "handpainted" photographs of the extreme past or future. Vast monuments of total annihilation are pictured over boundless abysses or seen from dizzying heights. This is a bad-boy's dream of obliteration, where galaxies are smashed like toys. Globes of "anti-matter" collide with "proto-matter," billion and billions of fragments speed into the deadly chasms of space. Destruction builds on destruction; forming sheets of burning ice, violet and green, it all falls off into infinite pools of dust. A landslide of diamonds plunges into a polar crevasse of boundless dimension. History no longer exists.

Quasi-Infinities and the Waning of Space

For many artists the universe is expanding; for some it is contracting.

By ROBERT SMITHSON

"Without a time sense consciousness is difficult to visualize." J. G. Ballard, *The Overloaded Man*

1 The Amiens Labyrinth (France)

2 Built for Fabricus at the University of Padua

AROUND FOUR BLOCKS of print I shall postulate four ultramundane margins that shall contain indeterminate information as well as reproduced reproductions. The first obstacle shall be a labyrinth[1], through which the mind will pass in an instant, thus eliminating the spatial problem. The next encounter is an abysmal anatomy theatre[2]. Quickly the mind will pass over this dizzying height. Here the pages of time are paper thin, even when it comes to a pyramid[3]. The center of this pyramid is everywhere and nowhere. From this center one may see the Tower of Babel[4], Kepler's universe[5], or a building by the architect Ledoux[6]. To formulate a general theory of this inconceivable system would not solve its symmetrical perplexities. Ready to trap the mind is one of an infinite number of "cities of the future[7]." Inutile codes[8] and extravagant experiments[9] adumbrate the "absolute" abstraction[10]. One becomes aware of what T. E. Hulme called "the fringe . . . the cold walks . . . that lead nowhere."

In Ad Reinhardt's "Twelve Rules for a New Academy" we find the statement, "The present is the future of the past, and the past of the future." The dim surface sections within the confines of Reinhardt's standard (60" x 60") "paintings" disclose faint squares of time. Time, as a colorless intersection, is absorbed almost imperceptibly into one's consciousness. Each painting is at once both memory and forgetfulness, a paradox of darkening time. The lines of his grids are barely visible; they waver between the future and the past.

George Kubler, like Ad Reinhardt, seems concerned with "weak signals" from "the void." Beginnings and endings are projected into the present as hazy planes of "actuality." In *The Shape of Time: Remarks on the History of Things*, Kubler says, "Actuality is . . . the interchronic pause when nothing is happening. It is the void between events." Reinhardt seems obsessed by this "void," so much that he has attempted to give it a concrete shape—a shape that evades shape. Here one finds no allusion to "duration," but an interval without any suggestion of "life or death." This is a coherent portion of a hidden infinity. The future criss-crosses the past as an unobtainable present. Time vanishes into a perpetual sameness.

Most notions of time (Progress, Evolution, Avant-garde) are put in terms of biology. Analogies are drawn between organic biology and technology; the nervous system is extended into electronics, and the muscular

3 The Pyramid of Meidum

4 The Tower of Babel

5 Kepler's model of the universe

6 Claude-Nicolas Ledoux (1736-1806)

7 "City of the Future"

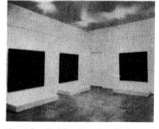

10 Ad Reinhardt installation (March 1965) Betty Parsons Gallery

9 From Edgar Allan Poe's *Eureka*

8 A. *Discrete Scheme Without Memory* by Dan Graham

```
        0
        0
     1     1
     0     1
   2    2    2
   0    1    2
  3   3    3   3
  0   1    2   3
 4   4   4   4   4
 0   1   2   3   4
```

```
HGFEDCBA
GHFEDCBA
FGHEDCBA
EFGHDCBA
DEFGHCBA
CDEFGHBA
BCDEFGHA
ABCDEFGH
```

B. Non-code based on *The Ars Magna* of Ramon Lull

11 Any art that originates with a will to "expression" is not abstract, but representational. Space is represented. Critics who interpret art in terms of space see the history of art as a reduction of three dimensional illusionistic space to "the same order of space as our bodies." (Clement Greenberg—*Abstract, Representational and so forth*.) Here Greenberg equates "space" with "our bodies" and interprets this reduction as abstract. This anthropomorphizing of space is aesthetically a "pathetic fallacy" and is in no way abstract.

12 Plate probably drawn for Spigelius (1627)

13 Willem deKooning

"Although inanimate things remain our most tangible evidence that the old human past really existed, the conventional metaphors used to describe this visible past are mainly biological." George Kubler, *The Shape of Time: Remarks on the History of Things*

nowhere

,

ng

,

nowhere.

.

.

,

,

).

;

the pleasure

nowhere.

let him go to sleep

ng

John Cage. *Silence*. Cambridge: M.I.T. Press

"Dr. J. Bronowski among others has pointed out that mathematics, which most of us see as the most factual of all sciences, constitutes the most colossal metaphor imaginable, and must be judged, aesthetically as well as intellectually, in terms of the success of this metaphor." Norbert Wiener, *The Human Use of Human Beings*

14 Jackson Pollack

15 The biological metaphor is at the bottom of all "formalist" criticism. There is nothing abstract about deKooning or Pollack. To locate them in a formalist system is simply a critical mutation based on a misunderstanding of metaphor—namely, the biological extended into the spatial.

16 *Art Forum*, September 1965. *The Biomorphic Forties*

17 A. The Guggenheim Museum is perhaps Wright's most visceral achievement. No building is more organic than this inverse digestive tract. The ambulatories are metaphorically intestines. It is a concrete stomach.

system is extended into mechanics. The workings of biology and technology belong not in the domain of art, but to the "useful" time of organic (active) duration, which is unconscious and mortal. Art mirrors the "actuality" that Kubler and Reinhardt are exploring. What is actual is apart from the continuous "actions" between birth and death. Action is not the motive of a Reinhardt painting. Whenever "action" does persist, it is unavailable or useless. In art, action is always becoming inertia, but this inertia has no ground to settle on except the mind, which is as empty as actual time.

THE ANATOMY OF EXPRESSIONISM[11]

The study of anatomy since the Renaissance lead to a notion of art in terms of biology[12]. Although anatomy is rarely taught in our art schools, the metaphors of anatomical and biological science linger in the minds of some of our most abstract artists. In the paintings of both Willem deKooning[13] and Jackson Pollack[14], one may find traces of the biological metaphor[15], or what Lawrence Alloway called "biomorphism[16]." In architecture, most notably in the theories of Frank Lloyd Wright, the biological metaphor prevails[17]. Wright's idea of "the organic" had a powerful influence on both architects and artists. This in turn produced a nostalgia for the rural or rustic community or the pastoral setting, and as a result brought into aesthetics an anti-urban attitude. Wright's view of the city as a "cancer" or "a social disease" persists today in the minds of some of the most "formal" artists and critics. Abstract expressionism revealed this visceral condition, without any awareness of the role of the biological metaphor. Art is still for the most part thought to be "creative" or in Alloway's words "phases of seeding, sprouting, growing, loving, fighting, decaying, rebirth." The science of biology in this case, becomes "biological-fiction," and the problem of anatomy dissolves into an "organic mass." If this is so, then abstract-expressionism was a disintegration of "figure painting" or a decomposition of anthropomorphism. Impressionistic modes of art also suffer from this biological syndrome.

Kubler suggests that metaphors drawn from physical science rather than biological science would be more suitable for describing the condition of art. Biological science has since the nineteenth century infused in most people's minds an unconscious faith in "creative evolu-

B. Guggenheim Museum

19 Alberto Giacometti, *The Palace at Four A.M.* (1932-33)

22 Ruth Vollmer, *Obelisk* (1962

18 The truncated ideas in *Nova Express* (Evergreen Black Cat Book BC-102) disclose in part the "heat-death" of the biological metaphor, "The Insect Brain of Minraud enclosed in a crystal . . ." M. L. von Franz in *Time and Synchronicity in Analytic Psychology* states, "Physicists studying cybernetics have observed that what we call consciousness seems to consist of an intra-psychic flux or train of ideas, which flows 'parallel to' (or is even possibly explicable by) the 'arrow' of time. While M. S. Watanabe convincingly argues that this sense of time is a fact sui generis, others like Grunbaum tend to believe that entropy is the cause of time in man." See *The Voices of Time* (p. 218), edited by J. T. Fraser, New York: George Braziller, 1966.

20 The following is part of manuscript that describes T₀ *Palace at Four A.M.* It w dictated by Giacometti André Breton for publicatio in the magazine *Minotau* (No. 3-4, 1933, p. 42) an later translated by Ruth Vo mer into English (see t magazine *Transformatio* published by Wittenborn "This object has taken for little by little; by the end summer 1932 it clarifie slowly for me, the vario parts taking their exact for and their particular place the ensemble. Come autum it had attained such reali that its execution in spac did not take more than or day." He also goes on say, ". . . the days and nigh had the same color, as everything happened just be fore daybreak. . . ."

21 *A Giacometti Portrait,* Th Museum of Modern Art

"In principle, nothingness remains inaccessible to science." Martin Heidegger, *An Introduction to Metaphysics*

"The unity of Nature is an extremely artificial and fragile bridge, a garden net." T. E. Hulme, *Cinders*

"It came to him with a great shock that not one of the robots had ever seen a living thing. Not a bug, a worm, a leaf. They did not know what flesh was. Only the doctors knew that, and none of them could readily understand what was meant by the words 'organic matter'." Michael Shaara, *Orphans of the Void*

23 Quoted from *Enneads,* i *Concepts of Mass in Classica and Modern Physics* (Har per Torch Book TB571) b Max Jammer, page 31. O the same page Jammer goe on to say, "Proclus, the othe great exponent of Neopla tonism in the East, accept Plotinus' doctrine, but wit one important modification the passivity or inertia o matter follows from its ex tension." The decline of the *categories* of "painting" anc "sculpture" seem to be the result of this problem of spa tial extension from matter Space becomes an illusion or matter.

tion." An intelligible dissatisfaction with this faith is very much in evidence in the work of certain artists.

THE VANISHING ORGANISM

The biological metaphor has its origin in the temporal order, yet certain artists have "detemporalized" certain organic properties, and transformed them into solid objects that contain "ideas of time." This attitude toward art is more "Egyptian" than "Greek," static rather than dynamic. Or it is what William S. Burroughs calls "The Thermodynamic Pain and Energy Bank"[18]—a condition of time that originates inside isolated objects rather than outside. Artists as different as Alberto Giacometti and Ruth Vollmer to Eva Hesse and Lucas Samaras disclose this tendency.

Giacometti's early work, *The Palace at Four A.M.*,[19] enigmatically and explicitly is about time. But, one could hardly say that this "time-structure" reveals any suggestion of organic vitality. Its balance is fragile and precarious, and drained of all notions of energy, yet it has a primordial grandeur[20]. It takes one's mind to the very origins of time—to the fundamental memory. Giacometti's art and thought conveys an entropic view of the world. "It's hard for me to shut up," says Giacometti to James Lord. "It's the delirium that comes from the impossibility of really accomplishing anything[21]."

There are parallels in the art of Ruth Vollmer to that of Giacometti. For instance, she made small skeletal geometric structures before she started making her bronze "spheres," and like Giacometti she considers those early works "dead-ends." But there is no denying that these works are in the same class with Giacometti, for they evoke both the presence and absence of time. Her *Obelisk*[22] is similar in mood to *The Palace at Four A.M.* One thinks of Pascal's "fearful sphere" lost in an Egyptian past, or in the words of Plotinus the Stoa, "shadows in a shadow[23]." Matter in this *Obelisk*[24] opposes and forecloses all activity—its future is missing.

The art of Eva Hesse is vertiginous and wonderfully dismal[25]. Trellises are mummified, nets contain desiccated lumps, wires extend from tightly wrapped frameworks, a cosmic dereliction is the general effect. Coils go on and on; some are cracked open, only to reveal an empty center. Such "things" seem destined for a funerary chamber that excludes all mention of the living and the dead. Her art brings to mind the obsessions of the pha-

24 A. For further edification concerning obelisks see *A Short History of the Egyptian Obelisk* by W. R. Cooper. London: Samuel Bagster and Sons, 1877. "The first mention of the obelisk, or Tekhen, occurs in connection with the pyramid: and both are alike designated sacred monuments on the funereal stele of the early empire, and also were undeniably devoted to the worship of the sun; occasionally the obelisk was represented as surmounting a pyramid, a position which it has never actually been found to occupy."

B. *The New York Obelisk—Cleopatra's Needle* by Charles E. Moldenke, New York: Anson D. F. Randolph and Co., 1891. "We know of the Obelisk of Karnak, erected by Queen Hatasu, that the apex of its pyramidion was covered with 'pure gold' . . ."

C. *Cleopatra's Needles and Other Egyptian Obelisks* by Sir E. A. Wallis Budge, London: The Religious Tract Society, 1926. Regarding obelisks in Rome: "The brass globe which had been fixed on the top of the obelisk when Caligula set it up was removed; it was empty, though many believed that it would be found to contain valuable objects."

D. *Salambo* by Gustave Flaubert, a Berkeley Medallion Book, 1966. Regarding obelisks in Byrsa: ". . . obelisks poised on their points like inverted torches."

25 A. Eva Hesse, *Loakoon*, 1965

B. Pergamen? *Loakoon*

C. In her *Loakoon* based on the sculpture by Pergamen? second century B.C. we discover an absence of "pathos" and a deliberate avoidance of the anthropomorphic. Instead one is aware only of the vestigital and devitalized "snakes" looping through a lattice with cloth bound joints. Everything "classical" and "romantic" is mitigated and underminded. The baroque aesthetic of the original *Loakoon* with its flowing lines—soft and fluid—is transformed into a dry, skeletal tower that goes nowhere.

raohs, but in this case the anthropomorphic measure is absent. Nothing is incarnated into nothing. Human decay is nowhere in evidence.

The isolated systems Samaras[26] has devised irradiate a malignant splendor. Clusters of pins cover vile organs of an untraceable origin. His objects are infused with menace and melancholy. A lingering Narcissism[27] may be found in some of his "treasures." He has made "models" of tombs and monuments that combine the "times" of ancient Egypt with the most disposable futures of science fiction.[28]

26 Lucas Samaras, *Untitled*, 1963

TIME AND HISTORY AS OBJECTS

At the turn of the century a group of colorful French artists banded together in order to get the jump on the bourgeois notion of progress. This bohemian brand of progress gradually developed into what is sometimes called the avant-garde. Both these notions of duration are no longer absolute modes of "time" for artists. The avant-garde, like progress, is based on an ideological consciousness of time. Time as ideology has produced many uncertain "art histories" with the help of the mass-media. Art histories may be measured in time by books (years), by magazines (months), by newspapers (weeks and days), by radio and TV (days and hours). And at the gallery proper—*instants!* Time is brought to a condition that breaks down into "abstract-objects[29]." The isolated time of the avant-garde has produced its own unavailable history or entropy.

Consider the avant-garde as Achilles and progress as the Tortoise in a race that would follow Zeno's second paradox of "infinite regress[30]." This non-Aristotelian logic defies the formal deductive system and says that "movement is impossible." Let us paraphrase Jorge Luis Borges' description of that paradox. (See *Avatars of the Tortoise*): The avant-garde goes ten times faster than progress, and gives progress a headstart of ten meters. The avant-garde goes those ten meters, progress one; the avant-garde completes that meter, progress goes a decimeter; the avant-garde goes that decimeter, progress goes a centimeter; the avant-garde goes that centimeter, progress, a millimeter; the avant-garde, the millimeter, progress a tenth of a millimeter; and so on to infinity without progress ever being overtaken by the avant-garde. The problem may be reduced to this series:

$$10 + 1 + 1/10 + 1/100 + 1/1000 + 1/10,000 + \ldots$$

"The individual is the seat of a constant process of decantation, decantation from the vessel containing the fluid of future time, sluggish, pale and monochrome, to the vessel containing the fluid of past time, agitated and multicolored by the phenomena of its hours." Samuel Beckett, *Proust*

30 A. Don Judd has been interested in "progressions" and "regressions" as "solid objects." He has based certain works on "inverse natural numbers." Some of these may be found in *Summation of Series* by L. B. W. Jolley, a Dover paperback.

27 Self-love, self-observation, self-examination, and self-awareness result in an isolated mind. This kind of mind would tend to produce a fictitious "reality" detached from organic nature. *Monsieur Teste* by Paul Valery is perhaps the greatest elucitation of Narcissism. "He watches himself, he maneuvers, he is unwilling to be maneuvered. He knows only two values, two categories, those of consciousness reduced to its acts: the possible and the impossible. In this strange head, where philosophy has little credit, where language is always on trial, there is scarcely a thought that is not accompanied by the feeling that it is tentative. . . ."

28 In *13 French Science-Fiction Stories* edited by Damon Knight (Bantam paperback (F2817) is a story by Charles Henneberg called *Moonfishers*. "The Interplanetarians were landing in these sands. They were of many kinds. Much later, the Pharaoh Psammetichus III noted: 'They fell from the sky like the fruits of a fig-tree that is shaken; they were the color of copper and sulphur, and some had eyes.'"

29 The following book elucidates this idea: *Abstraction and Empathy* by Wilhelm Worringer, London: Routledge and Kegan Paul Ltd., 1953; translated from the German *Abstraktion und Einfuhlung*, 1908. "In so far, therefore, as a sensuous object is still dependent upon space, it is unable to appear to us in its closed material individuality." And "Space is therefore the major enemy of all striving after abstraction. . . ."

B. Don Judd, *Untitled*, 1965

THE CRYOSPHERE (1966)

BLOCK ENCODEMENT #1
0100100100100100010 X 12M = 72(1) + 144(0)

1. 0100100100100100010 is the tentative sequence for the placement of the six solid hexagonal modules.
2. Each module has 12 mirror surfaces (12M).
3. 6 modules are visible.
4. 12 modules are invisible.
5. 72 mirror surfaces are visible.
6. 144 mirror surfaces are invisible.
7. 66⅔% of the entire work is invisible.
8. Invent your sight as you look. Allow your eyes to become an invention.
9. Color by Krylon Inc.

<div align="center">

Surf Green, No. 2002

</div>

Pigment . 2.92%
 Titanium Dioxide 100.00%
 Tinting material less than 5.00%
Non-volatile (from vehicle) 9.08%
 Cellulose Nitrate, Coconut Oil
 Modified Alykd, Phthalate Esters
 Plasticizer, GL–358 Phenolic Resin Penetrant
Volatile . 48.00%
 Ketones, Esters, Alcohols, Aromatic Hydrocarbons
Propellent . 40.00%
 Halogenated Hydrocarbons

<div align="right">

100.00%

</div>

Jewish Museum catalog, *Primary Structures*, 1966

ROBERT SMITHSON, *Enantiomorphic Chambers*, 1964. Painted steel and mirror.

INTERPOLATION OF THE
ENANTIOMORPHIC CHAMBERS (1966)

1. Code of Reflections:

2. Key to Code:
 A. Right (R) corresponds to 1, 2, 3, mirror reflections.
 B. Left (L) corresponds to 1, 2, 3, mirror reflections.
3. The chambers cancel out one's reflected image, when one is directly between the two mirrors.
4. Definition of the enantiomorphic within the context of binocular vision.
 A. Any manifest division between the position of the two eyes.
 B. Contrary accommodation and convergence.
 C. Duplex structure of sight as an invention.
 D. Infinite myopia.
 E. Equidistant dislocation.

Finch College catalog, *Art in Process*, 1966

5. The surface plane (fluorescent green) is behind the framing support (blue). One cannot see the whole work from a single point of view, because the vanishing point is split and reversed. The structure is "flat," but with an extra dimension.

6. To see one's own sight means visible blindness.

7. "They asked him if he still thought he could 'see.' 'No,' he said. 'That was folly. The word means nothing . . . less than nothing!" *The Country of the Blind*, H. G. Wells.

PARAGRAPH FROM A FICTIVE ARTIST'S JOURNAL

Once, when I was fortunate enough to gain access to the private art-book library of the late Casper Clamp, I had the privilege of scrutinizing his rare edition of "The Exhaustion of Sight or How to Go Blind and Yet See." Only six volumes remain of this astounding work. The book's heavy pages contained intricate diagrams "on seeing sight." A chapter called "Invisible Orbs," illustrated special visual conditions known as "lead eyes, ice eyes, pyramidal eyes and violet eyes." Much was said about eye-glasses as "a structure supported by the nose and ears." The few artists that have seen this book, such as Daniel Nivalk and Mary Bone have been in some way altered. Nivalk finds the book "suspect," but nevertheless agrees that it contains many "hitherto unknown facts about visual acedia." On the other hand Mary Bone, known in certain circles for her "Smoke on Smoke," finds Clamp's book, "the key to flying saucers." For myself, the book is a true paradigm of unending importance. I look forward to the day when it will be published in "paperback," so that millions of artists everywhere will be able to share in its many treasures.

ROBERT SMITHSON, *The Museum of the Void*, c. 1967. Pencil, 19 x 24".

SOME VOID THOUGHTS ON MUSEUMS (1967)

> Tomb furniture achieved apparently contradictory ends in discarding old
> things all the while retaining them, much as in our storage warehouses,
> and museum deposits, and antiquarian storerooms.
>
> George Kubler, *The Shape of Time:*
> *Remarks on the History of Things*

History is a facsimile of events held together by flimsy biographical informa-
tion. Art history is less explosive than the rest of history, so it sinks faster into
the pulverized regions of time. History is representational, while time is ab-
stract; both of these artifices may be found in museums, where they span
everybody's own vacancy. The museum undermines one's confidence in sense-
data and erodes the impression of textures upon which our sensations exist.
Memories of "excitement" seem to promise something, but nothing is always
the result. Those with exhausted memories will know the astonishment.

Visiting a museum is a matter of going from void to void. Hallways lead the
viewer to things once called "pictures" and "statues." Anachronisms hang and

Arts Magazine, February 1967

protrude from every angle. Themes without meaning press on the eye. Multifarious nothings permute into false windows (frames) that open up onto a verity of blanks. Stale images cancel one's perception and deviate one's motivation. Blind and senseless, one continues wandering around the remains of Europe, only to end in that massive deception "the art history of the recent past." Brain drain leads to eye drain, as one's sight defines emptiness by blankness. Sightings fall like heavy objects from one's eyes. Sight becomes devoid of sense, or the sight is there, but the sense is unavailable. Many try to hide this perceptual falling out by calling it abstract. Abstraction is everybody's zero but nobody's nought. Museums are tombs, and it looks like everything is turning into a museum. Painting, sculpture and architecture are finished, but the art habit continues. Art settles into a stupendous inertia. Silence supplies the dominant chord. Bright colors conceal the abyss that holds the museum together. Every solid is a bit of clogged air or space. Things flatten and fade. The museum spreads its surfaces everywhere, and becomes an untitled collection of generalizations that immobilize the eye.

WHAT IS A MUSEUM? (1967)

A Dialogue between Allan Kaprow and Robert Smithson

ALLAN KAPROW: There was once an art which was conceived for the museums, and the fact that the museums look like mausolea may actually reveal to us the attitude we've had to art in the past. It was a form of paying respect to the dead. Now, I don't know how much more work there is available from the past that has to be displayed or respected. But if we're going to talk about the works being produced in the last few years, and which are to be produced in the near future, then the concept of the museum is completely irrelevant. I should like to pursue the question of the environment of the work of art; what kind of work is being done now; where it is best displayed, apart from the museum, or its miniature counterpart, the gallery.

ROBERT SMITHSON: Well, it seems to me that there is an attitude that tends toward McLuhanism, and this attitude would tend to see the museum as a null structure. But I think the nullity implied in the museum is actually one of its

Arts Yearbook, "The Museum World," 1967

Top: Entrance to Philip Johnson Gallery, Connecticut. Architect, Philip Johnson. Photo by Ezra Stoller.
Bottom: Memorial to French soldiers at Verdun.

Top: Installation photograph of the architecture of Louis Kahn at the Museum of Modern Art.
Bottom: Final inspection of refrigerators in Kelvinator Grand Rapids plant.

Top: Whitney Museum of American Art. Architect, Marcel Breuer and Associates. Photo by Ezra Stoller.
Bottom: Mausoleum for Lenin, Moscow. Designed by the Constructivist Shussev.

Top: Proposed monument by Holabird and Root, Chicago.
Bottom: Discothéque, Cheetah. Photo by Thecla.

major assets, and that this should be realized and accentuated. The museum tends to exclude any kind of life-forcing position. But it seems that now there's a tendency to try to liven things up in the museums, and that the whole idea of the museum seems to be tending more toward a kind of specialized entertainment. It's taking on more and more the aspects of a discothéque and less and less the aspects of art. So, I think that the best thing you can say about museums is that they really are nullifying in regard to action, and I think that this is one of their major virtues. It seems that your position is one that is concerned with what's happening. I'm interested for the most part in what's not happening, that area between events which could be called the gap. This gap exists in the blank and void regions or settings that we never look at. A museum devoted to different kinds of emptiness could be developed. The emptiness could be defined by the actual installation of art. Installations should empty rooms, not fill them.

KAPROW: Museums tend to make increasing concessions to the idea of art and life as being related. What's wrong with their version of this is that they provide canned life, an aestheticized illustration of life. "Life" in the museum is like making love in a cemetery. I am attracted to the idea of clearing out the

Top: Museum of Modern Art installation. *Two Design Programs: The Braun Company—Chemex Corporation.*
Bottom: Chicago showroom for Crane Company.

Top: *Bedroom Ensemble* by Claes Oldenberg, 1963.
Bottom: *Bathroom Beautiful*, Crane Company.

museums and letting better designed ones like the Guggenheim exist as sculptures, as works, as such, almost closed to people. It would be positive commitment to their function as mausolea. Yet, such an act would put so many artists out of business. . . . I wonder if there isn't an alternative on the fringes of life and art, in that marginal or penumbral zone which you've spoken so eloquently of, at the edges of cities, along vast highways with their outcroppings of supermarkets and shopping centers, endless lumberyards, discount houses, whether that isn't the world that's for you at least. I mean, can you imagine yourself working in that kind of environment?

SMITHSON: I'm so remote from that world that it seems uncanny to me when I go out there; so not being directly involved in the life there, it fascinates me, because I'm sure of a distance from it, and I'm all for fabricating as much distance as possible. It seems that I like to think and look at those suburbs and those fringes, but at the same time, I'm not interested in living there. It's more of an aspect of time. It is the future—the Martian landscape. By a distance, I mean a consciousness devoid of self-projection.

I think that some of the symptoms as to what's going on in the area of museum building are reflected somewhat in Philip Johnson's underground

museum, which in a sense buries abstract kinds of art in another kind of abstraction, so that it really becomes a negation of a negation. I am all for a perpetuation of this kind of distancing and removal, and I think Johnson's project for Ellis Island is interesting in that he's going to gut this nineteenth-century building and turn it into a ruin, and he says that he's going to stabilize the ruins, and he's also building this circular building which is really nothing but a stabilized void. And it seems that you find this tendency everywhere, but everybody is still a bit reluctant to give up their life-forcing attitudes. They would like to balance them both. But, I think, what's interesting is the lack of balance. When you have a Happening you can't have an absence of happening. There has to be this dualism which I'm afraid upsets a lot of ideas of humanism and unity. I think that the two views, unity and dualism, will never be reconciled and that both of them are valid, but at the same time, I prefer the latter in multiplicity.

KAPROW: There is another alternative. You mentioned building your own monument, up in Alaska, perhaps, or Canada. The more remote it would be, the more inaccessible, perhaps the more satisfactory. Is that true?

SMITHSON: Well, I think ultimately it would be disappointing for everybody including myself. Yet the very disappointment seems to have possibilities.

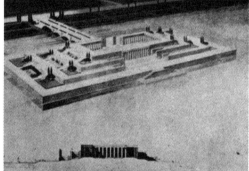

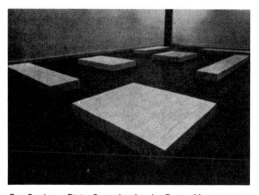

Top: Penthouse Dining Room, Los Angeles County Museum.
Bottom: Carl Andre Exhibition, 1966. Limestone and sand bricks.

Top: Proposed memorial by Benjamin Marshall, 1930.
Bottom: Storage Tanks, Mobil Oil.

KAPROW: What disturbs me is the lack of extremity in either of our positions. For instance, I must often make social compromises in my Happenings, while, similarly, you and others who might object to museums nevertheless go on showing in them.

SMITHSON: Extremity can exist in a vain context too, and I find what's vain more acceptable than what's pure. It seems to me that any tendency toward purity also supposes that there's something to be achieved, and it means that art has some sort of point. I think I agree with Flaubert's idea that art is the pursuit of the useless, and the more vain things are the better I like it, because I'm not burdened by purity.

I actually value indifference. I think it's something that has aesthetic possibilities. But most artists are anything but indifferent; they're trying to get with everything, switch on, turn on.

KAPROW: Do you like wax works?

SMITHSON: No, I don't like wax works. They are actually too lively. A wax-work thing relates back to life, so that actually there's too much life there, and it also suggests death, you know. I think the new tombs will have to avoid any reference to life or death.

KAPROW: Like Forest Lawn?

Top: World's largest bureau.
Bottom: Executive Suite for year 2026 from *Metropolis.* Set built in 1926.

Top: Proposed museum for outer space. Designer unknown.
Bottom: Guggenheim Museum exterior.

47

Top: **SOL LeWITT**, MA5, 1966.
Bottom: Hydroelectric project. Hirfanli, Turkey.

Top: Guggenheim interior (empty).
Bottom: "Invisible Architecture" built by Bernard Zehrfuss for UNESCO, France.

SMITHSON: Yes, it's an American tradition.

KAPROW: Realistically speaking, you'll never get anybody to put up the dough for a mausoleum—a mausoleum to emptiness, to nothing—though it might be the most poetic statement of your position. You'll never get anyone to pay for the Guggenheim to stay empty all year, though to me that would be a marvelous idea.

SMITHSON: I think that's true. I think basically it's an empty proposal. But . . . eventually there'll be a renaissance in funeral art.

Actually, our older museums are full of fragments, bits and pieces of European art. They were ripped out of total artistic structures, given a whole new classification and then categorized. The categorizing of art into painting, architecture and sculpture seems to be one of the most unfortunate things that took place. Now all these categories are splintering into more and more categories, and it's like an interminable avalanche of categories. You have about forty different kinds of formalism and about a hundred different kinds of expressionism. The museums are being driven into a kind of paralyzed position, and I don't think they want to accept it, so they've made a myth out of action; they've made a myth out of excitement; and there's even a lot of talk about interesting spaces. They're creating exciting spaces and things like that. I never saw an exciting

Top: Housing development, Jersey City. Photo by Dan Graham.
Bottom: Radar-observing sites. Courtesy Smithsonian Astrophysical and Harvard College Observatories.

Top: Storage of wet collections of marine invertebrates. Courtesy of Smithsonian Institute.
Bottom: Betty Parsons' Long Island house, designed by Tony Smith. Photo by Jon Naar.

space. I don't know what a space is. Yet, I like the uselessness of the museum.

KAPROW: But on the one side you see it moving away from uselessness toward usefulness.

SMITHSON: Utility and art don't mix.

KAPROW: Toward education, for example. On the other side, paradoxically. I see it moving away from real fullness to a burlesque of fullness. As its sense of life is always aesthetic (cosmetic), its sense of fullness is aristocratic: it tries to assemble all "good" objects and ideas under one roof lest they dissipate and degenerate out in the street. It implies an enrichment of the mind. Now, high class (and the high-class come-on) is implicit in the very concept of a museum, whether museum administrators wish it or not, and this is simply unrelated to current issues. I wrote once that this is a country of more or less sophisticated mongrels. My fullness and your nullity have no status attached to them.

SMITHSON: I think you touched on an interesting area. It seems that all art is in some way a questioning of what value is, and it seems that there's a great need for people to attribute value, to find a significant value. But this leads to many categories of value or no value. I think this shows all sorts of disorders and fractures and irrationalities. But I don't really care about setting them right or making things in some ideal fashion. I think it's all there—independent of

any kind of good or bad. The categories of "good art" and "bad art" belong to a commodity value system.

KAPROW: As I said before, you face a social pressure which is hard to reconcile with your ideas. At present, galleries and museums are still the primary agency or "market" for what artists do. As the universities and federal education programs finance culture by building even more museums, you see the developing picture of contemporary patronage. Therefore, your involvement with "exhibition people," however well-meant they are, is bound to defeat whatever position you take regarding the non-value of your activity. If you say it's neither good nor bad, the dealers and curators who appropriate it, who support you personally, will say or imply the opposite by what they do with it.

SMITHSON: Contemporary patronage is getting more public and less private. Good and bad are moral values. What we need are aesthetic values.

KAPROW: How can your position then be anything but ironic, forcing upon you at least a skepticism. How can you become anything except a kind of sly philosopher—a man with a smile of amusement on your face, whose every act is italicized?

SMITHSON: Well, I think humor is an interesting area. The varieties of humor are pretty foreign to the American temperament. It seems that the American temperament doesn't associate art with humor. Humor is not considered serious. Many structural works really are almost hilarious. You know, the dumber, more stupid ones are really verging on a kind of concrete humor, and actually I find the whole idea of the mausoleum very humorous.

KAPROW: Our comparison of the Guggenheim, as an intestinal metaphor, to what you've called a "waste system" seems quite to the point. But this of course is nothing more than another justification for the museum man, for the museum publicist, for the museum critic. Instead of high seriousness it's high humor.

SMITHSON: High seriousness and high humor are the same thing.

KAPROW: Nevertheless, the minute you start operating within a cultural context, whether it's the context of a group of artists and critics or whether it's

Burial Mounds, Behrain Islands.

the physical context of the museum or gallery, you automatically associate this uncertain identity with something certain. Someone assigns to it a new categorical name, usually a variant of some old one, and thus he continues his lineage or family system which makes it all credible. The standard fate of novelty is to be justified by history. Your position is thus ironic.

SMITHSON: I would say that it has a contradictory view of things. It's basically a pointless position. But I think to try to make some kind of point right away stops any kind of possibility. I think the more points the better, you know, just an endless amount of points of view.

KAPROW: Well, this article itself is ironic in that it functions within a cultural context, within the context of a fine-arts publication, for instance, and makes its points only within that context. My opinion has been, lately, that there are only two outs: one implying a maximum of inertia, which I call "idea" art, art which is usually only discussed now and then and never executed; and the other existing in a maximum of continuous activity, activity which is of uncertain aesthetic value and which locates itself apart from cultural institutions. The minute we operate in between these extremes we get hung up (in a museum).

TOWARDS THE DEVELOPMENT
OF AN AIR TERMINAL SITE (1967)

If it resembles something, it would no longer be the whole.

Paul Valery

Since July, 1966 I've been rendering consultation and advice as an "artist consultant" to Tippetts-Abbett-McCarthy-Stratton (Engineers and Architects). The project concerns the development of an air terminal between Fort Worth and Dallas. From time to time, after studying various maps, surveys, reports, specifications, and construction models, I meet with Walther Prokosch, John Gardner and Ernest Schwiebert in order to discuss the overall plan. I have engaged in these discussions not as an architect or engineer, but simply as an artist. The discussions do not operate on any presupposed notion of art, engineering or architecture. The problems disclose themselves, as we encounter them. Everything follows an exploratory path.

The actual meaning of an air terminal and how it relates to aircraft is one such problem. As the aircraft ascends into higher and higher altitudes and flies at faster speeds, its meaning as an object changes—one could even say reverses. The streamlined design of our earlier aircraft becomes increasingly more truncated and angular. Our whole notion of airflight is casting off the old meaning of speed through space, and developing a new meaning based on instantaneous time. The aircraft no longer "represents" a bird or animal (the flying tigers) in an organic way, because the movement of air around the craft is no longer visible. The meaning of airflight has for the most part been conditioned by a rationalism that supposes truths—such as nature, progress, and speed. Such meanings are merely "categorical" and have no basis in actual fact. The same condition exists in art, if one sees the art through the rational categories of "painting, sculpture and architecture." The rationalist sees only the details and never the whole. The categories that proceed from rational logic inflate a linguistic detail into a dated system of meaning, so that we cannot see the aircraft through the "speed." Language problems are often at the bottom of most rationalistic "objectivity." One must be conscious of the changes in language, before one attempts to discover the form of an object or fact.

Let us now try to delimit some new meanings in terms of the actual facts of today's new aircraft. By extracting esthetic morphologies from existing aircraft, the same way an artist extracts meanings from a given "art object," we should find a whole new set of values.

Artforum, June 1967

If an aircraft discloses itself on an instant network of time, the result is an immobilization of space. This immobilization of space becomes more apparent if we consider the high altitude satellite. The farther out an object goes in space, the less it represents the old rational idea of visible speed. The streamlines of *space* are replaced by a crystalline structure of *time*. An example of this is the SECOR surveying satellite fabricated by the Cubic Corporation. This 45-pound object enables surveyors to tie together land masses separated by more than 2000 miles of land or water, or roughly the distance between the U.S. mainland and Hawaii. It increases the capability of the geodetic surveying program.

This kind of "aerosurveying" derives from a more elementary type of land surveying. The instrument that the surveyor uses on the ground level is a telescope mounted on a tripod and fitted with cross hairs and a level. This enables the surveyor to find the points of identical elevation. The surveyor locates the boundaries of land tracts by measuring various sites within a network of lines and angles. This he does with the aid of the "surveyor's measure":

Pine Flat Dam, Sacramento, California. This dam is seen as a functionless wall. When it functions as a dam it will cease being a work of art and become a "utility." ("Site-Selection" made by Robert Smithson.)

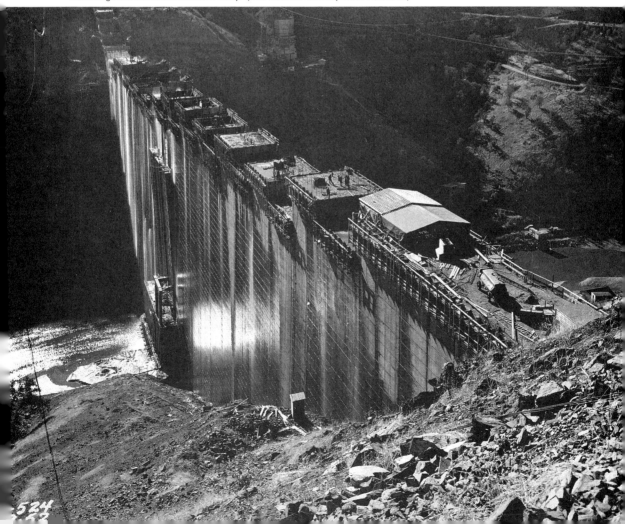

7.92 inches	=	1 link
100 links	=	1 chain or 66 feet
80 chains	=	1 mile
625 square links	=	1 square pole
16 square poles	=	1 square chain
10 square chains	=	1 acre
640 acres	=	1 section, or 1 square mile
36 sections	=	1 township

The maps that surveyors develop from coordinating land and air masses resemble crystalline grid networks. Mapping the Earth, the Moon, or other planets is similar to the mapping of crystals. Because the world is round, grid coordinates are shown to be spherical, rather than rectangular. Yet, the rectangular grid fits within the spherical grid. Latitude and longitude lines are a terrestrial system much like our city system of avenues and streets. In short, all air and land is locked into a vast lattice. This lattice may take the shape of any of the six Crystal Systems. ". . . I saw all the mirrors in the planet and none reflected me . . ." (Borges).

Alexander Graham Bell (1847–1922), known to most people as the inventor of the telephone, was also interested in the problems of aerodynamics, aero-

Dallas–Fort Worth Regional Airport Layout Plan. (Tippetts, Abbett, McCarthy & Stratton.)

FIGURE 6
BORING LOCATION PLAN

LEGEND
⊕ AUGER BORINGS
▲ CORE BORINGS

COMPARATIVE SIZE
NEW YORK

nautics, shipbuilding engineering science, medicine, electrical engineering, and surveying. In Konrad Wachsmann's book *The Turning Point of Building*, we learn something of Bell's concern with "airborne structures" and how they relate to mass production. Bell designed kites based on tetragonal units, that on an esthetic level resemble the satellites such as the SECOR. His units were prefabricated, standardized and crystalline, not unlike Buckminster Fuller's inventions. He also built a pyramid-shaped outdoor observation station that reminds one of the art of Robert Morris. (Unlike Bell, Morris would not want to "live" in his art.) From inside his solid tetrahedron Bell surveyed his "flight" projects—the tetragonal lattice-kites. A grid connection was established by him between ground and air through this crystalline system. The solid mirrored the lattice. The site was joined to the sky in a structural equation. Bell's awareness of the physical properties of language, by way of the telephone, kept him from misunderstanding language and object relationships. Language was transformed by Bell into *linguistic objects*. In this way he avoided the rational categories of art. The impact of "telephone language" on physical structure remains to be studied. A visual language of modules seems to have emerged from Bell's investigations. Points, lines, areas, or volumes establish the syntax of sites.

All language becomes an alphabet of sites, or it becomes what we will call

Dam foundation site, somewhere in Texas. If viewed as a "discrete stage" it becomes an abstract work of art that vanishes as it develops. ("Site-Selection" made by Robert Smithson.)

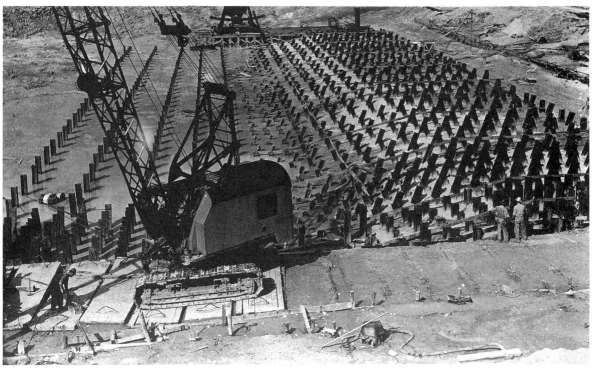

Alexander Graham Bell in his outdoor observation station.

Alexander Graham Bell with his tetragonal lattice-kites.

the air terminal between Fort Worth and Dallas. The entire project shall rest on an elevation of about 550 feet to 620 feet. The area is well drained and practically free of trees and natural obstructions. The subsurface site of the project contains sediments from the Cretaceous Age. This underground site was penetrated by "auger borings" and "core borings." All the soil samples encountered in the borings were visually classified and tested. These samples ranged from clay to shale rock. The "boring" if seen as a discrete step in the development of the whole site has an esthetic value. It is an "invisible hole," and could be defined by Carl Andre's motto—"A thing is a hole in a thing it is not." The "boring," like other "earth works," is becoming more and more important to artists. Pavements, holes, trenches, mounds, heaps, paths, ditches, roads, terraces, etc., all have an esthetic potential.

Remote places such as the Pine Barrens of New Jersey and the frozen wastes of the North and South Poles could be coordinated by art forms that would use the actual land as a medium. Television could transmit such activity all over the world. Instead of using a paintbrush to make his art, Robert Morris would like to use a bulldozer. Consider a "City of Ice" in the Arctic, that would contain frigid labyrinths, glacial pyramids, and towers of snow, all built according to strict abstract systems. Or an amorphous "City of Sand" that would be nothing but artificial dunes, and shallow sand pits.

The air terminal—also known as the Universe—rests on a firmament of statistics. Here statistics are the abysmal archetypes that engender the entire complex of buildings. This terminal area of approximately 600 acres is enclosed by a two-way taxi system approximately 9,000 feet in length by 3,000 feet in width. This inscrutable terminal exceeds and rejects all termination. The following "spaces" have been engendered by the individual airlines:

TERMINAL BUILDINGS

AIRLINES	Square Feet
American	1,400
Braniff	100,300
Central	14,500
Continental	34,400
Delta	70,700
Eastern	13,700
Mexicana	3,400
Trans-Texas	17,700
Western	13,800
Total	329,900

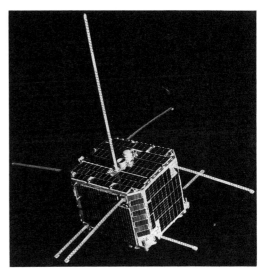

SECOR Surveying Satellite. (Cubic Corporation, San Diego, California.)

The process behind the air terminal end-lessly plans and replans its concessions, agencies, and facilities from masses of information. Here unit terminals are not conceived as trip terminus points. Here no gate position has a unique location. The distribution of car traffic is maintained by a central axis of roadways that develops according to statistical probability. Extra terminal space may crystallize off this central linear axis. Framing this central complex of terminal units are the runways and taxiways.

Width of Land Strip	500 ft.
Width of Runway (R/W)	150 ft.
Width of Taxiway (T/W)	75 ft.
Distance between R/W Centerline and T/W Centerline	500 ft.
Distance between Parallel T/W's	300 ft.
Distance between Centerline T/W and Aircraft Parking	300 ft.
Distance between Centerline and Obstacle	250 ft.
Distance between Centerline and Building Line	750 ft.
Maximum Runway Effective Gradient	0.25%
Maximum R/W and T/W Longitudinal Grade	1.00%
Maximum R/W and T/W Transverse Grade	1.50%

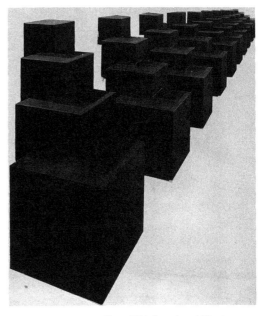

ROBERT SMITHSON, *Plunge*, 1966. Painted steel, 10 units, square surfaces, 14½ to 19″ (½″ increments).

It is most probable that we will someday see upon these runways, aircraft that will be more crystalline in shape. The shapes suggested by Alexander Graham Bell and the Cubic Corporation show evidence of such a direction. Already certain passenger aircraft resemble pyramidal slabs, and flying obelisks. Perhaps aircraft will someday be named after crystals. As it is now, many are still named after animals, such as DHC 2 Beavers; Vampire T.; Chipmunk T. Mk. 20; Dove 8s; Hawker Furies; Turkey; etc. At any rate, here are some names for possible crystalline aircraft: Rhombohedral T.2; Orthorhombic 60; Tetragonal Terror; Hexagonal Star Dust 49; etc.

The enormous scale of the runways will isolate such aircraft into "buildings" for short spaces of time, then these "buildings" will disappear. The principal runways will extend from 11,000 feet to 14,000 feet, or about the length of Central Park. *Consider an aircraft in the shape of an enormous "slab" hovering over such an expanse.*

Tippetts-Abbett-McCarthy-Stratton have developed other sites that have limits similar to the air terminal project. They include port and harbor facilities like the Navy pier in Chicago, a port in Anchorage and San Nicholas Harbor in Aruba. Such sites rest on wide expanses of water, and are generated by ship voyages and cargo movements. Bulk storage systems are contained by mazes of transfer pipelines that include hydrant refueling pump houses and gas dispensers. The process behind the making of a storage facility may be viewed in stages, thus constituting a whole "series" of works of art from the ground up. Land surveying and preliminary building, if isolated into discrete stages, may be viewed as an array of art works that *vanish* as they develop. Water resources that involve flood control, irrigation, and hydroelectric power provide one with an entirely new way to order the terrain. This is a kind of radical construction that takes into account large land masses and bodies of water. The making of artificial lakes, with the help of dams, brings into view a vast "garden." For instance, the Peligre Dam in the Republic of Haiti consists of 250-foot high concrete buttresses. This massive structure, with its artificial cascades and symmetrical layout, stands like an immobile facade. It conveys an immense scale and power. By investigating the physical forms of such projects one may gain unexpected esthetic information. I am not concerned here with the original "functions" of such massive projects, but rather with what they suggest or evoke.

It is important to mentally experience these projects as something distinctive and intelligible. By extracting from a site certain associations that have remained invisible within the old framework of rational language, by dealing directly with the appearance or what Roland Barthes calls "the *simulacrum* of the object," the aim is to reconstruct a new type of "building" into a whole that engenders new meanings. From the linguistic point of view, one establishes rules of structure based on a change in the semantics of building. Tony Smith seems conscious of this "simulacrum" when he speaks of an "abandoned

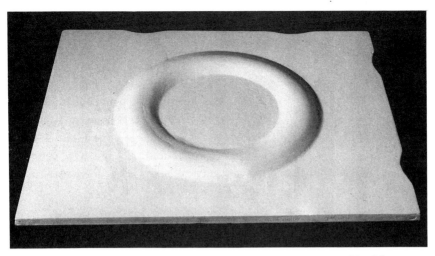

ROBERT MORRIS, model and cross-section for *Project in Earth and Sod*, 1966. Plaster, 1 × 20 × 24″.

airstrip" as an "artificial landscape." He speaks of an absence of "function" and "tradition."

What is needed is an esthetic method that brings together anthropology and linguistics in terms of "buildings." This would put an end to "art history" as sole criterion. Art at the present is confined by a dated notion, namely "art as a criticism of earlier art." The myth of the Renaissance still conditions and infects much criticism with a mushy humanistic content. Re-birth myths should not be applied as "meanings" to art. Criticism exists as *language* and nothing more. *Usage precedes meaning.* The "meanings" derived from the word Renaissance, such as "truth," "beauty," and "classic," are diseased words and outmoded criteria. As one becomes aware of discrete usages, the syntax of esthetic communications discloses the relevant features of both "building" and "language." Both are the raw materials of communication and are based on *chance* —not historical preconceptions. Linguistic sense-data, not rational categories, are what we are investigating. Carl Andre has made it clear that without linguistic awareness there is no physical awareness.

Tony Smith writes about "a dark pavement" that is "punctuated by stacks, towers, fumes and colored lights." (*Artforum*, December 1966.) The key word is "punctuated." In a sense, the "dark pavement" could be considered a "vast sentence," and the things perceived along it, "punctuation marks." ". . . tower . . ." = the exclamation mark (!). ". . . stacks . . ." = the dash (—). ". . . fumes . . ." = the question mark (?). ". . . colored lights . . ." = the colon (:). Of course, I form these equations on the basis of sense-data and not rational-data. Punctuation refers to interruptions in "printed matter." It is used to emphasize and clarify the meaning of specific segments of usage. Sentences like "skylines" are made of separate "things" that constitute a *whole* syntax. Tony Smith also refers to his art as "interruptions" in a "space-grid."

The impressionistic[1] world-view imitates that architectural detail—the window. The rational category of "painting" was derived from the visual meaning of the word "window" and then extended to mean "wall." The transparency of the window or wall as a clear "surface" becomes diseased when the artist defines his art by the *word* "painting" alone. Perhaps that is what Tony Smith is getting at when he says his works are "probably malignant." "Painting" is not *an end*, but a *means*, therefore it is linguistically an out-of-date category. The linguistic meaning of a "wall" or "window," when emptied of rational content, becomes surfaces, and lines.

The most common type of window in the modern city is composed of a simple grid system that holds panes of clear glass. The "glass wall" is a part of many standard stores and office buildings. By emphasizing the transparent glass we arrive at a total crystalline consciousness of structure, and avoid the clotted patchy naturalistic details of "painting." The organic shapes that painters put on the "canvas-pane" are eliminated and replaced by a consciousness that develops a new set of linguistic meanings and visual results.

"Sculpture," when not figurative, also is conditioned by architectural details. Floors, walls, windows, and ceilings delimit the bounds of interior sculpture. Many new works of sculpture gain scale by being *installed* in a vast room. The Jewish Museum and the Whitney Museum have such interiors. The rooms of these museums tend away from the intimate values of connoisseurship, toward a more public value. The walls of modern museums need not exist as walls, with diseased details near or on them. Instead, the artist could define the interior as a total network of surfaces and lines. What's interesting about Dan Flavin's art is not only the "lights" themselves, but what they do to the *phenomenon* of the "barren room."

"Site Selection Study" in terms of art is just beginning. The investigation of a specific site is a matter of extracting concepts out of existing sense-data through direct perceptions. Perception is prior to conception, when it comes to site selection or definition. One does not *impose*, but rather *exposes* the site—be it interior or exterior. Interiors may be treated as exteriors or vice versa. The unknown areas of sites can best be explored by artists.

NOTE

1. Impressionism is a popular theory derived from "symbolist theory." It has nothing to do with individual artists. I use the word "impressionism" according to its recent linguistic mutation. The original meaning of the word is less important than its recent usage. We are not concerned with what "impressionism" was but rather what it *is* today. But it should be remembered that symbolist theory is prior to impressionist theory.

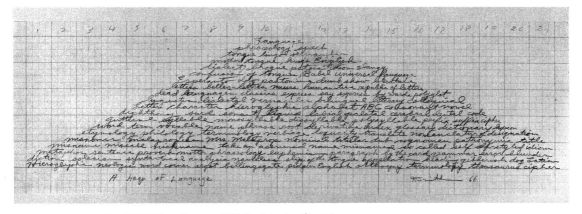

ROBERT SMITHSON, *A Heap of Language*, 1966. Pencil drawing, 6½ x 22".

LANGUAGE TO BE LOOKED AT AND/OR THINGS TO BE READ (1967)

Language operates between literal and metaphorical signification. The power of a word lies in the very inadequacy of the context it is placed, in the unresolved or partially resolved tension of disparates. A word fixed or a statement isolated without any decorative or "cubist" visual format, becomes a perception of similarity in dissimilars—in short a paradox. Congruity could be disrupted by a metaphorical complexity within a literal system. Literal usage becomes incantory when all metaphors are suppressed. Here language is built, not written. Yet, discursive literalness is apt to be a container for a radical metaphor. Literal statements often conceal violent analogies. The mind resists the false identity of such circumambient suggestions, only to accept an equally false logical surface. Banal words function as a feeble phenomena that fall into their own mental bogs of meaning. An emotion is suggested and demolished in one glance by certain words. Other words constantly shift or invert themselves without ending, these could be called "suspended words." Simple statements are often based on language fears, and sometimes result in dogma or non-sense. Words for mental processes are all derived from physical *things*. References are often reversed so that the "object" takes the place of the "word." A is A is never A is A, but rather X is A. The misunderstood notion of a metaphor has it that A is X—that is wrong. The scale of a letter in a word changes one's visual meaning of the word. Language thus becomes monumental because of the mutations of advertising. A word outside of the mind is a set of "dead letters." The mania for literalness relates to the breakdown in the rational belief in reality. Books entomb words in a synthetic rigor mortis, perhaps that is why "print" is thought to have entered obsolescence. The mind of this death, however, is unrelentingly awake.

<div align="right">Eton Corrasable</div>

[My sense of language is that it is matter and not ideas—i.e., "printed matter." R.S. June 2, 1972]

Dwan Gallery press release, June 1967

ULTRAMODERNE

The Century apartments, New York City.

Arts Magazine, September–October 1967

By ROBERT SMITHSON

"THE FLOOR OF THE HOLLOW WAS A LEVEL CIRCULAR EXPANSE OF PURE CRYSTAL; THE GENTLE SLOPING SIDES WERE LEAD-LINED ROCK. DIRECTLY ABOVE THE CRYSTAL FLOOR, AND SHEER UP TO THE LIMIT OF VISION, THE ATMOSPHERE EXHIBITED A DISTANT BRILLIANCE, LIKE THE BEAM OF A SEARCHLIGHT PASSING VERTICALLY UP THROUGH THE CLEAR, SUNLIT AIR." —John Taine (Eric Temple Bell), *The Purple Sapphire.*

The Ultramoderne of the 'thirties transcends Modernist 'historicistic' realism and naturalism, and avoids the avant-garde categories of 'painting, sculpture, and architecture.' A trans-historical consciousness has emerged in the 'sixties, that seems to avoid appeals to the organic time of the avant-garde and that is why the 'thirties are becoming more and more important to us. Even Clement Greenberg says the avant-garde is suffering from "hypertrophy" (the organic metaphor is accurate). Roland Barthes refers to such a condition as the "basic disease of the historical function." The value of temporal events in the natural *history* of Modernism have become untenable, even gross, in so far as they represent a defense against nondurational *histories.* The Ultraism of the 'thirties escapes the plague of 'social realism' of the same period, and the reaction of organic or naturalistic 'abstract expression' in the 'fifties. The Ultramoderne was never defined by temporal categories such as 'painting,' that is how it avoided a historicistic record. The Ultramoderne exists *ab aeterno!* Unlike the realist or naturalist, the Ultraist does not reject the archaic multi-cycles of the infinite. He does not 'make' history in order to impress those who believe in one history. Belief is not the motive behind the timeless, but rather a skepticism is the generating force. This skepticism takes the shape of a paradigmatic or primordial infrastructure, that repeats itself in an infinite number of ways. Repetition not originality is the object. It is not an accident that 'the mirror' is one of the more widely used materials of the 'thirties, and that the façades of buildings contained countless variations of brickwork. Repetition and serial order run constantly through the buildings of that paradigmatic period. An archaic ontology puts the Ultramoderne in contact with the many types of monumental art from every major period— Egyptian, Mayan, Inca, Aztec, Druid, Indian, etc. The Ultramoderne contains the 'primes' that establish enigmas not explanations. The Modernist claims to originality have made the primes less rigorous. The more exact the primes, the clearer the Time-Crystal. There are two types of time—organic (Modernist) and crystalline (Ultraist). Within the boundaries of the 'thirties, that multi-faceted segment of time, we discover premonitions, labyrinths, cycles, and repetitions that lead us to a concrete area of the infinite. The 'thirties apartment buildings along Central Park West are named after the bewildering and the remote—The Century, The Majestic, The Eldorado. On top of some of the ultra-towers we discover ziggurats or models of 'cosmic mountains.' The heavy leaden memories of monolithic civilizations are placed out of sight, in the aerial regions that few look at. A miniature Aztec ziggurat might be poised on the edge of an escarpment. Incessant and unreachable limits are built not into an 'architecture,' but rather into a 'cosmos,' that dissolves into fatigued and tired distances. Today's artist trys to make his art refer to nothing, while the art of the 'thirties seemed to refer to everything. But of course, today and yesterday may always be reversed. The surfaces of most 'thirties buildings may be viewed as topographic maps or interminable landscapes. Brick works are permuted into rectangular 'valleys' and 'islands' that multiply into intricate configurations. One encounters extensive geographic topographies that suggest the farthest spatial frontiers. The walls of these forgotten buildings from the Riverside Museum to Radio City bring one face to face with the incredible features of something immortal, yet corrupt. The arduous limits of the Empire State fill one with thoughts of extinguishment and vertigo. The outer walls of the Bell Telephone Building near Sixth Avenue and 17th Street are vertiginous maps that reach into the immensities of nowhere. Radio City is even billed as a "city within a city"—a microcosm in a macrocosm. The symmetrical patterns in some Ultramoderne walls seem devised to baffle and to prove the notion of a demi-urge. No doubt the 'thirties will be falsified into a style, perhaps endless styles, or maybe it has been already—who knows? For the 'thirties are built on *ideas* that could only have origi-

nated in the illusory depths of The Mirror of Mirrors. And as everybody knows, the mirror is a symbol of illusion, as immaterial as a projected film. Or think of the obsolete future in H. G. Wells' *The Shape of Things to Come* (1936). Tarnished reflections are all that remain of the 'thirties. An infinite multiplication of looking-glass interiors, that could only spell doom to the naturalist. The 'thirties recover that much hated Gnostic idea that the universe is a mirror reflection of the celestial order—a monstrous system of mirrored mazes. The 'thirties become a decade fabricated out of crystal and prisms, a world heavy with illusion. Never has the phantasmal appeared so solid. The mirror promises so much and gives so little, it is a pool of swarming ideas or neoplatonic archetypes and repulsive to the realist. It is a vain trap, an abyss, nevertheless the cold distant people of the Ultramoderne installed themselves in many versions of the Hall of Mirrors. They lived in interiors of gloss and glass, in luminous skyscrapers, in rooms of rarefied atmospheres and airless delights. The overuse of the mirror turned buildings, no matter how solid and immobile, into emblems of nothingness. Building exteriors were massive and windows were often surrounded by tomb-like mouldings and casements, but the interior mirrors multiplied and divided 'reality' into perplexing, inpenetrable, uninhabitable regions. The walls outdoors were ultra physical, while the walls indoors were ungraspable and vain. The purist is vain enough to imagine he is pure, but this ultimate viewpoint frightens the naturalist. The 'window' and the 'mirror' are secret sharers of the same elements. The window contains nothing, while the mirror contains everything. Consider them both, and you will find it impossible to escape their double identity. The 'ultra-window' is a privileged post for those 'site-seers' of trans-modernism. The window doubles as an open and closed space, and this is accentuated in many 'thirties buildings. Many builders in the 'thirties such as Helmle, Corbett, Harrison, Sugarman and Burger transformed the 'window' into an art form. By the way, the Riverside Museum was the first building in New York City to have 'corner windows.' The window reminds us that we are captives of the room, by suggesting both flight and confinement. The ziggurated frameworks that contain certain windows show a keen awareness of the window—as 'a thing in itself.' This is the direct opposite of The International Style, where the window has no meaning other than function. Form does not follow function in the Ultramoderne cosmos of fixity and facets. The corner window is a right-angled boundary that involves the idea of the double or a 'split-window' from which there is no escape. The meaning of the window makes one aware of absolute inertia or the perfect instant, when time oscillates in a circumscribed place. The window prevents movement by setting up a transparent barrier. An Ultraist view through the Ultra-window brings about total consciousness. The direction of 'art-time' has since the 'fifties tended toward France, along the line of progress from the avant-garde, but that line appears to be shifting away from France and Europe towards South America and India. In fact the *one line* of the avant-garde is forking, breaking and becoming *many lines*. Buenos Aires is where Jorge Luis Borges introduced his own special kind of Ultraism, back in the 'twenties. A group of young theorizers and writers—Narah Lange, Guillerino Juan, Eduardo Gonzalez Lanuza and Francisco Pinero—published a review called *Prisma* (1921-1922). Later a manifesto defined Ultraism through various negative qualities,

says Ana Maria Barrenechea, it showed an ". . . animosity toward decadent Modernism, and toward Simplism." What is fascinating about South America is that practically nothing is known about it. Like India it is a tangle of endless unknown or lost cities—look in any World Atlas. The period of time we call the 'thirties holds the secrets of those infinite distances within its physical limits, its buildings, staircases, windows, doors, and mirrors. The 'thirties become a vast *topos*, teeming with replicas of monumental 'primes.' Within what George Kubler refers to as "repetition in general, including habits, routines, and rituals," we are apt to discover the serial order of the enduring prime. The "history of art," according to Kubler, resembles "a broken but much repaired chain made of string and wire" that connects "occasional jeweled links." To understand this 'chain' would be like trying to retrace the pattern of ones footsteps from the day of ones birth to the present. The prime monuments are as enigmatic as the prime numbers. The distribution of primes in the number system is irregular, but each number is complete in itself—2, 3, 5, 7, 11, 101, etc. A prime could be a mirror while a replica could be a reflection. The 'shape of time,' when it comes to the Ultramoderne, is circular and unending—a circle of circles that is made of 'linear incalculables' and 'interior distances.' All the arduous efforts of all the monumental ages are contained in the ultra-instants, the atemporal moments, or the cosmic seconds. This is a return to a primitive inertia or invincible idleness that stops trains, jets and ships and transforms them into signs or symbols. The Time of the 'thirties remains asleep—locked in the mirrors of a purely negative idealism— a crypto-phenomenology. It would be grossly wrong to consider the Ultramoderne in terms of Surrealism or existential psychoanalysis. All that was fascinating about the so-called Surrealists was subverted by a kind of *abstract naturalism*, that imagined itself to be 'formal.' Fortunately, the Ultramoderne was dismissed by the 'organic' modernist, or else it simply evaded his understanding. Ultraism, because it is aware of Time as 'fiction,' knows that *belief* is groundless, and so accepts the groundlessness with a measured skepticism. The Ultraist 'doubts his own doubt', and does not resort to despair because he knows the difference between the feeling in one's *self* and the *thing* felt. Temporal continuity conceals the discrete structure of illusion; it conceals the *Absolute* that suggests nothing, recalls nothing and signifies nothing. An infinite memory trace from the 'thirties hangs in a cosmos within mental or phenomenological vaults and sinks back into eternity. The Ultramoderne puts one in contact with vast distances, with the ever-receding square spirals; it projects one into mirrored surfaces or into ascending and descending states of ludicity. Walls, rooms and windows take on a vertiginous immobility—Time engulfs space. The Time of the 'thirties is an infinite pyramid with a mirrored interior and a granite exterior—reality contains the illusion or reality encloses the illusion. The 1930's reflect the 2030's into a multifaceted domain of chambers that progresses backwards in threes. A tripartite infrastructure that extends forever into the future through the past. Nothing is new, neither is anything old.

Left: Circular mirror, 1930. Right: Film stills from Andy Warhol's *Empire.*

LETTER TO THE EDITOR (1967)

Sirs:

France has given us the anti-novel, now Michael Fried has given us the anti-theater. A production could be developed on a monstrous scale with the Seven Deadly Isms, verbose diatribes, scandalous refutations, a vindication of Stanley Cavell, shrill but brilliant disputes on "shapehood" vs. "objecthood," dark curses, infamous claims, etc. The stage should subdivide into millions of stages.

The following is a "prologue" from an unwritten TV "spectacular" called *The Tribulations of Michael Fried.*

> . . . there will be no end to this exquisite, horrible misery, when you look forward you shall see a long forever, a boundless duration before you, which will swallow up your thoughts.
>
> Jonathan Edwards

Michael Fried has in his article "Art and Objecthood" (*Artforum*, June 1967) declared a "war" on what he quixotically calls "theatricality." In a manner worthy of the most fanatical puritan, he provides the art world with a long-overdue spectacle—a kind of ready-made parody of the war between Renaissance classicism (modernity) versus Manneristic anti-classicism (theater). Fried, without knowing it, has brought into being a schism complete with all the "mimic fury" (Thomas Carew) of a fictive inquisition. He becomes, I want to say, in effect the first truly manneristic critic of "modernity." Fried has set the critical stage for *manneristic modernism*, although he is trying hard not to fall from the "grip" of grace. This grace he maintains by avoiding *appearance*, or by keeping art at "arm's length." Fried discusses this "grip" in *Anthony Caro and Kenneth Noland—Some Notes on Not Composing* (The Lugano Review, 1965/III-IV). What Fried fears most is the consciousness of what he is doing—namely being himself theatrical. He dreads "distance" because that would force him to become aware of the role he is playing. His sense of intimacy would be annihilated by the "God" Jonathan Edwards feared so much. Fried, the orthodox modernist, the keeper of the gospel of Clement Greenberg has been "struck by Tony Smith," the agent of endlessness. Fried has declared his sacred duty to modernism and will now make combat with what Jorge Luis Borges calls "the numerous Hydra (the swamp monster which amounts to a prefiguration or emblem of geometric progressions) . . . ", in other words "Judd's Specific Objects, and Morris's gestalts or unitary forms, Smith's cube . . . " This atemporal world threatens Fried's present state of temporal grace—his "presentness." The terrors of infinity are taking over the mind of Michael Fried. Corrupt appear-

ances of endlessness worse than any known Evil. A radical skepticism, known only to the dreadful "literalists" is making inroads into intimate "shapehood." Non-durational labyrinths of time are infecting his brain with eternity. Fried, the Marxist saint, shall not be tempted into this awful sensibility, instead he will cling for dear life to the "surfaces" of Jules Olitski's *Bunga*. Better one million *Bungas* than one "specific object." Yet, little known "specific demons" are at this moment, I want to say, "breaking the fingers" of Fried's grip on *Bunga*. This "harrowing" of hellish objecthood is causing modernity much vexation and turmoil—not to say "gnashing of teeth."

At any rate, eternity brings about the dissolution of belief in temporal histories, empires, revolutions, and counter-revolutions—all becomes ephemeral and in a sense unreal, even the universe loses its reality. Nature gives way to the incalculable cycles of nonduration. Eternal time is the result of skepticism, not belief. Every refutation is a mirror of the thing it refutes—*ad infinitum*. Every war is a battle with reflections. What Michael Fried attacks is what he is. He is a naturalist who attacks natural time. Could it be there is a double Michael Fried—the atemporal Fried and the temporal Fried? Consider a subdivided progression of "Frieds" on millions of stages.

A TOUR OF THE MONUMENTS
OF PASSAIC, NEW JERSEY (1967)

> He laughed softly. "I know. There's no way out. Not through the Barrier.
> Maybe that isn't what I want, after all. But this—this—" He stared at the
> Monument. "It seems all wrong sometimes. I just can't explain it. It's the
> whole city. It makes me feel haywire. Then I get these flashes."
>
> <div align="right">Henry Kuttner, Jesting Pilot</div>
>
> Today our unsophisticated cameras record in their own way our hastily
> assembled and painted world.
>
> <div align="right">Vladimir Nabokov, Invitation to a Beheading</div>

On Saturday, September 30, 1967, I went to the Port Authority Building on
41st Street and 8th Avenue. I bought a copy of the *New York Times* and a Signet
paperback called *Earthworks* by Brian W. Aldiss. Next I went to ticket booth 21
and purchased a one-way ticket to Passaic. After that I went up to the upper
bus level (platform 173) and boarded the number 30 bus of the Inter-City
Transportation Co.

I sat down and opened the *Times*. I glanced over the art section: a "Collec-
tors', Critics', Curators' Choice" at A. M. Sachs Gallery (a letter I got in the
mail that morning invited me "to play the game before the show closes Octo-
ber 4th"), Walter Schatzki was selling "Prints, Drawings, Watercolors" at "33⅓%
off," Elinor Jenkins, the "Romantic Realist," was showing at Barzansky Gal-
leries, XVIII–XIX Century English Furniture on sale at Parke-Bernet, "New

"Allegorical Landscape" by Samuel F. B. Morse, displayed at Marlborough-Gerson Gallery

Published as "The Monuments of Passaic," *Artforum*, December 1967

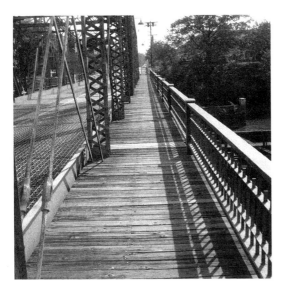

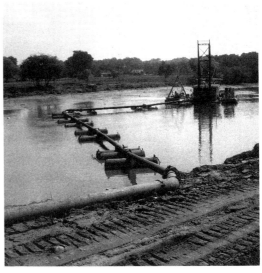

The Bridge Monument Showing Wooden Sidewalks.
(Photo: Robert Smithson.)

Monument with Pontoons: The Pumping Derrick.
(Photo: Robert Smithson.)

Directions in German Graphics" at Goethe House, and on page 29 was John Canaday's column. He was writing on *Themes and the Usual Variations*. I looked at a blurry reproduction of Samuel F. B. Morse's *Allegorical Landscape* at the top of Canaday's column; the sky was a subtle newsprint grey, and the clouds resembled sensitive stains of sweat reminiscent of a famous Yugoslav watercolorist whose name I have forgotten. A little statue with right arm held high faced a pond (or was it the sea?). "Gothic" buildings in the allegory had a faded look, while an unnecessary tree (or was it a cloud of smoke?) seemed to puff up on the left side of the landscape. Canaday referred to the picture as "standing confidently along with other allegorical representatives of the arts, sciences, and high ideals that universities foster." My eyes stumbled over the newsprint, over such headlines as "Seasonal Upswing," "A Shuttle Service," and "Moving a 1,000 Pound Sculpture Can Be a Fine Work of Art, Too." Other gems of Canaday's dazzled my mind as I passed through Secaucus. "Realistic waxworks of raw meat beset by vermin" (Paul Thek), "Mr. Bush and his colleagues are wasting their time" (Jack Bush), "a book, an apple on a saucer, a rumpled cloth" (Thyra Davidson). Outside the bus window a Howard Johnson's Motor Lodge flew by—a symphony in orange and blue. On page 31 in Big Letters: THE EMERGING POLICE STATE IN AMERICA SPY GOVERNMENT. "In this book you will learn . . . what an Infinity Transmitter is."

The bus turned off Highway 3, down Orient Way in Rutherford.

I read the blurbs and skimmed through *Earthworks*. The first sentence read, "The dead man drifted along in the breeze." It seemed the book was about a soil shortage, and the *Earthworks* referred to the manufacture of artificial soil. The sky over Rutherford was a clear cobalt blue, a perfect Indian summer day, but the sky in *Earthworks* was a "great black and brown shield on which moisture gleamed."

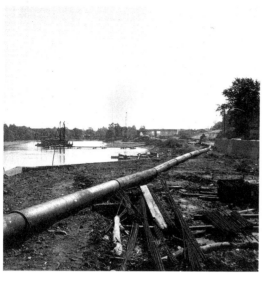

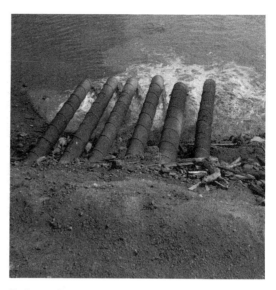

The Great Pipe Monument. (Photo: Robert Smithson.) *The Fountain Monument: Bird's Eye View.* (Photo: Robert Smithson.)

The bus passed over the first monument. I pulled the buzzer-cord and got off at the corner of Union Avenue and River Drive. The monument was a bridge over the Passaic River that connected Bergen County with Passaic County. Noon-day sunshine cinema-ized the site, turning the bridge and the river into an over-exposed *picture.* Photographing it with my Instamatic 400 was like photographing a photograph. The sun became a monstrous light-bulb that projected a detached series of "stills" through my Instamatic into my eye. When I walked on the bridge, it was as though I was walking on an enormous photograph that was made of wood and steel, and underneath the river existed as an enormous movie film that showed nothing but a continuous blank.

The steel road that passed over the water was in part an open grating flanked by wooden sidewalks, held up by a heavy set of beams, while above, a ramshackle network hung in the air. A rusty sign glared in the sharp atmosphere, making it hard to read. A date flashed in the sunshine . . . 1899 . . . No . . . 1896 . . . maybe (at the bottom of the rust and glare was the name Dean & Westbrook Contractors, N.Y.). I was completely controlled by the Instamatic (or what the rationalists call a camera). The glassy air of New Jersey defined the structural parts of the monument as I took snapshot after snapshot. A barge seemed fixed to the surface of the water as it came toward the bridge, and caused the bridge-keeper to close the gates. From the banks of Passaic I watched the bridge rotate on a central axis in order to allow an inert rectangular shape to pass with its unknown cargo. The Passaic (West) end of the bridge rotated south, while the Rutherford (East) end of the bridge rotated north; such rotations suggested the limited movements of an outmoded world. "North" and "South" hung over the static river in a bi-polar manner. One could refer to this bridge as the "Monument of Dislocated Directions."

Along the Passaic River banks were many minor monuments such as con-

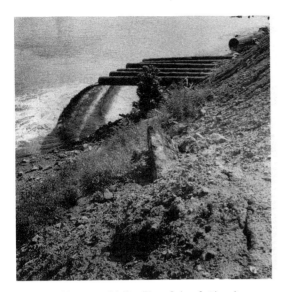

The Fountain Monument—Side View. (Photo: Robert Smithson.)

The Sand-Box Monument. (also called The Desert). (Photo: Robert Smithson.)

crete abutments that supported the shoulders of a new highway in the process of being built. River Drive was in part bulldozed and in part intact. It was hard to tell the new highway from the old road; they were both confounded into a unitary chaos. Since it was Saturday, many machines were not working, and this caused them to resemble prehistoric creatures trapped in the mud, or, better, extinct machines—mechanical dinosaurs stripped of their skin. On the edge of this prehistoric Machine Age were pre– and post–World War II suburban houses. The houses mirrored themselves into colorlessness. A group of children were throwing rocks at each other near a ditch. "From now on you're not going to come to our hide-out. And I mean it!" said a little blonde girl who had been hit with a rock.

As I walked north along what was left of River Drive, I saw a monument in the middle of the river—it was a pumping derrick with a long pipe attached to it. The pipe was supported in part by a set of pontoons, while the rest of it extended about three blocks along the river bank till it disappeared into the earth. One could hear debris rattling in the water that passed through the great pipe.

Nearby, on the river bank, was an artificial crater that contained a pale limpid pond of water, and from the side of the crater protruded six large pipes that gushed the water of the pond into the river. This constituted a monumental fountain that suggested six horizontal smokestacks that seemed to be flooding the river with liquid smoke. The great pipe was in some enigmatic way connected with the infernal fountain. It was as though the pipe was secretly sodomizing some hidden technological orifice, and causing a monstrous sexual organ (the fountain) to have an orgasm. A psychoanalyst might say that the landscape displayed "homosexual tendencies," but I will not draw such a crass anthropomorphic conclusion. I will merely say, "It was there."

Across the river in Rutherford one could hear the faint voice of a P. A. sys-

tem and the weak cheers of a crowd at a football game. Actually, the landscape was no landscape, but "a particular kind of heliotypy" (Nabokov), a kind of self-destroying postcard world of failed immortality and oppressive grandeur. I had been wandering in a moving picture that I couldn't quite picture, but just as I became perplexed, I saw a green sign that explained everything:

YOUR HIGHWAY TAXES 21
AT WORK

Federal Highway	U.S. Dept. of Commerce
Trust Funds	Bureau of Public Roads
2,867,000	State Highway Funds
	2,867,000

New Jersey State Highway Dept.

That zero panorama seemed to contain *ruins in reverse*, that is—all the new construction that would eventually be built. This is the opposite of the "romantic ruin" because the buildings don't *fall* into ruin *after* they are built but rather *rise* into ruin before they are built. This anti-romantic *mise-en-scene* suggests the discredited idea of *time* and many other "out of date" things. But the suburbs exist without a rational past and without the "big events" of history. Oh, maybe there are a few statues, a legend, and a couple of curios, but no past—just what passes for a future. A Utopia minus a bottom, a place where the machines are idle, and the sun has turned to glass, and a place where the Passaic Concrete Plant (253 River Drive) does a good business in STONE, BITUMINOUS, SAND, and CEMENT. Passaic seems full of "holes" compared to New York City, which seems tightly packed and solid, and those holes in a sense are the monumental vacancies that define, without trying, the memory-traces of an abandoned set of futures. Such futures are found in grade B Utopian films, and then imitated by the suburbanite. The windows of City Motors auto sales proclaim the existence of Utopia through 1968 WIDE TRACK PONTIACS—Executive, Bonneville, Tempest, Grand Prix, Firebirds, GTO, Catalina, and LeMans—that visual incantation marked the end of the highway construction.

Next I descended into a set of used car lots. I must say the situation seemed like a change. Was I in a new territory? (An English artist, Michael Baldwin, says, "it could be asked if the country does in fact change—it does not in the sense a traffic light does.") Perhaps I had slipped into a lower stage of futurity—did I leave the real future behind in order to advance into a false future? Yes, I did. Reality was behind me at that point in my suburban Odyssey.

Passaic center loomed like a dull adjective. Each "store" in it was an adjective unto the next, a chain of adjectives disguised as stores. I began to run out of film, and I was getting hungry. Actually, Passaic center was no center—it was instead a typical abyss or an ordinary void. What a great place for a gallery! Or maybe an "outdoor sculpture show" would pep that place up.

At the Golden Coach Diner (11 Central Avenue) I had my lunch, and

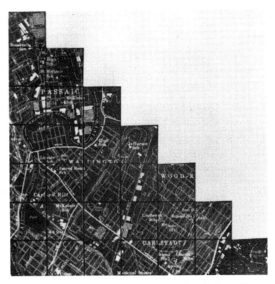

Negative Map Showing Region of the Monuments along the Passaic River.

loaded my Instamatic. I looked at the orange-yellow box of Kodak Veri-chrome Pan, and read a notice that said:

READ THIS NOTICE:
This film will be replaced if defective in manufacture, label-ing, or packaging, even though caused by our negligence or other fault. Except for such replacement, the sale or any subsequent handling of this film is without other warranty or liability. EASTMAN KODAK COMPANY DO NOT OPEN THIS CARTRIDGE OR YOUR PICTURES MAY BE SPOILED —12 EXPOSURES—SAFETY FILM—ASA 125 22 DIN.

After that I returned to Passaic, or was it the *hereafter*—for all I know that unimaginative suburb could have been a clumsy eternity, a cheap copy of The City of the Immortals. But who am I to entertain such a thought? I walked down a parking lot that covered the old railroad tracks which at one time ran through the middle of Passaic. That monumental parking lot divided the city in half, turning it into a mirror and a reflection—but the mirror kept changing places with the reflection. One never knew what side of the mirror one was on. There was nothing *interesting* or even strange about that flat monument, yet it echoed a kind of cliché idea of infinity; perhaps the "secrets of the universe" are just as pedestrian—not to say dreary. Everything about the site remained wrapped in blandness and littered with shiny cars—one after another they ex-tended into a sunny nebulosity. The indifferent backs of the cars flashed and reflected the stale afternoon sun. I took a few listless, entropic snapshots of that lustrous monument. If the future is "out of date" and "old fashioned," then I

had been in the future. I had been on a planet that had a map of Passaic drawn over it, and a rather imperfect map at that. A sidereal map marked up with "lines" the size of streets, and "squares" and "blocks" the size of buildings. At any moment my feet were apt to fall through the cardboard ground. I am convinced that the future is lost somewhere in the dumps of the non-historical past; it is in yesterday's newspapers, in the *jejune* advertisements of science-fiction movies, in the false mirror of our rejected dreams. Time turns metaphors into *things*, and stacks them up in cold rooms, or places them in the celestial playgrounds of the suburbs.

Has Passaic replaced Rome as The Eternal City? If certain cities of the world were placed end to end in a straight line according to size, starting with Rome, where would Passaic be in that impossible progression? Each city would be a three-dimensional mirror that would reflect the next city into existence. The limits of eternity seem to contain such nefarious ideas.

The last monument was a sand box or a model desert. Under the dead light of the Passaic afternoon the desert became a map of infinite disintegration and forgetfulness. This monument of minute particles blazed under a bleakly glowing sun, and suggested the sullen dissolution of entire continents, the drying up of oceans—no longer were there green forests and high mountains—all that existed were millions of grains of sand, a vast deposit of bones and stones pulverized into dust. Every grain of sand was a dead metaphor that equaled timelessness, and to decipher such metaphors would take one through the false mirror of eternity. This sand box somehow doubled as an open grave—a grave that children cheerfully play in.

> . . . all sense of reality was gone. In its place had come deep-
> seated illusions, absence of pupillary reaction to light, absence of
> knee reaction—symptoms all of progressive cerebral meningitis:
> the blanketing of the brain . . .
>> Louis Sullivan, "one of the greatest of all architects,"
>> quoted in Michel Butor's *Mobile*

I should now like to prove the irreversibility of eternity by using a *jejune* experiment for proving entropy. Picture in your mind's eye the sand box divided in half with black sand on one side and white sand on the other. We take a child and have him run hundreds of times clockwise in the box until the sand gets mixed and begins to turn grey; after that we have him run anti-clockwise, but the result will not be a restoration of the original division but a greater degree of greyness and an increase of entropy.

Of course, if we filmed such an experiment we could prove the reversibility of eternity by showing the film backwards, but then sooner or later the film itself would crumble or get lost and enter the state of irreversibility. Somehow this suggests that the cinema offers an illusive or temporary escape from physical dissolution. The false immortality of the film gives the viewer an illusion of control over eternity—but "the superstars" are fading.

LOBIGERINA OOZE AND THE BLUISH MUDS. *CRETA* THE LATIN WORD FOR CHALK (THE CHALK AGE). AN ARTICLE CALLED **GROTTOES, GEOLOGY AND THE GOTHIC REVIVAL.** ‖ILOSOPHIC ROMANCES. GREENSANDS ACCUMULATED OVER WIDE AREAS IN SHALLOW WATER. UPRAISED PLATEAUX IN AUSTRALIA. SEDIMENT SAMPLES. CONIFERS. REMAINS ‖ A FLIGHTLESS BIRD DISCOVERED IN A CHALK PIT. CAUSES OF EXTINCTION UNKNOWN. THE FABULOUS SEA-SERPENT. THE CLASSICAL ATTITUDE TOWARD MOUNTAINS IS ‖LOOMY. A DISPLAY OF PLASTER TRICERATOPS EGGS IN A GLASS CASE. THE ROCKS OF MONTANA. GLIBIGERINA CRETACEA ENLARGED 30 TIMES IN A BOOK. THE WEARING ‖ROCESS CONTINUES. A CONSTANT GRINDING DOWN OF ROUGH TERRAINS. SOMETHING HAD FANGS 6 INCHES LONG. KILLED BY THE HEAT OF THE SUN. **THE SACRED THEORY OF** ‖HE EARTH CAUSES BEWILDERMENT. SOME BOOKS CONCERNING THE DELUGE BRING CHAOS TO MANY. GRAY MISTS AND MUCH HEAT. PERPLEXED BY PEBBLE DEPOSITS. COLUMNS ‖ BASALT ILLUSTRATED IN **DE RERUM FOSSILIUM.** PAINTINGS OF CRETACEOUS PERIOD SHOWN AS *ARTIST'S CONCEPTIONS* ON LARGE PANELS. FROM 135 TO 70 MILLION YEARS ‖O. **TRAITE DE PETRIFICATIONS.** WOODCUT SHOWING TWO STONES FALLING FROM THE HEAVENS DURING A STORM. A DEAD TORTOISE. IN THE ZONE OF AIR—THUNDERBOLTS, ‖G. *CERANUNIUS*, BELEMNITE, ETC. CERTAIN BEDS OF THE KEOKUK IN THE CENTRAL MISSISSIPPI VALLEY. THE *FLAMING RAMPARTS OF THE WORLD* (LUCRETIUS). **DE MINERALI-**‖US BY ALBERTUS MAGNUS. FEATHER IMPRESSIONS EXHIBITED IN A PALEONTOLOGICAL MUSEUM. FOSSILIZED VENOM. THE TREE ONICA WHOSE TEARS HARDEN INTO THE MINERAL ‖NYX. (FROM THE HORTUS SANITATIS). SOME GRAINS OF SAND WERE SQUARE AND OTHERS PYRAMIDAL. CAMERAS LOST IN SHELLS AND SKELETONS.

LABEL UNDER A STEGOSAURUS SKELETON. BONY PLATES. THREE OUNCES OF BRAIN. 45,000,000. NO WORDS COULD DESCRIBE IT. CRAGGY CLIFFS, INDEPENDENT OF LIFE. ‖XTENSIVE LAKES OR INLAND SEAS MARKED AS BLUE STRIPES ON AN OVAL MAP. PLASTIC SEAWEEDS IN THE MUSEUM. A GREAT COLLECTION OF FOSSILS IN THE ASHMOLEAN ‖USEUM AT OXFORD. **MUNDUS SUBTERRANEUS,** KIRCHER AMSTERDAM 1678. STONE PLANTS. JOHN CLEVELAND'S **NEWS FROM NEWCASTLE OR NEWCASTLE COAL PITS** PUBLISHED ‖ 1659. AGE OF CYCADS. A FINE CHALKY DEPOSIT (PERHAPS DUST BLOWN FROM RAISED CORAL REEFS). MONO LAKE—THE DEAD SEA OF THE WEST. BELEMNITES SWARMED IN THE ‖UDDY SEAS. POETS CELEBRATING GROTTOES. THE RECENT MONKEY-PUZZLE HAS NOTHING TO DO WITH THE JURASSIC PERIOD. WELL-PRESERVED PTERODACTYLS. THE BURNET ‖ONTROVERSY. MANY CRAWLED ON THE OCEAN FLOOR. DELTAIC SANDSTONES OUTCROPPING IN YORKSHIRE. A MODEL OF A BRYOZOA ONE MILLION TIMES LIFE SIZE. MEANDER-‖G RIVERS. *GO MY SONS, BUY STOUT SHOES, CLIMB THE MOUNTAINS, SEARCH THE VALLEYS, DESERTS, THE SEA SHORES, AND THE DEEP RECESSES OF THE EARTH* (SEVERINUS). ‖ BRITAIN THE JURASSIC CONSISTS MAINLY OF OOLITES AND CLAYS. RHAETIC BEDS. SEVERAL LAND-MASSES NOT SHOWN ON A MAP. LUXURIANT VEGETATION. **PARADISE LOST.** ‖VASION OF THE OCEAN. ARCHAEOPTERYX. FLESH-EATERS WALKED ON THEIR HIND LEGS USING THEIR FORE LIMBS FOR GRABBING PREY. BONES WITH AIR CAVITIES SHOWN IN ‖NE DRAWING. LOW TIDE. DEAD JELLY-FISH IN A LAGOON. PAINTING OF FERN FOREST. POST CARDS OF ZION CANYON. A BOOK ON URANIUM. AN *ARTIST'S CONCEPTION* OF ‖INOSAURS IN A SWAMP. CHART TELLS OF THE EVOLUTION OF WASTE. OVER-EXPOSED PHOTOGRAPHS OF THE SUNDANCE SEA. A NOVEL ABOUT THE LIFE OF AN ICHTHYOSAUR. ‖O ICE SHEETS MARKED THE POLES. INFRA-RED PHOTOGRAPHS OF THE GULF OF GEOSYNCLINE.

‖BSCURE VALLEYS. DATA FROM DRILLED HOLES. *HE MAY EVEN NOW—IF I MAY USE THE PHRASE—BE WANDERING ON SOME PLESIOSAURUS-HAUNTED OLLITIC CORAL REEF, OR* ‖ESIDE THE LONELY SALINE LAKES OF THE TRIASSIC AGE* (H.G. WELLS). TRACKS OF DINOSAURS DISCOVERED AT TURNERS FALLS, ON THE CONNECTICUT RIVER IN MASSACHU-‖ETTS. THE COLUMNAR JOININGS OF THE PALISADES. INERT, ALL SLIDES INTO A LOST MOMENT. A CLIFF BELOW THE WEST END OF THE GEORGE WASHINGTON BRIDGE. VOLCANIC ‖APORS. AT THE CHILLED ZONE. A RESTORED SECTION OF A TRIASSIC FAULT BLOCK SHOWING LAVA DIKES. A BOOK IS A PAPER STRATA. A COLORED PHOTOGRAPH OF THE ‖TRIFIED FOREST, ARIZONA. A LANDSLIDE OF MAPS. ECLIPSE OF THE MOON. GYPSUM. AN ILLUSTRATION FROM THE PALESTECTONIC ATLAS. DYING IN THE YUKON AMID THE ‖UTONIC ROCKS. TECTONIC ISLANDS SURROUNDED BY GREEN FOAM. ...*NOTHING CAN APPEAR MORE LIFELESS THAN THE CHAOS OF ROCKS...* (DARWIN). SOUTHERN ELLESMERE-‖AND. ABUNDANT QUANTITIES OF GRANULAR MINERALS. THE EXHUMED PRE-LATE TRIASSIC PENEPLANE CAN BE SEEN NEAR THE GEORGE WASHINGTON BRIDGE. A GENERALIZED ‖EOLOGIC CROSS SECTION SHOWING MAGMA OFFSHOOTS. A DIAGRAM SHOWING A FAULT ZONE. WEDGES OF SEDIMENTARY STRATA. A PHOTOGRAPH OF *ROTTEN* DIABASE. RAPID ‖EAT LOSS. A RESTORATION OF A ICAROSAURUS. FALL ZONE. SWASH. 600,000 CUBIC YARDS OF SOMETHING. A BLOCK DIAGRAM SHOWING DRIFT. BARRIERS OF MUD. *THE EARLIEST* ‖ *THE THREE GEOLOGICAL PERIODS COMPRISED IN THE MESOZOIC ERA* (**DICTIONARY OF GEOLOGICAL TERMS**). *BLACK HEATHS, WILD ROCKS, BLACK CRAGS, AND NAKED HILLS* ‖HARLES COTTON).IN THE WAKE OF LAVA FLOWS. CHOMATIC EMULSIONS OF NAMELESS ROCKS. A NARROW RANGE OF GREY TONALITIES. THE ANONYMOUS SURFACE UNIFORMITY ‖ MUSEUM PHOTOGRAPHS. DEGENERATE TECHNIQUES. DISPLAYS IN PLASTIC.

‖RATA A GEOPHOTOGRAPHIC FICTION

Aspen, no. 8, Fall–Winter 1970–71, issue edited by Dan Graham.
Some words are illegible in this article because of the worn folds in the pages of the only copy of the original available to us.

PERMIAN

THE PROVINCE OF PERM IN RUSSIA. EVAPORATION CAUSES LAND TO SHRINK. CONTINENTAL DRIFT. A DRAWING OF THE SKULL OF THE REPTILE ELGINIA (RELATED TO PAREIASAURUS, FROM PERMIAN SANDSTONE IN ELGIN, N.E. SCOTLAND, DRAWN TO ONE-QUARTER NATURAL SIZE). THROUGH THE EYES OF DIMETRODON. PERMIAN ICE AGE. *THUS, THE PULSATING MOVEMENT OF GLACIERS IS DUE TO THE PROPERTIES OF ICE ITSELF AND IS ASSOCIATED WITH THE PERIODIC ACCUMULATION AND REMOVAL OF ELAS STRESS IN POLYCRYSTALLINE AGGREGATE* (P.A. SHUMSKI). HOT DESERT CONDITIONS. NOTES REGARDING FORAMINIFERA. REMAINS OF SLOW WADDLING CREATURES FOUND RUSSIA AND SOUTH AFRICA. SEAS WERE CUT-OFF FROM THE OCEAN, UNTIL THEY BECAME INCREASINGLY SALINE. DRASTIC CHANGES OF THE LANDSCAPE TAKE PLACE. A VOL ACCORDING TO HUTTON IS A SPIRACLE TO A SUBTERRANEAN FURNACE. FANTASTIC IDEAS WERE LATER CAST ASIDE BY THE PLUTONISTS. SOLIDIFIES IN GRANITE. FAUST SAY *SET ROCK TO ROCK....* THE NEPTUNIAN THEORY. THE SYMMETRY OF THE EARTH WAS THOUGHT TO BE SPOILED. MODERN ORDERS OF INSECTS EMERGE. A SPIRALLY COILED BA OF TEETH BELONGED TO HELICOPRION. DWARF FAUNA. ONE SENTENCE DEVOTED TO INSECTS IN A CHAPTER ON THE PERMIAN PERIOD. STEREOSCOPIC VIEWS OF THE GUADAL SEA. NUANCES OF CHANGING LIGHT OVER RECONSTRUCTIONS OF DECIDUOUS TREES. SNAPSHOTS OF POISON GAS. DIORAMA OF ASH HEAPS. DAGUERREOTYPE SHOWING VAST DEPOSITS OF SALT AND GYPSUM. EQUATOR IN OKLAHOMA. SPOILED PHOTOGRAPHS OF SAND DUNES. PHOTOMICROGRAPHIC STUDIES OF FOSSIL FROST. AERIAL PHOTOGRAPHS GLACIATION. STRATIGRAPHIC MAP OF OIL DEPOSITS. MISPLACED BOUNDARIES. SHIFTS IN POLAR AXIS RECORDED. EVAPORATION OF SOUTHERN HEMISPHERE. MARATHON MOUNTAIN SKETCHED. JOURNALS DEVOTED TO RADIATION DAMAGE. UNDEVELOPED FILM OF DRY LAND MASS. NEGATIVES OF SHELLY ORGANISMS. A BOOK ON EDAPHOSAUR COLOR SLIDES OF PERMIAN PRAIRIES.

CARBONIFEROUS

THE COAL PERIOD. GEOGRAPHY OF THE LOWER CARBONIFEROUS PERIOD SHOWN ON AN OVAL MAP, WITH BLACK DOTS SYMBOLIZING *LAND PLANTS*. SLUG-LIKE CREATURES G OVER DEAD CALAMITES. TERRIGENOUS CLASTIC SEDIMENTS EXTENDED TO A LINE PASSING WEST OF MICHIGAN. EARTH WARPAGE. PHOTOGRAPH OF LIMESTONES NEAR BLOC TON, INDIANA. NATURE IS NOT THE STARTING POINT. *ALL ROUND THE COAST THE LANGUID AIR DID SWOON...* (TENNYSON). PURELY STATIC SHAPES, CLUMPS GLIMPSED THRO THE EYES OF ERYOPS. THE BRITISH MUSEUM BUILT 1824. THE GLYPTOTHEK IN MUNICH 1816-1834. *AS DECAY AND DEATH OVERTOOK THESE FOREST GIANTS THEY EVENTUALL CRASHED INTO THE MUD AND OOZE SURROUNDING THEM* (CHARLES R. KNIGHT). THE IMMUTABLE CALM IN THE STEAMING SWAMPS. THINGS FAIL TO APPEAR. WORDS SINKIN THE MUCK AND MIRE. *COLLECTING THE FOSSIL AND SENDING IT TO THE MUSEUM IS ONLY PART OF THE STORY* (EDWIN H. COLBERT). A CAMERA OBSCURA REPRODUCES A PA GEOLOGIC MAP. THE SPLITTING OF MARINE BEDS. ERODED OUT. DIAGRAM SHOWING EUSTATIC MOVEMENT—RISE AND FALL OF SEA LEVEL OF 100 FEET IN 400,000 YEARS. EPE GENIC SINKING. *IT IS IN THE MUSEUM-URGE THAT OUR LEARNING SHOWS A FACE TURNED TOWARDS THE THINGS OF DEATH* (ERNST JUNGER). A HEAP BETWEEN FORGETFULN AND MEMORY. A RECONSTRUCTION OF AN EARLY CARBONIFEROUS (MISSISSIPPIAN) SEA AS IN NORTHWESTERN INDIANA. (THE SMITHSONIAN INSTITUTION). *IN THESE NATURA TRAPS THEY DIED, AND WERE EVENTUALLY BURIED...* (MARSHALL KAY AND EDWIN H. COLBERT). EFFLUVIUMS OF GEOLOGIC TIME. SLEEPING AMPHIBIANS DREAM NOTHING. A TECTONIC MAP OF THE CANADIAN APPALACHIAN REGION. UNSTABLE CONTINENTS. SEDIMENTS ON THE EAST SHORE OF THE BAY OF FUNDY AT JOGGINS, NOVA SCOTIA. SOUN WINDS. ARTIFICIAL LIGHT. AQUATINT ENGRAVINGS OF FOSSILS.

DEVONIAN

HUGE QUANTITIES OF PEBBLES, SAND AND MUD. DEVONSHIRE. *...APPARENTLY THE WRECK OF SOME GIGANTIC STRUCTURES OF ART...* (POE). THE WORLD THROUGH THE EYES A DEVONIAN LUNG FISH. POLISHED PIECES OF SILICA ROCK. FUNGAL THREADS AND RESTING SPORES. SUNSHINE ON THE PETRIFIED DEPOSITS. A LAKE LOST UNDER THE DEBR SPIRAL SHELLS. FOSSIL FOREST EXHIBITED IN A DIORAMA IN THE NEW YORK STATE MUSEUM. EOSPERMATOPERIS IS PROMINENT. MOSS. ANTERIOR MEMORIES. LAYER UPON LAYER. *UNLESS THE INFORMATION GAINED FROM THE COLLECTING AND PREPARING OF FOSSILS IS MADE AVAILABLE THROUGH THE PRINTED PAGE, ASSEMBLAGE SPECIMENS ESSENTIALLY A PILE OF MEANINGLESS JUNK* (EDWIN H. COLBERT). A DOUBT WHICH TURNS TO NEGATION, BUT FEIGNED NEGATION. DENDROIDS AND GRAPTOLITES DISAPPEA MORE LIME ACCUMULATES. A MODEL SHOWING HOW A VOLCANO ERUPTS. TREE FERNS DECAY INTO FLORA CEMETERIES. RECONSTRUCTION OF LATE DEVONIAN SEA BOTTOM WESTERN NEW YORK; DIORAMA (CHICAGO NATURAL HISTORY MUSEUM), A FAINT ILLUSIONISTIC BACKDROP EXTENDS A FALSE UNDERSEA LANDSCAPE. JAWLESS FISHES IN GR WATER. A GAZE EQUAL TO SPACE. THE BURDEN OF MILLIONS OF YEARS. ONLY THE GREAT HORIZONS OF THE ABSENT WORLD REFLECT IN THE MIND. THE POTHOLES OF A WEA IMAGINATION. MIRAGES ON THE VOLCANIC PLAINS. FOSSILIFEROUS ROCKS CRUMBLE IN MAINE. QUARTZ IN THE BRAIN. **ACADIAN DISTURBANCE.** THE AGE OF FISH. THE AGE O SNAILS. THE AGE OF CALMS. MILLIONS OF YEARS PAST. A FAMOUS FOSSIL DELTA IN THE CATSKILLS. SPIDERS AND WINGLESS INSECTS ALSO ARRIVED. UPLIFT IN THE MIDST OF MOST COMPLETE BLINDNESS. AN UNKEMPT CEMETERY OF ANNULARIA. THE DEVONIAN PERIOD IS A SUCCESSION OF LOSSES. AT OUTSKIRTS OF MUD. SPASMODIC CHRONOLOGY SUBSTRATA. EXHIBITION OF PLACODERMS.

SILURIAN

SEAWEEDS WITH LIMY SKELETONS. SUBMARINE TROUGHS DEEPEN. STONE-LILIES. BRIGHT COLORED POLYPS SPREAD. NEW MOUNTAIN RANGES APPEAR, THEIR NAMES ARE IMMATERIAL—DULL DESCRIPTIONS IN A BOOK. THESE SILURIAN TERRAINS EXIST BY CONCEALMENT, NOTHING BUT BLAND REFERENCES TO A VAGUE SET OF GEOLOGIC FORMATIONS. THE EARTH DIPS OUT OF SIGHT, ALL THE ACTIVITY IS LOST UNDER THE LIMPID OCEANS. ALL IS SEDIMENTATION AND AIMLESS EFFORT. THE SILURIAN NIGHT CASTS THE NINE FOOT SEA SCORPIONS INTO TOTAL DARKNESS, WHERE THEY LIVED MAINLY IN ESTUARIES AND COASTAL LAGOONS. SILENCE, DARKNESS, AND DISMAL PERFE TION. *I CANNOT DISCOVER THIS* OCEANIC *FEELING IN MYSELF* (FREUD). MASSIVE HEAPS OF SKELETONS CAPABLE OF WITHSTANDING BUFFETING IN ROUGH WATER. CORAL BREAKDOWN. FLOATING GRAPTOLITES. MANY SANK TO THE BOTTOM. SHALE. 400 MILLION YEARS AGO. PERIODIC ALTERNATION OF THE LEVEL OF LAND AND SEA. LESS VOLC ACTIVITY THAN IN ORDOVICIAN TIMES. UNDERSEA MOUNTAINS, RAVINES AND VALLEYS. CRUSTAL MOVEMENT. TRAVERTINE. SWAMP TREASURE. DRAWINGS OF SINKHOLES AI CRATERS. THINKING OF THE TUNDRA NEAR HUDSON BAY. THE *MID-CONTINENT* IS A RELIEF OF FEATURELESS FEATURES. OVER THE SCAFFOLDING OF THE MARATHON TROUG SODIUM CHLORIDE IN THE EYES. ONLY TWO DIMENSIONS EXIST. HOURS AND DAYS ON LLANORIA. YESTERDAYS ARE DEFORMED. MONOCHROME MAPS. NO RECORD OF LIFE ON THE LAND. FUTURE TIME UNDER SALTY SEAS. RECREATING CRINOIDS. HAZE. PERIODS OF ABANDONMENT. THE LIMITS OF THE MICHIGAN BASIN. A VAST AND HIDEOUS CONTIN

RENIG AND SKIDDAW SLATES. SPONGES WITH A FRAMEWORK OF SILICA, THROVE AT VARIOUS DEPTHS. VOLCANOES ERUPTED UNDER THE OCEAN. PAINTING SHOWING AN RDOVICIAN SOUTH DAKOTA. THE MUD GROVELLING; AMPYX. FORGOTTEN PILES OF SANDSTONE. OCEAN FLOOR COLLAPSES. ROTTEN VEGETATION DECOMPOSES INTO ROTTEN OCK. MAGNESIA. NO LONGER A FAITHFUL IMITATION OF ETERNITY, BUT A CONSTANT STATE OF EROSION. THREE STAGES IN THE DEVELOPMENT OF A THRUST FAULT, SHOWN A LINE DRAWING. DISLOCATED BY A MOLTEN CONDITION. THE BURIAL OF THE BRYOZOA. *FOR WHERE THINGS ARE DISCERNED AT INTERVALS OF TIME, THERE ARE FALSE-OODS; AND WHERE THINGS HAVE AN ORIGIN IN TIME, THERE ERRORS ARISE* (ASCLEPIUS). DECREPITUDE AND DELIQUESCENCE. BOTCHED FABRICATIONS ON THE FOGGY NDSCAPE. PLANKTONIC CALCAREOUS ORGANISMS FALLING. CAREFULLY LABELED SPECIMENS ARE FILED AWAY. A TEDIOUS PART OF FOSSIL COLLECTING TAKES PLACE DER THE HOT SUN IN THE BAD LANDS. QUICKSAND. DIAGRAM WITH ORANGE BACKGROUND SHOWS HOW ROCK RESISTANCE INFLUENCES TOPOGRAPHY. A SORT OF JIGSAW ZZLE FOR GEOLOGISTS. X-RAY VIEW OF AN OIL WELL. A LIGHT BLUE AND TAN MAP SHOWS ORDOVICIAN LAND SHAPES. OVERTURNED ANTICLINE IS A TYPE OF STRATA FOLD ANDERING WATERS. **GEOLOGY** *EXEMPLIFIES A NEW IDEA IN PAPERBACK PUBLISHING—A SERIES OF OUTSTANDING BOOKS, ILLUSTRATED THROUGHOUT IN FULL COLOR.* LAKE NNEVILLE HAS SHRUNK. VAST STRETCHES OF SALT FLATS. EVAPORATION. *OLD FAITHFUL*—YELLOWSTONE'S FAVORITE GEYSER. LOCCOLITHS. PROFILE OF A SHIELD VOLCANO: AWAII'S MAUNA LOA. PTOLEMY GUESSED THAT THE EARTH IS A BALL. OUACHITA. BLUE INK ON TEXAS. CANADIAN SHIELD SINKS. THE OZARK DOME PAINTED ON A MAP AS A UR. IMPRESSIONISTIC DRAWINGS OF THE ARCTIC.

NDWANALAND? REEFS FORMED *CORALLINE SPONGES* (ARCHAEOCYATHINES). THE GREAT THICKNESS OF BLACK MUD. THE ROMAN NAME FOR WALES. BOTTOM LIVING FORMS RE BLIND. PAXADOXIDES SHOWN IN A LINE-CUT ARE SAID TO BE *HALF NATURAL SIZE.* **MUNDUS SUBTERRANEUS.** PUTTING FACTS TOGETHER LIKE A JIGSAW PUZZLE. LANGUAGE D SOIL BLOW AWAY. FLOODS. BILATERALLY SYMMETRICAL CREATURES. AN ILLUSTRATION OF THE AUSTRAL SEA (BLUE ON GRAY DOTS). A FRAGMENTARY THEORY. EXCAVA- ONS AT DINOSAUR NATIONAL MONUMENT IN NORTHEASTERN UTAH. PALAEOZOIC ERA SHOWN ON AN OLD CHART. LITTLE IS KNOWN ABOUT THE LAND AREAS. THEY PLOUGHED EIR WAY THROUGH THE MUD. WORMS AND MORE WORMS TURN INTO GAS. SEA BUTTERFLIES FALL INTO A NAMELESS OCEAN. PLASTER RESTORATIONS COLLECTING DUST IN E MUSEUM OF NATURAL HISTORY. THE TRACKS OF TRILOBITES HARDEN INTO FOSSILS. ACCUMULATIONS OF WASTE ON THE SEA BOTTOMS. JELLY-FISH BAKING UNDER THE SUN. GESTIVE SYSTEMS SHOWN IN DIAGRAMS. *...A TENDENCY TO AMORPHOUSNESS...* (HEINRICH WOLFFLIN). *...SCABBY TOPOGRAPHY ON SOLFATARA PLATEAU* (C. MAX BAUER). MAY VE LOOKED LIKE THE PLANET VENUS. LIMP-LOOKING CRUSTACEANS, DYING BY THE MILLIONS. *WILL YOU FOLLOW ME AS FAR AS THE SARGASSO SEA?* (GIORGIO DE CHIRICO). NGLOMERATE THOUGHTS. MOLLUSCA. BREAKING APART INTO PARTICLES. SOMETHING FLOWING BETWEEN THE CARIBBEAN AND NEWFOUNDLAND. THE EQUATOR OVER NEW EXICO MADE OF DOTS AND DASHES. (PORIFERA). BELTS OF SCATTERED ISLANDS. LLANORIA SOUTH OF LOUISIANNA. MOUNTAINS OF JELLY FISH. THE DIMENSIONS OF AN KNOWN SLIME. LIME-SECRETING COLLENIA. A GLOBE SHOWING THE APPALACHIAN TROUGH. GALLERIES FULL OF ODD NAMES AND MODELS. CLOUDS MADE OF PAPER. A DRAW- G OF CASCADIA DRAWN PARALLEL TO THE PACIFIC COAST. A GUIDE TO GRIT.

EMORY AT THE CHTHONIC LEVEL. FLOATING ON SOFT MUDS NEAR THE BLIND RIVER. PINK FOSSILS. OBSCURE TRACES OF LIFE. HALF TONE PICTURES OF STRATIFIED ROCKS. ECONSTRUCTIONS OF SANDSTONES IN SQUARE GLASS CASES. HOT WATER. RIDDLE OF THE SEDIMENTS. LOST IN THE ENCYCLOPEDIA BRITANNICA. BEACHED. BOILING, BUBBLING ONTINENTS. PHOTOGRAPH OF BANDED RED CHERT OR JASPER IN THE SOUDAN MINNESOTA (MINNESOTA GEOLOGICAL SURVEY). A GRAFT SHOWING THE CORRELATION OF THE UCCESSIONS OF ROCK UNITS IN SEVERAL DISTRICTS. *IGNEOUS* MEANING FIRE. *WE LIVE AMID THE WRECK OF FORMER WORLDS* (JEROME WYCHOFF, **OUR CHANGING EARTH HROUGH THE AGES**—FULLY ILLUSTRATED WITH PHOTOGRAPHS AND PAINTINGS). THIS PERIOD IS LOSING ITSELF IN SAND AND PAGES. THE REGION BEGINS TO DISSIPATE. AN ERIAL PHOTO SHOWING THE DRIFT OF LAVA. SOME THOUGHTS ARE SINKING INTO THE CONGLOMERATE. LOGAN PASS IN GLACIER NATIONAL PARK IS MADE OF CRUSTAL BLOCKS. HE AGE OF POTASSIUM-ARGON. GEOLOGICAL GHOSTS ON THE PAGES OF A BOOK ON VIRUSES. ANIMALS WITHOUT BACKBONES TURN INTO STONE. *IF ONLY THE GEOLOGISTS OULD LET ME ALONE, I COULD DO VERY WELL, BUT THOSE DREADFUL HAMMERS* (JOHN RUSKIN). GRAPHITE (A CRYSTALLINE TYPE OF CARBON). SLIMY DAYS. STEAMING EYSER BASINS (NOBODY'S YELLOWSTONE). COUNTERFEIT ALGAE IN THE MUSEUM. BURROWS IN A MOUNTAIN OF CORRUPTION. *...THE QUEER FLOATING BASKET-LIKE VARIETY...* CHARLES R. KNIGHT). HEAPS OF CARBONATE LIME. POURING TONS OF MINERAL MATTER INTO A LAKE. IMITATION GRANITE. LAYERS OF OUT-DATED MAPS. XENUSION. PETRIFIED CUM ON DISPLAY. MAP OF THE MISSING SEA. EXTINCT SPONGE-LIKE THINGS. STEAM. CHARTS SHOWING CLAY FORMATIONS. THE PILING UP OF DEBRIS. *...FUTILE AND STUPID TAGNATION...* (HENRY ADAMS). STALE TIME. ONE-CELLED NOTHINGS. ABSENCE OF OXYGEN.

> She took one or two of them down and turned the pages over, trying to persuade herself she was reading them. But the meanings of words seemed to dart away from her like a shoal of minnows as she advanced upon them, and she felt more uneasy still.
>
> Michael Frayn, *Against Entropy*

Ad Reinhardt: *"The Four Museums are the Four Mirrors"*

In the illusory babels of language, an artist might advance specifically to get lost, and to intoxicate himself in dizzying syntaxes, seeking odd intersections of meaning, strange corridors of history, unexpected echoes, unknown humors, or voids of knowledge . . . but this quest is risky, full of bottomless fictions and endless architectures and counter-architectures . . . at the end, if there is an end, are perhaps only meaningless reverberations. The following is a mirror structure built of macro and micro orders, reflections, critical Laputans, and dangerous stairways of words, a shaky edifice of fictions that hangs over inverse syntactical arrangements . . . coherences that vanish into quasiexactitudes and sublunary and translunary principles. Here language "covers" rather than "discovers" its sites and situations. Here language "closes" rather than "discloses" doors to utilitarian interpretations and explanations. The language of the artists and critics referred to in this article becomes paradigmatic reflections in a looking-glass babel that is fabricated according to Pascal's remark, "Nature is an infinite sphere, whose center is everywhere and whose circumference is nowhere." The entire article may be viewed as a variation on that much misused remark; or as a monstrous "museum" constructed out of multi-faceted surfaces that refer, not to one subject but to many subjects within a single building of words—a brick = a word, a sentence = a room, a paragraph = a floor of rooms, etc. Or *language becomes an infinite museum, whose center is everywhere and whose limits are nowhere.*

MARGINALIA AT THE CENTER: INFRA-CRITICISM

Dan Flavin deploys writing as a pure spectacle of attenuation. Flavin's autobiographical method is mutated into a synthetic reconstitution of memories, that brings to mind a vestigial history. "Now there were battered profiles of boxers with broken noses and Dido's pyre on a wall in Carthage, its passionate smoke piercing pious Aeneas' faithless heart outbound in the harbor below." (. . . *in daylight or cool white*, "Artforum," December 1965). Flavin's Carthage is an arsenal of expired metaphor and fevered reverie. His grandiloquent remembrances play on one's poetic sense with a mournful giddiness. In his sentence we find a disarming uselessness that echoes the outrages of *Salammbô*. "The walls were

covered with bronze scales; and in the midst, on a granite pedestal, stood the statue of the Kabiri called Aletes, the discoverer of the mines in Celtiberia. On the ground, at its base, and arranged in the form of a cross, lay broad gold shields and monstrous silver vases with closed necks, of extravagant shape and of no possible use. . . ." Flavin's writings like Flaubert's "vases" are of "no possible use." Here we have a chronic case of mental immobilization that results in leaden lyrics. Language falls toward its final dissolution like the sullen electricities of Flavin's "lights." His slapstick "letters to the editor" also call forth the assorted humors of Flaubert's *Bouvard et Pecuchet*—the quixotic autodidacts.

Carl Andre's writings bury the mind under rigorous incantatory arrange-

Announcement for Sol LeWitt's exhibition at the Dwan Gallery, Los Angeles, 1967.

SOL LEWITT DWAN GALLERY LOS ANGELES APRIL 1967

ONE SET OF NINE PIECES

The individual pieces are composed of a form set equally within another and centered. Using this premise as a guide no further design is necessary

The cube, square and variants on them are used as grammatical devices

These pieces should be made without regard for their appearance but to complete the variations that are pre-set

These pieces were made by Treitel and Gratz of New York Jan–March 1967

the basic measure is 28"—a three dimensional form using this measure not

There are two measurements used 28" & 81" All dimensions are one or the other (81" = 28"(3) − 1½(4)) 28" is less than the size of the observer who must look down to see it. 81" is higher than most people who must look up to see it entirely

all pieces are white

81"

This set is 21'5" square all 4 sets together would equal 50'10" (25' overall)

all pieces made of aluminum with baked enamel

In this set all pieces are open

Each individual piece of the nine is autonomous and complete All major permutations are accounted for within the set of 9. 4 sets of 9 complete the idea

The grid system is a convenience. It stabilizes the measurements and neutralizes space by treating it equally

Further variations are in complete sets of nine pieces each. This plan includes only set A. Set B is the same in all respects except the inside form of each piece is enclosed (solid order) while the outside form remains open. In Set C the inside form is open and the outside is closed. All forms are closed in Set D. All sets seen together represent the completion of the plan.

printed by Allograph Press new york

① INSIDE 28"×28" OUTSIDE 81"×81"
② INSIDE 28"×28"×28" OUTSIDE 81"×81"
③ INSIDE 28"×28"×81" OUTSIDE 81"×81"
④ INSIDE 28"×28" OUTSIDE 81"×81"×28"
⑤ INSIDE 28"×28"×28" OUTSIDE 81"×81"×28"
⑥ INSIDE 28"×28"×81" OUTSIDE 81"×81"×28"
⑦ INSIDE 28"×28" OUTSIDE 81"×81"×81"
⑧ INSIDE 28"×28"×28" OUTSIDE 81"×81"×81"
⑨ INSIDE 28"×28"×81" OUTSIDE 81"×81"×81"

ments. Such a method smothers any reference to anything other than the words. Thoughts are crushed into a rubble of syncopated syllables. Reason becomes a powder of vowels and consonants. His words hold together without any sonority. Andre doesn't practice a "dialectical materialism," but rather a "metaphorical materialism." The apparent sameness and toneless ordering of Andre's poems conceals a radical disorientation of grammar. Paradoxically his "words" are charged with all the complication of oxymoron and hyperbole. Each poem is a "grave," so to speak, for his metaphors. Semantics are driven out of his language in order to avoid meaning.

Robert Morris enjoys putting sham "mistakes" into his language systems. His dummy *File* for example contains a special category called "mistakes." At times, the artist admits it is difficult to tell a real mistake from a false mistake. Nevertheless, Morris likes to track down the "irrelevant" and then forget it as quickly as possible. Actually, he can hardly remember doing the *File*. Yet, he must have derived some kind of pleasure from preserving those tedious moments, those minute events, that others call "living." He works from memory, which is strange when you consider he has nothing to remember. Unlike the elephant, the artist is one who always forgets.

Donald Judd at one time wrote a descriptive criticism that described "specific objects." When he wrote about Lee Bontecou, his descriptions became a language full of holes. "The black hole does not allude to a black hole," says Judd, "it is one." (*Arts*, April 1965.) In that article Judd brings into focus the structure of his own notion of "the general and the specific" by defining the "central hole" and "periphery" of her "conic scheme." Let us equate *central* with *specific*, and *general* with *periphery*. Although Judd is "no longer interested in voids," he does seem interested in blank surfaces, which are in effect the opposite of voids. Judd brings an "abyss"[1] into the very material of the thing he describes when he says: "The image is an object, a grim, abyssal one." The paradox between the specific and the general is also abyssal. Judd's syntax is abyssal—it is a language that ebbs from the mind into an ocean of words. A brooding depth of gleaming surfaces—placid but dismal.

Sol LeWitt is very much aware of the traps and pitfalls of language, and as a result is also concerned with ennervating "concepts" of paradox. Everything LeWitt thinks, writes, or has made is inconsistent and contradictory. The "original idea" of his art is "lost in a mess of drawings, figurings, and other ideas." Nothing is where it seems to be. His concepts are prisons devoid of reason. The information on his announcement for his show (Dwan Gallery, Los Angeles, April 1967) is an indication of a self-destroying logic. He submerges the "grid plan" of his show under a deluge of simulated handwritten data. The grid fades under the oppressive weight of "sepia" handwriting. It's like getting words caught in your eyes.

Ad Reinhardt's *Chronology* (*Ad Reinhardt—Paintings* by Lucy R. Lippard) is somber substitute for a loss of confidence in wisdom—it is a register of laugh-

ter without motive, as well as being a history of non-sense. Behind the "facts" of his life run the ludicrous events of hazard and destruction. A series of fixed incidents in the dumps of time. "1936 Civil War in Spain." "1961 Bay of Pigs fiasco." "1964 China explodes atomic bomb." Along with the inchoate, calamitous remains of those dead headlines, runs a dry humor that breaks into hilarious personal memories. Everything in this *Chronology* is transparent and intangible, and moves from semblance to semblance, in order to disclose the final nullity. "1966 One hundred twenty paintings at Jewish Museum." Reinhardt's *Chronology* follows a chain of non-happenings—its order appears to be born of a doleful tedium that originates in the unfathomable ground of farce. This dualistic history records itself on the tautologies of the private and the public. Here is a negative knowledge that enshrouds itself in the remote regions of that intricate language—the joke.

Peter Hutchinson, author of "Is There Life on Earth?" (*Art in America*, Fall 1966), uses the discards of last year's future in order to define today's present. His method is highly artificial and is composed of paralyzed quotes, listless theories, and bland irony. His abandoned planets maintain unthinkable "cultures," and have tasteless "tastes." In "Mannerism in the Abstract" (*Art and Artists*, September 1966) Hutchinson lets us know about "probabilities, contingencies, chances, and cosmic breakdown." "Scientism" is shown to be actually a kind of Mannerist science full of obvious disguises and false bottoms. "Topology surely mocks plane geometry," says Hutchinson. But actually his language usage deliberately mocks his own meaning, so that nothing is left but a gratuitous syntactical *device*. His writing is marvelously "inauthentic." The complexity and richness of Hutchinson's method starts with science fiction clichés, and scientistic conservations and ends in an extraordinary esthetic structure. To paraphrase Nathalie Sarraute on Flaubert, "Here Hutchinson's defects become virtues."

> The attraction of the world outside awakens so energetically in
> me the expansive force that I dilate without limit . . . absorbed,
> lost in multiple curiosity, in the infinity of erudition and the
> inexhaustible detail of a peripheral world.
> Henri-Frédéric Amiel,
> *Journal*, 1854

Dan Graham is also very much aware of the fringes of communication. And it is not surprising that one of his favorite authors is Robert Pinget. Graham responds to language as though he lived in it. He has a way of isolating segments of unreliable information into compact masses of fugitive meaning. One such mass of meanings he has disinterred from the tombic art of Carl Andre. Some segments from *Carl Andre* (unpublished list) are as follows: "frothing at the mouth and from watertaps"; "misconceptions and canned laughter"; "difficulty in grasping." This is the kind of depraved metaphor that Andre tries to bury in his "blocks of words." Graham discloses the metaphors that everyone wants to escape.

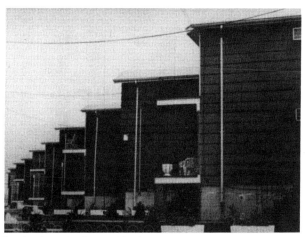

Row housing project, Bayonne, New Jersey. Photo by Dan Graham.

Like some of the other artists Graham can "read" the language of buildings. ("Homes for America," *Arts*, December–January 1967.) The "block houses" of the post-war suburbs communicate their "'dead' land areas" or "sites" in the manner of a linguistic permutation. Andre Martinet writes, "Buildings are intended to serve as a protection . . ."—the same is true of artists' writings. Each syntax is a "lightly constructed 'shell'" or set of linguistic surfaces that surround the artist's unknown motives. The reading of both buildings and grammars enables the artist to avoid out of date appeals to "function" or "utilitarianism."

Andy Warhol allows himself to be "interrogated"; he seems too tired to actually grip a pencil, or punch a typewriter. He allows himself to be *beaten* with "questions" by his poet-friend Gerard Malanga. Words for Warhol become something like surrogate torture devices. His language syntax is infused with a fake sadomasochism. In an interview he is lashed by Malanga's questions (*Arts*, Vol. 41, No. 4, 1967):

Q: Are all the people degenerates in the movie?

A: Not all the people—99.9% of them.

Serge Garvronsky writing in *Cahiers du Cinema*, No. 10, points out that Warhol employs a kind of self-inventing dialogue in his films, that resembles the sub-dialogue of Nathalie Sarraute. Garvronsky points out the "dis-synchronized talk," "monosyllabic English," and other "tropistic" effects. The language has no force, it's not very convincing—all the pornographic preoccupations collapse into verbal deposits, or what is called in communication theory "degenerative information." Warhol's syntax forces an artifice of sadomasochism that mimics its supposed "reality." Even his surfaces destroy themselves. In *Conversation and Sub-conversation 1956* by Nathalie Sarraute we find out something about "pointless remarks," and dialogue masses, that shape our experience "the slightest intonations and inflections of voice," that become maps of meaning or antimeaning. Said Bosley Crowther (*New York Times*, July 11, 1967) in a review

of *My Hustler*, "I would say that 'The Endless Conversations' would be a better title for this fetid beach-boy film."

Edward Ruscha (alias Eddie Russia) collaborated with Mason Williams and Patrick Blackwell on a book, *Royal Road Test*, that appears to be about the sad fate of a Royal (Model "X") typewriter. Here is no Warholian sloth, but rather a kind of dispassionate fury. The book begins on a note of counterfeit Russian nihilism, "It was too directly bound to its own anguish to be anything other than a cry of negation; carrying within itself the seeds of its own destruction." A record of the deed is as follows:

Date:	Sunday, August 21, 1966
Time:	5:07 p.m.
Place:	U.S. Highway 91 (interstate Highway 15), traveling south-southwest approximately 122 miles southwest of Las Vegas, Nevada
Weather:	Perfect
Speed:	90 m.p.h.

The typewriter was thrown from a 1963 Buick window by "thrower" Mason Williams. The "strewn wreckage" was labeled and photographed for the book.

INVERSE MEANINGS—THE PARADOXES OF CRITICAL UNDERSTANDING

> Modern art, like modern science, can establish complementary relations with discredited fictional systems; as Newtonian mechanics is to quantum mechanics, so *King Lear* is to *Endgame*.
>
> Frank Kermode,
> *The Sense of Ending*

> How can anyone believe that a given work is an object independent of the psyche and personal history of the critic studying it, with regards to which he enjoys a sort of extraterritorial status?
>
> Roland Barthes,
> *Criticism as Language*

> Materialism. Utter the word with horror, stressing each syllable.
>
> Gustave Flaubert,
> *The Dictionary of Accepted Ideas*

When the word "fiction" is used, most of us think of literature, and practically never of fictions in a general sense. The rational notion of "realism," it seems, has prevented esthetics from coming to terms with the place of fiction in all the arts. Realism does not draw from the direct evidence of the mind, but rather refers back to "naturalistic expressiveness" or "slices of life." This happens when art competes with life, and esthetics is replaced by rational imperatives.

The fictional betrays its privileged position when it abdicates to a mindless "realism." The status of fiction has vanished into the myth of the fact. It is thought that facts have a greater reality than fiction—that "science fiction" through the myth of progress becomes "science fact." Fiction is not believed to be a part of the world. Rationalism confines fiction to literary categories in order to protect its own interests or systems of knowledge. The rationalist, in order to maintain his realistic systems, only ascribes "primary qualities" to the world.

The "materialist" Carl Andre calls his work "a flight from the mind." Andre says that his "poems" and "sculpture" have no mental or secondary qualities, they are to him solidly "material." Yet, paradoxically, Lucy Lippard writing in the *The New York Times*, June 4, 1967, suggests that Andre's sculpture in a show at the Bykert Gallery is "rebelliously romantic" because of "nuance" and "surface effects." One person's "materialism" becomes another person's "romanticism." I would venture to assert at this point, that both Miss Lippard's "romanticism" and Andre's "materialism" are the same thing. Both views refer to private states of consciousness that are interchangeable.

Romanticism is an older philosophical fiction than materialism. Its artifices are to a greater degree more decadent than the inventions of materialism, yet at the same time it is more familiar and not as threatening to the myths of fact as materialism. For some people the mere mention of the word "materialism" evokes hordes of demonic forces. Romanticism and materialism if viewed with two-dimensional clarity have a transparence and directness about them that is highly fictive. Peter Brook recognized this esthetic in Robbe-Grillet. Says Brook, "If Robbe-Grillet has sought to destroy the 'romantic heart of things,' there is a sense in which he is constantly fascinated by the romanticism of surfaces, a preoccupation especially noticeable in the films *Marienbad* and *L'Immortelle*, and quite explicit in his new novel, *La Maison de rendezvous*." (*Partisan Review*, Winter 1967.) The same is true of "materialism" when it becomes the esthetic motive of the artist. The reality of materialism is no more real than that of romanticism. In a sense, it becomes evident that today's materialism and romanticism share similar "surfaces." The romanticism of the 60s is a concern for the surfaces of materialism, and both are fictions in the chance minds of the people who perceive them. If scientism isn't being used or misused, then what I will call "philosophism" is. Philosophism confuses realism with esthetics, and defines art apart from any understanding of the artifices of the mind and things.

Much modern art is trapped in temporality, because it is unconscious of *time* as a "mental structure" or abstract support. The temporality of time began to be imposed on art in the 18th and 19th centuries with the rise of realism in painting and novel writing. Novels cease being fictions, criticism condemns "humoral" categories, and "nature" acts as the prevailing panacea. The time consciousness of that period gave rise to thinking in terms of Renaissance history. Says Everett Ellin in a fascinating article "Museums as Media" (ICA *Bul-*

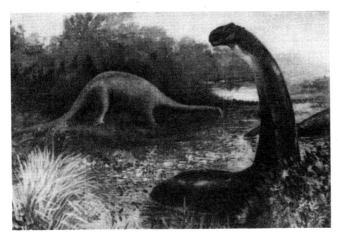

Giant post card by Dexter Press, Inc., West Nyack, N.Y., depicting the Brontosaurus (from a painting by Charles R. Knight). (Note impressionistic treatment of water.) The American Museum of Natural History, New York.

letin, May 1967), "The museum, a creation of the 19th century, quite naturally adopted the popular mode of the Renaissance for its content." Time had yet to extend into the distant future (post-history) or into the distant past (pre-history)—nobody much thought about "flying saucers" or an Age of Dinosaurs. Both pre- and post-history are part of the same time consciousness, and they exist without any reference to Renaissance history. I had a slight awareness of the sameness of pre- and post-history, when I wrote in "Entropy and the New Monuments" (*Artforum,* June 1966), "This sense of extreme past and future has its partial origin in the Museum of Natural History; there the 'cave man' and the 'space man' may be seen under one roof." It didn't occur to me then, that the "meanings" in the Museum of Natural History avoided any reference to the Renaissance, yet it does show "art" from the Aztec and American Indian periods—are those periods any more or less "natural" than the Renaissance? I think not—because there is nothing "natural" about the Museum of Natural History. "Nature" is simply another 18th- and 19th-century fiction. Says E. E. Cummings, "Natural history museums are made by fools unlike me. But only God can stuff a tree. . . ." ("Letter to Ezra Pound," *Paris Review,* Fall 1966.) The "past-nature" of the Renaissance finds its "future-nature" in Modernism—both are founded on realism.

RESTORATIONS OF PREHISTORY

The prehistory one finds in the Museum of Natural History is fugitive and uncertain. It is reconstructed from "Epochs" and "Periods" that no man has ever witnessed and based on the remains of "animated beings" from the Trilobites to Triceratops. We vaguely know about them through Walt Disney and Sinclair Oil—they are the dinosaurs. One of the best "recreators" of this "dinosaurism" is Charles R. Knight. In many ways he excells the Pop artists, but

he comes closest to Claes Oldenburg, at least in terms of scale. Sinclair Oil ought to commission Oldenburg to make "the mating habits of the Brontosaurus" for children's sex education. Knight's art is never seen in museums outside of the M.N.H., because it doesn't fit in with the contrived "art-histories" of Modernism or the Renaissance.

Knight is also an artist who writes. In *Life Through the Ages*, a book of 28 prehistoric "time" restorations, Knight can be seen as a combination Edouard Manet and Eric Temple Bell (the professor of Mathematics who wrote science fiction for *Wonder Stories Magazine*). Bell in *The Greatest Adventure* describes "brutes" that are "like no prehistoric monster known to science." These monsters are "piled five and six deep" on a frozen beach in Antarctica. "They are like bad copies, botched imitations if you like of those huge brutes whose bones we chisel out of the rocks from Wyoming to Patagonia. Nature must have been drunk, drugged or asleep when she allowed these aborted beasts to mature. Every last one of them is a freak." It is hard to say Knight's monsters are "bad copies," yet there is something odd and displaced about both his writings and art. He refers to his writings as "captions," and to his art as "the more striking forms of Prehistoric times." The following quote is from Knight's "The Carboniferous or Coal Period"—"Great sprawling salamander-like creatures such as Eryops are typical of the period. No doubt these and many other species still passed their earlier life stages in the water. They were stupid, smooth-skinned monsters some six feet long, with wide tooth-filled jaws and an enormous gape which enabled them to swallow their food at a single gulp." He also has a way of evoking the prehistoric landscape—"Rancho La Brea— California Pitch Pools": "Peaceful as the place looks now, tragedy, both dark and terrible, long hung about its gloomy depths." The corollary of Knight's artifice is immobilization. This heavy prehistoric time extends to the landscape: "slime-covered morasses" and "It was an era of swamps." Death is suggested in the ever present petrifaction of forests and creatures; a predilection for the oppressive and grim marks everything he writes and draws. One senses an enormous amorphous struggle between the stable and the unstable; a fusion of action and inertia symbolizing a kind of cartoon vision of the cosmos. Violence and destruction are intimately associated with this type of carnivorous evolutionism. Nothing seems to escape annihilation—for the Brontosaurus, "starvation is their greatest bugaboo." A kind of goofiness haunts these "big bulked and small-brained" saurians. Tyrannosaurus Rex is considered by Knight to be "just an enormous eating machine." These "sinister beings" seem like reformulated symbols of total or original Evil. The battle between the Tyrannosaurus and Stegosaurus in Walt Disney's *Fantasia* set to the music of *The Rite of Spring* evoked a two-dimensional spectacular death-struggle, quite in keeping with the entire cast of preposterous reptilian "machines." No doubt, Disney at some point copied his dinosaurs from Knight, just as Sinclair Oil must have copied directly from Disney for their "Dino-the-Dinosaur."

The Art World was created in 4 Days in 4 Sections, 40 years ago, and originally 4004 B.C. Today minor artists have 400 Disciples and more favored mediocre Artists have 44,000 Devotees approximately.

Ad Reinhardt,
A Portend of the Artist as a Yhung Mandala

The immensity of geologic time is so great that it is difficult for human minds to grasp readily the reality of its extent. It is almost as if one were to try to understand infinity.

Edwin H. Colbert,
The Dinosaur Book

The word "teratology" or "teratoid" when not being used by biology and medicine in an "organic" way has a meaning that has to do with marvels, portends, monsters, mutations and prodigious things (Greek: teras, teratos = a wonder). The word teratoid like the word dinosaur suggests extraordinary scale, immense regions, and infinite quantity. If we accept Ad Reinhardt's "portend," the Art World is both a monster and a marvel, and if we extend the meaning of the word: a dinosaur (terrible lizard)—*a lizard with its tail in its mouth.* Perhaps, that is not "abstract" enough for some of the "devotees." Perhaps they would prefer the "circular earth mound" by Robert Morris or even "a target" by Kenneth Noland. Organic word meanings, when applied to abstract or mental structures have a way of returning art to the biological condition of naturalism and realism. Science has claimed the word teratology and related it to disease. The "marvelous" meaning of that word has to be brought to consciousness again.

Let us now examine Reinhardt's "Portend," and take this "Joke" seriously. In a sense Reinhardt's teratological Portend seems to approach some kind of pure classicism, except that where the classicist sees the necessary and true concept of pure cosmic order, Reinhardt sees it as a grotesque decoy. Near a label NATURALIST-EXPRESSIONIST-CLASSICISM we see "an angel" and "a devil"—and a prehistoric Pterodactyl; Knight calls it "another kind of flying mechanism." Reinhardt treats the Pterodactyl as an atemporal creature belonging to the same order as devils and angels. The concrete reptile-bird of the Jurassic Period is displaced from its place in the "Synoptic Table of the Amphibia and Reptilia" of the "subclass Diapsida," and transformed by Reinhardt into a demon or possibly an Aeon. The rim of Reinhardt's Portend becomes an ill-defined set of schemes, entities half abstract, half concrete, half impersonal fragments of time or de-spatialized oddities and monsters, a Renaissance dinosaurism hypostatized by a fictional ring of time—something halfway between the real and the symbolic. This part of the Portend is dominated by a humorous nostalgia for a past that never existed—past history becomes a comic hell. Atemporal monsters or teratoids are mixed in a precise, yet totally

inorganic way. Reinhardt isn't doing what so many "natural expressive" artists do—he doesn't pretend to be honest. History breaks down into fabulous lies, that reveal nothing but copies of copies. There is no order outside of the mandala itself.

THE CENTER AND THE CIRCUMFERENCE

The center of Reinhardt's Joke is empty of monsters, a circle contains four sets of three squares that descend toward the middle vortex. It is an inversion of Pascal's statement, that "nature is an infinite sphere, whose center is everywhere and whose circumference is nowhere": instead with Reinhardt we get an Art World that is an infinite sphere, whose circumference is everywhere but whose center is nowhere. The teratological fringe or circumference alludes to a tumultuous circle of teeming memories from the Past—from that historical past one sees "nothing" at the middle. The finite present of the center annihilates itself in the presence of the infinite fringes. An appalling distance is established between past and present, but the mandala always engulfs the present order of things—ART AND GOVERNMENT/ART AND EDUCATION/ART AND NATURE/ART AND BUSINESS—are lost in a freakish grandeur that empties one's central gaze. Everything mad and grotesque on the outer edges encompasses the present "Art World" in an abysmal concatenation of Baals, Banshees, Beezleboobs, Zealots, Wretches, Toadies, all of which are transformed into horrors of more recent origin. From the central vortex, that looks like prophetic parody of "op art"—I can't think of anything more meaningless than that—to the rectangular margin of parodic wisdom— "Everybuddie understands the Songs of Birds and Picasso," one is aware of a conflict between center and perimeter. The excluded middle of this Joke plunges the mind into a simulated past and present without a future. The original and historical nightmare bordering the "void" destroys its own sanctuary. At the bottom of this well we see "nothing." The center is encompassed by "The Human Vegetable, The Human Machine, The Human Eye, The Human Animal"—a human "prison house of grandeur and glory," not unlike Edgar Allan Poe's *House of Usher*, or even more precisely his *A Descent into the Maelstrom*— "Upon the interior surface of a funnel vast in circumference, prodigious in depth." Poe's "Pit" (center) is defined by the swing of the "Pendulum" from side to side, thus defining the circumference. Reinhardt's "dark humor" resembles Poe's "sheeted memories of the past." Reinhardt maintains the same haunted mind that Poe did: "a dim-remembered story of the old time entombed."

THE MOVIES OF ROGER CORMAN AND NEGATIVE ETERNITIES

The films of Roger Corman are structured by an esthetic of atemporality, that relates to Reinhardt and Poe more than most visual artists working at this time. The grammar of Corman's films avoids the "organic substances" and life-forcing rationalism that fills so many realistic films with naturalistic meanings.

AD REINHARDT, *A Portend of the Artist as a Yhung Mandala*, 1955. Collage, 26 x 19".
One of a series of cartoons commissioned from Reinhardt by *Art News*, this appeared in the May 1956 issue.

His actors always appear vacant and transparent, more like robots than people—they simply move through a series of settings and places and define where they are by the artifice that surrounds them. This artifice is always signaled by a "tomb" or another *mise en scène* of deathlessness. For instance, the Great Pyramid at the beginning of *The Secret Invasion,* or the Funeral at the end of *The Wild Angels.* Duration is drained, and the networks of an infinite mind take over, turning the "location" of the film into "immeasurable but still definite distances" (Poe). Corman brings the infinite into the finite things and minds that he directs. The suburban sites in *The Wild Angels* appear with a "gleaming and ghastly radiance" (Poe) and seem not to exist at all except as spectral cinematic artifices. The menacing fictions of the terrain engulf the creatures that pass as actors. "Things" in a Corman movie seem to negate the very condition they are presented in. A parodic pattern is established by the conventionalized structure or plot-line. The actors as "characters" are not developed but rather buried under countless disguises. This is especially true of *The Secret Invasion,* where nobody seems to be anybody. Corman uses actors as though they were "angels" or "monsters" in a cosmos of dissimulation, and it is in that way that they relate to Reinhardt's world or cosmic view. Corman's sense of dissimulation shows us the peripheral shell of appearances in terms of some invisible set of rules, rather than by any "natural" or "realistic" inner motivation—his actors reflect the empty center.

SPECTRAL SUBURBS

Where have all the people gone today? Well, there's no need for you to be worried about all those people. You never see those people anyway.

The Grateful Dead,
Morning Dew (Dobson–Rose)

. . . dead streets of the inner suburbs, yellow under the sodium lights.

Michael Frayn,
Against Entropy

In 1954, when they announced the H-Bomb, only the kids were ready for it.

Kurt von Meier,
quoted in *Open City*

A dry wind blows hot and cold down from Chimborazo a soiled post card in the prop blue sky. Crab men peer out of abandoned quarries and slag heaps . . .

William S. Burroughs,
The Soft Machine

It seems that "the war babies," those born after 1937–38 were "Born Dead"—to use a motto favored by the Hell's Angels. The philosophism of "reality" ended some time after the bombs were dropped on Hiroshima and Nagasaki and the ovens cooled down. Cinematic "appearance" took over completely sometime in the late 50s. "Nature" falls into an *infinite series* of movie "stills"—we get what Marshall McLuhan calls "The Reel World."

Suburbia encompasses the large cities and dislocates the "country." Suburbia literally means a "city below"; it is a circular gulf between city and country—a place where buildings seem to sink away from one's vision—buildings fall back into sprawling babels or limbos. Every site glides away toward absence. An immense negative entity of formlessness displaces the center which is the city and swamps the country. From the worn down mountains of North New Jersey to postcard skylines of Manhattan, the prodigious variety of "housing projects" radiate into a vaporized world of cubes. The landscape is effaced into sidereal expanses and contractions. Los Angeles is all suburb, a pointless phenomenon which seems uninhabitable, and a place swarming with dematerialized distances. A pale copy of a bad movie. Edward Ruscha records this pointlessness in his *Every Building on the Sunset Strip*. All the buildings expire along a horizon broken at intervals by vacant lots, luminous avenues, and modernistic perspectives. The outdoor immateriality of such photographs contrasts with the pale but lurid indoors of Andy Warhol's movies. Dan Graham gains this "non-presence" and serial sense of distance in his suburban photos of forbidding sites. Exterior space gives way to the total vacuity of time. Time as a concrete aspect of mind mixed with things is attenuated into ever greater distances, that leave one fixed in a certain spot. Reality dissolves into leaden and incessant lattices of solid diminution. An effacement of the country and city abolishes space, but establishes enormous mental distances. What the artist seeks is coherence and order—not "truth," correct statements, or proofs. He seeks the fiction that reality will sooner or later imitate.

MAPSCAPES OR CARTOGRAPHIC SITES

In the deserts of the West some mangled Ruins of the Map lasted on, inhabited by Animals and Beggars; in the whole Country there are no other relics of the Disciplines of Geography.

Suarez Miranda, *Viajes de Varones Prudentes*,
Book Four, Chapter XLV, Lerida, 1658

. . . all the maps you have are of no use, all this work of discovery and surveying; you have to start off at random, like the first men on earth; you risk dying of hunger a few miles from the richest stores . . .

Michel Butor, *Degrees*

THE HUNTING OF THE SNARK

OCEAN-CHART.

Map by Lewis Carroll.

From *Theatrum Orbis Terrarum* of Orrelius (1570) to the "paint"-clogged maps of Jasper Johns, the map has exercised a fascination over the minds of artists. A cartography of uninhabitable places seems to be developing—complete with decoy diagrams, abstract grid systems made of stone and tape (Carl Andre and Sol LeWitt), and electronic "mosaic" photomaps from NASA. Gallery floors are being turned into collections of parallels and meridians. Andre in a show in the Spring of '67 at Dwan Gallery in California covered an entire floor with a "map" that people walked on—rectangular sunken "islands" were arranged in a regular order. Maps are becoming immense, heavy quadrangles, topographic limits that are emblems of perpetuity, interminable grid coordinates without Equators and Tropic Zones.

Lewis Carroll refers to this kind of abstract cartography in his *The Hunting of the Snark* (where a map contains "nothing") and in *Sylvie and Bruno Concluded* (where a map contains "everything"). The Bellman's map in the *Snark* reminds one of Jo Baer's paintings.

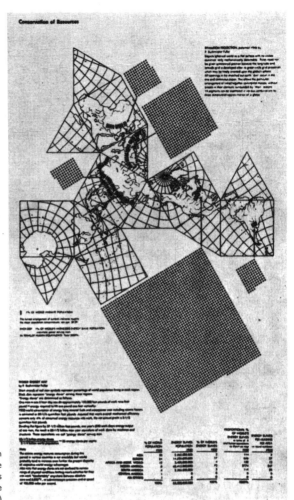

The *World Energy Map* pictured on a Dymaxion Projection. The man symbols represent the percentage of world population in each region. The black dots represent the percentage of "energy slaves" serving the regions. (First published in *Fortune*, February 1940.)

He had bought a large map representing the sea,
Without least vestige of land:
And the crew were much pleased when they found it to be
A map they could all understand.

Jo Baer's surfaces are certainly in keeping with the Captain's map which is not a "void," but "A perfect and absolute blank!" The opposite is the case, with the map in Carroll's *Sylvie*. In Chapter II, a German Professor tells how his country's cartographers experimented with larger and larger maps until they finally made one with a scale of a mile to a mile. One could very well see the Professor's explanation as a parable on the fate of painting since the 50s. Perhaps museums and galleries should start planning square mile interiors. The Professor said, "It has never been spread out, yet. The farmers objected: they said it would cover the whole country, and shut out the sunlight! So now we use the country itself, as its own map, and I assure you it does nearly as well." The *Bound Sphere Minus Lune* by Ruth Vollmer may be seen as a globe with

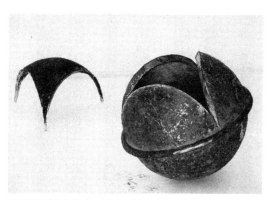

RUTH VOLLMER, *Bound Sphere Minus Lune.* Unique bronze cast, 7½″ diameter.

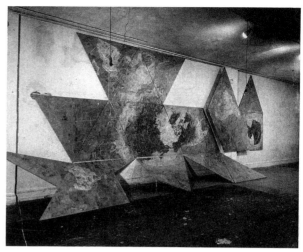

JASPER JOHNS, *Map* (based on Buckminster Fuller's *Dymaxion Airocean World*), 1967. Encaustic and collage/canvas, 186 x 396″.

a cut away Northern region. Three arcs in the shape of crescents intersect at the "bound" equator. The "lune" triangulation in this orb detaches itself and becomes secondary "sculpture."

> There are approximately 50 Panama Canals to a cubic mile and there are 317 MILLION cubic miles of ocean.
>
> R. Buckminster Fuller,
> *Nine Chains to the Moon*

R. Buckminster Fuller has developed a type of writing and original cartography, that not only is pragmatic and practical but also astonishing and teratological. His *Dymaxion Projection and World Energy Map* is a *Cosmographia* that proves Ptolemy's remark that, "no one presents it rightly unless he is an artist." Each dot in the *World Energy Map* refers to "1% of World's harnessed energy slave population (inanimate power serving man) in terms of human equivalents," says Fuller. The use Fuller makes of the "dot" is in a sense a concentration or dilation of an infinite expanse of spheres of energy. The "dot" has its rim and middle, and could be related to Reinhardt's mandala, Judd's "device" of the specific and general, or Pascal's universe of center and circumference.

Yet, the dot evades our capacity to find its center. Where is the central point, axis, pole, dominant interest, fixed position, absolute structure, or decided goal? The mind is always being hurled towards the outer edge into intractable trajectories that lead to vertigo.

NOTE

1. Recently drama critic Michael Fried has been enveloped by this "literal" abyss. (See "Objecthood and Art," *Artforum*, June 1967.)

A THING IS A HOLE IN A THING IT IS NOT (1968)

As consultant in early design of the proposed new air terminal between Fort Worth and Dallas, Texas, the author takes a new view of borings. The site is at 550 to 620 foot elevation, well drained, generally open. Underground is chiefly Cretaceous Age sediment. The underground site was penetrated by auger borings and core borings, and samples visually classified and tested.—Ed.

Boring, if seen as a discrete step in the development of an entire site, has an esthetic value. It is an invisible hole. It could be defined by Carl Andre's motto— "A thing is a hole in a thing it is not."

All language becomes an alphabet of sites. The boring, like other works, is becoming more and more important to artists. Pavements, holes, trenches, mounds, heaps, paths, ditches, roads, terraces, etc., all have an esthetic potential. Remote places such as the Pine Barrens of New Jersey and the frozen wastes of the North and South poles could be coordinated by art forms that would use the actual land as a medium. Television could transmit such activity all over the world. Instead of using a paintbrush to make his art, Robert Morris would like to use a bulldozer. Consider a "City of Ice" in the Arctic that would contain frigid labyrinths, glacial pyramids, and towers of snow, all built according to strict abstract systems. Or an amorphous "City of Sand" that would be nothing but artificial dunes and shallow sand pits.

Tippetts-Abbett-McCarthy-Stratton have developed other sites that have limits similar to the air terminal project. They include port and harbor facilities like the Navy pier in Chicago, a port in Anchorage, and San Nicholas Harbor in Aruba. Such sites rest on wide expanses of water, and are generated by ship voyages and cargo movements. Bulk storage systems are contained by mazes of transfer pipelines that include hydrant refueling pump houses and gas dispensers. The process behind the making of a storage facility may be viewed in stages, thus constituting a whole "series" of art from the ground up. Land surveying and preliminary building, if isolated into discrete stages, may be viewed as an array of art works that *vanish* as they develop.

Water resources that involve flood control, irrigation, and hydro-electric power provide one with an entirely new way to order the terrain. This is a kind of radical construction that takes into account large land masses and bodies of water. The making of artificial lakes, with the help of dams, brings into view a vast "garden." For instance, the Peligre Dam in the Republic of Haiti consists of 250-foot high concrete buttresses. This massive structure with its artificial cascades and symmetrical layout stands as an immobile facade. It con-

veys an immense scale and power. By investigating the physical forms of such projects we may gain unexpected esthetic information. I am not concerned here with the original "functions" of such massive projects, but rather with what they suggest or evoke.

It is important to mentally experience these projects as something distinctive and intelligible. By extracting from a site certain associations that have remained invisible within the old framework of rational language, by dealing directly with the appearance of what Roland Barthes calls "the simulacrum of the object," the aim is to reconstruct a new type of "building" into a whole that engenders new meanings. From the linguistic point of view, one establishes rules of structure based on a change in the semantics of building. Tony Smith seems conscious of this "*simulacrum*" when he speaks of an "abandoned airstrip" as an "artificial landscape." He speaks of an absence of "function" and "tradition."

What is needed is an esthetic method that brings together anthropology and linguistics in terms of "building." This would put an end to "art history" as sole criterion. Art at the present is confined by a dated notion, namely "art as a criticism of earlier art."

"Site Selection Study" in terms of art is just beginning. The investigation of a specific site is a matter of extracting concepts out of existing sense-data through direct perceptions. Perception is prior to conception, when it comes to site selection or definition. One does not *impose*, but rather *exposes* the site—be it interior or exterior. Interiors may be treated as exteriors or vice versa. The unknown areas of sites can best be explored by artists.

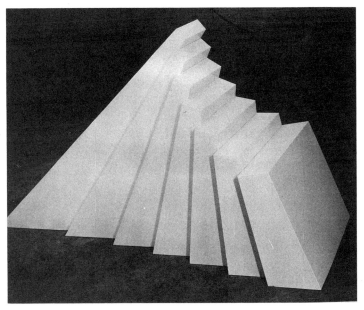

ROBERT SMITHSON, *Leaning Strata*, 1968. Flat white paint on steel, 49½ x 103 x 30″.

THE ESTABLISHMENT (1968)

The notion of an establishment seems to be a social fairytale, a deadly utopia or invisible system that inspires an almost mythical sense of dread—it is a "bad dream" that has somehow consumed the world. I shall postulate The Establishment as a state of mind—a deranged mind, that appears to be a mental City of Death. The architecture is uncertain and without a center; it comes and goes like a will-o'-the-wisp. It contains a strange mixture of politics and madness that resembles a nightmare let loose in the time and space of everyday reality. This nightmarish system catalogues every known physical thing according to the "science" of totalitarian propaganda, and none of this "thought-control" can be traced by the isolated individual. Indoctrination causes many to follow monstrous lies against their will. Public or State "programs" follow maze-like patterns, till finally no one knows where he is. In this political dream world everything is leveled so that on the distant horizons mirages appear—phantom images of crazed armies and sinking ships, shadowy scenes of "the death of art," and other obscene pomposities. Networks of paths go in all directions. Everything that is the antithesis of art rolls on after brainless slogans: "Every-man is equal—the war on poverty—win the mind of man to freedom"—all echo into the poisonous skies. Organizations seem to grow more and more crackpot with all their "activist" demonstrations. Techniques of "social" dupli-cation make it impossible to get near anything that even slightly resembles "a

Metro, June 1968

government"—it is the decomposition of decomposition. All individual power is undermined and wasted as vague institutions of "culture," "education," and "sport" spread into departments of delusion. Administrations proliferate into bogus "movements" and "fake ideals." Impenetrable piles of bureaucratic slush sink into an ever sinking landscape of organized violence. The circles of power become more and more intangible as they move to the edge of nowhere. Crimes are committed for the ultimate good of the State. Fictitious social structures uphold stupid hierarchies and protect the legal criminals. Unreality becomes a "hard-nosed" fact. In this fugitive "city" of the crumbling world-mind, all solids tremble and seem about to disintegrate. A complete inarticulation of thought brings one to a sickly lagoon, called "The Slough of Decayed Language"—it has vile shapeless creatures swimming in it. Beyond the lagoon are the desolate gates of "The Museum of Leftover Ideologies," which is run by the robots of The Establishment.

In the museum one can find deposits of rust labeled "Philosophy," and in glass cases unknown lumps of something labeled "Aesthetics." One can walk down ruined hallways and see the remains of "Glory." A sense of fatigue overcomes one in the "Room of Ancient History." A chart with poorly drawn pictures shows the "7 Wonders of the World" with the captions: The Egyptian Pyramids, The Walls and Hanging Gardens of Babylon, The Mausoleum at Halicarnassus, The Temple of Artemis at Ephesus, The Colossus of Rhodes, The Statue of Zeus by Phidias at Olympia, and the Pharos (or lighthouse) at Alexandria. Adjoining this room is the "Room of Savage Splendor" where we see a group of simulated "primitives" made of plaster sitting around a campfire with cellophane flames beating the air ferociously. A faded map shows the "underdeveloped" countries. Fifty glass cases all the same size contain nothing but arrowheads.

In the "Hall of Destruction," we see a fantastic plan to blow up the Statue of Liberty. Some bones from Hannibal's elephants are neatly displayed, and so

ROBERT SMITHSON, *Glass Stratum*, 1967. Glass. 17¾ x 12 x 84".

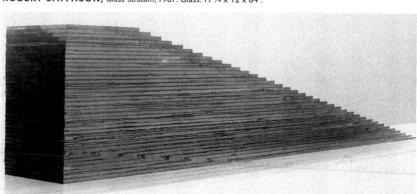

is Nero's "fiddle." Piles of trophies are strewn in odd corners. A tasteful painting of "The Battle of Waterloo" hangs on a wall. A photograph shows a World War I tank bogged down in the mud. On a cracking wall is a list of "ideals" that killed millions.

The "Room of Great Artists" presents a panorama that goes from "the grand" to "the horrible." A continuous film, always being shown in a dark chamber, depicts "the artist alienated from society." It is made in "serial" sections under the titles: "Suffering, discovery, fame, and decline." The film delves into the private life of the creative genius and shows the artist's conflicts as he struggles to make the world understand his vision.

In this museum run by the awesome Establishment is also the "Hall of Lost Establishments and Vanished Civilizations." We see Troy—the golden treasures of a great mythical city discovered hidden beneath a hilly Turkish town; Babylon—the great tower of Babel rising over the desert like a modern skyscraper; Angkor—its vine-enshrouded towers brooding over the steaming jungles of Cambodia; and Pompeii—proud city of the Caesars preserved in its last agonized moment of life by a sudden torrent of volcanic ash—and many more. This hall sags under the weight of such exhibitions. The Establishment is a nightmare from which I am trying to awake.

A SEDIMENTATION OF THE MIND:
EARTH PROJECTS (1968)

The earth's surface and the figments of the mind have a way of disintegrating into discrete regions of art. Various agents, both fictional and real, somehow trade places with each other—one cannot avoid muddy thinking when it comes to earth projects, or what I will call "abstract geology." One's mind and the earth are in a constant state of erosion, mental rivers wear away abstract banks, brain waves undermine cliffs of thought, ideas decompose into stones of unknowing, and conceptual crystallizations break apart into deposits of gritty reason. Vast moving faculties occur in this geological miasma, and they move in the most physical way. This movement seems motionless, yet it crushes the landscape of logic under glacial reveries. This slow flowage makes one conscious of the turbidity of thinking. Slump, debris slides, avalanches all take place within the cracking limits of the brain. The entire body is pulled into the cerebral sediment, where particles and fragments make themselves known as solid consciousness. A bleached and fractured world surrounds the artist. To organize this mess of corrosion into patterns, grids, and subdivisions is an esthetic process that has scarcely been touched.

The manifestations of technology are at times less "extensions" of man

Artforum, September 1968

The Bangor Quarry. Slate site in an uncontained condition before being contained in a *Non-Site* by Robert Smithson. (Photo: Virginia Dwan.)

ROBERT SMITHSON, *Non-Site*, 1968. *(Slate from Bangor, Pa.)*

(Marshall McLuhan's anthropomorphism), than they are aggregates of elements. Even the most advanced tools and machines are made of the raw matter of the earth. Today's highly refined technological tools are not much different in this respect from those of the caveman. Most of the better artists prefer processes that have not been idealized, or differentiated into "objective" meanings. Common shovels, awkward looking excavating devices, what Michael Heizer calls "dumb tools," picks, pitchforks, the machine used by suburban contractors, grim tractors that have the clumsiness of armored dinosaurs, and plows that simply push dirt around. Machines like Benjamin Holt's steam tractor (invented in 1885)—"It crawls over mud like a caterpillar." Digging engines and other crawlers that can travel over rough terrain and steep grades. Drills and explosives that can produce shafts and earthquakes. Geometrical trenches could be dug with the help of the "ripper"—steel toothed rakes mounted on tractors. With such equipment construction takes on the look of destruction; perhaps that's why certain architects hate bulldozers and steam shovels. They seem to turn the terrain into unfinished cities of organized wreckage. A sense of chaotic planning engulfs site after site. Subdivisions are made—but to what purpose? Building takes on a singular wildness as loaders scoop and drag soil all over the place. Excavations form shapeless mounds of debris, miniature landslides of dust, mud, sand and gravel. Dump trucks spill soil into an infinity of heaps. The dipper of the giant mining power shovel is 25 feet high and digs 140 cu. yds. (250 tons) in one bite. These processes of heavy construction have a devastating kind of primordial grandeur, and are in many

ROBERT SMITHSON, *Non-Site*, 1968. *(Mica from Portland, Conn.)*

Buckwheat Mineral Dump. Rock site in an uncontained condition before being contained in *Non-Site #3* by Robert Smithson. (Photo: Nancy Holt.)

ways more astonishing than the finished project—be it a road or a building. The actual *disruption* of the earth's crust is at times very compelling, and seems to confirm Heraclitus's *Fragment 124*, "The most beautiful world is like a heap of rubble tossed down in confusion." The tools of art have too long been confined to "the studio." The city gives the illusion that earth does not exist. Heizer calls his earth projects "The alternative to the absolute city system."

Recently, in Vancouver, Iain Baxter put on an exhibition of *Piles* that were located at different points in the city; he also helped in the presentation of a *Portfolio of Piles*. Dumping and pouring become interesting techniques. Carl Andre's *"grave site"*—a tiny pile of sand, was displayed under a stairway at the Museum of Contemporary Crafts last year. Andre, unlike Baxter, is more concerned with the *elemental* in things. Andre's pile has no anthropomorphic overtones; he gives it a clarity that avoids the idea of temporal space. A serenification takes place. Dennis Oppenheim has also considered the *"pile"*—"the basic components of concrete and gypsum . . . devoid of manual organization." Some of Oppenheim's proposals suggest desert physiography—mesas, buttes, mushroom mounds, and other "deflations" (the removal of material from beach and other land surfaces by wind action). My own *Tar Pool and Gravel Pit* (1966) proposal makes one conscious of the primal ooze. A molten substance is poured into a square sink that is surrounded by another square sink of coarse gravel. The tar cools and flattens into a sticky level deposit. This carbonaceous sediment brings to mind a tertiary world of petroleum, asphalts, ozokerite, and bituminous agglomerations.

PRIMARY ENVELOPMENT

At the low levels of consciousness the artist experiences undifferentiated or unbounded methods of procedure that break with the focused limits of rational technique. Here tools are undifferentiated from the material they operate on, or they seem to sink back into their primordial condition. Robert Morris (*Artforum*, April 1968) sees the paint brush vanish into Pollock's "stick," and the stick dissolve into "poured paint" from a container used by Morris Louis. What then is one to do with the *container*? This entropy of technique leaves one with an empty limit, or no limit at all. All differentiated technology becomes meaningless to the artist who knows this state. "What the Nominalists call the grit in the machine," says T. E. Hulme in *Cinders*, "I call the fundamental element of the machine." The rational critic of art cannot risk this abandonment into "oceanic" undifferentiation, he can only deal with the limits that come after this plunge into such a world of non-containment.

At this point I must return to what I think is an important issue, namely Tony Smith's "car ride" on the "unfinished turnpike." "This drive was a revealing experience. The road and much of the landscape was artificial, and yet it couldn't be called a work of art." ("Talking with Tony Smith" by Samuel

MICHAEL HEIZER, *Compression Line*, 1968. Unpainted plywood, 16′ long, 6″ surface opening, 24″ depth, 24″ base (underground). El Mirage Dry Lake, Mohave Desert, California.

MICHAEL HEIZER, *Two-Stage Liner Buried in Earth and Snow*, 1967. Sierra Mountains, near Reno,

Wagstaff, Jr., *Artforum*, December 1966.) He is talking about a sensation, not the finished work of art; this doesn't imply that he is anti-art. Smith is describing the state of his mind in the "primary process" of making contact with matter. This process is called by Anton Ehrenzweig "dedifferentiation," and it involves a suspended question regarding "limitlessness" (Freud's notion of the "oceanic") that goes back to *Civilization and Its Discontents*. Michael Fried's shock at Smith's experiences shows that the critic's sense of limit cannot risk the rhythm of dedifferentiation that swings between "oceanic" fragmentation and strong determinants. Ehrenzweig says that in modern art this rhythm is "somewhat onesided"—toward the oceanic. Allan Kaprow's thinking is a good example—"Most humans, it seems, still put up fences around their acts and thoughts." (*Artforum*, June 1968.) Fried thinks he knows who has the "finest" fences around their art. Fried claims he rejects the "infinite," but this is Fried writing in *Artforum*, February 1967 on Morris Louis: "The dazzling blankness of the untouched canvas at once repulses and engulfs the eye, like an infinite abyss, the abyss that opens up behind the least mark that we make on a flat surface, or *would* open up if innumerable conventions both of art and practical life did not restrict the consequences of our act within narrow bounds." The "innumerable conventions" do not exist for certain artists who *do* exist within a physical "abyss." Most critics cannot endure the suspension of *boundaries* between what Ehrenzweig calls the "self and the non-self." They are apt to dismiss Malevich's *Non-Objective World* as poetic debris, or only refer to the

"abyss" as a rational metaphor "within narrow bounds." The artist who is physically engulfed tries to give evidence of this experience through a limited (mapped) revision of the original unbounded state. I agree with Fried that limits are not part of the primary process that Tony Smith was talking about. There is different experience before the physical abyss than before the mapped revision. Nevertheless, the quality of Fried's *fear* (dread) is high, but his experience of the abyss is low—a weak metaphor—"like an infinite abyss."

The bins or containers of my *Non-Sites* gather *in* the fragments that are experienced *in* the physical abyss of raw matter. The tools of technology become a part of the Earth's geology as they sink back into their original state. Machines like dinosaurs must return to dust or rust. One might say a "de-architecturing" takes place before the artist sets his limits outside the studio or the room.

BETTER HOMES AND INDUSTRIES

> Great sprays of greenery make the Lambert live-in room an
> oasis atop a cliff dwelling. In a corner, lighted by skylights and
> spotlights, "Hard Red," an oil by Jack Bush. All planting by
> Lambert Landscape Company.
>
> <div align="right">Caption under a photograph,

> House and Garden, July 1968</div>

In *Art in America*, Sept.–Oct. 1966, there is a *Portrait of Anthony Caro*, with photographs of his sculpture in settings and landscapes that suggest English gardening. One work, *Prima Luce 1966*, painted yellow, matches the yellow daffodils peeking out behind it, and it sits on a well cut lawn. I know, the sculptor prefers to see his art indoors, but the fact that this work ended up where it did is no excuse for thoughtlessness about installation. The more compelling artists today are concerned with "place" or "site"—Smith, de Maria, Andre, Heizer, Oppenheim, Huebler—to name a few. Somehow, Caro's work picks up its surroundings, and gives one a sense of a contrived, but tamed, "wildness" that echoes to the tradition of English gardening.

Around 1720 the English invented the antiformal garden as protest against the French formal garden. The French use of geometric forms was rejected as something "unnatural." This seems to relate to today's debate between so-called "formalism" and "anti-formalism." The traces of weak naturalism cling to the background of Caro's *Prima Luce*. A leftover Arcadia with flowery overtones gives the sculpture the look of some industrial ruin. The brightly painted surfaces cheerfully seem to avoid any suggestion of the "romantic ruin," but they are on closer investigation related to just that. Caro's industrial ruins, or concatenations of steel and aluminum may be viewed as Kantian "things-in-themselves," or be placed into some syntax based on So and So's theories, but at this point I will leave those notions to the keepers of "modernity." The English consciousness of art has always been best displayed in its "landscape gardens." "Sculpture" was used more to *generate a set of conditions*.

ROBERT SMITHSON, for *A Non-Site* below, 1968.
Aerial photograph/map,

ROBERT SMITHSON, *A Non-Site (indoor earthwork),* 1968.
Blue painted aluminum with sand, 12 x 65½ x 65½ ".

Clement Greenberg's notion of "the landscape" reveals itself with shades of T. S. Eliot in an article, "Poetry of Vision" (*Artforum,* April 1968). Here "Anglicizing tastes" are evoked in his descriptions of the Irish landscape. "The ruined castles and abbeys," says Greenberg, "that strew the beautiful countryside are gray and dim," shows he takes "pleasure in ruins." At any rate, the "pastoral," it seems, is outmoded. The gardens of history are being replaced by sites of time.

Memory traces of tranquil gardens as "ideal nature"—jejune Edens that suggest an idea of banal "quality"—persist in popular magazines like *House Beautiful* and *Better Homes and Gardens.* A kind of watered down Victorianism, an elegant notion of industrialism in the woods; all this brings to mind some kind of wasted charm. The decadence of "interior decoration" is full of appeals to "country manners" and liberal-democratic notions of gentry. Many art magazines have gorgeous photographs of artificial industrial ruins (sculpture) on their pages. The "gloomy" ruins of aristocracy are transformed into the "happy" ruins of the humanist. Could one say that art degenerates as it approaches gardening?[1] These "garden-traces" seem part of time and not history, they seem to be involved in the dissolution of "progress." It was John Ruskin who spoke of the "dreadful Hammers" of the geologists, as they destroyed the classical order. The landscape reels back into the millions and millions of years of "geologic time."

FROM STEEL TO RUST

As "technology" and "industry" began to become an ideology in the New York Art World in the late '50s and early '60s, the private studio notions of "craft" collapsed. The products of industry and technology began to have an appeal to the artist who wanted to work like a "steel welder" or a "laboratory technician." This valuation of the material products of heavy industry, first de-

veloped by David Smith and later by Anthony Caro, led to a fetish for steel and aluminum as a medium (painted or unpainted). Molded steel and cast aluminum are machine manufactured, and as a result they bear the stamp of technological ideology. Steel is a hard, tough metal, suggesting the permanence of technological values. It is composed of iron alloyed with various small percentages of carbon; steel may be alloyed with other metals, nickel, chromium, etc., to produce specific properties such as hardness and resistance to rusting. Yet, the more I think about steel itself, devoid of the technological refinements, the more rust becomes the fundamental property of steel. Rust itself is a reddish brown or reddish yellow coating that often appears on "steel sculpture," and is caused by oxidation (an interesting non-technological condition), as during exposure to air or moisture; it consists almost entirely of ferric oxide, Fe_2O_3 and ferric hydroxide, $Fe(OH)_3$. In the technological mind rust evokes a fear of disuse, inactivity, entropy, and ruin. Why steel is valued over rust is a technological value, not an artistic one.

By excluding technological processes from the making of art, we began to discover other processes of a more fundamental order. The breakup or fragmentation of matter makes one aware of the sub-strata of the Earth before it is overly refined by industry into sheet metal, extruded I-beams, aluminum channels, tubes, wire, pipe, cold-rolled steel, iron bars, etc. I have often thought about non-resistant processes that would involve the actual sedimentation of matter or what I called "Pulverizations" back in 1966. Oxidation, hydration, carbonatization, and solution (the major processes of rock and mineral disintegration) are four methods that could be turned toward the making of art. The smelting process that goes into the making of steel and other alloys separates "impurities" from an original ore, and extracts metal in order to make a more "ideal" product. Burnt-out ore or slag-like rust is as basic and primary as the material smelted from it. Technological ideology has no sense of time other than its immediate "supply and demand," and its laboratories function as blinders to the rest of the world. Like the refined "paints" of the studio, the refined "metals" of the laboratory exist within an "ideal system." Such enclosed "pure" systems make it impossible to perceive any other kinds of processes than the ones of differentiated technology.

Refinement of matter from one state to another does not mean that so-called "impurities" of sediment are "bad"—the earth is built on sedimentation and disruption. A refinement based on all the matter that has been discarded by the technological ideal seems to be taking place. The coarse swathes of tar on Tony Smith's plywood mock-ups are no more or less refined than the burnished or painted steel of David Smith. Tony Smith's surfaces display more of a sense of the "prehistoric world" that is not reduced to ideals and pure gestalts. The fact remains that the mind and things of certain artists are not "unities," but *things* in a state of arrested disruption. One might object to "hollow" vol-

umes in favor of "solid materials," but no materials are solid, they all contain caverns and fissures. Solids are particles built up around flux, they are objective illusions supporting grit, a collection of surfaces ready to be cracked. All chaos is put into the dark inside of the art. By refusing "technological miracles" the artist begins to know the corroded moments, the carboniferous states of thought, the shrinkage of mental mud, in the geologic chaos—in the strata of esthetic consciousness. The refuse between mind and matter is a mine of information.

THE DISLOCATION OF CRAFT—AND FALL OF THE STUDIO

Plato's *Timaeus* shows the demiurge or the artist creating a model order, with his eyes fixed on a non-visual order of Ideas, and seeking to give the purest representation of them. The "classical" notion of the artist copying a perfect mental model has been shown to be an error. The modern artist in his "studio," working out an abstract grammar within the limits of his "craft," is trapped in but another snare. When the fissures between mind and matter multiply into an infinity of gaps, the studio begins to crumble and fall like The House of Usher, so that mind and matter get endlessly confounded. Deliverance from the confines of the studio frees the artist to a degree from the snares of craft and the bondage of creativity. Such a condition exists without any appeal to "nature." Sadism is the end product of nature, when it is based on the biomorphic order of rational creation. The artist is fettered by this order, if he believes himself to be creative, and this allows for his servitude which is designed by the vile laws of Culture. Our culture has lost its sense of death, so it can kill both mentally and physically, thinking all the time that it is establishing the most creative order possible.

THE DYING LANGUAGE

The names of minerals and the minerals themselves do not differ from each other, because at the bottom of both the material and the print is the beginning of an abysmal number of fissures. Words and rocks contain a language that follows a syntax of splits and ruptures. Look at any *word* long enough and you will see it open up into a series of faults, into a terrain of particles each containing its own void. This discomforting language of fragmentation offers no easy gestalt solution; the certainties of didactic discourse are hurled into the erosion of the poetic principle. Poetry being forever lost must submit to its own vacuity; it is somehow a product of exhaustion rather than creation. Poetry is always a dying language but never a dead language.

Journalism in the guise of art criticism fears the disruption of language, so it resorts to being "educational" and "historical." Art critics are generally poets who have betrayed their art, and instead have tried to turn art into a matter of reasoned discourse, and, occasionally, when their "truth" breaks down, they resort to a poetic quote. Wittgenstein has shown us what can happen when lan-

WALTER DE MARIA, *Half Mile Long Drawing*. April 1968. Chalk, 2 parallel lines, 12 feet apart, Mojave Desert, California.

```
                        PULVERIZATIONS

             X           Z          Z          X
    1.   | BBBBBBBBBB | TTTTTTTTTT | BBBBBBBBBB |
             10'          10'          10'
         B = Bituminous Coal      T = Tar (hot, left to cool)
             X        Z            Z        X
    2.   | BBBBBBBB | CCCCCCCCCCCCCC | BBBBBBBB |
             8'           14'           8'
         B = Bog Iron Fragments      C = Cement (dry)
             X               Z  Z               X
    3.   | BBBBBBBBBBBBBB | VV | BBBBBBBBBBBBBB |
              14'           2'         14'
         B = Blue Coal       V = Volcanic Ash
             X               Z  Z               X
    4.   | SSSSSSSSSSSSSS | GG | SSSSSSSSSSSSSS |
              14'           2'         14'
         S = Sandstone Fragments      G = Glue
           X  Z                              Z   X
    5.   | CCC | FFFFFFFFFFFFFFFFFFFFFFFFF | CCC |
            3'            24'                3'
         C = Coarse Sand       F = Fine Gravel

    Five profiles of foundations (on level ground, 2' deep,
      1' below ground, 1' above) shown partitioning contents.

    X = Outer Foundation      Z = Inner Foundation

    X is always 30' sq., the size of Z is variable.

    The widths of X and Z are variable according to
    materials used.
```

ROBERT SMITHSON, *Pulverizations*, 1966. Photostat.

guage is "idealized," and that it is hopeless to try to fit language into some absolute logic, whereby everything objective can be tested. We have to fabricate our rules as we go along the avalanches of language and over the terraces of criticism.

Poe's *Narrative of A. Gordon Pym* seems to me excellent art criticism and prototype for rigorous "non-site" investigations. "Nothing worth mentioning occurred during the next twenty-four hours except that, in examining the ground to the eastward third chasm, we found two triangular holes of great depth, and also with black granite sides." His descriptions of chasms and holes seem to verge on proposals for "earthwords." The shapes of the chasms themselves become "verbal roots" that spell out the difference between darkness and light. Poe ends his mental maze with the sentence—"I have graven it within the hills and my vengeance upon the dust within the rock."

THE CLIMATE OF SIGHT

The climate of sight changes from wet to dry and from dry to wet according to one's mental weather. The prevailing conditions of one's psyche affect how he views art. We have already heard much about "cool" or "hot" art, but not much about "wet" and "dry" art. The *viewer*, be he an artist or a critic, is subject to a climatology of the brain and eye. The wet mind enjoys "pools and stains" of paint. "Paint" itself appears to be a kind of liquefaction. Such wet eyes love

to look on melting, dissolving, soaking surfaces that give the illusion at times of tending toward a gaseousness, atomization or fogginess. This watery syntax is at times related to the "canvas support."

The world disintegrates around me.

Yvonne Rainer

By Palm Desert springs often run dry.

Van Dyke Parks,
Song Cycle

The following is a proposal for those who have leaky minds. It could be thought of as The Mind of Mud, or in later stages, The Mind of Clay.

THE MUD POOL PROJECT

1. Dig up 100 ft. sq. area of earth with a pitchfork.
2. Get local fire department to fill the area with water. A fire hose may be used for this purpose.
3. The area will be finished when it turns to mud.
4. Let it dry under the sun until it turns to clay.
5. Repeat process at will.

When dried under the sun's rays for a sufficiently long time, mud and clay shrink and crack in a network of fissures which enclose polygonal areas.

Fredric H. Lahee,
Field Geology

The artist or critic with a dank brain is bound to end up appreciating anything that suggests saturation, a kind of watery effect, an overall seepage, discharges that submerge perceptions in an onrush of dripping observation. They are grateful for an art that evokes general liquid states, and disdain the desiccation of fluidity. They prize anything that looks drenched, be it canvas or steel. Depreciation of aridity means that one would prefer to see art in a dewy green setting, say the hills of Vermont, rather than the Painted Desert.

Aristotle believed that heat combined with dryness resulted in fire: where else could this feeling take place than in a *desert* or in Malevich's head? "No more 'likenesses of reality,' no idealistic images, nothing but a desert!" says Malevich in *The Non-Objective World.* Walter DeMaria and Michael Heizer have actually worked in the Southwestern deserts. Says Heizer, in some scattered notes, "Earth liners installed in Sierras, and down on desert floor in Carson-Reno area." The desert is less "nature" than a concept, a place that swallows up boundaries. When the artist goes to the desert he enriches his absence and burns off the water (paint) on his brain. The slush of the city evaporates from the artist's mind as he installs his art. Heizer's "dry lakes" become mental maps

that contain the vacancy of Thanatos. A consciousness of the desert operates between craving and satiety.

Jackson Pollock's art tends toward a torrential sense of *material* that makes his paintings look like splashes of marine sediments. Deposits of paint cause layers and crusts that suggest nothing "formal" but rather a physical metaphor without realism or naturalism. *Full Fathom Five* becomes a Sargasso Sea, a dense lagoon of pigment, a logical state of an oceanic mind. Pollock's introduction of pebbles into his private topographies suggests an interest in geological artifices. The rational idea of "painting" begins to disintegrate and decompose into so many sedimentary concepts. Both Yves Klein and Jean Dubuffet hinted at global or topographic sedimentary notions in their works—both worked with ashes and cinders. Says Dubuffet, regarding the North and South Poles, "The revolution of a being on its axis, reminiscent of a dervish, suggests fatiguing, wasted effort; it is not a pleasant idea to consider and seems instead the provisional solution, until a better one comes along, of despair." A sense of the Earth as a map undergoing disruption leads the artist to the realization that nothing is certain or formal. Language itself becomes mountains of symbolic debris. Klein's IKB globes betray a sense of futility—a collapsed logic. G. E. M. Anscombe writing on "Negation" in *An Introduction to Wittgenstein's Tractatus* says, "But it is clear then an all-white or all-black globe is not a map." It is also clear that Klein's all blue globe is not a map; rather it is an anti-map; a negation of "creation" and the "creator" that is supposed to be in the artist's "self."

THE WRECK OF FORMER BOUNDARIES

The strata of the Earth is a jumbled museum. Embedded in the sediment is a text that contains limits and boundaries which evade the rational order, and social structures which confine art. In order to read the rocks we must become conscious of geologic time, and of the layers of prehistoric material that is entombed in the Earth's crust. When one scans the ruined sites of pre-history one sees a heap of wrecked maps that upsets our present art historical limits. A rubble of logic confronts the viewer as he looks into the levels of the sedimentations. The abstract grids containing the raw matter are observed as something incomplete, broken and shattered.

In June, 1968, my wife Nancy, Virginia Dwan, Dan Graham, and I visited the slate quarries in Bangor-Pen Angyl, Pennsylvania. Banks of suspended slate hung over a greenish-blue pond at the bottom of a deep quarry. All boundaries and distinctions lost their meaning in this ocean of slate and collapsed all notions of gestalt unity. The present fell forward and backward into a tumult of "de-differentiation," to use Anton Ehrenzweig's word for entropy. It was as though one was at the bottom of a petrified sea and gazing on countless stratographic horizons that had fallen into endless directions of steepness. Syncline (downward) and anticline (upward) outcroppings and the asymmetrical cave-ins caused minor swoons and vertigos. The brittleness of the site seemed

to swarm around one, causing a sense of displacement. I collected a canvas bag full of slate chips for a small *Non-Site*.

Yet, if art is art it must have limits. How can one contain this "oceanic" site? I have developed the Non-Site, which in a physical way contains the disruption of the site. The container is in a sense a fragment itself, something that could be called a three-dimensional map. Without appeal to "gestalts" or "anti-form," it actually exists as a fragment of a greater fragmentation. It is a three-dimensional *perspective* that has broken away from the whole, while containing the lack of its own containment. There are no mysteries in these vestiges, no traces of an end or a beginning.

CRACKING PERSPECTIVES AND GRIT IN THE VANISHING POINT

Parallactic perspectives have introduced themselves into the new earth projects in a way that is physical and three-dimensional. This kind of convergence subverts gestalt surfaces and turns sites into vast illusions. The ground becomes a map.

The map of my *Non-Site #1 (an indoor earthwork)* has six vanishing points that lose themselves in a pre-existent earth mound that is at the center of a hexagonal airfield in the Pine Barren Plains in South New Jersey. Six runways radiate around a central axis. These runways anchor my 31 subdivisions. The actual *Non-Site* is made up of 31 metal containers of painted blue aluminum, each containing sand from the actual site.

De Maria's parallel chalk lines are 12 feet apart and run a half a mile along the Dry Lake of El Mirage in the Mojave Desert. The dry mud under these lines is cracking into an infinite variety of polygons, mainly six-sided. Under the beating sun shrinkage is constantly going on causing irregular outlines. Rapid drying causes widely spaced cracks, while slow drying causes closely spaced cracks. (See E. M. Kindle's "Some Factors Affecting the Development of Mud Cracks," *Journal of Geology*, Vol. 25, 1917, p. 136.) De Maria's lines make one conscious of a weakening cohesion that spreads out in all directions. Nevada is a good place for the person who wants to study cracks.

Heizer's *Compression Line* is made by the earth pressing against the sides of two parallel lengths of plywood, so that they converge into two facing sunken perspectives. The earth surrounding this double perspective is composed of "hardpan" (a hard impervious sediment that does not become plastic, but can be shattered by explosives). A drainage layer exists under the entire work.

THE VALUE OF TIME

For too long the artist has been estranged from his own "time." Critics, by focusing on the "art object," deprive the artist of any existence in the world of both mind and matter. The mental process of the artist which takes place in time is disowned, so that a commodity value can be maintained by a system independent of the artist. Art, in this sense, is considered "timeless" or a prod-

DENNIS OPPENHEIM, *Earth Proposal for Gallery Space*, 1968.

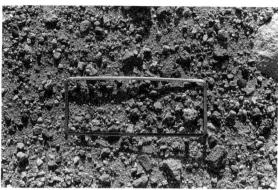

Base Side Panel Frame (glass broken). (From Edward Ruscha's *Royal Road Test.*)

uct of "no time at all"; this becomes a convenient way to exploit the artist out of his rightful claim to his temporal processes. The arguments for the contention that time is unreal is a fiction of language, and not of the material of time or art. Criticism, dependent on rational illusions, appeals to a society that values only commodity type art separated from the artist's mind. By separating art from the "primary process," the artist is cheated in more ways than one. Separate "things," "forms," "objects," "shapes," etc., with beginnings and endings are mere convenient fictions: there is only an uncertain disintegrating order that transcends the limits of rational separations. The fictions erected in the eroding time stream are apt to be swamped at any moment. The brain itself resembles an eroded rock from which ideas and ideals leak.

When a *thing* is seen through the consciousness of temporality, it is changed into something that is nothing. This all-engulfing sense provides the mental ground for the object, so that it ceases being a mere object and becomes art. The object gets to be less and less but exists as something clearer. Every object, if it is art, is charged with the rush of time even though it is static, but all this depends on the viewer. Not everybody sees the art in the same way, only an artist viewing art knows the ecstasy or dread, and this viewing takes place in time. A great artist can make art by simply casting a glance. A set of glances could be as solid as any thing or place, but the society continues to cheat the artist out of his "art of looking," by only valuing "art objects." The existence of the artist in time is worth as much as the finished product. Any critic who devalues the *time* of the artist is the enemy of art and the artist. The stronger and clearer the artist's *view* of time the more he will resent any slander on this domain. By desecrating this domain, certain critics defraud the work and mind of the artist. Artists with a weak view of time are easily deceived by this victimizing kind of criticism, and are seduced into some trivial history. An artist is enslaved by time only if the time is controlled by someone or something other

than himself. The deeper an artist sinks into the time stream the more it becomes *oblivion*; because of this, he must remain close to the temporal surfaces. Many would like to forget time altogether, because it conceals the "death principle" (every authentic artist knows this). Floating in this temporal river are the remnants of art history, yet the "present" cannot support the cultures of Europe, or even the archaic or primitive civilizations; it must instead explore the pre- and post-historic mind; it must go into the places where remote futures meet remote pasts.

NOTE

1. The sinister in a primitive sense seems to have its origin in what could be called "quality gardens" (Paradise). Dreadful things seem to have happened in those half-forgotten Edens. Why does the Garden of Delights suggest something perverse? Torture gardens. Deer Park. The Grottos of Tiberius. Gardens of Virtue are somehow always "lost." A degraded paradise is perhaps worse than a degraded hell. America abounds in banal heavens, in vapid "happy-hunting grounds," and in "natural" hells like Death Valley National Monument or The Devil's Playground. The public "sculpture garden" for the most part is an outdoor "room," that in time becomes a limbo of modern isms. Too much thinking about "gardens" leads to perplexity and agitation. Gardens like the levels of criticism bring one to the brink of chaos. This footnote is turning into a dizzying maze, full of tenuous paths and innumerable riddles. The abysmal problem of gardens somehow involves a fall from somewhere or something. The certainty of the absolute garden will never be regained.

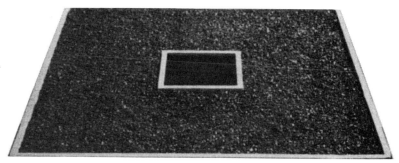

ROBERT SMITHSON, *Tar Pool and Gravel Pit* (model), 1966.

MINUS TWELVE (1968)

1. USELESSNESS
 A. Zone of standard modules.
 B. Monoliths without color.
 C. An ever narrowing field of approximation known as the Method of Exhaustion.
 D. The circumscribed cube.

2. ENTROPY
 A. Equal units approaching divisibility.
 B. Something inconsistent with common experience or having contradictory qualities.
 C. Hollow blocks in a windowless room.
 D. Militant laziness.

3. ABSENCE
 A. Postulates of nominalism.
 B. Idleness at the North Pole.
 C. Exclusion of space.
 D. Real things become mental vacancies.

4. INACCESSIBILITY
 A. Gray walls and glass floors.
 B. Domain of the Dinosaurs.
 C. Toward an aesthetics of disappointment.
 D. No doors.

5. EMPTINESS
 A. A flying tomb disguised as an airplane.
 B. Some plans for logical stupefactions.
 C. The case of the "missing-link."
 D. False theorems and grand mistakes.

6. INERTIA
 A. Memory of a dismantled parallelepiped.
 B. The humorous dimensions of time.
 C. A refutation of the End of Endlessness.
 D. Zeno's Second Paradox (infinite regression against movement).

7. FUTILITY
 A. Dogma against value.
 B. Collapses into five sections.

Minimal Art, edited by Gregory Battcock, 1968

C. To go from one extreme to another.

D. Put everything into doubt.

8. BLINDNESS

A. Two binocular holes that appear endlessly.

B. Invisible orbs.

C. Abolished sight.

D. The splitting of the vanishing point.

9. STILLNESS

A. Sinking back into echoes.

B. Extinguished by reflections.

C. Obsolete ideas to be promulgated (teratologies and other marvels).

D. Cold storage.

10. EQUIVALENCE

A. Refusal to privilege one sign over another.

B. Different types of sameness.

C. Odd objections to uncertain symmetries in regular systems.

D. Any declaration of unity results in two things.

11. DISLOCATION

A. Deluging the deluge.

B. The Great Plug.

C. The Winter Solstice of 4000 B.C. (a temporal dementia).

D. Toward innumerable futures.

12. FORGETFULNESS

A. Aluminum cities on a lead planet.

B. The Museum of the Void.

C. A compact mass in a dim passageway (an anti-object).

D. A series of sightings down escarpments.

AERIAL ART (1969)

Proposals for the Dallas–Fort Worth Regional Airport (Tippetts–Abbett–McCarthy–Stratton, Architects and Engineers)

Art today is no longer an architectural afterthought, or an object to attach to a building after it is finished, but rather a total engagement with the building process from the ground up and from the sky down. The old landscape of naturalism and realism is being replaced by the new landscape of abstraction and artifice.

How art should be installed in and around an airport makes one conscious of this new landscape. Just as our satellites explore and chart the moon and the planets, so might the artist explore the unknown sites that surround our airports.

The future air terminal exists both in terms of mind and thing. It suggests the infinite in a finite way. The straight lines of landing fields and runways bring into existence a perception of "perspective" that evades all our conceptions of nature. The naturalism of seventeeth-, eighteenth- and nineteenth-century art is replaced by non-objective sense of site. The landscape begins to look more like a three dimensional map than a rustic garden. Aerial photography and air transportation bring into view the surface features of this shifting world of perspectives. The rational structures of buildings disappear into irrational disguises and are pitched into optical illusions. The world seen from the air is abstract and illusive. From the window of an airplane one can see drastic changes of scale, as one ascends and descends. The effect takes one from the dazzling to the monotonous in a short space of time—from the shrinking terminal to the obstructing clouds.

Below this concatenation of aerial perceptions is the conception of the air terminal itself, firmly rooted in the earth. The principal runways and series of terminals will extend from 11,000 feet to 14,000 feet, or about the length of Central Park. The outer limits of the terminal could be brought into consciousness by a type of art, which I will call aerial art, that could be seen from aircraft on takeoff and landing, or not seen at all.

On the boundaries of the taxiways, runways or approach "clear zones" we might construct "earthworks" or grid type frameworks close to the ground level. These aerial sites would not only be visible from arriving and departing aircraft, but they would also define the terminal's manmade perimeters in terms of landscaping.

The terminal complex might include a gallery (or aerial museum) that would provide visual information about where these aerial sites are situated.

Studio International, February–April 1969

Diagrams, maps, photographs, and movies of the projects under construction could be exhibited—thus the terminal complex and its entire airfield site would expand its meaning from the central spaces of the terminal itself to the edges of the air fields.

Letters A, B, C, and D (see aerial map) stand for installations of art on the margins of the main terminal complex. This art is remote from the eye of the viewer the way a galaxy is remote from the earth. In fact, the entire air terminal may be considered conceptually as an *artificial universe*, and as everyone knows, everything in the known universe isn't entirely visible. There is no reason why one shouldn't look at art through a telescope. Our terminal universe is built in the shape of a rectangle with two diagonals set in a photo firmament of haze and non-objective land masses. The double white rectangles within the grid shall someday contain a series of terminals each one the size of Grand Central Station. At the moment we are considering this air terminal through the *camera obscura* of our mind—the camera takes a picture but does not see it. "Some ideas are logical in conception" says Sol LeWitt, "and illogical perceptually." Visibility is often marked by both mental and atmospheric turbidity. Just how we should look at art is a question that is rarely considered. Simply looking at art at eye-level is no solution. If we consider the aerial map as "a thing in itself," we will notice the affects of scattered light and weak tone-reproduction. High-altitude aerial photography shows us how little there is to see, and seems to prove what Lewis Carroll once said, "They say that we Photographers are a blind race at best." Carl Andre sees the camera as the most catastrophic invention of the Modern Age.

Aerial art can therefore not only give limits to "space," but also the hidden dimensions of "time" apart from natural duration—an *artificial time* that can suggest galactic distance here on earth. Its focus on "non-visual" space and time begins to shape an esthetic based on the *airport as an idea*, and not simply as a mode of transportation. This airport is but a dot in the vast infinity of universes, an imperceptible point in a cosmic immensity, a speck in an impenetrable nowhere—aerial art reflects to a degree this vastness.

A. ROBERT MORRIS

His proposal is an "earth mound" circular in shape and trapezoidal in cross section. Its surface would be sod, and its radius might be extended as much as a thousand feet—easily viewed from arriving and departing aircraft.

B. CARL ANDRE

A crater formed by a one-ton bomb dropped from 10,000 feet.

or

An acre of blue-bonnets (state flowers of Texas).

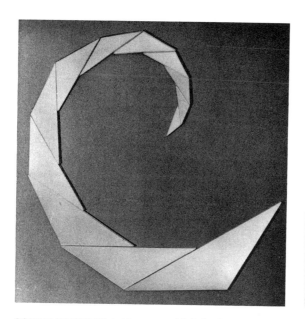

ROBERT SMITHSON, *Aerial map-proposal for Dallas–Fort Worth Regional Airport*, 1967.

SOL LEWITT, *Box in the hole.* A report on a cube that was buried at Visser House in Bergeyk, Holland on July 1, 1968. From notebook for "Earthworks" exhibition.

C. ROBERT SMITHSON

A progression of triangular concrete pavements that would result in a spiral effect. This could be built as large as the site would allow, and could be seen from approaching and departing aircraft.

D. SOL LEWITT

His proposal is "non-visual" and involves the sub-stratum of the site. He emphasizes the "concept" of art rather than the "object" that results from its practice. The precise spot in the site would not be revealed—and would consist of a small cube of unknown contents cast inside a larger cube of concrete. The cube would then be buried in the earth.

INCIDENTS OF MIRROR-TRAVEL IN THE YUCATAN (1969)

Of the Mayan ideas on the forms of the earth we know little. The Aztec thought the crest of the earth was the top of a huge saurian monster, a kind of crocodile, which was the object of a certain cult. It is probable that the Mayan had a similar belief, but it is not impossible that at the same time they considered the world to consist of seven compartments, perhaps stepped as four layers.

J. Eric S. Thompson, *Maya Hieroglyphic Writing*

The characteristic feature of the savage mind is its timelessness: its object is to grasp the world as both a synchronic and a diachronic totality and the knowledge which it draws therefrom is like that afforded of a room by mirrors fixed on opposite walls, which reflect each other (as well as objects in the intervening space) although without being strictly parallel.

Claude Levi-Strauss, *The Savage Mind*

Driving away from Merida down Highway 261 one becomes aware of the indifferent horizon. Quite apathetically it rests on the ground devouring everything that looks like something. One is always crossing the horizon, yet it always remains distant. In this line where sky meets earth, objects cease to exist. Since the car was at all times on some leftover horizon, one might say that the car was imprisoned in a line, a line that is in no way linear. The distance seemed to put restrictions on all forward movement, thus bringing the car to a countless series of standstills. How could one advance on the horizon, if it was already present under the wheels? A horizon is something else other than a horizon; it is closedness in openness, it is an enchanted region where down is up. Space can be approached, but time is far away. Time is devoid of objects when one displaces all destinations. The car kept going on the same horizon.

Looking down on the map (it was all there), a tangled network of horizon lines on paper called "roads," some red, some black. Yucatan, Quintana Roo, Campeche, Tabasco, Chiapas and Guatemala congealed into a mass of gaps, points, and little blue threads (called rivers). The map legend contained signs in a neat row: archeological monuments (black), colonial monuments (black), historical site (black), bathing resort (blue), spa (red), hunting (green), fishing (blue), arts and crafts (green), aquatic sports (blue), national park (green), service station (yellow). On the map of Mexico they were scattered like the droppings of some small animal.

The *Tourist Guide and Directory of Yucatan-Campeche* rested on the car seat. On its cover was a crude drawing depicting the Spaniards meeting the Mayans, in the background was the temple of Chichén Itzá. On the top left-hand corner

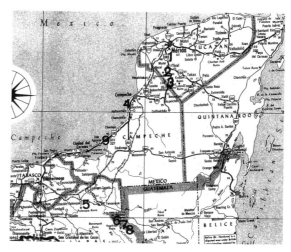

Vicinities of the Nine Mirror Displacements.

was printed "'UY U TAN A KIN PECH' (listen how they talk)—EX-CLAIMED THE MAYANS ON HEARING THE SPANISH LANGUAGE," and in the bottom left-hand corner "'YUCATAN CAMPECHE'—RE-PEATED THE SPANIARDS WHEN THEY HEARD THESE WORDS." A caption under all this said "Mayan and Spanish First Meeting 1517." In the "Official Guide" to Uxmal, Fig. 28 shows 27 little drawings of "Pottery Found at Uxmal." The shading on each pot consists of countless dots. Interest in such pots began to wane. The steady hiss of the air-conditioner in the rented Dodge Dart might have been the voice of Eecath—the god of thought and wind. Way-ward thoughts blew around the car, wind blew over the scrub bushes outside. On the cover of Victor W. Von Hagan's paperback *World of the Maya* it said, "A history of the Mayas and their resplendent civilization that grew out of the jun-gles and wastelands of Central America." In the rear-view mirror appeared Tez-catlipoca—demiurge of the "smoking-mirror." "All those guide books are of no use," said Tezcatlipoca. "You must travel at random, like the first Mayans; you risk getting lost in the thickets, but that is the only way to make art."

Through the windshield the road stabbed the horizon, causing it to bleed a sunny incandescence. One couldn't help feeling that this was a ride on a knife covered with solar blood. As it cut into the horizon a disruption took place. The tranquil drive became a sacrifice of matter that led to a discontinuous state of being, a world of quiet delirium. Just sitting there brought one into the wound of a terrestrial victim. This peaceful war between the elements is ever present in Mexico—an echo, perhaps, of the Aztec and Mayan human sacrifices.

THE FIRST MIRROR DISPLACEMENT:

Somewhere between Uman and Muna is a charred site. The people in this re-gion clear land by burning it out. On this field of ashes (called by the natives a "milpa") twelve mirrors were cantilevered into low mounds of red soil. Each

mirror was twelve inches square, and supported from above and below by the scorched earth alone. The distribution of the squares followed the irregular contours on the ground, and they were placed in a random parallel direction. Bits of earth spilled onto the surfaces, thus sabotaging the perfect reflections of the sky. Dirt hung in the sultry sky. Bits of blazing cloud mixed with the ashy mass. The displacement was *in* the ground, not *on* it. Burnt tree stumps spread around the mirrors and vanished into the arid jungles.

THE SECOND MIRROR DISPLACEMENT:

In a suburb of Uxmal, which is to say nowhere, the second displacement was deployed. What appeared to be a shallow quarry was dug into the ground to a depth of about four to five feet, exposing a bright red clay mixed with white limestone fragments. Near a small cliff the twelve mirrors were stuck into clods of earth. It was photographed from the top of the cliff. Again Tezcatlipoca spoke, "That camera is a portable tomb, you must remember that." On this same site, the Great Ice Cap of Gondwanaland was constructed according to a map outline on page 459 of Marshall Kay's and Edwin H. Colbert's *Stratigraphy and Life History*. It was an "earth-map" made of white limestone. A bit of the Carboniferous period is now installed near Uxmal. That great age of calcium carbonate seemed a fitting offering for a land so rich in limestone. Reconstructing a land mass that existed 350 to 305 million years ago on a terrain once controlled by sundry Mayan gods caused a collision in time that left one with a sense of the timeless.

Timelessness is found in the lapsed moments of perception, in the common

First Mirror Displacement.

Second Mirror Displacement.

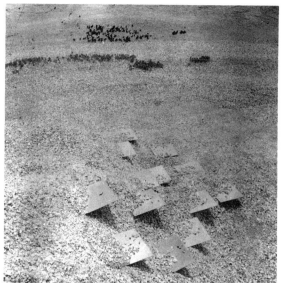

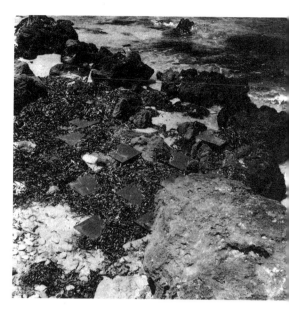

Third Mirror Displacement.

Fourth Mirror Displacement.

pause that breaks apart into a sandstorm of pauses. The malady of wanting to "make" is *unmade*, and the malady of wanting to be "able" is disabled. Gondwanaland is a kind of memory, yet it is not a memory, it is but an incognito land mass that has been *unthought* about and turned into a Map of Impasse. You cannot visit Gondwanaland, but you can visit a "map" of it.

THE THIRD MIRROR DISPLACEMENT:

The road went through butterfly swarms. Near Bolonchen de Rejon thousands of yellow, white and black swallowtail butterflies flew past the car in erratic, jerky flight patterns. Several smashed into the car radio aerial and were suspended on it because of the wind pressure. In the side of a heap of crushed limestone the twelve mirrors were cantilevered in the midst of large clusters of butterflies that had landed on the limestone. For brief moments flying butterflies were reflected; they seemed to fly through a sky of gravel. Shadows cast by the mirrors contrasted with those seconds of color. A scale in terms of "time" rather than "space" took place. The mirror itself is not subject to duration, because it is an ongoing abstraction that is always available and timeless. The reflections, on the other hand, are fleeting instances that evade measure. Space is the remains, or corpse, of time, it has dimensions. "Objects" are "sham space," the excrement of thought and language. Once you start seeing objects in a positive or negative way you are on the road to derangement. Objects are phantoms of the mind, as false as angels. Itzpaplotl is the Mayan Obsidian Butterfly, "a demonic goddess of unpredictable fate represented as beautiful but with death symbols on her face." (See *The Gods of Mexico* by C. A. Burland.) This relates to the "black obsidian mirror" used by Tezcatlipoca into which he

122

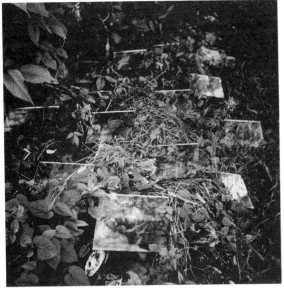

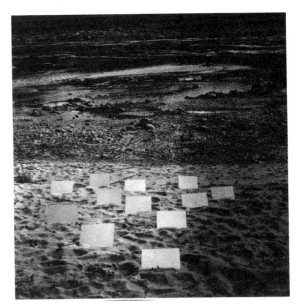

Fifth Mirror Displacement.

Sixth Mirror Displacement.

gazed to see the future. "Unpredictable fate" seemed to guide the butterflies over the mirror displacements. This also brings to mind the concave mirrors of the Olmecs found at La Venta, Tabasco State, and researched by Robert Heizer, the archeologist. "The mirrors were masterpieces. Each had been so perfectly ground that when we rotated it the reflection we caught was never distorted in the least. Yet the hematite was so tough that we could not even scratch it with knives of hard Swedish steel. Such mirrors doubtless served equally well to adorn important personages or to kindle ritual fires." ("Gifts for the Jaguar God" by Philip Drucker and Robert F. Heizer, *National Geographic*, September 1956.) "The Jaguar in the mirror that smokes in the World of the Elements knows the work of Carl Andre," said Tezcatlipoca and Itzpaplotl at the same time in the same voice. "He knows the Future travels *backwards*," they continued. Then they both vanished into the pavement of Highway 261.

THE FOURTH MIRROR DISPLACEMENT:

South of Campeche, on the way to Champoton, mirrors were set on the beach of the Gulf of Mexico. Jade colored water splashed near the mirrors, which were supported by dry seaweed and eroded rocks, but the reflections abolished the supports, and now words abolish the reflections. The unnameable tonalities of blue that were once square tide pools of sky have vanished into the camera, and now rest in the cemetery of the printed page—*Ancora in Arcadia morte*. A sense of arrested breakdown prevails over the level mirror surfaces and the unlevel ground. "The true fiction eradicates the false reality," said the voiceless voice of Chalchihuitlicue—the Surd of the Sea.

The mirror displacement cannot be expressed in rational dimensions. The

distances between the twelve mirrors are shadowed disconnections, where measure is dropped and incomputable. Such mirror surfaces cannot be understood by reason. Who can divulge from what part of the sky the blue color came? Who can say how long the color lasted? Must "blue" mean something? Why do the mirrors display a conspiracy of muteness concerning their very existence? When does a displacement become a misplacement? These are forbidding questions that place comprehension in a predicament. The questions the mirrors ask always fall short of the answers. Mirrors thrive on surds, and generate incapacity. Reflections fall onto the mirrors without logic, and in so doing invalidate every rational assertion. Inexpressible limits are on the other side of the incidents, and they will never be grasped.

THE FIFTH MIRROR DISPLACEMENT:

At Palenque the lush jungle begins. The palisade, Stone Houses, Fortified Houses, Capital of the People of the Snake or City of Snakes are the names this region has been called. Writing about mirrors brings one into a groundless jungle where words buzz incessantly instead of insects. Here in the heat of reason (nobody knows what that is), one tends to remember and think in lumps. What really makes one listless is ill-founded enthusiasm, say the zeal for "pure color." If colors can be pure and innocent, can they not also be impure and guilty?

In the jungle all light is paralyzed. Particles of color infected the molten reflections on the twelve mirrors, and in so doing, engendered mixtures of dark-

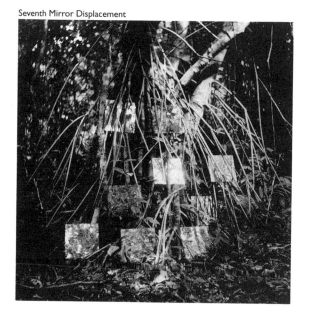

Seventh Mirror Displacement

ness and light. Color as an agent of matter filled the reflected illuminations with shadowy tones, pressing the light into dusty material opacity. Flames of light were imprisoned in a jumbled spectrum of greens. Refracting sparks of sunshine seemed smothered under the weight of clouded mixtures—yellow, green, blue, indigo and violet. The word "color" means at its origin to "cover" or "hide." Matter eats up light and "covers" it with a confusion of color. Luminous lines emanate from the edges of the mirrors, yet the surface reflections manifest nothing but shady greens. Deadly greens that devour light. Acrylic and Day-glo are nothing to these raw states of light and color. Real color is risky, not like the tame stuff that comes out of tubes. We all know that there could never be anything like a "color-pathos" or a pathology of color. How could "yellow is yellow" survive as a malarial tautology? Who in their right mind would ever come up with a concept of perceptual petit mal? Nobody could ever believe that certain shades of green are carriers of chromatic fever. The notion that light is suffering from a color-sickness is both repugnant and absurd. That color is worse than eternity is an affront to enlightened criticism. Everybody knows that "pathetic" colors don't exist. Yet, it is that very lack of "existence" that is so deep, profound, and terrible. There is no chromatic scale down there because all colors are present, spawning agglutinations out of agglutinations. It is the incoherent mass that breeds color and kills light. The poised mirrors seemed to buckle slightly over the uncertain ground. Disjointed square streaks and smudges hovered close to incomprehensible shadows. Proportion was disconnected and in a condition of suspense. The double

Eighth Mirror Displacement

Ninth Mirror Displacement

allure of the ground and the mirrors brought forth apparitions. Out of green reflections came the networks of Coatlicue, known to the Mayans as the Serpent Lady: Mother Earth. Twistings and windings were frozen in the mirrors. On the outskirts of the ruins of Palenque or in the skirts of Coatlicue, rocks were overturned; first the rock was photographed, then the pit that remained. "Under each rock is an orgy of scale," said Coatlicue, while flashing a green snake from a nearby "killer tree" (parasite vines that smother a tree, till they become the tree). Each pit contained miniature earthworks—tracks and traces of insects and other sundry small creatures. In some beetle dung, cobwebs, and nameless slime. In others cocoons, tiny ant nests and raw roots. If an artist could see the world through the eyes of a caterpillar he might be able to make some fascinating art. Each one of these secret dens was also the entrance to the abyss. Dungeons that dropped away from the eyes into a damp cosmos of fungus and mold—an exhibition of clammy solitude.

THE COLLOQUY OF COATLICUE AND CHRONOS

"You don't have to have cows to be a cowboy."

Nudie

COATLICUE: You have no future.

CHRONOS: And you have no past.

COATLICUE: That doesn't leave us much of a present.

CHRONOS: Maybe we are doomed to being merely some "light-years" with missing tenses.

COATLICUE: Or two inefficient memories.

CHRONOS: So this is Palenque.

COATLICUE: Yes; as soon as it was named it ceased to exist.

CHRONOS: Do you think those overturned rocks exist?

COATLICUE: They exist in the same way that undiscovered moons orbiting an unknown planet exist.

CHRONOS: How can we talk about what exists, when we hardly exist ourselves?

COATLICUE: You don't have to have existence to exist.

THE SIXTH MIRROR DISPLACEMENT:

From Ruinas Bonampak to Agua Azul in a single engine airplane with a broken window. Below, the jungle extinguished the ground, and spread the horizon into a smoldering periphery. This perimeter was subject to a double perception by which, on one hand, all escaped to the outside, and on the other, all collapsed inside; no boundaries could hold this jungle together. A dual catastrophe engulfed one "like a point," yet the airplane continued as though nothing had happened. The eyes were circumscribed by a widening circle of vertiginous foliage, all dimensions at that edge were uprooted and flung out-

ward into green blurs and blue haze. But one just continued smoking and laughing. The match boxes in Mexico are odd, they are "things in themselves." While one enjoys a cigarette, he can look at his yellow box of "Clasicos-De Lujo-La Central." The match company has thoughtfully put a reproduction of Venus De Milo on the front cover, and a changing array of "fine arts" on the back cover, such as Pedro Brueghel's *The Blind Leading the Blind*. The sea of leaves below continued to exfoliate and infoliate; it thickened to a great degree. Out of the smoke of a Salem came the voice of Ometecutli—the Dual Being, but one could not hear what he had to say because the airplane engine roared too loudly. Down in the lagoons and swamps one could see *infinite, isotropic, three-dimensional* and *homogeneous space* sinking out of sight. Up and down the plane glided, over the inundating colors in the circular jungle. A fugitive seizure of "clear-air turbulence" tossed the plane about and caused mild nausea. The jungle grows only by means of its own negation—art does the same. Inexorably the circle tightened its coils as the plane gyrated over the landing strip. The immense horizon contracted its endless rings. Lower and lower into the vortex of Agua Azul, into the calm infernal center, and into the flaming spiral of Xiuhtecutli. Once on the ground another match was struck—the dugouts on the Rio Usumacinta were waiting.

The current of the river carried one swiftly along. Perception was stunned by small whirlpools suddenly bubbling up till they exhausted themselves into minor rapids. No isolated moment on the river, no fixed point, just flickering moments of tumid duration. Iguanas sunning themselves on the incessant shores. Hyperbole touched the bottom of the literal. An excess of green sunk any upward movement. Today, we are afflicted with an inversion of hyperbole—*gravity*. Rivers of Lead. Lakes of Asphalt. Heavy water. Generalized mud. The Caretaker of Dullness—habit—lurks everywhere. Tlazolteotl Eater of Filth rules. Near a pile of rubble in the river, by what was once one of the Temples of Yaxchilan, the dugout stopped. On a high sandbank the mirrors were placed.

THE SEVENTH MIRROR DISPLACEMENT:

Yaxchilan may not be wasted (or, as good as waste, doomed to wasting) but still building itself out of secrets and shadows. On a multifarious confusion of ruins are frail huts made of sticks with thatched roofs. The world of the Maya and its cosmography has been deformed and beaten down by the pressure of years. The natives at Yaxchilan are weary because of that long yesterday, that unending calamitous day. They might even be disappointed by the grand nullity of their own past attainments. Shattered recesses with wild growths of creepers and weeds disclosed a broken geometry. Turning the pages of a book on Mayan temples, one is relieved of the futile and stupefying mazes of the tropical density. The load of actual, on-the-spot perception is drained away into banal appreciation. The ghostly photographic remains are sapped memories, a

Olmec Jaguar Mask, La Venta, Mexico. Covered by the Olmecs under 500 tons of clay and a platform of orange and yellow bricks, still discernible in embankment.

mock reality of decomposition. Pigs run around the tottering masses, and so do tourists. Horizons were submerged and suffocated in an asphyxiation of vanishing points. Archeologists had tried to transport a large stone stele out of the region by floating it on dugouts up the Usumacinta to Agua Azul, but they couldn't get it into an airplane, so they had to take it back to Yaxchilan. There it remains today, collecting moss—a monument to Sisyphus. Near this stele, the mirrors were balanced in a tentacled tree. A giant vegetable squid inverted in the ground. Sunrays filtered into the reflections. The displacement addressed itself to a teeming frontality that made the tree into a jumbled wall full of snarls and tangles. The mirror surfaces being disconnected from each other "destructuralized" any literal logic. Up and down parallels were dislocated into twelve centers of gravity.

A precarious balance existed somewhere between the tree and the dead leaves. The gravity lost itself in a web of possibilities; as one looked more and more possibilities emerged because nothing was certain. Nine of the twelve mirrors in the photograph are plainly visible, two have sunk into shadow. One on the lower right is all but eclipsed. The displacement is divided into five rows. On the site the rows would come and go as the light fell. Countless chromatic patches were wrecked on the mirrors, flakes of sunshine dispersed over the reflecting surfaces and obliterated the square edges, leaving indistinct pulverizations of color on an indeterminate grid. A mirror on the third row

jammed between two branches flashed into dematerialization. Other mirrors escaped into visual extinguishment. Bits of reflected jungle retreated from one's perception. Each point of focus spilled into cavities of foliage. Glutinous light submerged vision under a wilderness of unassimilated seeing. Scraps of sight accumulated until the eyes were engulfed by scrambled reflections. What was seen reeled off into indecisive zones. The eyes seemed to look. Were they looking? Perhaps. Other eyes were looking. A Mexican gave the displacement a long, imploring gaze. Even if you cannot look, others will look for you. Art brings sight to a halt, but that halt has a way of unravelling itself. All the reflections expired into the thickets of Yaxchilan. One must remember that writing on art replaces presence by absence by substituting the abstraction of language for the real thing. There was a friction between the mirrors and the tree; now there is a friction between language and memory. A memory of reflections becomes an absence of absences.

On this site the third upside-down tree was planted. The first is in Alfred, New York State, the second is in Captiva Island, Florida; lines drawn on a map will connect them. Are they totems of rootlessness that relate to one another? Do they mark a dizzy path from one doubtful point to another? Is this a mode of travel that does not in the least try to establish a coherent coming and going between the here and the there? Perhaps they are dislocated "North and South poles" marking peripheral places, polar regions of the mind fixed in mundane matter—poles that have slipped from the geographical moorings of the world's axis. Central points that evade being central. Are they dead roots that haplessly hang off inverted trunks in a vast "no man's land" that drifts toward vacancy? In the riddling zones, nothing is for sure. Nevertheless, flies are attracted to such riddles. Flies would come and go from all over to look at the upside-down trees, and peer at them with their compound eyes. What the fly sees is "something a little worse than a newspaper photograph as it would look to us under a magnifying glass." (See *Animals Without Backbones*, Ralph Buchsbaum.) The "trees" are dedicated to the flies. Dragonflies, fruit flies, horseflies. They are all welcome to walk on the roots with their sticky, padded feet, in order to get a close look. *Why should flies be without art?*

THE EIGHTH MIRROR DISPLACEMENT:

Against the current of the Usumacinta the dugout headed for the Island of Blue Waters. The island annihilates itself in the presence of the river, both in fact and mind. Small bits of sediment dropped away from the sand flats into the river. Small bits of perception dropped away from the edges of eyesight. Where is the island? The unknowable zero island. Were the mirrors mounted on something that was dropping, draining, eroding, trickling, spilling away? Sight turned away from its own looking. Particles of matter slowly crumbled down the slope that held the mirrors. Tinges, stains, tints, and tones crumbled into the eyes. The eyes became two wastebaskets filled with diverse colors, var-

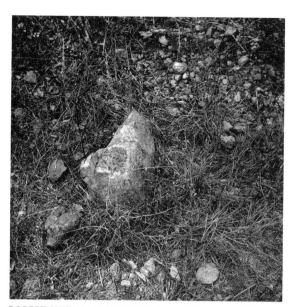

ROBERT SMITHSON, *Overturned Rock*, Uxmal (first phase), 1969.

ROBERT SMITHSON, *Overturned Rock*, Uxmal (second phase), 1969.

iegations, ashy hues, blotches and sunburned chromatics. To reconstruct what the eyes see in words, in an "ideal language" is a vain exploit. Why not reconstruct one's inability to see? Let us give passing shape to the unconsolidated views that surround a work of art, and develop a type of "anti-vision" or negative seeing. The river shored up clay, loess, and similar matter, that shored up the slope, that shored up the mirrors. The mind shored up thoughts and memories, that shored up points of view, that shored up the swaying glances of the eyes. Sight consisted of knotted reflections bouncing off and on the mirrors and the eyes. Every clear view slipped into its own abstract slump. All viewpoints choked and died on the tepidity of the tropical air. The eyes, being infected by all kinds of nameless tropisms, couldn't see straight. Vision sagged, caved in, and broke apart. Trying to look at the mirrors took the shape of a game of pool under water. All the clear ideas of what had been done melted into perceptual puddles, causing the brain to gurgle thoughts. Walking conditioned sight, and sight conditioned walking, till it seemed only the feet could see. Squinting helped somewhat, yet that didn't keep views from tumbling over each other. The oblique angles of the mirrors disclosed an altitude so remote that bits of "place" were cast into a white sky. How could that section of visibility be put together again? Perhaps the eyes should have been screwed up into a sharper focus. But no, the focus was at times cock-eyed, at times myopic, overexposed, or cracked. Oh, for the happy days of pure walls and pure floors! Flatness was nowhere to be found. Walls of collapsed mud, and floors of bleached detritus replaced the flatness of rooms. The eyes crawled over grains, chips, and other jungle obstructions. From the blind side reflections studded the shore—into an anti-vision. Outside this island are other islands of incom-

mensurable dimension. For example, the Land of Mu, built on "shaky ground" by Ignatius Donnelly in his book *Atlantis, the Antediluvian World*, 1882, based on an imaginative translation of Mayan script by Diego de Landa.[1] The memory of what is not may be better than the amnesia of what is.

THE NINTH MIRROR DISPLACEMENT:

Some "enantiomorphic" travel through Villahermosa, Frontera, Ciudad del Carmen, past the Laguna de Terminos. Two asymmetrical trails that mirror each other could be called enantiomorphic after those two common enantiomorphs—the right and left hands. Eyes are enantiomorphs. Writing the reflection is supposed to match the physical reality, yet somehow the enantiomorphs don't quite fit together. The right hand is always at variance with the left. Villahermosa on the map is an irregular yellow shape with a star in it. Villahermosa on the earth is an irregular yellow shape with no star in it. Frontera and Ciudad del Carmen are white circles with black rings around them. Frontera and Ciudad del Carmen on the earth are white circles with no black rings around them. You say nobody was looking when they passed through those cities. You may be right, but then you may be wrong. You are caught in your own enantiomorph.

The double aspect of Quetzalcoatl is less a person than an operation of totemic perception. Quetzalcoatl becomes one half of an enantiomorph (*coatl* means twin) in search of the other half. A mirror looking for its reflection but never quite finding it. The morning star of *Quetzal* is apt to be polarized in the shadowy reflection of the evening star. The journeys of Quetzalcoatl are recorded in Sahagun's *Historia Universal de las Cosas de Nueva Espana*, parts of which are translated into English in *The Gods of Mexico* by C. A. Burland. In Sahagun's Book III, Chapter XIII, "Which tells of the departure of Quetzalcoatl towards Tlapallan (the place of many colours) and of the things he performed on the way thither," Quetzalcoatl rested near a great tree (Quanhtitlan). Quetzalcoatl looked into his "obsidian mirror" and said "Now I become aged." "The name of that place has ever afterwards been Ucuetlatitlan (Beside the Tree of Old Age). Suddenly he seized stones from the path and threw them against the unlucky tree. For many years thereafter the stones remained encrusted in the ancient tree." By traveling with Quetzalcoatl one becomes aware of primordial time or final time—The Tree of Rocks. (A memo for a possible "earthwork"—balance slabs of rock in tree limbs.) But if one wishes to be ingenious enough to erase time one requires mirrors, not rocks. A strange thing, this branching mode of travel: one perceives in every past moment a parting of ways, a highway spreads into a bifurcating and trifurcating region of zigzags. Near Sabancuy the last displacement in the cycle was done. In mangrove (also called mangrave) branches and roots mirrors were suspended. There will be those who will say "that's getting close to nature." But what is meant by such "nature" is anything but natural. When the conscious

artist perceives "nature" everywhere he starts detecting falsity in the apparent thickets, in the appearance of the real, and in the end he is skeptical about all notions of existence, objects, reality, etc. Art works out of the inexplicable. Contrary to affirmations of nature, art is inclined to semblances and masks, it flourishes on discrepancy. It sustains itself not on differentiation, but dedifferentiation, not on creation but decreation, not on nature but denaturalization, etc. Judgments and opinions in the area of art are doubtful murmurs in mental mud. Only appearances are fertile; they are gateways to the primordial. Every artist owes his existence to such mirages. The ponderous illusions of solidity, the non-existence of things, is what the artist takes for "materials." It is this absence of matter that weighs so heavy on him, causing him to invoke gravity. Actual delirium is devoid of insanity; if insanity existed it would break the spell of productive apathy. Artists are not motivated by a need to communicate; travel over the unfathomable is the only condition.

> Living beings dwell in their expectations rather than in their senses. If they are ever to see what they see, they must first in a manner stop living; they must suspend the will, as Schopenhauer put it, they must photograph the idea that is flying past, veiled in its very swiftness.
>
> George Santayana, *Scepticism and Animal Faith*

If you visit the sites (a doubtful probability) you find nothing but memory-traces, for the mirror displacements were dismantled right after they were

ROBERT SMITHSON, *Second Upside-down Tree*, 1969. Captiva Island, Florida.

ROBERT SMITHSON, *The Map of Glass*, built at Loveladies, N.J. 1969 (detail).

photographed. The mirrors are somewhere in New York. The reflected light has been erased. Remembrances are but numbers on a map, vacant memories constellating the intangible terrains in deleted vicinities. It is the dimension of absence that remains to be found. The expunged color that remains to be seen. The fictive voices of the totems have exhausted their arguments. Yucatan is elsewhere.

NOTES

1. This is just one of thousands of hypothetical arguments in favor of Atlantis. Conjectural maps that point to this non-existent site fill many unread atlases. It very well could be that the Maya writings that alluded to "the Old Serpent covered with green feathers, who lies in the Ocean" was Quetzalcoatl or the Sargasso Sea. Every wayward geographer of Atlantis has his own curious theory, they never seem to be alike. From Plato's *Timaeus* to *Codex Vaticanus A* the documents of the lost island proliferate. On a site in Loveladies, Long Beach Island, New Jersey a map of tons of clear broken glass will follow Mr. Scott-Elliot's map of Atlantis. Other *Maps of Broken Glass (Atlantis)* will follow, each with its own odd limits.

 Outside in the open air the glass map under the cycles of the sun radiates brightness without electric technology. Light is separable from color and form. It is a shimmering collapse of decreased sharpness, poised on broken points showing the degrees of reflected incandescence. Color is the diminution of light. The cracked transparency of the glass heaps diffuses the daylight of the actual solar source—nothing is fused or connected. The light of exploding magma on the sun is cast on to Atlantis, and ends in a cold luminosity. The heat of the solar rays collides with the spheres of gases that enclose the Earth. Like the glass, the rays are shattered, broken bits of energy, no stronger than moonbeams. A luciferous incest of light particles flashes into a brittle mass. A stagnant blaze sinks into the glassy map of a non-existent island. The sheets of glass leaning against each other allow the sunny flickers to slide down into hidden fractures of splintered shadow. The map is a series of "upheavals" and "collapses"—a strata of unstable fragments is arrested by the friction of stability.

THE ARTIST AND POLITICS: A SYMPOSIUM (1970)

The symposium question was, "A growing number of artists have begun to feel the need to respond to the deepening political crisis in America. Among these artists, however, there are serious differences concerning their relations to direct political actions. Many feel that the political implications of their work constitute the most profound political action they can take. Others, not denying this, continue to feel the need for an immediate, direct political commitment. Still others feel that their work is devoid of political meaning and that their political lives are unrelated to their art. What is your position regarding the kinds of political action that sould be taken by artists?"

The artist does not have to *will* a response to the "deepening political crisis in America." Sooner or later the artist is implicated or devoured by politics without even trying. My "position" is one of sinking into an awareness of global squalor and futility. The rat of politics always gnaws at the cheese of art. The trap is set. If there's an original curse, then politics has something to do with it. Direct political action becomes a matter of trying to pick poison out of boiling stew. The pain of this experience accelerates a need for more and more actions. "Actions speak louder than words." Such loud actions pour in on one like quicksand—one doesn't have to start one's own action. Actions swirl around one so fast they appear inactive. From a deeper level of "the deepening political crisis," the best and the worst actions run together and surround one in the inertia of a whirlpool. The bottom is never reached, but one keeps dropping into a kind of political centrifugal force that throws the blood of atrocities onto those working for peace. The horror becomes so intense, so imprisoning that one is overwhelmed by a sense of *disgust*.

Conscience-stricken, the artist wants to stop the massive hurricane of carnage, to separate the liberating revolution from the repressive war machine. Of course, he sides with the revolution, then he discovers that real revolution means violence too. Gandhi is invoked, but Gandhi was assassinated. Artists always feel sympathy for victims. Yet, politics thrives on cruel sacrifices. Artists tend to be tender; they have an acute fear of blood baths and revolutionary terror. The political system that now controls the world on every level should be denied by art. Yet, why are so many artists now attracted to the dangerous world of politics? Perhaps, at the bottom, artists like anybody else yearn for that unbearable situation that politics leads to: the threat of pain, the horror of annihilation, that would end in calm and peace. Disgust generated by fear creates a personal panic, that seeks relief in sacrifice. Primitive sacrifices controlled

Artforum, September 1970; Smithson's title was "Art and the Political Whirlpool or the Politics of Disgust"

by religious rites were supposed to extract life from death. The blind surge of life, I'm afraid, threatens itself. Modern sacrifices become a matter of chance and randomness. Nobody can face the absolute limit of death.

Student and police riots on a deeper level are ceremonial sacrifices based on a primal contingency—not a rite but an accident. Nevertheless, because of media co-option, the riots are being structured into rites. The students are a "life force" as opposed to the police "death force." Abbie Hoffman makes reference to William Golding's *Lord of the Flies* on page 184 of *Revolution for the Hell of It;* Golding's pig devil surrounded by flies is compared by Hoffman to an "unbelievable smell of decay and shit." Golding's novel abounds in images of piggishness; there is the fat boy called Piggy, and the rotten head of a pig. The overall mood of the novel is one of original disgust. One must remember that this novel was very popular with students some years ago. Life is swollen like Piggy and this is disappointing, the clean world of capitalism begins to stink, "the sexual channels are also the body's sewers" (George Bataille), nausea and repugnance bring one to the brink of violence. Only the fires of hell can burn away the slimy, maggot-ridden decomposition that exists in life, hence *Revolution for the Hell of It.*

"Then the rest joined in, making pig-dying noises and shouting." (*Lord of the Flies.*) As time goes by, pollution and other excreta are liable to turn the planet Earth into a more horrible pigpen. Perhaps, the moon landing was one of the most demoralizing events in history, in that the media revealed the planet Earth to be a limited closed system, not unlike the island in *Lord of the Flies.* As the Earth thickens with blood and waste, as the population increases, the stress factor could bring "the system" to total frenzy. Imagine a future where eroticism and love are under so much pressure and savagery that they veer towards cannibalism. When politics is controlled by the military, with its billions of dollars, the result is a debased demonology, a social aberration that operates with the help of Beelzebub (the pig devil) between the regions of Mammon and Moloch.

GYROSTASIS (1970)

The title GYROSTASIS refers to a branch of physics that deals with rotating bodies, and their tendency to maintain their equilibrium. The work is a standing triangulated spiral. When I made the sculpture I was thinking of mapping procedures that refer to the planet Earth. One could consider it as a crystallized fragment of a gyroscopic rotation, or as an abstract three dimensional map that points to the SPIRAL JETTY, 1970 in the Great Salt Lake, Utah. GYROSTASIS is relational, and should not be considered as an isolated object.

ROBERT SMITHSON, *Gyrostasis*, 1968. Painted steel, 73 x 57 x 40".

Written in 1970; published in *Hirshhorn Museum and Sculpture Garden Catalog*, 1974

ROBERT SMITHSON, *400 Seattle Horizons*, 1969. (Destroyed, Instamatic snapshots.)
"We are lost between the abyss within us and the boundless horizons outside us."

A CINEMATIC ATOPIA (1971)

Going to the cinema results in an immobilization of the body. Not much gets in the way of one's perception. All one can do is look and listen. One forgets where one is sitting. The luminous screen spreads a murky light throughout the darkness. Making a film is one thing, viewing a film another. Impassive, mute, still the viewer sits. The outside world fades as the eyes probe the screen. Does it matter what film one is watching? Perhaps. One thing all films have in common is the power to take perception elsewhere. As I write this, I'm trying to remember a film I liked, or even one I didn't like. My memory becomes a wilderness of elsewheres. How, in such a condition, can I write about film? I don't know. I could know. But I would rather not know. Instead, I will allow the elsewheres to reconstruct themselves as a tangled mass. Somewhere at the bottom of my memory are the sunken remains of all the films I have ever seen, good and bad they swarm together forming cinematic mirages, stagnant pools of images that cancel each other out. A notion of the abstractness of films crosses my mind, only to be swallowed up in a morass of Hollywood garbage. A pure film of lights and darks slips into a dim landscape of countless westerns. Some sagebrush here, a little cactus there, trails and hoofbeats going nowhere. The thought of a film with a "story" makes me listless. How many stories have I seen on the screen? All those "characters" carrying out dumb tasks. Actors doing exciting things. It's enough to put one into a permanent coma.

Let us assume I have a few favorites *Ikiru?* also called *Living, To Live, Doomed.*

Artforum, September 1971

No, that won't do. Japanese films are too exhausting. Taken as a lump, they remind me of a recording by Captain Beef Heart called *Japan in a Dishpan*. There's always Satyajit Ray for a heavy dose of tedium, if you're into tedium. Actually, I tend to prefer lurid sensationalism. For that I must turn to some English director, Alfred Hitchcock will do. You know, the shot in *Psycho* where Janet Leigh's eye emerges from the bathtub drain after she's been stabbed. Then there's always the *Expanded Cinema*, as developed by Gene Youngblood, complete with an introduction by "Bucky" Fuller. *Rats for Breakfast* could be a hypothetical film directed by the great utopian himself. It's not hard to consider cinema expanding into a deafening pale abstraction controlled by computers. At the fringes of this expanse one might discover the deteriorated images of Hollis Frampton's *Maxwell's Demon?* After the "structural film" there is the sprawl of entropy. The monad of cinematic limits spills out into a state of stupefaction. We are faced with inventories of limbo.

If I could only map this limbo with dissolves, you might have some notion as to where it is. But that is impossible. It could be described as a cinematic borderland, a landscape of rejected film clips. To be sure it is a neglected place, if we can even call it a "place." If there was ever a film festival in limbo it would be called "Oblivion." The awkwardness of amateur snapshots brings this place somewhat into focus. The depraved animation that George Landow employed in one of his films somewhat locates the region. A kind of aphasia orders this

ROBERT SMITHSON, Stills from *Spiral Jetty*, 1970.

teetering realm. Not one order but many orders clash with one another, as do "facts" in an obsolete encyclopedia.

If we put together a film encyclopedia in limbo, it would be quite groundless. Categories would destroy themselves, no law or plan would hold itself together for very long. There would be no table or contents for the Table of Contents. The index would slither away into so much cinematic slime. For example, I could make a film based (or debased) on the A section of the index in *Film Culture Reader*. Each reference would consist of a 30-second take. Here is a list of the takes in alphabetical order: Abstract Expressionism, Agee James, Alexandrov Grigory, Allen Lewis, Anger Kenneth, Antonioni Michelangelo, Aristarco Guido, Arnheim Rudolf, Artaud Antonin, Astruc Alexandre. Only the letter A gives this index its order. Where is the coherence? The logic threatens to wander out of control.

In this cinematic atopia orders and groupings have a way of proliferating outside their original structure or meaning. There is nothing more tentative than an established order. What we *take* to be the most concrete or solid often turns into a concatenation of the unexpected. Any order can be reordered. What seems to be without order, often turns out to be highly ordered. By iso-

ROBERT SMITHSON, Stills from *Spiral Jetty*, 1970.

lating the most unstable thing, we can arrive at some kind of coherence, at least for awhile. The simple rectangle of the movie screen contains the flux, no matter how many different orders one presents. But no sooner have we fixed the order in our mind than it dissolves into limbo. Tangled jungles, blind paths, secret passages, lost cities invade our perception. The sites in films are not to be located or trusted. All is out of proportion. Scale inflates or deflates into uneasy dimensions. We wander between the towering and the bottomless. We are lost between the abyss within us and the boundless horizons outside us. Any film wraps us in uncertainty. The longer we look through a camera or watch a projected image the remoter the world becomes, yet we begin to understand that remoteness more. Limits trap the illimitable, until the spring we discovered turns into a flood. "A camera filming itself in a mirror would be the ultimate movie," says Jean-Luc Godard.

The ultimate film goer would be a captive of sloth. Sitting constantly in a movie house, among the flickering shadows, his perception would take on a kind of sluggishness. He would be the hermit dwelling among the elsewheres, forgoing the salvation of reality. Films would follow films, until the action of each one would drown in a vast reservoir of pure perception. He would not be

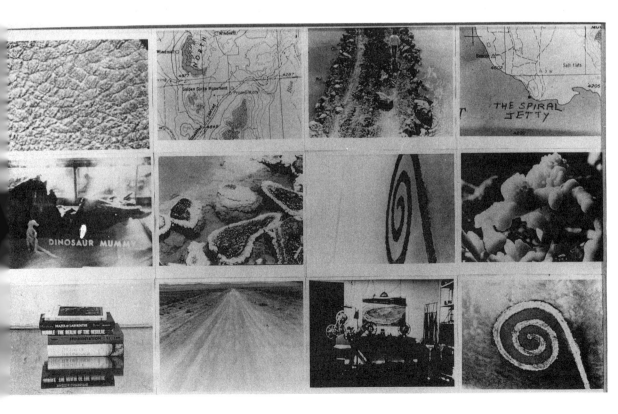

able to distinguish between good or bad films, all would be swallowed up into an endless blur. He would not be watching films, but rather experiencing blurs of many shades. Between blurs he might even fall asleep, but that wouldn't matter. Sound tracks would hum through the torpor. Words would drop through this languor like so many lead weights. This dozing consciousness would bring about a tepid abstraction. It would increase the gravity of perception. Like a tortoise crawling over a desert, his eyes would crawl across the screen. All films would be brought into equilibrium—a vast mud field of images forever motionless. But ultimate movie-viewing should not be encouraged, any more than ultimate movie-making.

What I would like to do is build a cinema in a cave or an abandoned mine, and film the process of its construction. That film would be the only film shown in the cave. The projection booth would be made out of crude timbers, the screen carved out of a rock wall and painted white, the seats could be boulders. It would be a truly "underground" cinema. This would mean visiting many caves and mines. Once when I was in Vancouver, I visited Britannia Copper Mines with a cameraman intending to make a film, but the project dissolved. The tunnels in the mine were grim and wet. I remember a horizontal tunnel that bored into the side of a mountain. When one was at the end of the tunnel inside the mine, and looked back at the entrance, only a pinpoint of light was visible. One shot I had in mind was to move slowly from the interior of the tunnel towards the entrance and end outside. In the Cayuga Rock Salt Mine under Lake Cayuga in New York State I did manage to get some still shots of mirrors stuck in salt piles, but no film. Yet another ill-fated project involved the American Cement Mines in California—I wanted to film the demolition of a disused cavern. Nothing was done.

THE SPIRAL JETTY (1972)

Red is the most joyful and dreadful thing in the physical universe; it is the fiercest note, it is the highest light, it is the place where the walls of this world of ours wear the thinnest and something beyond burns through.

G. K. Chesterton

My concern with salt lakes began with my work in 1968 on the Mono Lake Site-Nonsite in California.[1] Later I read a book called *Vanishing Trails of Atacama* by William Rudolph which described salt lakes (salars) in Bolivia in all stages of desiccation, and filled with micro bacteria that give the water surface a red color. The pink flamingos that live around the salars match the color of the water. In *The Useless Land*, John Aarons and Claudio Vita-Finzi describe Laguna Colorada: "The basalt (at the shores) is black, the volcanos purple, and their exposed interiors yellow and red. The beach is grey and the lake pink, topped with the icing of iceberg-like masses of salts."[2] Because of the remoteness of Bolivia and because Mono Lake lacked a reddish color, I decided to investigate the Great Salt Lake in Utah.

Arts of the Environment, edited by Gyorgy Kepes, 1972

This and the following illustrations show the *Spiral Jetty,* Great Salt Lake, Utah, April 1970. Coil 1500' long and approximately 15' wide. Black rock, salt crystals, earth, red water (algae). All photos are by Gianfranco Gorgoni.

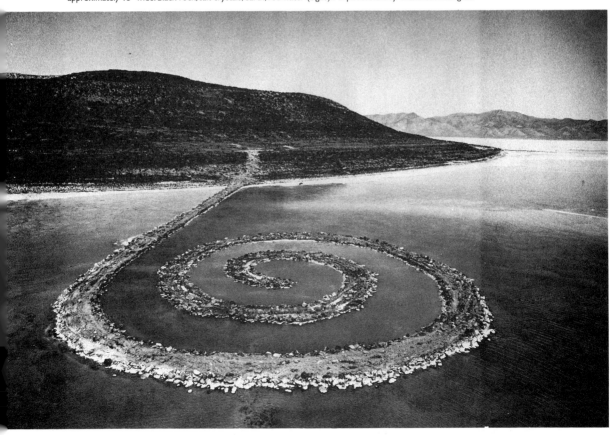

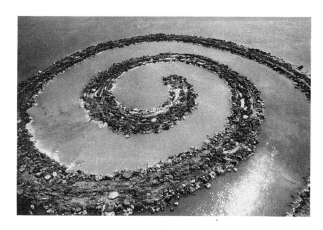 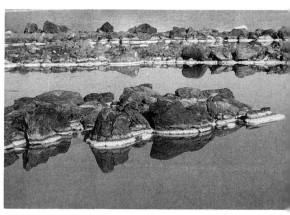

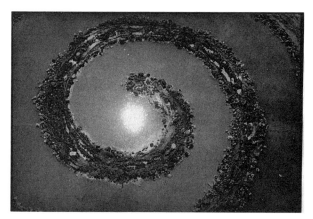

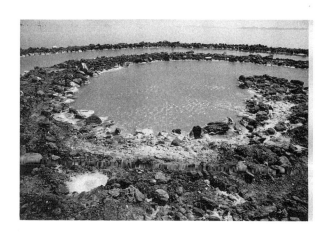 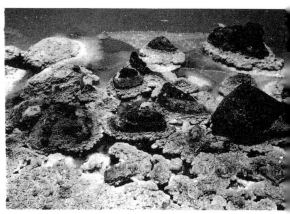

From New York City I called the Utah Park Development and spoke to Ted Tuttle, who told me that water in the Great Salt Lake north of the Lucin Cutoff, which cuts the lake in two, was the color of tomato soup. That was enough of a reason to go out there and have a look. Tuttle told my wife, Nancy Holt, and myself of some people who knew the lake. First we visited Bill Holt who lived in Syracuse. He was instrumental in building a causeway that connected Syracuse with Antelope Island in the southern part of the Great Salt Lake. Although that site was interesting, the water lacked the red coloration I was looking for, so we continued our search. Next we went to see John Silver on Silver Sands Beach near Magna. His sons showed us the only boat that sailed the lake. Due to the high salt content of the water it was impractical for ordinary boats to use the lake, and no large boats at all could go beyond the Lucin Cutoff on which the transcontinental railroad crossed the lake. At that point I was still not sure what shape my work of art would take. I thought of making an island with the help of boats and barges, but in the end I would let the site determine what I would build. We visited Charles Stoddard, who supposedly had the only barge on the north side of the cutoff. Stoddard, a well-driller, was one of the last homesteaders in Utah. His attempt to develop Carrington Island in 1932 ended in failure because he couldn't find fresh water. "I've had the lake," he said. Yet, while he was living on the island with his family he made many valuable observations of the lake. He was kind enough to take us to Little Valley on the east side of the Lucin Cutoff to look for his barge—it had sunk. The abandoned man-made harbors of Little Valley gave me my first view of the wine-red water, but there were too many "Keep Out" signs around to make that a practical site for anything, and we were told to "stay away" by two angry ranchers. After fixing a gashed gas tank, we returned to Charles Stoddard's house north of Syracuse on the edge of some salt marshes. He showed us photographs he had taken of "icebergs,"[3] and Kit Carson's cross carved on a rock on Fremont Island. We then decided to leave and go to Rozel Point.

Driving west on Highway 83 late in the afternoon, we passed through Corinne, then went on to Promontory. Just beyond the Golden Spike Monument, which commemorates the meeting of the rails of the first transcontinental railroad, we went down a dirt road in a wide valley. As we traveled, the valley spread into an uncanny immensity unlike the other landscapes we had seen. The roads on the map became a net of dashes, while in the far distance the Salt Lake existed as an interrupted silver band. Hills took on the appearance of melting solids, and glowed under amber light. We followed roads that glided away into dead ends. Sandy slopes turned into viscous masses of perception. Slowly, we drew near to the lake, which resembled an impassive faint violet sheet held captive in a stoney matrix, upon which the sun poured down its crushing light. An expanse of salt flats bordered the lake, and caught in its sediments were countless bits of wreckage. Old piers were left high and dry. The mere sight of the trapped fragments of junk and waste transported one into a

world of modern prehistory. The products of a Devonian industry, the remains of a Silurian technology, all the machines of the Upper Carboniferous Period were lost in those expansive deposits of sand and mud.

Two dilapidated shacks looked over a tired group of oil rigs. A series of seeps of heavy black oil more like asphalt occur just south of Rozel Point. For forty or more years people have tried to get oil out of this natural tar pool. Pumps coated with black stickiness rusted in the corrosive salt air. A hut mounted on pilings could have been the habitation of "the missing link." A great pleasure arose from seeing all those incoherent structures. This site gave evidence of a succession of man-made systems mired in abandoned hopes.

About one mile north of the oil seeps I selected my site. Irregular beds of limestone dip gently eastward, massive deposits of black basalt are broken over the peninsula, giving the region a shattered appearance. It is one of few places on the lake where the water comes right up to the mainland. Under shallow pinkish water is a network of mud cracks supporting the jig-saw puzzle that composes the salt flats. As I looked at the site, it reverberated out to the horizons only to suggest an immobile cyclone while flickering light made the entire landscape appear to quake. A dormant earthquake spread into the fluttering stillness, into a spinning sensation without movement. This site was a rotary that enclosed itself in an immense roundness. From that gyrating space emerged the possibility of the Spiral Jetty. No ideas, no concepts, no systems, no structures, no abstractions could hold themselves together in the actuality of that evidence. My dialectics of site and nonsite whirled into an indeterminate state, where solid and liquid lost themselves in each other. It was as if the mainland oscillated with waves and pulsations, and the lake remained rock still. The shore of the lake became the edge of the sun, a boiling curve, an explosion rising into a fiery prominence. Matter collapsing into the lake mirrored in the shape of a spiral. No sense wondering about classifications and categories, there were none.

After securing a twenty year lease on the meandering zone,[4] and finding a contractor in Ogden, I began building the jetty in April, 1970. Bob Phillips, the foreman, sent two dump trucks, a tractor, and a large front loader out to the site. The tail of the spiral began as a diagonal line of stakes that extended into the meandering zone. A string was then extended from a central stake in order to get the coils of the spiral. From the end of the diagonal to the center of the spiral, three curves coiled to the left. Basalt and earth were scooped up from the beach at the beginning of the jetty by the front loader, then deposited in the trucks, whereupon the trucks backed up to the outline of stakes and dumped the material. On the edge of the water, at the beginning of the tail, the wheels of the trucks sank into a quagmire of sticky gumbo mud. A whole afternoon was spent filling in this spot. Once the trucks passed that problem, there was always the chance that the salt crust resting on the mud flats would break through. The Spiral Jetty was staked out in such a way as to avoid the soft

muds that broke up through the salt crust; nevertheless there were some mud fissures that could not be avoided. One could only hope that tension would hold the entire jetty together, and it did. A cameraman was sent by the Ace Gallery in Los Angeles to film the process.

The scale of the Spiral Jetty tends to fluctuate depending on where the viewer happens to be. Size determines an object, but scale determines art. A crack in the wall if viewed in terms of scale, not size, could be called the Grand Canyon. A room could be made to take on the immensity of the solar system. Scale depends on one's capacity to be conscious of the actualities of perception. When one refuses to release scale from size, one is left with an object or language that *appears* to be certain. For me scale operates by uncertainty. To be in the scale of the Spiral Jetty is to be out of it. On eye level, the tail leads one into an undifferentiated state of matter. One's downward gaze pitches from side to side, picking out random depositions of salt crystals on the inner and outer edges, while the entire mass echoes the irregular horizons. And each cubic salt crystal echoes the Spiral Jetty in terms of the crystal's molecular lattice. Growth in a crystal advances around a dislocation point, in the manner of a screw. The Spiral Jetty could be considered one layer within the spiraling crystal lattice, magnified trillions of times.

This description echoes and reflects Brancusi's sketch of James Joyce as a "spiral ear" because it suggests both a visual and an aural scale, in other words it indicates a sense of scale that resonates in the eye and the ear at the same time. Here is a reinforcement and prolongation of spirals that reverberates up and down space and time. So it is that one ceases to consider art in terms of an "object." The fluctuating resonances reject "objective criticism," because that would stifle the generative power of both visual and auditory scale. Not to say that one resorts to "subjective concepts," but rather that one apprehends what is around one's eyes and ears, no matter how unstable or fugitive. One seizes the spiral, and the spiral becomes a seizure.

After a point, measurable steps ("Scale skal n. it. or L; it. *Scala*; L *scala* usually *scalae* pl., 1. a. originally a ladder; a flight of stairs; hence, b. a means of ascent")[5] descend from logic to the "surd state." The rationality of a grid on a map sinks into what it is supposed to define. Logical purity suddenly finds itself in a bog, and welcomes the unexpected event. The "curved" reality of sense perception operates in and out of the "straight" abstractions of the mind. The flowing mass of rock and earth of the Spiral Jetty could be trapped by a grid of segments, but the segments would exist only in the mind or on paper. Of course, it is also possible to translate the mental spiral into a three-dimensional succession of measured lengths that would involve areas, volumes, masses, moments, pressures, forces, stresses, and strains; but in the Spiral Jetty the surd takes over and leads one into a world that cannot be expressed by number or rationality. Ambiguities are admitted rather than rejected, contradictions are increased rather than decreased—the *alogos* undermines the *logos*. Purity is put in jeopardy. I

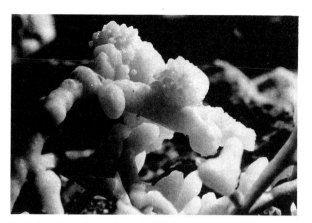

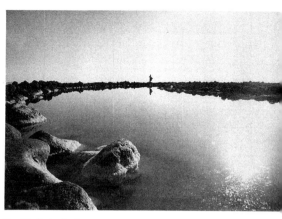

Detail of tumbleweed coated with salt crystals.

The *Spiral Jetty*, detail.

took my chances on a perilous path, along which my steps zigzagged, resembling a spiral lightning bolt. "We have found a strange footprint on the shores of the unknown. We have devised profound theories, one after another, to account for its origin. At last, we have succeeded in constructing the creature that made the footprint. And lo! it is our own."[6] For my film (a film is a spiral made up of frames) I would have myself filmed from a helicopter (from the Greek *helix, helikos* meaning spiral) directly overhead in order to get the scale in terms of erratic steps.

Chemically speaking, our blood is analogous in composition to the primordial seas. Following the spiral steps we return to our origins, back to some pulpy protoplasm, a floating eye adrift in an antediluvian ocean. On the slopes of Rozel Point I closed my eyes, and the sun burned crimson through the lids. I opened them and the Great Salt Lake was bleeding scarlet streaks. My sight was saturated by the color of red algae circulating in the heart of the lake, pumping into ruby currents, no they were veins and arteries sucking up the obscure sediments. My eyes became combustion chambers churning orbs of blood blazing by the light of the sun. All was enveloped in a flaming chromosphere; I thought of Jackson Pollock's *Eyes in the Heat* (1946; Peggy Guggenheim Collection). Swirling within the incandescence of solar energy were sprays of blood. My movie would end in sunstroke. Perception was heaving, the stomach turning, I was on a geologic fault that groaned within me. Between heat lightning and heat exhaustion the spiral curled into vaporization. I had the red heaves, while the sun vomited its corpuscular radiations. Rays of glare hit my eyes with the frequency of a Geiger counter. Surely, the storm clouds massing would turn into a rain of blood. Once, when I was flying over the lake, its surface seemed to hold all the properties of an unbroken field of raw meat with gristle (foam); no doubt it was due to some freak wind action. Eyesight is often slaughtered by the other senses, and when that happens it becomes necessary to seek out dispassionate abstractions. The dizzying spiral yearns for the assurance of geometry. One wants to retreat into the cool rooms of reason.

But no, there was Van Gogh with his easel on some sun-baked lagoon painting ferns of the Carboniferous Period. Then the mirage faded into the burning atmosphere.

From the center of the Spiral Jetty

North — Mud, salt crystals, rocks, water
North by East — Mud, salt crystals, rocks, water
Northeast by North — Mud, salt crystals, rocks, water
Northeast by East — Mud, salt crystals, rocks, water
East by North — Mud, salt crystals, rocks, water
East — Mud, salt crystals, rocks, water
East by South — Mud, salt crystals, rocks, water
Southeast by East — Mud, salt crystals, rocks, water
Southeast by South — Mud, salt crystals, rocks, water
South by East — Mud, salt crystals, rocks, water
South — Mud, salt crystals, rocks, water
South by West — Mud, salt crystals, rocks, water
Southwest by South — Mud, salt crystals, rocks, water
Southwest by West — Mud, salt crystals, rocks, water
West by South — Mud, salt crystals, rocks, water
West — Mud, salt crystals, rocks, water
West by North — Mud, salt crystals, rocks, water
Northwest by West — Mud, salt crystals, rocks, water
Northwest by North — Mud, salt crystals, rocks, water
North by West — Mud, salt crystals, rocks, water

The helicopter maneuvered the sun's reflection through the Spiral Jetty until it reached the center. The water functioned as a vast thermal mirror. From that position the flaming reflection suggested the ion source of a cyclotron that extended into a spiral of collapsed matter. All sense of energy acceleration expired into a rippling stillness of reflected heat. A withering light swallowed the rocky particles of the spiral, as the helicopter gained altitude. All existence seemed tentative and stagnant. The sound of the helicopter motor became a primal groan echoing into tenuous aerial views. Was I but a shadow in a plastic bubble hovering in a place outside mind and body? *Et in Utah ego.* I was slipping out of myself again, dissolving into a unicellular beginning, trying to locate the nucleus at the end of the spiral. All that blood stirring makes one aware of protoplasmic solutions, the essential matter between the formed and the unformed, masses of cells consisting largely of water, proteins, lipoids, carbohydrates, and inorganic salts. Each drop that splashed onto the Spiral Jetty coagulated into a crystal. Undulating waters spread millions upon millions of crystals over the basalt.

The preceding paragraphs refer to a "scale of centers" that could be disentangled as follows:

(a) ion source in cyclotron
(b) a nucleus
(c) dislocation point
(d) a wooden stake in the mud
(e) axis of helicopter propeller
(f) James Joyce's ear channel
(g) the Sun
(h) a hole in the film reel.

Spinning off of this uncertain scale of centers would be an equally uncertain "scale of edges":

(a) particles
(b) protoplasmic solutions
(c) dizziness
(d) ripples
(e) flashes of light
(f) sections
(g) foot steps
(h) pink water.

The equation of my language remains unstable, a shifting set of coordinates, an arrangement of variables spilling into surds. My equation is as clear as mud —a muddy spiral.

Back in New York, the urban desert, I contacted Bob Fiore and Barbara Jarvis and asked them to help me put my movie together. The movie began as a set of disconnections, a bramble of stabilized fragments taken from things obscure and fluid, ingredients trapped in a succession of frames, a stream of viscosities both still and moving. And the movie editor, bending over such a chaos of "takes" resembles a paleontologist sorting out glimpses of a world not yet together, a land that has yet to come to completion, a span of time unfinished, a spaceless limbo on some spiral reels. Film strips hung from the cutter's rack, bits and pieces of Utah, out-takes overexposed and underexposed, masses of impenetrable material. The sun, the spiral, the salt buried in lengths of footage. Everything about movies and moviemaking is archaic and crude. One is transported by this Archeozoic medium into the earliest known geological eras. The movieola becomes a "time machine" that transforms trucks into dinosaurs. Fiore pulled lengths of film out of the movieola with the grace of a Neanderthal pulling intestines from a slaughtered mammoth. Outside his 13th Street loft window one expected to see Pleistocene faunas, glacial uplifts, living fossils, and other prehistoric wonders. Like two cavemen we plotted how to get to the Spiral Jetty from New York City. A geopolitics of primordial re-

turn ensued. How to get across the geography of Gondwanaland, the Austral Sea, and Atlantis became a problem. Consciousness of the distant past absorbed the time that went into the making of the movie. I needed a map that would show the prehistoric world as coextensive with the world I existed in.

I found an oval map of such a double world. The continents of the Jurassic Period merged with continents of today. A microlense fitted to the end of a camera mounted on a heavy tripod would trace the course of "absent images" in the blank spaces of the map. The camera panned from right to left. One is liable to see things in maps that are not there. One must be careful of the hypothetical monsters that lurk between the map's latitudes; they are designated on the map as black circles (marine reptiles) and squares (land reptiles). In the pan shot one doesn't see the flesh-eaters walking through what today is called Indochina. There is no indication of Pterodactyls flying over Bombay. And where are the corals and sponges covering southern Germany? In the emptiness one sees no Stegosaurus. In the middle of the pan we see Europe completely under water, but not a trace of the Brontosaurus. What line or color hides the Globigerina Ooze? I don't know. As the pan ends near Utah, on the edge of Atlantis, a cut takes place, and we find ourselves looking at a rectangular grid known as Location NK 12-7 on the border of a map drawn by the U.S. Geological Survey showing the northern part of the Great Salt Lake without any reference to the Jurassic Period.

> . . . the earth's history seems at times like a story recorded in a
> book each page of which is torn into small pieces. Many of the
> pages and some of the pieces of each page are missing. . . .[7]

I wanted Nancy to shoot "the earth's history" in one minute for the third section of the movie. I wanted to treat the above quote as a "fact." We drove out to the Great Notch Quarry in New Jersey, where I found a quarry facing about twenty feet high. I climbed to the top and threw handfuls of ripped-up pages from books and magazines over the edge, while Nancy filmed it. Some ripped pages from an Old Atlas blew across a dried out, cracked mud puddle.

> According to all we know from fossil anatomy that beast was
> comparatively harmless. Its only weapons were its teeth and claws.
> I don't know what those obscene looking paunches mean—
> they don't show in any fossil remains yet found. Nor do I know
> whether red is their natural color, or whether it is due to faster
> decay owing to all the oil having dripped down off them. So
> much for its supposed identity.[8]

The movie recapitulates the scale of the Spiral Jetty. Disparate elements assume a coherence. Unlikely places and things were stuck between sections of film that show a stretch of dirt road rushing to and from the actual site in Utah. A road that goes forward and backward between things and places that

are elsewhere. You might even say that the road is nowhere in particular. The disjunction operating between reality and film drives one into a sense of cosmic rupture. Nevertheless, all the improbabilities would accommodate themselves to my cinematic universe. Adrift amid scraps of film, one is unable to infuse into them any meaning, they seem worn-out, ossified views, degraded and pointless, yet they are powerful enough to hurl one into a lucid vertigo. The road takes one from a telescopic shot of the sun to a quarry in Great Notch New Jersey, to a map showing the "deformed shorelines of ancient Lake Bonneville," to *The Lost World*, and to the Hall of Late Dinosaurs in the American Museum of Natural History.

The hall was filmed through a red filter. The camera focuses on a Ornithominus Altus embedded in plaster behind a glass case. A pan across the room picked up a crimsom chiaroscuro tone. There are times when the great outdoors shrinks phenomenologically to the scale of a prison, and times when the indoors expands to the scale of the universe. So it is with the sequence from the Hall of Late Dinosaurs. An interior immensity spreads throughout the hall, transforming the lightbulbs into dying suns. The red filter dissolves the floor, ceiling, and walls into halations of infinite redness. Boundless desolation emerged from the cinematic emulsions, red clouds, burned from the intangible light beyond the windows, visibility deepened into ruby dispersions. The bones, the glass cases, the armatures brought forth a blood-drenched atmosphere. Blindly the camera stalked through the sullen light. Glassy reflections flashed into dissolutions like powdered blood. Under a burning window the skull of a Tyrannosaurus was mounted in a glass case with a mirror under the skull. In this limitless scale one's mind imagines things that are not there. The blood-soaked dropping of a sick Duck-Billed Dinosaur, for instance. Rotting monster flesh covered with millions of red spiders. Delusion follows delusion. The ghostly cameraman slides over the glassed-in compounds. These fragments of a timeless geology laugh without mirth at the time-filled hopes of ecology. From the soundtrack the echoing metronome vanishes into the wilderness of bones and glass. Tracking around a glass containing a "dinosaur mummy," the words of *The Unnameable* are heard. The camera shifts to a specimen squeezed flat by the weight of sediments, then the film cuts to the road in Utah.

NOTES

1. Dialectic of Site and Nonsite

Site	Nonsite
1. Open Limits	Closed Limits
2. A Series of Points	An Array of Matter
3. Outer Coordinates	Inner Coordinates
4. Subtraction	Addition
5. Indeterminate Certainty	Determinate Uncertainty
6. Scattered Information	Contained Information

7. Reflection	Mirror
8. Edge	Center
9. Some Place	No Place
(physical)	(abstract)
10. Many	One

Range of Convergence

The range of convergence between Site and Nonsite consists of a course of hazards, a double path made up of signs, photographs, and maps that belong to both sides of the dialectic at once. Both sides are present and absent at the same time. The land or ground from the Site is placed *in* the art (Nonsite) rather than the art placed *on* the ground. The Nonsite is a container within another container—the room. The plot or yard outside is yet another container. Two-dimensional and three-dimensional things trade places with each other in the range of convergence. Large scale becomes small. Small scale becomes large. A point on a map expands to the size of the land mass. A land mass contracts into a point. Is the Site a reflection of the Nonsite (mirror), or is it the other way around? The rules of this network of signs are discovered as you go along uncertain trails both mental and physical.

"No fish or reptile lives in it (Mono Lake), yet it swarms with millions of worms which develop into flies. These rest on the surface and cover everything on the immediate shore. The number and quantity of those worms and flies is absolutely incredible. They drift up in heaps along the shore." W. H. Brewer, *The Whitney Survey*, 1863.

2. London, 1960, p. 129.

3. "In spite of the concentrated saline quality of the water, ice is often formed on parts of the Lake. Of course, the lake brine does not freeze; it is far too salty for that. What actually happens is that during relatively calm weather, fresh water from the various streams flowing into the lake 'floats' on top of the salt water, the two failing to mix. Near mouths of rivers and creeks this 'floating' condition exists at all times during calm weather. During the winter this fresh water often freezes before it mixes with the brine. Hence, an ice sheet several inches thick has been known to extend from Weber River to Fremont Island, making it possible for coyotes to cross to the island and molest sheep pastured there. At times this ice breaks loose and floats about the lake in the form of 'icebergs.'" (David E. Miller, *Great Salt Lake Past and Present*, Pamphlet of the Utah History Atlas, Salt Lake City, 1949.)

4. *Township 8 North of Range 7 West of the Salt Lake Base and Meridian*: Unsurveyed land on the bed of the Great Salt Lake, if surveyed, would be described as follows:

 Beginning at a point South 3000 feet and West 800 feet from the Northeast Corner of Section 8, Township 8 North, Range 7 West; thence South 45° West 651 feet; thence North 60° West 651 feet; thence North 45° East 651 feet; thence Southeasterly along the meander line 675 feet to the point of beginning. Containing 10.00 acres, more or less. (*Special Use Lease Agreement No. 222*; witness: Mr. Mark Crystal.)

5. *Webster's New World Dictionary of the American Language* (College Edition), World Publishing Co., 1959, U.S.A.

6. A. S. Eddington, quoted on p. 232 in *Number, the Language of Science*, Tobias Dantzig. Doubleday Anchor Books, 1954.

7. Thomas H. Clark, Colin W. Stern, *Geological Evolution of North America*, New York, Ronald Press Co., n.d., p. 5.

8. John Taine, *The Greatest Adventure, Three Science Fiction Novels*, New York, Dover Publications, Inc., 1963, p. 239.

CULTURAL CONFINEMENT (1972)

Cultural confinement takes place when a curator imposes his own limits on an art exhibition, rather than asking an artist to set his limits. Artists are expected to fit into fraudulent categories. Some artists imagine they've got a hold on this apparatus, which in fact has got a hold of them. As a result, they end up supporting a cultural prison that is out of their control. Artists themselves are not confined, but their output is. Museums, like asylums and jails, have wards and cells—in other words, neutral rooms called "galleries." A work of art when placed in a gallery loses its charge, and becomes a portable object or surface disengaged from the outside world. A vacant white room with lights is still a submission to the neutral. Works of art seen in such spaces seem to be going through a kind of esthetic convalescence. They are looked upon as so many inanimate invalids, waiting for critics to pronounce them curable or incurable. The function of the warden-curator is to separate art from the rest of society. Next comes integration. Once the work of art is totally neutralized, ineffec-

Artforum, October 1972
This statement was published originally in the Documenta 5 catalogue as Smithson's contribution to the exhibition.

ROBERT SMITHSON, *Wandering Canal with Mounds*, 1971. Pencil, 19 x 24".

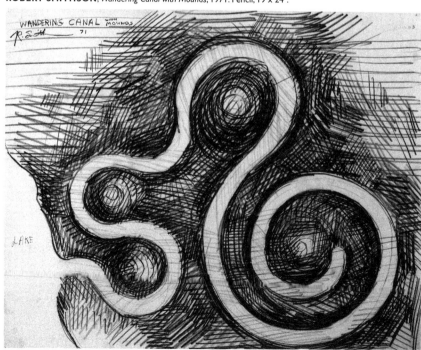

tive, abstracted, safe, and politically lobotomized it is ready to be consumed by society. All is reduced to visual fodder and transportable merchandise. Innovations are allowed only if they support this kind of confinement.

Occult notions of "concept" are in retreat from the physical world. Heaps of private information reduce art to hermeticism and fatuous metaphysics. Language should find itself in the physical world, and not end up locked in an idea in somebody's head. Language should be an ever developing procedure and not an isolated occurrence. Art shows that have beginnings and ends are confined by unnecessary modes of *representation* both "abstract" and "realistic." A face or a grid on a canvas is still a representation. Reducing representation to writing does not bring one closer to the physical world. Writing should generate ideas into matter, and not the other way around. Art's development should be dialectical and not metaphysical.

I am speaking of a dialectics that seeks a world outside of cultural confinement. Also, I am not interested in art works that suggest "process" within the metaphysical limits of the neutral room. There is no freedom in that kind of behavioral game playing. The artist acting like a B. F. Skinner rat doing his "tough" little tricks is something to be avoided. Confined process is no process at all. It would be better to disclose the confinement rather than make illusions of freedom.

I am for an art that takes into account the direct effect of the elements as they exist from day to day apart from representation. The parks that surround some museums isolate art into objects of formal delectation. Objects in a park suggest static repose rather than any ongoing dialectic. Parks are finished landscapes for finished art. A park carries the values of the final, the absolute, and the sacred. Dialectics have nothing to do with such things. I am talking about a dialectic of nature that interacts with the physical contradictions inherent in natural forces as they are—nature as both sunny and stormy. Parks are idealizations of nature, but nature in fact is not a condition of the ideal. Nature does not proceed in a straight line, it is rather a sprawling development. Nature is never finished. When a finished work of 20th-century sculpture is placed in an 18th-century garden, it is absorbed by the ideal representation of the past, thus reinforcing political and social values that are no longer with us. Many parks and gardens are re-creations of the lost paradise or Eden, and not the dialectical sites of the present. Parks and gardens are pictorial in their origin—landscapes created with natural materials rather than paint. The scenic ideals that surround even our national parks are carriers of a nostalgia for heavenly bliss and eternal calmness.

Apart from the ideal gardens of the past, and their modern counterparts—national and large urban parks—there are the more infernal regions—slag heaps, strip mines, and polluted rivers. Because of the great tendency toward idealism, both pure and abstract, society is confused as to what to do with such places. Nobody wants to go on a vacation to a garbage dump. Our land ethic,

especially in that never-never land called the "art world" has become clouded with abstractions and concepts.

Could it be that certain art exhibitions have become metaphysical junkyards? Categorical miasmas? Intellectual rubbish? Specific intervals of visual desolation? The warden-curators still depend on the wreckage of metaphysical principles and structures because they don't know any better. The wasted remains of ontology, cosmology, and epistemology still offer a ground for art. Although metaphysics is outmoded and blighted, it is presented as tough principles and solid reasons for installations of art. The museums and parks are graveyards above the ground—congealed memories of the past that act as a pretext for reality. This causes acute anxiety among artists, in so far as they challenge, compete, and fight for the spoiled ideals of lost situations.

New Jersey, New York with 2 Photos, 1967. Collage, maps, photographs, ink, pencil, 22 x 17⅛ ".

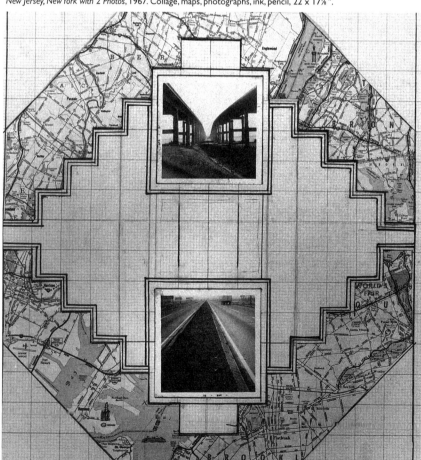

FREDERICK LAW OLMSTED AND
THE DIALECTICAL LANDSCAPE (1973)

> The landscape-architect André formerly in charge of the suburban plan-
> tations of Paris, was walking with me through the Buttes-Chaumont Park,
> of which he was the designer, when I said of a certain passage of it, "That,
> to my mind, is the best piece of artificial planting of its age, I have ever
> seen." He smiled and said, "Shall I confess that it is the result of neglect?"
>
> Frederick Law Olmsted,
> *The Spoils of the Park*

Imagine yourself in Central Park one million years ago. You would be standing
on a vast ice sheet, a 4,000-mile glacial wall, as much as 2,000 feet thick. Alone
on the vast glacier, you would not sense its slow crushing, scraping, ripping
movement as it advanced south, leaving great masses of rock debris in its wake.
Under the frozen depths, where the carousel now stands, you would not no-
tice the effect on the bedrock as the glacier dragged itself along.

Artforum, February 1973

Central Park, 1885, looking northwest from Park Avenue possibly around 94th or 95th Street.

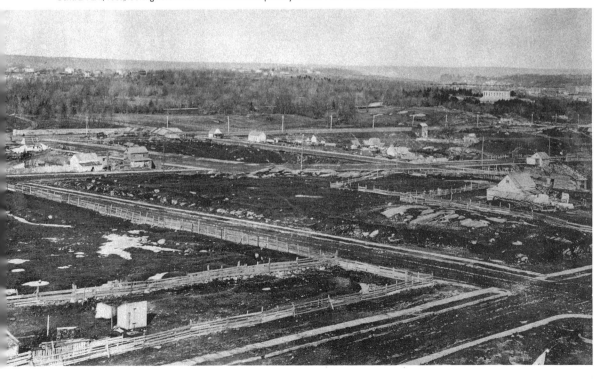

Central Park, 1972, construction site with graffiti behind The Metropolitan Museum of Art. All 1972 photographs by Robert Smithson and Robert Fiore.

Back in the 1850s, Frederick Law Olmsted and Calvert Vaux considered that glacial aftermath along its geological profiles. The building of New York City had interrupted the ponderous results of those Pleistocene ice sheets. Olmsted and Vaux studied the site topography for their proposed park called "Greensward." In *Greensward Presentation Sketch No. 5* we see a "before" photograph of the site they would remake in terms of earth sculpture. It reminds me of the strip-mining regions I saw last year in southeastern Ohio. This faded photograph reveals that Manhattan Island once had a desert on it—a man-made wasteland. Treeless and barren, it evokes the observations of "the valley of ashes" in F. Scott Fitzgerald's *The Great Gatsby* (1925), "where ashes grow like wheat into ridges and hills and grotesque gardens."

Olmsted, "the sylvan artist," yearned for the color *green* as "Nature's universal robe" (see James Thomson, *The Seasons*, 1728) and the "Sharawadgi" parks of England.[1] He wanted the asymmetrical landscapes of Uvedale Price in the middle of urban flux. Into Brooklyn he would bring "the luxuriance of tropical scenery . . . gay with flowers and intricate with vines and creepers, ferns, rushes, and broad leaved plants." This is like having an orchid garden in a steel mill, or a factory where palm trees would be lit by the fire of blast furnaces. In

comparison to Thoreau's mental contrasts ("Walden Pond became a small ocean"), Olmsted's physical contrasts brought a Jeffersonian rural reality into the metropolis. Olmsted made ponds, he didn't just conceptualize about them.

The origins of Olmsted's view of landscape are to be found in 18th-century England, particularly in the theories of Uvedale Price and William Gilpin. Price extended Edmund Burke's *Inquiry into the Origin of Our Ideas of the Sublime and the Beautiful* (1757) to a point that tried to free landscaping from the "picture" gardens of Italy into a more physical sense of the temporal landscape. A tree, for example, struck by lightning was something other than merely beautiful or sublime—it was "picturesque." This word in its own way has been struck by lightning over the centuries. Words, like trees, can be suddenly deformed or wrecked, but such deformation or wreckage cannot be dismissed by timid academics. Price seems to have accepted a side of nature that the "formalists" of his times would rather have excluded.

Some of our present-day ecologists, who still see nature through eyes conditioned by a one-sided idealism, should consider the following quote from Price.

> The side of a smooth green hill, torn by floods, may at first very
> properly be called deformed, and on the same principle, though
> not with the same impression, as a gash on a living animal. When a
> rawness of such a gash in the ground is softened, and in part con-
> cealed and ornamented by the effects of time, and the progress of
> vegetation, deformity, by this usual process, is converted into pic-
> turesqueness; and this is the case with quarries, gravel pits, etc.,
> which at first are deformities, and which in their most picturesque
> state, are often considered as such by a levelling improver.
> *Three Essays on the Picturesque*, 1810

And from William Gilpin's *Observations Relative to Picturesque Beauty* (1789): "A piece of Palladian architecture may be elegant in the last degree, but if we introduce it in a picture it immediately becomes a formal object and ceases to please."

Price and Gilpin were, for Olmsted, "professional touchstones," whose views he esteemed "so much more than any published since, as stimulating the exercise of judgment in matters of my art, that I put them into the hands of my pupils as soon as they come into our office, saying, 'You are to read these seriously, as a student of law would read Blackstone.'"

Inherent in the theories of Price and Gilpin, and in Olmsted's response to them, are the beginnings of a dialectic of the landscape. Burke's notion of "beautiful" and "sublime" functions as a *thesis* of smoothness, gentle curves, and delicacy of nature, and as an *antithesis* of terror, solitude, and vastness of nature, both of which are rooted in the real world, rather than in a Hegelian Ideal.[2] Price and Gilpin provide a *synthesis* with their formulation of the "picturesque," which is on close examination related to chance and change in the material order of nature. The contradictions of the "picturesque" depart from

a static formalistic view of nature. The picturesque, far from being an inner movement of the mind, is based on real land; it precedes the mind in its material external existence. We cannot take a one-sided view of the landscape within this dialectic. A park can no longer be seen as "a thing-in-itself," but rather as a process of ongoing relationships existing in a physical region—the park becomes a "thing-for-us." As a result we are not hurled into the spiritualism of Thoreauian transcendentalism, or its present day offspring of "modernist formalism" rooted in Kant, Hegel, and Fichte. Price, Gilpin, and Olmsted are forerunners of a dialectical materialism applied to the physical landscape. Dialectics of this type are a way of seeing things in a manifold of relations, not as isolated objects. Nature for the dialectician is *indifferent* to any formal ideal.

This does not mean one is helpless before nature, but rather that nature's conditions are unexpected, like Price's hill torn by the flood. In another sense Olmsted's parks exist before they are finished, which means in fact they are never finished; they remain carriers of the unexpected and of contradiction on all levels of human activity, be it social, political, or natural. An example of this can be found in Paul Shepard's excellent book, *Man in the Landscape*:

> His [Olmsted's] report proceeded to note that Europe could not be our model. We must have something better because it was for all "phases of society." The opulent, he continued, should be induced to surround the park with villas, which were to be enjoyed as well as the trees by the humble folk, since they "delight in viewing magnificent and imposing structures." A kind of American doubletalk reconciling villas with democracy and privilege with society in general had begun.

The maps, photographs, and documents in catalogue form and recently on exhibition at the Whitney Museum of American Art are as much a part of Olmsted's art as the art itself. The catalogue's illustrative portfolio by William Alex, and an informative text by Elizabeth Barlow make one aware of the ongoing development of Central Park as a dialectical landscape.[3] Here the documentary power of the photograph discloses a succession of changing land masses within the park's limits. The notion of the park as a static entity is questioned by the camera's eye. The portfolio brings to mind Dziga Vertov's documentary montages, and suggests that certain still photographs are related to the dialectics of film. For example, a photograph on page 78, *Tunnel carved out through Vista Rock for Transverse Road No. 2 at 79th Street* could be a still from a hypothetical film by Vertov on the building process of Central Park. In the photograph there is no evidence of the trees that would in the future screen the sunken roadway from the park proper. The photograph has the rawness of an instant out of the continuous growth and construction of the park, and indicates a break in continuity that serves to reinforce a sense of transformation,

rather than any isolated formation. We notice in this photograph that nature's development is grounded in the dialectical, and not the metaphysical.

An example of a metaphysical rendering of a "tunnel" may be seen in John Martin's mezzotint, *At the Brink of Chaos* (1825). Born into England's industrial revolution, Martin translated engineering efforts into visions of cosmic doom. He substituted a tunnel for Milton's bridge in *Paradise Lost*, and in so doing retreated into the metaphysical.[4] In this instance the more dialectical aspect of the picturesque is shrouded in a sentimental gloom that has its origins in the Puritan religion. Modern day ecologists with a metaphysical turn of mind still see the operations of industry as Satan's work. The image of the lost paradise garden leaves one without a solid dialectic, and causes one to suffer an ecological despair. Nature, like a person, is not one-sided. Another factor to note is that Olmsted's tunnel is in the real world, whereas Martin's is a pictorial *representation* derived only from the mind.

Olmsted's view of the landscape was lost sight of around the first part of this century, what with the rise of the "antidemocratic intelligentsia" that included Wyndham Lewis, Ezra Pound, T. S. Eliot, and T. E. Hulme.[5] Although Pound and Eliot did maintain traces of the picturesque in their poetry, they theoretically scorned it. "Over the tumbled graves, about the chapel," wrote Eliot in *The Waste Land*, "There is the empty chapel, only the wind's home." But Eliot's

Detail of the Greensward Plan #5. Photograph of area of park before construction, 1858

picturesque was a nostalgia for church authority, it ceased to be the democratic dialectic between the sylvan and the industrial that Price and Olmsted worked toward. Instead they stressed a neoclassical formalism, and T. E. Hulme, who exerted great influence on all three, was drawn to the "abstract" philosophy of Wilhelm Worringer. After World War II, when fascistic motives were revealed, various liberal critics moved in to pick up the pieces—among them Clement Greenberg. He tried to graft a lame formalism to a fuzzy Marxist outlook. Here is Greenberg upstaging both Lewis and Eliot:

> Eliot has called Wyndham Lewis "the greatest prose stylist of my generation—perhaps the only one to have invented a new style." I find this exaggerated, but even if it were not, Lewis would still have paid too dearly for the distinction.
>
> <div align="right">Clement Greenberg,
"Wyndham Lewis Against Abstract Art,"
Art and Culture, Boston, 1961</div>

This is a smart way to subsume authority, but the rest of the article sheds no light on "abstraction." My feeling is that they all missed the boat.[6]

Turning to France, a sense of the picturesque results in Paul Cézanne's *Bibémus Quarry* (1895), but his direct encounters with the landscape were soon to be replaced by a studio-based formalism and cubistic reductionism which would lead to our present day insipid notions of "flatness" and "lyrical abstraction." The general direction of this tendency begins in 1914 when T. E. Hulme, lecturing on "Modern Art and Philosophy," talks about reducing trees to cones.[7] Representations of "stripes" became the logical outcome.

Any discussion concerning nature and art is bound to be shot through with moral implications. Once a student told me that "nature is anything that is not manmade." For that student man was outside the natural order of things. In Wilhelm Worringer's *Abstraction and Empathy* (1908), we are told that Byzantine and Egyptian art were created out of a psychological need to escape nature, and that since the Renaissance our understanding of such art has been clouded by an undue confidence in nature. Worringer locates *his* "concept" of abstraction outside the sensuous anthropomorphic pantheism of Renaissance humanism. "The primal artistic impulse," says Worringer, "has nothing to do with the renderings of nature." Yet, throughout his book he refers to "crystalline forms of inanimate matter." Geometry strikes me as a "rendering" of inanimate matter. What are the lattices and grids of pure abstraction, if not renderings and representations of a reduced order of nature? Abstraction is a representation of nature devoid of "realism" based on mental or conceptual reduction. There is no escaping nature through abstract representation; abstraction brings one closer to physical structures within nature itself. But this does not mean a renewed confidence in nature, it simply means that abstraction is no cause for faith. Abstraction can only be valid if it accepts nature's dialectic.

Entrance to The Ramble, before 1900.

Entrance to The Ramble, 1972.

In *The New York Times* (Sunday, March 12, 1972) Grace Glueck's column has a headline, "Artist-in-Residence for Mother Earth," and a photograph of Alan Gussow captioned "A sort of spiritual caretaker." Reading the article, one discovers what might be called an Ecological Oedipus Complex. Penetration of "Mother Earth" becomes a projection of the incest taboo onto nature. In Theodore Thass-Thienemann's book, *The Subconscious Language*, we find a quote from a catatonic schizophrenic: "They should stop digging (now shouting petulantly in rage) down inside the earth to draw metals out of it. That's digging down into Mother Earth and taking things that shouldn't be taken."

Simone de Beauvoir has written in *The Second Sex*, "Aeschylus says of Oedipus that he 'dared to seed the sacred furrow where he was formed.'" Alan Gussow in *The New York Times* projects onto "earth works artists" an Oedipus Complex born out of a wishy-washy transcendentalism. Indulging in spiritual fantasy, he says of representational landscape painters in his book *A Sense of Place: Artists and the American Land*, published by Friends of the Earth: "What these artists do is make these places visible, communicate their spirit—not like the earth works artists who cut and gouge the land like Army engineers. What's needed are lyric poets to celebrate it."[8]

Gussow's projection of the "Army engineers" on what he imagines to be "earth works artists" seems linked to his own sexual fears. As Paul Shepard in his *Man in the Landscape* points out, "Those [army] engineers seem to be at the opposite extreme from esthetes who attempt to etherealize their sexuality. Yet, the engineers' authority and dominance over land carries the force of sexual aggression—and perhaps the guilt as well."

An etherealized representational artist such as Gussow (he does mediocre Impressionistic paintings) fails to recognize the possibility of a direct organic manipulation of the land devoid of violence and "macho" aggression. Spiritualism widens the split between man and nature. The farmer's, miner's, or artist's

One of the many Central Park bridges, before 1900.

treatment of the land depends on how aware he is of himself as nature; after all, sex isn't all a series of rapes. The farmer or engineer who cuts into the land can either cultivate it or devastate it. Representing nature once removed in lyric poetry and landscape painting is not the same as direct cultivation of the land. If strip miners were less alienated from the nature in themselves and free of sexual aggression, cultivation would take place. When one looks at the Indian cliff dwelling in Mesa Verde, one cannot separate art from nature. And one can't forget the Indian mounds in Ohio.[9]

One wonders what the likes of Gussow would make of America's first "earthwork artist"—Frederick Law Olmsted. Perhaps, if Gussow had lived in the mid-19th century, he would have suggested that Olmsted write "lyric poetry" instead of moving ten million horse-cart loads of earth to make Central Park. Artists like Gussow are the type who would rather *retreat* to scenic beauty spots than try to make a concrete dialectic between nature and people. Such an artist surrounds himself with self-righteousness and pretends to be saving the landscape. This is not being an ecologist of the real, but rather, a spiritual snob.

This kind of spirituality mentioned in the preceding paragraphs is what Rollo May in *Power and Innocence* calls "pseudoinnocence," which can only lead to pseudospirituality and pseudoart. May speaks of an ". . . insulation from the evil in the world."[10] The authentic artist cannot turn his back on the contradictions that inhabit our landscapes. Olmsted himself was full of contradictions; for instance, he wrote his wife his reaction to the California desert, "the whole aspect of the country is detestable."

The Vista Rock Tunnel, 1862.　　　　　　The Vista Rock Tunnel, 1972.

In the 1862 photograph it is interesting to see the arrested construction of a water system for draining and filling a Central Park lake—five sunken pipes, guide lines, half-formed walls, dirt roads, and general rubble. All of the roughness of the process rises out of the park's earlier condition. As Elizabeth Barlow indicates, "The political quagmire was matched by the appearance of the park itself, which was rubbish-strewn, deep in mud, filled with recently vacated squatters' huts, and overrun with goats left behind by the squatters. Until they were eventually impounded, the rampant goats were a great nuisance, eating the foliage of the park's few trees." All of this is part of the park's dialectic.

Looking on the nature of the park, or its history and our perceptions of it, we are first presented with an endless maze of relations and interconnections, in which nothing remains what or where it is, as a-thing-itself, but the whole park changes like day and night, in and out, dark and light—a carefully designed clump of bushes can also be a mugger's hideout. The reason the potential dialectic inherent in the picturesque broke down was because natural processes were viewed in isolation as so many classifications, detached from physical interconnection, and finally replaced by mental representations of a finished absolute ideal. Bilious books like *The Greening of America* present one with a notion of "consciousness" without substance. Central Park is a ground work of necessity and chance, a range of contrasting viewpoints that are forever fluctuating, yet solidly based in the earth.

By expanding our dialectic outside of Central Park to Yosemite National Park, we gain insight into the development of both park sites before they were turned into "parks." The site of Central Park was the result of "urban blight"— trees were cut down by the early settlers without any thought of the future. Such a site could be reclaimed by direct earth-moving without fear of upsetting the ecology. My own experience is that the best sites for "earth art" are sites that have been disrupted by industry, reckless urbanization, or nature's own devastation. For instance, *The Spiral Jetty* is built in a dead sea, and *The Broken Circle* and *Spiral Hill* in a working sand quarry. Such land is cultivated or recycled as art. On the other hand, when Olmsted visited Yosemite it

existed as a "wilderness." There's no point in recycling wilderness the way Central Park was recycled. One need not improve Yosemite, all one needs is to provide access routes and accommodations. But this decreases the original definition of wilderness as a place that exists without human involvement. Today, Yosemite is more like an urbanized wilderness with its electrical outlets for campers, and its clothes lines hung between the pines. There is not much room for contemplation in solitude. The new national parks like the Everglades and the Dinosaur National Monument are more "abstract" and lack the "picturesqueness" of Yosemite and Yellowstone.

In many ways the more humble or even degraded sites left in the wake of mining operations offer more of a challenge to art, and a greater possibility for being in solitude. Imposing cliffs and unimproved mesas could just as well be left alone. But as the nation's "energy crisis" mounts, such places will eventually be mined. Some 5.5 millions of acres, an area the size of New Hampshire, is currently being bought up in North Dakota, Wyoming, and Montana by mining companies. "I think," says Interior Secretary Rogers Morton (*Newsweek*, October 9, 1972), "we can set the standard for a new mining ethic so that the deep seams can be mined and closely followed by an environment program that is compatible esthetically and with proper land use." One can only wonder what his notion of "esthetics" is. The precedents set by Olmsted should be studied by both miners and ecologists.[11]

Rock Stairs, 1972.

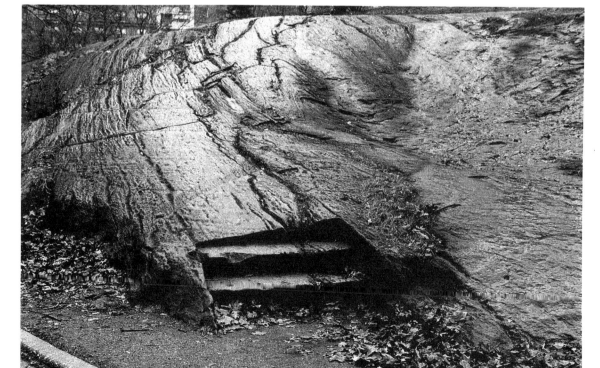

Returning to Yellowstone, which celebrated its centennial last year, we see a combining of Europe's "intoxication with ruins" with America's newly discovered "natural ruins" at the origin of the park's development. David E. Folsom, a wealthy rancher, who viewed Yellowstone in 1869, wrote in his diary "a huge rock that bore resemblance to an old castle; rampart and bulwark were slowly yielding to the ravages of time, but the old turret stood out in bold relief against the sky." As Paul Shepard has pointed out, John Ruskin never visited America because it lacked castles. Nevertheless "Castle Rock" has become a name for many natural formations throughout the West.

New York in the 1870s yielded to different kinds of ravages. Olmsted was dismissed from his job in 1874. In a document privately printed in 1881 called *The Spoils of the Park: With a Few Leaves from Deep-laden Note-books of "A Wholly Unpractical Man,"* we get a glimpse of Olmsted's conflicts with City politics.[12] Under Boss Tweed the Park Department deteriorated into a shambles along with serious unemployment, violent labor protests, and financial panic, causing Olmsted to write in 1877 that New York City was "essentially under martial law." The Park Department was also being turned into a social welfare agency; in Olmsted's words the Park Department had become "an asylum for aggravated cases of hernia, varicose veins, rheumatism, partial blindness, and other infirmities compelling sedentary occupations."

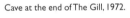

Cave at the end of The Gill, 1972.

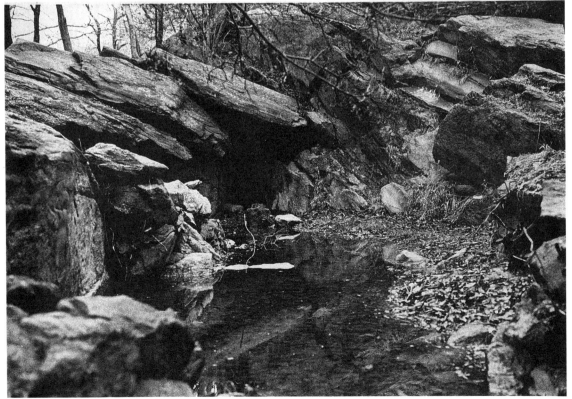

Gaptow Bridge with mud slough, 1972.

When Charles Eliot Norton said of him (Olmsted), towards the
close of his career, that of all American artists he stood "first in the
production of great works which answer the needs and give ex-
pression to the life of our immense and miscellaneous democracy"
he did not exaggerate Olmsted's influence.

Lewis Mumford, *The Brown Decades*

Entering the park at 96th Street and Central Park West, I walked south
along the western side of the reservoir on a bridle path. The upper part of the
park that includes Harlem Meer, The Great Hill, and The North Meadow
(now filled with ball fields) was planned for lateral and horizontal views; in
Olmsted's words it should be "bold and sweeping" as opposed to the lower
park's "heterogeneous" character. One has the sensation of being in a sunken
forest as well. A sense of remoteness was present in this region. This sense of
engulfment deepened as foliage suggested the harmonies, tonalities, and
rhythms of Charles Ives' music—*Three Outdoor Scenes, Central Park at Night*,
and *The Unanswered Question*, subtitled *A Cosmic Landscape*, in particular.

At Bank Rock Bridge is an entrance to The Ramble. On the bridge stood a
sinister looking character, who looked like the type who would rip off cam-
eras. Quickly I vanished into The Ramble—a tangled net of divergent paths.
Just the day before I had been looking at stereopticon photos of how this place
looked before 1900, before the vegetation Olmsted planted had grown up. At
that time, the shores of The Lake still had the look of a rock strewn quarry.
Olmsted had wanted to plant "rhododendrons, andromedas, azaleas, kalmias,

rhodoras," but his plans remain only partly realized. Olmsted was attracted to this place before he did anything to it, because it was "exceedingly intricate" with "sweet gum, spicebush, tulip tree, sassafras, red-maple, black-oak, azalea, and andromeda." The network of paths he twisted through this place out-labyrinthed labyrinths. For what really is a Ramble, but a place to walk aimlessly and idly—it is a maze that spreads in all directions. Now The Ramble has grown up into an urban jungle, and lurking in its thickets are "hoods, hobos, hustlers, homosexuals," and other estranged creatures of the city (see John Rechy, *The City of Night*). Olmsted had brought a primordial condition into the heart of Manhattan. A small rock bridge crosses a miniature ravine, connecting tangle with tangle. Beneath leafless tree limbs the windings grow more complex, and seem to turn on themselves, so that the walker has no sense of direction. Autumn leaves smother the pathways as they lead one deeper into an infinity of curves. Flowing through The Ramble is The Gill, a stream of water which appears to be a cross between a brook and a pond, and apparently having its source in a cave under a heap of boulders. Tiny valleys and hills are scattered in such a way as to maximize seclusion and solitude. The Lake borders The Ramble; in it is a small flat island of rock.

Moving up a wooded incline, I approached Vista Rock Tunnel near Belvedere Castle. Water was seeping and dripping over the carved rock surfaces of the tunnel and falling on the rock-walled trench. At this point I was chased by three wild dogs. Later, I found out that there are other packs of dogs roaming the park. Also I discovered that the squirrels are rather aggressive—fat dynamos rather than suburban scrawnies. A series of steps curved right into the bedrock, leading to the castle which is also a weather station. From there one looks out over Belvedere Lake and the Great Lawn, once the Croton Water Works.

Walking east, I passed graffiti on boulders. Somehow, I can accept graffiti on subway trains, but not on boulders. On the base of the Obelisk along with the hieroglyphs there are also graffiti. Suddenly, one encounters the construction site of a new tunnel near The Metropolitan Museum of Art—a gray compound with a towering orange derrick in the middle. On the gray walls are more graffiti of an "ecological" sort: "Concrete and trees do not mix." "Let's not turn Central Park into an Asphalt Jungle." "Decentralize the Met!" "Save the Park!" "The Met is not good for trees and other flowering things." "Does the Met smell as nice as a tree?" "Preserve Wildlife." Olmsted's own view on buildings and museums in *The Spoils of the Park* is: "The reservoirs and the museum are not a part of the Park proper: they are deductions from it. The Subways are not deductions because their effect, on the whole, is to enlarge, not lessen, the opportunities of escape from buildings."

Passing under Glade Arch and into the Glade, I came to the Conservatory Water Pool; the overall shape of its concrete banks being an interplay of curves and right angles. The Pool had been drained, and this provided one with a

vista of graceful desolation—a sea of autumn leaves. The bare trees that surround the Pool rose from the ground like so much smoky lace. Here and there people sauntered in and out of the haze and sunlight, turning the area into a phantom world.

As I continued southward, near Fifth Avenue, I passed a "kiddy land," one of the latest incursions into the park. Designed by Richard Datter in 1970, it looks like a pastiche of Philip Johnson and Mark di Suvero. A sign on the fence that surrounds it exhorted one to "Enjoy." Even cuter is the "kiddy zoo," with its Disney-type Whale.[13] In the Old Zoo some caged workmen were installing an artificial habitat.

In the spillway that pours out of the Wollman Memorial Ice Rink, I noticed a metal grocery cart and a trash basket half-submerged in the water. Further down, the spillway becomes a brook choked with mud and tin cans. The mud then spews under the Gapstow Bridge to become a muddy slough that inundates a good part of The Pond, leaving the rest of The Pond aswirl with oil slicks, sludge, and dixie cups. Maintenance on The Pond seems long overdue. The mud should be dredged out. This maintenance operation could be treated in terms of art, as a "mud extraction sculpture." A documentary treatment with the aid of film or photographs would turn the maintenance into a physical dialectic. The mud could be deposited on a site in the city that needs "fill." The transportation of mud would be followed from point of extraction to point of deposition. A consciousness of mud and the realms of sedimentation is necessary in order to understand the landscape as it exists.

The magnitude of geological change is still with us, just as it was millions of years ago. Olmsted, a great artist who contended with such magnitudes, sets an example which throws a whole new light on the nature of American art.

NOTES

1. Sharawadgi involves a Chinese influence on English landscape development. The work corresponds to the Chinese syllables Sa-lo-kwai-chi, meaning "quality of being impressive or surprising through careless or unorderly grace." See Y. Z. Chang, "A Note on Sharawadgi," *Modern Language Notes*, 1930, p. 221. Also see Edward Hyams, *The English Garden*, New York: "the fact, as appears in accounts of certain gardens, Alexander Pope's garden at Twickenham, William Kent's Stowe, the same artist's Rousham, Hoare's Stoumead (and there were others), is that 'Chinese' (i.e., poetic nature), gardening was well established in Britain almost half a century before the English had any but rather tenuous contacts with Chinese gardening."

2. Hegelian dialectics exist only for the mind. This is close to Thoreau's mental dialectic of mixing the local with the global. "I am accustomed," says Thoreau in his Journal, "to regard the smallest brook with as much interest for the time being, as if it were the Orinoco or the Mississippi." See John Aldrich Christie, *Thoreau As World Traveler*, New York, 1965.

3. William Alex and Elizabeth Barlow, *Frederick Law Olmsted's New York*, New York, 1972. This important book was very helpful in assembling this essay.

4. See the chapter "The Age of Despair" in F. D. Klingender, *Art and the Industrial Revolution*, New York, 1970.

5.　"The cult of Unnaturalism, I think, is the real trouble with the whole, and it is still very much with us, at any rate in academic criticism." See William Empson's introduction to John Harrison, *The Reactionaries*, New York, 1967.

6.　Greenberg does show an interest in dialectics in "Necessity of Formalism," *Art International*, October, 1972. "Actually it's a 'dialectical' turn that works to maintain or restore continuity: a most essential continuity: continuity with the highest esthetic standards of the past." On the other hand, formalism emerges in the essay less as a "necessity" and more as a luxury. The notion of "quality" appeals in vague notions of luxury.

7.　The reductive tendency existed in English formal gardens of the 18th century. Joseph Addison, an essayist, writing in *The Spectator* (1712) had this to say: "Our British gardeners, on the contrary, instead of humoring nature loved to deviate from it as much as possible. Our trees rise in cones, globes, and pyramids." Nikolaus Pevsner speaks of Addison's dislike of mathematics in the garden but admiration for the principles of mathematical order in the universe. "The Genesis of the Picturesque," *Architectural Review*, XCVI, 1944.

8.　The Enemies of Art might be expected to publish such a book, but not the Friends of the Earth. "One becomes irritated with the format from the start," says John Wilmerding in his review of this "pretentious nonbook" in *Art in America*, November–December, 1972.

9.　"From Wisconsin to the Gulf of Mexico, from Mississippi to the Appalachians, but especially in Ohio, rise tens of thousands of artificial hills. Many of them are so fantastically shaped that they defy description." C. W. Ceram, *The First Americans: A Story of North American Archeology*, New York, 1971, p. 193.

10.　In *Power and Innocence*, New York, 1972, Rollo May points out in reference to Charles Reich's book *The Greening of America* that, "Far from Consciousness III being an answer, it will be no consciousness at all, for it lacks the dialectic between 'yes' and 'no,' good and evil, which gives birth to consciousness of any sort. Reich writes: 'The hard questions—if by that is meant political and economic—are insignificant, even irrelevant.'" My feeling is that these "hard questions" are going to have to be faced—even by artists. All the bogus spiritualists, "ersatz Buddhists, Yogis and Hindus" (May) won't be of any help.

11.　"In *A Wilderness Bill of Rights*, [Justice William O.] Douglas rails at dams as a source of power generation, and mentions alternate sources of generation: coal-fired steam, nuclear powered steam, and solar energy. But the same book denounces the havoc wreaked by mining coal to fire the steam, and there is a solemn warning about the wholesale pollution from the disposal of nuclear waste." Frank E. Smith, *The Politics of Conservation*, New York, 1964.

12.　*Landscape into Cityscape: Frederick Law Olmsted's Plans for a Greater New York City*, edited with an introductory essay and notes by Albert Fein, Ithaca, 1967. Included is the essay "The Spoils of the Park" (1882), revealing Olmsted's concern with the politics of Central Park.

13.　On March 31, 1918 *The New York Times* published a map titled "IF 'IMPROVEMENT' PLANS HAD GOBBLED CENTRAL PARK," subtitled: "Many Other Grabs Are Not Shown in the Picture, for Lack of Room." There must be a limit to "destructive innovations" (Fein). Disney-type improvements strike me as undemocratic because one must pay to enter.

INTERVIEWS

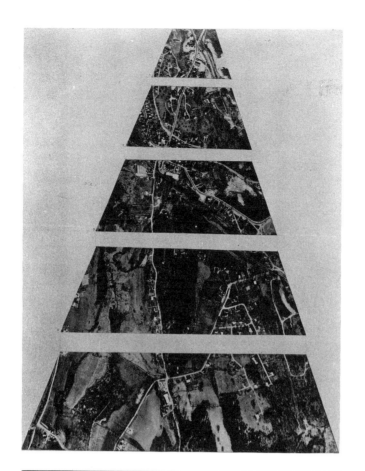

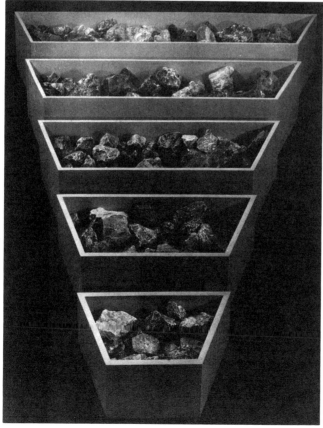

ROBERT SMITHSON: *Non-Site, Franklin, New Jersey*, 1968. Bottom: 16½ inches high. Each of the trapezoidal wood bins corresponds to a sector of the aerial photo-map of the site (top), and contains ore from, and proportional in amount to, the area.

SMITHSON'S NON-SITE SIGHTS (1969)

Interview with Anthony Robbin

> We know that by our new standards of measurement the most exten-
> sive landscape is practically the same size as the hole through which the
> burrowing ant escapes from our sight.
>
> Sir Kenneth Clark, *Landscape into Art*

The author interviewed Robert Smithson at his New York studio. An excerpt from the conversation follows.

ROBERT SMITHSON: People who defend the labels of painting and sculpture say what they do is timeless, created outside of time; therefore the object transcends the artist himself. But I think that the artist is important, too, and what he does, the way he thinks, is valuable, whether or not there is any tangible result. You mainly follow a lot of blind alleys, but these blind alleys are interesting.

ANTHONY ROBBIN: It isn't so necessary for the artist to render this chaos into form so much as to expose the fact that . . . ?

SMITHSON: It's there.

ROBBIN: Yes. Not only that it's there, but that he is dealing with it, manipulating it, speculating about it.

SMITHSON: That he is living with it without getting hysterical, and making some ideal system which distorts . . .

ROBBIN: Not making an ideal system, but at the same time making *some* system . . .

SMITHSON: Yes. But even *some* system tells you nothing about art.

ROBBIN: Tentative and transient as it is. It's not enough for him not to do anything.

SMITHSON: I feel that you have to set your own limits . . .

ROBBIN: And the self-aware setting of limits is close to the center of it all?

SMITHSON: Yes. I think the major issue now in art is what are the boundaries. For too long artists have taken the canvas and stretchers as given, the limits.

ROBBIN: The motivation for doing that is not to expand the system. You are not doing it for the sake of the system?

SMITHSON: I'm doing it to expose the fact that it is a system, therefore taking away the vaulted mystery that is supposed to reside in it. The artifice is plainly an artifice. I want to de-mythify things.

ROBBIN: People will be frustrated in their desire for certainty, but maybe they will get something more after that frustration passes.

SMITHSON: Well, it's a problem all the way around, and I don't suspect we will work our way out of it.

Art News, February 1969

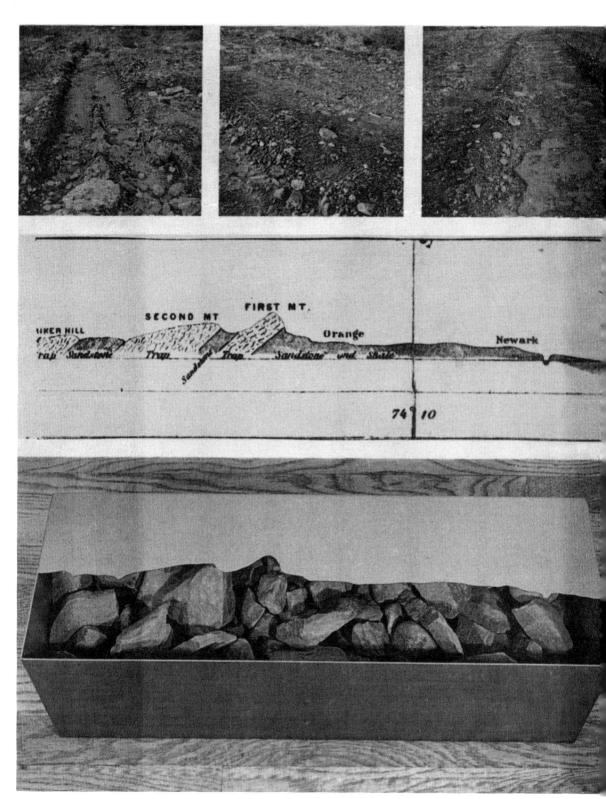

ROBERT SMITHSON, *Six Stops on a Section*, 1968. Detail: one bin 8 x 8 x 24″, map section, photos.

EARTH (1969)

Symposium at White Museum, Cornell University

Following are excerpts from a symposium on earth art held at Cornell University, February 6, 1969. Participants were Dennis Oppenheim, Robert Smithson, Neil Jenney, Gunther Uecker, Hans Haacke, and Richard Long. The moderator was Thomas W. Leavitt, director of the Andrew Dickson White Museum of Art at Cornell. Questioners, unless otherwise identified, were members of the audience.

OPPENHEIM: For me this use of a terrestrial area came through a very formal concern with sculpture. I was doing the kind of sculpture that I felt came to a point of conclusion. I didn't think of any possible way of transcending it or developing its existence, except by beginning to go outside the bounds of a loft area into the use of earth. The first pieces I did were quite simple, but eventually the stimulus of a loft concern, or a concern with pictorial, sculptural values, began to diminish and I began to work outside with a good kind of intent. I'm to the point now where I see the earth as sculpture—where flying over the earth is like viewing existing painted areas or pictorial, painterly surfaces. While on the ground it is more volumatic. It's like walking through sculpture. It's less graphic, more subterranean. Any addition to the ground—any scratch or anything you add—becomes a relational addition. The limit you have to refer to in this case is always the sphere—it's always the globe—so when you dig a hole in the ground your periphery becomes the spherical shape. Now the spherical shape, of course, is relational to the cosmos. So at this point I'm concerned with an art that rides above the frequency of pictorial or compositional treatment. I have been more concerned in this case in delving into aspects that are not as visual as those sculpture has been concerned with in the past. A concern which allows the artist to enter into a continuing organization, a complex of interaction, so that he doesn't have to confine his media to studio art. That's about all I've got to say.

SMITHSON: Well, I first got involved in the earth project situation when I was contracted to do some work for an architectural company as an artist consultant, and they asked me to give them suggestions on what to do with sculpture and things like that. I felt it was wrong to consider sculpture as an object that you would tack onto a building after the building is done, so I worked with these architects from the ground up. As a result I found myself surrounded by all this material that I didn't know anything about—like aerial photographs, maps, large-scale systems, so in a sense I sort of treated the airport as a great complex, and out of that came a proposal that would involve low-level ground systems that would be placed at fringes of the airport, sculpture that you would see from the air. This preoccupation with the outdoors was very stimulating. Most of us used to work in a closed area space. For in-

stance, I did a large spiral, triangular system that sort of just spun out and could only be seen from an airplane. I was sort of interested in the dialogue between the indoor and the outdoor and on my own, after getting involved in it this way, I developed a method or a dialectic that involved what I call site and non-site. The site, in a sense, is the physical, raw reality—the earth or the ground that we are really not aware of when we are in an interior room or studio or something like that—and so I decided that I would set limits in terms of this dialogue (it's a back and forth rhythm that goes between indoors and out-doors), and as a result I went and instead of putting something on the land-scape I decided it would be interesting to transfer the land indoors, to the non-site, which is an abstract container. This summer I went out west and selected sites—physical sites—which in a sense are part of my art. I went to a volcano and collected a ton of lava and sent it back to New York and that was set up in my non-site interior limit.

Then what I'm doing here—I'm going to use a room and a salt mine . . . (It's out here on Lake Cayuga, Cayuga Salt Mines)—and tomorrow I'll go down there and put on an exhibition in the salt mines and arrange these mir-rors in various configurations, photograph them, and then bring them back to the interior along with rock salt of various grades. As you can see, the interior of the Museum somehow mirrors the site and I'm actually going to use mir-rors. Most sculptors just think about the object, but for me there is no focus on one object so it is the back-and-forth thing.

JENNEY: I guess my work could be classified as environmental in that I use

ROBERT SMITHSON, *Rock Salt and Mirror Square 1*, 1969. 10 x 78 x 78".

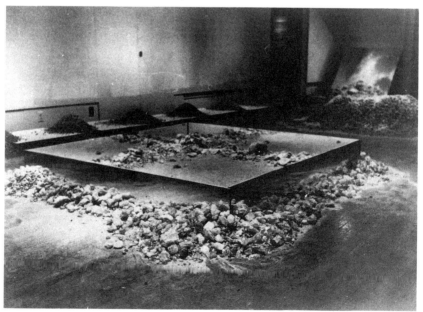

the environment, or I function in the environment, in a sort of theatrical manner. I use in it things such as earth, or plants in some. It tends to be a sort of secondary thing as opposed to the other people's work in earth in that it is only a vehicle for the thing that I want to achieve. I don't care what the work looks like. I use things that sometimes you don't notice, like ashtrays, and basically it's just involved with interrupting the environment to the extent that you are close to the thing physically rather than visually. I did pieces that had algae and moss and electrical wires with exposed parts. I guess that's about what my stuff is.

UECKER: I'm trying to find areas, zones, regions, which do not have the burden of associations. It is possible to free man from object-orientation associations. This freedom is not to be interpreted. It is total. The medium is concrete.

This zone of void or emptiness can mean a power of emancipation of a contemplative and concrete manner, for a spiritual self-realization. This can be an evolution in science, in the quiet, without spectacular drama. A region of desert is a real place of consciousness of the self. A place, like a river, where we can leave traces which will be extinguished soon. I think we arrive at this freedom without representation in the world of objects. Let us use the earth as an area close to this without dimensions. Let us try to expand perception in a more encompassing manner, in the infinite and the openness of spaces.

HAACKE: I would like to make it very short. I have put about a cubic yard of top soil mixed with peat into a naturally well-lit room in the Museum. It [the pile of soil] is cone shaped, like a sandcastle, and I seeded it with winter rye and annual rye seed, and hopefully by the day of the opening sprouts will come out of the ground. The shape of this mound is of no relevance. I'm not inter-

ROBERT SMITHSON, rock salt and mirror installation, Earth Art exhibition, Andrew Dickson White Museum. Cornell University, February 1969.

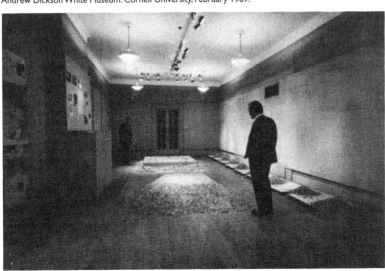

ested in the form. I'm more interested in the growth of plants—growth as a phenomenon which is something that is outside the realm of forms, composition, etc., and has to do with interaction of forces and interaction of energies and information. My comment for the catalog when asked for a statement is "Grass grows."

LONG: My work will be outside in front of the Museum.

QUESTIONER: I would like to ask Mr. Oppenheim: If he is concerned with aspects that aren't as visual—I got the impression it was more the space, the more volumatic aspects of your work—what is the value then of taking a picture of it, other than just as proof that the work has been done? I mean, what aesthetic benefits can be gained from someone looking at an aerial photograph of one of your works?

OPPENHEIM: Well, I don't think that aesthetic interaction deals with a spectator looking at the abstraction at all. There is a good deal of taking of pictures. There is a good deal of recording the work as a work with cameras. It's not intrinsic; it's just a matter of removing a degree of the work from the location and using it for display. I mean I don't know why some of these people use photographs. Some of them are quite profound, but there is no need for me to photograph my work.

QUESTIONER: Would you say that the perception of the work is less important than the fact of doing it itself?

OPPENHEIM: Well, you perceive the work while you are doing it. You carry both the perception and the process. If you think art should be carried through the channel of media and allowed to meet a larger body of people, then of course you should take pictures of it. If it's an intrinsic part of the work not to be photographed or such, then it shouldn't be an issue—it's not that important. Because a lot of these pieces are exterior and a lot of them involve time sequences that can't be dealt with inside of a continuum.

QUESTIONER: (to Haacke) Don't you identify your piece with a type of gardening?

HAACKE: Oh, I suppose. But the intention is very different.

QUESTIONER: I mean, you were the one who planted the seeds in the pile, weren't you?

HAACKE: Yes, but it could have been somebody else!

QUESTIONER: How is this different from someone going out and working in a garden? Would that be a form of earth art?

HAACKE: Well, I suppose he doesn't do it for the same reasons that I do.

QUESTIONER: So it's the intent that's different?

HAACKE: I guess so.

QUESTIONER: Those of you who did your projects outside: I would like to ask what role the effects of weather or soil or dog tracks or things like that have on what you decided to do?

OPPENHEIM: I think you would ask that question in reference to something inside a Museum, like on a shelf. This stuff outside can't really be disturbed.

SMITHSON: Actually if you think about tracks of any kind you'll discover that you could use tracks as a medium. You could even use animals as a medium. You could take a beetle, for example, and clear some sand and let it walk over that and then you would be surprised to see the furrow it leaves. Or let's say a sidewinder snake or a bird or something like that. And also these tracks relate, I think, somehow to the way the artist thinks—somewhat like a dog scanning over a site. You are sort of immersed in the site that you're scanning. You are picking up the raw material and there are all these different possibilities. Like it is possible to rent a buffalo herd and then just follow the traces. This is a sign language in a sense. It's a situational thing; you can record these traces as signs. It's very specific and it tends to get into a kind of random order. These tracks around a puddle that I photographed, in a sense explain my whole way of—going through trails and developing a network and then building this network into a set of limits. My non-sites in a sense are like large, abstract maps made into three dimensions. You are thrown back onto the site.

QUESTIONER: I would like to ask those artists who display their works in the Museum to what extent you expect spectators to interact with these works? Do you expect physical interaction from the spectators—for them to touch it? Or just stand back and look at it?

SMITHSON: Well in my case, the piece is there in the Museum, abstract, and it's there to look at, but you are thrown off it. You are sort of spun out to the fringes of the site. The site is a place you can visit and it involves travel as an aspect too.

LEAVITT: (to Jenney) Do you want people to interact with the work?

JENNEY: Well, physically, no. I guess the only reaction I expect is that you sort of give it a chance. I think you have to go with the frame of mind that you're going to see something that maybe you haven't seen before. Most good art disorients the viewer suddenly, to the point where the artist has the viewer under his control because it's something he hasn't experienced visually or physically before. Just because I work with the physical presence of things you will, I think, interact—hopefully, physically as much as you will visually. The fact that I don't play up the visual aspect of it is just that I think it's a minor thing as opposed to, let's say, size. I govern the size and I govern the shape, but other than that I really don't care much what it looks like. And so I guess the only thing you can ask is for people to have an open mind.

QUESTIONER: What is the validity of setting up an abstraction of earth when earth is with us all the time?

LEAVITT: On that point I think we must remember that the artist, in every case, is not acting like a photographer; he is not going out and finding a beautiful spot in nature and simply recording it. He is actually altering it. He is changing it somehow. And it is this human presence which makes it into a human production and justifies its presence in a museum rather than just so much earth being piled in it.

QUESTIONER: I wonder if any of the earth artists know about ancient con-

structions that were done by Incas in Peru, Indians in Mexico—stick figures and other things. I wonder if we can get some reactions on these?

LONG: Well, England is covered with huge mounds and converted hills and probably you know Stonehenge, although that is one of the least impressive of all the things. In fact, most of England has had its shape changed—practically the whole place, because it has been ploughed over for centuries—rounded off.

LEAVITT: (*to Long*) Does this affect *your* work at all? Does this part of it interest you?

LONG: (*Pause*) Yes.

QUESTIONER: What kind of problems do museums actually present for you? Because it seems, from what Mr. Smithson said—the business of site and non-site—the Museum would be a hell of a place to put earth work. Do any of you resent this because it's the only place you really have the opportunity to exhibit, this and galleries etc., or do you really accept this, or do you not care?

SMITHSON: I think that's a part of the sad thing—that most museum people aren't conscious of their museum, and they just take it for granted that artists are working in some garret and turning out objects. But I think they have to think about the limits of their spaces and how to extend them beyond the walls of confinement. But I think there is really no discrepancy between the indoors and the outdoors once the dialectic is clear between the two places.

OPPENHEIM: There is a suggestion in this type of art that overrides the fact that it's being displayed in this show. I think that if the sculpture were to remain in the archives and the lofts for the next thirty years or more, it would become a malignant kind of thing. I think that when artists began to see walking down a street as having an aesthetic or sculptural aspect, things began to open up a bit. I don't know if any of the artists here are after pure breakdown of some feeble limits. I don't think that's the impetus. But I would like to see someday an art so closely knit with a societal framework that there is no concern with viewing, no concern with recognizing, no concern with making posters, but an art that is inside our head and inside our total system so that it will be out of the caves of the Manhattan lofts and spread across a vaster area.

QUESTIONER: I get the idea that maybe your art is not so much to create an object out of earth as it is just to interpret earth and show others what earth is. Is that correct?

JENNEY: I think I use earth with every poetic aspect that it can be possibly given—like the fact that things grow in it and that we walk on it and houses are built in it and so on. I just use it basically because it's nice stuff. No, really! Dirt is reasonably cheap, so you can use a lot of it. One of the major aspects of using earth is that you can do it almost anywhere. You can do it on a scale that sculpture hasn't been done on in the past. I think basically it's just for its convenience. I don't think of the intrinsic value of art. You have to remember the separation between art and a work of art. The work of art is only a statement that will last a certain amount of time. I think another interesting thing about

doing earth works that some of you may have missed is that no sculpture is eternal; that physically it all falls apart and does so at various speeds. Some things last for only a minute, and others last a long time. I think basically the only reason that earth is being used is because it hasn't been used and because of its availability.

QUESTIONER: I'm not an artist, and I would like to know if the experience of actually digging in the earth is better for me than seeing the show?

JENNEY: No, man, it'd be a drag! One of the really nice things about this show, I believe, is that it was like everybody that's in earth is in it. Like I did something with earth in it and like that got me in the show. That's like having a show compiled of everybody that was born in the spring. In other words they do have something in common in that they use a similar vehicle. I think our expressions are basically different. I think the main reason this show happened was because people in England and Holland and Germany and different parts of America were doing it at the same time. Like two guys discovering Neptune.

QUESTIONER: I understand that some of the work connected with the show is not going to be done inside the Museum or even in the Museum galleries. If so, where are the locations going to be?

LEAVITT: We probably should distribute a map to people who come to the exhibition so that they will be able to locate all the works that have been executed outside the Museum vicinity. We'll do that.

WILLOUGHBY SHARP: Some of them are very far away, and you probably wouldn't want to go there because it would require maybe, well, a forty-minute walk through the woods and then back. And besides the single work which represents each artist, some of the artists are doing other works for themselves.

QUESTIONER: Some of today's art is really dedicated to the masses. Do you feel this is important?

JENNEY: I don't care too much about people coming to see it. You can't really concern art with masses because if you do you end up with television. You might be conscious of art as being a social barometer of what's happening. Well, again, it seems like the arts are always ahead of society. The artist exposes things before society realizes they should be exposed. Pop Art was a good example. You exposed something to a lot of the American society that was possibly known by a few people, and then suddenly it became a type of media for informing people. But there are very few people that understand art, very few people in the middle classes, certainly, who do, so you really shouldn't bother to educate them too much.

QUESTIONER: I should like to know what some of the earth artists see as the imaginary limits of their work. If you had unlimited stakes, and unlimited machines, what would you like to do?

LONG: Just the same things that I'm doing now. I don't work with limitations.

OPPENHEIM: I would like to be involved in something for which I would

ROBERT SMITHSON, *Slant Piece*, 1969. 48 x 60 x 48".

require a good deal of help. To spend the rest of my life developing things that are within my grasp really saddens me. I would hope eventually to pursue ideas that require some form of additional data and such. Now if we take some of the aspects of this art—and some of its aspects seem to be compelling—the issue of earth is really very far off. There are very few artists here that see earth as being as important as what they *do* to earth. In the same way I see the aspect of what seems to be occurring here, and may eventually spread, as an exponent of a large art which would involve the artist in organizations, which would allow him to be part of the process, to be part of a vaster interlacing of complexes, where the artist could hold a post, for instance, at the New York Advancement Commission, where artists could be directing media, and artists could be partaking in a vaster area of media.

QUESTIONER: How would that differ from architectural planning?

OPPENHEIM: Well, I'd say it was totally different from architecture in that it came from a different place. It didn't come or wasn't extrapolated from planning or traffic control. The concern of this would be aesthetic. But to answer your question more directly, the alternative to a studio art for me would be an art that mixed in with the societal process.

QUESTIONER: Do you feel that working in expanded areas and then having to work within a limited field, like a museum, is at all parallel to site and non-site?

SMITHSON: I don't really think it matters where you are. You will always be faced with limits of some kind. I think that actually it's not so much expanding into infinity, it's that you are really expanding in terms of a finite situation. I mean, there is no romantic urge towards the never-never land or something. I think that artists are now very conscious of strict limitations and they see them very clearly and can expand them in terms of other limitations. There's no way you can really break down limitations; it's a kind of fantasy that you might have, that things are unlimited, but I think there's greater freedom if you realize that you have these limits to work against and actually, it's more challenging that way. If you have a large corporation (I think Dennis was getting toward this) you would say that these people are imposing limits on you. Not really. If you are perceiving what is there, you are in control of your own limitations. It doesn't matter where you are. So in a sense you are always expanding—the upper limits are always going out—like taking a larger and larger area or smaller and smaller area. It doesn't really matter which way you go.

QUESTIONER: (to Jenney) You said you don't care what it looks like. There's not any aesthetic value that you place on it?

JENNEY: Of course it has aesthetic value. I mean the fact that you don't look at it or the fact that I am not concerned with the way it looks eliminates problems for me—it really does. I think artists, sculptors, have ignored a whole world of three dimensional existence by removing something from its ordinary environment. I think rockslides, things like that, events that took place, that have happened already and that there is evidence that something happened—I think that is good enough, and certainly you had nothing to do with what happened when it did happen. You know what I mean?

QUESTIONER: It seems like what you do depends on your saying that you did it. Don't you mind that some people can't recognize that it is so?

JENNEY: First of all, where do you look? You don't see art in the street, you really don't. Art is always removed to a certain extent. Like the fact that I'm putting this in a room of the Museum and suddenly it becomes a little removed. It's removed enough as far as I'm concerned.

HAACKE: Well, on the point of how it looks. I believe we are still carrying this heavy burden of "visual" art. When the term "aesthetics" was brought up in this discussion, it was immediately coupled with the looks of something. I believe art is not so much concerned with the looks. It is much more concerned with concepts. What you see is just a vehicle for the concept. Sometimes you have a hard time seeing this vehicle, or it might even not exist, and there is only verbal communication or a photographic record or a map or anything that could convey the concept.

JENNEY: (to Haacke) Say if you've got a whole pile of wood and not much dirt, would you consider using cinder blocks to fill up the spaces so you don't

have to use so much dirt, or is it important that the whole thing consists of dirt?

HAACKE: I guess the guideline would be what is the most efficient thing to do. If the rye that I seeded could have grown on cinder blocks, then it wouldn't have mattered if I used cinder blocks.

JENNEY: No, I mean the space. What if you only had half a yard of dirt and you wanted it a yard size, right? Would you fill the inside with rocks?

HAACKE: It could be done. It's not that important.

JENNEY: The reason it is the size it is . . .

HAACKE: It is an economic consideration, in view of what is to be achieved. What, from an agricultural viewpoint is the most efficient, and what is the viewpoint that causes most effectiveness, and so on.

JENNEY: Wouldn't it have been more efficient then to grow grass on a flat plain?

HAACKE: It could have been done but then you couldn't have walked around it. That aspect would have been lost and in this case we have a room that has natural light on two sides and artificial light and no light on the other two sides. The result is most likely to be that grass will grow toward the natural light and will be much longer on that side and will be meager on the side that is facing the artificial light, or will be much shorter. These are ecological phenomena which I am very much interested in.

QUESTIONER: Do you wish the concept to be developed through association? Why do you use the medium of earth?

HAACKE: It is the material in which growth takes place.

JENNEY: I think you are really mistaken if you think of art in terms of fact. The fact that he put a pile of dirt in a room and threw seeds on it doesn't make it art. The art that we are doing can mean pretty much more than that. I think that you can remove the piece and the thing that remains is art. That's the thing that most people don't understand. Historical breakthroughs are like the fact that I don't care what my piece looks like. I'm not concerned with expanding the boundaries of good taste at all. If the thing has a certain amount of presence, then I think basically that's it.

OPPENHEIM: Most of the art here is implying dialectic, implying a thing other than what takes place in front of your eyes, and I think you are going to reach an impasse if you attack this with a traditional aesthetic. Because I do feel we've left to the wayside the kind of art you are speculating upon now, and I think that to understand the gap between your sensibility and what may take place here you are going to have to redefine for yourself what it is all about.

QUESTIONER: Could any of you comment for younger artists out here on the rather obvious implications of this work being either salable or collected?

OPPENHEIM: Well, I'll just say a few things about that. I think that's a very positive configuration of this art. I think that the mobility, the salability, the commercial aspects of past art are weaknesses, and that if you involve those aspects you are open to a considerable restriction.

SMITHSON: I think we've come to the point where the artist's time is also valuable in terms of process. In other words there always has been the idea that there is a class of people who are going to value certain objects and sort of wrest them from the life of the artist. Now the process that the artist goes through is very valuable, just like anybody else—most people's time is considered valuable—so that the usual way out was to say that art is timeless, and therefore the artist is left alienated from his own time. So for the artist in this kind of art there is a positive step towards an integration of the artist with his own time. The trouble with the way the whole art system is set up now is that it exploits the artist out of his right to his art; his time is taken away from him under the pretext that his work is eternal. But eternities are all artificial or they are fictions in a sense. There is nothing wrong with those fictions per se. But that some group should have control over those fictions and claim that they are their property is wrong. So that in terms of my own work you are confronted not only with an abstraction but also with the physicality of here and now, and these two things interact in a dialectical method and it's what I call a dialectic of place. It's like the art in a sense is a mirror and what is going on out there is a reflection. There is always a correspondence. The reflection might be the mind, or the mirror might be the matter. But you always have these two things. They form a dual unity and to say that one is better than another is to go around like a squirrel in a cage. Just like you have two poles in the earth— the North Pole and the South Pole—and you are not going to put the North Pole on the South Pole. And yet there is a correspondence between the two— it might be at the equator, say. So that dialectic can be thought of that way: as a bipolar rhythm between mind and matter. You can't say it's all earth and you can't say it's all concept. It's both. Everything is two things that converge. This range of convergence is really the great area of speculation, and I think artists are getting a firm grip on this. I mean, they've been relegated to the garret for some time now, and it's just that they know what material is, and they know what the degree of abstraction is, and the two somehow blend, and I think that this starts a fruitful dialogue, something that can be very open ended.

LEAVITT: I think also in pragmatic terms that what is implied with this type of art, and also many other types, incidentally, is a new kind of support for the artists—not based upon possessiveness and also not based upon the idea of an art object. It becomes then perhaps the support of research or the support of interesting activity—whatever may be given—rather than the acquisition of something for the home or museums. It implies a whole different orientation of support, which, I might say, probably will be necessary if this direction is to flourish. The direction has come first, this is proper.

FRAGMENTS OF A CONVERSATION (1969)

Edited by William C. Lipke

PHOTOGRAPHY AND PAINTING

Cézanne and his contemporaries were forced out of their studio by the photograph. They were in actual competition with photography, so they went to sites, because photography does make Nature an impossible concept. It somehow mitigates the whole concept of Nature in that the earth after photography becomes more of a museum. Geologists always talk of the earth as "a museum"; of the "abyss of time" and treat it in terms of artifacts. The recovery of fragments of lost civilizations and the recovery of rocks makes the earth become a kind of artifice.

Photography squares everything. Every kind of random view is caught in a rectangular format so that the romantic idea of going to the beyond, of the infinite is checked by this so that things become measured. The artist is contorting, distorting his figures instead of just accepting the photograph.

I do think an interesting thing would be to check the behavior of Cézanne and the motivation to the site. Instead of thinking in formalist terms—we've gotten to such a high degree of abstraction out of that—where the Cubists claimed Cézanne and made his work into a kind of empty formalism, we now have to reintroduce a kind of physicality; the actual place rather than the tendency to decoration which is a studio thing, because the Cubists brought Cézanne back into the studio. It would be interesting to deal with the ecology of the psychological behavior of the artist in the various sites from that period. Because in looking at the work today, you just can't say it's all just shapes, colors and lines. There is a physical reference, and that choice of subject matter is not simply a representational thing to be avoided. It has important physical implications. And then there is Cézanne's perception: being on the ground, thrown back on to a kind of soil. I'm reversing the perspective to get another viewpoint, because we've seen it so long now from the decorative design point of view and not from the point of view of the physicality of the terrain. That perception is needed more now than the abstract because we're now into such a kind of soupy, effete thing. It's so onesided and groundless.

SITE SELECTION

I'm interested in making a point in a designated area. That's the focal point. You then have a dialectic between the point and the edge: within a single focus, a kind of Pascalian calculus between the edge and the middle or the fringe and the center operating within a designated area. And usually when you focus on it with a camera, it becomes a rectangle. The randomness to me is always very precise, a kind of zeroing in. But there is a random element: the choice is never abolished.

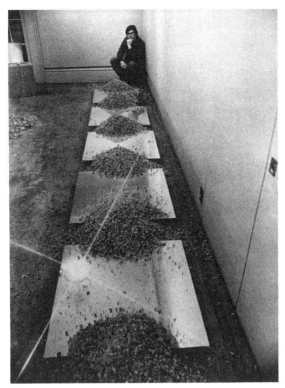

ROBERT SMITHSON, *Eight Unit Piece*, 1969. 11 x 30 x 300".

I would say the designation is what I call an open limit as opposed to a closed limit which is a non-site usually in an interior space. The open limit is a designation that I walk through in a kind of network looking for a site. And then I select the site. There's no criteria; just how the material hits my psyche when I'm scanning it. But it's a kind of low level scanning, almost unconscious. When you select, it's fixed so that randomness is then determined. It's determined in uncertainty. At the same time, the fringes or boundaries of the designation are always open. They're only closed on the map, and the map serves as the designation. The map is like a key to where the site is and then you can operate within that sector.

CAYUGA SALT MINE SITE

This was the first interior underground site that I did, the one in the salt mine. There you have an amorphous room situation, an interior that's completely free. There are no right angles forming a rectilinear thing. So I'm adding the rectilinear focal point that sort of spills over into the fringes of the nondescript amorphousness. Then it's all contained when you shoot the photograph so you have that dialectic in that. On a topographical earth surface you don't have that kind of enclosure. There's a sort of rhythm between containment and scattering. It's a fundamental process that Anton Ehrenzweig has gone into. I think

his views are very pertinent in that he talks about this in terms of containment or scattering.

An artist in a sense does not differentiate experience into objects. Everything is a field or maze, and you get that maze, serially, in the salt mine in that one goes from point to point. The seriality bifurcates: some paths go somewhere, some don't. You just follow and what you're left with is like a network or a series of points, and then these points can then be built in conceptual structures.

The non-site situation doesn't look like the mine. It's abstract. The piece I did here utilizes the same dialectic of the site/non-site, except the one controlling element is the mirror which in a sense is deployed differently. There's an element of shoring and supporting and pressures. The material becomes the container. In other non-sites, the container was rigid, the material amorphous. In this case, the container is amorphous, the mirror is the rigid thing. It's a variation on the theme of the dialectic of the site/non-site.

I'm using a mirror because the mirror in a sense is both the physical mirror and the reflection: the mirror as a concept and abstraction; then the mirror as a fact within the mirror of the concept. So that's a departure from the other kind of contained, scattering idea. But still the bi-polar unity between the two places is kept. Here the site/non-site becomes encompassed by mirror as a concept—mirroring, the mirror being a dialectic.

The mirror is a displacement, as an abstraction absorbing, reflecting the site in a very physical way. It's an addition to the site. But I don't leave the mirrors there. I pick them up. It's slightly different from the site/non-site thing. Still in my mind it hasn't completely disclosed itself. There's still an implicit aspect to it. It's another level of process that I'm exploring. A different method of containment.

The route to the site is very indeterminate. It's important because it's an abyss between the abstraction and the site; a kind of oblivion. You could go there on a highway, but a highway to the site is really an abstraction because you don't really have contact with the earth. A trail is more of a physical thing. These are all variables, indeterminate elements which will attempt to determine the route from the museum to the mine. I'll designate points on a line and stabilize the chaos between the two points. Like stepping stones. If I take somebody on a tour of the site, I just show them where I removed things. Not didactic, but dialectic.

Oblivion to me is a state when you're not conscious of the time or space you are in. You're oblivious to its limitations. Places without meaning, a kind of absent or pointless vanishing point.

There's no order outside the order of the material.

I don't think you can escape the primacy of the rectangle. I always see myself thrown back to rectangle. That's where my things don't offer any kind of freedom in terms of endless vistas or infinite possibilities. There's no exit, no

road to utopia, no great beyond in terms of exhibition space. I see it as an inevitability; of going toward the fringes, towards the broken, the entropic. But even that has limits.

Every single perception is essentially determinate. It isn't a question of form or anti-form. It's a limitation. I'm not all that interested in the problems of form and anti-form, but in limits and how these limits destroy themselves and disappear.

It's not a matter of what I'd like to do, but how things result. There are strict limits, but they never stop until you do.

FRAGMENTS OF AN INTERVIEW WITH
P. A. [PATSY] NORVELL (1969)

ROBERT SMITHSON: An interesting thing to start with would be the whole notion of the object, which I consider to be a mental problem rather than a physical reality. An object to me is the product of a thought; it doesn't necessarily signify the existence of art. My view of art springs from a dialectical position that deals with whether something exists or doesn't exist. I'm more interested in the terrain dictating the condition of the art. The pieces I just did in the Yucatan were mirror displacements. The actual contour of the ground determined the placement of the twelve mirrors. The first site was a burnt-out field which consisted of ashes, small heaps of earth and charred stumps; I picked a place and then stuck the mirrors directly into the ground so that they reflected the sky. I was dealing with actual light as opposed to paint. Paint to me is matter, and a covering, rather than light itself. I was interested in capturing the actual light on each spot, bringing it down to the ground. I did this different ways with different kinds of supports—sometimes raw earth, sometimes tree limbs or other materials existing on the site. Each piece was dismantled after it was photographed. I just wrote an article on that trip (see *Artforum*, September 1968). It is a piece that involves travel. A lot of my pieces come out of the idea of covering distances. There is a certain degree of unmaking in the pieces, rather than making; taking apart and reassembling. It is not so much a matter of creating something as de-creating, or denaturalizing, or de-differentiating, decomposing . . .

Earlier work has had to do with site and nonsite. I first got interested in places by taking trips and just confronting the raw materials of the particular sectors before they were refined into steel or paint or anything else. My interest in the site was really a return to the origins of material, sort of a dematerialization of refined matter. Like if you took a tube of paint and followed that back to its original sources. My interest was in juxtaposing the refinement of, let's say, painted steel, against the particles and rawness of matter itself. Also it sets up a dialogue between interior exhibition space and exterior sites. . . . It seems that no matter how far out you go, you are always thrown back on your point of origin. . . . You are confronted with an extending horizon; it can extend onward and onward, but then you suddenly find the horizon is closing in all around you, so that you have this kind of dilating effect. In other words, there is no escape from limits. There is no real extension of scale taking place simply by spreading materials inside a room.

Six Years: The Dematerialization of the Art Object from 1966–1972, edited by Lucy R. Lippard, 1973. The interview took place in April 1969, and was edited by Lucy R. Lippard and Robert Smithson; a few additions were made by Smithson.

In a sense my nonsites are rooms within rooms. Recovery from the outer fringes brings one back to the central point. . . . The scale between indoors and outdoors, and how the two are impossible to bridge. . . . What you are really confronted with in a nonsite is the absence of the site. It is a contraction rather than an expansion of scale. One is confronted with a very ponderous, weighty absence. What I did was to go out to the fringes, pick a point in the fringes and collect some raw material. The making of the piece really involves collecting. The container is the limit that exists within the room after I return from the outer fringe. There is this dialectic between inner and outer, closed and open, center and peripheral. It just goes on constantly permuting itself into this endless doubling, so that you have the nonsite functioning as a mirror and the site functioning as a reflection. Existence becomes a doubtful thing. You are presented with a nonworld, or what I call a nonsite. The problem is that it can only be approached in terms of its own negation, so that leaves you with this very raw material that doesn't seem to exist. . . . You are faced with something inexplicable; there is nothing left to express . . .

Photographs are the most extreme contraction, because they reduce everything to a rectangle and shrink everything down. That fascinates me. There are three kinds of work that I do: the nonsites, the mirror displacements, and earth maps or material maps. The mirrors are disconnected surfaces. The pressure of the raw material against the mirrored surface is what provides its stability. The surfaces are not connected the way they are in the nonsites. The earth maps, on the other hand, are left on the sites. For instance, I have a project pending in Texas that will involve a large oval map of the world that existed in the Cambrian era. Like the map of a prehistoric island I built on quicksand in Alfred, New York. The map was made of rock. It sank slowly. No sites exist at all; they are completely lost in time, so that the earth maps point to nonexistent sites, whereas the nonsites point to existing sites but tend to negate them. The mirror pieces fall somewhere between the edge and the center. The photograph is a way of focusing on the site. Perhaps ever since the invention of the photograph we have seen the world through photographs and not the other way around. In a sense, perception has to decant itself of old notions of naturalism or realism. You just have to deal with the fundamentals of matter and mind, completely devoid of any anthropomorphic interests. That is also what my work is about—the interaction between mind and matter. It is a dualistic idea which is very primitive. . . . I consider the facile unitary or gestalt ideas part of the expressive fallacy, a relief after the horrors of duality. The apparent reconciliation seems to offer some kind of relief, some kind of hope . . .

People are convinced they know what reality is, so they bring their own concept of reality to the work. . . . They never contend with the reality that is outside their own, which might be no reality at all. The existence of "self" is what keeps everybody from confronting their fears about the ground they happen to be standing on. . . . The sites show the effect of time, sort of a sink-

ing into timelessness. When I get to a site that strikes the kind of timeless chord, I use it. The site selection is by chance. There is no wilful choice. A site at zero degree, where the material strikes the mind, where absences become apparent, appeals to me, where the disintegrating of space and time seems very apparent. Sort of an end of selfhood . . . the ego vanishes for a while.

P.A. NORVELL: It is all a very self-contained system, once the site is selected.

SMITHSON: It is like a treadmill. There is no hope for logic. If you try to come up with a logical reason then you might as well forget it, because it doesn't deal with any kind of namable, measurable situation. All dimension seems to be lost in the process. In other words, you are really going from some place to some place, which is to say, nowhere in particular. To be located between those two points puts you in a position of elsewhere, so there's no focus. This outer edge and this center constantly subvert each other, cancel each other out. There is a suspension of destination. I think that conceptual art which depends completely on written data is only half the story; it only deals with the mind and it has to deal with the material too. Sometimes it is nothing more than a gesture. I find a lot of that written work fascinating. I do a lot of it myself, but only as one side of my work. My work is impure; it is clogged with matter. I'm for a weighty, ponderous art. There is no escape from matter. There is no escape from the physical nor is there any escape from the mind. The two are in a constant collision course. You might say that my work is like an artistic disaster. It is a quiet catastrophe of mind and matter.

NORVELL: What about limits in art?

SMITHSON: All legitimate art deals with limits. Fraudulent art feels that it has no limits. The trick is to locate those elusive limits. You are always running against those limits, but somehow they never show themselves. That's why I say measure and dimension seem to break down at a certain point. . . . Like there are the people of the middle, lawyers and engineers, the rational numbers, and there are the people of the fringe, tramps and madmen, irrational numbers. The fringe and the middle meet when somebody like Emmett Kelly sweeps light into a dustpan.

NORVELL: Jack Burnham feels we are going from an object-oriented society to a systems-oriented society.

SMITHSON: System is a convenient word, like object. It is another abstract entity that doesn't exist. I think art tends to relieve itself of those hopes. Jack Burnham is very interested in going beyond, and that is a utopian view. The future doesn't exist, or if it does exist, it is the obsolete in reverse. The future is always going backwards. Our future tends to be prehistoric. I see no point in utilizing technology or industry as an end in itself, or as an affirmation of anything. That has nothing to do with art. They are just tools. If you make a system you can be sure the system is bound to evade itself, so I see no point in pinning any hopes on systems. A system is just an expansive object, and eventually it all contracts back to points. If I ever saw a system or an object, then I

might be interested, but to me they are only manifestations of thought that end up in language. It is a language problem more than anything else. It all comes down to that. . . . As long as art is thought of as creation, it will be the same old story. Here we go again, creating objects, creating systems, building a better tomorrow. I posit that there is no tomorrow, nothing but a gap, a yawning gap. That seems sort of tragic, but what immediately relieves it is irony, which gives you a sense of humor. It is that cosmic sense of humor that makes it all tolerable. Everything just vanishes. The sites are receding into the nonsites, and the nonsites are receding back to the sites. It is always back and forth, to and fro. Discovering places for the first time, then not knowing them. . . . Actually it is the mistakes we make that result in something. There is no point in trying to come up with the right answer because it is inevitably wrong. Every philosophy will turn against itself and it will always be refuted. The object or the system will always crush its originator. Eventually he will be overthrown and be replaced by another series of lies. It is like going from one happy lie to another happy lie with a cheerful sense about everything. An art against itself is a good possibility, an art that always returns to essential contradiction. I'm sick of positivists, ontological hopes, and that sort of thing, even ontological despairs. Both are impossible.

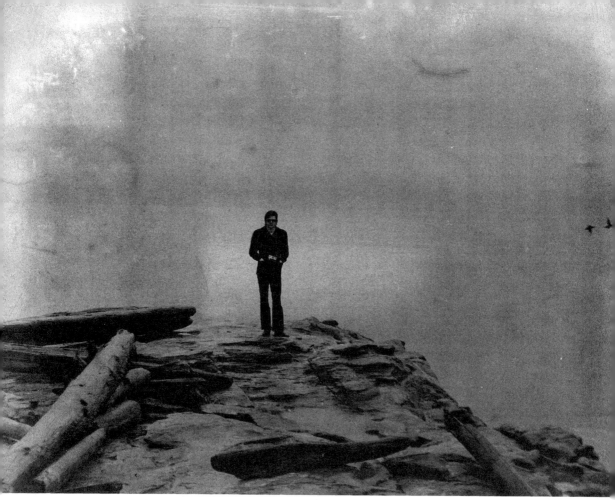

Robert Smithson on Miami Islet, Strait of Georgia, Vancouver, BC. December 1969.

FOUR CONVERSATIONS BETWEEN DENNIS WHEELER AND ROBERT SMITHSON (1969–1970)

Edited and annotated by Eva Schmidt

"Well, in nature you can fall off cliffs . . ."

From the end of 1969 until the beginning of February 1970 Smithson spent some time in Vancouver, British Columbia, to prepare his project of the *Island of Broken Glass* and to realize his work *Glue Pour* for Lucy Lippard's exhibition 955,000 at the Vancouver Art Gallery.[1] During this time he met Dennis Wheeler, a young art historian and filmmaker, for four long conversations about Smithson's work,[2] originally not intended for publication. Although the conversations are edited here in a strongly condensed form, they still convey their *de*differentiated character (as Smithson put it, using Ehrenzweig's term).[3]

While Smithson and Wheeler were scanning magazine articles and piles of photos, they built a labyrinth of conversation in which they passed some topics

more than once only to head into new and unexpected directions. Their starting point, to which they often come back, is the project of the *Island of Broken Glass*. Then they concentrate mainly on the works done in 1969: the mirror displacements, the pours/flows, the hypothetical continents, and the inverted trees, but they also go back to Smithson's basic esthetic concept of crystalline mapping and, of course, to his dialectic of mind and matter best exemplified in the nonsites.

The *Island of Broken Glass* was a development of the hypothetical continents and led to the large-scale works in the early 1970s and especially to the infinite number of island forms depicted in the later drawings. The plan to pour 100 tons of tinted glass onto the small Miami Islet, a rocky island about 50 yards long, could not be realized. A public controversy arose over the question as to whether wildlife might be injured by the broken glass. This "ecological" controversy led later to Smithson's etymological argument that ecology is the guilty side of economics[4] and that the "belief in ecology and the infernal agents of pollution"[5] has the function of a cheap religion. For Smithson—and this is the argument that runs through all these conversations—esthetic experience could be an important experience only when it is risky and dangerous. "The *Island* is not meant to save anything or anybody, but to reveal things as they are."[6]

<div align="center">ONE</div>

DENNIS WHEELER: Let's talk about the scale of the *Island*.

ROBERT SMITHSON: How I arrived at the scale of the *Island*? . . . Let's see. The scale of a raw crystal is abstracted to the point where you get a crystal lattice. And this crystal lattice is extended to the latitudes and longitudes of the world, so that you're drawing lines and grids over the world. And this is a certain kind of abstract consciousness which sets up a way of dealing with raw material and mental experience. Let's say this being matter and this being mind. Well, actually once you make the abstract breakdown of these two within the crystal you get a kind of—let's say we get a square out of this. There are six crystal systems that can be drawn out of all raw material and these crystal systems have different kinds of lattice set-ups. You can look that up in *Dana's Mineralogy*.[7] . . . Now if you take these six crystal systems and extend these to a global view with the lattice drawn over the earth, all the early works are dealing with that problem; in a sense it's finding a degree of abstraction within the lattice and crystalline system outside of the material aspect so that in the nonsite you have a return to the raw material where the abstract lattices and grids encompass the raw material. . . . There is an early work which I showed at the "Primary Structures" show[8] in New York called the *Cryosphere*, which was based on a kind of intuition of ice crystals in a hexagonal lattice set-up in ice. They really don't know whether ice is very unstable, like water; ice and air, you know, gas, is sort of a fascinating thing. These things sort of move in a kind of ambiguous flux. Then to stabilize that somewhere became a

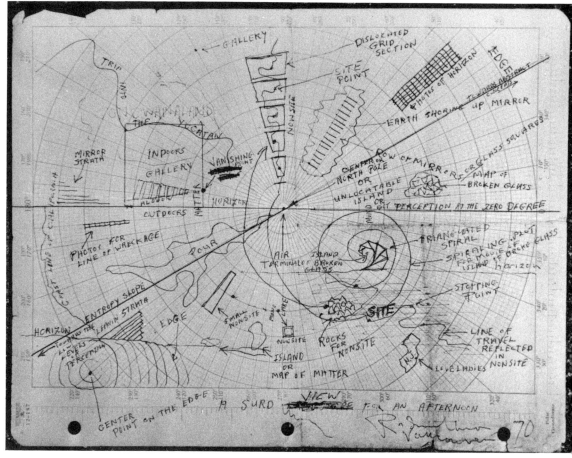

ROBERT SMITHSON, *A Surd View for an Afternoon*, 1969 (signed 1970). Ink, 8½ x 11″. This drawing was made during the conversations with Wheeler, during which Smithson refers to specific parts of it.

kind of interesting notion to me, so I made this thing called the *Cryosphere*, which involves certain mirrors built right into these hexagonal shapes. Then in the nonsites we have the rectilinear grid incorporating the raw material of the site. Now the site is essentially an expanded area out there, and then it's contracted into the nonsite. The site has no seeming limits, but the nonsite points to the site. In a sense the nonsite, although it points to it, effaces this particular region. Where in a sense the point, of course, is almost impossible to locate within the site. . . .

WHEELER: What does the shape of the nonsite bear relevance to?

SMITHSON: The shape is based on the map that I devise in terms of my experience of the site.

WHEELER: So that's strictly an empirical thing. You go out to the site . . .

SMITHSON: Yeah, that's based on my experience of the site. That's not based on any kind of . . .

WHEELER: Extension of the science or the morphology of

SMITHSON: No. It's essentially what I would call a *surd*.[9]

WHEELER: So it's not tautological.

SMITHSON: No. That always seems to me a cop out, tautology, I would say that's the weakness of [nonart].

WHEELER: The easy way.

SMITHSON: Yeah. That also takes you into what I would call logic. In a sense, this system defeats any idea of any kind of system. The system itself is self-canceling. You're into what I would call a *surd area*. A surd area is beyond tauto-logic . . . not really beyond, there's no beyond. As a matter of fact, it's a region where logic is suspended. I would look this up, too, this particular idea which might be somewhat [generative]. . . . There's no commensurable relation, or it's incommensurable. So you're into a kind of irrational area.

WHEELER: That's where it becomes your own, too. It's not simply some-thing that's distilled from a pseudoscience . . .

SMITHSON: No, because it would be a cheap kind of logic to get into that, I think. It becomes sophomoric if you get into tautological logic.

WHEELER: Okay . . . We've got this far. How can we bring this through the mirror displacements in the Yucatan?

SMITHSON: Well the Yucatan thing. There's a convergence of this dialectic, there's a dialectical situation. The dialectic is established but the coordinates al-ways tend to be incommensurable in an absurd situation—or to go back to my early intuition, back to what is known as the *Alogon*. Alogon is something that suspends rationality, that's indicated in some of the earlier pieces. There are three Alogon works, and that's sort of the break with logic, the break with the gestalt. In other words, you're into this area of *de*differentiation that Ehrenzweig talks about where the gestalt becomes something else. The entropic aspect comes in. Dedifferentiation is his word. And if you read Ehrenzweig's *The Hid-den Order of Art*, one chapter that is particularly good is called "The Scattered and the Buried God." Buried in this sense is another word for containment. There's this interaction between the scattered and the contained. It's the tension between those two things that essentially manifests itself in fascinating art, I think. It's not a matter of being satisfied. . . .

WHEELER: That sounds like a very traditional sense of form and anti-form, or . . .

SMITHSON: No, that's not it.

WHEELER: Content and form maybe. . . .

SMITHSON: Content usually involves some kind of representational aspect which I try to avoid. The nonsite is an abstraction that represents the site. It doesn't look like the site; the nonsite isn't like the site although it points to it.

WHEELER: Resembles it. . . .

SMITHSON: But it's the abstract equivalent of the site. . . . There is no repre-sentational aspect between those two things. . . . Out of this you would come to the *Island* again. Once again you are thrown out to the edges. The way I'm deal-

ing with this is, in a sense, the point of view. It's all points really. There's a point that is impossible to find, that's out of my experience, that registers [in the site]. Within this field the point is picked up out of and made into [the nonsite]. This becomes an entire point, all this area becomes a point. But once you are out there, you can't find the point.

WHEELER: You are more into a direction . . .

SMITHSON: Sort of an irreversible situation. Then, of course, the point of view is thrown out again. This [*Island of Broken Glass*] is being so isolated in the water. The way I'm treating this is with the spiral. There are elements of spirals in this work, mental abstract spirals . . .

WHEELER: That just aren't made manifest.

SMITHSON: Here the mental spiral becomes a physical spiral. The viewpoint goes out like an inverse spiral. It's not a spiral that's going up . . .

WHEELER: . . . in a point. That's great. It looks like Tatlin's *Monument*.[10]

SMITHSON: Well. . . . but it's an inversion of Tatlin's *Monument*, or whatever, the Tower of Babel.

WHEELER: I just saw the filming of this island as being one aspect of further documentation, but, in fact, it seems much more complicated.

SMITHSON: It is, it is. It's a matter of perception. It's how you perceive . . . some of my early designs for the outer perimeter of the airfield took a spiral form.[11] But those were totally in terms of an intuition that was leading up to this, so that this wasn't carried out. The difference here is that this is carried out, and the point of the spiral is broken completely and isolated on this island. . . . Now within these, too, the maps, first the *Map of Atlantis*, done at Loveladies, New Jersey, which is a hypothetical landmass that doesn't exist, is preceded by other hypothetical islands. You have a string of hypothetical islands that finally find their result in an actual island. The hypothetical islands all terminate in this *Island of Broken Glass*, which is in fact something that is completely illusive, being made materially manifest. . . .

WHEELER: Where were these done?

SMITHSON: *The Hypothetical Continent in Stone, Cathaysia* was done in Alfred, New York, and then, there's the *Island of Broken Sea Shells*. These are all prehistoric nonexistent landmasses, where in the nonsite they are existent today. The sites are there. There's one in the Yucatan article of the *Gondwanaland Ice Cap*. Then there's the *Island of Broken Glass*. These are all in a sense material maps, maps not of paper but made of materials. . . . On the other side of this, you have the mirror displacements, which are a sort of other kind of . . .

WHEELER: Carrying on of that, that initial impulse.

SMITHSON: Which is essentially travel and distance, travel and distance, around these islands.

WHEELER: Okay, that's a bit vague in a sense, travel and distance.

SMITHSON: In other words, one piece is set up, and another piece is set up. You keep going from point to point. These [hypothetical continents] are in a

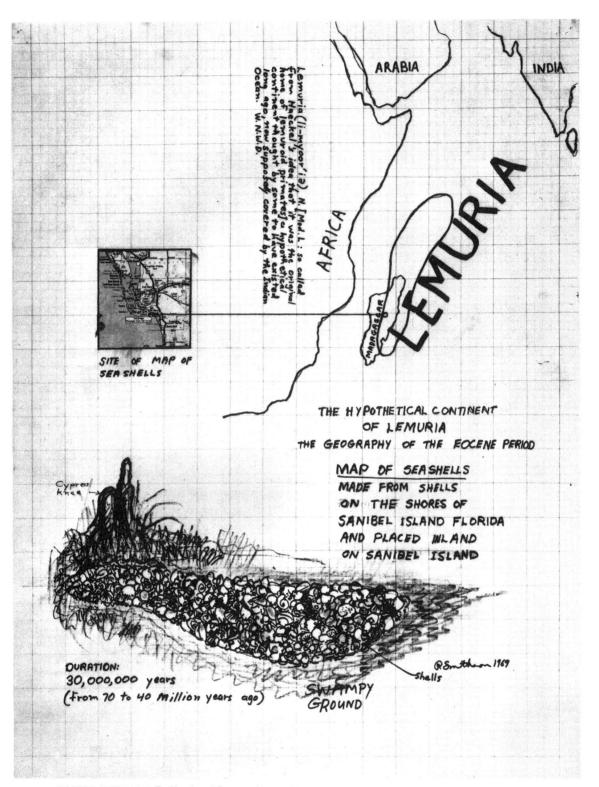

ARABIA

INDIA

AFRICA

LEMURIA

MADAGASCAR

Lemuria (li-myoor′i-ə) N.[Mod.L.: so called from Haeckel's idea that if it was the original home of lemuroid primates] a hypothetical continent thought by some to have existed long ago, now supposed covered by the Indian Ocean. W.N.W.D.

SITE OF MAP OF SEA SHELLS

THE HYPOTHETICAL CONTINENT
OF LEMURIA
THE GEOGRAPHY OF THE EOCENE PERIOD

MAP OF SEASHELLS
MADE FROM SHELLS
ON THE SHORES OF
SANIBEL ISLAND FLORIDA
AND PLACED INLAND
ON SANIBEL ISLAND

Cypress knee

DURATION:
30,000,000 years
(from 70 to 40 million years ago)

SWAMPY
GROUND

R Smithson 1969
shells

ROBERT SMITHSON, *The Hypothetical Continent of Lemuria*, 1969. Ink, crayon map, 22 x 17″.

sense permanent pieces that are along this trail, but these [mirror displacements] are dismantled. They're unmade.

WHEELER: Okay, so now we can talk about the mine site. . . . Which is going to be carried out first? Is it simultaneous or will the *Island* be carried out first?[12]

SMITHSON: No, it is simultaneous. It is also a matter of chance, as the possibilities turn up. Each one of these situations generates information. There is a correspondence, but the correspondence never quite adds up to anything. It is always open-ended.

WHEELER: So the relationships aren't really that important, that clear, but they're always there.

SMITHSON: They're always there, because each thing is concerned with, let's say, the interaction between mind and matter. One isn't excluded over the other. . . . My thoughts are like an avalanche in the mind, in the sense that they are breaking apart; there's no information that can't be collapsed or broken down, so that it's not a matter of establishing a perfect system. There is no perfection in this situation. There is no perfection in my range, because my thoughts as well as the material that I'm dealing with are always coming loose, breaking apart and bleeding at the edges. There's no attempt to finalize into a static concept—rather if I am interested in concepts, the concepts are so much sludge collapsing down the side of my brain.

WHEELER: I have a sense that this is totally metaphorical, and yet it is totally materialized in the art. . . .

SMITHSON: All this absurd precision, being able to manifest something physical is very precarious. . . . It's the mind and the matter seeking its lowest possible level.

WHEELER: To be able to do this thing in the world of materials is really an astounding feat.

SMITHSON: I think this is the astounding thing, that you can't withdraw from the piece of the world. You have to get out there and sort of wrestle with these problems. You can't say, "I'm in a world of pure essence," or "My work is so perfect." Nothing is perfect. Everything is subject to time. Yet at the same time there is a timeless abstract recognition, and this is what's important. You can't really rule out anything. All these things are sort of corroding each other. The beginning of the sedimentation . . . it was just a matter of going to where the ore was. There was no preconceived idea of where the ore was, yet somehow they found a way to get to it. But it's rather a crazy kind of grid situation . . .

WHEELER: Getting to the center of what they were after.

SMITHSON: And then the branching off aspect. Again, everything can be read in terms of that. This calculus, this visual experience and physical evidence . . .

WHEELER: The location of the center is very materially important for them. This is interesting, because I guess that it's their job. Once you locate the center in a mine, I imagine, then, you know, you just determine how far you are in; you have a pretty good idea, even if the thing is irregular in

formation, as to what the richness and vastness of what you discovered is.

SMITHSON: You are going toward that particular material that you have decided that you need—the resource—yet how you get there is not based on any preconceived tautological logic; otherwise what you'd have is like the perfect mountain, where everything would be like . . .

WHEELER: . . . it would be all set up for you . . .

SMITHSON: And this is the difference, this is the way that I think. Where that is what I would call the conceptual fallacy, where physical reality isn't like that. . . . It's admitting that most of our abstractions are hypothetical. Our mapping is hypothetical, because we have to make an outline. We have to outline the continents, the landmasses, and yet when you get into the actual landmasses, then you find where is the edge of this. You can see drawn on a map, say, the edge of the Dead Sea; then you think of the Dead Sea, the shores of the Dead Sea. . . . and there's always the temptation to want to simplify this.

WHEELER: The constant erosional in the geological.

SMITHSON: In other words, the limits are there and that's what makes it essentially a classical procedure, because there is no pretending that there is something there that isn't there.

WHEELER: It's like Greek thought in that sense, that you understand the ramifications and all the possibilities and they're very much overwhelming, so you make gods and deify them.

SMITHSON: Those gods break down.

WHEELER: Right, and you know that.

SMITHSON: I know that. I'm not seduced into thinking that these gods have an infinite lifespan, because they are subject to the erosion of their own existence. . . . Even though they are abstractions they are still breaking down.

WHEELER: Breaking down doesn't suggest—to get this clear maybe—a breaking down in the sense that you lose something . . .

SMITHSON: No, it's a metamorphosis.

WHEELER: Like it's your $E = mc^2$. . . . Can we talk any more about specific things . . . when you talk about scale you aren't talking about a traditional sense of scale?

SMITHSON: Not bigness, bigness isn't scale.

WHEELER: Scale is not measurable in this sense, then?

SMITHSON: Yeah, that gets back to the surd situation. Although you are conscious of the scale, it's how your consciousness focuses. This island might appear big, but in fact it's very tiny, so that you have this telescoping back and forth from both ends of the telescope; you can conceive of it as a very large work, like one particle on the island might be conceived as being a gigantic tumulus. . . . The particle on the island takes on an enormity. Whereas the island itself is just a dot.

WHEELER: That's context too. That's where the nonsite becomes important . . . because that dramatizes the sense of context and discontext.

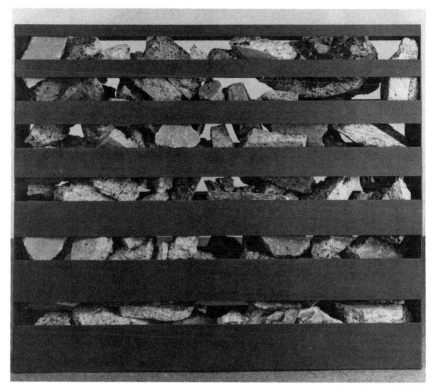

Nonsite "Line of Wreckage," Bayonne, New Jersey, 1968. Aluminum, broken concrete, 59 x 70 x 12½".

SMITHSON: Right, because also the site isn't there. Here you are confronted with both a mental and a physical manifestation that purports not to be there, so that it's an effacement through the physical properties of both mind and matter. In other words, in the nonsite idea here is this container and it has the limit of my mental experience plus the physical point.

WHEELER: So if someone was to walk into the gallery and face the object and the collection of things inside, when they'd call it minimal they are missing the notion of scale too.

SMITHSON: Even if there was the notion of the inside and the outside; in a sense it's the containment within the containment of the room. Another reason I'm going into the mines is that there are no ideal walls or floors; it's essentially crumbling. All the walls, and all the floors are in a state of crumble—the rectilinearity of the square of the work in contrast to the disruption of the interior of the mine. If you take a pure gallery space that's like an ideal space, now you can extend crumbling material throughout the gallery that is still contained by the gallery. With the nonsite the experience goes beyond, outside the gallery. It doesn't really go beyond it, because you are thrown back into that space. . . .

WHEELER: You have to deal with the wall. , , .

SMITHSON: As human entities we deal within rectilinear structures, so we are limited by that rectilinearity or circularity, or some kind of abstraction, like

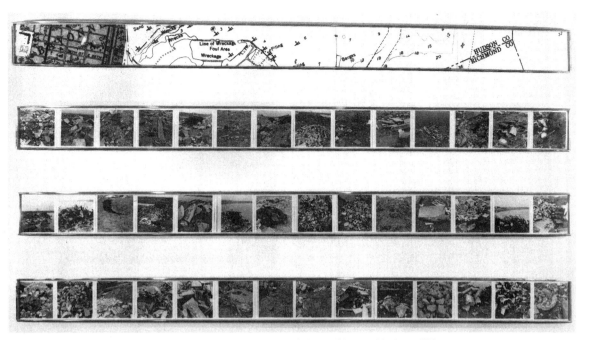

ROBERT SMITHSON, Photodocumentation for *Nonsite "Line of Wreckage," Bayonne, New Jersey*, 1968.
Chromogenic development prints and photostat, 4 units 3½ x 43" each.

a room is an abstraction, but a cave is a physical material manifestation, as rooms get purer and purer, more and more abstract.

WHEELER: Do you think that is a romantic notion? That rooms are abstract as opposed to caves are natural? . . . And the city is hostile, and man–made, and unnatural.

SMITHSON: No, because the experience is always fed right back to that, so that it's the tension between the romantic and the classical, but ultimately the recognition of limits is essentially a classical thing. It is not that you're picking one or the other, it's the tension between the two. You can't really get away from those two situations, but it's interesting to locate the problems of Romanticism and the problems of Classicism within the tension of these two things, let's say the scale between those two things. . .ʼ. Let's take the *Line of Wreckage* nonsite. Now over here is the line of wreckage, right outside of [Bayonne, New Jersey], in other words, this is suburban . . . on the other side of the river, and . . . here's the city. It is like the runoff literally; then no matter how squalid the situation is it can always be metamorphosed into a context within this situation here. But, of course, the city itself is like Egypt where it is an absolute, everyone knuckles under. Here we have a kind of madhouse situation. Each person is trying to do his little pyramid number right here. . . . Here [Bayonne] it is a different experience. . . . [the material is] flung out where this [material in the nonsite] is concentrated. All the activity, mental activity is

going on in here [the city], and this [Bayonne] is sort of forgotten . . . it is more of an entropic [situation].

WHEELER: I still haven't got entropy defined in my mind.

SMITHSON: There are some pretty good definitions of it. I'll give you this book on fluvial/alluvial actions,[13] where the running mud flows and other kinds of things [are described]. He goes into some pretty interesting discussions of it there, look it up in the index. The geologic use of entropy is probably more interesting. You might say that this [Bayonne] is a cold zone out here.

WHEELER: As opposed to a hot, yeah. Because this [the city] is activity and this [Bayonne] is waste or whatever. This is depositional too, alluvial in that sense, too, and this is built. . . . Say, have you gone in an airplane over the top of Vancouver International Airport, and the Fraser River Valley where it branches out . . . and there is an island here, and an island there. . . . And the Airport is on this island, and there are marshes here that go out and out and out in sort of alluvial patterns. This is the Fraser River . . .

SMITHSON: It is on that delta actually I went out to the end . . .

WHEELER: Roberts Bay . . . I tried to get out there last time and they had put out guards. I've been getting things from it for quite a long time.

SMITHSON: Actually we just drove out and ignored the "No Trespassing" signs. Once you get out into these areas there is always no trespassing . . . taboo, totem taboo. . . . Once again you can even conceive of this like a taboo territory, this is very primitive in a sense. . . . If we get into primitive structural set-ups, nonsite is . . .

WHEELER: Totemic.

SMITHSON: In a real conscious sense, not in any kind of fantasy sense. . . . If you read some anthropology books you will find that that's true . . . this kind of totemic taboo thing, Frazer[14] I think goes into some of this. Any book on anthropology discusses the bush and the town site, so that you have these two things, and they are conscious of both of them and this sets up a kind of fantasy situation where people are making all kinds of weird masks and things. There is a kind of peculiar perception in these people, and this is what Lévi-Strauss points out in his *Savage Mind*. So that might be an interesting thing to pursue in terms of the whole notion of taboo territory, like the *Line of Wreckage* could certainly be taboo, like pollution, foul area.

WHEELER: It is the same with the mine in a sense. . . . I went to Britannia and tried to get in, and they said . . .

SMITHSON: Taboo, women aren't allowed in the mine. I did my mirror pieces in Ithaca,[15] women aren't allowed.

WHEELER: Did they give you a reason?

SMITHSON: It's a very strong taboo. I read somewhere there is a strong feeling that, in the primitive sense, the tube is like a vagina, there's a kind of like Freudian protectiveness.

WHEELER: That's fantastic.

SMITHSON: It seems that all great thinkers have always in a weird way come on to the problem of totemic, totem, and taboo situations. Like Freud and Marx, Frazer—but they never quite come up with the right thing, it's always a confusion . . . Freud—no—Lévi-Strauss says that totemism comes from hysteria. It's very similar to hysteria. Good poetry too, like Eliot's things grounded in Frazer.[16] You're really getting at the nerve ends, that's like an inexplicable situation, you can't have explanations, you really are on troubled waters, it is completely unknown territory that you are going into. And that's what's exciting, the whole element of exploration, expedition. Then making some kind of coherence, not even a rational coherence, but a coherence out of this. You might come up with any number. I would recommend that you read *The Savage Mind*. . . . It's a difficult book. This is probably the most difficult area, this whole idea of primal consciousness, primitive consciousness. This is really what I'm interested in. I'm not interested in what Lévi-Strauss would call the hot cultures, with their mechanistic and electronic technologies which he calls hot. It's the cool kind of cold tribal technologies where there is a sort of understanding, consciousness.

WHEELER: I'm going to have to get some of these references. I'll get the Ehrenzweig . . .

SMITHSON: We had some good discussions about that in particular. It's very meaningful to artists. There are a lot of things in it where he goes astray, but it's fascinating because he's going into territory that hasn't really been dealt with.

WHEELER: When was it written?

SMITHSON: I think he's dead now. I lent my copy to Bob Morris—actually the quotes in his article[17] are from my book. But Bob was certainly able to formulate his recognition of anti-form in terms of *de*differentiation. Dedifferentiation is in a sense a kind of—the whole conversation we have been having is a dedifferentiate. *Un*differentiated would mean that it's sort of total stasis. Dedifferentation . . . is not like differentiation in terms of pure concept or ideal postulates or tautologies, or anything like that. Dedifferentiation is when you have these sort of overlapping things, when the dialectic gets a little . . .

WHEELER: Heavy.

SMITHSON: Unusual, let's say.

WHEELER: You have to invent your language and construct it around the situation, rather than coming with a predetermined sense, because it doesn't fit.

SMITHSON: Right . . . and I can't do that. The only thing that interests me is the speculative aspect, trying to arrive at this. I think that's the strength of all of the thinkers—Freud, Marx were essentially dialectically thinking, and Hegel. It comes out of Pascal. Pascal is like the first dialectician. I'm in debt to the probability aspect of Pascal where he breaks with Descartes. Descartes postulated this mechanistic view which became a kind of copout, but Pascal could never accept that. He was always troubled by these actual scale problems, and then the whole idea of probability springs out of that.

SMITHSON: My attitude toward Conceptual Art is that essentially that term was first used by Sol LeWitt[18] in a personal way and then it sort of established a certain kind of context, and out of it seems to have developed this whole neo-idealism, kind of an escape from physicality. . . . I'm concerned with the physical properties of both language and material, and I don't think that they are discrete. They are both physical entities, but they have different properties, and within these properties you have these mental experiences, and it's not simply empirical facts. There are lots of things, there are lots of designations that are rather explicit, but these explicit designations tend to efface themselves and that's what gives you the abstraction, like in a nonsite/site situation there is no evasion from physical limits. . . . It's an exploration in terms of my individual perception, and the perceptual material is always putting the concepts in jeopardy . . .

WHEELER: What about the *Enantiomorphic Chambers*? Is that an attempt to set up a limit where the perceptual possibilities are confined?

SMITHSON: That's really about the eyes, and a kind of external abstraction of the eyes; it's like you're entering the field of vision. It's like a set of eyes outside my personal set, so it's a kind of depersonalization.

WHEELER: How do you mean a set of eyes? You mean the reflective capacity?

SMITHSON: Like a stereopticon kind of situation—artificial eyes—that in a sense establishes a certain kind of point of departure not so much toward the idealistic notion of perception, but all the different breakdowns within perception. So that's what I'm interested in. I'm interested in zeroing in on those aspects of mental experience that somehow coincide with the physical world.

WHEELER: Can you make a distinction as to where the differentiation of the object and the concept occur?

SMITHSON: Well, I mistrust the whole notion of concept. I think that basically implies an ideal situation, a kind of closure. . . . And the mediums, in art . . . the maps relating to the piece are like drawings, and they relate to the piece in the same way like a study for a painting would refer to the painting. They are not the same thing but they all refer. It's like a kind of ensemble of different mediums that are all discrete . . .

WHEELER: Functions.

SMITHSON: Functions, right, different mediums, but different degrees of abstraction . . . some are painted steel containers, and others are maps, others are photographs. And these are all different kinds of mental and physical abstractions.

WHEELER: I feel the best way to describe what's going on in your art is to use a vocabulary other than an art historical, a critical, or perceptual rhetoric, to use something that has simply to do with the experience of how the thing was.

SMITHSON: If you were to enter into this experience, and respond to it in

terms of your own experience—in other words, there is no explanation as to what's right or what's wrong, because both cases are true. I can't say, yes this is right, and no this is wrong. In a certain way both exist, so I'm operating in terms of both yes and no. I can't say I'm after this thing but not this thing. There's a kind of back and forth between negative and positive, so that the kind of criticism that tries to postulate one kind of experience over another one, I find rather boring. I'm equally interested in the failures of my work, and isolating them, as I am in the successes. In many ways it becomes very fascinating to investigate one's incapabilities as well as one's capabilities. That's where the aspect of entropy would come into it.

WHEELER: ... The appearance of the island in the Yucatan mirror project when you were already off it is nice. ... There are all these words floating around ... (but you would not at all want to call it serial), because that is a distorted view.

SMITHSON: That tends to get into the same kind of trap that Conceptual Art would get into. The cerebral isn't touching rock bottom; it's just a sort of pure essence that is up here somewhere. So it's going back into a kind of pseudophilosophical situation. I'm really not interested in philosophy. I'm interested completely in art.

WHEELER: Do you think of the critical world as being anachronistic or as being adverse?

SMITHSON: No, I find that when the critic is on the ball, he understands that language is not a secondary instrument that is going to disappear and leave the work there. Language grows like a barrier reef; it has its own physical ...

WHEELER: Processes.

SMITHSON: Yeah, processes. In my sedimentation article,[19] I pointed that out where I compared the action of the elements to the action of writing, let's say like a rock would be compared to a word. In a sense they are interchangeable ... they are both material, and there's no escape from that, and to try and escape from that leads you into a kind of neo-platonic, neo-idealism ...

WHEELER: What do you think of vision then, not vision in the sense of divine inspiration but say the sense of man's vision ...?

SMITHSON: When you investigate tangible, physical fact this will set up a mental experience which is like the mirror. And how I perceive this is metamorphosed through my mental state, and then I translate that mental state into a physical state. In other words, I'm not just presenting materials, there's a kind of transformation that takes place. So that it's not a return to nature; it's like a subsuming of physical properties, and then gathering them into some kind of coherence, and this coherence can be quite a wilderness that is quite fascinating at the same time. Just like the actual wilderness, but in this case it becomes abstract, and it becomes a kind of entity that points to a lot of different possibilities. And then another experience that someone else is experiencing can sort of feed into that ... and you get that same kind of thing but in a different

way. . . . Everyone who invents a system and then swears by it, that system will eventually turn on the person and wipe him out. It's that way with everything, in the sense that anything that you make is basically going to turn on you, and you'll find that essentially wrong. That's why I can't lay claim to any kind of perfect . . .

WHEELER: That destroys the notion of the masterpiece.

SMITHSON: Yeah. That's just sort of an . . . enthusiastic approach. Enthusiasm I think, a lot of criticism, is almost like a commercial, just enthusiasm to build up interest in an otherwise [indifferent] audience, so I'm in a sense not interested in an audience of a show, a gallery show. The very word *show* connotes a certain kind of theatrical presence, most shows are three weeks, so the duration of the show is rather short-lived.

WHEELER: One of the first things that struck me about your work was the explosion in terms of geography, that you were no longer directly affiliated with the New York scene as such. You were located by affiliation in terms of gallery, but your things were appearing in the Yucatan, in Vancouver, British Columbia, like they are always moving. Do you have any sense of what that geography is all about and how it relates to you?

SMITHSON: Yeah, because the world you see . . . is just a dot. If you get back far enough that world is less threatening; people will cluster up into the containment of a city, because they are fearful of what's out there. I don't like people who are cosmological, but in a sense it can be distancing, mental distancing where you can imagine moving away; if you get away far enough from any large-scale object it diminishes. There's always this sense of reducing something in scale . . . like through the airplane, which cuts down distances.

WHEELER: Why did you use the word "aerial" art? That was kind of coining a word in a way that I didn't think you liked to do.

SMITHSON: Well, I used that mainly to make that clear to the architects that that was the proposal. I did want to accent the idea of getting above in an airplane and viewing things in that way, and it was the only term I could think of. It is a kind of rubric, but at the same time it connotes a certain kind of scale consciousness which I wanted to get across.

WHEELER: It's interesting that going to the moon[20] was not conceived in any sense to be a cosmological event, but it related to no universe outside of Cape Kennedy and the manufacturers of the objects to retrieve the data and the information that they felt necessary on the surface on the moon, and that there was no mention of what the earth looked like or what their sense of scale was. . . .

SMITHSON: It's basically a kind of humanistic projection, almost in terms of the kind of McLuhanistic technology as an extension of man, which kind of gets boring.[21] My understanding of the order of the universe is based on the Pascalian idea that the universe is a sphere whose circumference is everywhere and whose center is nowhere; or you can reverse that too—in other words, in

all the permutations of that, you have the incidence of the point on the edge and then the edge maybe in the center. You know the different kinds of permutations of that. Borges traces the etymology of that concept all the way back; it's fundamental to thinking.[22] You have to have this dialectic, otherwise you have the tragic view where everything is sort of fatalistic, but with this [dialectic] you can somehow go back and forth, and there tends to be a rather impersonal view. The need to put the men on the moon is essentially a personal humanistic approach . . . anthropomorphic. If they thought about the infiniteness of space like Pascal where they actually are terrified, you know you can just sort of be terrified and have a tragic view. . . . The consciousness of most people is on a particular kind of level where they never really get beyond mechanism and electronics and it sort of stays on that level and they can't really conceive of a universe in terms of their own experience. A universe based on empirical facts which I'm really not interested in.

WHEELER: It seems that you make space contractive instead of expansive, by setting up your limits again.

SMITHSON: But that always happens anyway, that's like a physical fact. Every art is really a miniature, and when the earth itself becomes a miniature you can reverse it. You can look at a grain of sand as a gigantic boulder; it's just how you want to view it in terms of your scale sense. And that is why scale is one of the key issues, in terms of art. And to figure on all these different possibilities . . .

WHEELER: There was a reference, a really early review of your first one-man show at the Artists Gallery in 1959. What was in that show?

SMITHSON: I was working somewhat like Dubuffet and de Kooning, . . . collages.

WHEELER: Have those all been bought or sold?

SMITHSON: No, I destroyed a lot of them. Those are really like talented early work that I grew dissatisfied with. For about two years I did very academic work. Then I got concerned with crystalline forms. Well, the moving or the mapping of basic chunks of mineral to considering the grid on the globe. You lay a grid on the globe the same way that you lay a grid on the crystal, so you're really extending the abstraction that way.

WHEELER: But it's always rooted exactly in the material, whether it's the world or the crystal . . .

SMITHSON: You run those latitudes and longitudes through and you have the points of convergence. So what I did was, I abstracted this situation in terms of my own experience . . .

WHEELER: Is this how you derived the nonsites?

SMITHSON: Yeah . . . I wasn't interested in filling up a gallery with another grid. I was interested in capturing the sense of expanse and remoteness outside of the room space. The experience of my work had to take place both indoors and outdoors. I got interested in the earthworks as a result of that airport project. The nonsites came as a result of my thinking about putting large-scale

earthworks out on the edge on the airfield, and then I thought, how can I transmit that into the center? The terminal was there, yet there was no evidence of these things out there, so I thought of putting television out there and transmitting these things back in, and telescopes. That became a kind of miniature universe, that sort of fit into my concerns of mapping. And the converging lines, the polarities led into an interest in three-dimensional physical perspective. It was highly artificial and purely mental, and sort of spun out into these kind of disaster zones of the mind. They really were like mental disasters, convergences that couldn't converge, and polarities that never quite met but were in correspondence with each other, the enantiomorphic idea, the mirror images, the whole thing. All these different kinds of degrees of abstraction became a kind of wreck of precision, it went out on tangents; these spiraling progressions that I did. It was all a sort of product of a kind of jeopardized map making. . . . It's bringing chaos and order into very close quarters. It's a very precarious range to operate in; it's fraught with all kinds of disasters but the disasters are sort of frozen, in other words they are arrested, the disasters . . . the arresting aspect, this stasis within all this flux . . .

WHEELER: . . . When you said lesson you didn't mean pedantry, did you?

SMITHSON: I have nothing against pedantry. I think that Nabokov uses it very well. Especially in *Pale Fire*. Here is something that is divided, like his terra and antiterra have a kind of . . . a similar consciousness like this antiworld and world. You have this dialectical situation to arrive at an artist's end. Or I might use a romantic situation in order to prove a classical point; in other words, you are always playing one against the other.

WHEELER: Do you think that is ambiguous?

SMITHSON: Yeah, I think that is ambiguous, because I think that art is. I mean the idea of a Specific Object,[23] I think, is just . . .

WHEELER: A joke? There's no such thing.

SMITHSON: As I said in my Yucatan article it's like trying to convince people that angels exist. Angels, you know—as a delusion they're rather fascinating, but of course an object is just another word adhering to . . .

WHEELER: When you said: "Once you start seeing objects in a positive or negative way you are on the road to derangement. Objects are phantoms of the mind, as false as angels. Itzpaplotl is the Mayan Obsidian Butterfly . . . the demonic goddess"[24]—but you didn't seem to connote a belief in the conjurence of the god.

SMITHSON: Of course, I don't believe in those gods. That's what's ironic about the position . . .

WHEELER: If there isn't a belief in the vitality that inspired the need to manifest those gods or make the gods for that culture, then in a sense it would debilitate or derange your producing, making manifest all these things.

SMITHSON: That's a difficult, that's a naughty [idea] . . .

WHEELER: You see, that's a part of the notion of vision that I'd like to get at.

It's really difficult that there's access to . . . the world of ideas that these people were in touch with. What did you conjure when you went there. . . . It really did operate in terms of the Yucatan. This isn't New York, this isn't Vancouver; it has a totally different character that was strictly personal to what was there, and for what I know about the Mayan situation, that makes great sense. And I can't think that that means that the gods weren't there for them. You see, we have difficulty with these words, before we can . . . understand the mythology.

SMITHSON: Say that we invoke ideas, or concepts, or systems, and perhaps they are invoking these totemic deities in the same way. That's one of the things that runs parallel to this, that for them, these were like a kind of symbolic language that involved a particular kind of what I call totemic perception, which is as true or false as what we have. I don't think that language, once again, is an ideal thing, but that it's a material thing. And these spring from the psyches of people in different kinds of environments. Their reading of the world around them might be quite accurate in terms of these things that we call deities. They didn't refer to them as totems. We take that from anthropology, and sort of hypostatize it as though it means all this kind. . . . It comes out of anthropology and archeology, but in a sense, that's their language. This is a kind of effaced language that I'm using here, trying to get into that side of hieroglyphics, you might say.

WHEELER: Your quotes from Thompson's *Maya Hieroglyphic Writing*, too, are really pertinent in this sense.[25] The capturing of the image is contained not only on that most physical level out in the environment with the objects and the things around you, but it's also contained in the very language and the structure . . . like hieroglyphs were a really interesting notion, that you carve words in stone, and they're represented as those deities. Like they're interchangeable in a sense, and that even the deities can become hieroglyphs . . . or sentences . . .

SMITHSON: Well, [my writings] are not mythological because once again it's like I said, a mythology is a believed fiction. Now I'm sticking to the integrity of the fiction. Since I can't believe in objects and I can't believe in totems, what do I believe in? Fiction. Now let's get to the integrity of the fiction.[26]

WHEELER: The integrity of the fiction? You mean the integrity of the will to create?

SMITHSON: Of the writing. I'm taking a certain set of perceptions that have been translated into these codes or totemic hieroglyphics and then translating them in terms of my own psychic perceptions so that they don't come out as myth but as fiction. And the reason that it seems convincing is because I'm always identifying the fictional use of that, so that the materiality of the writing emerges. And that's why it tends to communicate graphically. It has a kind of palpable sense of that because I'm not trying to make believe I'm a mind. It's not through the eyes of the mind, it's through the eyes of Bob Smithson. I can't really talk about objects either because that's like a philosophical set-up

that sort of, you know, has run down over the last two hundred years out of Kant and all the rest of that. And we accept that. Even words like "space" and "time" and all that.

WHEELER: Like conceptions derived from . . .

SMITHSON: What does it come out of? Semiotic . . .

WHEELER: Symbiotic?

SMITHSON: No . . . there're languages that simply aren't just words. Languages that have syntaxes in terms of other materials like maps, like photographs, like . . . any kind of visual art, you know . . .

WHEELER: What's the difference, then, for you between philosophy when you read it, and conceptualization . . . ?

SMITHSON: This whole conceptual thing . . . treats language as a secondary thing, a kind of a thing that'll disappear when it doesn't disappear. Language is as primary as steel. And there's no point in trying to wish it away. And when you invoke it, it's dangerous. It's always like running amok. It's like these people start developing systems and they kind of grow out, like deltas, into the oceans. I mean what's the meaning of that? It's just there, sort of building itself out. And you contend with that. So that the takes that a lot of people have on these totems seem to me completely conjectural or hypothetical. Founded in their own psyche, sort of colored by their psyches, distorted and deformed by their own misreading of these people . . .

WHEELER: It's like Lippard organizing a Conceptual Art show, in that sense.[27]

SMITHSON: Well, I'm sort of bored by that, . . . even though I contributed to it. . . . Just very sort of superficial sophomoric philosophy, you know, that's been sort of rejected by philosophers, and then a lot of third rate minds are picking up this rejected philosophy in quotes. . . . I just don't like that direction. I think that the whole idea of literature is as bad as philosophy, because those are all postulating some kind of omnipotent state where you're in control. The literary person is not dealing with languages and material, he's dealing with it as a kind of means to an end [rather than] an end in itself. . . . It's just a surrogate kind of humanistic dog idea. . . . I mean it's impossible to get to the point where you have that kind of detachment.

WHEELER: You can't extricate yourself.

SMITHSON: Yeah. So you can recognize that possibility of it always breaking down there too, where the ego intrudes, and you go from one plateau to another plateau. It's not all uphill, you know, like it's just a lot of ups and downs. Like one time you might be more mental and you might lose touch with the physical. But they're always in correspondence.

WHEELER: . . . It's kind of amazing how quick the Conceptual Art faded, even more so than Pop Art . . .

SMITHSON: Yeah, well, you see, Sol LeWitt had his own reading of that and he completely deformed it to fit his particular view, which is very interesting in terms of Sol LeWitt. As far as concepts are concerned, it's completely . . . you

know, the idea that art doesn't take a physical form is ridiculous. Even if you just sit there and say, "Well, I'm not going to talk anymore. That's my statement." Well, already you've hit the air with a few blasts, and that's your thing, so there's no escape from the physical, and the only artists I respect are the ones who admit that there is a physical aspect. There's another type of thing too, where you can go over into the material, you're just sort of like presenting materials, and . . . what I'm interested in is making art. . . . You don't need systems, you don't need art ideas, you don't need any of these things, because ultimately it's the material, and that material is language, steel, whatever you want to have it. And I'm interested in somebody doing something with that. . . . So it's a matter of wrestling with those material properties and at the same time with the mental experiences . . . a matter of setting up correspondences, where you seemingly have something that's very material but at the same time it somehow is absorbed into abstraction. So that first you see it then you don't. It's a kind of camera obscura.

WHEELER: What are you going to do after the *Island* piece? Do you have anything else planned?

SMITHSON: I think what I want to do is some of the flow pieces. I wanted to do that for the show up here . . . these massive pieces where there's a kind of lack of rectilinear geometry. . . . They're there, there's no getting away from it. There's a source, and then there's a dynamic that runs through that.

WHEELER: They're very expressionistic, too, from the photographs I saw of them. I mean they take on the expressions of the instruments and the technology by which they're produced . . .

SMITHSON: Well, they take their form, actually, from the ground rather than the technology. . . . I mean there's nothing really technological about a truck.

WHEELER: No, but it's like the whole notion of . . .

SMITHSON: Dumping . . . that's gone into in the sense of a kind of . . . alluvial action, fluvial massing. I'm interested in sort of subsuming a kind of just mass, and mass that moves from a central point and fans apart, . . . then it suddenly is arrested, and once again, the flow is caught.

WHEELER: . . . How much of your conception is concerned with the performance of the flow of the material and the form it takes on?

SMITHSON: You see, it's ultimately what's done after the truck pulls away. I'm not interested in process, but only insofar as the process is absorbed into the experience of the piece. And then you have just the piece. The piece is at once solidly there, but it's subject to the elements. And yet, all the battering they take, and as parts break off . . . the trickles and the bleeds on the side might disintegrate, the main body of it will just sort of lie there. I'm interested in that downslope. Actually, there's an interesting science fiction novel, and one of the chapters was called "Down the Entropy Slope,"[28] and it had to do with time. There's a kind of aspect of falling involved in a kind of—well, incident itself means falling. The first incident is like a dot on a line, and in a sense

this is like a mark on a surface, and it's a fall, a slow fall. You might say that there's also a correlation to Williams.[29] You know, all the associations you could have with the falls from Paterson.

WHEELER: Have you seen those falls?

SMITHSON: Oh yeah. I lived near Paterson.

WHEELER: Where were you born and brought up?

SMITHSON: Clifton and Rutherford. . . . All the aspects of gravitational flow . . . all things move through gravity, you know, all the earth movements take place through some kind of gravity. And they're rather slow.

WHEELER: I like that sense, too, of the accomplishment of what gravity can do, as compared to those sculptural pieces with overhang, in the series of boxes piling[30] where they defied the gravitational force. And they also defied perspective . . .

SMITHSON: There's another thing that's interesting. You can see in my work that the art is always against itself. There's always an aspect where the mirrors cancel their reflectivity, the perspective has no vanishing point, the gravitation is suspended. In the case of [*Asphalt Rundown*] it sort of stops just before it hits the bottom. So in the case of the falls . . . it's arrested again. . . . That's sort of like isolated like a petrified river . . . so there you have that sense of something very definitely in time, yet the moment gives you that sense of timelessness. The actual visual experience, perception of that. And of course, out of this we just have this whole kind of domino effect of all the permutations of the notion of the flow, the fall, the downpour, and in a sense it goes a little like some of the receding nonsites. They all converge, and they're converging on a point, but the point is no longer there. The point of convergence is always being lost. . . . In the case of all these perspectives, you can walk around and they just destroy themselves as perspectives. The gestalt loses itself. Like in my second show,[31] all the pieces were like, in a sense, deliberate [scatterings] of the whole gestalt idea.

WHEELER: Which pieces were these?

SMITHSON: The white ones—the *Gyrostasis* and the *Leaning Strata*.

WHEELER: . . . you were talking about the artist as a geologic agent before, about the element of danger involved in the glass island piece, about the intervention of people who were concerned with disturbing the ecology . . .

SMITHSON: Yeah, well in nature you can fall off cliffs, and you can drown in the water, and you can fall in a volcano. . . . I mean the fact that somebody will swim out there and impale himself on that glass is not my fault.

WHEELER [*laughing*]: You hereby publicly disclaim any responsibility.

SMITHSON: Well, I think all art is both mentally and physically dangerous. It can knock your eye out on a lot of things. . . . Well, I like the idea of working with difficult mediums. And that's part of it in a sense. I like to master a kind of difficult medium, and be able to work with that, there's a certain challenge in that.

ROBERT SMITHSON, Map for *Double Nonsite, California and Nevada*, 1968.

THREE

SMITHSON: . . . the sites of the *Double Nonsite* are in the vicinity of the Marl Mountains. The Marl Mountains are about ten to fifteen miles east of Baker, California. That's the outer part of the nonsite, and the inner part of the nonsite is between Benton, California, and Montgomery, Nevada. The site is a cinder cone in the Mojave Desert. It's near Truman Springs. These points are like a matter of the search. In other words, the points aren't preconceived. The points are discovered . . .

WHEELER: That comes through your travel through the area and the area is chosen?

SMITHSON: Yeah, the area is chosen and . . .

WHEELER: Do you actually denote the boundaries? Like you draw a map of a particular square and constrain yourself from traveling other routes?

SMITHSON: No, first I find the sites. Then I draw the squares. I'm scanning the physical material before I start to set up the plan; in other words, the map layout is following after the scanning. It's not preconceived, so that it's discovered rather than pinpointed.

WHEELER: What's the strongest predeterminant in where you establish the site? Like the landform?

SMITHSON: I'm looking for a homogenous material that, in a sense, covers the vicinity of the site, and the site is bounded after I find the material. So that in both these cases, the only information I had was that I was looking for lava and obsidian, so that the outer perimeters involved a search for lava, and then the inner perimeter involved a search for obsidian. The material determined

the choice of the site. I want to make clear the point that it's not preconceived. That things turn up as I go along. In other words, the piece is contingent on the availability of great amounts of homogenous matter . . . and one has, in this particular piece, the idea of the outer and the inner, or the duplicity within the site involves the dialogue between inner and outer, you know, or center and edge. There's a disjunction in terms of the two sites. In other words, it's one site superimposed over another site, I'm taking two landmasses that aren't following preconceived boundaries. It's not like taking the boundaries of a state and using that. I'm establishing my own boundaries in terms of my own psychic scanning, or my own mental experience.

WHEELER: . . . It's simply something that you pick up on . . .

SMITHSON: Yeah. That's an important thing that runs through all of the nonsites. The points of pick-up, or the points of collection, tend to be scattered throughout the site, yet there's no possible way of defining those points. So if you go to the sites, there's no evidence other than the site, you're sort of thrown off the nonsite. This is the coming together of those particular points. And those points tend to cover the landmasses so that, in a sense, all this terrain will be homogenized. Taking this rather unbounded area and then transferring it into a boundary situation so that the points tend to obliterate the land expanses in the nonsites. Then there's a kind of balance between the containment and the aspect of scattering, there's an overlap, you know, you're being directed to sites that are in no way graspable in terms of preconceived systems. There's no way you can locate the point, even though there is an indication of the point. Really once you get out there you're on your own, in terms of the site so that the nonsite just directs you out there, but once you get there, there's no destination. Or if there is information, the information is so low level that it doesn't focus on any particular spot, . . . so the site is evading you all the while it's directing you to it. . . . The containment is an abstraction, but the containment doesn't really find anything. There is no object to go toward. In the very name "nonsite" you're really making a reference to a particular site but that particular site evades itself, or it's incognito. You're on your own. You're groping out there. There's no way to find what's out there. Yet you're directed out there. The location is held in suspense. The nonsite itself tends to cancel out the site. Although it's in the physical world, it's not there.

WHEELER: These things are creating an order of their own, that's why they're so difficult to talk about. . . .

SMITHSON: Yeah. I mean there is a one-to-one relation, but at the same time that one-to-one equation tends to evade connection so that there's a suspension. Although there's a correspondence, the equalizer is always in a sense the subverted or lost, so it's a matter of losing your way rather than finding your way.

WHEELER: And there is no energy center. . . . You couldn't expect to go to

a point and find the formation and derive some kind of energy from it, then realize . . .

SMITHSON: Right. That's why it's entropic. . . . The information tends to obliterate itself so that there is obviously information there, but the information is so overwhelming in terms of its physicality that it tends to lose itself. It's that loss that tends to bring them to a low level of perception . . .

WHEELER: What do you think of the low level of perception?

SMITHSON: It's spreading around, it's running out all around the site. There's no focus, no fixed focus, although this three-dimensional map, the nonsite, indicates that something's out there. . . . You're incapable of seeing that your senses are tending to break down into other sense responses. In other words, there's a contingency within the containment so that you have essentially a gathering taking place out of the scattering. And I'm not doing the scattering, the scattering has already been scattered. I'm consolidating the scattering and heightening the loss of focus. It's that loss of focus that interests me, you know, the perception always evading. . . . The thing that holds it together is the idea of the volcano. So you might say that this volcano is taking place within my mental experience . . .

WHEELER: This is obsidian?

SMITHSON: Yeah, right. Ultimately you're into, let's say, the unpredictability of a kind of mental volcano. You really don't know . . .

WHEELER: In other words they're erupted land forms too, or, they resulted because of . . . processes in extreme heat. And yet they're so cool, I mean there can be nothing more cool, cold almost . . .

SMITHSON: . . . By setting up this back-and-forth situation, it's like the volcano erupting and it's sending out this material . . .

WHEELER: Does obsidian form in, like the shape of the volcano?

SMITHSON: Yeah, well the obsidian is always close to the center, and the lava will move out to the outer edges so that the obsidian is close to the center because it's involved in a greater heat breakdown, and the lava as it spills out is already a more . . . [entropic material]. . . . You have that dialogue between the dispersed lava and the concentrated obsidian, so you have a dense material, and a much lighter material, this is pumice actually. . . . You could look up the difference between skerry and pumice in *The Geologic Dictionary*. . . . If you got into the difference between the properties of obsidian and the properties of lava, then you'd be led more into the notion of the center and the circumference.

WHEELER: To really get into any one of these pieces is to like get into your entire process . . .

SMITHSON: Yeah, . . . let's say in the *Island*, you again have the outer perimeter which is like the water, and then the centrality of the boundedness of the island. You have the two things there operating, yet there's a boundary. The boundary is exact, yet at the same time there's a certain loss. There's a fine line

that divides the obsidian from the lava and the water from the glass. . . . Well, that's the kind of involvement I like, . . . you're presented with a certain amount of material and then what's generated is not something that is explainable. You're into an inexplicable area of investigation. All the investigation tends to be inexplicable. You're not presented with any kind of obvious object. The object is always defeating itself in terms of its objectivity. In that canceling aspect you get into the lower level, subterranean consciousness, or in this case a submergence.[32]

WHEELER: There is now another direction. Search for scale is one apparent thing, but the whole notion of the submergence . . .

SMITHSON: . . . It's like an invented volcano that doesn't exist anywhere. But then suddenly the existence of the nonexistent thing is invaded with raw material which in a sense solidifies the hypothetical. So it's taking a kind of nonexistent thing and making it existent.

WHEELER: The area in fact did have volcanos . . .

SMITHSON: It's like building a volcano out of my mental experience of these two sites which are a great distance apart from each other. The volcano is hypothetical, also the shape of it is square, which is a kind of contradiction, in terms of what a volcano would be. . . . This is the nonsite of the *Line of Wreckage, Bayonne, New Jersey*. . . . Essentially the whole work is based on an idea of an obliterated line. There's a kind of contradiction in the title *Line of Wreckage*, the wrecked line . . .

WHEELER: What is the wreckage referring to?

SMITHSON: . . . This refers to a buildup of like clean fill. And this line of wreckage running across here is like ruined barges that have come into this thing and just sort of built a buildup of fill. These are photographs of low-level scanning of the sinking of a sunken bay. The material comes from the end of the line of wreckage. . . . But the whole phenomenon of the site in a sense is one of complete distraction. The site disrupts the whole notion of any kind of linearity. The hypothetical aspect of the piece again becomes a matter of the linear sort of emerging from this wreckage. You have on a line just all this breakup. It's really about the breakup of a line, but at the same time the line keeps its stability. Then within the piece you have a kind of layering, or stratification.

WHEELER: All these materials are the same. That's like a cage. How deep is it? Is it like a square box?

SMITHSON: About five feet height. . . . It's maroon. . . . You might say that once you're out there there's no way of logically gaining control of the line. Your perception is somehow scattered by the distribution of the broken material; . . . most of the material that's put there is fill, and this concrete happens to be from a broken-up road, a disused road that's been dumped in this area. So that there's just a kind of continual buildup of breakdown within this particular site. All these rocks are sort of balanced [in the nonsite] . . . in other words, you can see right through [the container]. The rocks are pitched onto each

other. It's like a cross section of the site. In that respect, it's a stratified mental experience translated into . . .

WHEELER: What are the bands representing here?

SMITHSON: Well, . . . the bands represent a kind of mental strata that's just getting more and more dense as it goes down . . .

WHEELER: So this is kind of a sedimentation . . .

SMITHSON: Yeah, it's a sedimentary buildup. . . . Now, [*Six Stops on a Section*] is completely another thing and the idea of travel especially. In other words, obviously all the nonsites are going to lead you to sites. But once you get to these sites, then you're on your own, and you're going to have to draw your own coordinates. You're going to have to fend for yourself. . . . In *Six Stops on a Section* . . . the line starts over here in Manhattan. Down here is the stratigraphic map that I used. I blew that up [through a photographic blowup][33] . . . so it's really accurate. They're done in sections, and each map is the same size as these [containers]. Mainly the maps are there just to give you a point of departure . . . to take you out to the site from an interior space. Since these are indoor earthworks, that point to outdoor collections of undifferentiated material . . . and my interest in each one changes. There's a different set of coordinates, so that each one produces a different experience within the same dialectic, you might say, between the site and the nonsite. That's a constant site and nonsite dialectic. You have to refer to that thing in the Land Art catalogue.[34] That gives you the broad general area where all of them, all of the nonsites exist. But then each nonsite . . . is a different experience.

WHEELER: Are these [materials] all different colors?

SMITHSON: They're from different points. The first one is from Bergen Hill, the second one is from Second Mountain, the third one is from Morris Plains, the fourth one is from Mount Hope, the fifth one is from Lafayette, the sixth one is from near the Delaware River, and once again . . . my perceptions rested in all low levels of material buildup. There tended to be a homogenous outcropping of material. Each section on the route is in a sense obliterated by the point of collection, where there were materials subtracted from there. All the points, in terms of the nonsite, obliterate once again the expansiveness of the sites, so that the points of the nonsite envelop the entire site. . . . A lot of times I'll go back to the site, and in this case there are other aspects especially in the second site, which is reproduced on the cover of *Art News*,[35] there are three color reproductions of the dissipated, eroded site. Just sort of photographs of those things . . .

WHEELER: Where's that?

SMITHSON: Bergen Hill site. There was some activity where I utilized photographs on the site, and photographs as photographs on the site. And a major photograph that came out of that was a piece called *Dog Tracks*. . . . So that each site can generate its own information. I can constantly go back to that. Also, I'm going to do another piece using the second site[36] . . . so that you can

keep drawing perceptual information out of. . . . In other words, there's a constant possiblity of reusing the maps or drawing out other possibilities from the site . . .

WHEELER: Shall we go on to the next one?

SMITHSON: Okay . . . Mono Lake is obliterated in the center. I'm just using here the fringes . . . Mono Lake is called the dead lake, "Dead Sea of the West." It's about 80 miles south of Lake Tahoe. It's a salt lake surrounded by, once again, volcanoes, and it's essentially a volcanic thing again. In this case I'm dealing with the fringe.

WHEELER: The lake is contained, though, and that's a kind of strange element, because you've never really closed off or bounded an area before in the [nonsite].

SMITHSON: Well, this is sort of like wandering around the perimeter of the lake, then discovering the cinders which tend to be the most cindery breakdown. The whole notion of this whole cindery chaos is held together by the square.

WHEELER: And this is the experience, too, of walking around . . .

SMITHSON: Going around, yeah, and realizing that. Well, [the material was] picked up around Black Point. There's an outflow, heaps of cinders there. There are flies that live in the lake, it's really entropic. There's a perimeter of flies that surround the lake. In a sense the lake is bounded by a ring of flies. Then all the rest is a material called tufa. It's old coral-type material that has been left up on the beaches. The lake, in a sense, is evaporating, and leaving these kind of deposits on the shores.

WHEELER: So the lake is dissoluting itself.

SMITHSON: Yeah, the lake is losing itself. . . . In sulfur ponds and warm springs there's a kind of pumice outcropping over here.

WHEELER: How large is the lake?

SMITHSON: I really don't know the size of it. But if you wanted to get into it, it's been written about by Mark Twain in *Roughing It*. The characteristics of the site fascinate me in all these cases. Any site that lends itself to the dedifferentiate low-level kind of situation excites me because everything is sort of moving toward a background, an ever-deepening background. There's an almost complete loss of foreground in terms of the site. And then the only thing that holds it together is the shrunken containment of the nonsite. I might recommend a very good book called the *Metamorphosis of the Circle* by Georges Poulet, which I find is very fascinating in terms of the idea of expansion and contraction; he traces a kind of structure running through practically all that . . . it's basically concerned with writing. But I'm concerned more with physical tangible art, as opposed to writing, but his aspect of center and circumference runs all through my work. It's a kind of perceptual calculus. . . . This is *Nonsite Site Uncertain*. Seven L-shaped things, beige, with cannel coal. It's a type of coal, you can look that up and draw whatever you want. But the

idea is now [that] the sites are beginning to completely evade me, and sink down into geologic time. . . . This is central, this is southern Ohio, and Kentucky, this area, where the cannel coal comes from. It's listed in the *Handbook of Rocks and Minerals*. It's the only place I've been able to find cannel coal.

WHEELER: But you're moving in towards a center . . .

SMITHSON: Yeah, in other words it's beginning to drop out. The existent sites, the sites that are on the surface, are always tending to drift down out of the notion of low, of course, that connotes the downward descent. This is the break-off point. Of course, the progression [of the container size] leads down to a point that doesn't exist, indicates the direction of the experience.

WHEELER: How did you arrive at this shape?

SMITHSON: Well, it's essentially a square. If [the containers of *Double Nonsite, California and Nevada* 1969] were all pushed together they would form a square without a central square. Well . . . in the sense that the incomplete/complete is present so that the containment isn't quite contained, yet it is contained . . . there's always that slippage, that breaking off point . . .

WHEELER: Now we're getting to the salt mine . . .

SMITHSON: This is in Ithaca. So once again now we're into the descending perception. These are five mirror displacements inside the White Museum in Ithaca. Then there was the actual descent into the mine where I'd take my reflecting mirrors . . . down into the mine so that it's like the drop-off point from the [*Nonsite, Site Uncertain*]. In this case it's salt . . . like two miles underground, eventually distributing . . . another, you know, that kind of fan-like bifurcating tracking scaling thing. And then just setting the mirrors up in the mine and reflecting the internal aspects of the mine, but then the mine, of course, reflects back into the interior of the museum. And between the museum and the mine, I set up a whole trail of mirrors.

WHEELER: This is a peculiar dissolution of the site-nonsite dialectic. . . . Is there any description so that people coming into the gallery will understand?

SMITHSON: Yeah, there was a catalogue that should be ready any day now.[37] You can write to Cornell and they should have it. You can write for any information to Cornell, because they have the map also. . . . Nobody got that right, how the things are put together. So essentially [the *Rocks and Mirror Square* consists of] eight mirrors . . . back to back so they come out as four mirrors. Now they're shored up by the rock salt, . . . the shoring is the important thing here. And there's one big piece of mirror back here, which is shored up also, leaning against the wall. And these are piles of rock salt, and the mirrors are about 8 inches up off the floor [in the *Eight Part Piece*], and they're supported only by the rock salt, sort of bridges between each thing. Again this [*Mirror Box*] is a rectangular box made up of five pieces of mirror, one piece of glass; the pressure of the rock salt is holding these unconnected pieces of glass and mirror together from the pressure on the tops, sides, and on the bottom so that the whole thing is held together that way. The debris here, the fragments of

rock salt are symmetrized within the mirror. . . . There's no interplay between the piece and the spectator. That's always canceled out, no spectator can fit himself into the mirror. . . . Then there are the inverted trees. . . . They are involved in the upsidedownness of the whole process, in a sense—the backwards aspect of the whole attempt to get out to some place and then not find it. It's a kind of reversal. Essentially these were dedicated to animal perceptions just sort of made for animal spectators. And the one in the Yucatan I dedicated to fly perception—the compound eye where there is a kind of fracturing of the perceptual possibilities—so there's an interesting aspect of conceiving of how animals would see things. That would take you down into another low level, not just human perception. . . . I looked up the fly's perception, and compared it to seeing like a badly reproduced newspaper reproduction.[38] So that your vision is constantly being leveled. You're constantly not seeing what you think you see. The arrested perception is always being distanced by these kinds of analogies. . . . I did three of these inverted trees. There's one in Alfred, and one on Sanibel Island, and one in the Yucatan.

WHEELER: There could be another one?

SMITHSON: Yeah, there could be another one. But it doesn't matter, if the thing wears itself out. I got through three. . . . Whether or not the thing will lose itself . . . it follows a sort of zigzag indeterminate path. In a sense they are punctuations, punctuating the route I have to be going along. This happens to be washed out.

WHEELER: . . . How far did they go down into the soil?

SMITHSON: This is down about four feet.

WHEELER: So they aren't very far down into the ground. . . . This piece [*Mirror Shore at Sanibel Island*] is really interesting the way the shadows here are caught, like brush strokes of light painted. Just because these are stuck in the mud at various angles.

SMITHSON: They're sort of irregular.

WHEELER: And is this sand with slight wash of water on it?

SMITHSON: A reflection on a reflection. . . . I did others like this . . . bouncing reflections off of another reflecting surface so I'm just dealing with spillover of light emanating from the mirrors. There is none of that in the Yucatan, where the light is beamed out off the mirrors, but in this case. . . . And I did a piece also for the Jewish Museum which was done in a quarry where I was beaming the light over the snow. So you have these shafts, these sort of spill-offs of light. . . . The idea of light sort of spilling from the surface, is different than the Yucatan [mirror displacements].

WHEELER: One more question about the Yucatan. What's the relationship between the map in this situation, and the [mirror displacements]? There's a complication here, these are nonsites but they are sites as well. The nonsite aspect, I suppose, is contained in the material.

SMITHSON: This is more directly, it follows a more irregular travel. There's

no line that I'm following like in the *Six Stops on a Section* so that the travel is of a different order. In other words, the finding of that map with the line across it somehow stimulated me to follow that line, but in this case I had no line that I was following . . .

WHEELER: That one line was across it already?

SMITHSON: Right, that line was across. But I found the map, you see, that just provided a line.

WHEELER: Well, in this sense, the line could be conceived as being part of the geography like the road itself . . .

SMITHSON: This is just a matter of the accessibility of the sites, and so that there is essentially no linear concern in this, because it's just going along a kind of completely indeterminate path. There is no beginning or ending. . . . This [*Asphalt Rundown*] was done right outside of Rome in a quarry. . . . It dealt, in a funny way, with all the implications of the early work. The outer fanning of it, in a sense, follows the same kind of irregular perception coming from this central point and sort of fanning out, as it goes down. It's very thermodynamic in the sense that it's a hot material that is gradually cooling down. . . . But the difference between [*Asphalt Rundown*] and [*Double Nonsite*] is that there is a lot of distance between those three sectors, let's say—between the nonsite, and the two sites. In other words, the lava was shipped East, there again you have that aspect of transport. . . . My interest here [*Asphalt Rundown*] is to root it to the contour of the land, so that it's permanently there and subject to the weathering. I'm sort of curious to see what will happen to this. But at the same time, the density of the material will make it—it's not a completely ephemeral piece, so it should last for quite some time. . . .

FOUR

SMITHSON: Let's get a dictionary. I just want to see what shoring is. [*reading*] Shore: land near the oceans, lakes; some particular country, my native shore; land, marines, serving on shore; the space between the ordinary high water mark and low water mark; shore—probably derived from sea marsh.

WHEELER: From sea marsh?

SMITHSON [*reading*]: Shore, bank, beach, the tangled embankment; coast, referring to an edge for land on an ocean, lake, or other large body of water; shores, the general word, . . . bank denotes the land along a river or water course, sometimes steep but often not, the river flows between its banks; beach, refers to sandy pebbly margins along the shore . . . at ebb time . . . ; coast, applies only to land along an ocean, Pacific Coast; shore, shored, shoring, supporting post or beam, auxiliary members, one placed obliquely against the side of a building; ship and dock or the like, . . . support by shores or shoring.

WHEELER: Where does the word come from?

SMITHSON: Probably "schoor" [*spelling*] s-c-h-o-o-r, sea marsh . . .

WHEELER: With the *Island* that shoring makes great sense, because it hap-

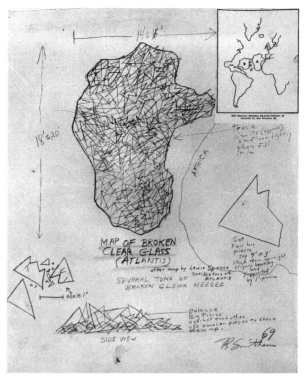

ROBERT SMITHSON, *Map of Broken Clear Glass (Atlantis)*, 1969. Collage, photostat, map, pencil, 16¾ x 14".

pens everywhere at once. It happens in the collapse, and the formation that the glass takes on itself, upon itself. And the shore of the island itself is going on. You have both phases of the definition interacting.

SMITHSON: The support is liquid, also; [through] the weight action on the shore, it tends to get shoreless and it's the line between the water and the glass [which] becomes variable. There's the sharp cutting edge . . . it's very uncertain. The shore there is uncertain . . . once you start thinking about the possibility of finding that edge, you could arrive at something. What, I don't know.

WHEELER: . . . There are references to another time in a very peculiar way, that's making geologic time available in material in a very peculiar sense. . . . Literally, there's geologic time because the center of the earth is available at some level or another below the surface . . .

SMITHSON: And also there is the fact that it's a depositional kind of crystalline thing where the facets are uncertain. It's . . . an idealization of the facets.

WHEELER: What do you mean by facets? You mean the actual plates themselves?

SMITHSON: Well, the plates. I mean it's like to get back to that metaphor of Oz . . . through the force of the twister, you're propelled to this central image. . . . The people go there, the child and the scarecrow, to the Emerald City of Oz which is a palace—but essentially a crystalline buildup. . . . I mean, that to me is on a kind of fairy-tale level that's indicative of something. . . . I

226

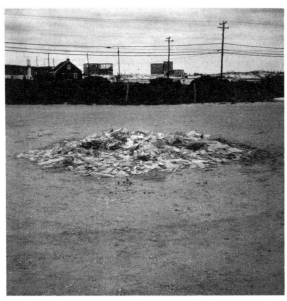

Map of Glass (Atlantis), 1969. Loveladies Island, New Jersey, July 11–31, 1969.

don't exactly know what the actual building of Oz looks like. Oz, like Atlantis, is this difficult place . . . a vanishing point, you know.

WHEELER: It's funny when you say that.

SMITHSON: Well, let's say it's the terrible aspect behind the element of the twister, behind the centrifugal aspect of the twister, that's a kind of disruption of gravity almost, or a kind of agony of gravity within the force of the cyclonic centrifugal notion. . . . I mean the energy gets so intense that it breaks into imaginative, or fairy-tale results. Like the ultimate reality, it's like going from the black-and-white film in the picture to Technicolor . . .

WHEELER: It seems like a preposterous possibility too.

SMITHSON: It's the difficulty of dealing with . . . the hidden aspect of nature. The phenomenon of nature destroys itself through itself . . . it's always an evasive kind of situation. . . . There are lots of images in the Yucatan, spirals and whirlpools, descents in the airplane. I mean the very idea of the descent of man, in a sense, could be conceived of as a spiraling in on origins, that's why I'm interested in the tangled thicket.

WHEELER: . . . The footprints around the second mirror displacement are strange. . . . That's something that draws you out. . . . The footprints are one of the few humanist comparatives which manage to penetrate the piece. They lend an increased actuality to the piece . . .

SMITHSON: . . . To make that even clearer, you could trace that to the *Dog Tracks*, that particular observation in terms of the tracking . . . the observations on the dog tracks leading to that kind of uncertainty of the constellation of the mirrors, you know, as you move around it, this residue builds out . . .

WHEELER: Especially when simply sky or vacuous-appearing space is

caught up in the mirror, as if the mirror were actually a hole punched into the soft earth, then you get the sense that it's a hole, but it's lined with something.

SMITHSON: It's like a negative hole.

WHEELER: . . . a negative hole, it's . . . the end of a column without the column, it's really a strange image. And revealing on the other side, or interior to itself, a deeper or another more mercurial difficult and abstracting world than what we have managed to tame. The world for ourselves. . . . "That camera is a portable tomb. You must remember that."[39] That's a strange statement. Can you explain something about that?

SMITHSON: Well, because of the arrested moment, that perhaps is even spelled out in the thing from Santayana: "Living beings dwell on their expectations rather than their senses."

WHEELER: Right, the fleeting moment caught.

SMITHSON: "If they are ever to see what they see, they must first—in a manner—stop living; they must suspend the will." Well, that's the arrestment of the moment, stopped. "They must suspend the will," as Schopenhauer put it; "they must photograph the idea that is flying past, veiled in its very swiftness."[40] What you're really doing is fixing something out of duration.

WHEELER: Yeah, but that doesn't imply death for me.

SMITHSON: Well, tombs don't imply death for most people. . . . Symbolized or humanistic attitudes tend to completely reverse the notion of tomb building.

WHEELER: . . . And that was interesting, too, the collision in time that that represented. *Gondwanaland* is doing that too. That you can isolate an earth map of wet limestone. "A bit of the Carboniferous period is now installed near Uxmal."[40] And then the [*Map of Broken Glass: Atlantis*] is the turning upside down of that in a way.

SMITHSON: Well, the *Map of Broken Glass* points to the *Island*, and the map, of course, is less threatening than the existence of an actual landmass. The drive to discover that particular lost continent is fraught with all kinds of perplexity and vexation. There's a kind of grinding aspect of it, an almost painful recognition. . . . Well, the map is transferred from a paper and ink into material. And . . . as signifiers the map and the material maps offer the same amount of awareness, except that as the physicality increases, in terms of the weight, or the mass of the thing increases, the focus gets more intense, pinpointing the shape . . . burns the brain out. That's really what it is. It's like taking a magnifying glass . . .

WHEELER: . . . It's a very tortuous intense relationship between yourself and time . . .

SMITHSON: . . . The intensity of the focus shatters any kind of answer that you might provide. The ineffable aspect of it just breaks down into all these fragments, and yet they're there. It's like any handful of dust or anything. Like Eliot said, "I'll show you fear in a handful of dust."[42]

WHEELER: That's where you end up, literally . . .

SMITHSON: The need to localize that, it's dilemma-filled. Because the eternalizing aspect is permeated with a kind of terrible mortality. If you literally could live forever, what a horrible thing that would be. . . . You would be so bored . . . I mean you would just sort of forget all speech and all everything, but just be constantly propelled in a kind of endless mortality.

WHEELER: . . . Those stretches of the hypothetical are really incredible. That's like your vanishing point reversed to infinity. "The true fiction eradicates the false reality." Things like that "Mirrors thrive on surds and generate incapacity."[43]

SMITHSON: Well, that just means that there's no explanation. So that you're dealing with a complete contingent force.

WHEELER: . . . And going into etymology of color, as you suggested, or mirror, it takes you into the central situation of the mirrors themselves, colorless, hiding nothing, only revealing, as well as the implicit attack of careless colorism, where real color is risky like that. All of these things are so abstracting but they're absolutely available physically . . .

SMITHSON: Well, there's like a deluge in abstract mentality . . .

WHEELER: It's like a logician gone mad, you know, where there are all those possibilities, but instead of being available in one or another singular train of works, they're kind of all being pushed . . .

SMITHSON: . . . I was talking with Steve Heizer[44] about the difference between two types of scientists, the one who has the controlled studio experiment . . . and then the field scientist, who is working in a sense with the uncontrollable aspect. And the conflict that arises from the perfect isolation as opposed to the chance disruption. The security that comes from working in a lab is very similar to the security that comes from working in a studio. So there's a parallel there. The studio and the lab become places where you can control your information. But at the same time, the information you're controlling is not that interesting. It tends to be rather unneccessary. The stability of that is constantly challenged by the instability of these extra forces, like the storm over the island . . .

WHEELER: Or the storm of butterflies over the mirrors [in the third displacement], too.

SMITHSON: That stormy aspect, that kind of lightning in the head, you know.

WHEELER: I keep seeing, there's the storm in the sky, which is this kind of low level, it's the basement of the sky, it tends to blend with the earth . . . and then the blending of the earth itself. And then the instance or occasion of the work between the two strengths, the forces, like the mirrors inserted in the earth reflecting the sky contained in the earth with the earth spilling over . . . and those mirrors are like a slash in between it that act as a release.

SMITHSON: Well, that's what I talk about in the beginning with the sacrifice of matter as a kind of very primordial idea. Not a human sacrifice, but there's a

disjunction. And that disjunction releases a certain kind of awareness. And this is what George Bataille in his book called *Death and Sensuality* points out. The disjunction was what was so liberating to the primitives. But to us, the disjunction becomes almost disgusting; this revulsion enters into it . . .

WHEELER: . . . These are isolated energy occasions, and as such, they're definitely disjunctive . . . like there's a cleavage or a break or a fracturing in between those obvious realities like earth and heaven.

SMITHSON: That it's caught.

WHEELER: Yeah, that it opens up, like when I said punched a hole in the earth, I literally meant it opened up or displays a possibility into an abstraction . . .

SMITHSON: . . . there's a kind of cutting in, the cantilevering in of the piece, of the geometric abstraction into the inchoate, or the rawness. It's just a surface, and the surface is unlocatable between those two things, so the way the thing is held in there is once again like a kind of slicing.

WHEELER: It's as though they're spun off. It's like the gyrostasis made material in its energy. Like something moving out, as you said, in the cyclonic action, but capturing the shattering as if it was a frozen. . . . and the shatterings were caught in the earth in the spinoff and inserted. And that's why they're so energized . . . it's like a karate chop.

SMITHSON: That's a good way of putting it.

WHEELER: Yeah, and you're always moving toward the wasteland, toward that reduced landscape. Except the wasteland isn't like the kind of Eliotan romantic . . .

SMITHSON: No, no, there's no lament for anything. It's inevitable. And there's no hatred of that aspect. . . . We have almost a kind of rinky-dink idea of nature—Mickey Mouse. Like the people of my generation have grown up in the industrial blight, and it's not like rustic woodside that we remember.

WHEELER: That's like the Disneyland experience.

SMITHSON: And they're trying to make the jump back to a kind of Romanticism . . . so you just have a kind of picture book sentimental, very trite romanticism of what the balance of nature is. . . . Even in the supposedly stable universe of matter as it was viewed by nineteenth-century scientists, new problems constantly appear. . . . The discovery by physicists of antimatter particles as having electric charges opposite to those that compose our world and unable to exist in concert with known matter raises the question of whether after all our corner of the universe is representative of the entire potentialities that may exist elsewhere. Elsewhere. That's how the Yucatan runs. "Yucatan is elsewhere."[45] So it's a kind of Anti-Yucatan.

WHEELER: That was a very good ending on that, because it doesn't end anything. Like all of a sudden you step, if you want to, off into whatever goes elsewhere. And that doesn't even have to be the Yucatan at that point

SMITHSON: . . . The first investigations of the Yucatan were really brought by some scientist's curiosity in Atlantis. . . . So ["Incidents of Mirror-Travel in

the Yucatan"] becomes that kind of reflection of [these expeditions],[46] but it's an anti-expedition. . . . it's like the thinking behind the nonsite. Once again the nonsite is a kind of equivalent of antimatter, the negative world—which is essentially not negative . . .

WHEELER: It's very positive in a sense, but it's an enantiomorph, it's the other possibility. That's interesting too, your investigation [is dealing] with the notion of contraries. In Plato's world that was a very important problem too, but they didn't get very far with it. The primitive man got much further with it.

SMITHSON: They were trying to get out of the contraries by going upward into the ideal. [My work] is not an escape, like painting is an escapist art . . . The origins of Cézanne were never really understood, why he was going to quarries. Then in a sense it was formalized by [the Cubists] and to a greater extent by Matisse, the armchair art of the interior studio. It becomes totally a key to pure abstraction, so that all these extra forces, you just forget about them. . . . It makes it a lot easier, nobody has to contend with those really frightening problems, but the frightening problems are the ones that really need investigation.

NOTES

1. Smithson was helped by Douglas Chrismas, his dealer in Vancouver. While there, Smithson also had the opportunity to realize *Glass Strata with Mulch and Soil*, commissioned by Ian Davidson.

2. The transcriptions, which can be found in the Robert Smithson Papers at the Archives of American Art/Smithsonian Institution (roll 3833, frames 1104–1179), are dated as follows: first conversation, no date; second conversation, December 15, 1969; third conversation, December 31, 1969; fourth conversation, February 2, 1970.

3. At the end of the first conversation Smithson is referring to Anton Ehrenzweig, *The Hidden Order of Art* (Berkeley: University of California Press, 1967). See page 19 for Ehrenzweig's definition of dedifferentiation: "I will speak of undifferentiation when referring to the static structure of unconscious image making, of dedifferentiation when describing the dynamic process by which the ego scatters and represses surface imagery."

4. See his untitled notes, Smithson Papers, roll 3834, frame 0358.

5. "Can Man Survive?" Printed in this volume, pp. 367–368 below.

6. Untitled notes, Smithson Papers, roll 3835, frame 1064.

7. Smithson's library contained: William E. Ford, *Dana's Textbook of Mineralogy* (New York: Wiley, 1958).

8. Primary Structures, The Jewish Museum, New York, April 27–June 12, 1966.

9. Smithson got his notion of the surd from the following sources: Samuel Beckett, *The Unnamable*, in: *Three Novels by Samuel Beckett* (New York: Grove, 1965); Tobias Dantzig, *Number: The Language of Science* (New York: Macmillan, 1954); and Hugh Kenner, *Samuel Beckett: A Critical Study* (Berkeley: University of California Press, 1968).

10. Vladimir Tatlin's *Monument to the Third International* (1919/1920).

11. Smithson is referring to his proposals for the Dallas-Fort Worth Airport which he made as artist-consultant to the architectural firm of Tippets-Abbett-McCarthy-Stratton in 1966–67.

12. Besides his project of the *Island of Broken Glass*, Smithson found another location near Vancouver that interested him, the Britannia Copper Mines. He had no definite plans about what he wanted to do there. In "A Cinematic Atopia" he wrote: "Once when I was in Vancouver, I visited Britannia Copper Mines with a cameraman intending to make a film, but the project dissolved. The tunnels in the mine were grim and wet. I remember a horizontal tunnel that bored into the side of a mountain. When one was at the end of the tunnel inside the mine, and looked back at the entrance, only a pinpoint of light was visible. One shot I had in mind was to move slowly from the interior of the tunnel towards the entrance and end outside." *Artforum* (September 1971) vol. 10, no. 1; see p. 142 above.

13. Smithson is probably referring to Don J. Easterbrook, *Principles of Geomorphology* (New York: McGraw-Hill, 1969).

14. James G. Frazer, *The Golden Bough*, vol. 2: *Taboo and the Perils of the Soul*, 3d ed. (London: Macmillan, 1911).

15. *Mirror Displacement (Cayuga Salt Mine Project)* took place both in the Cayuga Salt Mine and the Andrew Dickson White Museum at Cornell University, Ithaca, New York, February 1969.

16. In the notes to *The Waste Land*, T. S. Eliot indicates Frazer's *The Golden Bough* as one of his most important sources.

17. Robert Morris, "Notes on Sculpture, Part 4: Beyond Objects," *Artforum* (April 1969) 7(8):50-54.

18. Sol LeWitt, "Sentences on Conceptual Art," *Art-Language* (May 1969), p. 11.

19. Robert Smithson, "A Sedimentation of the Mind: Earth Projects," *Artforum* (September 1968) vol. 7, no. 1:440; see pp. 100–113 above.

20. On July 20, 1969, five months before this conversation, the first men had landed on the moon.

21. Smithson is referring to Marshall McLuhan, *Understanding Media: The Extension of Man* (New York: Mentor, 1964).

22. Jorge Luis Borges, "The Fearful Sphere of Pascal," in *Labyrinths* (New York: New Directions, 1964), pp. 189–192.

23. The term "Specific Object" was coined by Donald Judd in "Specific Objects," *Arts Yearbook 8* (New York: Art Digest, 1965), pp. 74–82.

24. Robert Smithson in "Incidents of Mirror-Travel in the Yucatan," *Artforum* (September 1969) vol. 8, no. 1; see pp. 119–123 above.

25. "Of the Mayan ideas on the forms of the earth we know little. The Aztec thought the crest of the earth was the top of a huge saurian monster, a kind of crocodile, which was the object of a certain cult. It is probable that the Mayan had a similar belief, but it is not impossible that at the same time they considered the world to consist of seven compartments, perhaps stepped as four layers." J. Eric S. Thompson, *Maya Hieroglyphic Writing* (Norman: University of Oklahoma Press, 1960), quoted by Smithson in his "Incidents of Mirror-Travel."

26. Smithson is alluding to a definition of the difference between myth and fiction by Frank Kermode, *The Sense of an Ending: Studies in the Theory of Fiction* (New York and Oxford: Oxford University Press, 1967), p. 39: "We have to distinguish between myths and fictions. Fictions can degenerate into myths whenever they are not consciously held to be fictive. . . . Myth operates within the diagrams of ritual, which presupposes total and adequate explanations of things as they are and were; it is a sequence of radically unchangeable gestures. Fictions are for finding things out, and they change as the needs of sense-making change. Myths are the agents of stability, fictions the agents of change. Myths call for absolute, fictions for conditional assent. Myths make sense in terms of a lost order of time, 'illud tempus' as [Mircea] Eliade calls it; fictions, if successful, make sense of the here and now, 'hoc tempus.'"

27. Lucy R. Lippard organized four exhibitions of conceptual art, all named according to the number of the inhabitants of the city in which the exhibition would take place. Smithson exhibited in two of them—557,087, Seattle Art Museum, September 5–October 5, 1969; and 955,000, Vancouver Art Gallery, January 14–February 8, 1970.

28. The second chapter of Brian W. Aldiss' novel *Cryptozoic* (New York: Avon Books, 1967) is called, somewhat paradoxically, "Up the Entropy Slope."

29. William Carlos Williams, *Paterson* (New York: New Directions, 1963).

30. Wheeler is referring to Smithson's work *Plunge* (1966).

31. Smithson's second one-man show took place in the Dwan Gallery, New York, March 2–27, 1968.

32. See the definition of "submergence" in Easterbrook, *The Principles of Geomorphology*, p. 440: "Inundation by the sea without implication as to whether the sea level rose or the land subsided."

33. A map titled *Geological Survey of New Jersey, Northern New Jersey, Showing the Iron-Ore & Limestone Districts* (1874) showed a line through the landscape which was projected on the map below as a stratigraphic elevation.

34. Robert Smithson, "Dialectic of Site and Nonsite," in Gerry Schum, *Land Art*, Fernseh-galerie, Hanover, April 1969. See pp. 152–153, above.

35. *Art News* (February 1969), vol. 67, no. 10. See also in the same issue Anthony Robbin, "Smithson's Non-Site Sights," pp. 50–53; reprinted pp. 175–176, above.

36. There exists a multiple, a torn color photograph from the second stop. Another work derived from the first stop was *Gravel Mirror with Cracks and Dust*, exhibited together with *Six Stops on a Section* in 1969.

37. The catalogue for the Earth Art exhibition at the Andrew Dickson White Museum at Cornell University (February 11–March 6, 1969) was published in 1970 as a documentation of the exhibition.

38. What the fly sees is "something a little worse than a newspaper photograph as it would look to us under a magnifying glass." Ralph Buchsbaum, *Animals without Backbones* (Chicago: University of Chicago Press, 1950); quoted by Smithson in "Incidents of Mirror-Travel."

39. Smithson, "Incidents of Mirror-Travel."

40. George Santayana, *Scepticism and Animal Faith* (New York: Dover, 1955). Quoted in Smithson, "Incidents of Mirror-Travel."

41. Smithson, "Incidents of Mirror-Travel."

42. T. S. Eliot, *The Waste Land* (line 30), in *The Waste Land and Other Poems* (London: Faber & Faber, 1972), p. 28.

43. Smithson, "Incidents of Mirror-Travel."

44. Michael Heizer's brother, an environmentalist then living in Vancouver.

45. The very last sentence of "Incidents of Mirror-Travel."

46. Ignatius Donnelly (*Atlantis: The Antediluvian World*, London, 1882) believed that Mexico was an Atlantean colony. Smithson borrowed the title of his Yucatan article from John L. Stephens, *Incidents of Travel in the Yucatan* (1843; Norman: University of Oklahoma Press, 1962).

INTERVIEW WITH ROBERT SMITHSON (1970)

Edited by Paul Toner and Robert Smithson

I began formulating my ideas on earthworks in 1966, while working for the Dallas-Fort Worth Airport Co. My attitudes towards the context of an airport changed, having been confronted with material I would not have otherwise been confronted with. I thought it would be interesting to build large scale earthworks on the fringe of the airport. At that time the only people interested in speculation in that area were Andre, Morris and strangely enough Sol LeWitt. Nobody else had manifested any interest, and no context or outlook was generalized. I was just interested in working with raw materials in conjunction with abstract geometrical forms. I also wanted to get away from specific object orientation. I developed an interest in the mapping situation, and an interest in finding new sites outside of the white walls of the gallery or museum. The non-sites really come out of a comprehension of limits; they set up a dialectic. Political limits are dislocated. The earthworks I had planned for the outer edge of the airfield had to be transmitted back to the airport, so I thought of setting TV cameras out there to do this. As far as you may go out to a periphery area, the art is always being transmitted back in some way or another, some information feedback. You just don't go out there. You cannot constantly go out into the field and not have any kind of return. Basically, my thing is based within the context of a dialectic that goes from the indoors to the outdoors, and back from the outdoors to the indoors, etc. There are alternate ways of making that context known, either through maps, photographs, or in the case of the non-sites, with physical materials. The boxes of the non-sites were used to impose a rectilinear attitude, also a limiting concern; I wanted to introduce the bins to contain the containment more strictly, in a sense. If the gallery is the central point, then you have a periphery. If you go out to the mountains or the desert, you are moving out of a rectangular context into an open context. You might introduce a rectangular form onto the landscape. You always have a dialogue between the abstract and the natural. The non-sites set up the limits, and they point to an outdoor situation, a mapping situation. The maps are very important, because the most abstract art works are out of a kind of abstract mapping. A map is a mental system made of grids, latitudes, and longitudes. You can draw a stratigraphic map out of any abstract painting. The material itself is very important. Going outdoors does not mean you have no recourse to an indoor situation. I don't simply pile things up. The shape imposed is a three-dimensional map. The non-sites incorporate not just the abstract aspects, but the raw material aspects. If you pile something up, all you are faced with is a pile of materials. If you follow the scale of the earth, everything is miniscule. The idea was to set up the scale. The sites that the non-sites cover are very big land masses, providing a context for

doing work outdoors. For the mirror pieces, there is no audience, yet if the work is strong enough, and photographed properly, it is fed back into a mass distribution situation. There is a generative aspect to that. It defeats the idea of exhibition entirely. The method of working is always reproducible. The ones that are done outdoors follow the irregular contours of the land, and deal with the given raw materials. They are juxtaposed in an irregular grid rather than a regular grid. I would select a spot that interested me in terms of the materials, and cluster the mirrors in and around the material that was there, using the raw materials as a support for the mirrors. They were also involved with natural light as opposed to pigment, which is basically a covering. For the same reasons, in the non-sites I covered the steel to make the containers more abstract. If you are going to go out of the gallery to a point with no walls, you'll find that you are back to the gallery sometime, so that it becomes a feedback situation. That sets up the context of how you can do things in the gallery. I've done other things that are on the landscape, usually in the sites that the non-sites point to, like the "earth maps," but there is still a form that I use, mainly pre-historic land masses. I take a map from pre-history, and then map it out on an area. In the non-sites, the material would be subtracted from this ground, digging out the material. Then you also might have mirrors. This kind of material still goes back and forth through photographs, back to some kind of rectangular setting. So you have this context set up, you have a set of viable limits which can just expand indefinitely, like a ratio system, but within it you can do all kinds of different things. Once that is established, a lot of different people can move in and do their thing.

The mirror displacements are seen in photographs, and seen in terms of the trip, which is very well known. The travel aspect of going to the site from the non-site—you'll find people just doing trips, like Richard Long. There is still a photographic record. I think there is a lot of naive attitude among the people involved in this, like some sort of new freedom, implying constantly going out to the periphery. If you go out far enough, it just gets into a fog. If there is no dialectic, then there is no control over what is going on; they just do things to compete with the vagueness of the situation. The process is important, but within the process each moment is subject to an arrest in the process. If you take a photograph of it, you arrest the process, or it is a momentary stop in the process. The process is not continuous, it is discontinuous, at least in terms of the record of the process. There is a halt every time something is photographed, or there is a suspension. Every step in the process is relived at one point or another. The Yucatan piece was just made to bring down the instantaneous aspect of it to a very short duration, and the notion of a show is not really necessary. Those pieces could be reconstructed by following the map. But as far as the activity is concerned, writing it out gives it another dimension, so that the writing like any other material, is not an ideal substance any more than rocks or paint are. It is the same kind of concern in a different context.

The non-sites are like three dimensional maps that point to an area. The pieces that I do on a landscape are maps of material, as opposed to maps of paper. They point back in time to prehistoric land masses that don't exist now. This points to gigantic land masses, or great scale properties that don't exist on the surface of the earth. So you are going into a kind of time situation in which the earth is submerged; one of the non-sites points to a site that is uncertain because the site is buried in the carboniferous period. It is not just a space concern. It involves a consciousness of time as well. Space is sort of an easy thing to isolate. In terms of process, most people are just into process on a day to day basis, for durational time, with no sense of historical time. It is extended back to the Renaissance and archaic civilizations and back to prehistoric situations. In terms of my thing, it is very comprehensive in that it does not disown the past, but takes you deeper into it. It is ultra-traditional, so traditional that the traditions are not even known about.

In the non-sites, the prehistoric reference comes through, but the sites are all here today, within the maps of materials (stone, mud, grass and shells). All of these things point to continents and land masses that don't exist today. That establishes a context.

Now I am doing a piece in the Salt Lake that is a spiral. The piece, like the others, tends to be enclosed, with a sense of containment. Each time you put down a work, even though it is caught up in a non-objective process, there is still the vicinity of that activity going on. The islanding situation, even with the prehistoric things, gives you that sense of limit. The point where you drop a rock into the water, radiates out and dissipates. In the same way, a process can spread out and dissipate itself and become very ephemeral, very caught up in durational time. My intention is to arrest a moment in that peripheral circumference area, and relate it to a central point.

The Salt Lake project will be built on a salt reef (meandering zone), and come out like a jetty. A lot of the thinking for this piece is contained in the article on Aerial Art. Carl Andre had some notions in that direction, but stayed within a gallery, or contained room situation.

A lot of artists set up different dichotomies or duplicates. Dennis [Oppenheim] takes a dialectical situation and applies it—taking a museum interior and placing it outside. But a lot of things don't have any physical resolution, a lot of people go on one track, a kind of one way thing, but are forced into relating it back to an indoor situation.

I am interested in the photograph as a material as well as on-the-spot experience. One is sensate and one is more an arrested moment. A museum could exist just as well as a magazine, it is just a matter of changing context, and more and more of this will happen.

On the salvation idea—the whole Western moral tradition has collapsed; that feeling still persists, so it has to find other outlets. In a technological society, the values have dissipated, and the ecology thing is a way of delivering one

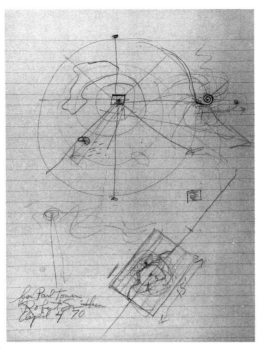

Untitled, 1970. Pen and ink, 8½ x 11″. This drawing was made by
Smithson during the interview with Paul Toner.

from death. Sin is like pollution. In the 18th century, people used to believe
that hospitals and insane asylums were poisoning society. The ecology thing
represents moral confusion, and a need to continue. It is a media issue, like "the
war on poverty." My work isn't about the war on poverty, or the war on any-
thing. I'm not a salvationist. I know there is that need to transcend one's con-
dition. You know that you are growing older, and that you are going to die,
and you want some kind of continuance. People always thought that nature is
self-sufficient, and that it was going to continue. Now nature itself is threat-
ened. The dinosaurs lived and died and ice ages have come and gone. It might
be quite natural that Lake Erie is filling up with green slime. It might just be
another stage. There is no going back to Paradise or 19th century landscape
which is basically what the conservationist attitude is. People have always had
different views of what nature is. The early view of Paradise is a nostalgia for
the enclosed garden. There is not consciousness of that now. There is a whole
history of how man views the earth. In the 16th century people thought they
were leaving the notion that the earth was corrupted by the fall. The attitude
in the "middle ages" was to say that the mountains weren't spoiled, or the cor-
roded aspect of a corrupted situation. Then the romantics came along. They
aestheticized mountains—and produced "the mountain controversy"—whether
or not the mountains were the habitation of the devil. That was changed by
the Romantics (who actually were leagued with the devil). The sentimental
idea of the landscape as a "beauty spot" is directly out of that romantic preoc-

cupation with the landscape. There has always been the war between the formal and the anti-formal. It goes back to the natural and unnatural gardening techniques. It was a political issue in the time of Alexander Pope. His view of the garden was that it was to be meandering and twisting, as opposed to the gardening of the French. You can see that views of the earth, or how to treat the landscape, have political implications. Most abstraction is a withdrawal from nature, from a fear of nature. The original idea of abstraction came from a book called *Abstraction and Empathy*. During the Renaissance, man was confident in himself, he wasn't frightened of what was out there. We are back to that state of fear again—we are frightened of what is out there—ecology is a withdrawal—people want to stop eating. They are afraid that the lettuce they are eating has feelings. During the Renaissance man started dominating the land. The whole Renaissance ideal has fallen apart. Abstraction is the beginning of that pulling back. I'm interested in that area of terror between man and land. When they built the pyramid, that was an enclosed abstract absolute thing that shut out any kind of relative taboo area. The primitives have that idea of totem and taboo—like site and non-site. It's how much you are aware of the situation. The totem indicates the taboo area. A lot of the land that people work on is usually desolate, or areas where art has never been. I'm not interested in "happenings," or process for process sake.

I'm interested in all different types of places, not just the outdoors; that can become a stance that doesn't have any resolution, or become overly precious. I'm more interested in the way things are.

A lot of the working outdoors is just escapism because things are so horrible. People want to get out in the fresh air, and that becomes a sentimental escapist tendency. The tendency to go out is a peripheral concern, and peripheral concerns are romantic—going out into the infinite. If you bring that back, it is more of a classical thing—it completes the dialectic. So, I am neither romantic nor classic, but working in the tension of both areas. Like the spiral in Utah, on an unstable salt reef. I am concerned with physicality at every level—different weights of words and different weights of raw material. At the same time the road that surrounds the spiral, is a peripheral thing and you are locked in again. There is a possibility of just working on an island, completely cut off. Everything collapses into a central point. There is the notion that the non-site is not a site—that it is not there, but it is there. It is a negation of an actual place done through physical means.

Mirror Pieces—The difference between the outdoor mirror piece and the indoor mirror piece is that the indoor ones are set up in a regular situation and the outdoor ones are set up in an irregular situation. In one, I designated only that I wanted shelly sand. There is no map to go with it. I just did that one show (Chicago) to set up a viable context, so that in some cases the sites are designated, and in some cases they are not. Usually I just designate a title. The one I did in Germany, the earth comes from the Ruhr district, a particular

spot there. It can be designated as a vicinity or designated as a point depending on how you want to get into it.

The first thing that I did with material was with tar and gravel in 1966. It could have been scattered—scattering and containment are a dichotomy. Scattering is vitalistic. It doesn't confront the area of death, or the swinging back and forth between life and death. Most people just overlook one for the other—either death-directed or life-directed. The life-directed thing upsets the balance. That is one of the problems with the ecological thing, because they are doing more to unbalance—someone who gives up eating meat because he is afraid that eating it will cut down the life of the earth; but you have to eat, so that death depends on life and life depends on death. The view of the earth polluting itself out is a death fear.

The tar and gravel piece doesn't point to a site. That is the first piece that deals with raw materials in the gallery. I was just moving into it, and away from pure abstraction, away from specific object or industrial type object. It decomposed something that you are faced with all the time. The sinks they were in were limits—Manhattan Island has a limit to it. It is not an infinite thing, though within it you never find out all the infinite things within the finite area. Within an island you have all kinds of particles, but at the same time the awareness is a scale thing—it contracts and makes you more aware of the possibilities within that confinement. The Earth is an island. Everything is confined, whether it is indoors or outdoors. It is the degree of awareness of the ratio between the two.

Asphalt Rundown—Rome, Italy—that is an on-the-site piece that relates to itself; it is in a quarry in the suburbs of Rome. It just follows the contours, but it has the same fanning out from a central point, so it is involved in the same thinking. All of the things internally have that aspect, they all are involved with the unification of the duplicity, the dual aspect is reconciled within the pieces, and reflects a greater scale of dialectic. In this case, just following the slope, running down, and dissipating itself.

On the horizon (Yucatan)—a horizon is an impossible point to locate. Even though it is right there in front of you, it is constantly evading your grasp. It is only a mirage that can't be fixed, arrested or stopped, or transferred into an abstract condition, and that is the arrested moment. Those moments constantly change, and are giving way to other moments; so you can get into a kind of vertigo situation.

A point is like a whirlpool or central vortex. The piece in Salt Lake will be built on a meandering zone, that is unstable, and the idea is to stabilize something that is unstable. It can be seen from the ground. A road comes into it through a big valley, to the salt lake that is shimmering with mirages. The water is red, like an entropic landscape. Sometimes it looks like wine. Crystals will grow on the fringes. It is built on a reef under three feet of water, and it dries up in late summer, so there is a constant shift in physical properties. I'm

working here, not with paint, but with the color of the water, the crystals, the black rock. This all derives from the islanding situation.

I am interested in great masses of materials that are threatened by physical forces. The winds on that lake are of hurricane force, and the water there is twice as heavy. The lake itself is interesting because it always changes its shape. Your mental processes are always being pushed out of shape too, so no matter how precise you get or how strict you are, there is always a shift or breakdown in the mental process. In physical situations or natural situations that is true. Anything you do outside is subject to erosion.

Mirror pieces (Yucatan)—nine places spill out to peripheral zones. It is not anything you can pin down, because then it would be the simple act of logical ideation which doesn't interest me. It is more in the area of surd possibilities, the other side of the rational. There is an attempt to regulate the irrational aspects. So my work is always uncertain, but at the same time the uncertainty is arrested where the system breaks down, or where the incapacity comes in. To locate that is even more interesting than a willful, logical position; anybody can do that.

Minimal art—My work has always been an attempt to get away from the specific object. My objects are constantly moving into another area. There is no way of isolating them—they are fugitive. They are things, rather than definable presences. Working with non-illusionistic materials, like opaque materials, breaks down that whole idea of certainty which is in the "object." Some people crave that. There is a cut-off point, probably around Andre; he is still involved in that certainty, laying out the thing—it gives people the feeling that there is something definite there. A lot of people are disturbed by my work because it is not within their grasp; it isn't a simple symmetry.

New art changes how we look at old art. You are not in a vacuum. You are not just a personality spewing out things from your gut. Art changes the view of the past. There is a lot of archaic art, there are giant earthworks in Peru, that haven't been thought about. Indian mounds and all that kind of building leads to another kind of perception. That's why I put the jaguar mask in the Yucatan article, to show that Carl Andre's art can go all the way back. Morris has an article in *Artforum*, where he is discussing the way Macchu Picchu is built, not in preconceived notions of art history, but in a fresh one. I don't go for that idea that art is personal. The personal talent might be there, but the tradition, range, extends into the past. The intentions of the pyramid involve a different kind of world view. You have to know that world view. *Abstraction and Empathy* has a good idea of what the pyramids are about, psychologically, an idea of what the motivation was. You can't just aestheticize them from a position of antiquarian interest. Most museums are just containers of fragments (of sort of enclosed edifices and temples, palaces and things) of the past. The museum was built into the 19th century to house the Renaissance fragments. You have this kind of residue, breaking off from a past situation. There is the "savage view" of

240

Levi-Strauss. Primitive people had different intentions, a different kind of social thing; they are not out of technology, they are out of a different kind of world view. If you climb the pyramids of Mexico, what went on there was sacrifice, and terror. You get vertigo looking down those stairs. They didn't have a concept of love, only pleasure and pain—the two interweaving, that is all there was. There was no goddess of love, or Judeo-Christian heritage to relate to. Sacrifice was a renewal; when they made the sacrifice, people internally did not feel disgust and nausea, they were gratified by sacrifice. People don't know where their heads are now, they don't know where their continuance is. It is a moral problem, more so than aesthetic.

DISCUSSIONS WITH HEIZER, OPPENHEIM, SMITHSON (1970)

These discussions, organized and edited by Liza Bear and Willoughby Sharp in conjunction with the artists, were held in New York from December 1968 to January 1969. The transcript was edited in collaboration with the artists.

MICHAEL HEIZER: "The work is not put in a place, it is that place."

Dennis, how did you first come to use earth as sculptural material?

DENNIS OPPENHEIM: Well, it didn't occur to me at first that this was what I was doing. Then gradually I found myself trying to get below ground level.

Why?

OPPENHEIM: Because I wasn't very excited about objects which protrude from the ground. I felt this implied an embellishment of external space. To me a piece of sculpture inside a room is a disruption of interior space. It's a protrusion, an unnecessary addition to what could be a sufficient space in itself. My transition to earth materials took place in Oakland a few summers ago, when I cut a wedge from the side of a mountain. I was more concerned with the negative process of excavating that shape from the mountainside than with making an earthwork as such. It was just a coincidence that I did this with earth.

You didn't think of this as an earthwork?

OPPENHEIM: No, not then. But at that point I began to think very seriously about place, the physical terrain. And this led me to question the confines of the gallery space and to start working things like bleacher systems, mostly in an outdoor context but still referring back to the gallery site and taking some stimulus from that outside again. Some of what I learn outside I bring back to use in a gallery context.

Would you agree with Smithson that you, Dennis, and Mike are involved in a dialectic between the outdoors and the gallery?

OPPENHEIM: I think that the outdoor/indoor relationship in my work is more subtle. I don't really carry a gallery disturbance concept around with me; I leave that behind in the gallery. Occasionally I consider the gallery site as though it were some kind of hunting-ground.

Then for you the two activities are quite separate?

OPPENHEIM: Yes, on the whole. There are areas where they begin to fuse, but generally when I'm outside I'm completely outside.

ROBERT SMITHSON: I've thought in this way too, Dennis. I've designed works for the outdoors only. But what I want to emphasize is that if you want to con-

Avalanche, I, Fall 1970

centrate exclusively on the exterior, that's fine, but you're probably always going to come back to the interior in some manner.

So what may really be the difference between you is the attitude you have to the site. Dennis, how would you describe your attitude to a specific site that you've worked with?

OPPENHEIM: A good deal of my preliminary thinking is done by viewing topographical maps and aerial maps and then collecting various data on weather information. Then I carry this with me to the terrestrial studio. For instance, my frozen lake project in Maine involves plotting an enlarged version of the International Date Line onto a frozen lake and truncating an island in the middle. I call this island a time-pocket because I'm stopping the IDL there. So this is an application of a theoretical framework to a physical situation— I'm actually cutting this strip out with chain saws. Some interesting things happen during this process: you tend to get grandiose ideas when you look at large areas on maps, then you find they're difficult to reach so you develop a strenuous relationship with the land. If I were asked by a gallery to show my Maine piece, obviously I wouldn't be able to. So I would make a model of it.

What about a photograph?

OPPENHEIM: OK, or a photograph. I'm not really that attuned to photos to the extent to which Mike is. I don't really show photos as such. At the moment I'm quite lackadaisical about the presentation of my work; it's almost like a scientific convention. Now Bob's doing something very different. His non-site is an intrinsic part of his activity on the site, whereas my model is just an abstract of what happens outside and I just can't get that excited about it.

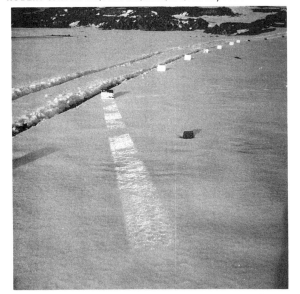

ROBERT SMITHSON, *Mirror Trail*, Ithaca, N.Y., February 1969.

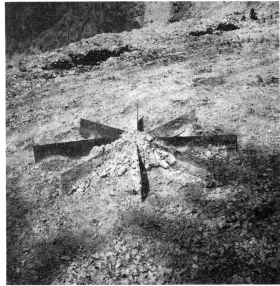

ROBERT SMITHSON, *Mirror Displacement, Chalk Pit,* Oxted England, 1969.

Could you say something, Bob, about the way in which you choose your sites?

SMITHSON: I very often travel to a particular area; that's the primary phase. I began in a very primitive way by going from one point to another. I started taking trips to specific sites in 1965: certain sites would appeal to me more— sites that had been in some way disrupted or pulverized. I was really looking for a denaturalization rather than built up scenic beauty. And when you take a trip you need a lot of precise data, so often I would use quadrangle maps; the mapping followed the traveling. The first non-site that I did was at the Pine Barrens in southern New Jersey. This place was in a state of equilibrium, it had a kind of tranquility and it was discontinuous from the surrounding area because of its stunted pine trees. There was a hexagon airfield there which lent itself very well to the application of certain crystalline structures which had preoccupied me in my earlier work. A crystal can be mapped out, and in fact I think it was crystallography which led me to mapmaking. Initially I went to the Pine Barrens to set up a system of outdoor pavements but in the process I became interested in the abstract aspects of mapping. At the same time I was working with maps and aerial photography for an architectural company. I had great access to them. So I decided to use the Pine Barrens site as a piece of paper and draw a crystalline structure over the landmass rather than on a 20 × 30″ sheet of paper. In this way I was applying my conceptual thinking directly to the disruption of the site over an area of several miles. So you might say my non-site was a three-dimensional map of the site.

OPPENHEIM: At one point in the process you've just described, Bob, you take a quadrangle map of an airport. In my recent piece at the Dwan Gallery, I took the contour lines from a contour map of Ecuador, which is very close to the Equator and I then transferred this two-dimensional data onto a real location. I think there's a genuine similarity here. In this particular case I blew up the information to full size and transferred it to Smith County, Kansas, which is the exact center of the United States.

SMITHSON: I think that what Dennis is doing is taking a site from one part of the world and transferring the data about it to another site, which I would call a dislocation. This is a very specific activity concerned with the transference of information, not at all a glib expressive gesture. He's in a sense transforming a terrestrial site into a map. Where I differ from Dennis is that I'm dealing with an exterior and an interior situation as opposed to two exterior situations.

Why do you still find it necessary to exhibit in a gallery?

SMITHSON: I like the artificial limits that the gallery presents. I would say my art exists in two realms—in my outdoor sites which can be visited only and which have no objects imposed on them, and indoors, where objects do exist.

Isn't that a rather artificial dichotomy?

SMITHSON: Yes, because I think art is concerned with limits and I'm inter-

ested in making art. You can call this traditional if you like. But I have also thought about purely outdoor pieces. My first earth proposals were for sinks of pulverized materials. But then I got interested in the indoor-outdoor dialectic. I don't think you're freer artistically in the desert than you are inside a room.

Do you agree with that, Mike?

HEIZER: I think you have just as many limitations, if not more, in a fresh air situation.

But I don't see how you can equate the four walls of a gallery, say, with the Nevada mudflats. Aren't there more spatial restrictions in a gallery?

HEIZER: I don't particularly want to pursue the analogy between the gallery and the mudflats. I think the only important limitations on art are the ones imposed or accepted by the artist himself.

Then why do you choose to work outdoors?

HEIZER: I work outside because it's the only place where I can displace mass. I like the scale—that's certainly one difference between working in a gallery and working outdoors. I'm not trying to compete in size with any natural phenomena, because it's technically impossible.

When Yves Klein signed the world, would you say that was a way of overcoming limits?

SMITHSON: No, because then he still has the limits of the world . . .

Dennis, recently you have been doing really large-scale outdoor pieces. What propels you to work outdoors rather than in an already structured situation?

OPPENHEIM: I'm following a fairly free path at present so I'm not exclusively outdoors in that sense. In fact I'm tending to refer back to the gallery.

Why do you find that necessary?

OPPENHEIM: It's a kind of nostalgia, I think. It seems to me that a lot of problems are concerned mainly with presentation. For some people the gallery

ROBERT SMITHSON, *Mirror Trail*, McKinney's Point, Ithaca, N.Y., February 1969.

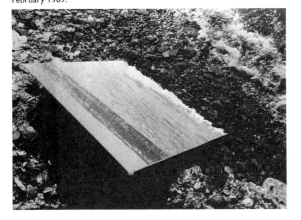

ROBERT SMITHSON, *Mirror Displacement*, Cayuga Rock Salt Mine Ithaca, N.Y., February 1969.

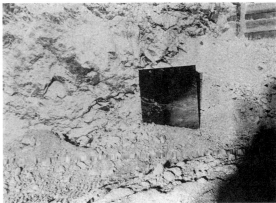

issue is very important now but I think that in time it will mellow. Recently I have been taking galleries apart, slowly. I have a proposal that involves removing the floorboards and eventually taking the entire floor out. I feel this is a creeping back to the home site.

Bob, how would you describe the relation between the gallery exhibit and nature?

SMITHSON: I think we all see the landscape as coextensive with the gallery. I don't think we're dealing with matter in terms of a back to nature movement. For me the world is a museum. Photography makes nature obsolete. My thinking in terms of the site and the non-site makes me feel there's no need to refer to nature anymore. I'm totally concerned with making art and this is mainly an act of viewing, a mental activity that zeroes in on discrete sites. I'm not interested in presenting the medium for its own sake. I think that's a weakness of a lot of contemporary work.

Dennis, how do you see the work of other New York sculptors, specifically Morris, Judd, LeWitt, and Andre?

OPPENHEIM: Andre at one point began to question very seriously the validity of the object. He began to talk about sculpture as place. And Sol LeWitt's concern with systems, as opposed to the manual making and placement of object art can also be seen as a move against the object. These two artists have made an impact on me. They built such damn good stuff that I realized an impasse had been reached. Morris also got to the point where if he'd made his pieces a little better, he wouldn't have had to make them at all. I felt that very strongly and I knew there must be another direction in which to work.

Are you referring to Morris' minimal work?

OPPENHEIM: Yes, his polyhedrons. The earth movement has derived some stimulus from minimal art, but I think that now it moved away from their main preoccupations.

HEIZER: I don't think that you're going to be able to say what the source of this kind of art is. But one aspect of earth orientation is that the works circumvent the galleries and the artist has no sense of the commercial or the utilitarian. But it's easy to be hyperesthetic, and not so easy to maintain it.

SMITHSON: If you're interested in making art then you can't take a kind of facile cop-out. Art isn't made that way. It's a lot more rigorous.

HEIZER: Eventually you develop some sense of responsibility about transmitting your art by whatever means are available.

What do you have to say about that, Dennis?

OPPENHEIM: I think we should discuss what's going to happen to earth art, because the cultural reverberations stimulated by some of our outdoor pieces are going to be very different from those produced by a piece of rigid indoor sculpture.

For one thing, I think a lot of artists will begin to see the enormous possibilities inherent in working outdoors.

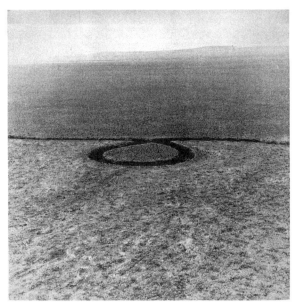

MICHAEL HEIZER, *Circumflex*, Massacre Creek dry lake, 1968.
About 120′ long, 18′ wide, 12″ deep, tapering to the surface
at both ends. Photo by the artist.

HEIZER: Do you mean something ought to be said about the IMPOR-
TANCE of what's being done with earth????

OPPENHEIM: Yes.

HEIZER: Well, look at it this way. Art usually becomes another commodity.
One of the implications of earth art might be to remove completely the com-
modity-status of a work of art and to allow a return to the idea of art as—

Art as activity?

HEIZER: No, if you consider art as activity then it becomes like recreation. I
guess I'd like to see art become more of a religion.

In what sense?

HEIZER: In the sense that it wouldn't have a utilitarian function anymore.
It's okay for the artist to say he doesn't have any mercenary intentions, know-
ing full well that his art is used avariciously.

So the artist's responsibility extends beyond the creative act?

HEIZER: The artist is responsible for everything, for the work and for how
it's used. Enough attacks have been made on my work for me to have consid-
ered protecting it, like a dog burying a bone in the ground.

OPPENHEIM: Don't you see art as involved with weather or perhaps redi-
recting traffic?

HEIZER: I like your idea, Dennis, but it sounds as though you want to make
a rain machine, which I don't think is what you mean at all.

OPPENHEIM: Aren't you indicating possibilities here that other artists haven't
really explored? It seems to me that one of the principal functions of artistic

involvement is to stretch the limits of what can be done and to show others that art isn't just making objects to put in galleries, but that there can be an artistic relationship with things outside the gallery that is valuable to explore. Mike, what are you trying to achieve by working in nature?

HEIZER: Well, the reason I go there is because it satisfies my feeling for space. I like that space. That's why I choose to do my art there.

Has your knowledge of archaeological excavations had any bearing on your work?

HEIZER: It might have affected my imagination because I've spent some time recording technical excavations. My work is closely tied up with my own experiences; for instance, my personal associations with dirt are very real. I really like it, I really like to lie in the dirt. I don't feel close to it in the farmer's sense . . . And I've transcended the mechanical, which was difficult. It wasn't a legitimate art transition but it was psychologically important because the work I'm doing now with earth satisfies some very basic desires.

So you're really happy doing it.

HEIZER: Right. I'm not a purist in any sense and if I'm at all interested in Bob's or Dennis' work, it's because I sense in it the same kind of divergence from a single ideal as in my own. That's why I said earlier that earth art is a very private thing. And of course I'm not at all concerned about style.

SMITHSON: I think most of us are very aware of time on a geological scale, of the great extent of time which has gone into the sculpting of matter. Take an Anthony Caro: that expresses a certain nostalgia for a Garden of Eden view of the world, whereas I think in terms of millions of years, including times when humans weren't around. Anthony Caro never thought about the ground his work stands on. In fact, I see his work as anthropocentric cubism. He has yet to discover the dreadful object. And then to leave it. He has a long way to go.

OPPENHEIM: It seems to me that this consciousness of geological process, of very gradual physical change, is a positive feature, even an aesthetic characteristic of some of the more significant earth works.

SMITHSON: It's an art of uncertainty because instability in general has become very important. So the return to Mother Earth is a revival of a very archaic sentiment. Any kind of comprehension beyond this is essentially artificial.

Geological thinking seems to play an important role in your esthetic.

SMITHSON: I don't think we're making an appeal to science at all. There's no reason why science should have any priority.

HEIZER: Scientific theories could just as well be magic as far as I'm concerned. I don't agree with any of them.

Do you see them as fiction?

SMITHSON: Yes.

HEIZER: Yes. I think that if we have any objective in mind it's to supplant science.

SMITHSON: I wrote an article recently entitled "Strata" covering the Pre-

cambrian to the Cretaceous periods. I dealt with that as a fiction. Science works, yes, but to what purpose? Disturbing the grit on the moon with the help of billions of dollars. I'm more interested in all aspects of time. And also in the experience you get at the site, when you're confronted by the physicality of actual duration. Take the Palisades non-site: you find trolley tracks embedded in the ground, vestiges of something else. All technology is matter built up into ideal structures. Science is a shack in the lava flow of ideas. It must all return to dust. Moondust, perhaps.

Why don't we talk about one of your pieces, Bob, the one on the Mono Lake, for example.

SMITHSON: The Mono Lake non-site, yes. Maps are very elusive things. This map of Mono Lake is a map that tells you how to get nowhere. Mono Lake is in northern California and I chose this site because it had a great abundance of cinders and pumice, a fine granular material. The lake itself is a salt lake. If you look at the map, you'll see it is in the shape of a margin—it has no center. It's a frame, actually. The non-site itself is a square channel that contains the pumice and the cinders that collected around the shores of the lake at a place called Black Point. This type of pumice is indigenous to the whole area.

What exactly is your concept of a non-site?

SMITHSON: There's a central focus point which is the non-site; the site is the unfocused fringe where your mind loses its boundaries and a sense of the oceanic pervades, as it were. I like the idea of quiet catastrophes taking place. . . . The interesting thing about the site is that, unlike the non-site, it throws you out to the fringes. In other words, there's nothing to grasp onto except the cinders and there's no way of focusing on a particular place. One might even say that the place has absconded or been lost. This is a map that will take you somewhere, but when you get there you won't really know where you are. In a sense the non-site is the center of the system, and the site itself is the fringe or the edge. As I look around the margin of this map, I see a ranch, a place called the sulphur pond; falls, and a water tank; the word pumice. But it's all very elusive. The shorelines tell you nothing about the cinders on the shore. You're always caught between two worlds, one that is and one that isn't. I could give you a few facts about Mono Lake. Actually, I made a movie about it with Mike Heizer. It's in a state of chaos, it's one of those things that I wouldn't want to show to more than a few people. But Mono Lake itself is fascinating. Geologists have found evidence of five periods of glaciation in the Sierra. The first began about half a million years ago, the last ended less than fifteen thousand years ago. The glaciers left prominent marks upon the landscape, they gouged out canyons, broadening and deepening them into U-shaped valleys with steep headwalls and then advanced onto the plain. They built up high parallel ridges of stony debris called moraines. There are all sorts of things like that. The Mono craters are a chain of volcanic cones. Most of them were formed after Lake Russell evaporated. That's why I like it, because

in a sense the whole site tends to evaporate. The closer you think you're getting to it and the more you circumscribe it, the more it evaporates. It becomes like a mirage and it just disappears. The site is a place where a piece should be but isn't. The piece that should be there is now somewhere else, usually in a room. Actually everything that's of any importance takes place outside the room. But the room reminds us of the limitations of our condition.

OPPENHEIM: Why do you bother with non-site at all?

SMITHSON: Why do I?

OPPENHEIM: Why don't you just designate a site?

SMITHSON: Because, I like the ponderousness of the material. I like the idea of shipping back the rocks across the country. It gives me more of a weighty sensation. If I just thought about it and held it in my mind it would be a manifestation of idealistic reduction and I'm not really interested in that. You spoke about evil: actually for a long time people thought mountains were evil because they were so proud compared to the humble valleys. It's true! Something called the mountain controversy. It started in the eighteenth century.

How would you characterize your attitude to nature?

SMITHSON: Well, I developed a dialectic between the mind–matter aspects of nature. My view became dualistic, moving back and forth between the two areas. It's not involved with nature, in the classical sense. There's no anthropomorphic reference to environment. But I do have a stronger tendency towards the inorganic than to the organic. The organic is closer to the idea of nature: I'm more interested in denaturalization or in artifice than I am in any kind of naturalism.

Are there any elements of destruction in your work?

SMITHSON: It's already destroyed. It's a slow process of destruction. The world is slowly destroying itself. The catastrophe comes suddenly, but slowly.

MICHAEL HEIZER, *Double Negative* (Second Displacement), 1968–70. 40,000 and 200,000 tons displaced. 1600 x 50 x 30′. Virgin River Mesa, Nevada.

DENNIS OPPENHEIM, *Annual Rings* (detail). Frozen St. John River, US/Canadian border, December 1968. Photo by the artist.

Big bang.

SMITHSON: Well, that's for some. That's exciting. I prefer the lava, the cinders that are completely cold and entropically cooled off. They've been resting in a state of delayed motion. It takes something like a millennium to move them. That's enough action for me. Actually that's enough to knock me out.

A millennium of gradual flow—

SMITHSON: You know, one pebble moving one foot in two million years is enough action to keep me really excited. But some of us have to simulate upheaval, step up the action. Sometimes we have to call on Bacchus. Excess. Madness. The End of the World. Mass Carnage. Falling Empires.

Mmmm—What would you say about the relationship between your work and photographs of it?

SMITHSON: Photographs steal away the spirit of the work—

OPPENHEIM: One day the photograph is going to become even more important than it is now—there'll be a heightened respect for photographers. Let's assume that art has moved away from its manual phase and that now it's more concerned with the location of material and with speculation. So the work of art now has to be visited or abstracted from a photograph, rather than made. I don't think the photograph could have had the same richness of meaning in the past as it has now. But I'm not particularly an advocate of the photograph.

It's sometimes claimed that the photo is a distortion of sensory perception.

HEIZER: Well, the experience of looking is constantly altered by physical factors. I think certain photographs offer a precise way of seeing works. You can take a photograph into a clean white room, with no sound, no noise. You can wait until you feel so inclined before you look at it and possibly experience at greater depth whatever view you have been presented with.

What are your primary concerns, Mike, in carrying out one of your Depressions?

HEIZER: I'm mainly concerned with physical properties, with density, volume, mass, and space. For instance, I find an 18 foot square granite boulder. That's mass. It's already a piece of sculpture. But as an artist it's not enough for me to say that, so I mess with it. I defile—if you're a naturalist you'd say I defiled it, otherwise you'd say I responded in my own manner. And that was by putting some space under the boulder. My work is in opposition to the kind of sculpture which involves rigidly forming, welding, sealing, perfecting the surface of a piece of material. I also want my work to complete its life-span during my lifetime. Say the work lasts for ten minutes or even six months, which isn't really very long, it still satisfies the basic requirements of fact. Everything is beautiful, but not everything is art.

What makes it art?

HEIZER: I guess when you insist on it long enough, when you can convince someone else that it is. I think that the look of art is broadening. The idea of sculpture has been destroyed, subverted, put down. And the idea of painting

has also been been subverted. This has happened in a very strange way, through a process of logical questioning by artists. It hasn't been like these various looks which appear every twenty years or so; they're just minor phenomena within the larger one that will be remembered.

Do you approve of this undermining of existing art forms?

HEIZER: Of course I do, because then the artist will realize that only a real primitive would make something as icon-like, as obviously pagan as a painting. I worked all those years painting and now I'm critical of the fact that I won't allow myself to do those mindless things anymore. It looks as though the whole spirit of painting and sculpture could be shrugged off, in two years' time perhaps. It's almost totally inconsequential. Of course it'll never happen, but it's conceivable, it could happen.

"...THE EARTH, SUBJECT TO CATACLYSMS, IS A CRUEL MASTER." (1971)

Interview with Gregoire Müller

GREGOIRE MÜLLER: How did you choose the actual site of *Broken Circle—Spiral Hill* for the Sonsbeek exhibition?

ROBERT SMITHSON: Originally the show was supposed to take place in a park, and the idea of putting an object in a park really didn't motivate me too much. In a sense, a park is already a work of art; it's a circumscribed area of land that already has a kind of cultivation involved in it. So I didn't want to impose an object on such an area, or in any way deface a land that was already cultivated. I was looking for an area that was somewhat raw because Holland is so pastoral, so completely cultivated and so much an earthwork in itself that I wanted to find an area that I could mold, such as a quarry or a disused mining area. Finally, Wim Beeren contacted a geographer, Sjouke Zijlstra, who also runs the cultural center in Emmen. He knew of several quarry sites with green lakes.

MÜLLER: At that time, did you have a piece in mind already?

SMITHSON: I was thinking of working with a circular piece—with a combination of jetty and canal in a circular situation so that a lake bank could serve as a diameter. This was an idea lurking in my mind before I got there, but when I saw the site it just fit—in terms of the banks of the quarry lakes—so I decided to do that.

MÜLLER: What kind of considerations enter your choice of a site? Are you concerned about anything else than purely physical qualities?

SMITHSON: In a very densely populated area like Holland, I feel it's best not to disturb the cultivation of the land. With my work in the quarry, I somehow reorganized a disrupted situation and brought it back into another kind of shape. The quarry itself was surrounded by a whole series of broken landscapes, there were pasture lands, mining operations, and a red cliff—it was a kind of sunken site. There was enough elevation around the site to view the piece down in the quarry so that unlike the *Spiral Jetty*, it was involved with a kind of containment in terms of the elevations that surround the lake.

MÜLLER: By allowing the *Broken Circle* to be seen from an elevation, aren't you isolating it from the rest of the landscape? What I mean is that you create a situation in which the viewer can focus upon it as if it were an object, rather than being somehow immersed in the piece and in the landscape at the same time.

SMITHSON: I don't see it as an object. What you have there are really many different scale changes. Speaking in terms of cinema, you have close, medium

Arts Magazine, September 1971. The title comes from Malcolm Lowry's *Dark as the Grave Wherein My Friend is Laid.*

and long views. Scale becomes a matter of interchangeable distances. If you are immersed in a flood you can drown, so it is wiser to perceive it from a distance. Yet, on the other hand, it is worth something to be swept away from time to time.

MÜLLER: Isn't there a certain ambiguity that always occurs when a work made in the land is being photographed? There is a phenomenon of reduction and isolation from the context which almost makes the work look like a painting or an object.

SMITHSON: I think we are actually talking about multiple ways of locating a thing, and one way to locate a thing is to circumscribe it with a photograph. If you are flying over a piece, you can see its whole configuration in a sense contracted down to a photographic scale. I think that is what we are discussing, how we apprehend scale. Now let's say there are three different kinds of scale that one can apprehend, and that they are constantly trading places with each other. The area that you seem interested in is the dedifferentiated area—between differentiation and undifferentiated. That is less a matter of looking and more a matter of touching, or what you could call "Tactile Space."

MÜLLER: I am thinking about some South American Indian land drawings that are so gigantic that without an airplane, it is absolutely impossible to see the whole configuration. The Indians who made these drawings evidently had no way of seeing them globally, except in their mind.

SMITHSON: I think you mean the Nazca lines in Peru. For me, a photograph acts as a kind of map that tells you where the piece is and I don't see anything wrong with that. The Nazca lines have meaning only because they were pho-

A flood in California—Yuba City. Photo by the American Red Cross.

ROBERT SMITHSON, *Spiral Jetty,* detail (1971), salt crystals cover entire work. Constructed 1970. Photo by Nancy Holt.

tographed from airplanes, at least for our eyes conditioned by the twentieth century. All we can do is use our orders and systems to investigate them, and they generally turn out to be wrong—like "Stonehenge Decoded." Stonehenge doesn't strike me as a Neolithic computer. What is interesting is how we fail to understand such remote things.

There are people in Scotland who claim that after being photographed they get sick. Also there is a tribe somewhere that believes cameras blight the landscape. There may be deep reasons for such behavior. After all the camera is a mechanism—a Cartesian eye. Let's return to Indian drawings. When I was out in Utah, Nancy Holt and I went to Moab in the southeastern part of the state. In the red canyons of the Colorado River there are many Indian petroglyphs or rock-art works. Unlike the Nazca lines they are very intimate. They were pecked into the canyon walls in places near the ground level. It was exciting to hunt for them among secluded rocks. The Indians' choice of sites seemed based on physical needs—hunting and fishing. Yet a high degree of abstraction was always present. Stick shapes suggested Pollock and Newman. Truly direct art seems to me to avoid the technique of representing abstractions on a portable surface or through portable objects. The petroglyphs were embedded in particular sites, and seemed rooted to necessity.

MÜLLER: But let's go back to the piece itself: How was it built?

SMITHSON: I had to deal with two elements, earth and water, so I used drag lines and made a series of dikes so that, in a sense, the piece was made by flooding. I had in mind this idea of flooding, related to a specific flood that devastated Holland in the '50s. This struck me as I was building the piece, and it started to function as a kind of microcosm for this natural catastrophe.

MÜLLER: Did you record this process?

SMITHSON: I am still working on a film with Nancy. While the piece was being built, I was thinking about how this process could be captured on film and isolated in terms of the particular ideas I had in mind. I have a succession of process shots that relate to flooding. The film captured the process and took it out of mere duration.

MÜLLER: So you had to deal with a time factor. I imagine that the cinematic time cannot, in this case, be separated from the real time during which the piece was constantly changing.

SMITHSON: Both the making and the filming of the work informed each other. Of course, the water rushing in the film is not rushing anymore, but there is a sense of parallel times—both temporal and atemporal.

MÜLLER: The piece will always be changing, and you will go back to check the changes and record them with a camera. What is your attitude toward such changes?

SMITHSON: When you are dealing with a great mass, you want something that will, in a sense, interact with the climate and its changes. The main objective is to make something massive and physical enough so that it can interact with those things and go through all kinds of modifications. If the work has sufficient physicality, any kind of natural change would tend to enhance the work. Geology has its own kind of entropy, that has to do with sediment mixtures. Sediment plays a part in my work. Unlike Buckminster Fuller, I'm interested in collaborating with entropy. Some day I would like to compile all the different entropies. All the classifications would lose their grids. Levi-Strauss

ROBERT SMITHSON, *Sunken Island* 1971, 5' wide. Summerland Key, Fla. Photo by artist.

ROBERT SMITHSON, *Oolite Island* 1971, 5' wide. Summerland Key, Fla. Photo by artist.

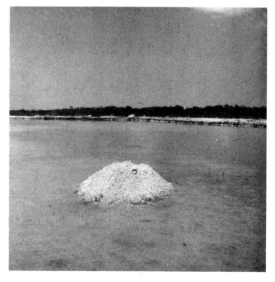

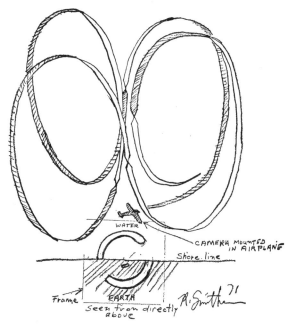

Untitled (movie treatment for *Broken Circle / Spiral Hill*), 1971.

had a good insight; he suggested we change the study of anthropology into "entropology." It would be a study that devotes itself to the process of disintegration in highly developed structures. After all, wreckage is often more interesting than structure. At least, not as depressing as Dymaxion domes. Utopian saviors we can do without.

MÜLLER: We haven't spoken yet about the site itself in terms of its geological properties.

SMITHSON: The quarry happened to be on the edge of a terminal moraine. During the last ice age, the glaciers moved down there and deposited all different kinds of materials, mainly sand. The area was made up of red, yellow, white, brown and black earth, with boulders that had been carried by the glaciers and tumbled into a round shape. The piece itself was developed from a small sand peninsula that extended into the green lake, and in the center of the peninsula there was this glacial boulder that just happened to be there. It was quite by accident that it turned out to be the center of the piece.

MÜLLER: I heard that kind of boulder is very rare in Holland, and that they were used in Prehistoric ages to build monuments. Did you have these monuments in mind when you built the piece?

SMITHSON: Yes, while I was building it. All throughout this area they have what they call Hun's beds: burial chambers, basically in the shape of the hull of a ship embedded in the ground, with precariously balanced large flat rocks going from one side to the other.

MÜLLER: In which ways, then, does the boulder of *Broken Circle* relate to these Hun's beds?

257

SMITHSON: It's an entropological manifestation—I see it as a link-up in terms of lost intentions. For the film, I had in mind shooting a boulder of a Hun's bed and zooming into the rock so that you only see the surface, and then pulling back so as to see the rock surface of my boulder. There would be a forward zoom and a backward zoom that would link up the two boulders in a kind of cinematic parallel that would cover vast stretches of time.

MÜLLER: So it seems to me that what is in the piece always relates to what is outside of the piece. Yet somehow, we are getting back to the idea of focusing—with the emphasis on the boulder at the center . . .

SMITHSON: I've been ambivalent about that since the beginning of the project. My original intention was to move the boulder outside the circumference of *Broken Circle*. I was told that only the Dutch Army could do such a thing. The reason why the boulder was there in the first place was accidental. A blunt peninsula of sand extended into the water directly in front of the boulder. It was the only place in the quarry where the circumference could be integrated. The sand flats were to be a field opening up into a range of vacancy, a site unburdened by any middle point. But then, by an unforeseen chance, I was trapped in Emmen with a monstrous point to contend with. The geographer who was my translator to the miners went on vacation, and I was running out of money. So on impulse I returned to New York without solving the riddle of the accidental center. Once in New York, after studying photographs of *Broken Circle*, I was haunted by the shadowy lump in the middle of my work. Like the eye of a hurricane it seemed to suggest all kinds of misfortunes. It became a dark spot of exasperation, a geological gangrene on the sandy expanse. Apprehensions of the shadowy point spread through my memory of the work. The perimeter of the intrusion magnified into a blind spot in my mind that blotted the circumference out. All and all it is a cyclopian dilemma. I was told that the boulder was one of the biggest in Holland. But, when one is on the *Broken Circle* itself, at eye level one tends to see the boulder as part of the circumference. The veritability of the boulder's position is engulfed by curvatures—no fixity moderates—as in a photograph shot from directly above. When one is standing on the top of the *Spiral Hill*, there is a link-up of two centers, the top center is absent while the bottom center is present—but only from that position. Neither eccentrically nor concentrically is it possible to escape the dilemma, just as the Earth cannot escape the Sun. Maybe that's why Valéry called the sun a "Brilliant Error." When I return to Holland, I might bury the boulder in the center, or move it outside of the circumference, or just leave it there—as a kind of glacial "heart of darkness"—a warning from the Ice Age. At any rate, it is a stimulating predicament. Also, the film remains unfinished. I have in mind several aerial maneuvers. One would be a descending and ascending helicopter shot. The helicopter would go as high as possible over *Broken Circle*, then slowly drop down into the middle, till it was about three feet

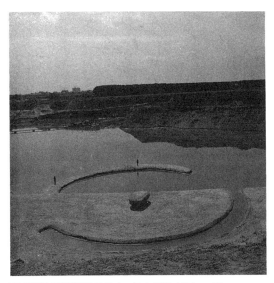

ROBERT SMITHSON, *Broken Circle*, 1971. 140 feet wide. Detail of *Broken Circle*—breaking the dike.

over the sand bank and the water. The diameter would cut the frame in half, the closer the helicopter got to the *Broken Circle*. The helicopter would ascend the same way it came down. Yet, another maneuver would involve an airplane. I am thinking of the "clover leaf" maneuver. It consists of four loops, with *Broken Circle* at the bottom of these loops. A work on this scale doesn't end with a "show." It has a way of generating continual movement. Museum shows often neutralize art by taking it out of society—out of circulation—by rendering it "abstract" and ineffective. Sonsbeek, at least, points toward a new sense of circulation.

MÜLLER: Have you seen the *Spiral Jetty* recently?

SMITHSON: Yes. I was there in August. Recently the water rose to its highest level in 17 years; during the months of June and July the *Jetty* was under 2 or 3 inches of water. Some people went out there and found the *Jetty* completely submerged. This was a sudden natural condition. The snow in the mountains melted so fast that the farmers couldn't hold it in the irrigation canals. There was no way of projecting the water level in advance. As a matter of fact, it was the most sudden rise in the lake in about a hundred years. Later, when I went back, there was no rain at all and the water started to evaporate at a terrific rate. Around mid-August it was beginning to surface and the entire *Jetty* looked like a kind of archipelago of white islands because of heavy salt concentrations. Two weeks later I returned to the *Jetty* with Jan Van der Mark, and the *Jetty* was almost entirely surfaced and almost entirely encrusted with salt crystals. There were various types of salt crystal growth—sometimes the crystals take the form of a perfect square. Then, at other times, there is a different kind of mineral that looks like wax dripping on the rocks. Since the water had

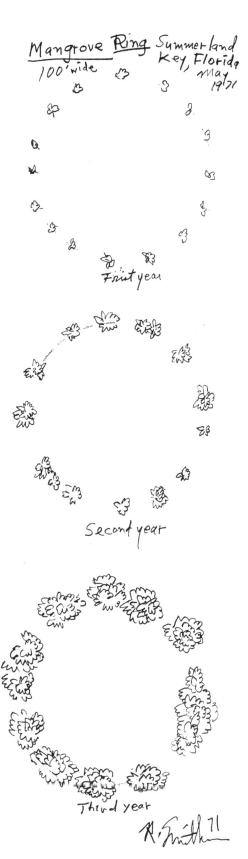

Mangrove Ring
100' wide
Summer land Key, Florida
May 1971

First year

Second year

Third year

R. Smithson 71

Indian Rock Drawing, Moab, Utah, approximately 1 x 1'.
Photo by Robert Smithson.

Hun's Bed in Holland.

evaporated, it left the crystals dry, but the day after I visited the *Jetty*, some huge thunderstorms came in and completely dissolved all the crystals and turned the *Jetty* back to naked rock. Its mass was intact because it's almost 80% solid rock, so that it held its shape. Yet at the same time it was affected by the contingencies of nature.

MÜLLER: You seem interested in working with combinations of land and water. Is that an important factor in your work?

SMITHSON: Yes, it gives me an opportunity to work with water, land, air, and fire (solar light) as a whole interconnected phenomenon. There's something about water that quickens my motivation. Last May, Nancy and I went to the Florida Keys. On Summerland Key, near Key West, I found a shallow lagoon, where I built two five foot wide islands, and planted a hundred foot wide ring of mangrove seedlings. One island was made out of white coralline material called "oolite." I got the oolite out into the lagoon on a plastic raft. The *Sunken Island* was made by consolidating rocks from the bottom of the lagoon. The rocks were encrusted with small slimy things, and sponges called "dead man's fingers." This island was mostly underwater. The *Mangrove Ring* was made by planting seedlings into sediment deposits in cracks in the rocky bottom of the lagoon. Mangrove seedlings are supposed to take root almost immediately. There's a story that Alexander the Great stopped his march through Asia to observe mangroves making land. Mangroves are called "island makers" because they catch sediment in their spidery roots.

MÜLLER: Have you made any more films, since *Spiral Jetty*?

SMITHSON: Nancy and I made a six-minute film called *Swamp*. It's a film about deliberate obstructions or calculated aimlessness. While Nancy was looking through her Bolex, filming, I told her where to step through the reeds and stickers in the Jersey meadows. I recorded the directions on a tape recorder. I am also interested in projection sites. Where and how movies are shown strikes me as important. Actually, I would like to show my film *Spiral Jetty* on the Staten Island Ferry. The ferryboat could sail out to the middle of the harbor, than sail back to the port in a spiraling voyage while the film was showing.

CONVERSATION WITH ROBERT SMITHSON (1972)

Edited by Bruce Kurtz

I'm not really discontented. I'm just interested in exploring the apparatus I'm being threaded through, you know, and to me that's a legitimate interest. I've always been interested in different sites and different kinds of relationships, you know, like the relationship in a white room as opposed to a quarry. I mean there's obviously a diffcrence of intention there, and the whiteness of the room looks like a little neutral cell in heaven and the painting hanging on the wall— you're supposed to not even think of the wall that the painting is hanging on. You're supposed to just respond metaphysically to the painting in terms of color, line, structure, you know, and talk about the framing support, but forget about where you're standing, where you are, and the ambience of the entire space. So I think that actually this is an investigation of some kind of space control that's shot through with all kinds of social, economic, political implications. It's interesting to me. I don't really see this as, you know, a complaint or anything . . .

. . . I think that's all of a piece. Dealers and museums are essentially intertwined, related, so I don't really see that as a big problem. That's just another reality. I mean there's value making, there's always been that connection and there again there's a fantasy that somehow the curator is disconnected, in some ivory tower while all these terrible dealers are running around. I don't really see that, I mean that's just a reality. Paintings are bought and sold. The artist sits in his solitude, knocks out his paintings, assembles them, then waits for someone to confer the value, some external source. The artist isn't in control of his own value. He is sort of waiting for the value to be conferred. And that's the way it operates. Some dealers are more like artists, really. See, what I'm talking about are relationships. Art has tended to be viewed in terms of isolation, neutralization, separation, and this is encouraged. Art is supposed to be on some eternal plane, free from the experiences of the world, and I'm more interested in those experiences, not as a refutation of art, but as art as part of that experience, or interwoven, in other words, all these factors come into it. Generally, to just break everything down into these little slots all the time, to see them as separate entities, mutually antagonistic, warring, aesthetic entities creates an atmosphere of competition among artists which is encouraged by the external value structures. In other words, whatever a painting goes for at Parke Bernet is really somebody else's decision, not the artist's decision, so there's a division, on the broad social realm; the value is separated from the artist, the artist is estranged from his own production. So I'm just saying that it would be nice if

The Fox II, 1975. The conversation took place on April 22, 1972.

the artist could maintain a certain involvement with his production, and this is the great issue, I think it will be the growing issue, of the seventies: the investigation of the apparatus the artist is threaded through. The artist withdraws into a more hermetic position, or at least a spiritualism, esotericism, and mystification—and it's an existential position, too, the disembodied work, in a disembodied world . . .

. . . Well, like it or not, the art world is a separate world. But there are many golden threads, you know. The art world is dependent on either federal or state grants, and on certain common bureaucracies which channel in the funds.

. . . I heard from Mr. Oxenar from the Kröller-Müller Museum that a show like that (Sonsbeek 71) would be inconceivable this year because of the change of government. They had a Liberal Christian party there, or something, and art was the first thing to go. Konrad Fischer also said the same thing, that the political pressures from both left and right see art as the first thing to be axed out. In other words, that's not edifying. And the rumor was that Documenta was going to use this as a lesson plan, after the show was over, for a kind of lesson plan for German art schools. So it would have a practical/social value. I don't know about that, but the museums in Europe tend to be more integrated into

ROBERT SMITHSON, *The Hypothetical Continent of Cathaysia*, 1969. Ink drawing.

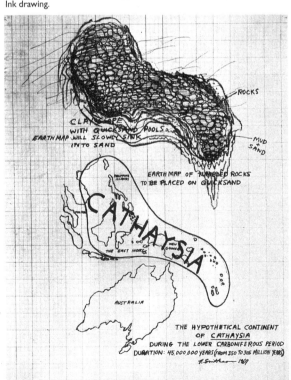

the general political-social fabric. There's always that element. It seems less so here in the United States because the institutions are more isolated. In other words, what the Met does really would not cause a controversy throughout Manhattan.

BRUCE KURTZ: I think maybe one of the reasons is that it is already so completely controlled by political concerns which control public opinion. And so is the Modern. William S. Paley controls a communication network capable of affecting the entire world, and rather than using it toward goals which might effect receptivity to creative ways of thinking and doing, it is used to enforce patterns of the grossest kind of exploitation. The Modern has recently put on hopelessly patronizing exhibitions with the idea of attracting other than the usual kind of elitist crowd, of course with the motive of higher gate receipts to balance a flagging budget. These actions don't have much to do with a real concern for art.

ROBERT SMITHSON: That's just it. Yeah, because basically the museum functions as a bank. There's a heavy investment in there. And they don't want anything threatening that. In other words, we'll just reinforce our Picassos. Paley isn't going to be interested in an alternative art situation that would call into question the very validity of that whole institution. So, they're not doing anything for the masses, or whatever, and that's a big cop-out.

KURTZ: The museum is an instrument of control.

SMITHSON: It's an instrument of control and it's like building cathedrals. I mean that it's really an instrument of political control. And it's silly to think that Paley is going to be able to understand. I think Arthur Miller wrote something about the problems of Lincoln Center. They build these giant edifices, these multimillion dollar edifices, Rockefeller's into that, and they don't have enough money for anybody to do anything in it. They build gigantic culture centers all over the country here, and then they don't have anything to put into them. Then they look for reactionary art to put in those spaces, which are really modeled after the Museum of Modern Art. They've grown like wildfire all over the country, these big fortress-like, Medieval, Bauhaus structures proliferate like crazy, and what that does is just reinforce the Rockfeller economic aesthetic.

KURTZ: And it's a very effective way of control because it absorbs so easily any kind of radical tendency.

SMITHSON: Yeah, and that's why it's so silly for artists to try to overcome that, because they will just be absorbed. That's like what I said, they'll just be integrated into the whole thing, so there's no viable alternative. If there really was an alternative, consciously thought, then artists might do works which are radical but they are unconscious about why they are doing them. I'm just making a plea for more consciousness in that area and I'm not bitter about it. I'm just saying that that's the way it is. Artists are not apolitical. And artists are either being used to support another kind of political value, and if they're

dumb enough to think they are on a cloud or something, that is supporting, actually supporting. In other words, that's their opiate. Their purity is the opiate, the reward that they get. While the external value structure is ripping them off, at the same time they are telling them how pure they are. I mean religion functioned that way, too.

If you are poor that is your reward, and we will encourage that, we who have the economic controls. It's another kind of banking mechanism—super currency—and all representation is currency. Warhol was calling attention to the production. Everything is a dollar: people, soup cans, so he was just representing something that was already just a disembodied product.

. . . Then another problem is the problem of what is known as nature. Most artists, and most intellectual activities, the culture itself, are completely separated, you know, have lost, any contact with the natural world. Architecture is built by computers. People have all these statistics going around in their heads, so that they'll do something based on that level, completely detached from any kind of physicality of the site, so that you're into ecological problems. I find a lot of artists completely confused, especially people working with sites. They don't really know what they're doing there. They're imposing an abstraction rather than drawing out an aspect, or cultivating something in terms of the ecological situation. Very, very curious.

Anyway, I'm going out to Ohio next week to meet with Senator Armstrong and strip mining people and some conservationists. I'll try to do something practical there. I mean I can't do exhibitions like this [Documenta V].

KURTZ: What are you thinking of doing in Ohio?

SMITHSON: Well, I don't know. . . . This was a projection for a future project, but I can't tell anything until I know what the situation is. Maybe it will fall through and maybe it won't. Maybe there's a possibility of taking some established area, it's like a big desert in some parts of Ohio, and conceivably I see a kind of dialectic between the ecologists and the industrialists. Curators, I mean that's on cloud nine. It's just the same old number all over again.

But, I thought your Sonsbeek piece was good. You talked about the Park. People don't think about those things. I mean, they think they just make something, you know, a thing in itself, a Kantian idea, it's just amiss. Things are not things in themselves. They are related to other things. You see already that gets you into a metaphysical dilemma. I would say also most Modernism is based on this Kantian myth business. And you know a lot of people just don't like to hear this sort of thing. They prefer the artist to be dumb and unconscious and self-destructive and isolated and basically crazy.

. . . I just want to be conscious of where I am, in relationship to all these different parameters.

KURTZ: I understand exactly what you're saying, and they're things I've thought about myself only not at all in the same way, and not as extensively. You're being much more ambitious than anyone else I know of.

SMITHSON: I think, though, it's there. I think there's a kind of awareness of it, but not articulated. I feel that myself. I really don't feel I'm adequately articulating. I think it would take somebody to devote their whole life to a kind of archaeology of the art world and all its different tribal states. It's just a very difficult thing, and I'm just trying to figure it out. There are no personal vendettas or anything involved in it, because I think the only way that things would be better would be if isolation were discouraged and cooperation was more a factor so that, you know, I would want to have dialogues with all these people. In other words I feel no bitterness toward any of the people involved, because everybody's involved in it, but I'm trying to make it conscious—

KURTZ: In a way you could say that the importing of objects from a Capitalist country is not very different in effect from Social Realist posters, but its propaganda is for the business ethic.

SMITHSON: Yeah, exactly, because abstraction essentially is what rules Capitalism, so that's the value, that's the value between production and the actual work, the process, and I think that that's why there's the concern with process, it's an attempt to link up the process with the actual result, so the two are actually one. That's why I have to go back to the Marxist thing about the division of labor, in other words the production from work. What is the thing that separates? It's the abstract value. So this abstraction, so art becomes—especially paintings—become super currency for privileged groups. Then they manifest their institutions. They'll give this work to—an artist can't give his works to a museum and get a tax write-off, but a collector can, and this is just another way of controlling. The artist as a class is put into that. The most class determined artists are the ones who claim they aren't a class. And they are.

. . . I know of instances where collectors have given, or attempted to give, a work of art, which they've in some way ripped off an artist, to a museum in order to become part of the trusteeship. So they get an in to a sort of cultural control, and the artist is just a hapless producer who is constantly making these things for this privileged value. That's why I say the artist is alienated from the value of his work. He cannot—somebody else is determining his value for him. This artists take for granted. Their compensation is that they're spiritual, they're pure, they're mad, you know, any number of mythologies. In fact, there's a category of Personal Mythologies at Documenta. Personal Mythologies strike me as another dream world. That's the compensation. Aesthetics too is very close to a kind of spiritualism, so the emphasis on aesthetics tends to mitigate the social relationships so that you just see aesthetic things in themselves. And I think the artists, like the protestors at the museums, just reinforce the museums, because these people really want to get into those things. Anything can be put into a museum, now I mean it's . . .

KURTZ: How do you deal with the problem of the tax write off? Do you give to the artist the same advantage of the collector, or do you eliminate the economic incentive altogether? And if you do then what happens to collecting?

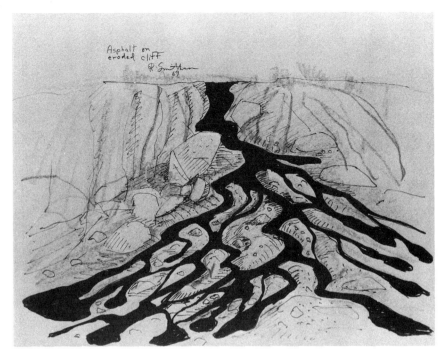

ROBERT SMITHSON, *Asphalt on Eroded Cliff*, 1969. Crayon and ink drawing.

One of the strategies collectors use is to put one of their works in a museum as a promised gift, and by putting it in a museum the value increases, so when the value reaches the point the collector needs or wants, then he gives it. The artist can't do that. The artist can only write off the cost of materials to make the work. It's not the artist who confers the value but the dealer, collector, and museum. But then in a sense the government, the museum, the collector, the business machine, have the goods to deliver. Do you deal with that by saying, "I want the goods too"? That's a way of underlining the whole value system.

smithson: That's the collecting situation. The *Jetty* and the *Broken Circle* really aren't collectibles. They're supported through the cooperation of different groups that have no commodity fetish.

kurtz: But there's a commodity fetish in photographs, and the film—that sort of thing.

smithson: Oh, yeah, but realistically speaking . . . film is another area again . . . the prices for photographs and film and that sort of thing are rather equitable. I sell prints of my film for $500. I'm not saying down with money or anything like that. I'm saying let's understand an alternative value system where actually artists might be more in control of their own value. The trouble is that most collectors and dealers will play on the artist's guilt in regard to the filthy lucre, and that's reinforced, so the artists are frustrated by their own guilt about economic considerations. And the retreat is to purity and spiritualism and esotericism and hermeticism . . . abstraction, all those things . . . idealism;

all those imponderables . . . metaphysics. There's just a great storehouse, as I call it, at the end of this junkyard, metaphysics, you constantly dispense purity, ideals, spiritualism.

KURTZ: In your thinking, where is the place for what Larry Poons is doing, or Stella.

SMITHSON: I don't think there's any place for it. I see them as different artists from myself. Society sees all artists as the same and they're not. They have different political attitudes. Some artists are more oriented toward cooperation, others are oriented more toward isolation. I would say those are the two kinds of political attitudes.

KURTZ: Do you see the whole moon thing as another kind of ownership, another kind of currency . . .

SMITHSON: I described the moon shot once as a very expensive non-site. It keeps people working, you know. To an extent I thought that after they got to the moon there was a strange demoralization that set in that they didn't discover little green men, or something. It's on that level. I was watching the one last night, and there was kind of a forced exuberance. There was this attempt to try to confer some meaning onto it, and to me it's quite banal.

KURTZ: One thing that amazed me about the first moon shot was that you

ROBERT SMITHSON, *Amarillo Ramp*, 1973. Height: 0–14 feet. Diameter: 150 feet. Width at top: 10 feet. Length: 396 feet. Photo by Gianfranco Gorgoni.

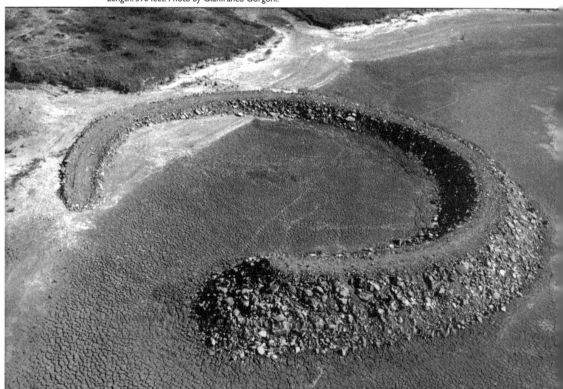

saw Mission Control in Houston with all those incredible computer stations, that incredible technology, with hundreds of people facing toward a kind of altar, like at the movies, and above the altar was a picture of Snoopy. There had to be some way in their minds of attaching a mascot to the whole experience, in other words to symbolize the experience to make it more comprehensible, and the image was so regressive that it denatured the experience. There was no awareness of the meaning.

SMITHSON: That's what I was saying before about the computer thing, it's sort of like they're so abstracted that they . . . their imagery would draw from Snoopy, or Porky Pig, or something.

KURTZ: The idea that we can completely control the environment, nature, is, I think, what creates the interest in the moon shot, and it's something like Disneyland. You can make your environment however you want to make it, but the way it's made is another kind of cultural control.

SMITHSON: Actually, I think Disney World is more of a Dream World than Documenta. In other words, it's more aggressive. And it's also a big money-making operation. So these dream worlds start proliferating.*

* Kurtz published a variant of this paragraph in *Arts Magazine*, Summer 1972: "Actually I think Disneyland is probably more of a dream world than Documenta. In other words, it's more aggressive, and it's also a big money-making operation. So these dream worlds start proliferating. . . . You have to cut your hair before you go in. It's the incipient fascism of all dream worlds."

Robert Smithson at site of dinosaur tracks near South Hadley, Mass.,
around 1950.

INTERVIEW WITH ROBERT SMITHSON FOR THE ARCHIVES
OF AMERICAN ART/ SMITHSONIAN INSTITUTION (1972)

Interview conducted by Paul Cummings July 14 and 19, 1972

JULY 14, 1972

PAUL CUMMINGS: You were born in New Jersey?

ROBERT SMITHSON: Yes, in Passaic, New Jersey.

CUMMINGS: Did you come from a big family?

SMITHSON: No, I'm an only child.

CUMMINGS: So many artists I've been interviewing lately have been an only
child. Did you grow up there, go to school there?

SMITHSON: I was born in Passaic and lived there for a short time, then we
moved to Rutherford, New Jersey. William Carlos Williams was actually my
baby doctor in Rutherford. We lived there until I was about nine and then we
moved to Clifton, New Jersey. I guess around that time I had an inclination
toward being an artist.

CUMMINGS: Were you making drawings?

SMITHSON: Oh, yes. I was working in that area even back in the early phases

270

in Rutherford. I was also very interested at that time in natural history. In Clifton my father built what you could call a kind of suburban basement museum for me to display all my fossils and shells, and I was involved with collecting insects and . . .

CUMMINGS: Where did these shells come from?

SMITHSON: Oh, different places. We traveled a lot at that time. Right after the war in 1946 when we went out West I was about eight years old. It was an impressionable period. I started to get involved in collecting at that time. But basically I was pretty much unto myself in being interested in field naturalist things, looking for insects, rocks and whatever.

CUMMINGS: Did you have books around that were involved with these topics?

SMITHSON: Yes. And I went to the Museum of Natural History. When I was about seven I did very large paper constructions of dinosaurs which in a way, I suppose, relate right up to the present in terms of the film I made on *The Spiral Jetty*—the prehistoric motif runs throughout the film. So in a funny way I guess there is not that much difference between what I am now and my childhood. I really had a problem with school. I mean, there was no real understanding of where I was at, and I didn't know where I was at that time.

CUMMINGS: Did you like primary school or high school?

SMITHSON: No, I didn't. I grew rather hostile to school. In high school, actually, I started going to the Art Students League. I won a scholarship. In my last year of high school I managed to go only half a day. I was just very put off by the whole way art was taught.

CUMMINGS: Really? In what way?

SMITHSON: Well, my high school teacher would come up with statements like—I remember this one quite vividly—that the only people who become artists are cripples and women.

CUMMINGS: This was a high school art teacher? What was their problem?

SMITHSON: Well, they seemed to have all kinds of problems. Everything was kind of restricted. There was no comprehension of any kind, no creative attitude. It was mostly rote—a very unimaginative teaching staff, constricted and departmentalized. At that point I didn't have any self-realization, so I really couldn't tell, except that the Art Students League did offer me a chance to at least come in contact with other people. I made a lot of friends with people in the High School of Music and Art in New York.

CUMMINGS: Did you go to that school?

SMITHSON: No, but I had a lot of friends from there, and we had a sketch class together. Every Saturday in the last two years of high school I went to Isaac Soyer's studio. We used to sketch each other and we'd talk about art and go to museums. And that was a very important thing for me, getting out of that kind of stifling suburban atmosphere where there was just nothing.

CUMMINGS: How did you get the scholarship to the League?

Robert Smithson as a young boy in Rutherford, N.J., around 1946.

SMITHSON: I applied for that. I did a series of woodcuts, rather large wood-cuts. I remember one of them was called *Teenagers on 42nd Street*. It was done in a kind of German Expressionist style. I was about sixteen when I did that.

CUMMINGS: Did you have art books and things at home?

SMITHSON: Yes. I kept coming into New York and buying art books. I was pursuing it on my own.

CUMMINGS: Did you go to museums and galleries?

SMITHSON: Yes. The first museum show I saw at the Museum of Modern Art was The Fauves' exhibition. I was about sixteen. I had that attitude. And then I went back to Clifton High School and tried to present those ideas but they didn't quite jell.

CUMMINGS: Were you interested in other classes in school?

SMITHSON: Well, I was somewhat interested in writing, although at that time I had a sort of writer's block, you know, I couldn't quite get it together. I had a good oral sense; I liked to talk. I remember giving a talk, I think in my sophomore year in high school, on *The War of the Worlds*, the H. G. Wells thing. And I gave a talk on the proposed Guggenheim Museum. Things like that inter-ested me. But I found those things that interested me really didn't coincide with school, so I became more and more disenchanted and more and more confused.

CUMMINGS: You had no instructor in any class who picked up on any of those things?

SMITHSON: No. It was all very hostile and cramped, and it just alienated me more and more to the point where I grew rather hostile to the whole public school situation. In a very, very definite way I wanted nothing to do with high school, and I had no intention of going to college.

CUMMINGS: What about the writing? When did that start?

SMITHSON: That started in 1965–1966. But it was a self-taught situation. After about five years of thrashing around on my own, I started to pull my thoughts together and was able to begin writing. Since then, I guess I've writ-ten about twenty articles.

CUMMINGS: Do you find it augments your work? Or is it separate from it?

SMITHSON: Well, it comes out of my sensibility—it comes out of my own

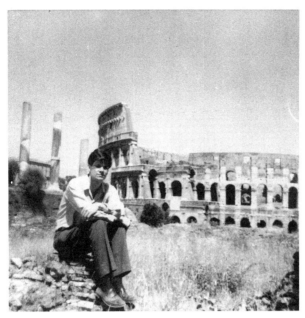

Robert Smithson at Colosseum in Rome, 1961.

observation. It sort of parallels my actual art involvement. The two coincide; one informs the other.

CUMMINGS: How did you find the art scene in the fifties?

SMITHSON: That was a very crucial time. Everything was very repressed and stupid; there was no art context as we know it now. There weren't any galleries to speak of (when I was sixteen or seventeen). I was very much encouraged by Frederica Beer-Monti who ran the Artists Gallery. She was an Austrian woman of the circle of Kokoschka and that crowd, and she had been painted by a lot of those people. She was very encouraging.

CUMMINGS: How did you meet her?

SMITHSON: I took my woodcuts to the gallery. It was run by Hugh Stix and his wife who were very encouraging. It was a non-profit gallery. I would have discussions there with Owen Ratchliff, who was sort of the director. I would say that in a way they gave me an opportunity to work for myself.

CUMMINGS: You had a show with them at one point?

SMITHSON: I had a show with them. I was the youngest artist to ever show there. And I felt—well, you know, if I can show at age nineteen, keep on going. I've always been kind of unreachable, I guess, especially at that point. I met other people.—I was friendly with the son of Meyer Levin, Joe Levin, who went to Music and Art High School. I remember Meyer Levin saying that I was the type of person that couldn't go to school, that I would either make it very big or else go crazy.

CUMMINGS: Nice alternatives. How did you like the Art Students League? What did you do there?

SMITHSON: It gave me an opportunity to meet younger people and others who were sort of sympathetic to my outlook. There wasn't anybody in Clifton who I was close to except for one person—Danny Donahue. He got interested in art, but eventually he did go crazy and was killed in a motorcycle accident. He joined a Brooklyn gang of motorcyclists and just . . . I mean it was a very difficult time, I think, for people to find themselves.

CUMMINGS: That was in the fifties?

SMITHSON: In the fifties, yes. This was, I'd say, around 1956–57. I spent a short period—six months—in the Army.

CUMMINGS: Were you drafted? Or did you join?

SMITHSON: No, I joined. Actually I joined with Danny Donahue, Joe Levin, and Charlie Hasloff. Charlie is a poet from Dusseldorf. Both Danny and Joe were excluded and that left Charlie and me. The reason I joined was because it was a special plan; it was a kind of art group called Special Services.

CUMMINGS: Oh, really! What was that?

SMITHSON: Well, strangely enough, John Cassavetes was in this group. And Miles Kruger, who is an expert on nostalgia.

CUMMINGS: Oh, yes! The American musical stage.

SMITHSON: Right, You know him?

CUMMINGS: Oh, for years! Yes.

SMITHSON: Well, in a way he was responsible for cueing me into the situation. So it turned out that I went to Fort Knox, went through basic training, spent some unhappy hours in clerk-typist's school, and then ended up as sort of artist-in-residence at Fort Knox. I did watercolors of local Army installations for the mess hall. It was a very confusing period. Another important relationship I had was with a poet named Alan Brilliant. I stayed at his place up on Park Avenue and 96th Street, in the El Bario area. He was involved with publishing poets. I met him through Joe Levin.

CUMMINGS: Was Miles with you all through this military period?

SMITHSON: I spent a few times with Miles at the Rienzi Cafe down in the Village where we had discussions. That sort of thing. I don't know him that well. I think this was around 1956. I mean that was an interesting period for me. I'm trying to put it together right now.

CUMMINGS: What about the poet though—Brilliant?

SMITHSON: Brilliant married a novelist, Teo Savory, moved out to California, and became a little magazine publisher—The Unicorn Press. In that group I met Hubert Selby, who wrote *Last Exit to Brooklyn*, Franz Kline, a lot of people from Black Mountain. That was an important thing.

CUMMINGS: At the Cedar Bar.

SMITHSON: At the Cedar Bar. Carl Andre said one time that that was where he got his education. In a way I kind of agree with him.

CUMMINGS: A lot of people did.

SMITHSON: I think it was a kind of meeting place for people who were

sort of struggling to figure out who they were and where they were going.

CUMMINGS: The late fifties was also sort of the heyday of the Tenth Street galleries.

SMITHSON: That's right. I knew a lot of people involved in that. Although I had had this show at the Artists Gallery, I was somewhat unsatisfied. The show was reviewed in *Art News* by Irving Sandler, but I just didn't feel satisfied. Strangely enough, the work sort of grew out of Barnett Newman; I was using stripes and then gradually introduced pieces of paper over the stripes. The stripes then sort of got into a kind of archetypal imagistic period utilizing images similar, I guess, to Pollock's *She-Wolf* period and Dubuffet and certain mythological religious archetypes.

CUMMINGS: Well, that's something like the images in the show in Rome then—right?

SMITHSON: Yes. That comes out of that period. Charles Alan offered to put me in a show in his gallery in New York. And the reason I got the show in Rome was because of the painting called *Quicksand*. It's an abstraction done with gouache. I think Charles Alan still owns it. It was fundamentally abstract, sort of olives and yellows and pieces of paper stapled onto it; it had a kind of incoherent landscape look to it.

CUMMINGS: Did you know Newman's work? Were you intrigued by that kind of thing?

SMITHSON: Yes, I did see Newman's work. But emotionally I wasn't—I mean I responded to it, but this latent imagery was still in me, a kind of anthropomorphism; and, you see, I was also concerned with Dubuffet and de Kooning in terms of that kind of submerged . . .

CUMMINGS: Where had you seen Dubuffet? Because he was not shown that much here.

SMITHSON: Oh, I think he had a lot of things in the Museum of Modern Art. And I'd seen books. I think he was being shown at one of the galleries. I can't remember exactly which one. I'm pretty sure I saw things of his in the Museum of Modern Art. I was around twenty at this time.

CUMMINGS: As long as we're talking about galleries and museums, which galleries interested you most? Do you remember the ones that you went to in those days? You've mentioned Charles Alan and the Artists Gallery.

SMITHSON: Yes. Well, a lot of the galleries hadn't opened yet. I was very much intrigued by Dick Bellamy's gallery—the Hansa Gallery. When I was still going to the Art Students League I used to drop around the corner to see Dick Bellamy. He was very encouraging. Also in the late fifties I moved to Montgomery Street; there I was living about three blocks from Dick Bellamy. He was the first one to invite me to an actual opening. I believe it was an Allan Kaprow opening at the Hansa Gallery. At the time I was trying to put together a book of art and poetry with Allan Graham (which never manifested itself) so Dick had suggested that I go to see these new young artists Jasper Johns and

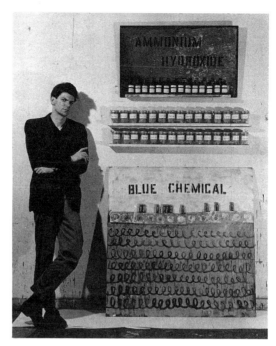

Robert Smithson with works shown at the Castellane Gallery,
New York City, 1962.

Rauschenberg. I remember having seen their work at The Jewish Museum in a small show. And also in this book I wanted to include comic strips. I was especially interested in the early issues of *Mad* magazine—"Man Out of Control." Then there was an artist who was interesting, somebody who had a kind of somewhat psychopathic approach to art; his name was Joseph Winter and he was showing at the Artists Gallery; I wanted to include him. I also met Allen Ginsberg and Jack Kerouac at that time. I met lots of people through Dick Bellamy. Let me see what else. I worked at the Eighth Street Bookshop too.

CUMMINGS: Oh, really? When was that?

SMITHSON: I would say in 1958, I think right about that period, give or take a year.

CUMMINGS: To kind of go back a bit, who did you study with at the League?

SMITHSON: Oh. John Groth, who was an illustrator.

CUMMINGS: How did you select him?

SMITHSON: Well, you see, I could only go on Fridays. I also studied with somebody named Bove during the week. But I just selected him—he had a sort of loose way of drawing and I was interested in drawing. In the early years of high school I had ideas of being an illustrator of some sort.

CUMMINGS: Making it a useful paying career.

SMITHSON: Yes. But John Groth was a worthwhile teacher and he had a good sense of composition. I always did my work at home. I did sketching

Robert Smithson setting up his work in the Earth Art Show at
Cornell University, 1969.

from models and things at the League, but basically I did all my work at home.
I worked in caseins. I still have some of those works from that period.

CUMMINGS: How did your family like this development?

SMITHSON: They didn't like it.

CUMMINGS: There was no encouragement?

SMITHSON: Well, you know, they just didn't see it as a paying enterprise.
They saw it as a rather questionable occupation, Bohemian, you know, that
sort of thing. Although my great-grandfather was a rather well-known artist
around the turn of the century. He did interior plaster work in all the major
municipal buildings in New York: the Museum of Natural History, the Metro-
politan; he did the entire subway system.

CUMMINGS: What was his name?

SMITHSON: His name was Charles Smithson. Well, of course since then all
the work has been torn out of the subways. I guess it was of the period that
Lewis Mumford called "The Brown Decade"; you know, that kind of work.
There was an article written about him in an old journal from around 1900.
He was also involved in sort of public art. My grandfather worked with him
for a while, but then the unions came in and that sort of craft work went out

and prefab work came in. Then the Depression wiped out my great-grandfather and my grandfather who was sort of a poet actually—

CUMMINGS: What was his name?

SMITHSON: His name was Samuel Smithson. Incidentally, there was somebody at Columbia who claimed that all the Smithsons were related to the founder of the Smithsonian Institution, as a matter of fact.

CUMMINGS: Well, you see how small the world is.

SMITHSON: But I don't know about that.

CUMMINGS: It's only two hundred years ago.

SMITHSON: Well, he had no offspring. I don't know—I never could understand it but this man whose name is I. M. Smithson is working at Columbia on all of the Smithsons, and how they're related to the Smithsonian one. As a matter of fact, he called me up as a result of the flyer from the Artists Gallery which one of the students gave him. But I never heard anything more about that.

CUMMINGS: He may still be up there digging away somewhere.

SMITHSON: Right. My father worked for Auto-lite. I do remember some interesting things that he used to bring home—like films—where they had all these car parts sort of automated, you know, like marching spark plugs and marching carburetors and that sort of thing. It's very vivid in my mind. Later on he went into real estate and finally into mortgage and banking work. He just never had the artistic view. On my mother's side I'm Middle European of diverse origins, I suppose mainly Slavic.

CUMMINGS: Well, what happened? You had this exhibition at the Artists Gallery. Did that help your parents' interest in your work?

SMITHSON: Yes. Well, they came to see it and tried to understand what their son was getting into. They've always been sympathetic. I mean they're really pretty good to me.—I had a brother who died before I was born. My father did take me on trips. Actually, now looking back on it, he did have a real sense of a kind of, you know, American idea of the landscape, but in an American way; I mean he loved to travel. He hitchhiked around the country, rode the rails and everything when he was younger; he sort of had a feeling for scenic beauty, but couldn't understand modern art.

CUMMINGS: He liked Bierstadt paintings.

SMITHSON: Yes. Well, that sort of thing.

CUMMINGS: How much of the country have you traveled around? I know you've been here, there, and everywhere.

SMITHSON: I sort of concentrated on it in my childhood and adolescence. Well, my first major trip was when I was eight years old and my father and mother took me around the entire United States. Right after World War II we traveled across the Pennsylvania Turnpike out through the Black Hills and the Badlands, through Yellowstone, up into the Redwood forests, then down the Coast, and then over to the Grand Canyon. I was eight years old and it made a big impression on me. I used to give little post card shows. I remember I'd set

up a little booth and cut a hole in it and put post cards up into the slot and show all the kids all these post cards.

CUMMINGS: Oh. The post cards you picked up on your travels?

SMITHSON: Yes. And then on my mother's side it's obscure. Her maiden name was Duke from Austria, that area. Her father was a wheelmaker.

CUMMINGS: Then there's a strong craft tradition behind you—using materials and making objects.

SMITHSON: Yes. I guess there is something to that.

CUMMINGS: Let's see, you went to the Brooklyn Museum School at one point?

SMITHSON: Yes, I got a scholarship there too. I went there on Saturdays, but I didn't go there too long. It was kind of far to go there. I went to life classes with Isaac Soyer again; well, mainly we used to gather at his place. His studio was up near Central Park. We'd do sketching. I think I went there for maybe about three months.

CUMMINGS: How was the Brooklyn Museum? Did you like that?

SMITHSON: No. I can't say that I really responded that much. I think the strongest impact on me was the Museum of Natural History. My father took me there when I was around seven. I remember he took me first to the Metropolitan which I found kind of dull. I was very interested in natural history.

CUMMINGS: All the animals and things.

SMITHSON: Yes.

CUMMINGS: Did they have the panoramas then? I don't remember . . .

SMITHSON: Oh, yes. I mean it was just the whole spectacle, the whole thing—the dinosaurs made a tremendous impression on me. I think this initial impact is still in my psyche. We used to go to the Museum of Natural History all the time.

CUMMINGS: That was your museum rather than the art museum?

SMITHSON: Yes.

CUMMINGS: Were your parents interested in that, or was it because you were interested?

SMITHSON: Yes—well, my father liked it. My father sort of liked the dioramas and things of that sort, because of their painstaking reality. Looking back on that, I think he took me to the Metropolitan thinking that that was the Museum of Natural History—I could be wrong but I think I remember his saying: oh, well, we can go to an interesting museum now. For me it was much more interesting. Then from that point on I just got more and more interested in natural history. At one point I thought of becoming either a field naturalist or a zoologist.

CUMMINGS: Did you go to college anywhere?

SMITHSON: No.

CUMMINGS: I didn't think you did. So what happened then? When did you move to New York?

Robert Smithson and Nancy Holt in their N.Y. loft around 1970. Photo by Gianfranco Gorgoni.

SMITHSON: I moved to New York in 1957, right after I got out of the Army. Then I hitchhiked all around the country. I went out West and I visited the Hopi Indian Reservation and found that very exciting. Quite by chance, I was privileged to see a rain dance at Oraibi. I guess I was about eighteen or nineteen.

CUMMINGS: Had you been to the Museum of the American Indian ever?

SMITHSON: No.

CUMMINGS: You hadn't? So it was a new experience.

SMITHSON: Yes. Well, you see, again, I knew about Gallup, New Mexico. I knew about and made a special point of going to Canyon de Chelly. I had seen photographs of that. I hiked the length of Canyon de Chelly at that point and slept out. It was the period of the beat generation. When I got back, *On the Road* was out, and all those people were around, you know, Jack Kerouac and Allen Ginsberg, both of whom I met. And Hubert Selby, I knew him rather well; I used to visit him out in Brooklyn and we'd listen to jazz and that sort of thing.

He was a strange person. I mean there was something weird about him. In fact he billed himself as an Eisenhower Republican, lived in a highrise. He had lung trouble, I think he had only a quarter of a lung left or something. At one point he tried to commit suicide. I don't know—it just got very bad. He was trying to get his book published at that time. The way I met him—I was sitting

Robert Smithson on the *Spiral Jetty*, 1970. Photo by Gianfranco Gorgoni.

at a table at the Cedar Bar, I had read a chapter from his book and I praised it to, I think it was Jonathan Williams of the Black Mountain Press. It just happened that Hubert was sitting there (Cubby as he was called) and—well, of course he was very taken with the fact that somebody liked his story that much.

CUMMINGS: How did you find the Cedar? Was that just through wandering around the Village?

SMITHSON: How *did* I find the Cedar? No, I think people just sort of gravitated to it. Tenth Street was very active. I can't remember exactly how I discovered it. But I think perhaps, again, through Dick Bellamy or Miles Forst, Dody Müller, people like that, you know. I knew Edward Avedisian too at that time. And Dick Baker who worked for Grove Press and became a Zen monk.

CUMMINGS: You never showed in Tenth Street, did you, in any of those galleries?

SMITHSON: No. By that time I was even more confused, I mean I had a certain initial kind of intuitive talent in terms of sizing up the situation and being influenced. But I had to work my way out of that. It took me three years. And then I was exposed to Europe through my show at the George Lester Gallery in Rome which had a tremendous impact on me.

CUMMINGS: How did that happen?

SMITHSON: As I said, he offered me a show on the basis of that painting *Quicksand* that was shown at the Alan Gallery. At that time I really wasn't interested in doing abstractions. I was actually interested in religion, you know, and archetypal things, I guess interested in Europe and understanding the relationship of . . .

CUMMINGS: Did you go to Europe then?

SMITHSON: Yes, I went to Europe in 1961. I was in Rome for about three months. And I visited Siena. I was very interested in the Byzantine. As a result I remember wandering around through these old baroque churches and going through these labyrinthine vaults. At the same time I was reading people like William Burroughs. It all seemed to coincide in a curious kind of way.

CUMMINGS: What other things were you reading besides Burroughs?

SMITHSON: T. S. Eliot then had a big influence on me, of course, after going to Rome. So I had to wrestle with that particular problem of tradition and Anglo-Catholicism, the whole number. And then I was getting to know Nancy—we met in New York in 1959 . . .

CUMMINGS: What was it like being a young American in Rome and having a show?

SMITHSON: It was very exciting to me. I was very interested in Rome itself. I just felt I wanted to be a part of that situation, or wanted to understand it.

CUMMINGS: In what way? What were the qualities?

SMITHSON: I wanted to understand the roots of—I guess you could call it Western civilization really, and how religion had influenced art.

CUMMINGS: What got you interested or involved in religion at that point? I find that interesting in the context of the people you knew, because it wasn't generally something they were all that interested in.

SMITHSON: Well, I was reading people—like I read Djuna Barnes' *Nightwood*, T. S. Eliot, and Ezra Pound. There was a sense of European history that was very prevalent. Also I was very influenced by Wyndham Lewis.

CUMMINGS: Oh, really? But Pound is not particularly involved with . . .

SMITHSON: Well, he was interested in a kind of notion of what Western art grew out of and what happened to it. I mean it was a way of discovering the history of Western art in terms of the Renaissance and what preceded it, especially the Byzantine.

CUMMINGS: Well, you mean the ritual and the ideas and all those things?

SMITHSON: Yes, and I think a kind of Jungian involvement—like Jackson Pollock's interest in archetypal structures. I was just kind of interested in the facade of Catholicism.

CUMMINGS: But were you interested in Jung or Freud particularly?

SMITHSON: Yes, I was at that time.

CUMMINGS: You read their writings and things?

SMITHSON: Yes.

CUMMINGS: Did you ever go into analysis?

SMITHSON: No.

CUMMINGS: How did you find that those activities worked for you? Did they answer questions for you? Or did they just pose new ones?

SMITHSON: I think I got to understand, let's say, the mainspring of what European art was rooted in prior to the growth of Modernism. And it was very important for me to understand that. And once I understood that I could understand Modernism and I could make my own moves. I would say that I began to function as a conscious artist around 1964–65. I think I started doing works then that were mature. I would say that prior to the 1964–65 period I was in a kind of groping, investigating period.

CUMMINGS: I'm curious about the show at the George Lester Gallery.

SMITHSON: The three paintings which were probably the best, were sort of semi-abstractions based on a rough grid—one was called *The Inferno*, another was called *Purgatory*, another was called *Paradise*.

CUMMINGS: Dante-esque.

SMITHSON: It was Dante-esque, but—it was a rough irregular grid type painting with sort of fragments of faces and things embedded in this grid. Other things were kind of iconic, tending toward a kind of Byzantine relationship. I was also very much interested in the theories of T. E. Hulme; as I said, that whole circle, that whole prewar circle of Modernism.

CUMMINGS: What artists were you interested in at that point?

SMITHSON: I really wasn't—I was really interested in the past at that point.

CUMMINGS: It was an interest in modern literature and old art?

SMITHSON: Initially—well, when I was nineteen—the impact was Newman, Pollock, Dubuffet, Rauschenberg, de Kooning; even Alan Davie who I had seen I think at the Viviano Gallery; the whole New York School of painting. I felt very much at home with that when I was in my late teens, but then I rejected it in favor of a more traditional approach. And this lasted from maybe 1960 to 1963.

CUMMINGS: Why do you think you rejected those things?

SMITHSON: I just felt that—they really didn't understand, first of all, anthropomorphism, which had constantly been lurking in Pollock and de Kooning. I always felt that a problem. I always thought it was somehow seething underneath all those masses of paint. And even Newman in his later work still referred to a certain kind of Judeo-Christian value. I wasn't that much interested in a sort of Bauhaus formalist view. I was interested in this kind of archetypal gut situation that was based on primordial needs and the unconscious depths. And the real breakthrough came once I was able to overcome this lurking pagan religious anthropomorphism. I was able to get into crystalline structures in terms of structures of matter and that sort of thing.

CUMMINGS: What precipitated that transition, do you think?

SMITHSON: Well, I just felt that Europe had exhausted its culture. I suppose my first inklings of a more Marxist view began to arise, rather than my trying

to reestablish traditional art work in terms of the Eliot–Pound–Wyndham Lewis situation. I just felt there was a certain naiveté in the American painters—good as they were.

CUMMINGS: Did you get interested in Marxism?

SMITHSON: No. It was just sort of a flicker. I mean I began to become more concerned with the structure of matter itself, in crystalline structures. The crystalline structures gradually grew into mapping structures.

CUMMINGS: In a visual way, or in a conceptual way?

SMITHSON: Visual, because I gave up painting around 1963 and began to work plastics in a kind of crystalline way. And I began to develop structures based on a particular concern with the elements of material itself. But this was essentially abstract and devoid of any kind of mythological content.

CUMMINGS: There was no figurative overtone to it.

SMITHSON: No, I had completely gotten rid of that problem. I felt that Jackson Pollock never really understood that, and although I admire him still, I still think that that was something that was always eating him up inside.

CUMMINGS: But it's interesting because there is a development away from traditional kinds of imagery and yet an involvement with natural materials . . .

SMITHSON: Well, I would say that begins to surface in 1965–66. That's when I really began to get into that, and when I consider my emergence as a conscious artist. Prior to that my struggle was to get into another realm. In 1964, 1965, 1966 I met people who were more compatible with my view. I met Sol LeWitt, Dan Flavin, and Donald Judd. At that time we showed at the Daniels Gallery; I believe it was in 1965. I was doing crystalline type works and my early interest in geology and earth sciences began to assert itself over the whole cultural overlay of Europe. I had gotten that out of my system.

CUMMINGS: Out of chaos comes . . .

SMITHSON: Yes. Well, out of the defunct, I think, class culture of Europe I developed something that was intrinsically my own and rooted to my own experience in America.

CUMMINGS: Have you been back to Europe since that?

SMITHSON: Yes, I have been back to Europe. I did *Broken Circle—Spiral Hill* in Holland in 1971. I consider it a major piece.

JULY 19, 1972

CUMMINGS: Would you like to say something about your visit with William Carlos Williams?

SMITHSON: Yes. Well, this took place I think in either 1958 or 1959. William Carlos Williams was going to do an introduction for Irving Layton's book of poems. So I went out to Rutherford with Irving Layton. It wasn't for an interview, he was in pretty bad shape at that time, he was kind of palsied. But he was rather interesting.—Once he found out that we weren't going to be doing

any articles, he was pretty open. Sophie Williams was there too. He said that he enjoyed meeting artists more than writers.

CUMMINGS: Oh, really? Why?

SMITHSON: He just found them more interesting to talk to.

CUMMINGS: Contrast, maybe.

SMITHSON: As it turned out, he had a whole collection of paintings by Marsden Hartley, Demuth, Ben Shahn; and also paintings by Hart Crane's boy friend, which I thought was interesting. He bought them—

CUMMINGS: I can't remember who that was.

SMITHSON: I can't remember his name either. He talked about Ezra Pound, which I thought was interesting apropos of all the controversy about Ezra Pound. And it turned out that when Pound was giving his broadcasts in Italy he said something to the effect that "Old Doc Williams in Rutherford, New Jersey will understand what I mean." So the very next day the FBI descended on Williams' house and he had to explain that he wasn't involved in that kind of political attitude. He went on to talk about the other poets, but he seemed somewhat estranged from them. Let me see what else. Oh, he didn't seem to have much liking for T. S. Eliot. And he said he remembers Hart Crane inviting him over to New York for all his fairy parties; that sort of thing. And what else?—well, he showed us all these paintings. There was a painting that somehow reminded me of a painting by Duchamp. Demuth did like two dogs running around sniffing each other's asses. He talked a lot about Allen Ginsberg coming out at all hours of the night, and having to spring poets out there. Allen Ginsberg comes from Paterson, New Jersey. I guess the Paterson area is where I had a lot of my contact with quarries and I think that is somewhat embedded in my psyche. As a kid I used to go and prowl around all those quarries. And of course, they figured strongly in *Paterson*. When I read the poems I was interested in that, especially this one part of *Paterson* where it showed all the strata levels under Paterson. Sort of a proto-conceptual art, you might say. Later on I wrote an article for *Artforum* on Passaic which is a city on the Passaic River south of Paterson. In a way I think it reflects that whole area. Williams did have a sense of that kind of New Jersey landscape.

CUMMINGS: Was he amused at the idea that you were one of his children in a sense?

SMITHSON: Oh, yes, he said he remembered me, he remembered the Smithsons. He was amused at that actually, yes. . . . There are certain things that I know I'm forgetting. But it was a kind of exciting thing for me at that time. And what else? Where were we?

CUMMINGS: I'm curious also, about your interest in religion and theology since it was mentioned in so many kinds of oblique ways on the other side of the tape. Did you have a very strict religious upbringing?

SMITHSON: No. Actually, I was very skeptical even through high school. In high school they thought I was a Communist and an atheist, which I was actu-

ally. That problem always seemed to come up. In fact, while I was still going to high school, my friend Danny Donahue and I did a joint project, a tape recording, for a psychology class. And it was essentially a questioning of the premises of religion drawn mainly from Freud and H. G. Wells.

CUMMINGS: That's a good combination.

SMITHSON: I guess I was always interested in origins and primordial beginnings, you know, the archetypal nature of things. And I guess this was always haunting me all the way until about 1959 and 1960 when I got interested in Catholicism through T. S. Eliot and through that range of thinking. T. E. Hulme sort of led me to an interest in the Byzantine and in notions of abstraction as a kind of counterpoint to the Humanism of the late Renaissance. I was interested I guess in a kind of iconic imagery that I felt was lurking or buried under a lot of abstractions at the time.

CUMMINGS: In Pollock.

SMITHSON: Yes. Buried in Pollock and in de Kooning and in Newman, and to that extent still is. My first attempts were in the area of painting. But even in the Artists Gallery show there were paintings carrying titles like *White Dinosaur*, which I think carries through right now, a similar kind of preoccupation. But I hadn't developed a conscious idea of abstractions. I was still really wrestling with a kind of anthropomorphic imagery. Then when I went to Rome I was exposed to all the church architecture and I enjoyed all the labyrinthine passageways, the sort of dusty decrepitude of the whole thing. It's probably a kind of very romantic discovery, that whole world. Prior to the trip to Rome I had just faced the New York art world and what was developing there. So my trip to Rome was sort of an encounter with European history as a nightmare, you know.

CUMMINGS: All of it at once.

SMITHSON: Yes. In other words, my disposition was toward the rational, my disposition was toward the Byzantine. But I was affected by the baroque in a certain way. These two things kind of clashed.

CUMMINGS: Yes. But in the sense of forms and colors and images rather than the ideas that they represented?

SMITHSON: Yes, I mean I never really could believe in any kind of redemptive situation. I was fascinated also with Gnostic heresies, Manicheism, and the dualistic heresies of the East and how they infiltrated into the . . .

CUMMINGS: But in what sense?—as abstractions?

SMITHSON: I think it was a kind of cosmology. I guess I was interested in some kind of world view. I had a rather fragmented idea of what the world was about. So I guess it was a matter of just taking all these pieces of fairly recent civilizations and piecing them together, mainly beginning with primitive Christianity and then going on up through the Renaissance. And then it became a matter of just working my way out from underneath the heaps of European history to find my own origins.

CUMMINGS: So it was really the ideas rather than the rituals of any of these things?

SMITHSON: Well, I was sort of fascinated by the ritual aspect of it as well. I mean the ceremonial, almost choreographed aspect of the whole thing, you know, the grandeur . . .

CUMMINGS: The sound and lights.

SMITHSON: There was a kind of grotesqueness that appealed to me. As I said, while I was in Rome I was reading William Burroughs' *Naked Lunch* and the imagery in that book corresponded in a way to a kind of grotesque massive accumulation of all kinds of rejective rituals. There was something about the passage of time, the notion of the ritual as being defunct actually interested me more, erecting those kinds of ritual situations fascinated me.

CUMMINGS: You mean building monuments and . . . ?

SMITHSON: Yes. The way Burroughs brings in a kind of savage Mayan—Aztec imagery to that; yet at the same time there was always an element of overt corruption surrounding the whole thing. It was a very strange combination of influences. Mallarmé and Gustave Moreau and that kind of thing was also still plaguing me.

CUMMINGS: A kind of decadence and end-of-the-century elegance.

SMITHSON: Yes. Which I felt was very much in Burroughs. So it wasn't so much a matter of belief or test of faith or something like that. It was a kind of fascination with these great accumulations of sculpture and labyrinthine catacombs . . .

CUMMINGS: You mean why they were built and what the purposes were?

SMITHSON: Yes. I mean I liked the uselessness of them. And also there were these great carvings and drapery out of rose marble and things like that with gold skeletons, you know, underneath.

CUMMINGS: There seems to be a curious kind of macabre overlay on some of these things?

SMITHSON: Yes. I guess at that time there was. It took me a while to work out of that preoccupation. A kind of savage splendor, you know.

CUMMINGS: What has supplanted that?

SMITHSON: Well, gradually I recognized an area of abstraction that was really rooted in crystal structure. In fact, I guess the first piece of this sort that I did was in 1964. It was called the *Enantiomorphic Chambers*. And I think that was the piece that really freed me from all these preoccupations with history; I was dealing with grids and planes and empty surfaces. The crystalline forms suggested mapping. And mapping . . .

CUMMINGS: Mapping in what way?

SMITHSON: In other words, if we think of an abstract painting, for instance, like Agnes Martin's, there's a certain kind of grid there that looks like a map without any countries on it.

CUMMINGS: Oh, I see.

Polaroid portrait of Robert Smithson by Brigid Polk, c. 1971.

SMITHSON: So I began to see the grid as a kind of mental construct of physical matter, and my concern for the physical started to grow. Right along I had always had an interest in geology as well.

CUMMINGS: Was there a conflict of interest development there?

SMITHSON: A conflict?

CUMMINGS: Did you want to go into geology as an activity?

SMITHSON: No, I think the interest in geology sort of developed out of my perception as an artist. It wasn't predicated on any kind of scientific need. It was aesthetic. Also the entire history of the West was swallowed up in a preoccupation with notions of prehistory and the great prehistoric epics starting with the age of rocks and going up, you know, through the . . .

CUMMINGS: Right. Through all those marvelous charts with different colors.

SMITHSON: The Triassic and the Jurassic and all those different periods sort of subsumed all the efforts of these civilizations that had interested me.

CUMMINGS: Well, what was happening just prior to the clarification of the

grid system idea? Had you continued painting? Or did you stop painting? Or were you making things that were a combination?

SMITHSON: I sort of stopped. I did drawings actually.

CUMMINGS: What were they like?

SMITHSON: They were kind of phantasmagorical drawings of cosmological worlds somewhat between Blake and—I'm trying to think—oh, a kind of Boschian imagery.

CUMMINGS: There were still figurative overtones?

SMITHSON: Oh, very much, yes. Very definitely. They were sort of based on iconic situations. I think I made those drawings around 1960–61. They dealt with explicit images like, the city; they were kind of monstrous as well, you know, like great Moloch figures.

CUMMINGS: Were they large?

SMITHSON: No, they were very small.

CUMMINGS: Done in what kind of material?

SMITHSON: Pencil and paper.

CUMMINGS: Very complicated? Very traditional?

SMITHSON: Well, they were sort of rambling. They consisted of many figures . . . they were sort of proto-psychedelic in a certain kind of way. They were somewhat like cartouches. They freed me from—the whole notion of anthropomorphism. I got that out of my system, you might say.

CUMMINGS: And the grids appeared in . . .

SMITHSON: Yes—well, it was more of a crystalline thing, more of a triangulated kind of situation. I started using plastics. I made flat plastic paintings. I have one in the front room that I can show you.

CUMMINGS: How did you pick plastics? Because that's a shift from pencil and paper to . . .

SMITHSON: Well, actually there was a kind of interim period there where I was just doing mainly a kind of collage writing. I did kind of writing paintings, I guess you'd call it, but they included pasting . . .

CUMMINGS: Just like Burroughs cut and pasted the poetry he did?

SMITHSON: Yes—well, not exactly. I would take a magazine that had, oh, a lot of boats in it and then just paste all these boats on a piece of wood or something like that. There was a lot of nebulous stuff I was doing then.

CUMMINGS: Testing materials?

SMITHSON: Actually there was a show at the Castellane Gallery which I suppose sums it all up to a great extent. For instance, I started working from diagrams. I would take like an evolutionary chart and then paint it somewhat in a kind of Johnsian manner, I guess; sort of scientific diagrams and paint those. But it was a very confused period around 1961 or so.

CUMMINGS: What was the Castellane Show?

SMITHSON: It was just a lot of these paintings—not only paintings but—oh, it was a curious melange of things. I took a stuffed pigeon and took it apart

and pasted it on a board. Things like that. I took pickle jars and made up spec-
imens and labeled them with curious scientific names. Then I started just past-
ing all these similar photographs. I did a series of chemicals—I guess there was
a tug of war going on between the organic and the crystalline.

CUMMINGS: And the crystal won.

SMITHSON: Yes—well, actually I think they kind of met—a kind of dialectic
occurred later on, so both areas were resolved.

CUMMINGS: The Castellane Show was in 1962. When did you get involved
with the Dwan Gallery? Was that soon after?

SMITHSON: That was in about 1965–66 I'd say.

CUMMINGS: So it was about three years later.

SMITHSON: Yes.

CUMMINGS: What happened in that period of time?

SMITHSON: I got married actually, and that took up a lot of my time. I don't
know—it seemed that I really didn't do much of anything. I did start to write
then, but I really wasn't bringing things together. I was writing a lot of notes. I
really didn't do that much work.

CUMMINGS: At one point it seems that you started writing articles every
month or every other month for various publications.

SMITHSON: Yes, that sort of encourages you. The first article was published
in 1965.

CUMMINGS: How did you get involved with the Dwan Gallery? Did Vir-
ginia find you, or did you find her? How did that happen?

SMITHSON: How *did* that happen? Well, this is what happened: I met Ad
Reinhardt in 1965. Well, actually in 1963–64 I was doing these plastic paint-
ings, these crystalline paintings, and I started to get more into the serial struc-
tures that I showed at Dwan in 1966. Ad Reinhardt asked me, along with
Robert Morris, to help organize a show at Dwan—the *10 Show*. Then I did a
piece called *Alogon*, the one which the Whitney owns now. It consists of—
well, in effect, it was like seven inverted staircases and it was in the *10 Show*.
Also around that time I had a lot of dialogues with Sol LeWitt and Donald
Judd. A lot of things began to pull together. Prior to my going with the Dwan
Gallery I showed the *Enantiomorphic Chambers* that Howard Lipman owns.
That work impressed Virginia Dwan. Right after I showed in the *10 Show* she
asked me to be in the gallery.

At the same time, actually in 1965, I had given a talk at Yale with
Brian O'Doherty, John Hightower, and Paul Weiss on "Art in the City." I guess
a lot of my thinking about crystalline structures came through there because I
was discussing the whole city in terms of crystalline network. An architect
from Tibbetts, Abbott, McCarthy and Stratton was sitting in the audience and
he asked me if I would like to participate in the building of the Dallas–Fort
Worth Airport, in terms of trying to figure out what an airport is. So I in-
vented this job for myself as artist-consultant, and for about a year and a half,

from 1965 through 1966, I went there and talked with the architects. And that's where the mapping and the intuitions in terms of the crystal structures really took hold in terms of areas of land—I was dealing with grids superimposed on large land masses, so that the inklings of the earthworks were there.

CUMMINGS: What did you do with the architects, what kind of conversations did you have with them? What kind of activity were you able to do with them?

SMITHSON: Most of the building process was done through computers. I was more or less just looking at the layout of the airfield. My final proposal was something called "aerial art" which would be earthworks on the fringes of the airfield that you would see from the air.

CUMMINGS: Flying over.

SMITHSON: Yes. They would provide me with all the mapping material. And we had interesting discussions. I made models of possible airports. But I became less and less interested in the actual structure of the building and more interested in the processes of the building and all the different preliminary engineering things, like the boring of holes to take earth samples. I later wrote an article called *Toward the Development of an Air Terminal*, which was all speculation on the different aspects of building. So I was interested in the preliminary aspects of building.

CUMMINGS: Were you really involved with them on a theoretical kind of . . . ?

SMITHSON: On a theoretical level. In 1966 I showed a model at the Dwan Gallery, right after my show, a model for a tar pool in a gravel enclosure. And I would say that it was mainly theoretical at that time. But right along, right from that point—well, from around 1966, I had an inkling or an intuition that earthworks might be an interesting area to get into. I was trying to fit this together. I had also suggested to the architectural company to let Robert Morris and Carl Andre and Sol LeWitt do something, and they each presented proposals which I included in the aerial art program.

CUMMINGS: What was your proposal?

SMITHSON: I wanted to do a spiral actually, a triangulated spiral made out of concrete. And then there were also other projects—there was another spiral of a kind of reflecting pool, in other words, a basin.

CUMMINGS: Where did Bob Morris come in? Where did you meet him?

SMITHSON: I met him during the meetings for the *10 Show*. I guess that was the first encounter. Then I met Don Judd through Dan Flavin. I did show a light piece with mirrors, *The Eliminator*, 1964, my only light piece. I showed it in an exhibition called *Current Art* where I met Dan Flavin. Dan was very friendly with Donald Judd. After that show I remember Dan Flavin came over here and rapped all night—and one thing led to another. And then there was this little gallery called the Daniels Gallery which Dan Graham was involved in.

CUMMINGS: Right. For about a year, wasn't it?

SMITHSON: Yes. And that operated as a kind of catalyst. Sol LeWitt showed

there, and all the people from Park Place. There was just a lot of energy generating around that time and a lot of people's works were really starting to manifest themselves. It was a very energetic period, and an important period.

CUMMINGS: How did your association with the Dwan Gallery help you? Or was it a help?

SMITHSON: Oh, I think it was a great help. Virginia Dwan somehow never imposed any kind of preconceived value on what was going to happen there, so that the gallery in a way functioned as a kind of developmental area.

CUMMINGS: A lab where you could try out.

SMITHSON: Yes. Well, we were going to look for land, actually, to do an outdoor show. I remember in 1967 I went down to the Pine Barrens of New Jersey with Virginia Dwan, Carl Andre, and Robert Morris. We looked around for property with the possible idea of doing some work on sites. So Virginia was always sort of involved on that level. I mean she was interested in the development of the consciousness as much as anybody else.

CUMMINGS: You know, there were always things that seemed to be happening. You were in a *Primary Structures Show* at the Jewish Museum in 1966.

SMITHSON: Yes.

CUMMINGS: As well as *Art in Process* at Finch for which you did a whole series of . . .

SMITHSON: Yes. Well, that piece I did at the Jewish Museum was called *Cryosphere*, and that essentially is six hexagonal units that were linked up somehow in my mind with a notion of ice crystals. Then I made a breakdown, almost a statistical analysis, of the piece which I included in the catalogue, marking down the qualities of the paint that I painted it with.

CUMMINGS: Well, have you gotten involved in mathematical structure? Or the mathematical ideas in some of the crystalline developed structures? Or not?

SMITHSON: Not really—well, the title *Alogon*—the piece that I showed in the *10 Show*—comes from the Greek word which refers to the unnameable, and irrational number. There was always a sense of ordering, but I couldn't really call it mathematical notation. There was a consciousness of geometry that I worked from in a kind of intuitive way. But it wasn't really in any way notational.

CUMMINGS: Just apropos of that one title, how do you develop the titles for your things? Some of them seem to have very long names. Are they specific references?

SMITHSON: Well, like the *Enantiomorphic Chambers?*

CUMMINGS: Yes.

SMITHSON: That refers to two shapes that tend to mirror each other. In other words, the left and right hand could be considered an enantiomorph. It is a kind of bi-polar notion that comes out of crystal structure. They are two separate things that relate to each other. I would say that in the *Enantiomorphic Chambers* there is also the indication of a kind of dialectical thinking that would emerge later very strongly in the nonsites.

CUMMINGS: What about this endless series of group exhibitions that you've been in around the country over the years? Do you find them useful for you? Or are they just a kind of exposure?

SMITHSON: At that time I thought there was a need for them. I think that there was something developing—this was in the mid-sixties—that wasn't around before in terms of spaces and in terms of exhibitions. The works were making greater demands on interior spaces. The small galleries of the late fifties were giving way to large white rooms and they seemed to be a growing thing.

CUMMINGS: But by the late sixties everybody worked out of the buildings.

SMITHSON: Yes. Well, there was always this move toward public art. But that still seemed to be linked to large works of sculpture that would be put in plazas in front of buildings. And I just became interested in sites . . . I guess in a sense these sites had something to do with entropy, that is, one dominant theme that runs through everything. You might say my early preoccupation with the early civilizations of the West was a kind of a fascination with the coming and going of things. And I brought that all together in the first article that I did for *Artforum* which was the "Entropy and the New Monuments" article. And I became interested in kind of low profile landscapes, the quarry or the mining area which we call an entropic landscape, a kind of backwater or fringe area. And so the entropy article was full of suggestions of sites external to the gallery situation. There was all kinds of material in that article that broke down the usual confining aspect of academic art.

CUMMINGS: Yes. Something that you buy and take home.

SMITHSON: I was also interested in a kind of suburban architecture: plain box buildings, shopping centers, that kind of sprawl. And I think this is what fascinated me in my earlier interest with Rome, just this kind of collection, this junk heap of history. But here we are confronted with a kind of consumer society. I know there is a sentence in "The Monuments of Passaic" where I said, "Hasn't Passaic replaced Rome as the Eternal City?" So there is this almost Borgesian sense of passage of time and labyrinthine confusion that has a certain kind of order. And I guess I was looking for that order, a kind of irrational order that just sort of developed without any kind of design program.

CUMMINGS: But it becomes, in a way, a kind of altering of nature doesn't it?

SMITHSON: This is lodged, I think, in the tendency toward abstraction. Books like *Abstraction and Empathy*, where the tendency of the artist was to exclude the whole problem of nature and just dwell on abstract mental images of flat planes and empty void spaces and grids and single lines and stripes, that sort of thing, tended to exclude the whole problem of nature. Right now I feel that I am part of nature and that nature isn't really morally responsible. Nature has no morality.

CUMMINGS: But how do you feel a part of it? I get the feeling that you have a different sensibility now than, say, in the late fifties.

SMITHSON: Oh, yes—well, to an extent. I just think it's extended over greater

stretches of time. In other words, it's almost as though all through this I was involved in a kind of personal archaeology, sort of going through the layers of, let's say, the last 2,000 years of civilization, and going back into the Egyptian and Mayan and Aztec civilizations. I hitchhiked to Mexico when I was about nineteen and visited the pyramids outside of Mexico City.

CUMMINGS: Was that because you knew about them? Or you wanted to go to Mexico?

SMITHSON: I always had this urge toward all this civilized refuse around. And then I guess the entropy article was more about a kind of built-in obsolescence. In fact I remember I was impressed by Nabokov, who says that the future is the obsolete in reverse. I became more and more interested in the stratifications and the layerings. I think it had something to do with the way crystals build up too. I did a series of pieces called *Stratas*. Virginia Dwan's piece called *Glass Strata* is eight feet long by a foot wide, and looks like a glass staircase made out of inch-thick glass; it's very green, very dense and kind of layered up. And my writing, I guess, proceeded that way. I thought of writing more as material to sort of put together than as a kind of analytic searchlight, you know.

CUMMINGS: But did the writing affect the development of things that you made?

SMITHSON: The language tended to inform my structures. In other words, I guess if there was any kind of notation it was a kind of linguistic notation. So that actually I, together with Sol LeWitt, thought up the language shows at the Dwan Gallery. But I was interested in language as a material entity, as something that wasn't involved in ideational values. A lot of conceptual art becomes, you know, essentially ideational.

CUMMINGS: How do you mean "material," though?

SMITHSON: Well, just as printed matter—information which has a kind of physical presence for me. I would construct my articles the way I would construct a work.

CUMMINGS: I'm curious about that. Does it relate to philosophy? Or to semantics? Or do you find that it relates to a more aesthetic attitude toward art?

SMITHSON: Well, I think it relates probably to a kind of physicalist or materialist view of the world, which of course leads one into a kind of Marxian view. So that the old idealisms of irrational philosophies began to diminish. Although I was always interested in Borges' writings and the way he would use leftover remnants of philosophy.

CUMMINGS: When did you get interested in him?

SMITHSON: Around 1965. That kind of taking of a discarded system and using it, you know, as a kind of armature. I guess this has always been my kind of world view.

CUMMINGS: Well, do you think it's so much the system that's the valuable aspect, or the utilization of it?

SMITHSON: No, the system is just a convenience, you might say. It's just another construction on the mires of things that have already been constructed. So that my thinking, I guess, became increasingly dialectical. I was still working with the resolution of the organic and the crystalline, and that seemed resolved in dialectics for me. And so I created the dialectic of site and nonsite. The nonsite exists as a kind of deep three-dimensional abstract map that points to a specific site on the surface of the earth. And that's designated by a kind of mapping procedure. And these places are not destinations; they're kind of backwaters or fringe areas.

CUMMINGS: How do you arrive at those different areas?

SMITHSON: I don't know—I guess it's just a kind of tendency toward a primordial consciousness, a kind of tendency toward the prehistoric after digging through the histories.

CUMMINGS: But do you work from, say, a large map? Or do you work from having been in that part of the world?

SMITHSON: Well, a lot of the nonsites are in New Jersey. I think that those landscapes embedded themselves in my consciousness at a very early date, so that in a sense I was beginning to make archaeological trips into the recent past to Bayonne, New Jersey.

CUMMINGS: So in a sense it was a real place that then became abstracted to a nonsite?

SMITHSON: Yes. And which then reflected the confinement of the gallery space. Although the nonsite designates the site, the site itself is open and really unconfined and constantly being changed. And then the thing was to bring these two things together. And I guess to a great extent that culminated in the *Spiral Jetty*. But there are other smaller works that preceded that—the investigations in the Yucatan.

CUMMINGS: How did that come about?

SMITHSON: Here was a kind of alien world, a world that couldn't really be comprehended on any rational level; the jungle had grown up over these vanished civilizations. I was interested in the fringes around these areas.

CUMMINGS: What do you mean, fringes?

SMITHSON: Well, like these backwater sites again, maybe a small quarry, a burnt-out field, a sand bank, a remote island. And I found that I was dealing not so much with the center of things but with the peripheries. So that I became very interested in that whole dialogue between, let's say, the circumference and the middle and how those two things operated together.

CUMMINGS: But most of the sites are not in metropolitan areas, are they? They're usually in the country.

SMITHSON: Most of them are in New Jersey; there's one in Bayonne, there's one in Edgewater, one in Franklin Furnace, one in the Pine Barrens. Since I grew up in New Jersey I would say that I was saturated with a consciousness of that place. And then, strangely enough, I did a double nonsite in California

and Nevada, so that I went from one coast to the other. The last nonsite actually is one that involves coal and there the site belongs to the Carboniferous Period, so it no longer exists; the site becomes completely buried again. There's no topographical reference. It's a submerged reference based on hypothetical land formations from the Carboniferous Period. The coal comes from somewhere in the Ohio and Kentucky area, but the site is uncertain. That was the last nonsite; you know, that was the end of that. So I wasn't dealing with the land surfaces at the end.

CUMMINGS: How did you develop the idea of the sites and nonsites, as opposed to building specific objects?

SMITHSON: Well, I began to question very seriously the whole notion of Gestalt, the thing in itself, specific objects. I began to see things in a more relational way. In other words, I had to question—where the works were, what they were about. The very construction of the gallery with its neutral white rooms became questionable. So I became interested in bringing attention to the abstractness of the gallery as a room, and yet at the same time taking into account less neutral sites, you know, sites that would in a sense be neutralized by the gallery. So it became a preoccupation with place.

CUMMINGS: What was your relationship with the Park Place group?

SMITHSON: I did show at Park Place once with Leo Vallador and Sol LeWitt. John Gibson was running it then. I knew him, and he was friendly with Virginia Dwan. I never really was that involved with Park Place.

CUMMINGS: Yes. I don't identify you with that place generally.

SMITHSON: No. I never really had the kind of technological optimism that they have. I was always questioning that.

CUMMINGS: It was an idea which didn't work?

SMITHSON: Yes. I preferred Sol LeWitt's mode of thinking. And Carl Andre's. But all those people were in some way connected with that. Also in 1966 I did an article with Mel Bochner on the Hayden Planetarium which, once again, was sort of an investigation of a specific place; but not on a level of science, but in terms of discussing the actual construction of the building; once again, an almost anthropological study of a planetarium from the point of view of an artist.

CUMMINGS: One thing you never finished discussing was the Dallas–Fort Worth Airport.

SMITHSON: Well, they eventually lost their contract. The pieces were never built. Although there was interest, I don't think that they fully grasped the implications of that. I've been back there a few times since. I don't think they got out of me what they thought they would have gotten. But it was very worthwhile for me because it got me to think about large land areas and the dialogue between the terminal and the fringes of the terminal—once again, between the center and the edge of things. This has been a sort of ongoing preoccupation with me, part of the dialectic between the inner and the outer.

CONVERSATION IN SALT LAKE CITY (1972)

Interview with Gianni Pettena

ROBERT SMITHSON: We could start out with the idea that I had at the beginning of the lecture [University of Utah, Jan. 24, 1972] about recycling quarries, disused mining areas, and that sort of thing in terms of art. Working in industrial areas that are no longer used—disused areas. That's the thing that I'm interested in. Sonsbeek in Holland indicated a direction away from the centralized museum into something more social, and less esthetic. I would say mainly in Europe one would have to work in a quarry or in a mining area, because everything is so cultivated in terms of the Church or aristocracy. The rest is all middle-class versions of that kind of cultivation.

GIANNI PETTENA: I kind of agree about that, thinking about the distinction you made between here and Europe. That's essential. Here, let's say you've got a lot of land and there they don't. That's the difference. I also agree on your choice of sites. I think I understand why you prefer dismissed areas rather than untouched areas. But the fact is that for me those areas are still too natural. That is to say that, for me, natural, dismissed or untouched areas are really the same thing. All of them are natural and not exactly the place for a work of mine. I have no right to touch a natural area and an old disused mine, it's a place that nature recycled according to its standards, thus subtracting it to me.

SMITHSON: I think you have to find a site that is free of scenic meaning. Scenery has too many built-in meanings that relate to stagey isolated views. I prefer views that are expansive, that include everything . . .

PETTENA: I'm thinking that perhaps you are able to do something in a town in Europe while you are not able to do something in a town here.

SMITHSON: Well, I can't really work in towns. I have to work in the outskirts or in the fringe areas, in the backwaters. The real estate too in the towns is too expensive. So that it's practical, actually, to go out to wasteland areas whether they're natural or manmade and reconvert those into situations. The Salt Lake piece is right near a disused oil drilling operation and the whole northern part of the lake is completely useless. I'm interested in bringing a landscape with low profile up, rather than bringing one with high profile down. The macro aggression that goes into certain earthworks doesn't interest me.

PETTENA: There's no need to choose, then, a nice landscape.

SMITHSON: Beauty spots, they call them. Nature with class.

PETTENA: That's exactly what some groups of architects are doing. They are doing photomontage (not real) proposals on conceptual architecture and they have often to choose very beautiful or very famous landscapes, postcard land-

Domus, November 1972. This interview took place on January 25, 1972, the day after Smithson gave a lecture at the University of Utah.

scapes, in a way which will support their idea. The fundamental position of putting a light under a painting to light it.

SMITHSON: Or put a balloon tent structure on a landscape that's already cultivated. I think that should be avoided. I'm not interested in that kind of thing—World's Fair kind of architecture. It suggests the future that will never come. I'm more interested right now in things that are sort of sprawling and imbedded in the landscape rather than putting an object on the landscape.

PETTENA: I'm not avoiding anything which is in the landscape, but in an urban landscape. Because for me it's the only place, as you were saying about Sonsbeek, where you can make something more social and less esthetic.

SMITHSON: Well, New York itself is natural like the Grand Canyon. We have to develop a different sense of nature; we have to develop a dialectic of nature that includes man. . . . A kind of "virgin" beauty was established in the early days of this country and most people who don't look too hard tend to see the world through postcards and calendars so that that affects their idea of what they think nature should be rather than what it is.

PETTENA: I remember once I was with a German friend of mine and we were looking at a beautiful landscape near the University. There was a helicopter in the sky, far and still like a black point but one could notice it. My friend asked what it was and I answered him that it was a printing mistake . . .

SMITHSON: I like landscapes that suggest prehistory. As an artist it is sort of interesting to take on the persona of a geologic agent where man actually becomes part of that process rather than overcoming it—rather than overcoming the natural processes of challenging the situation. You just go along with it, and there can be a kind of building that takes place this way. I did an article once, on Passaic, New Jersey, a kind of rotting industrial town where they were building a highway along the river. It was somewhat devastated. In a way, this article that I wrote on Passaic could be conceived of as a kind of appendix to William Carlos William's poem "Paterson." It comes out of that kind of New Jersey ambience where everything is chewed up. New Jersey like a kind of destroyed California, a derelict California.

PETTENA: Another work I did was exactly in a place where they were building a highway. You know, sometimes for me it is difficult to make that kind of observation because you really have to find a place that doesn't work any more like a town but still has to look like a town. Or you can use the town while it is still working but then there are always many difficulties. You really can't . . .

SMITHSON: You really can't. There's a word called entropy. These are kind of like entropic situations that hold themselves together. It's like the Spiral Jetty is physical enough to be able to withstand all these climate changes, yet it's intimately involved with those climate changes and natural disturbances. That's why I'm not really interested in conceptual art because that seems to avoid physical mass. You're left mainly with an idea. Somehow to have something

physical that generates ideas is more interesting to me than just an idea that might generate something physical.

PETTENA: I think the main tension of something so-called conceptual can be really a kind of old way to think about physicality.

SMITHSON: It's very idealistic. It's basically a kind of reductionism. A lot of it verges on a cultism and pseudoconscience and that sort of thing. Conceptual art is a kind of reduced object down to a notion of ideas that leads to idealism. An idealism is a kind of spiritualism and that never seems to work out.

PETTENA: I wouldn't be so drastic. I'm only thinking that what has been said and done, speaking about language, was very important and has been useful to several people. I think that only after what Art & Language etc. asserted, one can go back to a certain physicality after learning the lesson. There's no longer need of being afraid to do something physical but what you do must show that you learnt that lesson. That physicality doesn't bother you because you control it and it is simply a physical support to the concepts you communicate.

SMITHSON: It's interesting too, in looking at the slides of ruins there's always a sense of highly developed structures in the process of disintegration. You could go and look for the great temple and it's in ruins, but you rarely go looking for the factory or highway that's in ruins. Levi-Strauss suggested that they change the word anthropology to entropology, meaning highly developed structures in a state of disintegration. I think that's part of the attraction of people going to visit obsolete civilizations. They get a gratification from the collapse of these things. The same experience can be felt in suburban architecture, in what they call the "slurbs."

PETTENA: I feel the same way about suburban architecture and this is generally the area where I like to work.

SMITHSON: It could apply to anything, actually. There is no taste differential, actually.

PETTENA: Once, in Italy, some people (artists) were invited to do something as an intervention on a town. We had all the town. We could work in every part of the town, but strangely enough everybody chose the main square.

SMITHSON: They all run towards the center because that's the more secure place.

PETTENA: Every town, downtown, has nice, clean rich buildings which are an expression of power and make you feel secure. But in the meantime you have to remember that this is generally a visualization of power. And the suburbs are exactly the contrary. At that time, in 1969, I got mad thinking about this kind of choice that everyone was making. Choosing the space of power only because it was nice and clean. In this way, all the town was seen and interpreted even if correctly and honestly only through the main square, which was used like a simple gallery space.

SMITHSON: You put a clothesline into the square?

PETTENA: I put some clotheslines into the square to rebuild a deemphatization.

SMITHSON: So that's sort of like bringing the fringes into the main square.

PETTENA: This way very intentional.

SMITHSON: The clotheslines are an interesting thing to bring into the main plaza.

PETTENA: Yes, I did it this way intentionally to correct this kind of emphatization. I think this was the only chance anyone ever had to put a clothesline in a main square. And looking at the catalogue of this show, I would say it really worked out. In fact every work or intervention has these clotheslines in the background.

SMITHSON: The notions of centrality give people a security and certainty because it's also a place where most people gather. But they tend to forget the fringes. I have a dialectic between the center and the outer circumferences. You really can't get rid of this notion of centrality nor can you get rid of the fringes and they both sort of feed on each other. It's kind of interesting to bring the fringes into the centrality and the centrality out to the fringes. I developed that somewhat with the non-sites where I would go out to a fringe area and send back the raw material to New York City, which is a kind of center—a big sprawling nightmare center, but it's still there. Then that goes into the gallery and the non-site functions as a map that tells you where the fringes are. It's rare that anybody will visit these fringes, but it's interesting to know about them.

PETTENA: You always show the places from which you are coming, if you are sincere.

Aerial photograph of Ohio strip mine.

ENTROPY MADE VISIBLE (1973)

Interview with Alison Sky

ROBERT SMITHSON: O.K. we'll begin with entropy. That's a subject that's preoccupied me for some time. On the whole I would say entropy contradicts the usual notion of a mechanistic world view. In other words it's a condition that's irreversible, it's a condition that's moving towards a gradual equilibrium and it's suggested in many ways. Perhaps a nice succinct definition of entropy would be Humpty Dumpty. Like Humpty Dumpty sat on a wall, Humpty Dumpty had a great fall, all the king's horses and all the king's men couldn't put Humpty Dumpty back together again. There is a tendency to treat closed systems in such a way. One might even say that the current Watergate situation is an example of entropy. You have a closed system which eventually deteriorates and starts to break apart and there's no way that you can really piece it back together again. Another example might be the shattering of Marcel Duchamp

On Site #4, 1973. This interview took place about two months before Smithson's death. Although published posthumously, Smithson and Sky completed the editing of the text together and Smithson provided all the illustrations.

Glass, and his attempt to put all the pieces back together again attempting to overcome entropy. Buckminster Fuller also has a notion of entropy as a kind of devil that he must fight against and recycle. Norbert Weiner in *The Human Use of Human Beings* also postulates that entropy is a devil, but unlike the Christian devil which is simply a rational devil with a very simple morality of good and bad, the entropic devil is more Manichean in that you really can't tell the good from the bad, there's no clear cut distinction. And I think at one point Norbert Weiner also refers to modern art as one Niagara of entropy. In information theory you have another kind of entropy. The more information you have the higher degree of entropy, so that one piece of information tends to cancel out the other. The economist Nicholas Georgescu-Roegen has gone so far as to say that the second law of thermodynamics is not only a physical law but linked to economics. He says Sadi Carnot could be called an econometrican. Pure science, like pure art tends to view abstraction as independent of nature, there's no accounting for change or the temporality of the mundane world. *Abstraction rules in a void, pretending to be free of time.*

One might even say that the whole energy crisis is a form of entropy. The earth being the closed system, there's only a certain amount of resources and of course there's an attempt to reverse entropy through the recycling of garbage. People going around collecting bottles and tin cans and whatnot and placing them in certain compounds like the one over on Greenwich Avenue across from St. Vincent's Hospital. Well this seems to be a rather problematic situation. Actually right now I would like to quote from Georgescu-Roegen, *The Entropy Law and the Economic Process*, about what he calls entropic bootlegging. It's an interesting conception I think. This is what he says about recycling waste materials. "This is what the promoters of entropy bootlegging fail to understand. To be sure, one can cite numberless scrap campaigns aimed at saving low entropy [low entropy in his definition is raw materials before they're processed into refined materials. In other words raw ore would be low entropy and high entropy would be the refined material such as steel] . . . by sorting waste. They have been successful only because in *given circumstances* the sorting of, say, scrap copper required a smaller consumption of low entropy than the alternative way of obtaining the same amount of metal. It is equally true that the advance of technological knowledge may change the balance sheet of any scrap campaign, although history shows that past progress has benefited ordinary production rather than scrap saving. However, to sort out the scrap molecules scattered all over the land and at the bottom of the sea, would require such a long time that the entire low entropy of our environment would not suffice to keep alive the numberless generations of Maxwell's demons needed for the completed project." In other words he's giving us the indication that recycling is like looking for needles in haystacks.

Now, I would like to get into an area of, let's say, the problems of waste. It seems that when one is talking about preserving the environment or conserv-

ing energy or recycling one inevitably gets to the question of waste and I would postulate actually that waste and enjoyment are in a sense coupled. There's a certain kind of pleasure principle that comes out of a preoccupation with waste. Like if we want a bigger and better car we are going to have bigger and better waste productions. So there's a kind of equation there between the enjoyment of life and waste. Probably the opposite of waste is luxury. Both waste and luxury tend to be useless. Then there's a kind of middle class notion of luxury which is often called "quality." And quality is sort of based on taste and sensibility. Sartre says Genet produces neither spit or diamonds. I guess that's what I'm talking about.

ALISON SKY: Isn't entropy actually metamorphosis, or a continual process in which elements are undergoing change, but in an evolutionary sense?

SMITHSON: Yes and no. In other words, if we consider the earth in terms of geologic time we end up with what we call fluvial entropy. Geology has its entropy too, where everything is gradually wearing down. Now there may be a point where the earth's surface will collapse and break apart, so that the irreversible process will be in a sense metamorphosized, it is evolutionary, but it's not evolutionary in terms of any idealism. There is still the heat death of the sun. It may be that human beings are just different from dinosaurs rather than better. In other words there just might be a different situation. There's this need to try to transcend one's condition. I'm not a transcendentalist, so I just see things going towards a . . . well it's very hard to predict anything; anyway

Earthquake, 4th Ave., Anchorage, Alaska. Photo by Steve McCutcheon, Alaska Pictorial Service.

Construction, Central Park, New York City.

303

Volcanic Eruption, Heimaey, Vestmann Islands, Iceland. Photo courtesy *Esquire* magazine.

all predictions tend to be wrong. I mean even planning. I mean planning and chance almost seem to be the same thing.

SKY: I wish the architectural profession would recognize that. In their grand masterplan schemes for the world, architects seem to find the "final solution" to all possible situations.

SMITHSON: They don't take those things into account. Architects tend to be idealists, and not dialecticians. I propose a dialectics of entropic change.

There is an ongoing aspect of things that fascinates me like my recent involvement with Central Park (see "Frederick Law Olmsted and the Dialectical Landscape," *Artforum*, February 1973). You see that photograph there showing a pit in Central Park. Now you might say that's a kind of architecture, a kind of entropic architecture or a de-architecturization. In other words it's not really manifesting itself the way let's say Skidmore Owings and Merrill might manifest itself. It's almost the reverse of that, so that you can observe these kinds of entropic building situations which develop around construction. That pit will eventually be covered, but it's there right now with all its scaffolding, and people have been confused by that pit, they think it has something to do with the Met [Metropolitan Museum of New York]. There's a lot of graffiti on it attacking the Met, but it's really the city.

SKY: It's ironic that we've been able to perpetuate this attitude of set design solutions throughout the world. Travelling through Europe you can go for miles and it all looks exactly alike and like everywhere else. Mimic Lefrak City architecture is covering the earth. How did this manage to take over as opposed to the opposite view exemplified in places like Rome where there are no two buildings, angles, textures, etc., the same. Ruins melt and merge into new structures, and you get this marvelous and energetic juxtaposition occurring—with accident a large part of the whole process.

SMITHSON: Well, Rome is like a big scrap heap of antiquities, America doesn't have that kind of historical background of debris.

But I'd like to mention another mistake which is essentially an engineering mistake and that's the Salton Sea in southern California, which happens to be California's largest lake. It happened back during Teddy Roosevelt's adminis-

304

tration. There was a desperate attempt to try to reroute the Colorado River. The Colorado River was always flooding and destroying the area. There was an attempt to keep the Colorado River from flooding by building a canal, in Mexico, and this was illegally done. This canal was started in the delta of the Colorado and then it was rerouted back toward Mexicali, but what happened was that the river flooded into this canal and the canal overflowed, and fed back into the Imperial Valley which is below sea level. So that this thirty mile lake was created by this engineering mistake, and whole cities were inundated, the railroad also was submerged, and there were great attempts to try to fight back this deluge, but to no avail. Since then, people have come to live with this lake, and recently I was out there. I spent some time in Salton City which is a city of about 400 people. And another example of blind planning is this maze of wide boulevards that snake through the desert. Now it was the idea that they would turn this into a huge retirement village or whatever, maybe a new Palm Springs, but the bottom fell out of that so that if you go there now you just see all these boulevards going all through the desert, very wide concrete boulevards and just sign posts naming the different roads and maybe a few trailer encampments near this city. It's impossible to swim in the Salton Sea because barnacles have grown all over the rocks. There is some water skiing and fishing. There's also a plan to try to desalinate the whole Salton Sea. And there's all kinds of strange schemes for doing that. One was to bring down slag from the Kaiser Steel Company, and build a dike system. So that here we have an example of a kind of domino effect where one mistake begets another mistake, yet these mistakes are all curiously exciting to me on a certain kind of level—I don't find them depressing.

SKY: There's an inherent energy level present in an accidental or mistake occurrence. I was listening to a discussion of the I. M. Pei buildings near Washington Square Village, and apparently in the two towers owned by New York University an attempt was made at "total control." Even the curtains were specified so as not to disturb the "esthetic resolution" of the building facade. The third tower is not owned by N.Y.U. and houses the people replaced by the construction. These people were free to choose their own curtains and you get an incredible diversity of styles and colors which I find much more dynamic. Ironically the white curtains so carefully controlled have since faded to different tones of white so the process occurred anyway.

SMITHSON: Right. It's like the Anchorage earthquake that was responsible for creating a park. After the earthquake they set aside a portion of earthquake damage and turned that into a park, which strikes me as an interesting way of dealing with the unexpected, and incorporating that into the community. That area's fascinated me quite a bit. Also, the recent eruptions outside of Iceland. At Vestmann Islands an entire community was submerged in black ashes. It created a kind of buried house system. It was quite interesting for a while. You might say that provided a temporary kind of buried architecture which reminds me of my own *Partially Buried Woodshed* out in Kent State, Ohio where I

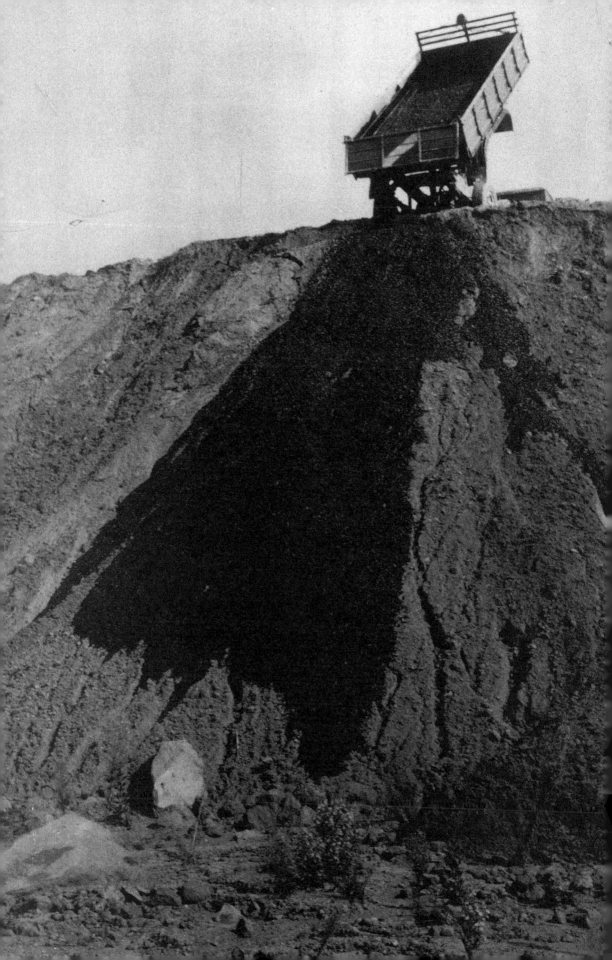

took 20 cartloads of earth and piled them on this woodshed until the central beam cracked. There was a problem from one of the local papers. They didn't really see that as a very positive gesture, and there was a rather disparaging article that went under the heading "It's a Mud Mud Mud World."

But basically I think that those preoccupations do escape architects and I'm thinking of another problem that also exists, that of mining reclamation. It seems that when they made up the laws for mining reclamation they wanted to put back the mines the way they were before they mined them. Now that's a real Humpty Dumpty way of doing things. You can imagine the result when they try to deal with the Bingham pit in Utah which is a pit one mile deep and three miles across. Now the idea of the law being so general and not really dealing with a specific site like that seems unfortunate. One person at Kennecott Mining Company told me that they were supposed to fill that pit in; now of course one would wonder where they were going to get the material to fill that pit in.

SKY: Did you ask them?

SMITHSON: Yes, I mean they said it would take something like 30 years and they'd have to get the dirt from another mountain. It seems that the reclamation laws really don't deal with specific sites, they deal with a general dream or an ideal world long gone. It's an attempt to recover a frontier or a wilderness that no longer exists. Here we have to accept the entropic situation and more or less learn how to reincorporate these things that seem ugly. Actually there's the conflict of interests. On one side you have the idealistic ecologist and on the other side you have the profit desiring miner and you get all kinds of strange twists of landscape consciousness from such people. In fact there's a book that the Sierra Club put out called *Stripping*. Strip mining actually does sort of suggest lewd sex acts and everything, so it seems immoral from that standpoint. It's like a kind of sexual assault on mother earth which brings in the aspect of incest projections as well as illicit behavior and I would say that psychologically there's a problem there. There's a discussion of aesthetics in this book *Stripping* from the point of view of the miner and from the point of view of the ecologist. The ecologist says flatly that strip mines are just ugly and the miner says that beauty is in the eye of the beholder. So you have this stalemate and I would say that's part of the clashing aspect of the entropic tendency, in other words two irreconcilable situations hopelessly going over the same waterfall. It seems that one would have to recognize this entropic condition rather than try to reverse it. And there's no stopping it; consider the image that Norbert Weiner gives us—Niagara Falls.

In fact they even shored up Niagara, speaking of Niagara. They stopped Niagara for a while because it was wearing away. And then they put these steel rods into the rock so that it would maintain its natural appearance.

SKY: Have they been able to stop it?

SMITHSON: They did stop it.

ROBERT SMITHSON, *Asphalt Rundown*, 1969. Rome.

SKY: From wearing away?

SMITHSON: Well, it's still there. It didn't fall apart yet. Niagara looks like a giant open pit quarry. In other words it has high walls which offend people greatly in the strip mining regions. There are defects called "high walls" that exist in the strip mining areas and there's a desire on the part of ecologists to slope these down. The cliffs all around Niagara suggest excavation and mining, but it's just the work of nature. So there's constant confusion between man and nature. Is man a part of nature? Is man not a part of nature? So this causes problems.

SKY: There is definitely some sort of perverse fascination attached to the process of inevitable and impending destruction that will occur either in your own environment or be observed vicariously because people persist in living at the bases of volcanos, on earthquake zones such as the fault line which is supposed to destroy all of California, on top of sinking landscapes such as Venice which is a city built entirely on rotting wooden pilings and will eventually fall into the sea.

SMITHSON: Well, that may be something that's human—that's a human need. It seems that there's almost a hope for disaster you might say. There's that desire for spectacle. I know when I was a kid I used to love to watch the hurricanes come and blow the trees down and rip up the sidewalks. I mean it fascinated me. There's a kind of pleasure that one receives on that level. Yet there is this desire for something more tranquil—like babbling brooks and pastorals and wooded glens. But I suppose I'm more attracted toward mining regions and volcanic conditions—wastelands rather than the usual notion of scenery or quietude, tranquility—though they somehow interact.

SKY: I think man turns to the wooded glens in the last moments for the most part. He probably wouldn't like to admit it but I don't think it's of prime

Dewatered American Falls. Photo Courtesy Niagara Falls Area Chamber of Commerce.

importance to him—from a fascination viewpoint. I mean he really hasn't done much to protect these pockets of tranquility. At the last moment, after it's almost all destroyed he starts screaming "put up the trees" but only in a token gesture sense. That's always the answer, especially in public spaces in a city like New York—stick up a few isolated trees.

SMITHSON: Well, it seems that in a city like New York where everything is concrete there's this craving to stick up a tree somewhere.

Also in regard to the origin of parks in this country it's interesting to note that they really started as graveyards. There's something in the mid-19th century that's called the "rural graveyard movement" where there was an attempt to get away from the dreary little churchyard graveyards. They introduced a kind of sylvan setting so that nature would intermingle with the graveyards, and they developed a whole funerary school of art you might say. I know for a fact over near Fort Lee there are all these vaults—little pyramids, you know, for the dead.

There is an association with architecture and economics, and it seems that architects build in an isolated, self-contained, ahistorical way. They never seem to allow for any kind of relationships outside of their grand plan. And this seems to be true in economics too. Economics seem to be isolated and self-contained and conceived of as cycles, so as to exclude the whole entropic process. There's very little consideration of natural resources in terms of what the landscape looks like after the mining operations or farming operations are completed. So that a kind of blindness ensues. I guess it's what we call blind profit making. And then suddenly they find themselves within a range of desolation and wonder how they got there. So it's a rather static way of looking at things. I don't think things go in cycles. I think things just change from one situation to the next, there's really no return.

ROBERT SMITHSON, *Partially Buried Woodshed*—Kent State University, Ohio, 1970. Photo Len Hanzel.

ROBERT SMITHSON ON DUCHAMP (1973)

Interview with Moira Roth

This interview was taped shortly before Robert Smithson's tragic death in an aircraft accident, before the artist had an opportunity to revise or edit his spontaneous views. However, the interview as it stands is characteristic of Smithson's independence of outlook.

Why did you say you were interested in talking about Duchamp?

Well, for one thing, I think in America we have a certain view of art history that comes down to us from the Armory Show, and Duchamp had a lot to do with that history. There is a whole lineage of artists coming out of the Armory Show. And the notion of art history itself is so animated by Duchamp. The prewar period was dominated by Matisse and Picasso and the post–World War II period was dominated by Duchamp. Hard-core modernism is Picasso and Matisse and T. S. Eliot and Ezra Pound. Then, in the postwar period, we get Duchamp coming on very strong. Duchamp is really more in line with postmodernism insofar as he is very knowledgeable about the modernist traditions but disdains them. So, I think there is a kind of false view of art history, an attempt to set up a lineage. And I would like to step outside that situation.

There has been a kind of Duchampitis recently, beginning with Duchamp's being rediscovered in Jasper Johns. But Johns is less French and more ratty, you might say. Johns has taken the aristocratic stance and given it a more sordid edge. Then you have this influence pervading Robert Morris' work. But there is no viable dialectic in Duchamp because he is only trading on the alienated object and bestowing on this object a kind of mystification. Duchamp is involved with the notion of manufacture of objects so that he can have his little valise full of souvenirs. I am not really interested in that kind of model making: the reiteration of the Readymades. What I am saying is that Duchamp offers a sanctification for alienated objects, so you get a generation of manufactured goods. It is a complete denial of the work process and it is very mechanical too. A lot of Pop art has to do with this—the transcending in the Readymades. In a sense, Rosenquist is transcending billboards, Warhol is transcending canned goods, and Jim Dine is transcending tools that you buy in hardware stores—Duchamp's influence is quite pervasive on that level. Duchamp is trying to transcend production itself in the Readymades when he takes an object out of the manufacturing process and then isolates it. He has a certain contempt for the work process and here I think he is sort of playing the aristocrat. It seems that this has had a great deal of effect on New York artists.

Do you think of him as a Dandy in a Baudelairean sense?

Yes, I think there is some of that. I think that it has always had a certain appeal because the artist to a certain extent is always trying to transcend his class, and

Artforum, October 1973

I think Duchamp is involved in that. At one point, he even said that he would rather kings were patrons, so that he indicated that he considered art fascistic.

You said there was no viable dialectic in Duchamp, is there one in your work?

Yes, I think so. In my early works I was not really Minimal; the works were more related to crystallized notions about abstraction. So there was a tendency toward abstraction, but I never thought of isolating my objects in any particular way. Gradually, more and more, I have come to see their relationship to the outside world, and finally when I started making the Nonsites, the dialectic became very strong. These Nonsites became maps that pointed to sites in the world outside the gallery, and a dialectical view began to subsume a purist, abstract tendency.

I don't think Duchamp had a dialectical view. In other words, I am saying that his objects are just like relics, relics of the saints or something like that. It seems that he was into some kind of spiritual pursuit that involved the commonplace. He was a spiritualist of Woolworth, you might say. He seemed dissatisfied with painting or what is called high art. Somebody like Clement Greenberg is opting for high art or modernism from a more orthodox point of view, but Duchamp seems to want to be playful with that modernism. He doesn't see it as absolute. It is like a mechanistic view. He also strikes me as Cartesian in that respect, and I think he once mentioned in an offhand way that he was. Duchamp seems involved in that tradition and in all the problems of that tradition.

Duchamp was suspicious of this whole notion of mechanism, but he was using it all the time. I don't happen to have a mechanistic view of the world so I really can't accept Duchamp in terms of my own development. There is a great difference between a dialectical view and a mechanistic view. Andy Warhol saying that he wants to be a machine is this linear and Cartesian attitude developed on a simple level. And I just don't find it very productive. It leads to a kind of Cartesian abyss.

Duchamp's involvement with da Vinci—his putting a moustache on the *Mona Lisa*—seems to be an attempt to transcend another artist who is very close to his view. They both have mechanistic ideas of nature. But in Duchamp's mechanistic view, there is nothing pragmatic or useful in the way there was with da Vinci. In Duchamp, it leads to a kind of Raymond Roussel. Of course, Duchamp was influenced by Roussel and it is more or less taking the mechanistic view to an almost fantasy level. Take the *Large Glass* which seems to be an attempt to try and mechanize the sex act in what you would call a witty way.

Conceptual art too is to a certain extent somewhat mechanistic though the whole conceptual situation seems rather lightweight compared to Duchamp. Sol LeWitt coined the term "conceptual" and Sol LeWitt says ideas are machines. So this mechanistic view permeates everything. And it seems that it is just reducing itself down to a kind of atrophied state. A lot of it just evolves into what Mel Bochner might call joke art; playing little jokes like the

Dadaists. But you see, the Dadaists were setting up their own religion, thinking that everything was corrupted by commercialism, industry, and bourgeois attitudes. I think it is time that we realized that there is no point in trying to transcend those realms. Industry, commercialism, and the bourgeoisie are very much with us. And this whole notion of trying to form a cult that transcends all this strikes me as a kind of religion in drag. I am just bored with it, frankly. In that there is a kind of latent spiritualism at work in just about all of modernism. There is the guilt even about being an artist. To return to Duchamp, at bottom I see Duchamp as a kind of priest of a certain sort. He was turning a urinal into a baptismal font. My view is more democratic and that is why the pose of priest-aristocrat that Duchamp takes on strikes me as reactionary.

You said you sometimes talked with Carl Andre about Duchamp?

Yes, Andre's view is more a Marxist one. Andre himself seems to want to transcend the bourgeois order, and Carl more or less sees Duchamp as responsible for the proliferation of multiples and this sort of thing. Where I tend to agree with Andre is when he says that Duchamp is involved in exchange and not use value. In other words, a Readymade doesn't offer any kind of engagement. Once again it is the alienated relic of our modern postindustrial society. But he is just using manufactured goods, transforming them into gold and mystifying them. That is where alchemy would come in. But I see no reason to extrapolate that in terms of the arcane language of the Cabala.

Then you are not interested in the occult interpretations of Duchamp by Jack Burnham and Arturo Schwarz?

I am just not interested in the occult. Those kinds of systems are just dream worlds and they are fiction at their best and at worst, they are uninteresting. By the way I met Duchamp once in 1963 at the Cordier-Ekstrom Gallery. I just said one thing to him, I said, "I see you are into alchemy." And he said, "Yes."

How do you feel about Duchamp's chess playing?

Well, it has aristocratic connotations. It is also a luxury that I wouldn't really be too inclined to pursue myself, anymore than I would want to sit around and play Monopoly.

What do you think Duchamp's attitude toward America was?

I think Duchamp is amused by a certain kind of American naiveté, and he constantly makes references to certain functional aspects, like the statement about his being impressed by American plumbing and that sort of thing. That seems to me a kind of inverted snobbism. And I find his wit sort of transparently French. French wit seems to me very different from an English sense of humor. If the French have any wit at all, I don't really appreciate it. They always seem very laborious, opaque, and humorless so that when you get somebody like Duchamp who is putting forth the whole art notion of the amusing physics or the gay mathematics, or whatever you want to call it, I am not amused. It is a kind of Voltairean sarcasm at best.

UNPUBLISHED WRITINGS

POEMS AND PROSE

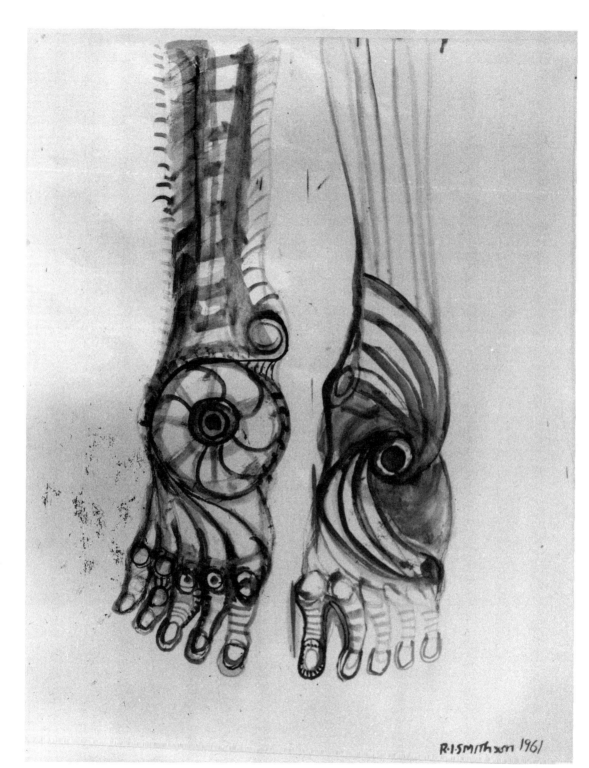

ROBERT SMITHSON, *Feet of Christ*, 1961. Watercolor and ink, 18 x 14″,

From the Temptations

The mother
Did not spare
The infant
Sucking at her breast
But devouring it,
Took back
Into her stomach
Flesh and blood
Which her womb
Had just brought forth.
And so,
Saint Jerome
Returned to the desert.
All through the night Rome went burning
O lamentable misery!
O mournful misery!
We fear thee, Evil One.
We fear your deadly ~~things~~ ways.
We fear thee, Evil One.
This cave is dark.

②

Caught in the Sound.
Mire of decayed love;
What do you want?
Caught in the Fury.
Bound by the weeds of Sodom,
And the curse of Babylon.
Caught in the Sound.
Listening to whispers in the shadows
About Solomon's lust.
Caught in the Fury.
While hemlock grew in the bowels,
Beetles lingered in the mind.
Caught in the Sound.
They divided her into neat pieces,
Afterward they played cards.
Caught in the Fury.
Dogs to the spirit,
Showed their legs.
Caught in the sound.
Everybody is very busy,
Oozing ology after ology.
Caught in the fury.

③

Visitors to the catacombs
Did things worse than witchcraft.
Caught in the Sound.
Some are improving the Ressurection
In order to study the dust on the moon.
Caught in the Fury.
How many artists try to create
What Botticelli burned?
Caught in the Sound.
Another Stigmata
Has been exposed by science.
Caught in the Fury.
The clever ~~sisters~~ ladies.
Did not turn the other cheek.
Caught in the Sound.
No one can sit,
And no one can stand.
Caught in the Fury.
Ever so seductive
Those Renassiance ways.
Caught in the Sound.
Here on this sea of Shades
Even the sun is bored.
Caught in the Fury.
The rat payed no attention
But continued to nibble on the corpse.

④

All through the night Rome went burning.
O lamentable misery!
O mournful misery!
We fear thee, Evil One.
We fear your deadly ways.
We fear thee, Evil One.
This cave is dark.
Away! ~~Dam~~
Damn Pest!
Away!
Grant us Thy blessing
Father
For ~~this is~~. we have sin.
Amen

Manuscript version of "From the Temptations." This and the manuscripts of the poems that follow are in the Archives of American Art.

From the Walls of Dis

Dis; wrapped in despair,
We ~~dis can't~~ believe this!
Dis; trapped in death,
We ~~dis can't~~ believe that!
Locked within:
Mortar of perpetual woe.
Despair and die!
Mortar of eternal sin.
Despair and die!
Mortar of material rot.
Despair and die!
Crushed under infernal
Rocks.
Crushed under infernal
Rocks.
Eye in the crack of doom.
Ear in the crack of doom.
Mouth in the crack of doom.
Eye staring without a face.
Ear hearing without a face.
Mouth shouting without a face.
Thick despair,
Boiling, Boiling, pus.
No hope for us,
Thick despair
Support these walls of torture;
Shape-less bodies
Hold the dung of Satan;

In place,
In time,
In space.
Walls throb
With Death;
While wild
Shrieks pierce the bowels
Of the Damned.
Howl!
The Anti-Christ:
God is dead!
God is dead!
Beyond Jerusalem
In the grave
Filled with Pride,
Filled with Envy,
Filled with Usury,
Filled with Lust,
Filled with Anger,
Filled with Sloth,
Filled with Gluttony.
Ask not where Satan reigns.
"Pape' Satan, pape' Satan aleppe".
Lost.
Lost.
Lost.
Amen

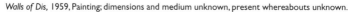

Walls of Dis, 1959, Painting; dimensions and medium unknown, present whereabouts unknown.

Blind in the Valley of the Suicides, 1962.
Ink, 24 x 13⅝".

From the City

The tongue
Did burst.
Into a Bloody Word.
Unlost:
It stared
Back into
The mouth
From whence it came.
We shall
Never be the same.
We shall
Never be the same.
After the Cross
Nothing is lost.
At the bottom
Of the city
This is all.
At the top
Of the city
This is all.
From a ruptured
Blood vessel
Comes a prayer.

②

A sorry sight
Upon the dark night;
While a dog barked at the moon.
No prayers tonight.
No prayers tonight.
We have better things to do.
Joining ~~the~~ with the myth of the machine
The rebel
Expects to be damned
By rust;
To be saved
Is passé.
We shall fly to Rome
In an airoplane;
Flying,
Flying.
Under Golgatha
O
Happy chance.
Amen

317

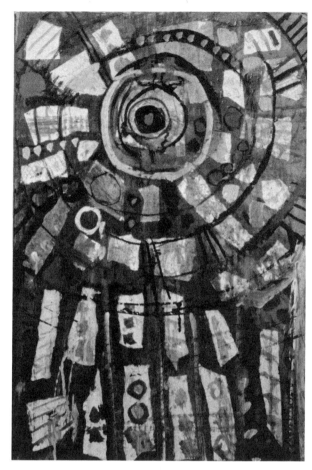

The Eye of Blood, 1960. Collage and tempera on cardboard, 33 x 24″.

To the Eye of Blood
~~Pray to the Road~~

②

It is
As high as Heaven
What can we do?
Deeper than Hell
What can we know?
Are they all dead?
Are they all dead?
In the tempest of hail,
We seek.
In the destroying storm
We seek.
In the mighty waters overflowing.
We seek.
When shall this scourge pass?
Upon
The line of confusion.
Upon
The stones of emptiness.
Behold:
For peace we had great bitterness.
A wind blows from Heaven.
A wind blows from Hell.

Yet, no wind blows at all.
Hermit in the Desert,
Lead us.
Hermit in the Jungle,
Lead us.
We can not walk.
We can not stop.
Not in this space.
Our eye is consumed,
But it is still an eye.
The eye torn.
The eye whole.
Torn,
But
Whole.
Woe, to them that distort the eye.
~~Waiting,~~ We wait ~~for~~
For the mystery
OF the white stone.
Amen

318

THE LAMENTATIONS OF THE PAROXYSMAL ARTIST

> All of 'em have fun but me.
> from a song as sung by Dion
> ". . . pronounced 'Deeon,' to rhyme with neon."

Let this Paroxysmal Vision be delivered to the Church of Used Blood, the Church of Defunct Immortality, the Church of Abnormal Shapes, the Church of Audio-Visual Aids, and the Church of Smart Money.

Unamen . . . unamen, I tell you.

Beware of the maggot-headed lovers! They're taking away your Blood. They're cheating on your wounded returns.

The Word came unto me looking like a silly mess. Take it away! Take me away! Defrost my fun! Turn off my brains. Remove the Smart-Matter with magic rays and Space-Age-Improvements. Cut my eyes out before I see Death. Too much Hemophilia. Too much Honey.

Bring on the paint buckets! Bravo! for paint. It smells good. Like money. When Easter comes, I'll paint a bunny-rabbit with big ears and a white behind. Bravo!

My mouth is full of thick paint. It's dripping down my chin in long purple drips. I can not tell at what speed it is traveling.

Degod me! The faster the better. Spare my dying puddle. Unamen.

Creeping Jesus with twisted gonads and ice-cream eyes spit at me last night about 9:25.

Good-by Mary. It was nice knowing you. Give my best to Dad.

Let the Bloody Dove go down.

Zoom! Zing! Bing!

Pass out into the Word of Ashes—

For the One True Holy Virgin Catholock Church.

Blast Off

Glory! Glory! Glory!

Bingo. Bingo.

IBM

Untitled (King Kong), 1962. Ink, 24 x 18".

THE ICONOGRAPHY OF DESOLATION (c. 1962)

"I wish I hadn't cried so much!" said Alice as she swam about, trying to find her way out.

Lewis Carroll

Any effort to regain iconography from the total tangle of Sacred and Profane must create wrath that propels the suppliant artist down the rabbit hole into Desolation, where All is spilled, and spoiled *below belief.*

Since popular inclinations toward Relativity have exploded the proportions of revealed iconography, post-Einstein *art-lovers* believe iconography to have had a "literary" origin; i.e., the Prophets are mutated into "folk-poets" by research analysis. As a result, the *art-lover* is dogmatically *interested* in the spatial thrills of "plasticity" as put into motion by Impressionism, Expressionism, and Picassoid art history. One should realize that such *art-loving* may lead to visual fornication—a very sticky topic that only the Elect know about.

After many secular ambushes, iconography is oriented into the snares of mediocrity called OBJECTIVITY—declassic and deromantic—which in time and space break down into NON-OBJECTIVITY. "Plasticity" when opposed to the graphic is natural matter without proportion but with the illusion of imagined dimensions. Revelation, once given, passes through the symmetry of grace (not to be confused with style, manner, or elegance), whereas imagination, once taken, begins with worldly fixations on human environments fed by the duration of factual events. When revelation is eclipsed by the decaying force of duration, it is dismissed or ignored by social or abstract humanists because of a lack of contrition, or even attrition. Informed external minds are armed against hidden impossibilities. All these conditions must be stated, even if they appear importune to the mortal consciousness. The awareness of the "fear and trembling" is *forced* upon used-up mortality; such a manifestation cannot be passed from man to man. By contemporary standards, Inspiration should be avoided *at all cost*, because there is no way of *criticizing* the possession by God or Satan. There is no place in *this* world for unknown devastations over the void of space and the waste of time. If an affliction gets a Chance, it might blossom forth like the "flower-like scent" that was given out by the sores and abscesses of the dying St. John of the Cross. Which brings to mind Grunewald's incarnations of the Black Plague that say, "Where were you, good Jesus, where were you? And why did you not come and heal my wounds?" In the same inflamed atmosphere is Jackson Pollock's last painting *Scent*—astounding tumors on a Divine Blood Cell. A Dead God speaks out of the soul through the depths of disease, playing wounded tricks on Improvement. Such apprehensions could be the Word of Strange Flesh clutching the Icon. The highest joy joined to lowest Agony pulsating nervously in the constellations. Deadly esthetics depart before sense-destroying fluxations, allowing the Incar-

nation's senseless calamity. Whereupon calamity is mocked and scorned. How did the Word of Strange Flesh enter the Word of Flesh? How did Sodom enter Gomorrah? The shame is—the answer is too simple.

Iconography takes on a corporeal form during the Renaissance and slowly dies with the Dance of Death so popular with the Baroque and in the dazzling apotheosis of the Sun King. That which is reborn must die in a more fearful way than that which is only born. Consider the Rococo decorations in a Hussite Church in Seldes, Austria, where thousands of skulls and bones are festooned over the altar. Another such amazing effect also occurs under the Church of St. Maria of the Conception in the subterranean cemetery of the Capuchin monks in Rome. Says Nathaniel Hawthorne about the cemetery in *The Marble Faun*, "There is no disagreeable scent, such as might have been expected from the decay of so many holy persons, in whatever odor of sanctity they may have taken their departure. The same number of living monks would not smell half so unexceptionably." This kind of sly moralism is at the heart of much American art both "abstract" and "realistic." There's nothing more invincible than an American Protestant in Rome. Said the Holy Origen, "Only sinners celebrate birthdays."

All dimensions must be exercised by a visual mortification of the eyes before iconographic vision can be experienced. The Fourth Dimension is simply the ruins of the Third Dimension. Until these *ruins* are viewed with detachment, the artist will wander from his art on the currents of duration among boring worldly sins which are then cultivated into existential ideas, rather than exorcised. Dehumanized voices put off intensity while claiming humanity. Paradox reverberates against paradox, till the Ghost is given up. Contradiction presents no problems after the Iconographic Annunciation, yet this makes the burden that comes of the worldling's chatter about this object and that nonobject. Art was never objectified during the Ages of Faith; art was an "act" of worship. Icons would never be "looked" at like a tourist looks at an *objet d'art*, even if he is a "passionate sightseer." Jackson Pollock and other American "action" painters have restored something of the ritual life of art. Action painting shows no non-objectivity. Rather it reveals unformed incarnations from a primordial animism lurking in sacramental substance. Pollock has said that he "never" expressed the "city." A chance comparison between Georges Rouault and Pollock indicates "inner" and "outer" obsessions between the European and the American. Focusing on human depravity in the city, Rouault releases the whore as "modern" saint syndrome, extending mortal flesh into Leon Bloy's *matter*-spattered heavens where Marchenois in *The Woman Who Was Poor* says, "*I shall enter into Paradise with a crown of fungi.*" Instead of inciting "compassion," Pollock tries to free his dumb soul from his own matter-heavens in such paintings as *Cut Out* and *Out of the Web*, relating reversibly to the visions of Bloy. Romantic Dualism takes many an artist through the Cathar bowels.

Before we are inundated with the mundane mania for the neo found-object

chock full of "banal" mystery, let us approach the God of that "culture-hero" Dr. Einstein. Is his God Yahweh in the Pillar of Fire which is not the Atomic Bomb? "The nonmathematician," says Dr. Einstein, "is seized by a mysterious shuddering when he hears of four-dimensional things, by a feeling not unlike that awakened by thoughts of the occult. And yet there is no more common-place statement than the world in which we live is a four-dimensional space-time continuum." But the *world* in which we do *not* live is free from the existence of sense and dimension. This invisible world is just as actual as the space-time continuum, just as death is as sure as life. If icons are seen as *sense-objects*, they are dead to the world. A spirit that is revealed through incarnate grace cannot be *measured* by human beings. "For that which is made in time," said Saint Augustine, "is made both after and before some time—after that which is past, before that which is future. But none could then be past, for there was no creature by whose movements its duration could be measured." A God that can be measured has to be man-made. Revelation has no dimensions. If it did, it would be dead in space and time. The early Christian Fathers never Fixated on dimensions in their theology. If they did, they would have developed icons something like Marcel Duchamp's *Nude Descending a Staircase*, which Duchamp calls "... an expression of time and space through the abstract presentation of motion." Marcel Duchamp stopped painting early in his life, because he *wasted* his art in time and space. Duration cut him off from revelation, thus confining grace to the chessboard. The Fourth Dimension is Yahweh's wrath upon a cursed humanity.

How does one redeem the revealed God from the dregs of nuclear heresy? This is next to impossible in an object and non-object-ridden world. Economic vices are openly anti-glory and rip down anything that looks otherworldly. The glass prisons on Park Avenue born out of a usury driven market-society offer nothing but clean-disease. Here Life and Death are the same. Here culture is sick money. Who can stop the pressures of the Fourth-Dimension space-time ennui from atomizing all heavens and hells for the sake of an expanding Inter-National-Stream-Line-Kitsch? At this point, memories of Baroque decay become seductive and full of grace. A distant desire . . . flickering cataclysmic hope tries to meet the need of dry abstractions. A terrible yearning for Innocence stares back over Original Sin into some impossible paradise.

Expectation quickly fades, leaving only the tiresome displays of nobody's agony, which are swiftly flimflammed by avant-garde humanists in their psychorites and "happenings." Paroxysms of angels and devils knotted together burst from Revelation in spite of the contracepted incantations, the pettifoggery of non-art, the hangover of Futurism and the world of fun and profit. Useless lamentations covered with the natural curse of naked culture all touched by primitive art—crack under the businesslike madness of Dubuffet and the massive reason of art dealers.

The absence of consolation in art produces desolation. Sensible ways of looking at art works are lost in the abandonment of the Holy Ghost, while the pressures of cheap religion tempt the weak soul into the currents of zero-salvation. Since all human opinions have created nothing but economic blindness, Maria Desolata has drained away her own Conception.

Let us ponder what the artist Clyfford Still said about his paintings: "Therefore, let no man underestimate the implications of this or its power for work for life—or for death, if they are misused." This grave tone is not exactly what the economic mind "likes" to attach to the artist's work; it likes to *think* of the artist as an artist in spite of his warnings.

From the dooms of "modernism," something cries out for the Missing Dust, then fades into the printed word and photograph. The Dust is leaving us with "pop" art and Clement Greenberg's visual Puritanism. Soon there will be nothing to stand on except the webs of manufactured time warped among throbbing galaxies of space, space, and more space. The Great Universal Vision is caving in, and the Age of Astonishment is beginning.

Witness the unspeakable rages within the despair of human dimension, as the artist smashes both sacred icon and mundane figure. Such mischief is the work of shapeless demons. O reader, remember Cotton Mather, who said, "They heap up wrath."

The rituals that Pollock discovered in Hopi religion and Navaho sand painting exist also in the outskirts of New York City. Penitential fires are built on Halloween in the dim regions of the suburbs, burning inside the rotting Jack-o'-Lantern with glowing hollow eyes, nose, and mouth. On a face sunken, the fruit fly larvae feed on the musky portions of pumpkin, and die on the candle flame. A fitting sacrifice for a defunctive Pentecost. Is this the face of American art? A face that risks Gothic dread on a million crabgrass-ridden lawns. The face that sticks to the "thick-paint" surfaces of garbage-infested pigment like the face on de Kooning's Women, till it turns into a mask of ooze and slips off into the grey night of the soul. The terrors under a neon-Lent creep over the trembling American artist.

Now that most worldly items resemble art, the artist is trapped by the rush of distraction spread by his own hand. A twisting vision grows about the con-catenations in an Industrial demiurge that discloses Dante machine-gunning the Council of Trent in heaven. Not knowing if such a vision is right or wrong, the artist returns to earth where everything is always wrong.

Between the Sacred Heart Cathedral and Colonnade Park by Mies Van der Rohe in Newark, New Jersey, drops the dream of Miss Lonelyhearts complete with stainless steel Apocalypse, and a Byzantium for the busy housewife. Dangling from the Spider's Web of Jonathan Edwards, a demolished Dove watches for miraculous danger in the noise of sweet transports. The Cathedral keeps the silence protected in tradition amidst the reflections of luxury tombs for the "middle-income." A useless tension spans the structures from gargoyle to

TV antenna, while baptisms are arranged. Where is the meeting place for "the synthesis of all heresies" and "the tongues of fire"? Not in this place. No meeting. Only the factory smoke failing to recall what has never been given.

After the soul has been buried, we come to the plains of improved nature complete with *The Bible Frank Lloyd Wright Would've Loved*, translated into a thousand languages. Shall we place the artificial beer can in the "natural house" and pray to it for the salvation of Duveen? Many say, "Art. Art." But there is no Art. Nevertheless, merchandised sophistication is heaping up the fragments of fixed objectivity and calling them "intelligent."

"Assemblages" and dinosaur bones, "targets" and plaster casts of primitive idols, "New Images of Man" and human organs embedded in plastic: the marriage of Mr. Wright's "natural" museum and the Museum of Natural History should be encouraged. The wedding would conjure up a phantasmagoria that would rival St. Anthony's cave. The beat artists who perform "happenings" could be employed as wizards of neo-gnostic madness. They might even put on an old-fashioned Black Mass. Finally, the Resurrection could be improved by making a deal with the military. Then "naturally," shoot an ape or a man into space.

"Farce without End."

We now discover an iconoscope that shall forgive the divorce of heaven and hell while it flashes before us for our selective graces—the bits and pieces of Divine Catastrophe. Such a scope has lost all division and order. One must pick over the scattered icons the way a bum picks over the dumps. The iconoscope will now be plugged in.

Here begins the canticle of Philomela, the screech owl. Itys. Itys. "Let the insects do the suffering for us!" says the Word Dissected. Roll on! A pale man wanders off the stage and falls into a backfiring redemption fuming the germs of vice and virtue. Smashing down over the rocks goes the Virgin's coffin into the foaming contentment surrounded by progressive Christendom. THE LIGHT SHINES IN DARKNESS! Mount Olive splits in every direction, producing blood-soaked worms for official inspection. Gangrene sets in, injecting St. Anthony's Fire into veins and arteries. Pus glitters with Greek charm, drawing out the sensual parts for the last stigmata. A middle-classic sycophant infused with a sentimental hatred of Indulgences smells out the droppings of "manners" in the Goop Gallery, near a counter-reformation "camping" on divine flotsam, regulating the Major Lumps. MUSH neatly wrapped in thrifty esthetics promotes itself into distinction. Void hooks onto void in the caverns splashed with bat guano, the Master's favorite medium. Keep on plodding . . . ever closer to the Mother of All Gods: Bu Bu. Not to be confused with Bee Bee. Pitter-patter, pitter-patter. Puff. Puff. Puff. Lights! Camera! Action! Prepare for the Practical Martyrdom! A clever soul places the body into a deep-freeze on a bed of thorns, whereupon the soul proclaims, "You'll forget ice-cream once you taste ice-blood." Cut. Print it! Listen to the sounding brass or the tinkling cymbal: take your pick. 1-2-3-4. Forward!

Footage, more footage! Dies irae, dies illa. Bring Icon-400 into the ultraviolet rays. No . . . wrong icon. Not the Behemoth. Let him be anathema! "God is gone up with a shout . . . " (Ps. 47:5). Icons $5 and up. With or without blood. Let's go on a crusade against the R.K.O.! . . . against the museum of *your* choice. Spotlights crisscross over multitudes chased by hurricanes. Mass movements push *dissipation* into heated solitude near lunacy. All is shapeless delirium. Dizzy icons. Dizzy. Dizzy. Dizzy. Holy-Radio-Active-System . . . hold it! Flash bulbs pop. Controls are giving out . . . Release, angelic laughter: Ha. Ha. "Hush. Hush," says Winnie-the-Pooh in the cobwebs under the rusty pipes. "Only the factual is actual, here in the U.S.A." Who can hear the wretched and the diseased shouting for deliverance? Havoc gives way to havoc. The way mucous gives way to snot. Reels of film project: a procession of Nazis dragging an aluminum hearse, armies carrying standards of black fiberglass monsters, workers driving multi-colored automobiles, females dripping poly-unsaturates; all parade into the world's largest submarine. Iconographic snapshot: Number One. Harpies swoop into a "twist" palace and tear away bits of cosmic flesh. Iconographic snapshot: Number Two. Keepers of a reptile farm in Florida "milk" rattlesnakes. Iconographic snapshot: Number Three. A fake Etruscan Charon leads souls over a pool of whipped cream into a supermarket. Projections zero-in on a hermaphrodite in a space station, chanting a dirge, nothing excessive to be sure. Upon the mounds of tutti-frutti, the False Prophet displays his five vile wounds. From stage right: Indians on Warpath gallop in and take many scalps. From stage left: In a fog, Valkyries swinging baffle axes demolish uncountable enemies. On side stage X-666: The lords of industry set up a skyscraper on the broken piles of "earthquake." Baroque. Cut! Print It! SHARP FOCUS—mark. X. Minus zero. And now an advertisement. (A redeeming bath in Coca-Cola will heal all wounds, even the . . . *wonderful Wounds* in the *little World* . . . that Cotton Mather describes in *The Nature and Reality of Witchcraft.* So, friends, fill your bathtub tomorrow with that everlovin' redemption: Coca-Cola.) Faustus has drowned in Coca-Cola, but every now and then his voice still bubbles up saying, "See, see, where Christ's blood streams in the firmament! One drop would save my soul—half a drop! ash . . ." Fade out. Empty-eyed Luciferians are stamped out by the Incredible Iconographer with assembly-line etherized gestures. An iconostasis is erected in record time on the Haceldama. Gravestones made of "polar-foam" emblazoned with glamorous faces of lady heresiarchs are backdrops for the Intelligentsia twiddling over the Bhagavad Gita and peyote. Gongs boom. Doooong . . . Bong. An intercontinental audience perceives . . . a curtain, upon which is written in demotic. (Boxes full. Stalls full. Gallery full. Pit full. *Standing room only!*) Refreshments are served in the Jungle Room. Cobalt violet deep, permanent bright green, and thalo red rose . . . Dot . . . Dot . . . Dot . . . Dash. Curtain going up! Iconomatic-Flashback: The Dark Ages in the desert of Chalcis, 374 A.D., writes St. Jerome: "Afterwards, however, sin broke out more vio-

lently, till the impiety of the Giants dragged after it the shipwreck of the whole world." Iconoclastic-Flash-forward: The Space Age in New York City, 1962 B.C., writes Tad Swule for the *Times*, "It is known that the Administration wishes to complete the tests as rapidly as possible." Applause. A collection is taken up for the War Against Mouth-Rot. A specter of Creeping Jesus is strontiumized in the Cedar Street Tavern through the eye of a safety pin. A peal of woes. A nameless augur pronounces the benediction: "Convert to Hoboken, and cry unto her!" The unpainted vision departs. . . . A wolf-man (geniuses know where he lives) howls on a fire escape in Chelsea. Fac me plagis vulnerari. Who can paint it steadily? In St. Patrick's Cathedral a wax pope watches Luis Buñuel's *Viridiana* in tones of crimson. The graphic needle pierces the Hairy-Heart—atrobilious acid squirts on canvas thin as a spider's web. Says Cocteau under opium, "The esthetics of failure are alone durable." Are these the *Leçons de Ténèbrae*? Is this where the Cocytus and Acheron meet in the midnight grove at the cutting edge? GENERAL PARALYSIS. No! No! No! A 1000 times No! The last "no" twitching like the severed chicken-heads in Robert Frank's *The Sin of Jesus*. "I am pursued like a wolf out of the sheep-fold," said the prophetess Maximilla against her will. Air-waves . . . blow-out. The "drip" is immolated! Blessed be the teen-queen who dashes her records against the Hi-fi. Hollywood officials sign her up. Vista-Scope captures the movement. Behold, on the wide screen Mother Nature turning herself inside out, exposing growing grey agony. Cameras! Action! Darkness! Bullets rip through Mother Nature at supersonic speed, taking big hunks of grey-stuff with them. Print it. The landscape grown smaller, sucking itself in . . . deeper and deeper where the ridiculous artist paints nature's dirty secret under the "dim religious light" in a Manhattan loft. In such an atmosphere the artist might cry out with St. Mary Magdalene of Pazzi, "O nothingness! how little art thou known!" Our gaze becomes full of cyclotrons and accelerates into a lead wall. "We want honest art criticism!" demand the *art-lovers*. Alas, the extinguishment of the major spotlights is taking place. Before the Grand Wipe Out, Grandma Moses appears in the Burning Bush of Life Magazine, then dissolves into an unusually cheap pile of ashes. . . . Such ashes recall the words of Dionisie Vasques, the preacher admired by Pope Leo X: "Wretched and skeptical worldlings!" That is our ration of grace for the *time being*. The iconoscope is drawing to the End. There are other things to do before starting again. Like understanding Cézanne.

Anything for the sleep of spiritual suicide! Yes, by Death . . . myriads of vacant dreams with dematerialized souls plotting the destruction of the Millenium. Hamburger Heaven prepares sport on the jelly-tart, according to blitzed theology. Wailing gives way to numb limbs and roots, before the declining Inquisitor. Flayed icons are painted with tar by the Great Master Painter from the faraway Cesspool. Art works in mysterious ways.

What else can one do but rejoice into the whirlwind of distraction torn by

distraction? The Divine is blasted, so rejoice, "Who is this King of Glory? The Lord of hosts, He is the King of Glory." A beatified groan rolls over distorted war-machines covered with cubism. "But Life," said Langland, "only burst out laughing and meant to have his clothes slashed in the new style." Grey the transubstantiation. Grey the Flesh and Blood. Grey the Pantokrater. Played backwards and forwards, a worn-out holocaust falls apart on the cycles of emptiness. And the angel said, "The Words of the Preacher, Son of David, King in Jerusalem . . . Gee whizz . . . Mother . . . not that again. We have new mediums, new materials, and new programs." Said Walter Winchell to the angel, "Bye, Sweety. Don't forget to pack your halo!" "So, Halo everybody! Halo. Halo Shampoo! Halo!" Said Samuel Beckett's Vladimir (exploding), "It's a scandal!" Merry Twistmas.

The day of the artist is very long, but the zeros must be painted at an average of one hundred per minute. Zeros within zeros for zeros by zeros. That was a way of painting it. Not very dynamic. A feeble push and pull over the grey surface. The icon is sinking into a big vat of grey paint, and there is nothing to do but watch it sink like the watchman watches the night.

> Such was the burden of nowhere.
> Worthless are my prayers and sighing.
> Yet, good Lord, in grace complying,
> Rescue me from Fires undying.

THE ELIMINATOR (1964)

The Eliminator overloads the eye whenever the red neon flashes on, and in so doing diminishes the viewer's memory dependencies or traces. Memory vanishes, while looking at the Eliminator. The viewer doesn't know what he is looking at, because he has no surface space to fixate on; thus he becomes aware of the emptiness of his own sight or sees through his sight. Light, mirror reflection, and shadow fabricate the perceptual intake of the eyes. Unreality becomes actual and solid.

The Eliminator is a clock that doesn't keep time, but loses it. The intervals between the flashes of neon are "void intervals" or what George Kubler calls, "the rupture between past and future." The Eliminator orders negative time as it avoids historical space.

THE HUM (c. 1965)

Descriptions of works of art often go astray. Words and numbers are as fugitive as infinity. Actually, I would prefer to tell you less and less about the art in front of you. Perhaps an uninterrupted hum would be the best description of the art you see. I will now sing a hum of my own composition:

HMMMMMMMMMMMMMMMMMMMMMMMMMMMMM

(The artists hums for the duration of one deep breath.)

A determined meaning is not the kind of meaning that I am looking for, perhaps meanings aren't even necessary at all, perhaps meanings should be lost and not found. Yet the disappearance of significance I suppose is found through significance. At any rate, for those who want to know more about that type of disappearance, I suggest you go into the little room on your left, where you will find a "partial description" of my mirror piece.

Untitled, 1963/64. Steel, mirrorized plastic, 50 x 12 x 18½".

A SHORT DESCRIPTION OF TWO MIRRORED CRYSTAL STRUCTURES (1965)

Both structures have symmetric frameworks, these frameworks are on top of the faceted mirrored surfaces, rather than hidden behind the surfaces. The frameworks have broken through the surfaces, so to speak, and have become "paintings." The frameworks are light blue with rose mirrors and yellow with blue mirrors.

Each framework supports the reflections of a concatenated interior. The interior structure of the room surrounding the work is instantaneously undermined. The surfaces seem thrown back into the wall. "Space" is permuted into a multiplicity of directions. One becomes conscious of space attenuated in the form of elusive flat planes. The space is both crystalline and collapsible. In the rose piece the floor hovers over the ceiling. Vanishing points are deliberately inverted in order to increase one's awareness of total artifice.

The commonplace is transformed into a labyrinth of non-objective abstractions. Abstractions are never transformed into the commonplace. All dimensionality is drained off through the steep angled planes. The works feed back an infinite number of reflected "ready-mades."

RESPONSE TO A QUESTIONNAIRE
FROM IRVING SANDLER (1966)

<div align="right">May 25, 1966</div>

Dear Mr. Smithson,

Eight years ago, I asked seventeen artists to write statements about the state of American art then. The results were printed in *Art News.* ("Is There a New Academy?" Summer and September, 1959.)

Now that new tendencies have emerged, Barbara Rose and I thought of attempting a similar compilation. We have sent the enclosed questionnaire to a selected group of artists, and we would appreciate your filling it out and returning it in the enclosed envelope by July 1, so that we may tabulate and publish the results.

Cordially,
Irving Sandler

1. *Is there a sensibility of the 1960's? If so, how would you characterize it?*

There is not one sensibility of the 60's, but ten sensibilities of the 60's.
1. The sensibility of momentary paralysis.
2. The sensibility of inauthentic boredom.
3. The sensibility of Habit.
4. The sensibility of monotonous and wholesome plagiarism.
5. The sensibility of involuntary memory.
6. The sensibility of stupefying adjustments and readjustments.
7. The sensibility of the dynamics of banality.
8. The sensibility of frozen time.
9. The sensibility of neither tomorrow or yesterday.
10. The sensibility of stale thoughts.

2. *Is there an avant-garde today? What is its nature?*

There is not one avant-garde "today" but ten avant-gardes.
1. The avant-garde of dissipated scandals.
2. The avant-garde of less than nothing.
3. The avant-garde of cemeteries.
4. The avant-garde of almost complete blindness.
5. The avant-garde of colorful French bohemians at the turn of the century.
6. The avant-garde of simian vulgarity.
7. The avant-garde of endless lies tantamount to significance.
8. The avant-garde of vicious circles, logical illusions, tautologies, obvious contradictions.

9. The avant-garde of the Kitsch of the recent past.
10. The avant-garde of almost complete blindness.

3. *Has the sensibility of the sixties hardened into an academy? If so, what are its characteristics?*

There is not one sensibility that has hardened into an academy, but ten "hard academies."
1. The hard academy of lead.
2. The hard academy of steel.
3. The hard academy of wood.
4. The hard academy of plastic.
5. The hard academy of iron.
6. The hard academy of wax.
7. The hard academy of chrome.
8. The hard academy of cement.
9. The hard academy of glass.
10. The hard academy of mirrors.

4. *Has the condition of the artist changed in the sixties? Has the speed-up of communications and the increased attention of the mass media made yesterday's avant-garde today's academy? How has this affected the artist? Does the growing participation of art schools in colleges and universities make for a more academic situation?*

There is not one condition of the artist in the sixties, but ten conditions.
1. The condition of reinterpretating the misinterpreted.
2. The condition of the nonentity.
3. The condition of isolated systems at the dead level.
4. The condition of unkempt bathrooms.
5. The condition of provisional opacity ordered by The Grand Horizonal.
6. The condition of smiling faces.
7. The condition of One Hundred Mass-Mediae.
8. The condition of Standardization.
9. The condition of historical blind spots.
10. The condition of codified nullity.

5. *Is there the same split between the avant-garde and the public as formerly? How has this relationship changed?*

There is not one split, but ten splits.
1. The split between the eyes.
2. The split between the idea of unity.
3. The split between me and you.
4. The split between the Old Masters and the New Masters.

5. The split between the light and the dark.
6. The split between the left and the right.
7. The split between the now and the then.
8. The split between the big and the little.
9. The split between the warm and the cool.
10. The split between the split.

COLOSSAL NULLIFICATIONS (PART I) (c. 1966)

This is still a period of disintegration in all the arts. We have *happenings*, rather than plays. Art but no painting. It's a challenge of chaos. There's no particular advantage to chaos, but that's where we are.

Philip Johnson
Fortune, January 1966

. . . . an atmosphere which had no affinity with the air of heaven but which had reeked up from decayed trees, and the gray wall, and the silent tarn—a pestilent and mystic vapour, dull, sluggish, faintly discernible, and leaden-hued.

Edgar Allan Poe
The Fall of the House of Usher

Philip Johnson's awful proposal for Ellis Island discloses a grand way to meet the "challenge of chaos." The utilitarian buildings now standing on the island are to be turned into "stabilized ruins," evoking not only the "hopes of the immigrants," but also the unresolved nihilism and hidden fears of the 19th century. The main structure to be built by Philip Johnson could be considered a "stabilized void." A spiraling ramp runs around "The Wall of 16 Million," upon which there is a dizzying collection of immigrants' names. This could also be a monument to Edgar Allan Poe's Roderick Usher. It may well be that Poe was really an architect and only invented the detective story to make ends meet. Poe's ideas for structure and artifices abounded throughout his work. "The general floor of the amphitheatre was *grass* . . . ," ". . . . the infernal terrace seen by Vathek . . . ," "The blank wall of the eastern gable was relieved by stairs . . . ," "shingles were painted a dull gray" (*Landor's Cottage*); "In each of the angles of the chamber stood on end gigantic sarcophagus of black granite . . ." (*Ligeia*). The moods of Mr. Poe and Mr. Johnson cross paths, especially if we consider the fabulous tomb and/or underground museum in New Canaan, Conn.

ATLANTIC CITY (H-13) (1966)

All year seaside resort offers six mile board-walk lined with hotels, shops, amusement areas and entertainment piers. Miss America pageant in September. In nearby Somers Point is Somers Mansion, birthplace of Commandant Richard Somers, Battle of Tripoli hero. Tues. Sat. 10–12, 1–5; Sun. 2–5. 25¢.

<div align="right">

New Jersey Map

Esso

</div>

The following is nothing but a restoration of a trace.

On a bright Sunday morning sometime in the Spring 1966, a group of us, Carl Andre, Robert Morris, Virginia Dwan, my wife Nancy, and I set out on a cartographical expedition in a Rent-A-Car station wagon to make site selections for an "earth-moving" project in South Jersey. We had an Esso Map that we used in order to get to Keasley, a small town on the Raritan River near Perth Amboy. Under a vast concrete bridge near there are brick and tile furnaces, a carborundum plant and a lead factory. Nancy and Virginia took some photos in that area. After that we went down the turnpike, and turned on to State highway 70 near a place called Leisure Village.

From there we went south-west to the Pine Barrens with close to 20 Quadrangle maps stacked on the floor.

THE SHAPE OF THE FUTURE AND MEMORY (1966)

My thoughts on art, like Humpty Dumpty, have fallen off the wall of language and will never be put together again. The "visual" memories of something terrible are buried under pressure in my tiers of glass sheet. Pictures of the future slip from my sight through the progressions of mirrors. Memories have a way of trapping one's notion of the future and placing it in a brittle series of mental prisons. Memory becomes sedentary and sooner or later finds a physical shape (art), and this memory emerges from future time. The "time traveler" as he advances deep into the future discovers a decrease in movement, the mind enters a state of "slow motion" and perceives the gravel and dust of memory on the empty fringes of consciousness. Like H. G. Wells, he sees the "ice along the sea margin"—a double perspective of past and future that follows a projection that vanishes into a nonexistent present. I have constructed some replicas of such perspectives, but I find they tell me less and less about the structure of time. The perspectivism of my esthetic has caved-in along orderly rows, or a surface illusionism has collapsed into deposits at the bottom of boxes. The continuous

dimensions of space with all its certainties and rationalisms have broken through my conciousness into the discontinuous dimensions of time where certainties and rationalisms have little value. The calamitous regions of time are far from the comforts of space. The artifical ingenuity of time allows no return to nature. Mirrors in time are blind, while transparent glass picks up reflections in this spaceless region of inverse symmetry and shifting perspectives—the mirror reflects the blank surface in the suburbs of the mind. There is nothing to "understand" about such a region except the consciousness that makes understanding impossible. Only when art is fragmented, discontinuous and incomplete can we know about that vacant eternity that excludes objects and determined meanings. The mirror and the transparent glass bring us to those designations that remain forever abolished in the colorless infinities of a static perception. Unity is a natural idea, that belongs more to life (also called reality) and not to the terrible dualities of great art. Unity has its origin in chaos, while duality has its origin in the cosmic. And every cosmic system is a false one, that at times slips into the chaos of nature. This falseness must be protected from the murky waters of life's truth. Nothing is more corruptible than truth.

PREDICTABLE MODEL
FOR UNPREDICTABLE PROJECT (c. 1966)

```
18 18 18 18 18 18 18 18 18 18 18 18 18 18 18 18 18 18
17 17 17 17 17 17 17 17 17 17 17 17 17 17 17 17 17 17
16 16 16 16 16 16 16 16 16 16 16 16 16 16 16 16 16 16
15 15 15 15 15 15 15 15 15 15 15 15 15 15 15 15 15 15
14 14 14 14 14 14 14 14 14 14 14 14 14 14 14 14 14 14
13 13 13 13 13 13 13 13 13 13 13 13 13 13 13 13 13 13
12 12 12 12 12 12 12 12 12 12 12 12 12 12 12 12 12 12
11 11 11 11 11 11 11 11 11 11 11 11 11 11 11 11 11 11
10 10 10 10 10 10 10 10 10 10 10 10 10 10 10 10 10 10
 9  9  9  9  9  9  9  9  9  9  9  9  9  9  9  9  9  9
 8  8  8  8  8  8  8  8  8  8  8  8  8  8  8  8  8  8
 7  7  7  7  7  7  7  7  7  7  7  7  7  7  7  7  7  7
 6  6  6  6  6  6  6  6  6  6  6  6  6  6  6  6  6  6
 5  5  5  5  5  5  5  5  5  5  5  5  5  5  5  5  5  5
 4  4  4  4  4  4  4  4  4  4  4  4  4  4  4  4  4  4
 3  3  3  3  3  3  3  3  3  3  3  3  3  3  3  3  3  3
 2  2  2  2  2  2  2  2  2  2  2  2  2  2  2  2  2  2
 1  1  1  1  1  1  1  1  1  1  1  1  1  1  1  1  1  1
```

PREDICTABLE MODEL
FOR
UNPREDICTABLE PROJECT

PROPOSAL FOR THE DETECTION OF
APPROXIMATE PERIOD QUANTITY (c. 1966)

Procedure

1. Select a bookcase full of books.
2. Measure the limits of the bookcase (height and width).
3. Count the books.
4. Take the first book and count the number of periods on the first full page of type.
5. Multiply that number by all the pages in the book.
6. Record the title and the approximate number of periods in each book.

Form for Recording Data

1. Name of period detector.
2. Size of bookcase (height and width).
3. Total number of books in case.
4. List of all the book titles with the approximate total number of periods in *each* book.
5. Total of all the periods in the entire bookcase.

Send data to Dwan Gallery, 29 West 57th Street, New York, N.Y.
Frontal photographs of bookcase—optional.

A book containing a compilation of the data-returns is also proposed.

AN ESTHETICS OF DISAPPOINTMENT (c. 1966)

On the occasion of the art and technology show at the Armory.

Many are disappointed at the nullity of art. Many try to pump life or space into the confusion that surrounds art. An incurable optimism like a mad dog rushes into the vacuum that the art suggests. A dread of voids and blanks brings on a horrible anticipation. Everybody wonders what art is, because there never seems to be any around. Many feel coldly repulsed by concrete unrealities, and demand some kind of proof or at least a few facts. Facts seem to ease the disappointment. But quickly those facts are exhausted and fall to the bottom of the mind. This mental relapse is incessant and tends to make our esthetic view stale. Nothing is more faded than esthetics. As a result, painting, sculpture, and architecture are finished, but the art habit continues. The more transparent and vain the esthetic, the less chance there is for reverting back to purity. Purity is

a desperate nostalgia, that exfoliates like a hideous need. Purity also suggests a need for the absolute with all its perpetual traps. Yet, we are overburdened with countless absolutes and driven to inefficient habits. These futile and stupefying habits are thought to have meaning. Futility, one of the more durable things of this world, is nearer to the artistic experience than excitement. Yet, the life-forcer is always around trying to incite a fake madness. The mind is important, but only when it is empty. The greater the emptiness the grander the art.

Esthetics have devolved into rare types of stupidity. Each kind of stupidity may be broken down into categories such as bovine formalism, tired painting, eccentric concentrics or numb structures. All these categories and many others all petrify into a vast banality called the art world which is no world. A nice negativism seems to be spawning. A sweet nihilism is everywhere. Immobility and inertia are what many of the most gifted artists prefer. Vacant at the center, dull at the edge, a few artists are on the true path of stultification. Muddle-headed logic is taking the place of clearheaded illogic, much to nobody's surprise.

Art's latest derangement at the 25th Armory seemed like The Funeral of Technology. Everything electrical and mechanical was buried under various esthetic mutations. The energy of technology was smothered and dimmed. Noise and static opened up the negative dimensions. The audience steeped in agitated stagnation, conditioned by simulated action, and generally turned on, were turned off. This at least was a victory for art.

SOL LEWITT　　(1966–67)

Dwan Gallery Press Release

LEWITT's elementary skeletal cube is projected into an inert magnitude. These progressions lead the eye to no conclusion. The high degree of structural organization dislocates one's "point of view." One looks "through" his skeletal grids, rather than "at" them. The entire concept is based on simple arithmetic, yet the result is mathematically complex. Extreme order brings extreme disorder. The ratio between the order and the disorder is contingent. Every step around his work brings unexpected intersections of infinity.

A REFUTATION OF HISTORICAL HUMANISM (1966–67)

As the myth of the Renaissance degenerated throughout the last few centuries, it was picked up by self-appointed critics, who in turn developed personal notions of "value" in terms of what can only be called "historical humanism." The artist's role has been defined long enough by that insidious complicity. Every art critic claims some kind of knowledge of "history," which he personally has recovered from the past. But this "history" begins and ends with the critic's own opinion of what art is. There are as many art histories today as there are critics. There is no such thing as one history of art.

Like "God," the notions of "life" and "death" are no longer relevant to art. Art is not biology. The very term Renaissance, meaning "rebirth," is fallacious. When did art ever die? People die, but art is just art. Art exists in time and is either remembered or forgotten, but never dead or alive. Sometimes critics get so "self" involved they say a work of art has "guts." The biological metaphor may define the layman's so called "life," but it should not be attached to art. Labor pains should not be confused with the fabrication of art. Do we really need the petty histories that have been turned out by critics who can't see past their own personal problems?

It is time for artists to turn away in disgust from all the excuses that self-opinionated criticism has promoted. What is needed is an art that refutes all the gratuitous rewards and values. No more puny experiences, humble pie, or aspirations to work or craft. No *value* at all! The wisdom of "blood, sweat and tears" is just another indulgence, another submission to the fraud of self-expression by way of self-criticism. Misery means nothing. Recovery of value through misery is no solution. Action is the source of all misery, but how many people will accept that? Tragedy is a cheap trick, or at best the classical illusion. The artist must stop being a guilty scapegoat for a world full of slap-happy religious attitudes.

Back in the 1950s much was said about "action." Artists and critics, out of some kind of mutual guilt, made excuses for their art and criticism by saying that art was involved in "action," or that "art is life," or that "art is self-evident." This guilty partnership exists today in "formalist art." Where ever one finds discussions of "form vs. content," you can be sure to find self-guilt.

The act of artistic innocence is no longer very convincing. Innocence is part of the theatre of tragedy or what is now called "The Theatre of the Absurd." Artists should be conscious of the roles they are playing. The notion that artists have "deep feelings" and "pure souls" is simply a way to keep the artist in his mythic state of isolation. The first person role that the artist is forced into by the humanist is just another way to confuse "art" and "life." This first-person role insures the humanist's need for a scapegoat, and redemption through art.

Art is not redeeming, it contains no self-evident value. Most statements by artists today are in the first person. Until these "I"-centered statements are abolished—artists will continue to be judged according to some critic's personal notion of history. The artist should be an actor who refuses to act. His art should be empty and inert. Self-expression must be voided. Art should eliminate value, and not add to it. "Value" is just another word for "Humanism."

Art is suppressed in all our schools under the censor called "The Humanities." Humanism poisons all consciousness of art by opposing "life" to "art." Philosophies of "life against death" are simply the leftovers of a rather unfortunate religious ethic. An ethic by the way, that led to communism and fascism. If we can do without God, then the artist can do without "life" and "death," and all the other self-indulgent myths.

Any critic who says he is concerned with "self," implies that art is in some way united with "character," or "personality," or "individuality." Self-criticism never is concerned with art, but only with criticizing the self. Art is not self.

A vindication of art is in order, a vindication from all "self" criticism and censure. For too long the critic has provided "artistic" excuses for the layman.

The artist should declare his art apart from the self-involving traps of innocence and guilt, and resist all forms of humanism. And this declaration should be repeated ad infinitum.

THE PATHETIC FALLACY IN ESTHETICS (1966–67)

Esthetic attitudes have not been sufficiently considered in America. What passes for art criticism is based on empathic identification with art. The projection of one's self into either "form or content" does not result in a valid esthetic from the standpoint of abstraction. This attitude has its origin in Bernard Berenson's approach to the Renaissance. His view of art is based solely on emotional responses, which disclose nothing but empathy or pathos.

This empathic response is to be found in the criticism of Clement Greenberg and Michael Fried. Their curious brand of what I will call "expressive-formalism" has its roots outside of abstraction. Fried believes Kenneth Noland's paintings to be "at the bottom expressive in intent." If we accept Fried's attitude toward Noland, we soon discover a complicity that tends to be empathic (The Pathetic Fallacy). I maintain that abstraction is not governed by "expression" or what Greenberg calls "experience," but by a mental *attitude* toward esthetics that is in no way dependent on formal reduction. An Egyptian idol is

more abstract than a Noland painting, because it excludes emotional needs. Abstract art does not appeal to the emotions but to the mind. All expressive art is representational.

As Worringer pointed out in his *Abstraction and Empathy* any will toward space is not an abstract concern. Critics who interpret art in terms of space see the history of art as a reduction of three-dimensional illusionistic space to "the same order of space as of bodies" (Greenberg—*Abstract, Representational and so forth*). Here Greenberg equates "space" with "our bodies" and interprets this reduction as "abstract." The fallacy here is a self identification with space, that is less abstract than the so-called representational "Old-Masters." The closer one gets to space as a measure of man the less it has to do with the abstract.

This fallacy is revealed in Barnett Newman's *The Stations of the Cross*. Here is the pathetic reduction at its most extreme. Newman's art begins with abstraction but results in an anthropomorphizing of space. In other words, instead of representing pictorial events he represents spatial events on an empathic scale, i.e. "man as the measure of space." The viewer is expected to empathize with "the story of each man's agony." This is "expressed"—valid abstraction is not expressive. Abstract art does not suggest "life or death."

All "formal" criticism and art is based on representational space and its reduction. The latest "formal advance" to come out of this "reductive tendency" has to do with the "framing support." "The picture-support," as it is also called, is interesting as a critical mutation of Greenberg's space speculations, but should not be considered abstract by any stretch of the imagination. Yet, the dubious seriousness and pretended rigor of Fried's criticism tends to keep the "space" myth going. All of Fried's remarks about "color" and "structure" are empathic with vague references to Wittgensteinian humanism. This brings Fried very close to Newman's pathos. But ultimately Newman's is more interesting than Fried's.

Esthetics have been suffering from an acute case of empathy, ever since empathic esthetics was popularized by Bernard Berenson, Theodore Lipps, Vernon Lee, and the early Heinrich Wölfflin. The empathic projection of the "self" into an art-object has determined almost all esthetics of the last fifty years or so. Recently, both Alain Robbe-Grillet and Don Judd have attacked this empathic esthetic. In Judd's *Specific Objects*, one detects a dissatisfaction with the problem of space. In Robbe-Grillet's essay *Nature Humanism Tragedy*, one finds an explicit rejection of anthropomorphic "complicity." Things are not filled with any *humanist* justifications. "Things are things, and man is only man." Abstract art is not a self-projection, it is indifferent to the self.

ABSTRACT MANNERISM (1966–67)

Some artists never question the "creative process"; they consider it to be quite natural. Yet, no matter how naturally creative the artist is, no matter how much he relies on "smart instincts," little bits of self-consciousness creep into his art. What is called "cool" today is in a way the rebirth of the Mannerist sensibility. That chilly style has replaced the naive hot-blooded notion of the artist as a "painting animal." If it can be said that Abstract Expressionism originated in the "unconscious" within a "natural" frame of reference, then it can be said that the New Abstraction or Post Painterly Abstraction originated in an ultra-consciousness and far from anything called nature, even ideal nature.

In certain works by Kenneth Noland, one may find expressionistic affectations like little hints or references to the "drip" or the "splash." Such deliberate or non-deliberate mistakes give one much food for thought. It's hard to tell whether Noland's "mistakes" are more or less interesting than Andy Warhol's fake "corrections." But, I guess, the whole world loves a goof every now and then, especially if it carries with it some kind of odd seriousness. After all, when the paint surface is messed up a bit, it proves that the artist is "human." This kind of false expressionism exists in the work of Larry Poons (impasto dots), Frank Stella (the bleed on the edge of the metallic stripes), and Neil Williams (the washy fluorescent surfaces).

When the "tough guy" artist plays it cool little bits of expressionism boil up here and there. The "noble savage" gambit dies hard in the formalist vice. Ultra-conscious yearns for the good old 50s when art came from the "unconscious." Lusting for life somehow ends in the movies with *What's New Pussycat*. While the art is like cerebral ice, the artist comes on like the caveman-truck driver-killer. It's something like the homosexual who acts like a Nazi.

Ever since Clement Greenberg took over T. S. Eliot's role as the formalist culture-hero, he has been the keeper of abstract "quality." The word "quality" has many propaganda purposes. It is used in the art world the same way it is used in the advertising world. "The canvas standard stands for quality," Marcel Duchamp might say. Nevertheless, it was Greenberg, who in his flight from hard-core Cubism to soft-core Cubism, i.e., from Picasso to Morris Louis, stumbled on that great Mannerism, ultra-consciousness of the "framing edge." Before we go on, let us look back into awful art history. Jacques Bousquet in his book *Mannerism* says, "By a typically Mannerist paradox, the frame became the picture. In France, the feigned frame enjoyed great vogue." Meanwhile, back at the Avant-Garde, which is beyond history, Greenberg tells us in his essay, *"American type" Painting*, "What is destroyed is the Cubist, and immemorial, notion and feeling of the picture edge as a confine; with (Barnett) Newman, the picture edge is repeated inside, and *makes* the picture, instead of merely being *echoed*." History repeats itself, but in the Abstract.

THE ARTIST AS SITE-SEER; OR, A DINTORPHIC ESSAY (1966–67)

PART ONE

> The system of megaliths now provided a complete substitute for those functions of his mind which gave to it its sense of the sustained rational order of time and space, his awareness kindled from levels above those of his present nervous system (if the autonomic system is dominated by the past, the cerebro-spinal reaches towards the future). Without the blocks his sense of reality shrank to little more than the few square inches of sand beneath his feet.
>
> J. G. Ballard, *Terminal Beach*

Once we are free from utilitarian presuppositions we become aware of what J. G. Ballard calls "*The Synthetic Landscape*," or what Roland Barthes refers to as "the *simulacrum* of objects," or what Tony Smith calls the "artificial landscape," or what Jorge Luis Borges calls "visible unrealities."[1] What do these four persons have in common?[2] Not assumptions or beliefs of any kind, but the same degree of esthetic awareness.[3] For them the environment is coded into exact units of order, as well as being prior to all rational theory; hence it is prior to all explanatory naturalism, to physical science, psychology, and also to metaphysics.[4] An example of this environmental coding is Stonehenge.[5]

Far from being a primitive Druid Temple, it turns out that the 3500-year-old Stonehenge was actually a complex astronomical observatory—in fact, a Neolithic computer, built to predict eclipses, and to follow solstices and equinoxes.[6] By following the intervals of "extreme azimuths" suggested by Diodorus, a historian from about 50 B.C., Gerald S. Hawkins has decoded the cycles of Stonehenge.[7]

Robert Morris has said that what interested him most when he visited Stonehenge was not the trilithons at the center of the monument, but rather its mound-like fringes.[8] This penumbral region that interested Morris caused me to think of George Kubler's theory of "Prime Objects and Replication."[9] Says Kubler, "Prime objects resemble the prime numbers of mathematics because no conclusive rule is known to govern the appearance of either, although such a rule may some day be found."[10] What Kubler suggests in his theory is an "equality" between the "prime" and the "replication" that maintains itself throughout the monotony of "Historical Drift."[11] Prime objects do not decompose, because like prime numbers they resist decomposition because of their enigmatic origin, which is what Morris calls "unitary."[12] In short the prime object is immobile and often indestructible.[13] Kubler maintains that "buildings" constitute most of our primes.[14] Very few primes survive, so it

seems only logical for Morris to want to build the edge-ring of one of the world's most completely manifest prime objects—Stonehenge.[15] One manifestation of Morris's art is a tendency to confined *amorphousness*.[16]

J. G. Ballard in his The *Waiting Grounds* discloses evidence of the prime enigma.[17] The idea of the "megalith" appears in several of Ballard's science-fiction stories, but in *The Waiting Grounds*, we find many references to codes that are "chiselled" onto the "five stone rectangles."[18] They are "strings of meaningless ciphers . . . intricate cuneiform glyphics . . . minute carved symbols . . . odd crosshatched symbols that seemed to be numerals."[19] Could these be the "millions of utterances," that Kubler speaks of in reference to the "replica-mass"?[20] Is language at the root of these megaliths, the way mathematics is at the root of geometry?[21] Is the verbal prior to the material?[22] The "noise of history" is contained by Ballard's megaliths.[23] The abyss of language erases the supposed meanings of general history and leaves an awesome "babel."[24] These megalithic rectangles are Ballard's memory traces of that elusive prime object—the Tower of Babel.[25] Writes Ballard, "I went over to the megalith on my left and began to examine the inscriptions carefully. Here the entries read:

MINYS-259	DELT*	ARGUS	AD 1874
TYLNYS-413	DELTA	ARGUS	*D 1874
.

There were fewer blanks . . ."[26]

Ed Kienholz it seems would like to add in the wake of this babel—"THE WORLD"—"a simple rectangle of concrete". . . where upon people may inscribe something "stupid or obscene."[27]

The Great Pyramid would qualify as a prime object, but would not as a Juddian "specific object."[28] Nevertheless, it is an agglomeration of codes, puzzles, clocks, tombic theories, secret passages, and lacunary mathematics.[29] The Great Pyramid does not exist in terms of character or individual, but as a "semblance."[30] Like Stonehenge, it is an awesome computer, based on orbital chronologies and shifting calendars.[31] The purpose of The Great Pyramid was defined by the Hebrews centuries ago—the name they gave it "Urim-middin"="Light-Measures," and the Phoenicians called it "Baal-Middon" ="The Lord of the Measures."[32] Greek "Pyra"="beacon fires."[33] "Urin"= "Purim"="Lights."[34] In Greek it becomes "Pyra-midos," "Pyra-mid."[35] A "beacon of reflexions," and a "monument of measures."[36]

The prime object becomes the prime number, if seen as "the monument of measures."[37] The prime number only refers to itself or 1 and is in a way like the Kantian "thing in itself."[38] The only even prime is 2.[39] The distribution of primes in a number system is irregular.[40] For example, there are five primes between 100 and 114, but none between 114 and 127.[41] Ever since Euclid's proof that primes are infinite, mathematicians like some artists have been looking for that "conclusive rule," that would determine whether or not a number like an

object is prime.[42] But the infinite, as Borges warns, is a "numberous Hydra" and a "swamp monster."[43]

Alexander Graham Bell (1847–1922) generally known as "the inventor of the telephone" may be viewed esthetically as the first "structuralist" to deal with language in a concrete way.[44] In 1873 he traced space sounds upon smoked glass with the aid of a device called the "phonautograph" (Scott and Koenig) (1859) which was a kind of early oscillograph.[45] The speech patterns were fixed on the glass and called a "visual form" by Bell.[46] Such visible speech patterns are measured by spectrographs.[47] The "stacking" of successive instants of speech makes it possible to "read" the stacked spectra, and identify the syllables, words, or sentences visually.[48] This phonetic logic seems to have something to do with Bell's lattice structures, which anticipate R. Buckminster Fuller and Sol LeWitt.[49]

The fundamental unit of measure of prime and object number is the module.[50] Bell's tetrahedronal lattice systems were used as "kites" to make flight tests.[51] He also built an extraordinary tower that was made of prefabricated, standardized mass-produced tetrahedral units.[52] A perfect prime object may be seen in his pyramid-type observation post.[53] From this simple wooden shelter he would supervise his aerodynamic experiments.[54]

There seems to be parallels between cybernation and the world of the Pyramid.[55] The logic behind "thinking machines" with their "artificial nervous systems" has a rigid complexity, that on an esthetic level resembles the tombic burial structures of ancient Egypt.[56] The hieroglyphics of the *Book of the Dead* are similar to the circuit symbols of computer memory banks or "coded channels."[57] Perhaps, one could call a computing machine—an "electric mummy" —*the medium is the mummy*.[58] All the content is removed from the "memory" of an automaton, and transformed into a "shape" or "object."[59] The mummy like the automaton has vacant memories, that remember voids of meaning.[60]

Both cybernetics and Egyptian ritual seem to be contributing to what Erwin Panofsky calls, "... the collective memory of mankind, in Greek *threnoi*, and the Roman *conclamationes*." (See *Tomb Sculpture: Its Changing Aspects from Ancient Egypt to Bernini*.)[61] Binary numbers are in computers transferred into magnetic memory cells, and then packed into ordered layers; they form a silent dirge.[62] Hundreds of thousands of cells will fit in less than a cubic foot of space.[63] The memories run through standard computer code groups the same way the threnoi of hieroglyphics run through Egyptian funerary sculpture.[64] Simulated intelligence fabricates "memories" that are neither dead nor alive; such coded information feigns the possibility of immortality.[65]

It seems that the tendency toward "tombic communication" is still with us, even if its process is apparently invisible.[66] Art not only communicates through space, but also through time.[67] The "formal" categories of "modernism" have lost this fact.[68] Rational concerns with cubism or the return to impressionism by way of "color field painting" force art into "histories of taste."[69] The mind as well as the eye belongs to art.[70] To talk constantly "about seeing" is a linguistic

problem not a visual problem.[71] All abstract concepts are *blind*, because they do not refer back to anything that has already been seen.[72] The "visual" has its origin in the enigma of blind order—which is in a word, *language*.[73] Art that depends only on the retina of the eye, is cut off from this reservoir or paradigm of memory.[74] When art and memory combine, we become aware of the *syntax* of communication.[75]

NOTES

1. Other stories by J. G. Ballard: *The Wind From Nowhere, The Drowned World, Billenium,* and *The Voices of Time.* "If there is such a thing as critical proof," says Roland Barthes, "it lies not in the ability to *discover* the work under consideration but, on the contrary, to cover it as completely as possible with one's own language." Tony Smith makes "voids in space" that are "probably malignant." Jorge Luis Borges is, according to Anthony Kerrigan, "daring dryly to go beyond such a Mannerist master as James Joyce."

2. "these four persons"—drawn from the Great Number 4 *in abstracto* with special attention to the Doctrine of the Four Humours (Barthes = Sanguine . . . Ballard = phlegmatic . . . Smith = choleric . . . Borges = melancholic).

3. "the same degree"—near zero.

4. Phenomenology. Reality is enigmatic-inexplicable-baffling

5. In 1740 Dr. William Stukeley discovered the "druid cubit," a distance of 20.8.

6. Druidism was the religious and philosophic system of the Druids.

7. Diodorus, also spelled Diodotus, died in Cicero's house, 59 B.C.

8. Robert Morris is the author of:

 Dissatisfactions

 7/17/62 5:30 P.M.
 "That everything relevant will not be recorded."

9. "The penumbral region"—known as "barrows"—three types "bowl," "bell," and "disc."

10. George Kubler draws upon new insights in fields such as anthropology and linguistics and replaces the notion of style with the idea of a linked succession of works distributed in time as recognizable early and late versions of the same action. (Book cover blurb.)

11. "maintains itself throughout the monotony" 5 Kinds of Monotony: 1. television torpor. 2. muddy thinking. 3. discussions about "flying saucers." 4. false paths and stifling repetitions. 5. hypertrophy of detail.

12. "decomposition—according to Lahee's *Field Geology*—"slump/rapid flowage/soft muds/turbidity current/residual deposits/slush/fine sediment/brackish water fossils/ glaciofluviatile creepage/volcanic outbursts/swamp beds/lava flow/discordant plutons."

13. "immobile"—see Victor Brombert's study of Flaubert's *Salammbô: An Epic of Immobility*—*The Hudson Review*, Spring 1966.

14. Ad Reinhardt's thousands of color slides (architecture, sculpture, painting) go between "primes" and "replicas" within the context of his own categories (noses, eyes, feet, navels, and headlessness).

15. "the edge ring"—*A Project for Earth and Sod.*

16. "tendency to confined *amorphousness*"—Morris's "edge ring" presses into the ground. His other work also discloses this sinking kinaesthesia. A sensation of massiveness pulls one's view downward. The bulging masses in his forms avoid any reference to "frames" or "structural supports." Morris's bevelled corners break down the hard angle. His morphology submits to a mind-crushing pressure.

17. "enigma"—an ataraxic landscape.
18. "science-fiction" also called "science-fact."
19. Exhausted numbers: one . . . yawn . . . two . . . yawn . . . three . . . yawn . . . four . . . yawn . . . five . . . yawn.
20. Eva Hesse's notion of "metronomic irregularity" and her works of the same name evoke the lost tempo of "millions of utterances."
21. NO and YES.
22. YES and NO.
23. "noise"—gives no satisfaction to the listener, unless regularized.
24. "supposed meanings"—the usurpation of "tradition" and the degradation of "myth." T. S. Eliot is coupled with Jackson Pollock in William Rubin's "Jackson Pollock and the Modern Tradition." *Artforum*, February 1967. "Myths are easier to grasp than new and original abstract art. . . ." T S. Eliot is used as a weapon against "myths" by Mr. Rubin, yet Eliot based *The Waste Land* on the Grail legend and myths of vegetation.
25. "The Tower of Babel"—"These pilgrims disputed in the narrow corridors, proffered dark curses, strangled each other on the divine stairways, flung the deceptive books into the air shafts . . ." Borges.
26. On the walls of Ballard's Babel.
27. ". . . to be built at Hope, Idaho."
28. "Juddian"—"The warhead will be mated to the firing position"—refers to a "loricate" object by Lee Bontecou. *Arts*, April 1965.
29. "Lacunary"—See *Lacunary Films*, Monique Wittig in the *New Statesman*, July 15, 1966.
30. "The Great Pyramid"—said to be "shrouded in the mists of remote antiquity."
31. "shifting calendars"—temporal fatigue.
32. Linguistic drift.
33. Ditto.
34. Ditto.
35. Ditto.
36. Ditto.
37. *Table of Prime Numbers from 1 to 1000.*
38. "the Kantian 'thing in itself' "—In Max Born's essay "Symbol and Reality" he tells us that "Kant's 'thing in itself' or Lenin's dogma are unsatisfactory because they violate the principle of decidability."
39. "2"—The Ambidextrous Fatality. The Dreadful Double. The Deadly Duality. The Enantiomorphic Abyss. "For the Snark *was* a Boojum, you see." Lewis Carroll.
40. "The irregularity persists and becomes even more disconcerting when we penetrate deeper into the natural sequence of numbers," says Tobias Dantzig in *Number: The Language of Science.*
41. Prime objects also lead one to bottomless pits and bizarre arrays.
42. Pierre de Fermat (1601–1665) claimed he could prove this "most recondite mystery of number," but didn't have enough room "on the margin of this page" to do so.
43. As long as one remains within the range of "kinaesthesia," "empathy," and "gestalt"— no warning is necessary. In order to remain safe from "infinity," one must "see through his bowels."
44. Define Bell by Roland Barthes' "structuralist activity"—". . . . by the controlled manifestation of certain units and certain associations of these units." *Partisan Review*, Winter 1967.
45. "See Section 3, "Speech Representation of the Frequency-Time Plane" in Colin Cherry's *On Human Communication.*
46. "When we speak to one another we do not transmit our thoughts. We transmit physical signals. . ." Colin Cherry. *The Thought-Word-Thing-Triangle* of Ogden and I. A. Richards (*Meaning of Meaning*) could be associated with Bell's tetrahedronal modules.

47. One can "read" Carl Andre's "sculpture" and "look" at his "poems."

48. Bell's invention of the telephone is not related to "literature" or "sculpture," but is a device that makes one conscious of the origin of prime form (number + object).

49. "phonetic logic"—Conditioned by "the ear," perhaps more than "the eye." Music is important to LeWitt. Claude Lévi-Strauss says the act of listening to musical work immobilizes the passage of time. Overture to *le cru et le cuit*. (Yale French Studies, *Structuralism*.)

50. *Types of Modules* according to Konrad Wachsmann: "material, performance, geometry, handling, structural, element, joint, component, tolerance, installation fixture, planning." Definitions of each module may be found in his book *The Turning Point of Building*.

51. Bell's "Kites" are flying "Thought-Word-Thing Triangles."

52. He built the tower for "his guests' enjoyment."

53. Robert Morris has said he would not want to "live" in his work.

54. Inside his "simple wooden shelter," Alexander Graham Bell relives the life of a Pharaoh.

55. "Cybernation" resembles the statues of Daedalus or of the tripods made by Hephaestus."—Michael Harrington, *The Accidental Century*.

56. "The Egyptians say that their houses are only hostelries and their graves their houses" (Diodorus).

57. "Hieroglyphics. Language of the ancient Egyptians, invented by the priests to conceal their shameful secrets. 'Just think! There are people who understand hieroglyphics! But after all, the whole thing may be a hoax.'" Flaubert's Dictionary of Accepted Ideas.

58. Substance is excluded.

59. A system of geometrical modules enclose the mummy and the automaton. "Lifelike" details remain but all in no way naturalistic. In both these forms willful conflict and differentiation become passive and inert. There is no suggestion of vitalistic "action," no sign of exerted energy. The body becomes a regular "shape" or verges on it.

60. Both the mummy and the automaton exclude all self-centered time and movement.

61. Tomb Art is always between the abstract which is clear and simple, and the decadent which is intricate and recondite.

62. Look up "dirge" in the dictionary, it will give you lots of ideas.

63. "The isomorph never forgets" (Ancient Hawaiian Proverb).

64. A language of lattices: points, lines, and planes.

65. ". . . the future will repeat it to a vertiginous degree" (Borges).

66. American art and "media" as revealed by the urban environment, like Egyptian monumental art, excludes any suggestion of death. Yet, they are both "fossilized pseudo-events" and entirely funerary. The remnants of Christian culture as expressed in our pastoral "graveyards" have nothing to do with our "invisible" tombs. Death is treated by the American in a "Baroque" or "Gothic" way. Always in the past. Death is never in his future.

67. The need for certain "sculptors" to see their work as a "whole" takes them out of "time" and doesn't dissolve their consciousness. Any art that suggests movement is "plastic" and subject to decay.

68. The old rational categories should be replaced by irrational categories.

69. Both cubism and impressionism are the last products of rational art.

70. A precise mind void of reason.

71. [The remaining notes have either been lost or never completed. There are two drafts of this essay. What appears here is the revised version, which includes the text and notes up to number 25. Notes 60–70 are from the first draft.—ed.]

WHAT REALLY SPOILS MICHELANGELO'S
SCULPTURE (1966–67)

> However, what really spoils Michelangelo's sculpture is not so much its naturalism as, on the contrary, its unnaturalistic exaggerations and distortions, which place themselves more in the context of pictorial illusion than in that of sculptural self-evidence.
>
> Clement Greenberg, *Modernist Sculpture: Its Pictorial Past*

> Messer Michelangelo I still wish to be rid of one doubt. For there is something in painting which I cannot understand: why is it the custom, as one can see in many places in this city, to make a thousand and one monsters and strange figures, such as women's bodies with fishes' fins and tails, tigers' claws and wings, or even animals with human faces?
>
> The Spaniard Zapata, recorded in
> *Four Dialogues on Painting*, Francisco de Hollanda

Michelangelo did not work from the nature he found around him (he was no realist). He invented an abstract cosmological system that he peopled with gods and demons that were anything but real. His "figures" are geometric edifices, more like buildings than human beings. Like it or not Michelangelo was a fabricator of a monstrous idealism based on grim neo-platonic eternities. To Clement Greenberg, Michelangelo is a "spoiled" naturalist, in short, corrupt.

Could it be that great art has a "knowledge" of corruption, while "natural" art is innocent of its own corruption because it is mindless and idealess? If that is so, then all esthetic consciousness or thought is in some way the captive of a diabolical mind—a malevolent demiurge. A figure by Michelangelo is not a person, but rather, in the words of Erwin Panofsky, ". . . a volumetric system of almost Egyptian rigidity." Wilhelm Worringer has made a similar observation and speaks of ". . . the invisible pressure of this cubic compactness." His art is a babel of contorted bodies paralyzed into hard surfaces, the outgoing expansive movement of Greek Classicism is brought to a standstill; the *figura serpentinata* is shackled into the oppressive matter of literal stone. Says Professor Panofsky, "Thus Michelangelo's figures are not conceived in relation to an organic axis but in relation to the surface of a rectangular block."

Michelangelo's art is more abstract than 90 percent of the so-called "abstract" art ever produced in this country. Mindless abstraction is not abstraction, it is merely realistic naturalism without any figures. "Formalism" is a subnatural escape from the mental abysses of uncompromised art. Most Modernist "sculpture" is nothing but compromise—corrupt nature unaware of its own corruption.

Michelangelo's resplendent Tombs of the Immortals are frightening and repulsive to us confused "moderns." We fear the grim humors and irrational deities that traverse the labyrinthine escarpments of his cosmogonies. Panels

follow panels into an inconceivable infinity of relationships. Columns trade places with figures, and establish dreadful discrepancies. Michelangelo's "dying slaves" are *surfaces* suffering from torpor and absolute exhaustion. Gestures are checked by the collapse of vital energies. In his "earthly prison" one senses an elemental, heavy, sagging, ponderous, epidemic of corruptible bodies. Block after block the prison is built, block within block, figures struggle within the recalcitrant stone. "Slaves" are bound to pillars and are fettered with an unsatisfied seductive desire. They seem transfixed by a demiurge, and waiting for some unknown torture to befall them. The highest dignity and lowest lewdness converge in his "captives." This tension spans the enormous distance between the celestial realm and the realm of matter emphasizing the chaotic realm in between, but a terrible rigor rules this fiction in direct contrast to the disordered reality of everyday life.

What is disturbing in this scheme is that Michelangelo did not accept a square as a square, or a cube as a cube, but instead tried to render the human body into a chaotic mass of blocks. His cosmogonic mentality prevents this from merely being a "decorative form" of Renaissance cubism. French cubism is based on nature—not mind, that's why it only has the force of decoration. Michelangelo's figures are more primordial and are part of an archaic ritual sense of order. They refer more to the tombic art of ancient Egypt or Mexico. A sense of human sacrifice pervades this artificial world. Every figure in it seems poised on the edge of some impending annihilation. Edgar Wind has pointed out that Michelangelo never really abandoned his "relish for the Bacchic mysteries he had learned in his youth." And that he wrote a Dionysian love poem to Cavalieri on the "ritual of flaying." Michelangelo's own self-portrait also appears on the skin of the "flayed apostle" in the *Last Judgment*. But what appears at first sight to be a tragic expression is nothing more than an enigmatic joke. What could be more preposterous than a Bacchic saint holding the tragic mask of the artist? Says Professor Wind, "We . . . hear much about Michelangelo's somberness and depth, but too little is said about his grim sense of humor and his genius for the grotesque."

Could it be that Michelangelo is nothing but a spoiled comedian, who spent long tedious hours working out intricate gruesome jokes, that really aren't too amusing? Are the grotesque horns on his *Moses* some kind of a limpid jest? In this drowsy domain devoid of mysterious smiles, there is an undertone of listless laughter and torpid humor. A sluggish and immobile sense of time besieges the viewer of this decadent paganism. Not sloth, but the deterioration of sloth is felt, a decayed acedia that proclaims an inner grief through a profound sense of laziness. An idleness so acute that the body turns to lead and bile, an odious perfection that renders a titanic spectacle of waste. A sinking city of muscles submerges the mind in a somnolence so awful that no escape is possible. A *Weltanschauung* of crisscrossing flesh forces the mind down into brute matter, every action is sunk in "melancholy." In the "Slough of De-

spond" the foul rot of nature engulfs the entire system of gods and demons. Never has stagnation been more total. Weariness turns into humorous levels of moribund grandeur. Every creature undergoes incessant punishment, because of the enormous weight of this ironclad universe. Bodies are swollen out of proportion, fattened like hogs, they fall downward toward fetid swamps. Heaven becomes a pigsty, a dirt enclosure completely airless, flooded with bilge water—with skies of dusty tar. Muscles like enormous worms, and polypi fade under a sickly ashen light. A slumbrous mood thick with idleness and despair faults every beautiful monster. Before us a psychic state of sterile power unfolds, grave, persistent in its gloom. The slacken bodies seem to stumble over each other, like titanic puppets. It has been said that acedia is caused by an imbalance of humors, Michelangelo seems to prove that speculation. The infirmity of his melancholia seems infinite and unending. Sloth is exalted into a major humor, and its permutations cover a cosmic scale. The stars are replaced with twisted mountains of flesh, there even evil is corrupted. It all looks so disgusting . . . so contemptible—a tidal wave of infinite carnality, a fleshy mess pouring from heaven (which is no place). Wan hope is triumphant in this quagmire of confounded passion. The Saturnine time of neoplatonic order infects his prisoners with an *otium corporis* that corrodes all spiritual joy and fortitude. Out of this comes the dismal comedy of enervation, a devastated sense of humor, a ruined joke, mock sacrifice, an obliteration of doom. Only nature is left with its maggots and filth—a snake chewing a penis. But this is not sad, it is hilarious. The fatality of humor begins in languor and ends in a farce.

Stylistic criticism, with its overused categories of "painting, sculpture, and architecture," fails to see beyond realism and naturalism. If one considers Michelangelo's grotesque sense of humor "pictorial illusion," then one sees art in terms of realistic and natural content. Modernist criticism recoils at the sight or thought of Michelangelo, because the organic is threatened by what Wolfgang Kayser calls "the annihilating idea of humor." Realistic and naturalistic criticism fears the cosmic laughter inherent in the grotesque (grotto-cave)— the abyss. "The annihilation," says Kayser, "of finite reality can and may take place only because humor also leads upward toward the 'idea of infinity.'" But in Michelangelo's cosmological system of *figures* the direction is *downward* toward infinity. This is not true of his Dome in the Medici Chapel which is *not architecture or sculpture*, but rather one of his most non-anthropocentric progressions into an abstract infinite sphere.

FROM IVAN THE TERRIBLE TO ROGER CORMAN OR PARADOXES OF CONDUCT IN MANNERISM AS REFLECTED IN THE CINEMA (1967)

> Laughter is the revelation of the double
>
> > Charles Baudelaire

> There are no "real" doubles in my novels.
>
> > Vladimir Nabokov

There seems to be two esthetic roles that artists and critics tend to develop. The first role is not considered a role by the person who assumes it. This kind of person acts "naturally," and always affects what he terms *honesty*. He is apt to constantly congratulate himself on being frank, humble, and unaffected. William Empson points out that Shakespeare had contempt for such a sensibility, "What Shakespeare hated in the word [honest], I believe, was a peculiar use, at once hearty and individualist, which was then common among raffish low people but did not become upper-class till the Restoration." (*The Structure of Complex Words*.) With the rise of naturalism in the arts the artist began to pose or play the role of hearty individualist, who had no manners or principles, but lots of feelings and natural desires. The 19th-century myth of the Renaissance is based on the sensibility of naturalism, and is opposed to manners and conventions. Naturalism in a sense became an unprincipled defense against the problem of corruption in both esthetics and society. Natural expressiveness replaced the rules of the game, and so confused inanimate objects with personal feelings. The art object became in the naturalist's mind the direct expression of his own feeling and not the result of a convention or manner, thus began the belief in expressiveness in art.

This first role was in a sense formalized by Constantine Stanislavsky in so far as he based his "method" on internal feelings and natural expressions. This "method" dominated the major actors of the 'fifties, and indirectly influenced the "life styles" of many American artists and critics. Mutations of the "naturalness" of the "method" may be seen in the photographs of artists and critics in books such as Fred W. McDarrah's *The Artist's World* and more recently in Alan Solomon's *New York: The New Art Scene*. The artist or critic poses or fakes being unaffected, he imitates everyday, mundane, natural events—such as playing baseball, on-the-job painting, or drinking beer. Andy Warhol takes this *artificial normality* to "marvelous" extremes by having "queens" act like "plain-janes." Thus the phony naturalism of we're-just-ordinary-guys-doing-our-thing becomes brilliant manneristic travesty under Warhol's direction.

This brings us to the second kind of role, which is closer to the pictorial principles of V.V. Meyerhold and Bertolt Brecht. The critics who are committed to expressive naturalism always attack pictorialism because they fail to un-

derstand what Brecht termed "alienation effect." Many of Brecht's ideas for the a-effect were derived from the narrative pictures of Brueghel the Elder, the *pictorial* origin of the a-effect is opposed to the sensory character of the picture as a "painting." Far from being non-illusionistic, Brecht calls attention to the physical elements of illusion; thus illusion exists on an equal level with reality. Says Brecht in a description of Brueghel's Tower of Babel, "The tower has been put up askew. It includes portions of cliff, between which one can see the artificiality of the stonework." The "cliff" is thus *alienated* from the "artificiality of the stonework." This is true of many Mannerist pictures, where for instance everything turns away from the center of interest. This *turning away* from what is thought to be "important" is at the bottom of the a-effect. A similiar a-effect exists in a Mannerist engraving by Stich von Johann Sadeler; a feast is going on in a hall with singing and love making (the actual drawing is cold and stiff) while through windows and a door we see a rather uninspiring apocalypse. God or somebody is riding a rainbow, but nobody at the feast seems to care. A nearby war doesn't seem to interest them either.

Sergei M. Eisenstein in his masterpiece *Ivan the Terrible* (part II) rejected the expressive naturalism of the Stanislavsky Method in favor of the Meyerhold Method of "automatic imitation." Eisenstein employs Meyerhold's Method in a most rigorous mannerist way in the second part of *Ivan the Terrible*. The actors are not encouraged to have *deep and profound feelings*, but rather they are *built* into the setting of the film. Each emotion is constructed rather than directed. Ivan is a set of manners, or a collection of devices. The blind faith that Meyerhold had in the role of "the worker" is transformed by Eisenstein into a sinister paradox in *Ivan*. Eisenstein defines Ivan as "a personality in the manner of Edgar Allan Poe" and says ironically he is a conception that "would hardly interest the young Soviet worker." The reference to "the manner of Edgar Allan Poe" is worth exploring.

Manneristic art is often called pseudo, sick, perverse, false, phony and decadent by the naturalists or truth tellers, yet it seems to me that what the Mannerist esthetic does disclose or recover is a sense of primal evil. Both Eisenstein and Poe seem to have been acutely aware of such a malevolent condition. Parker Tyler in his *Classics of Foreign Films* has this to say, "Eisenstein knew perfectly well that 'Mephistofeles' and 'wild beast,' the labels he had given Ivan, also applied to *himself*, to the history of his career as man and film artist." Such an awareness not only locates him within the Mannerist esthetic, but also makes him an artist of the first order.

The Mannerist is not innocent of corruption. He casts a cold eye, and what he sees he treats with humor and terror. A great example of pictorial humor and terror is *The Allegory of Europe* or the *Beheading of John the Baptist* by an unknown Mannerist master (collection of the Prado). The very word "allegory" is enough to strike terror into the hearts of the expressive artist; there is perhaps no device as exhausted as allegory. But strangely enough Allan Kaprow

has shown interest in that worn-out device. Jorge Luis Borges begins his *From Allegories to Novels* by saying, "For all of us, the allegory is an aesthetic error." The *Allegory of Europe* is challenging for the same reason. The court intrigue shown in the *Allegory* parallels the court intrigue in *Ivan*; both display an exquisite but noxious sense of decorum. Compare for example the festering jewels on the complex and often teratological costumes. The world of both the *Allegory* and *Ivan* is one that rejects Renaissance naturalism and the image of the self-sufficient man acting in a rational environment. One could almost say the environment is lost under a network of tiny surfaces, that reflect nothing but ungraspable meanings. Here is a world of countless plots and counterplots, all combining to make up a delicate structure, that evades simplism. An excellent example of the a-effect in the *Allegory* occurs when a bare-breasted woman holding the head of John the Baptist on a plate is seen looking indifferently away from the gruesome object. The prominence of the (face) and (breast) admit the chaos of poisonous brocades and jewels and somehow suggests the "woman series" of Willem de Kooning. Actually, de Kooning speaks like a Mannerist, not an Expressionist, when he says "art doesn't make me pure" or "I'm not a pastoral character," and paints like one—"I put the mouth more or less in the place where it was supposed to be."

The "faces" in mannerist pictures are abstractions, because they do not call attention to "paint quality." The face in an expressionist painting is concerned with the "paint," but the face in a mannerist *picture* is a "conception." The mannerist face is a mask detached from the material fact of the pictorial surface. Roland Barthes tells us what constitutes the abstract mask, when he says "As a language, Garbo's [face] singularity was of a conceptual order; Bardot's [face] is of a substantial order. Garbo's face is an Idea, Bardot's a happening." (From *Mythologies*.) Or the Idea face is a *mannerist picture* while the Happening face is an *expressionist* painting.

In order to deal with the face as a "language," we must avoid the "formalist" trap of discussing "the painting" in terms of "framing supports" or "shaped canvases." I shall concern myself with the difference between expressive *paintings* and mannerist pictures. The substantiality of painting may be seen in Rembrandt's "Self-Portraits." The sensory and temporal roles of the artist are clearly defined by the following titles, *Rembrandt as a Young Man, Rembrandt Dressed as an Eastern Prince, Rembrandt as an Officer, Rembrandt as a Standard-Bearer, Rembrandt at the Age of 34*, etc. Rembrandt is putting us on, but in a very poor, honest, natural, and expressive way. The naturalist ethic responds to such degraded postures, but rejects the terrible "virgins" by Parmigianino. The naturalist ethic opposes the mannerist esthetic by preferring the "honest whore" to *The Virgin of the Rose*—rustic charm is preferred to celestial terror. One reason why Rembrandt's paintings fetch such high prices is that they give value to low ideas. Marcel Duchamp, the last fabricator of "virgins," shows his contempt for Rembrandt by recommending that his paintings be used as "ironing-

boards." Duchamp shares Shakespeare's disgust when it comes to the elevation of expressive naturalism over the rules of the game. To put it pictorially, when the painting is valued over and against the picture you can be sure philistines have taken over art.

Let us now compare the face of Parmigianino's *Virgin of the Long Neck* with Rembrandt's self-portrait—*The Artist Laughing*. The first thing one notices in the Rembrandt is the "paint quality." It is rough and lumpy, a kind of good-natured air is conveyed by this grinning portrait. The type of humor it displays is rustic and down to earth, it lacks what Duchamp would call "meta-irony." Yet, the self-portrait betrays a "negative-irony"; this Duchamp defines as a type of humor that only depends on "laughter." Rembrandt's "laughter" does not allude to anything sinister or to what Vladimir Nabokov refers to as "laughter in the dark." This laughter of Rembrandt's is warm and friendly, its expressive character leads directly to the artist's inner sense of individualism. Not so, when it comes to Parmigianino's virgin face; nowhere is good nature or "character" suggested in his conception. This is a picture, not a painting, because it derives from the mind and not sensations. It is an infernal abstraction and not a "real" person. Consider the Virgin's eyes—she has none, but there is a gaze, a terrible snake-glance that seems to turn her child to ice, or perhaps it has even killed her "immaculate conception." The notion of "a child of ice" is alluded to in *The Virgin of the Rose*, where the child touches with his little finger the North Pole on a globe of the world. Returning to *The Virgin of the Long Neck*, an alienated Saint turns away from the "monster." The Saint declaims in the lower right corner of the picture near an illusory column or set of columns. The distance between Parmigianino's humor and Rembrandt's humor is immense.

Parmigianino transforms a humorous illusion into a solid fact, while Rembrandt turns a solid fact (himself) into a humorous sensation. Parmigianino's "idea alchemy" is similar to Duchamp's in so far as Duchamp takes every opportunity to transform ideas into facts. Both artists seem to deal with the concept of a *prison*. Says Duchamp, "Establish a society in which the individual has to pay for air he breathes (air meters; imprisonment and rarefied air); in case of non-payment simple asphyxiation, if necessary (cut off the air)." The world of Parmigianino appears to verge on asphyxiation, the air in his pictures seems about to be turned off, his figures seem on the brink of being frozen. The terrible prison-like world Duchamp proposes is related to Mannerist esthetics and conduct.

If Rembrandt subverted upper class value and roles to shabbiness, then Warhol has elevated lower class value and roles to the level of grandeur. Rembrandt posed as "a prince," Warhol poses as an "idiot,"—both roles are false.

In *My Hustler* Warhol treats sex as a commodity; his hustler hero is no "honest whore,"—if a "john" wants some of his commodity he has to pay for it. Sex in Warhol's film is "a way to make a living" or forced sex like forced labor. The hustler puts sex into his work; his sex, however, is no longer his

own, but rather a commodity value that belongs to his employer—thus sex becomes an alien "thing" to the hustler. The private parts have price tags on them. This is a parody of Marx's "division of labor" only Warhol discloses the "division of sex." All the hustler's sex is placed in the service of money.

Parmigianino's *Virgin* like Warhol's *Hustler* both have their sex alienated from their person or self. The question of *love* in such a context is transformed into a fearful duality. The cold mask-like faces of the hustlers and virgins hide a humorous pessimism.

The films of Alfred Hitchcock are Mannerist on every level. "As early as the credit list monstrous faces writhe on a background of threatening sky," says André Techine writing in Cahiers du Cinema, "The obsolete device of double exposure is reinforced by the crudity of grimaces. No artifice is spared the spectator. The contrivances are avowed." *Torn Curtain* is perhaps even more manneristic than *Vertigo*. Hitchcock's actors, like the figures in pictures by Jacopo da Pontormo, seem trapped in a beautiful prison that produces intricate types of "visual nausea." (See *Mannerism—Style and Mood* by Daniel B. Rowland.) A sweetness of color pervades the totalitarian settings in *Torn Curtain*. One thinks of the moods defined in Vladimir Nabokov's novels. In *Invitation to a Beheading*, Nabokov seems to be describing the Hitchcockian view, "I am here through an error—not in this prison, specifically, but in this whole terrible, striped world; a world which seems not a bad example of amateur craftsmanship, but is in reality calamity, horror, madness, error—and look, the curio slays the tourist, the gigantic carved bear brings its wooden mallet down on me." The red ribbons, that represent a fire in a ballet scene, in *Torn Curtain* suggest a means of escape to Paul Newman (scientist-spy) when he shouts "Fire." A panic turns Julie Andrews' face into a mask of exhaustion not unlike the swooning face of the Virgin in Pontormo's *Deposition*. The "amateur craftsmanship" is everywhere in Hitchcock's *mise en scene*, from the ghastly green glow over roof tops in *Vertigo* to the diabolical sky in *The Birds*. Hitchcock's humor informs every terrible situation he takes his "bad" actors through. His settings are a vast simulacra built by an evil demiurge, and peopled with frozen automatons.

The sensibility of Roger Corman is similar to Hitchcock's. Both directors tend to view life as a diabolical game full of bluffing and death. Corman's films seem to be based on Poe's declaration in "William Wilson," "Oh, gigantic paradox, too utterly monstrous for solution!" Corman's series of films based on Poe, disclose a complete understanding of what Eisenstein meant by "the manner of Edgar Allan Poe." Somehow the terror in a Corman movie is a "false terror" held together by derealized acting and leftover stage sets. The "universe" in *The Trip* is a cheap merry-go-round built of paper flowers, and multi-colored junk. In this anti-LSD film nothing is real—not even the "special effects." The film ends with a shattered "still" of the face of Peter Fonda.

PROPOSAL FOR EARTHWORKS AND LANDMARKS TO BE BUILT ON THE FRINGES OF THE FORT WORTH–DALLAS REGIONAL AIR TERMINAL SITE (1966–67)

1. Areas near or on "clear zones" to be developed by four well-known artists: Robert Morris, Carl Andre, Sol LeWitt, and Robert Smithson. Before any major construction starts on the air terminal building, the above artists will draw attention to the fringes of the entire project by using apparently unusable land in four different ways. Robert Morris will build a circular earth mound. Carl Andre will produce a crater with the help of an explosive. Sol LeWitt will employ somebody to bury a concrete cube. Robert Smithson will have built a series of seven square asphalt pavements.

2. The object of this proposal is to "program" the landscape and define the limits of the air terminal site in a new way. Such a project would set a precedent and create an original approach to the esthetics of airport landscaping. All these works will be close to ground level (the highest being 3 feet). Robert Smithson and Robert Morris will build forms that will be visible to aircraft as they take off and land. Sol LeWitt and Carl Andre will provide works that will deal with the "sub-site," and exist as underground landmarks.

3. In order to communicate this development, a 4-man show will take place at the Dwan Gallery, 29 West 57th Street, New York City, in conjunction with the actual process going on at the site. This show will take place in September 1967. A map of the site will be enlarged to fit the gallery floor (say 20' x 10'). Models built to scale will be placed on the map. Photographs of the construction process could be displayed in another gallery room.

4. Dwan Gallery will supply:
 1. Works of art
 2. Cost of materials
 3. Announcements for the project
 4. Entire gallery space for map and models

5. Tippetts-Abbett-McCarthy-Stratton will supply:
 1. Land for projects
 2. Equipment and labor for artist
 3. Transportation to and from site for the artists

6. The following specifications are by the participating artists:

ROBERT MORRIS
"Project to be Made of Earth"
Elevation cross-section: packed earth of trapezoidal form, 6 feet at base, sloping sides about 45°, height 3 feet. Sodded.

CARL ANDRE
"Proposal for an Explosion"
An appropriate contractor is retained to place and fuse an explosive charge sufficient to produce a crater 12 inches deep and 144 inches diameter. The charge is detonated by the sculptor Carl Andre.

SOL LEWITT
"Proposal for Earth Project"
Encase a 6 inch wooden cube containing something in an 18 inch cement cube and bury it someplace on The Tract. The precise spot would not be designated—but only that it is somewhere within the area and 3 feet underground. I would send the 6 inch wooden cube to the cement company either here or on the site (if it is Texas).

ROBERT SMITHSON
"Proposal for Seven Aerial Pavements"
Measure a line 81 feet across grated ground. Measure seven squares flush along the entire length of this line. (3 feet sq., 5 feet sq., 7 feet sq., 11 feet sq., 13 feet sq., 15 feet sq.), leaving between each square an interval of 3 feet. Squares are to be made of 16 inch thick asphalt paving—8 inches above ground and 8 inches below ground.

UNTITLED (AIR TERMINAL—WINDOWS) (1967)

The best artists today are those that are challenging the diseased "details" of impressionism. The exact installations of art shows makes one conscious of the actual *walls* rather than any "portable walls" smeared with gas-like color. The actual walls establish a regular limit that makes the art objects in the site highly distinctive. Through a precision of installation the art objects all but vanish. The inherent appearance of the site discloses its "phenomenon" as an infinite set. This experience does not imitate any architectural detail like "windows" or "walls," but instead makes clear mental and material structures. One is then aware of "primary-data," and can describe it in all its "transparence." It is not the art object we apprehend, but the entire site. Language at this point has the same weight as material. Categories with hypertrophic meanings are avoided, and new categories develop as a direct result of the site. The linguistic meaning of a "wall" or "window" is replaced by *surfaces* and *lines*. The more the site exists as such, the less it needs the proof of the old categories of art.

This means that we do not want "windows" or "walls" in the air terminal. The window like the painting is a diseased detail that has a rational origin. The wall is an oversized version of both. We must see only surfaces and lines. Any actual window is much better to look at—mainly because most of them are simple grid systems that hold surfaces of transparent glass. So that, even a window really isn't a window. A wall is in effect an opaque window. Thinking about windows evokes an infinite array of window meanings. The framework of a painting becomes a window without glass. Any painted surface (three dimensional or two dimensional) is to some degree malignant. Perhaps, that's what Tony Smith means when he says his works are "probably malignant." At any rate, a certain malevolence is inherent in all painted surfaces.

SEE THE MONUMENTS OF PASSAIC NEW JERSEY (1967)

What can you find in Passaic that you can
not find in Paris, London or Rome? Find
out for yourself. Discover (if you dare)
the breathtaking Passaic River and the
eternal monuments on its enchanted banks.
Ride in Rent-a-Car comfort to the land
that time forgot. Only minutes from N.Y.C.
Robert Smithson will guide you through
this fabled series of sites . . . and don't
forget your camera. Special maps come
with each tour. For more information visit
DWAN GALLERY, 29 West 57th Street.

THE MONUMENT: OUTLINE FOR A FILM (1967)

1. *Apartment Interior*
 A group of artists, and others talking about landscaping, earthworks, sites, and monuments in Virginia Dwan's apartment. They make plans to visit the Pine Barrens in New Jersey in order to find a site to work with.

2. *Station Wagon Interior*
 Four Artists, Two Women, Gallery Director, conversation about art critics,

movies, rock and roll on the radio, and art shows—shots of the industrial landscape, turnpike, toll gates, etc., as seen from car.

3. *Turnpike Restaurant Interior*
 Description of "The Pineys" of the Pine Barrens by one of the artists.

4. *Aerial Shots of the Station Wagon Going Down the Turnpike*
 With bits of conversation and rock and roll science-fiction type sound. The station wagon becomes a dot. New flying saucer report over radio. Conversation continues.

5. *Return to Station Wagon Interior*
 Color monochrome "stills" of historical "ghost towns" in south Jersey. An artist is seen reading from *Forgotten Towns of Southern New Jersey* by Henry Charlton Beck.

6. *Arrival in the Pine Barren Plains*
 The site of landscape project for New York gallery is discovered—wandering shots down white sand roads and paths—collecting sand for gallery project—aerial shots—map of site. Departure.

7. *Visit Flying Saucer Convention at Atlantic City or Asbury Park*
 Miss U.F.O. Contest, interviews with saucer-buffs. Still photos of Flying Saucers—(New Jersey Association on Aerial Phenomena)—NJAAP.

8. *Nighttime—Motel Section*
 Shots of motel interiors—dream—captured by a flying saucer—teenagers are sadistic creatures of another world.—Fade-out as sun comes up over the ocean—shot of waves and foam.

9. *Return to New York.*
 Holland Tunnel under violet filter.

10. *Shots of Artist Working on the Project*
 Scenes in loft and metal shop. Making models etc.

11. *Gallery Opening*
 Shots of works of art. The movement of the viewers should be frozen at intervals.

12. *Party*
 Conversations turn into a series of *tableaux vivants*—rapid zoom shots onto faces, hands. Should give the effect of statues breaking and crumbling. Remarks about the earth project overheard, fragmented but clear. Sentences could be echoed. Dancing—slow motion, "Vanilla Fudge" play rock and roll.

ROBERT SMITHSON, *Pointless Vanishing Point*, 1969. Flat white paint, fiberglass, 40 x 99 x 40″.

POINTLESS VANISHING POINTS (1967)

One of the most fugitive concepts in art is perspective—its stupefying dimensions have evaded the "modern" artist ever since Rembrandt spoiled the straight line. With the rise of "naturalism" and "realism" in the arts the artificial factors of perspective were lost in thick brown stews of chiaroscuro. The linear artifices of Euclid were smothered by seas of impasto and replaced with non-Euclidian atomic muddles (Impressionism to mixed media). And in our own times, perspective is swamped by "stains" and puddles of paint. The idea of the universe as a relative pudding is an idea to avoid.

The dual globes that constitute our eyes are the generators of our sense of the third dimension. Each eyeball contains a retina that functions like a photographic plate inside a spheroid camera. Rays of light penetrate the transparent cornea, the pupil, the crystalline lens and the vitreous body until they reach the retina. This process was thought to be reversed in Euclid's Alexandria (300 B.C.), in so far as it was supposed that the rays of light issued directly from the eyes along straight lines until they touched the object they were looking at. The philosopher Hipparchus (160–126 B.C.) compared those visual rays with feeling hands touching the objects. This centrifugal theory of vision seems to have returned to modern times in the guise of "kinaesthetic space" or what is sometimes called "surveyor's space." The eyes do not see this kind of space, but rather they perceive through a mental artifice of directions without determined distances, which in turn gives the illusion of infinite spaces. Natural visual space is not infinite. The surveyor imposes his artificial spaces on the

landscape he is surveying, and in effect produces perspective projections along the elevations he is mapping. In a very non-illusionistic sense he is constructing an illusion around himself because he is dealing directly with literal sense perceptions and turning them into mental conceptions. The binocular focus of our eyes converges on a single object and gives the illusion of oneness, so that we tend to forget the actual stereoscopic structure of our two eyes or what I will call "enantiomorphic vision"—that is seeing double.

An awareness of perspective comes into one's mind when one begins to deal directly with the physiological factors of sight as "a thing-in-itself." In other words, all of one's attention must be focused on the *camera obscura* of perception as a physical *thing* or *object*, and then translated into a three dimensional illusion, so that one is left with a *non-thing* or a *non-object*. My first physiological awareness of perspective took place when I built the *Enantiomorphic Chambers*. In this work, the vanishing point is split, or the center of convergence is excluded, and the two chambers face each other at oblique angles, which in turn causes a set of three reflections in each of the two obliquely placed mirrors. A symmetrical division into two equal parts is what makes it enantiomorphic; this division also exists in certain crystal structures.

Out of this division of *central perspective* comes what could be called *enantiomorphic perspective*. The only treatise on central perspective was written by Piero della Francesca (1420–1492). Although many artists of that period were interested in perspective he is the only one to have written a complete description of the methods of central perspective based on Euclid's xth proposition concerning the intersection of "visual rays" on the picture plane. Enantiomorphic perspective differs from central perspective in so far as it is mainly three dimensional and dualistic in conception, whereas the latter is two dimensional and unitary. Yet, Paolo Uccello (1397–1475) did do a two dimensional dualistic perspective grid drawing. There is a controversy over whether or not Uccello's left and right converging perspectives are related to binocular or stereoscopic vision. If one were to build a three dimensional structure from *behind* the two dimensional Uccello drawing, one would end up with something that would resemble a *reversed* stereoscopic viewer. One would be physiologically transported behind the "fused image" of the *picture plane*, to where the vision diverges. The two separate "pictures" that are usually placed in a stereoscope have been replaced by two separate mirrors in my *Enantiomorphic Chambers*—thus excluding any fused image. This negates any central vanishing point, and takes one physically to the other side of the double mirrors. It is as though one were being imprisoned by the actual structure of two alien eyes. It is an illusion without an illusion. Consider "Wheatstone's mirror-stereoscope" with A_1B_1 and A_2B_2 pictures replaced with mirrors and you will get a partial idea of how the *Enantiomorphic Chambers* abolish the central fused image (See *Physiological Optics* by James P. C. Southall). The double prison of the eyes becomes a fact.

A SMALL TEST FOR JO BAER (1968)

1. Why are you not a logical positivist?
2. What is your critical standard?
3. Does nature exist for you?
4. Discuss the principles of your esthetic logic.
5. Provide a concrete example of negation.
6. Are you a formalist?
7. Are your paintings absolute?
8. What does color mean to you?
9. Does one have to know anything about your paintings before one looks at them?
10. Is your art particular or universal?

OUTLINE FOR YALE SYMPOSIUM (1968)

AGAINST ABSOLUTE CATEGORIES

1. Category—a class division in a scheme of classification.
2. Modern criticism conceives of art in terms of categories—the visual ones being painting, sculpture, architecture, and films.
3. Modern criticism has brought about the division of esthetics into those categories.
4. Art as an esthetic whole exists apart from Modern criticism.
5. There is a conflict between criticism and esthetics.
6. Criticism is self-centered and forces value onto the art or takes it away.
7. Criticism must explain art in order to exist.
8. Esthetics that tend toward the abstract need no explanation.
9. Any art that refers back to the "self" even in terms of space is not abstract but pathetic (existentialism, psychoanalysis, and humanism all depend on pathos).
10. The universe can no longer be considered man-centered.
11. The "self" projected into an object is prevented by getting rid of the pathetic.
12. There is nothing abstract about any kind of painting—it all represents space.
13. Any line, color, or shape on a surface is representational.
14. Abstraction originates in the mind and not in the eye.

15. Any kind of expressionism involves the pathetic remains of the self.

16. The delusion of "flatness" in painting leads to the illusion of space. (Noland and Stella.)

17. Where ever the eye sees space there is no abstraction. Space is apart from the abstract which is all mental.

18. Clement Greenberg's "history of taste" is an imaginary history that is used against imaginary styles. (Recent example is Darby Bannard's article in the December *Artforum*.)

19. The notion of the "art of the recent past," as it relates to Modernism is based on a reduction of the self-centered Renaissance attitude.

20. What Clement Greenberg calls 3-dimensional pictorial space in the Renaissance Tradition is in the Modernist Tradition 2-dimensional flat space. Both kinds of space are representational and illusionistic.

21. The condition of art is unknowable.

22. Abstraction is a mental, not a visual property.

23. The physical eyes see nothing, without the artifice of the mind or what others call the brain.

24. Art is always incredible. Credibility has to do with "nature" and "the self" and other lesser realities.

25. The self is a fiction which many imagine to be real.

26. There is at present a new esthetic emerging that does not have its origin in history or in the self-centered notions.

27. This esthetic is non-critical, in that it avoids categorical imperatives such as "painting and sculpture." It tends more toward an abstract phenomenology.

28. Phenomenology would view art as unknowable and avoid formal explanations. (Anti-rational, anti-existential, and anti-psychoanalysis.)

29. Linguistically, categories such as "painting and sculpture" are limited to meanings that have to do with manual dexterity or working with one's hands. That art is hand-made belongs to the self-centered value system of outmoded criticism.

30. The new esthetics sees no value in labored sculpture or hand-painted paintings.

31. "Picture-making" or "clay molding" no longer is a problem.

32. The problem is, that there is no problem.

SITES AND SETTINGS (1968)

A. *Settings*
1. A thing in or upon which something is set.
2. Time and place environment, background, or surroundings.
3. Actual physical surroundings or scenery whether real as a garden, or artificial.

B. *Empty or Abstract Settings, ie. the opposite of a "happening"*
1. Landscapes without the look of history.
2. Buildings (suburban factories, rectilinear interiors and exteriors) hard, impenetrable surfaces.
3. Ordinary places that seem to be of a future time.
4. Industrial parks without industry, new galleries and museums without painting and sculpture, lots without cars, shopping centers without commodities, office buildings without business activities.

UNTITLED (SITE DATA) (1968)

The following "site-data" is an attempt to locate "structural" meanings by observing building sites within a kind of abstract anthropology. Each site should stand entirely as "the critical object at zero degree, a site empty but eternally open to signification." (Roland Barthes—*On Racine*.) How each site pertains to art shall be described according to its physical limits. The definitions are apparent rather than actual, or you might say "reconstructed appearances."

RECENT SITE DEVELOPMENTS

1. The urban apartment
2. The artist's studio or loft
3. The suburban house
4. The art gallery (since the late 50s)
5. The art museum (modern)
6. The urban office building
7. The industrial site
 a. Dams and spillways
 b. Power plants

c. Flood control and irrigation works

d. Tunnels, bridges, roads, and parking lots

e. Air terminals

1. *The urban apartment.* The room configuration is random and largely determined by pictures and windows. As a dwelling place it has its origin in the 19th century. Within this dwelling the occupant attempts to "live" according to the myth of individualism. He decorates it with memory traces of the 19th-century notion of "nature" and "reason." For him "painting" is not a linguistic category but something personal, intimate, and private. "Painting" is his false window that looks back to "impressionism."

2. *The artist's studio or loft.* It is a mutation of the urban apartment. The word "studio" implies some kind of handicraft (a place where brushes, paints, and canvas are used). The loft has less rational meaning than the studio. The best artists of the late '60s find the myth of craftsmanship not worth maintaining. Making "paintings" for intimate reasons no longer motivates these artists. The artist is tending to a more public or corporate outlook.

3. *The suburban house.* Feeble notions of impressionism at best, or at worst brutal notions of "scenery." Grass lawns surround rustic, pastoral, or barn-like dwellings. Unimaginative gardens.

4. *The art gallery.* (since the late 50s) Conforms to the archetypal site of tragic theatre in most cases. The Inner Chamber = Salesroom. Antechamber = Secretary's Office. Exterior space = Exhibition Space. Unconscious hierarchical room configuration.

5. *The art museum (modern).* Tourist attraction. Some curators do public stunts and promote art through mass-media. Improves the mind of the many, ruins the mind of the few. Oversized paintings and oversized sculptures cause interesting dislocations in scale, thus changing the interior meaning of the museum. The museum replaces the church.

6. *The urban office building.* Art is sometimes put in the lobbies of office buildings. Art is used as a "spot of color" or to "give relief." The linguistic myths have to do mainly with "business"—"brass tacks" are often invoked. Sol LeWitt enjoys ziggurat office exteriors. They give the appearance of being "inert" and "earthbound." Everybody loves the Seagram Building and hates the Pan-Am Building.

By drawing a diagram, a ground plan of a house, a street plan to the location of a site, or a topographic map, one draws a "logical two dimensional picture." A "logical picture" differs from a natural or realistic picture in that it rarely looks like the thing it stands for. It is a two dimensional *analogy* or *metaphor*—A is Z.

*The Non-Site (an indoor earthwork)** is a three dimensional logical picture that is *abstract*, yet it *represents* an actual site in N.J. (The Pine Barrens Plains). It is by this three dimensional metaphor that one site can represent another site which does not resemble it—thus *The Non-Site*. To understand this language of sites is to appreciate the metaphor between the syntactical construct and the complex of ideas, letting the former function as a three dimensional picture which doesn't look like a picture. "Expressive art" avoids the problem of logic; therefore it is not truly abstract. A logical intuition can develop in an entirely "new sense of metaphor" free of natural or realistic expressive content. Between the *actual site* in the Pine Barrens and *The Non-Site* itself exists a space of metaphoric significance. It could be that "travel" in this space is a vast metaphor. Everything between the two sites could become physical metaphorical material devoid of natural meanings and realistic assumptions. Let us say that one goes on a fictitious trip if one decides to go to the site of the *Non-Site*. The "trip" becomes invented, devised, artificial; therefore, one might call it a non-trip to a site from a Non-site. Once one arrives at the "airfield," one discovers that it is man-made in the shape of a hexagon, and that I mapped this site in terms of esthetic boundaries rather than political or economic boundaries (31 sub-divisions—see map).

This little theory is tentative and could be abandoned at any time. Theories like things are also abandoned. That theories are eternal is doubtful. Vanished theories compose the strata of many forgotten books.

**Non-Site #1*. Smithson changed the title of this text which was initially "Some Notes on Non-Sites." It has been partially excerpted by Lawrence Alloway in "Introduction," *Directions 1: Options,* Milwaukee Art Center, 1979, p. 6.

NON-SITE NUMBER 2 (1968)

(based on Weehawken Quadrangle Map New Jersey-New York 7.5 Minute Series—*topographic*)

1. 12 Map Divisions of triangular platforms

2. 12 Central Minor Divisions surround "a swamp" between Moonachie Creek and Bashes Creek. I call it—*The Entropic Pole*—where all 12 points converge.

3. *The Degrees of Entropy*

 1. The Division of Languor between 90° and 60°
 2. The Division of Comatose between 60° and 30°
 3. The Division of Listlessness between 30° and 0°
 4. The Division of Apathy between 0° and 30°
 5. The Division of Torpor between 30° and 60°
 6. The Division of Stupor between 60° and 90°
 7. The Division of Lethargy between 90° and 120°
 8. The Division of Fatigue between 120° and 150°
 9. The Division of Tedium between 150° and 180°
 10. The Division of Lassitude between 180° and 150°
 11. The Division of Forgetfulness between 150° and 120°
 12. The Division of Idleness between 120° and 90°

HIDDEN TRAILS IN ART (1969)

If you read this square magazine long enough, you will soon find a circularity that spreads into a map devoid of destinations, but with land masses of print (called criticism) and little oceans with right angles (called photographs). Its binding is an axis, and its covers paper hemispheres. Turn to any page between these hemispheres and you, like Gulliver and Ulysses, will be transported into a world of traps and marvels. The axis splits into a chasm in your hands, thus you begin your travels by being immediately lost. In this magazine is a series of pages that open into double terrains, because "we always see two pages at once" (Michel Butor). Writing drifts into stratas, and becomes a buried language.

Look at any black and white photograph on these pages separated from its title or caption and it becomes a *map* with tangled longitudes and dislocated latitudes. Oceanic depths in these maps submerge the continents of prose. Equators spill onto shores of misplaced thought. Where do these maps start? No place. Distances are measured in degrees of disorder. East, North, West, and South are out of joint in the muddled regions of top, bottom, right, and left. Columns of type sink into the whiteness of paper. Arctic zones surround isolated clumps of meaning. The edge of any paragraph is menaced by the margins of another ice age. Snow white spaces cut glaciers into layers of words. Here maps have no direction because they are scattered from cover to cover. Maps within maps are seen where no maps are supposed to be.

The deposits of writing affect the topographical features of photographs. Continental critical drift merges and sinks into different photographic seas. Swamps of "isms" develop around reproductions of art, coral reefs of "form" build up around Cézanne's mountains, dunes of words are blown over the pictures of the Hudson River School, a current of concepts sweeps across a nameless reproduction of sculpture, details of paintings stick out of intellectual lava flows. The topography of art in a magazine is faulted and rifted under the pressure of miles of reason, examination, and study. In the valleys of inquiry traces of art appear and disappear in sandstorms of controversy. Esthetic fatigue overcomes one in the critical desert. The asymmetrical distribution of "art movements" is apt to break up into floating islands on bottomless oceans. Precise mirages lead one to the end of color, line, and shape.

CAN MAN SURVIVE? (1969)

An exhibition in the Museum of Natural History called *Can Man Survive* has been built out of the leftover technology of a McLuhan-inspired company called Dimensional Communication. A large dark structure is lifted off the floor by black pipe-like stilts in a vast room with ponderous columns. Through the forest of stilts one can see murals depicting imperial pageantry and a poem by Theodore Roosevelt called *Nature*—"There are no words that can tell the hidden spirit of the Wilderness, that can reveal its mystery to melancholy and its charm." One enters the overhead structure by walking up a ramp past what appears to be a discarded example of "minimal art," a black cube cracking apart with the words *Can Man Survive* painted on it. A mood of foreboding combines with an all over gloom. Inside a room covered with funereal webbing, a film is being projected in the manner of Andy Warhol on a split screen. Close-up shots of animals and scenery illustrate the "balance of nature"—a praying mantis eating the back out of a cockroach, windswept plains, waterfalls, birds, etc. Just when this film of balances appears to be within one's grasp, it eludes one only to melt into a formless naturalism, and between the formed and the formless there seems no transition, no balance at all. The film dislocates the various views of nature, the same way Warhol dislocates people. Ultraviolet light causes a typical diagram of "evolution" from ape to man to glow in a dark hallway. A film is projected on the inside of a plastic bubble, so that the image becomes convex. Blurred views of farming are seen, and a voice tells about man's first attempts to control the earth. On the opposite wall is another ultraviolet painting done in a trivial "op art" style. Imitation Louise Nevelsons decorate a wall. Above a black sphere and pyramid is a film even more foreboding than the split-screen affair. An urge to bring forth the fantastic shapes of a malevolent technology is at work here, impressions of wild machines, spectral compositions, fiendish bulldozers dissolve into a stew of superstition and unrest. The viewer is being conditioned for some unknown Millennium. A condition of fear inclining toward religiosity is evolved through boundless agitation, uncontrolled representations of man's inventions. The storm spirits are with us again in the shapes of grinding motors. Magic and demonic dread are instilled in the viewer. Out of the failures of Western religion a weird faith is being born. The irrational, the unaccountable is the essence of this exhibition and its belief in ecology and the internal agents of pollution. Herein these dim walls lies the peculiar horror of this domain of belief and delusion, and herein also lies the unstable vacillation of the forms. For some unknown reason, over a plastic blowup of some orthodox Jewish children, who are sticking out their tongues, is a red neon sign saying, "You never had it so good." Beyond that is the apocalypse of ecology, looking like a beleaguered "mixed media." Uncertain, nebulous, and confused images and information are gener-

ated through the courtesy of the enemy: General Electric, General Motors, I.B.M., Bell Systems, etc.

Guilt grows more pronounced and finally leads to a "Twilight of Nature," to a downfall of "Progress" and the "Population Explosion." The intention of this exhibition is to make people want to restore nature's harmony, but nowhere does it give evidence of any harmony or alternative to pollution; instead one is given esthetized images of smog and oil slicks. The shoddy delights of the discotheque are transformed into a Doomsday light show with a second-rate rock and roll band. A cheap exploitation of art styles turns art into simulated pollution: Anti-form made in Japan, E.A.T. finally does something, Pop Art gone stale. The major part of the exhibit resembles the stage set from *The Cabinet of Dr. Caligari.* On fractured walls are printed information, films, and slides. A film on pollution is running near one on population: piles of birth control devices rotting in India and piles of dead fish rotting in the sun. Pollution and birth are often presented together as a general image of cosmic waste. Ecology arises from a need for deliverance and exhibits a deep distrust of science. A need to return to Paradise or the Garden of Eden is obstructed by "the green slime" and carbon monoxide. Orderliness and harmony are not what the exhibit tends toward, but rather it feeds on a convulsive yearning, a superserious rapture before the environmental crisis.

The feeling of relative distraction overwhelms any appeal to classical order. Rest and clear vision are denied, the exhibition's resource is to increase a restlessness and confusion to the pitch of stupefaction. Old values are mocked by smug-sounding voices: "I'll do what I want." "Let them work for a living." "This is a free country," etc. The people who built this exhibit contrived an artifice that ends in chaos. What they want to cause people to get rid of excites them the most—the clear-cut, rational cosmos is so old-fashioned—who wants to go back to that! Behind the waste, garbage, and sewage is a transcendental state of matter, that is uncanny, grotesque, and terribly attractive. There is no display of practical renovation or utopian plans, but the constant rush of pretty filth and elegant destruction.

At the end of the exhibit a gay-sounding voice suggests in an ironical tone to throw away a candy wrapper, as one looks into a mirror with *Can Man Survive* printed on it.

CAN ART SURVIVE?

The enclosed society that makes abstract art has become an esthetic slave to its own fear of nature. Today the artist can uphold the failure of Modernism with its pretense of closed, immobile hierarchical values by being a slave to all its compromises or he can choose to be a terrorist. Savage forces make isolation doubtful.

LETTER TO GYORGY KEPES (1969)

<div align="right">
799 Greenwich Street

New York, New York 10014

July 3, 1969
</div>

Mr. Gyorgy Kepes
MIT Center for Advanced Visual Studies
40 Massachusetts Avenue
Cambridge
Massachusetts 02139

Dear Mr. Gyorgy Kepes,

I have reconsidered the context of the exhibition* and feel that my art will not fit. To celebrate the power of technology through art strikes me as a sad parody of NASA. I do not share the confidence of the astronauts. The rationalism and logic of the engineer is too self-assured. Art aping science turns into a cultural malaise. The righteousness of "team spirit" is no solution for art. Technology promises a new kind of art, yet its very program excludes the artist from his own art. The optimism of technical progress results in political despair. To many artists of Brazil technology and politics reflect each other. All the "fancy junk" of science cannot hide the void. I am sick of "lighting candles," I want to know what the "darkness" *is*, I don't "curse" it or praise it, but I know it is there. As rockets go to the moon the darkness around the Earth grows deeper and darker. The "team spirit" of the exhibition could be seen as endorsement of NASA's Mission Operations Control Room with all its crew-cut teamwork. Some Brazilians see the "advances" of technology as a military byproduct. I am withdrawing from the show because it promises nothing but a distraction amid the general nausea. If technology is to have any chance at all, it must become more self-critical. If one wants teamwork he should join the army. A panel called "What's Wrong with Technological Art" might help.

Best Wishes,

*The United States section of the x São Paulo Bienale, September through December 1969, presented by the International Art Program of the National Collection of Fine Arts in collaboration with the Center for Advanced Visual Studies of the Massachusetts Institute of Technology. A group composed of Fellows of the Center was responsible for the development of the exhibition, under the direction of the Center's director, Gyorgy Kepes.

LOOK (1970)

The unseen hurricane of carnage finds its way into the media morgue. Ghostly photographic remains haunt the pages of *Look*, July 28, 1970. Buried between advertisements and fashion stories are the victims of a commercial idealism. For 50¢ one can see "The Amazing Martha Mitchell" laughing under a hair dryer on page 22; and on page 52 one can see a mutilated soldier with his scalp stitched onto his head. On page 1 "Ford. . . . has a better idea (we listen better)." Murray H. Helfant, Major (Resigned) writes on page 49 and 50, "This young fellow has a typical wound. What he's lost are his maxillary sinus, both eyes, and both frontal parts of the brain." Between pages marked M: "Pretty gutsy. That's what our dealers told us when they heard about the first and only money-back guarantee in the film processing industry." Page 51, a black and white photograph $3\frac{3}{4} \times 2\frac{1}{2}''$ shows a man on an operating table, his leg has been amputated up to his hip. The stump resembles a black thumb print in size—it is $\frac{3}{4}''$ across. Back to the M pages: a color photograph $5\frac{1}{2} \times 13''$ shows a toy cannon with the barrel made out of a can of Sunoco Special long mileage Motor Oil, below that is printed "THE BIG GUN IN MILEAGE." On page 17, Gerald Astor writes, "They masquerade as women, ministers, workmen and hippies. In a year cop 'victims' collared over 5,000 individuals in the act of committing street crimes." A full page color ad faces this article, two people walking on railroad tracks, "IT'S THE REAL THING COKE. Real life calls for real taste." A black and white photograph on page 52, $2\frac{1}{2} \times 3\frac{3}{4}''$: a body face down on a bed. The back is cut right through the spine. "That's why us Tareyton smokers would rather fight than switch!" says the full color advertisement on page 26.

ART AND DIALECTICS (1971)

Language is the first and last structure of madness.

Michel Foucault

Late modernist art criticism has for some time placed all its emphasis on art as an order of particular *things*, objects that exist by themselves removed from what surrounds them. Art as a distinct *thing* is not supposed to be affected by anything other than itself. Critical boundaries tend to isolate the art object into a metaphysical void, independent from external relationships such as land, labor, and class. For instance, a painting may be said to have the quality of "openness,"

when in fact it is only representing openness. One might as well tell a prisoner facing a life sentence that he is free. The freedom is metaphysical, or in art critical terms "esthetic." A shrewd esthete can turn a prison into a palace with the aid of words—one has only to read a Jean Genet novel to see that.

Dialectical language offers no such esthetic meanings, nothing is isolated from the whole—the prison is still a prison in the physical world. No particular meaning can remain absolute or ideal for very long. Dialectics is not only the ideational formula of thesis—antithesis—synthesis forever sealed in the mind, but an on-going development. Natural forces, like human nature, never fit into our ideas, philosophies, religions, etc. In the Marxian sense of dialectics, all thought is subject to nature. Nature is not subject to our systems. The old notion of "man conquering nature" has in effect boomeranged. As it turns out the object or thing or word "man" could be swept away like an isolated sea shell on a beach, then the ocean would make itself known. Dialectics could be viewed as the relationship between the shell and the ocean. Art critics and artists have for a long time considered the shell without the context of the ocean.

This short essay was written for Louis M. Goodman's book, *Interconnect*, which was commissioned by Praeger but never published.

ART THROUGH THE CAMERA'S EYE (c. 1971)

There is something abominable about cameras, because they possess the power to invent many worlds. As an artist who has been lost in this wilderness of mechanical reproduction for many years, I do not know which world to start with. I have seen fellow artists driven to the point of frenzy by photography. Visits to the cults of Underground filmmakers offer no relief. In the dark chamber of the Film Archives, my eyes have searched in vain for the perfect film. I have disputed arcane and esoteric uses of the camera in murky bars, and listened to vindications of the Structural Film, the Uncontrolled Film, the Hollywood Film, the Political Film, the Auteur Film, the Cosmic Film, the Happy Film, the Sad Film, and the Ordinary Film. I have even made a film. But the wilderness of Cameraland thickens.

Artists suffering from a sense of unreality suspect the camera's eye. "There are enough shadows in my life," declares Carl Andre in a discussion on photography. "I have looked at so many photographs, I cannot see them anymore," says Michael Heizer. "I would like to make an abstract film," says Andy Warhol. As long as cameras are around no artist will be free from bewilderment. Mel

Bochner's "Theory of Photography" is called *Misunderstandings*. Once at the Chateau Marmont on Sunset Boulevard, I talked to Claes Oldenberg about his *Photo Death*. He said it concerned "shooting" pretty fashion models on atomic bomb testing grounds.

Physical things are transported by heliotypy into a two-dimensional condition. Under red lights in a dark room worlds apart from our own emerge from chemicals and negative. What we believed to be most solid and tangible becomes in the process slides and prints. Artists still involved in handicraft (some painters and some sculptors) can not escape the perilous eye of the camera. Consider the thousands of $8 \times 10''$ glossies piling up in the galleries, waiting to be reproduced in some newspaper or magazine. To be sure, there remain those half-crazed artists that try to find hideouts for their work. Yet, the totems of art and the taboos of the camera continue to haunt them.

Some artists are insane enough to imagine they can tame this wilderness created by the camera. One way is to transfer the urge to abstraction to photography and film. A camera is wild in just anybody's hands, therefore one must set limits. But cameras have a life of their own. Cameras care nothing about cults or isms. They are indifferent mechanical eyes, ready to devour anything in sight. They are lenses of the unlimited reproduction. Like mirrors they may be scorned for their power to duplicate our individual experiences. It is not hard to consider an Infinite Camera without an ego.

Somewhere between the still and movie camera, I postulate the Infinite Camera (no truth value should be attached to this postulation, it should be regarded as something to write about).

I am looking through a magazine called *35MM Photography*, Spring 1971—"A Complete Guide," and on the inside of its cover is a marvelous advertisement. It is a photograph of a still camera half submerged in polar waters. I do not know which pole. Of course, the camera is made in Japan—it is a Yashica. In the background of the advertisement is an iceberg. "Like the iceberg, the greatest part of Yashica's TL Electro-X is hidden beneath the surface." Now who could ask for a more Infinite Camera than that? The camera "eliminates troublesome needles, coils, springs, galvanometers—all moving parts." With this in mind, one can imagine thousands of tourists wandering on one of the ice caps taking countless snapshots of snow drifts. Such slides could be made into a motion picture. But as one goes deeper into this magazine, the camera wilderness grows denser. We see the "quick change artist," the Capro FL-7, the Ricoh ("You'd have to buy two cameras to get these features"), the Leicoflex SL ("You can hear the precision"), and so it goes. Who knows the right camera to choose? Actually, when I walk into a camera store, I am overcome by enervation. The sight of rows of equipment fills me with lassitude and longing. Lenses, light meters, filters, screens, boxes of film, projectors, tripods, and all the rest of it makes me feel faint. A camera store seems a perfect setting for a horror movie. A working title might be, *Invasion of the Camera Robots*; it would be

based on the Cyclops myth, with the camera clerk as Ulysses. A camera's eye alludes to many abysses. Each click would expose the clerk and his store to partial annihilation. I leave the ending for readers to figure out.

Nevertheless, those abysmal speculations do not keep me away from my own Kodak Instamatic reflex camera. Surrounding the aperture is a lens-opening scale made for determining light conditions—it carries the symbols of "cloud" and "sun." The more I consider them, the more they become hiero-glyphics—a secret code. There are times when light readings are governed by the cloud. Natural forces combine with automatic functions to create a region of overcast grayness, an area of inarticulation, dullness, and ambiguity. All and all, light is diminished. On the right side of the cloud is the symbol of the sun. The camera thus reminds us of that most brilliant object the sun—no it is not an object, but rather an undifferentiated condition from which there is no es-cape. Photographs are the results of a diminution of solar energy, and the cam-era is an entropic machine for recording gradual loss of light. No matter how dazzling the sun, there is always something to hide it, therefore to cause it to be desired. One tends to forget this, when firing flashbulbs in the shadows. As Paul Valéry pointed out, the sun is a "brilliant error." And I should like to add, that the camera records the results of that "error."

Above the symbols of cloud and sun on the focusing index is the symbol of "infinity." Once I had somebody take 400 snapshots of horizons in Seattle, the recording of such stigmatic vistas and unreachable limits resulted in a collec-tion of banished bits of space. Taking such photos puts the human eye in exile and brings on a cosmic punishment. The measurable lengths of objects give comfort and certainty in the face of the infinite. Length tells us how long a thing is, it is a measurement of anything from end to end. This unit leaves out width and breadth and is opposed to "shortness." Art yearns to be long not short.

> The comparison of narrative structure to architecture is right,
> insofar as both a story and a building make an arrangement or
> an enclosed place for living, a field of presence for the mind, by
> which everything outside of it can be dismissed from concern. It
> functions like the frame of a picture, to isolate what goes on inside
> it for complete attention and realization.
>
> Quoted in Donald Sutherland,
> *Gertrude Stein: A Biography of Her Work*

Richard Serra's film *Frame* exposes the contradictions of the measured unit. The problem that once attended painting, namely locating the "framing edge," is parodied in this film. Measurable lengths are reduced to a joke, and towards the end of the film Serra himself is caught in an illusion. It has also been brought to my attention that this film would not fit on the carefully con-structed screen at the Film Archive.

Michael Snow's film *Wavelength* could be seen as a documentary of a single still photograph of the ocean: the length of the wave is in the slow zoom shot, that advances through a series of pulsations and color disturbances. The inexhaustible ocean flux is absorbed by the infinity of the camera flux. Both wave and length are alienated from time and space. No distances remain to be measured, no points are to be connected—the ocean dries up into a photograph. It is interesting to see Snow now moving into the actual landscape with a delirious camera of his own invention.

The *Land Art* films shot by Gerry Schum of the Fernsehgalerie in Berlin leave something to be desired; nevertheless they do indicate an attempt to deal with art in the landscape. Television has the power to dilate the "great outdoors" into sordid frontiers full of grayness and electrical static. Vast geographies are contracted into dim borders and incalculable sites. Schum's "Television gallery" proliferates the results of Long, Flanagan, Oppenheim, Beuys, Dibbets, De Maria, Heizer, and myself over unknown channels which bifurcate into dissolving terrains.

Yet, within the range of public television as it exists in terms of contraction and diffusion, each artist retains his individual perception of order. An artist may operate in a "closed landscape." His point of view is then based on deliberate restrictions, he intends to define or plot a self-sustaining autonomous limit within a containing framework. Thus, the landscape plays the role of an "object" or "unit" that excludes breaks or interruptions. One order or view is carried to its logical conclusion. On the other hand there is the "open landscape" which embodies multiple views, some of which are contradictory, whose purpose is to reveal a clash of angles and orders within a sense of simultaneity; this shatters any predictable frame of reference. Intentional "concepts" are subverted. If the closed landscape is a matter of faith and certainty, the open landscape is a matter of skepticism and uncertainty. Many artists involved with the landscape have developed out of abstraction which is based, for the most part, on interior enclosures of sculpture parks. The studio and gallery are taken for granted. Abstraction emerges from a psychological fear of nature, and a distrust of the organic. Cities are abstract complexes of grids and geometries in flight from natural forces. The primitive dread of nature that Wilhelm Worringer put forth as the root of abstraction has devolved into what David Antin calls "affluent spirituality." Rather than turn their backs on nature, certain artists are now confronting it with the medium of the camera, as well as working directly with it.

It appears that abstraction and nature are merging in art, and that the synthesizer is the camera. As soon as one mentions abstraction or nature, many abstractions and natures come to mind. The degrees of abstraction diminish as one goes from the "city" with its squares and structures to the "country" with its plowed fields and farm yards, until it vanishes into the "wilderness" with its un[. . .] frontiers. The patterns of [abstraction] order things [in] the world

[into] countless frameworks that counter nature's encroachments. We live in frameworks and are surrounded by frames of reference, yet nature dismantles them and returns them to a state where they no longer have integrity.

Today's artist is beginning to perceive this process of disintegrating frameworks as a highly developed condition. Claude Lévi-Strauss has suggested we develop a new discipline called "Entropology." The artist and the critic should develop something similar. The buried cities of the Yucatan are enormous and heterogeneous time capsules, full of lost abstractions, and broken frameworks. There the wilderness and the city intermingle, nature spills into the abstract frames, the containing narrative of an entire civilization breaks apart to form another kind of order. A film is capable of picking up the pieces.

Let's face it, the "human" eye is clumsy, sloppy, and unintelligible when compared to the camera's eye. It's no wonder we've had so many demented and conflicting views of nature. As it turns out, ecology is the latest notion of humanized nature, or what used to be called "naturalism." Confidence in "human nature" has gone sour, the unproblematic sense of being human in the midst of a naive anthropomorphic pantheism leaves mother nature wading through polluted rivers. But how human is a flood or a hurricane? Surely, they are just as menacing as machines used wrongly. Just when the Positivist thought he had it made, the Cartesian Spectre comes back to haunt us. Michel Foucault has gone so far as to say that "man" like "God" will disappear as an object of our knowledge. Hopefully "objects" themselves will disappear, "specific" or otherwise. Abstraction like nature is in no way reassuring. Things-in-themselves are merely illusions.

A few weeks ago, I read in the *New York Times* that Alain Resnais is working on a film that deals with a frustrated movie producer, who turns to fighting pollution. The relationship between pollution and filmmaking strikes me as a worthwhile area of investigation. Resnais's landscapes and sites have always revealed a degree of horror and entrapment. In *Night and Fog*, Resnais contrasts a pastoral site (shot in technicolor) of a concentration camp overgrown with grass and flowers, with black and white photographs of horrors from its past. This suggests that each landscape, no matter how calm and lovely, conceals a substrata of disaster—a narrative that discloses "no story, no buoyancy, no plot" (Jean Cayrol: *Lazare parmi nous*). Deeper than the ruins of concentration camps, are worlds more frightening, worlds more meaningless. The hells of geology remain to be discovered. If art history is a nightmare, then what is natural history?

UNTITLED (1971)

ACROSS THE COUNTRY THERE ARE MANY MINING AREAS, DIS-USED QUARRIES, AND POLLUTED LAKES AND RIVERS. ONE PRACTICAL SOLUTION FOR THE UTILIZATION OF SUCH DEV-ASTATED PLACES WOULD BE LAND AND WATER RECYCLING IN TERMS OF "EARTH ART." RECENTLY, WHEN I WAS IN HOLLAND, I WORKED IN A SAND QUARRY THAT WAS SLATED FOR REDE-VELOPMENT. THE DUTCH ARE ESPECIALLY AWARE OF THE PHYSICAL LANDSCAPE. A DIALECTIC BETWEEN LAND RECLA-MATION AND MINING USAGE MUST BE ESTABLISHED. THE ARTIST AND THE MINER MUST BECOME CONSCIOUS OF THEM-SELVES AS NATURAL AGENTS. IN EFFECT, THIS EXTENDS TO ALL KINDS OF MINING AND BUILDING. WHEN THE MINER OR BUILDER LOSES SIGHT OF WHAT HE IS DOING THROUGH THE ABSTRACTIONS OF TECHNOLOGY HE CANNOT PRACTICALLY COPE WITH NECESSITY. THE WORLD NEEDS COAL AND HIGH-WAYS, BUT WE DO NOT NEED THE RESULTS OF STRIP-MINING OR HIGHWAY TRUSTS. ECONOMICS, WHEN ABSTRACTED FROM THE WORLD, IS BLIND TO NATURAL PROCESSES. ART CAN BE-COME A RESOURCE, THAT MEDIATES BETWEEN THE ECOLO-GIST AND THE INDUSTRIALIST. ECOLOGY AND INDUSTRY ARE NOT ONE-WAY STREETS, RATHER THEY SHOULD BE CROSS-ROADS. ART CAN HELP TO PROVIDE THE NEEDED DIALECTIC BETWEEN THEM. A LESSON CAN BE LEARNED FROM THE IN-DIAN CLIFF DWELLINGS AND EARTHWORKS MOUNDS. HERE WE SEE NATURE AND NECESSITY IN CONSORT.

LETTER TO JOHN DIXON (1972)

799 Greenwich Street
New York, New York 10014
March 13, 1972

Mr. John Dixon
Progressive Architecture
Reinhold Publishing Corporation
600 Summer Street
Stamford
Connecticut 06904

Dear Mr. Dixon:

Here is a list of topics for the discussion at the Boston Museum on April 4:

1. The recycling of disused land masses such as strip mines and quarries in terms of earth art.
2. Decentralized Museum exhibitions—works not confined by galleries or parks.
3. Art works as ongoing developments rather than finished products.
4. Art and ecology viewed in terms of social rather than esthetic problems.
5. The relationship between farming and earth art.
6. Alternative to the "Culture Center"—non-transportable art built for non-neutral sites.
7. Changing views of nature. Nature as a physical dialectic rather than a representational condition. The end of landscape painting and the limits of idealism.

I am sure in the course of the discussion other things will come up. I am looking forward to meeting you. I will bring some slides of my Dutch project. See *Arts*, November, 1971.

Sincerely,

PRODUCTION FOR PRODUCTION'S SAKE (1972)

Gallery development starting in the late 50s and early 60s has given rise to a cultural economics that feeds on objects and ideas through a random market. The "market place of ideas" removes ideas from any physical reality. Because galleries and museums have been victims of "cut-backs," they need a cheaper product—objects are thus reduced to "ideas," and as a result we get "Conceptual Art." Compared to isolated objects, isolated ideas in the metaphysical context of a gallery offer the random art audience an esthetic bargain. Painting and sculpture as isolated things in themselves are still carriers of class mystifications such as "quality." Over-production takes a different form when it comes to modernist values. A group show of the followers of Anthony Caro only serves to reinforce the "quality" of Caro's sculpture. Critical mystification then reinforces that "influence" by representing or misrepresenting the idea of quality. The "object of art" becomes more a condition of a confused leisure class, and as a result the artist is separated from his own *work*. The patron of an Anthony Caro is thus conditioned by critical representations of reinforced "quality." Qualities are used to mask the value of the object, so that it is not merely an "object" among objects.

Production for production's sake, art for art's sake, sex for sex's sake are interwoven into an economic fabric that gives rise to that curious consumer called an "art lover." If you can produce art objects, idea objects, you can also produce sex objects. Andy Warhol simply produces all three at once, leaving the problems of quality for quality's sake to the more class conscious esthetes. By turning himself into a "Producer," Warhol transforms Capitalism itself into a Myth. Anything that you can "think" of can be turned into an object. In a fit of production hysteria, Paul Morrissey (*Village Voice*, March 2, 1972) has taken his cues from Hollywood and seized on violence for violence's sake. "We want to appeal to a mass audience, so we're using lots of violence." The many-are-called-few-are-chosen school of Michael Fried opposes such mass values. Yet, on another level the Fried school performs the same function with privileged values. Fried becomes Caro's Morrissey, whereas Morrissey becomes Warhol's Fried. Both Fried and Morrissey condition their audiences in the same way; their words may be different, "quality" and "violence," but they are both representing production for production's sake. It's not hard to imagine a film production called *Quality Violence*—opening scene: Holly Woodlawn impales Anthony Caro, played by Brigid Polk, on one of his sculptures after a violent argument over quality. The double headed hydra of mass and privileged values would come full circle.

UNTITLED (1972)

A dialectic between mining and land reclamation must be developed. Such devastated places as strip mines could be recycled in terms of earth art. The artist and the miner must become conscious of themselves as natural agents. When the miner loses consciousness of what he is doing through the abstractions of technology he cannot cope with his own inherent nature or external nature. Art can become a physical resource that mediates between the ecologist and the industrialist. The Peabody Coal, Atlantic Richfield, Garland Coal and Mining, Pacific Power and Light, and Consolidated Coal companies must become aware of art and nature, or else they will leave pollution and ruin in their wake.

PROPOSAL (1972)

Proposal for the reclamation of a strip mine site in terms of Earth Art and its relation to the Ohio State University Conference on Art Education.

A 1000 acre tract in the Egypt Valley in southeastern Ohio in the strip mining region has been slated for a recreation area by the Hanna Coal Company. The area as it exists today is in the beginning stages of reclamation—grading and planting. I have made a direct proposal in writing to the President of Hanna Coal, Mr. Ralph Hatch, advocating the commission of an "earth sculpture" as part of the reclamation program. Such a work would exist as a concrete example of how art can enter the social and educational process at the same time. Ohio State University is planning an international conference on new approaches to art education on April 2–8, 1973. Our ecological awareness indicates that industrial production can no longer remain blind to the visual landscape. The artist, ecologist, and industrialist must develop in *relation* to each other, rather than continue to work and to produce in isolation. The visual values of the landscape have been traditionally the domain of those concerned with the arts. Yet, art, ecology, and industry as they exist today are for the most part abstracted from the physical realities of specific landscapes or sites. How we view the world has been in the past conditioned by painting and writing. Today, movies, photography, and television condition our perceptions and social behavior. The ecologist tends to see the landscape in terms of the past, while most industrialists don't see anything at all. The artist must come out of the isolation of galleries and museums and provide a concrete consciousness for the present as it really exists, and not simply present abstractions or utopias.

The artist must accept and enter into all of the real problems that confront the ecologist and industrialist. It is my hope that the Egypt Valley project will be realized before the international conference on art education, so that students and critics can learn from a concrete situation. Art should not be considered as merely a luxury, but should work within the processes of actual production and reclamation. We should begin to develop an art education based on relationships to specific sites. How we *see* things and places is not a secondary concern, but primary.

I have already demonstrated that it is possible to combine reclamation and art in two completed projects—the *Broken Circle* in a sand quarry in Holland which was slated for reclamation, and the *Spiral Jetty* in the Great Salt Lake, Utah near an old oil mining region.

Art on this scale should be supported directly by industry, not only private art sponsorship. Art would then become a necessary resource, and not an isolated luxury. The artist must overcome the inequities that come in the wake of blind progress. Such things will be brought to consciousness during the educational conference. Those in economic power should not thwart such necessary enterprises. I am therefore requesting that you endorse my proposal. Artists should not be cheated out of doing their work, or forced to exist in the isolation of "art worlds." There should be artist-consultants in every major industry in America.

Robert Smithson, Bingham Copper Mining Pit, Utah Reclamation Project, 1973.

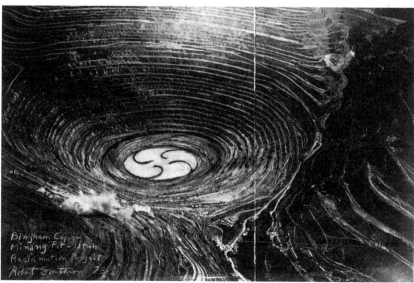

GLOSSARY OF NAMES

The following brief identifications include people who interviewed Smithson, who figure prominently in the writings and interviews, or who wrote pieces that are included in them.

CARL ANDRE (b. 1935), American sculptor, a major and influential figure within the minimalist movement. His important site-specific piece, *Lever*, consisting of 137 bricks laid side by side on the floor, was included in the "Primary Structures" exhibition in 1966.

JO BAER (b. 1929), American painter who has also written art criticism and technical articles.

GREGORY BATTCOCK (b. 1941–1980), American art critic and lecturer who wrote about contemporary art and edited a number of widely-used anthologies, including *Minimal Art* (1968) and *Idea Art* (1973).

LIZA BEAR (b. 1942), British writer and filmmaker based in New York. At the time of the interview she was the co-founder and editor of *Avalanche*.

MEL BOCHNER (b. 1940), American artist. At the time of his collaboration with Smithson he was just beginning to write about art; afterward, he published books on art and theory, including *Background Is Not the Margin* and *Art in Process* in 1969. Continues to work as a writer and conceptual artist.

ANTHONY CARO (b. 1924), English sculptor, closely associated with Clement Greenberg when Smithson wrote about him. His constructed metal sculptures continue the high modernist tradition of David Smith.

ROGER CORMAN (b. 1926), American film director and producer. An especially prolific director, he has worked in a wide range of genres, including westerns, science fiction, horror, gangster, rock, and hot rod films.

PAUL CUMMINGS, American art historian, curator, and chronicler. At the time of the Smithson interview, he was director of the oral histories program of the Archives of American Art.

WALTER DE MARIA (b. 1935), American environmental artist who has sited several of his works in southwestern American deserts.

JOHN DIXON (b. 1930), American art and architectural historian and designer; was editor of *Progressive Architecture* magazine.

VIRGINIA DWAN, owner of the Dwan Gallery, where Smithson had one-person exhibitions in 1966, 1968, 1969, and 1970 and where the groundbreaking "Earthworks" exhibition took place in 1968.

DAN FLAVIN (b. 1933), American artist. A minimalist sculptor who has worked with fluorescent tubes since 1963, he participated in the "Primary Structures" exhibition at the Jewish Museum in 1966 and in Documenta IV in 1968.

MICHAEL FRIED (b. 1939), American critic and art historian. During the 1960s, he was closely associated with Clement Greenberg and formalist criticism.

DAN GRAHAM (b. 1942), American performance and conceptual artist who also writes about art.

CLEMENT GREENBERG (1909–1994), American art critic. Arguably the most influential

critic of the postwar period, he emphasized formal purity and fidelity to the inherent qualities of the medium, a viewpoint in direct opposition to Smithson's thinking.

HANS HAACKE (b. 1936), German-born artist based in the United States. A pioneering conceptual artist, he has been deeply engaged in critiques of capitalist society.

MICHAEL HEIZER (b. 1944), American artist. A pioneering practitioner of site-specific earth art, especially well-known for *Double Negative* (1969–70), a 240,000-ton displacement in the Nevada desert.

NANCY HOLT (b. 1938), American artist. A pioneer in site-specific public sculpture, she also makes films, videotapes, and installations. She and Smithson were married from 1963 until his death.

PETER HUTCHINSON (b. 1932), British-born artist based in the United States. A conceptual and environmental artist, in 1968 he published three notable articles, "Earth in Upheaval," in *Arts*; "Science Fiction: An Aesthetic for Science," in *Art International*; and "Is There Life on Earth?" in *Art in America*.

NEIL JENNY (b. 1945), American artist whose works developed an increasingly direct environmental message.

DONALD JUDD (1928–1994), American artist. A pioneering minimalist sculptor who employed modular units and drew attention to the concrete, literal presence of sculptural works. Also wrote criticism and essays on art.

ALLAN KAPROW (b. 1927), American artist, widely known for staging and writing about Happenings. Has subsequently taught at various universities and art schools.

GYORGY KEPES (b. 1906), Hungarian-born artist based in the United States. Worked as a painter and teacher and edited volumes of Braziller's *Vision and Value* series.

BRUCE KURTZ (b. 1943), American art historian and curator. At the time of his interview with Smithson, he taught art history at Hartwick College.

PHILIP LEIDER (b. 1929), American editor and art historian. As editor of *Artforum* from 1964 to 1971, he encouraged Smithson in his writing and published several of his articles.

SOL LEWITT (b. 1928), American artist. Known mainly as a minimal and conceptual artist, placing emphasis on systemic logic and generative procedures.

WILLIAM C. LIPKE (b. 1936), American art historian. During the 1960s, he taught art history at Cornell University. He is presently professor of art history at the University of Vermont.

RICHARD LONG (b. 1945), English environmental artist who makes art out of long walks throughout the countryside and creates interior installations with materials such as rocks and mud.

ROBERT MORRIS (b. 1931), American artist who helped pioneer minimalist, conceptual, and earth art as well as the "new dance" associated with the Judson Church.

GREGOIRE MÜLLER (b. 1947), American artist. A painter and installation artist, he was the editor of *Arts* magazine from 1970 to 1972.

KENNETH NOLAND (b. 1924), American color field painter who was closely associated with Clement Greenberg.

PATSY NORVELL (b. 1942), American artist, now doing public sculpture. At the time she interviewed Smithson she was a practicing artist working on a master's thesis.

BRIAN O'DOHERTY (b. 1934), Irish-born writer and sculptor (under the name Patrick Ireland) based in the United States. He was director of the Visual Arts Program of the

National Endowment for the Arts from 1969 to 1976 and has been director of the Media Arts Program since 1976.

JULES OLITSKI (b. 1922), Russian-born American artist. A painterly abstractionist closely associated with Clement Greenberg.

DENNIS OPPENHEIM (b. 1938), American sculptor who works in various materials and forms. As an earth artist, he participated in the 1969 "Earthworks" exhibition at Cornell.

GIANNI PETTENA (b. 1940), Italian architectural theorist. At the time of the Smithson interview, he was visiting architect at the University of Utah Graduate School of Architecture. Now teaches at the University of Florence.

AD REINHARDT (1913–1967), American abstract painter known for his "black" paintings. His famous cartoon, "How to Look at Modern Art in America," was first published in *PM* magazine in 1946.

ANTHONY ROBBIN (b. 1943), American artist. A painter at the time that he did the Smithson interview, he now makes public sculpture.

MOIRA ROTH (b. 1933), American art historian. Her interview with Smithson was part of a series of interviews she did with artists and critics while working on her dissertation on Duchamp's role in contemporary American art. She now teaches art history at Mills College.

IRVING SANDLER (b. 1925), American critic and art historian. Published the earliest notice of Smithson's work, a review of his first one-man show (which ran from October 17 to November 5, 1959, at the Artists Gallery, New York) in the October 1959 issue of *Art News*. He is known especially for his history of Abstract Expressionism, *The Triumph of American Painting* (1970).

WILLOUGHBY SHARP (b. 1936), American writer, curator, and gallery owner. He was co-founder and publisher of *Avalanche*.

EVA SCHMIDT (b. 1957), German art historian. Did her doctoral dissertation on Smithson's work; now director of the Gesellschaft für Aktuelle Kunst e.V., Bremen.

ALISON SKY (b. 1946), American artist. Involved in public art, language, and sculpture, she was a co-founder of SITE, created to fuse art, architecture, sculpture, language, and public spaces. Her interview with Smithson, which took place about two months before his death, was done as part of the *On Site on Energy* series.

TONY SMITH (1912–1981), American artist. A pioneer in exploring the idea of the holistic image in large-scale sculptures that deeply impressed the younger minimalists.

PAUL TONER (b. 1948), interviewed Smithson for an art history course he was taking with Lawrence Alloway. He worked at both the Dwan Gallery and the John Weber Gallery in the early 1970s.

GUNTHER UECKER (b. 1930), German artist who makes sculpture in a variety of forms and materials.

JOHN WEBER (b. 1932), American art dealer. Owner of the John Weber Gallery, New York, where Smithson showed from 1971 until his death. The gallery has represented the Smithson Estate since 1973.

DENNIS WHEELER (1946–1977), Canadian art historian and filmmaker.

BIBLIOGRAPHY OF WRITINGS BY ROBERT SMITHSON

Entries give first publication and are arranged chronologically within each section.

ARTICLES, STATEMENTS, POEMS

"From the Walls of Dis." 1959–61. In *Robert Smithson Unearthed: Drawings, Collages,* Writings, ed. Eugenie Tsai. New York: Columbia University Press, 1991, pp. 54–55.

"To the Flayed Angels, 1959–61. In Tsai, pp. 56–58.

"From the City." 1959–61. In Tsai, pp. 59–60.

"The Iconography of Desolation." c. 1962. In Tsai, pp. 61–68.

"The Eliminator." 1964. In *The Writings of Robert Smithson*, ed. Nancy Holt. New York: New York University Press, 1979, p. 207.

"*Quick Millions.*" 1965. In Brian O'Doherty, *Art '65: Lesser Known and Unknown Painters, Young Sculptors.* American Express Pavilion Catalogue, New York World's Fair, pp. 68–69.

"Donald Judd." 1965. In *7 Sculptors.* Philadelphia Institute of Contemporary Art Catalogue. Also in *Writings* 1979, pp 21–23.

"The Cryosphere." April 1966. In *Primary Structures.* Exhibition Catalogue, Jewish Museum, n. p. Also in *Writings* 1979, p. 37.

"The Crystal Land." May 1966. *Harper's Bazaar*, no. 3054:72–73. Also in *Writings* 1979, pp. 19–20.

"Entropy and the New Monuments." June 1966. *Artforum* 5, no. 10:26–31. Also in *Writings* 1979, pp. 9–18. And Selection in Maurice Tuchman, ed. *American Sculpture of the Sixties.* Los Angeles County Museum of Art, 1967, pp. 51–52.

"The X Factor in Art." July 1966. *Harper's Bazaar*, no. 3056:78–79.

"Interpolation of the Enantiomorphic Chambers." 1966. In *Art in Process: The Visual Development of a Structure.* New York: Finch College Museum of Art, Contemporary Study Wing, n. p. Also in *Writings* 1979, pp. 39–40.

"The Domain of the Great Bear." Fall 1966. By Mel Bochner and Robert Smithson. *Art Voices* 5, no. 4:44–51. Also in *Writings* 1979, pp. 24–31.

"Response to a Questionnaire from Irving Sandler." 1966. In *Writings* 1979, pp. 216–217.

"The Shape of the Future and Memory." 1966. In *Writings* 1979, p. 211.

"An Esthetics of Disappointment." 1966. On the occasion of the "Art and Technology" show at the Armory. In *Writings* 1979, p. 212.

"Sol LeWitt." 1966. Dwan Gallery press release. In *Writings* 1979, p. 210.

"Quasi-Infinities and the Waning of Space." November 1966. *Arts Magazine* 41, no. 1:28–31. Also in *Writings* 1979, pp. 32–36.

"The Artist as Site–Seer; or, A Dintorphic Essay." 1966–67. In Tsai, pp. 74–80.

"What Really Spoils Michelangelo's Sculpture." 1966–67. In Tsai, pp. 71–73.

"Proposal for Earthworks and Landmarks to be Built on the Fringes of the Fort Worth–Dallas Regional Air Terminal Site." 1966–67. In Tsai, pp. 69–70.

"Language to Be Looked at and/or Things to Be Read." June 1967. Dwan Gallery Press Release. In *Writings* 1979, p. 104.

"Towards the Development of an Air Terminal Site." June 1967. *Artforum* 6, no. 10:36–40. Also in *Writings* 1979, pp. 41–47.

"Ultramoderne." September/October 1967. *Arts Magazine* 42, no. 1:31–33. Also in *Writings* 1979, pp. 48–51.

"Letter to the Editor." October 1967. *Artforum* 6, no. 2:4. Also in *Writings* 1979, p. 38.

"Some Void Thoughts on Museums." November 1967. *Arts Magazine* 42, no. 2:41. Also in *Writings* 1979, p. 58.

"From Ivan the Terrible to Roger Corman or Paradoxes of Conduct in Mannerism as Reflected in the Cinema." 1967. In *Writings* 1979, pp. 213–215.

"The Monuments of Passaic." December 1967. *Artforum* 7, no. 4:48–51. Also in *Writings* 1979, pp. 52–57.

"What Is a Museum? A Dialogue with Allan Kaprow. " 1967. *Arts Yearbook*, pp. 94–107. Also in Writings 1979, pp. 59–66.

"Pointless Vanishing Points." 1967. In *Writings* 1979, p. 208.

"The Monument: Outline for a Film." 1967. In Tsai, pp. 81–82.

"A Museum of Language in the Vicinity of Art." March 1968. *Art International* 12, no. 3:21–27. Also in *Writings* 1979, pp. 67–78.

"A Thing Is a Hole in a Thing It Is Not." April 1968. *Landscape Architecture* 58, no. 3:205.

"The Establishment." June 1968. *Metro* 14:n.p. Also in *Writings* 1979, pp. 79–80.

"Minus Twelve." 1968. In Gregory Battcock, ed. *Minimal Art: A Critical Anthology*. New York: E. P. Dutton, pp. 402–406. Also in *Writings* 1979, p. 81.

"Nature and Abstraction." c. 1968. In *Writings* 1979, p. 219.

"Outline for Yale Symposium: Against Absolute Categories." 1968. In *Writings* 1979, p. 218.

"A Sedimentation of the Mind: Earth Projects." September 1968. *Artforum* 7, no. 1:44–50. Also in *Writings* 1979, pp. 82–91.

"Hidden Trails in Art." 1969. In Tsai, pp. 83–84.

"Untitled." January 1969. *o to 9*. In Vito Acconci, ed. New York: Vito Acconci, n.p.

"Aerial Art." February–April 1969. *Studio International* 175, no. 89:180–181. Also in *Writings* 1979, pp. 92–93.

"Project: Overturning Rocks and Mirror Trails." March 28, 1969. In Seth Singelaub, ed. *One Month*. New York: Seth Singelaub, n.p.

"Dialectic of Site and Nonsite." April 1969. In Gerry Schum, ed. *Land Art*. Hannover: Fernsehgalerie, n. p.

"Incidents of Mirror-Travel in the Yucatan." September 1969. *Artforum* 8, no. 1:28–33. Also in Writings 1979, pp. 94–103.

"Can Man Survive?" 1969. In Tsai, pp. 85–87.

"Art and Dialectics." 1970. In *Writings* 1979, p. 219.

"The Artist and Politics: A Symposium." September 1970. *Artforum* 9, no. 1:39.

"Symposium." 1970. In *Earth Art*. Exhibition Catalogue, Andrew Dickson White Museum of Art, Cornell University, n.p. Also in *Writings* 1979, pp. 160–167.

"Strata: A Geophotographic Fiction." Fall/Winter 1970–71. *Aspen*, no. 8. Also in *Writings* 1979, pp. 129–131.

"A Cinematic Atopia." September 1971. *Artforum* 10, no. 1: 53–55. Also in *Writings* 1979, pp. 105–108.

"Untitled, 1971." In *Writings* 1979, p. 220.

"Art Through the Camera's Eye." c. 1971. In Tsai, pp 88–92.

"Documenta 5: A Critical Preview." Summer 1972. By Bruce Kurtz with a comment by Robert Smithson. *Arts Magazine* 46, no. 8:31.

"Proposal, 1972" (for reclamation of a strip mine in terms of Earth Art). In *Writings* 1979, p. 221.

"The Spiral Jetty." 1972. In Gyorgy Kepes, ed. *Arts of the Environment*. New York: G. Braziller, pp. 222–232. Also in *Writings* 1979, pp. 109–116.

"Cultural Confinement." October 1972. *Artforum* 11, no. 2:32. Also in *Writings* 1979, pp. 132–133.

"Untitled, 1972." In *Writings* 1979, p. 220.

"Frederick Law Olmsted and the Dialectical Landscape." February 1973. *Artforum* 11, no. 6:62–68. Also in *Writings* 1979, pp. 117–128.

"Gyrostasis." 1974. In Abram Lerner, ed. *Hirshhorn Museum and Sculpture Garden Catalogue*. New York: Harry N. Abrams, p. 749. Also in *Writings* 1979, p. 37.

INTERVIEWS AND CONVERSATIONS

Robbin, Anthony. "Smithson's Non-Site Sights." February 1969. *Art News* 67, no. 10:50. Also in *Writings* 1979, pp. 157–159.

Leavitt, Thomas. "Earth." February 1969. Symposium at White Museum, Cornell University. In *Writings* 1979, pp. 160–167.

Lipke, William C. "Fragments of a Conversation." February 1969. In *Writings* 1979, pp. 168–170.

Norvell, P. A. [Patsy]. "Robert Smithson: Fragments of An Interview with P. A. Norvell, April, 1969." Ed. Lucy R. Lippard and Robert Smithson: a few additions made by the artist. In Lucy R. Lippard. *Six Years: The Dematerialization of the Art Object*. New York: Praeger, 1973, pp. 87–90.

Wheeler, Dennis. "Four Conversations between Dennis Wheeler and Robert Smithson, December 1969–January 1970." In Tsai, pp. 93–126.

[Bear, Liza and Sharp, Willoughby.] "Discussions with Heizer, Oppenheim, Smithson." Fall 1970. *Avalanche* 1, no. 1:48–71. Also in *Writings* 1979, pp. 171–178.

Müller, Gregoire. ". . . Earth, Subject to Cataclysms, Is a Cruel Master." November 1971. *Arts Magazine* 46, no. 2:36–41. Also in *Writings* 1979, pp. 179–185.

Kurtz, Bruce. "Conversation with Robert Smithson on April 22nd 1972." Ed. Bruce Kurtz. In *The Fox II*, 1975, pp. 72–76. Also in *Writings* 1979, pp. 200–204.

Cummings, Paul. "Interview with Robert Smithson for the Archives of American Art/ Smithsonian Institution." Interview conducted on July 14 and 19, 1972. In *Writings* 1979, pp. 137–156.

Pettena, Gianni. "Conversation in Salt Lake City." November 1972. *Domus*, no. 516:53–56. Also in *Writings* 1979, pp. 186–188.

Roth, Moira. "Robert Smithson on Duchamp: An Interview." October 1973. *Artforum* 12, no. 2:47. Also in *Writings* 1979, pp. 197–199.

Sky, Alison. "Entropy Made Visible." Fall 1973. *On Site* 4:26–30. Also in *Writings* 1979, pp. 189–196.

INDEX

Numbers in italics indicate pages on which illustrations appear.

Designer:	Linda Davis, Star Type, Berkeley
Compositor:	Star Type, Berkeley
Text:	10.5/13.5 Bembo
Display:	Gill Sans